THE CAVE CHURCH OF PAUL THE HERMIT

AT THE MONASTERY OF ST. PAUL, EGYPT

EDITED BY

WILLIAM LYSTER

THE CAVE CHURCH
OF PAUL THE HERMIT
AT THE MONASTERY OF
ST. PAUL, EGYPT

❖

AMERICAN RESEARCH CENTER IN EGYPT, INC.

YALE UNIVERSITY PRESS NEW HAVEN AND LONDON

This publication was made possible through support provided by the Office of Environment and Infrastructure/ Environment and Engineering (EI/EE), USAID/Egypt, United States Agency for International Development, under the terms of Grant No. 263-G-00-96-00016-000. The opinions expressed herein are those of the authors and do not necessarily reflect the views of the United States Agency for International Development.

Designed by Leslie Fitch Design
Set in Minion and Quay by Leslie Fitch
Printed in Singapore by CS Graphics

Library of Congress Cataloging-in-Publication Data
The cave church of Paul the Hermit at the monastery of St. Paul, Egypt / edited by William Lyster

 p. cm.

 Includes bibliographical references and index.

 ISBN 978-0-300-11847-6 (cloth : alk. paper)

 1. Monastery of St. Paul the Hermit (Egypt) 2. Monasteries—Egypt. 3. Christian antiquities—Egypt. 4. Egypt—Antiquities. 5. Coptic Church—Egypt—History. 6. Church architecture—Egypt—History. I. Lyster, William.

 BX138.M67C38 2008

 271'.817209623—dc22 2007027922

A catalogue record for this book is available from the British Library.

The paper in this book meets the guidelines for permanence and durability of the Committee on Production Guidelines for Book Longevity of the Council on Library Resources.

10 9 8 7 6 5 4 3 2 1

During the course of the American Research Center in Egypt's intervention at the Monastery of St. Paul (1997–2005), Anba Agathon, bishop of Ismailia and abbot of the monastery, passed away, as did the conservation maestro Adriano Luzi. This book is dedicated to their memory.

CONTENTS

PART I PAUL THE HERMIT AND HIS MONASTERY: GENERATION, IMITATION, AND RECEPTION

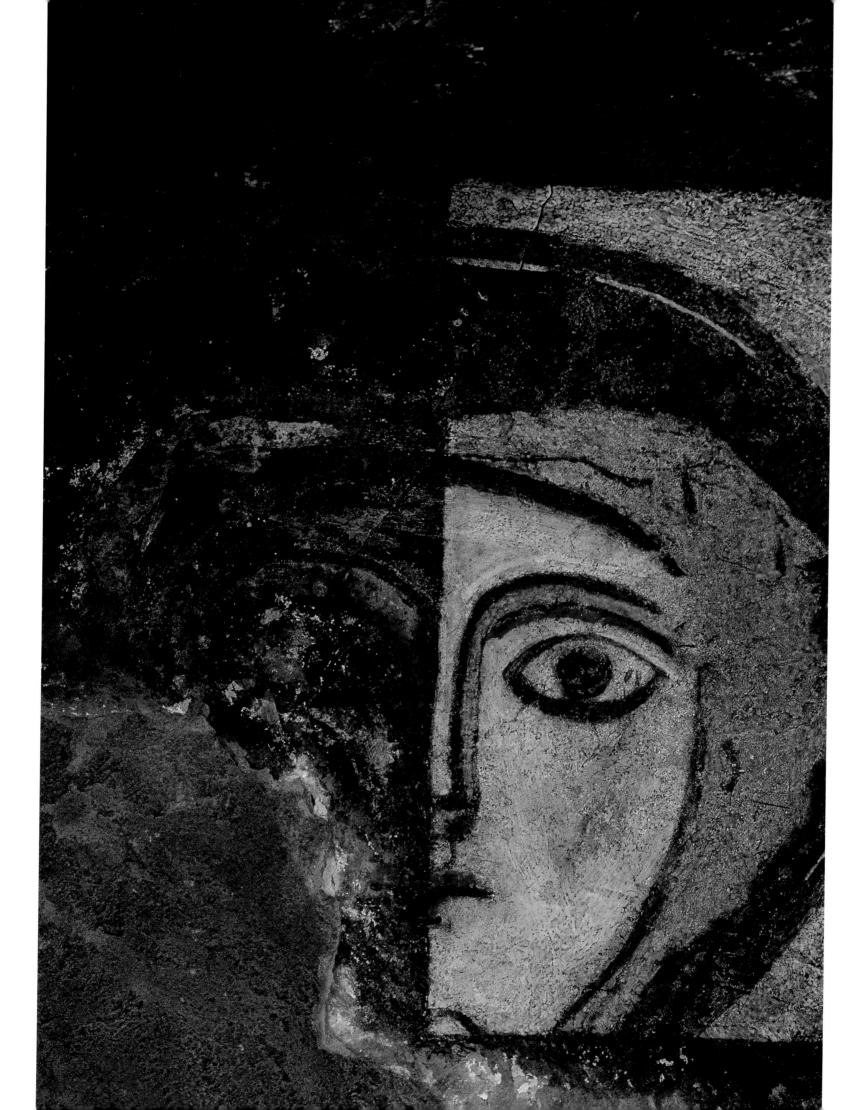

FOREWORD

PRESERVING THE PAST FOR THE FUTURE: THE AMERICAN RESEARCH CENTER IN EGYPT

FIGURE 1

Virgin Mary (E6), first half of the
thirteenth century, after the first
test cleaning in 1999. ADP/SP 12
s149 99.

In 1992, Cairo suffered a significant earthquake that damaged many of its historic buildings. In response to this natural disaster, the U.S. Congress launched a special conservation initiative to conduct cultural heritage conservation projects throughout Egypt. The organization selected to carry out this ambitious proposal was the American Research Center in Egypt (ARCE), because of its long-standing collaborative relationship with Egypt's Supreme Council of Antiquities (SCA). Funding for the project was through a generous grant from the United States Agency for International Development (USAID). The resulting enterprise, ARCE's Egyptian Antiquities Project, has flourished for over a dozen years and has carried out more than forty projects, reflecting a broad range of conservation work at monuments that cover the full sweep of Egypt's long history: prehistoric, pharaonic, Greco-Roman, Coptic, and Islamic (fig. 1).

Because of the great success of ARCE's initial conservation work, USAID offered additional funding for a second conservation grant to ARCE as an activity of Subcommittee III for Sustainable Development and the Environment of the U.S.-Egyptian Partnership for Economic Growth and Development. This time, however, conservation work was to be conducted specifically in Egypt's Red Sea region, and the initiative was named the Antiquities Development Project. Three sites for conservation were selected: the Ottoman Fort at Quseir, the Monastery of St. Antony, and the Monastery of St. Paul. Each of these three projects is to be published, with the first, on the Monastery of St. Antony, having already appeared as a joint ARCE/Yale University Press publication.

It is, therefore, a special pleasure to join once again with Yale University Press in the publication of a companion volume on ARCE's work at the Monastery of St. Paul. This book represents the deep dedication and professional excellence of those who performed the work, whether the actual conservation measures, the painstaking recording of the results, or the scholarly examination of what the conservation program uncovered. Because of the tireless efforts of conservators, scholars, members of the clergy, and other specialists, this extraordinary monument may now be seen in its full glory for the first time in generations. In addition, new material has been brought to light, and it is a privilege to be able to share these discoveries with a wider audience through this publication. ARCE is grateful to each of the contributors, especially to William Lyster, the editor, to Michael Jones, who oversaw much of the fieldwork for each of ARCE's Antiquities Development Projects, and to Patrick Godeau, whose photographs of St. Paul's enrich this volume.

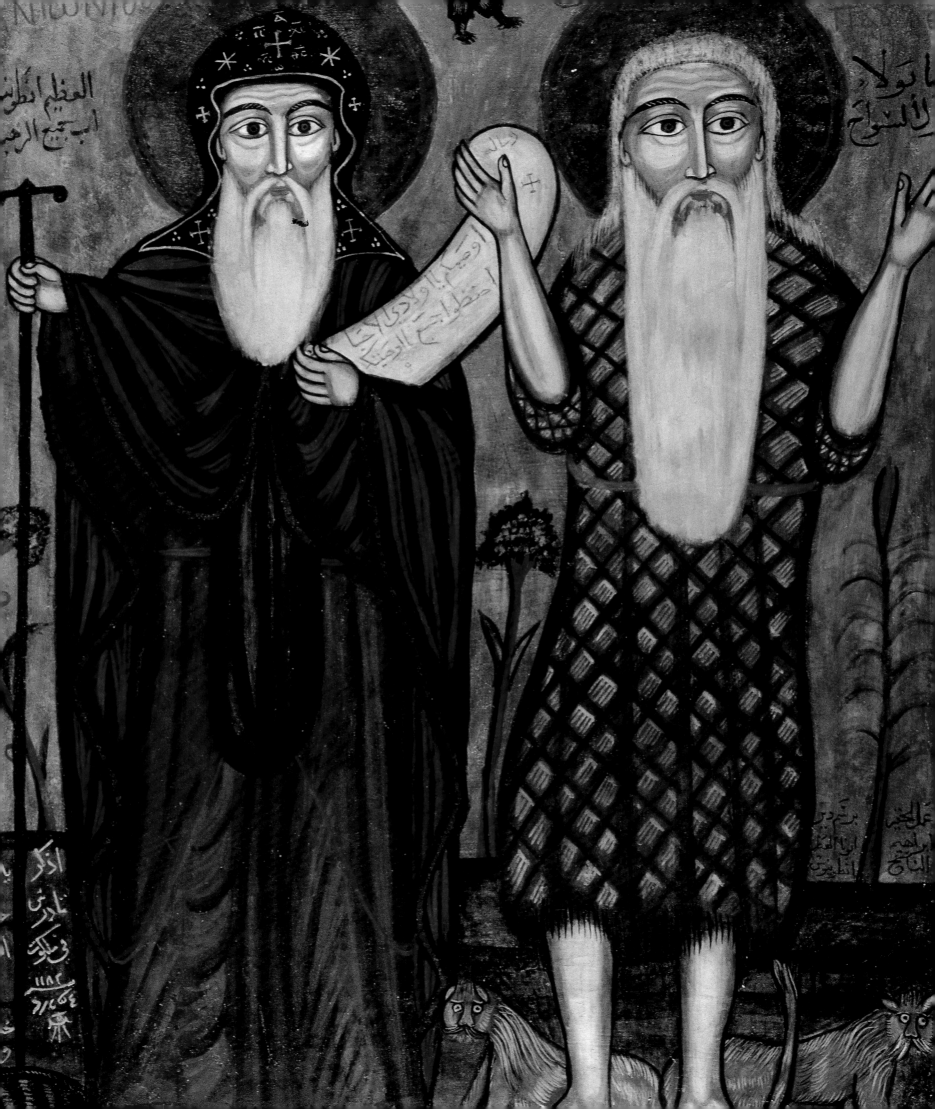

PREFACE

THE HISTORICAL RELATIONSHIP BETWEEN THE MONASTERIES OF ST. ANTONY AND ST. PAUL

In the early fourth century of the Christian era, St. Antony the Great (251–356) withdrew from the monastic community he had founded near the Nile valley and moved deeper into the Eastern Desert in search of a more remote hermitage. He eventually came to the northern face of the South Galala plateau, near the Red Sea, where he found a natural spring at the base of the mountain. St. Antony fell in love with the place at once and spent the rest of his long life in a cave set in the cliff face of his Inner Mountain.

When St. Antony was a very old man he had a vision of another ascetic living even deeper in the desert. He set out in search of this hermit, although he had no idea where he lived. Guided by God, he crossed the South Galala plateau and found St. Paul, who had lived alone in a cave on the other side of the mountain for more than ninety years (fig. 2). St. Paul told St. Antony about his life, and St. Antony afterward passed the story on to his disciples. It was from these younger monks that St. Jerome first heard of St. Paul the Hermit.

Although St. Jerome's *Life of Paul* corresponds closely to the Coptic tradition, there are a few important discrepancies. St. Jerome, for example, says that St. Paul fled into the desert to escape the storm of persecution, and then made a virtue of necessity by becoming a hermit. We know, however, that St. Paul did not withdraw from human society in an attempt to save his own life but, rather, willingly embraced the difficult existence of a desert hermit out of love of God and the desire for perfection. St. Paul told St. Antony: "Whoever flees from hardship flees from God."

Ever since their meeting in the desert, St. Antony and St. Paul have been associated with each other. John

Cassian, writing circa 428, already was describing the two saints as the originators of Christian monasticism. Their encounter is frequently depicted in the art of both the Orthodox and Catholic churches. In a similar manner, the Coptic Red Sea monasteries dedicated to St. Antony and St. Paul have also been closely connected throughout their long histories. The earliest monastic settlement around the cave of St. Paul was founded by monks of St. Antony's, seeking a retreat of greater austerity. For most of their recorded histories, the monasteries were two branches of the same community, which was ruled by a single abbot. Today, the monks of St. Antony and St. Paul still feel that they belong to one and the same monastery, even though the two communities are now officially separated and each is under the authority of its own resident bishop.

Until the mid-twentieth century, when the Red Sea monasteries were first connected by a modern road, the monks of St. Antony and of St. Paul could communicate with each other only by crossing the Galala plateau or circling around it. The fastest route, as well as the most difficult, is to climb directly over the mountain by way of a narrow trail. Robert Vincent provides an account his own crossing of the plateau by this route in the Prologue of this book. A second, much easier way, circles the base of the mountain while following the Red Sea coast. This is how Claude Sicard traveled between the monasteries in 1716, stopping to collect seashells on the way. The monks of the Eastern Desert, however, also know a third route, which linked the two communities until modern times. It follows a path through a series of small wadis to the southwest of the Monastery of St. Antony that leads to one of the lowest peaks of

the plateau, which is about eleven hundred meters above sea level. The great advantage of this way is that it is faster than the second route, but much easier than the first. In particular, both the ascent and descent are gradual enough for camels and other animals to transverse.

Before the building of the modern coastal road, the monks of the Monastery of St. Paul followed this third route to the Monastery of St. Antony every year for the celebration of the feast of St. Antony on 22 Tuba of the Coptic calendar (January 30). They were escorted by bedouin guides who supplied camels to carry the food and water necessary for the journey, as well as gifts for the monks of St. Antony's. The monks of St. Paul's brought these gifts especially for the occasion from the Nile valley. They also took a calf, which walked alongside them over the mountain. It served as the communal meal that marked the end of the feast.

Upon reaching the monastery, the monks of St. Paul's presented their gifts to the monks of St. Antony's: two pairs of underwear, two cassocks, and two pairs of shoes for each one. The abbot of St. Antony's presented all the keys of the monastery to the monks of St. Paul's, who were thus placed in charge for the duration of the feast. On the evening before the feast, the monks gathered in procession, carrying crosses and icons of St. Antony and St. Paul, while singing hymns in honor of the two saints. At midnight, they celebrated the night office in the Church of St. Antony, followed by the liturgy. The holy mass would finish early in the morning, after which all the monks would break their fast together, sharing a strong feeling of brotherhood. The monks of St. Paul's remained at the monastery for about week until it was

time to prepare for the feast of St. Paul on 2 Amshir (February 9). Then the monks of St. Antony's would accompany the monks of St. Paul's across the mountain, bringing a calf and gifts of their own. Upon reaching the monastery the monks of St. Paul would greet their brethren from St. Antony's with a reciprocal exchange of keys and duties before celebrating the feast of St. Paul.

Today, the monks of the Red Sea monasteries still visit each other to celebrate the feasts of St. Antony and St. Paul, although we no longer exchange keys and duties. Nor do we use this route across the Galala plateau on an annual basis. It has been replaced by modern roads, just as camels have been replaced by automobiles. Toward the end of the ARCE conservation project at the Cave Church, in April 2005, I led a small group along the old path between the Red Sea monasteries. Among our numbers were Father Tomas of the Monastery of St. Paul, Luigi De Cesaris and his team of conservators, and representatives of ARCE and USAID. We followed the example of earlier monks and walked across the mountain accompanied by four bedouin guides, with four camels carrying our supplies. The journey took two and a half days, during which time we walked for sixteen hours and covered about fifty kilometers. I then returned to the Monastery of St. Antony by car, which took only about forty-five minutes. Although much has changed for the monks of St. Antony and St. Paul in a very short period of time, the spiritual bonds uniting the monastic brotherhood dedicated to the two great saints of the Eastern Desert remain as strong as ever.

PROLOGUE

IN THE FOOTSTEPS OF ST. ANTONY

Fran and I had long wanted to climb over the mountains between the Red Sea monasteries of St. Antony and St. Paul (fig. 3). These are extremely holy places historically, because they literally embody Antony, the father of monasticism, and Paul, the first hermit. In the mid-fourth century, Antony, at age ninety, took this route, finding and meeting an ailing Paul, who died not long after. Legend has it that he was buried by Antony with the assistance of two desert lions that helped dig the grave out of respect for the saint. Similarly, the conservation work of ARCE followed the same direction, starting at the Church of St. Antony and then proceeding to the Cave Church of St. Paul, bringing new life to both of these venerated houses of worship. My wife and I looked forward to the challenge of a hike across the mountain on which we had to carry all our provisions, could not call on outside support, and faced a potentially dangerous route. We thought we could manage the hike by ourselves because we were fit, experienced walkers and had spent a great deal of time in the deep desert.

When we arrived at the Monastery of St. Paul the day before the hike, we learned, much to our surprise and delight, that two of our friends would join us. Father Macari, who knew the area well after years of solitary retreat in a cave in the mountain, would guide us, and Father Tomas, the monastic site manager of the conservation work in the Cave Church, wanted to make the trip for the first time. We suspected that Father Macari felt concerned about us and wished not only to lead us but to make sure no harm came to us. The traces of the trail are neither clearly visible nor well marked, and the journey can be treacherous. Just the previous summer a lone walker had wandered off the route and died of dehydration. On the recommendation of Father Macari we decided to start our hike from the Monastery of

St. Antony. Not only would we be following the direction Antony himself took, but we would also encounter the most difficult parts of the walk while still fresh. We shouldered our packs and took to the trail at seven in the morning on November 27, 2002.

The first couple of hours we strolled in the wadi gravels, adjusting ourselves to the trip. But as we began to ascend the harder limestone of the mountain, we had a tricky time finding the correct wadi for the climb up. Father Macari's memory was tested, but he identified the path that eventually brought us to the base of what seemed like an insurmountable cliff. He was heavily fatigued, and I was worried for him. It was not surprising since, as he told us, he had confined himself to prayer and meditation in his cave and had not walked for more than an hour at a time in the past couple of years. So we paused and considered while he reached into his voluminous pouch pockets and pulled out a handful of dried dates. These proved to be restorative, and after some water and rest, he was transformed. We cannot help but imagine that Antony must have carried the same food with him. With a new sense of purpose, Father Macari led us straight up to the base of the cliff.

There was no path, just a series of short friable terraces that served as upward steps (fig. 4). Suddenly we were on the narrow edge of the cliff along a faint trail at what seemed like a forty-five-degree angle on loose crumbly stones. A few meters down-slope, the edge of a cliff dropped straight down for six hundred meters. The monks, who had been ahead of us, were now nowhere to be seen. We were thrilled, yet we could sense the danger—we knew that this part of the journey was going to be daunting: a stretch that was hardly a trail with a dangerous precipice that could mean certain death in a fall.

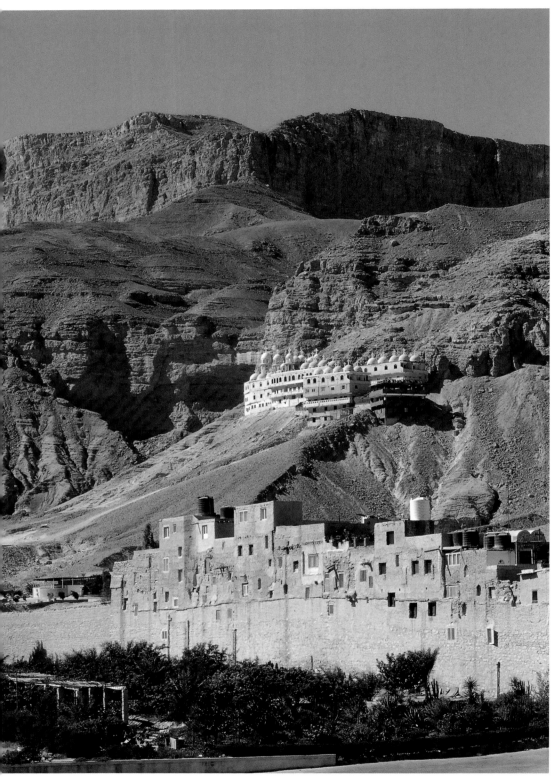

FIGURE 3

Monastery of St. Paul, looking
northwest toward the South Galala
plateau, 2004. EG 3 S33 04

Neither Fran nor I are comfortable with heights, and
it was terrifying swinging along with fifteen kilos in our
backpacks that raised our center of gravity, unbalancing
us, and reduced our ability to hug the mountain. We lo-
cated the two fathers ahead of us, almost dancing along in
their long cassocks. Father Macari was even videotaping the
drop-off for posterity and as a guide for future travelers! I
had been worried about this part of the hike, and we had
come across it so suddenly that I was almost paralyzed. Fran
and I shuffled along, leaning into the mountain, focusing
on putting one foot in front of the other and hoping not to
freeze up. Finally, we reached an area of safety, the bottom
of a wadi cut through the limestone where the edge dropped
off. At this spot, aptly nicknamed the "waterfall wadi," we
sat and rested, the adrenaline subsiding and our heart rates
dropping. We realized it was far better to have just come
upon this stretch and traversed it rather than fretting about
it as we watched it approach. We were pleased to have over-
come it, and we had no option but to continue, as the idea
of going back the same way was terrifying.

It had taken us five hours to reach this point (going
from an elevation of 500 meters to 1,330 meters above sea
level). We walked up and out of this high wadi and then
hiked for another four hours along a curving ridge, past the
highest peak at 1,475 meters, up and down a bleak, stony,
barren landscape. We discovered that none of this terrain
was easy walking, and by sunset we were all very tired. We
were running out of time and light as we searched for an
adequate place to stop. Just as darkness fell, we sighted
a slightly level place in a shallow ravine where we could
spend the night and be somewhat sheltered from the wind.
After a simple meal of lentil soup to celebrate the American
Thanksgiving holiday, we were asleep at seven o'clock.

The second day, our packs were lighter by three kilos
of water each, so we were better able to wander along the
top of the plateau, where the walking was not as demanding.
By lunchtime we had approached the high ridge behind the
Monastery of St. Paul. The way down was steep and hugged
the mountainside. By this stage in the hike we walked ac-
cording to our own rate and we were somewhat strung out
along the trail. But, as we came to the lower reaches at about
2 P.M., just above a side wadi, we all gathered together again
(fig. 5). As we stood talking, a few drops of rain splashed on
our faces. We looked up to see where they had come from
but saw no dark clouds, just wispy traces of white. Father
Macari spoke, "It is St. Paul," he said, "welcoming us back."
I felt this sentiment so strongly that tears came to my eyes,
mixing with the rain on my cheeks.

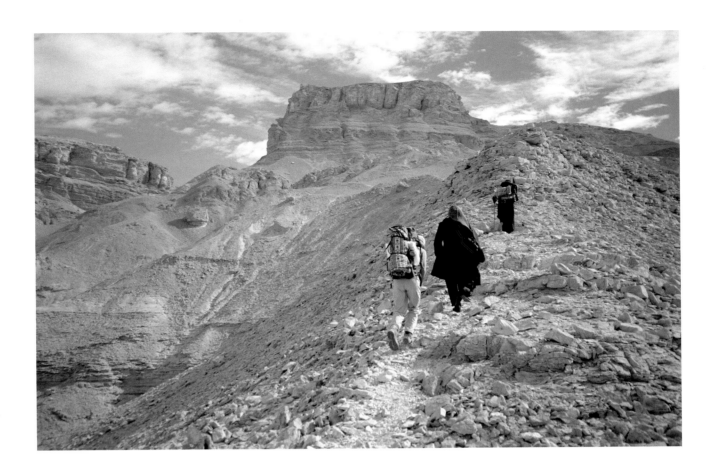

Within an hour we were at the monastery. We had
spent two days together, companions in a lasting journey.
We had walked for a total of nineteen hours and covered
forty-five kilometers; and we sensed a real appreciation for
what must have been the arduous struggle of the ninety-
year-old Antony on his way to find Paul. More than that, we
had felt the exhilaration that comes from hard physical ex-
ercise, the wholesomeness that comes from accomplishing
a goal, the warmth that comes from good fellowship, and
the radiance from following in the steps that Antony took
to Paul. As you read this book, consider what St. Antony
accomplished on his own in the wilderness as he searched
for St. Paul. By his pioneering journey he established a rela-
tionship that continues today between the two monasteries,
particularly on feast days, when the monks travel to visit
each other. Consider too the link between the two monas-
teries and the link between the monastic life and that of the
hermits. Even today there are many monks who have "gone
to the mountain" to live a life of solitude. Lastly, consider
that in the pages of this book you will learn about and see
details of the beauty of the religious life founded by these
two great saints. ARCE is proud to have played a part in
preserving this tradition.

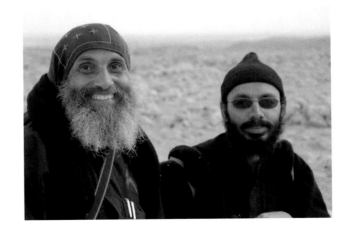

Acknowledgments

The American Research Center in Egypt (ARCE) undertook the Monastery of St. Paul Conservation Project with funding from the United States Agency for International Development (USAID), in collaboration with the Egyptian Supreme Council of Antiquities (SCA), and with the blessings of His Holiness Pope Shenouda III and the fathers of the Monastery of St. Paul.

All participants in the project, whose dedication has produced the results presented in this book, have relied on support and encouragement from numerous people. Without them the Cave Church and other historic buildings at St. Paul's could not have been preserved. At USAID, funding was ensured by four mission directors, John Westley, Richard Brown, William Pierson, and Kenneth Ellis, and three project officers, Thomas Dailey, Anne Paterson, and Seifallah Hassanein, assisted by Philip Tresch. Their constant interest in the work provided valuable confirmation of our efforts, and our appreciation cannot be overstated.

We are equally grateful to the minister of culture, His Excellency Farouk Hosni, and to the four secretaries general who have presided over the SCA during the course of the project, Dr. Abd el-Halim Nur el-Din, Dr. Ali Hassan, Dr. Gaballah Ali Gaballah, and Dr. Zahi Hawass. Also deserving special mention are the heads of the Coptic and Islamic sector of the SCA, Dr. Abdallah al-Attar and his successor in that office, Dr. Abdallah Kamel, as well as Magdi al-Ghandour, head of foreign missions affairs at the SCA. The SCA representatives responsible for the Red Sea region, Muhammad Abd al-Latif, Nasr Muhammad Awayda, Abd al-Hamid Yussef, and Ayad Gad al-Rabb Shahata, attended to the work on site.

Our deepest gratitude goes to the monks of the Monastery of St. Paul. The late Bishop Aghathon, abbot of the monastery from 1974 to 1999, gave his blessing at the inception of our work, and thereafter the generous hospitality of the monks provided every possible assistance and comfort required by the conservators, specialists, scholars, and visitors attached to the project. Father Sarapamon and Father Tomas, in particular, not only saw to our physical needs but also participated as colleagues and friends at every stage of our work in the Cave Church. We also thank Bishop Daniel, Father Macari, Father Matta, and Father Yuhanna for everything they have done throughout the nine years we have been their guests.

Everyone at the American Research Center in Egypt was personally involved in the success of the project. We thank Directors Mark Easton, Robert Springborg, and Gerry Scott, Interim Directors Irene Biermann and Jere Bacharach, and Deputy Director Amira Khattab, for all of their support and confidence in our work. Our special gratitude goes to Robert (Chip) Vincent, director of the Egyptian Antiquities Project, and Michael Jones, project manager at both of the Red Sea monasteries. We also appreciate the assistance of Technical Directors William Remsen and Jarosław (Jarek) Dobrowolski; Grant Administrators Cynthia Shartzer, Brian Martinson, Barbara Bruening, and Janie Abd al-Aziz; and Mary Sadek, the ARCE program coordinator, and Marwa Moustafa, the Egyptian Antiquities Project secretary.

Numerous people who worked with us at the Monastery of St. Paul were vital for the success of the conservation project. El-Dahan and Farid Engineering Consultants, Ltd., carried out architectural conservation on the mill building and refectory, and Karem el-Dahan managed the on-site aspects of this work. Groundwater specialists Dr. Kamal Hefny, Shree Gokhale, and Dr. Muhammad Saad Hassan provided advice on dealing with the moisture affecting the

Cave Church. Conor Power undertook the structural stability survey of the Cave Church. Surveys of the monastery and the Cave Church were carried out in 1998 by Mallinson Architects, London, assisted by Peter Sheehan, Sameh Gayed, and Sami Adli; in 2001 by Peter Sheehan and Michael Dunn; and in 2005 by Peter Sheehan and Nicholas Warner. Peter Sheehan also undertook the archaeological study of the Cave Church.

The biggest single component of the project was the cleaning, conservation, and documentation of the wall paintings in the Cave Church, the remarkable results of which make up the visual centerpiece of this volume. Luigi De Cesaris and the late Adriano Luzi led the conservation team, which included Alberto Sucato, Diego Pistone, Emiliano Albanese, Emiliano Ricchi, and Gianluca Tancioni. We thank Andrea Weiglein and Allegra Getzel for logistical support in Rome. Our work at St. Paul's Monastery would have been impossible without Father Maximous El-Anthony. He was an indispensable member of the project both as liaison with the Coptic Church and as a member of the conservation team undertaking every task that presented itself, from architectural conservation to organizing purchase and transport of supplies and materials. Between 1997 and 2006, Patrick Godeau photographed all stages of the conservation process, and the final results of all aspects of the project. Most of the photographs in this volume are drawn from his photodocumentation of the monastery. Nicholas Warner produced the architectural drawing of the monastery and the Cave Church, and Sergio Tagliacozzi and Maria Antonietta Gorini provided the graphic documentation of the conservation of the church on behalf of Luigi De Cesaris.

In producing the present book, we especially thank Alice-Mary Talbot and Natalia Teteriatnikov of Dumbarton Oaks, Washington, D.C., for their generous assistance and support throughout the project. We also are grateful to the following people, libraries, and museums for allowing the reproduction of images used in this book: Meline Nielsen, Curator of the Mingana Collection at the University of Birmingham; Doris Nicholson, Department of the Oriental Collection, Bodleian Library, Oxford; Rebecca Akan, senior library assistant, the Image Library at the Metropolitan Museum of Art, New York; Bruno Baudry, Directeur du Département de la Reproduction, Bibliothèque Nationale de France, Paris; Barbara Goldstein Wood, Department of Visual Services, National Gallery of Art, Washington, D.C.; Yves Lebrec, Conservateur de la Photothèque, Institut Catholique de Paris; and the staffs of the Walters Art Museum, Baltimore, the libraries of Princeton University, Princeton, Art Resource, New York, and VG Bild-Kunst, Bonn.

All of the contributors to this book have been a joy to work with. Their enthusiasm and spirit of cooperation greatly enriched our collective study of Paul the Hermit and the monastery and church dedicated to him. In particular, the editor thanks Mark Swanson for his advice and willingness to take on extra work, and Michael Jones, whose commitment to the conservation of the Cave Church and the subsequent publication of our findings has made this book possible. I am especially indebted to Elizabeth Bolman, who participated at every stage of the long process of producing such an ambitious volume.

Apart from these professional acknowledgments, the editor personally dedicates this book to the late Samir Aziz Morcos, with whom I first visited the Red Sea monasteries in 1977, and to William and Cynthia Lyster, my parents.

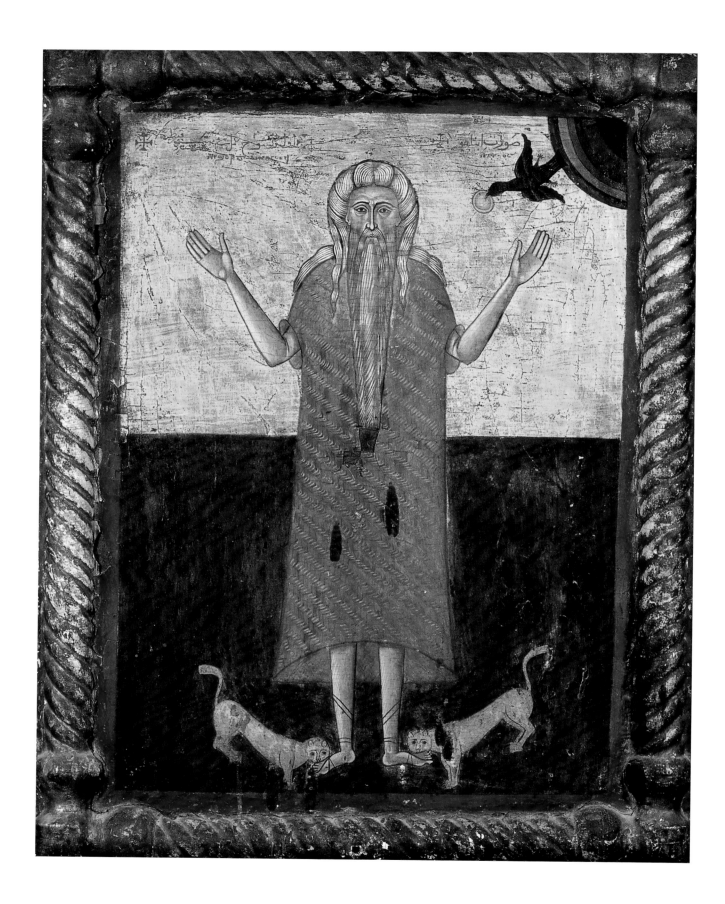

INTRODUCTION

THE MONASTERY OF ST. PAUL THE HERMIT

The elusive figure of Paul the Hermit has exerted a compelling draw on the imaginations of Christians from late antiquity to the present day (fig. 6). Identified through the centuries as the first Christian hermit, Paul is believed to have lived most of his long life in a cave in the Egyptian desert near the Red Sea. In time, his hermitage became the core of a monastic settlement, in which his cave served as a church. The Cave Church of Paul the Hermit gives material witness to sustained devotion to the saint in the form of multiple phases of enlargement, medieval and eighteenth-century wall paintings, icons, and liturgical furnishings. Today it is also surrounded by extensive monastic buildings. The contributors to this volume explore the dynamic interactions between historical texts, devotional practices, art and architecture, and their generative impulse, Paul the Hermit. Another force behind the production of this book is the major conservation endeavor undertaken at the Monastery of St. Paul by the American Research Center in Egypt (ARCE), with funding from the United States Agency for International Development (USAID), in collaboration with the Coptic Church and the Egyptian Supreme Council of Antiquities. This publication documents the conservation project and builds on the data it produced.

My objective in this introduction is to provide the reader with an understanding of Paul, his cave, and his monastery prior to the start of conservation work and the new, multidisciplinary research undertaken for this book. At the end of the introduction I set out the topics explored in this volume. These new studies transform our understanding of Paul, the monastery dedicated to the saint, and the larger Christian community of Egypt in the medieval and Ottoman periods. The authors analyze the results of the

wall painting conservation project undertaken as a central component of ARCE's involvement at the site, as well as new textual and archaeological information. I leave a discussion of the exciting implications of these studies for the conclusion to this volume.

St. Paul, the First Hermit, and His Monastery

Egypt has long been regarded as the birthplace of Christian monasticism.[1] Antony the Great (ca. 251–356) is usually deemed the father of the monastic movement, but the Catholic and Orthodox Churches agree that Paul the Hermit preceded him in withdrawing into the desert.[2] According to his biography, first written by Jerome (ca. 331–420), Paul took refuge in the Egyptian desert in 250 during the persecution of the emperor Decius.[3] His brother-in-law is said to have plotted to report him to the authorities in order to obtain his wealth. Once the danger had passed, Paul moved farther into the desert, eventually reaching the site of the monastery that now bears his name. Surviving on spring water and the fruit of a date palm, Paul lived in isolation for more than ninety years.

At the end of his life Paul was discovered by Antony, who thirty years before had established a similar hermitage on the other side of the same mountain. Antony found the dying Paul in a cave, wearing a tunic of woven palm fibers. Following Paul's death, Antony buried him somewhere nearby. Jerome did not mention the precise spot, but tradition, attested to in Coptic and Arabic versions, places it within the saint's cave.[4] The Monastery of St. Paul grew around the physical sites associated with the hermit: his spring, cave, and grave.

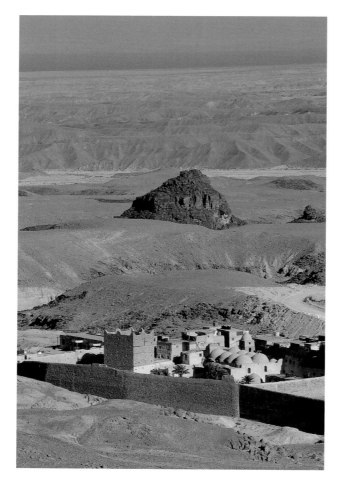

FIGURE 7
Monastery of St. Paul, looking
southeast toward the Gulf of Suez
and Sinai. ADP/SP 12 SI124 97.

The Monastery of St. Paul is one of the most remote of the Coptic (Egyptian Christian) desert monasteries.[5] Isolated in the Eastern Desert, it sits at the base of a steep plateau overlooking the Gulf of Suez, the portion of the Red Sea that separates Egypt from Sinai. The sheer limestone walls of the plateau rise to a height of 1,100 meters directly behind the monastery. The walled compound is hidden at the end of a desert wadi that runs from the cliff face through 12 kilometers of sandstone hills before reaching the barren coastal plain. From the surrounding hills, 244 meters above sea level, the Gulf of Suez and the mountains of Sinai can be seen in the distance. The area is made habitable only by a natural spring that flows from the foot of the mountain. The unlikely presence of water in the desert has supported a monastic community for most of the past sixteen hundred years. The settlement is traditionally held to be one of the oldest functioning monasteries in the Christian world (fig. 7).[6]

The Monastery of St. Paul lies at the base of the eastern escarpment of the South Galala plateau, part of a series of mountain chains that run parallel to the Red Sea coast.[7] They were formed in response to the tectonic movement of Arabia away from the African plate, a geological event that also saw the creation of the rift valley that became the

Red Sea.[8] The Galala plateau is to the far north of the group, overlooking the Gulf of Suez. It is divided into a northern and southern block by the Wadi al-ʿAraba, another rift valley, in this case formed by a longitudinal fault that runs from the sea toward the Nile.[9] The southern plateau, known in Arabic as Galala al-Qibliya, is composed primarily of Cretaceous and Paleogene limestone, formed over a period of a hundred million years, when prehistoric seas covered much of Egypt.[10] During the past twenty-five million years, tectonic disturbances repeatedly uplifted the limestone beds, creating a plateau, rising steeply on all sides, that covers an area of 15,000 square meters and reaches an elevation of 1,464 meters above sea level (fig. 8).[11]

Annual precipitation in the area is minimal, but every few decades a torrential storm from the Mediterranean will blow across the Isthmus of Suez against the steep cliffs of the coastal mountains.[12] Flash floods then pour down the slopes, moving boulders and sediment to lower levels. For the last five million years the water has run toward the Nile or the Red Sea, cutting wadis that now stripe the Eastern Desert.[13] Every rainstorm enlarges earlier valleys while forming new channels and ravines. Some of the rainwater penetrates the porous limestone of the Galala plateau, filtering through the rock until reaching the earliest Cretaceous strata at the base. This limestone is mixed with chalk and clay, forming an impermeable layer upon which the water pools within the mountain.[14] Gradually the water follows channels leading to the exterior, surfacing as natural springs at a number of sites around the base of the plateau.[15] Two of these perpetual springs, found on opposite sides of the Galala al-Qibliya, enabled early hermits and monks to live in this remote part of the desert.

Currently, the spring at the Monastery of St. Paul produces about three cubic meters of water a day in a continuous flow.[16] After heavy rains the volume increases dramatically. The trickle then becomes a stream rushing down to the sea. Over the last couple of geological epochs, the water has carved the Wadi al-Dayr (Valley of the Monastery) from the cliff face to the coastal plain. This erosion was assisted by flash floods that result from the same desert storms. Immediately to the east of the spring, the water has cut a channel about thirty-five meters wide through the limestone bedrock.[17] The Monastery of St. Paul is built around this shallow trench. The bed of the wadi serves as the monastic garden, while most of the buildings are constructed on the shelf above (fig. 9). There is an abrupt drop of about four meters from the top of the shelf to the floor of the garden.

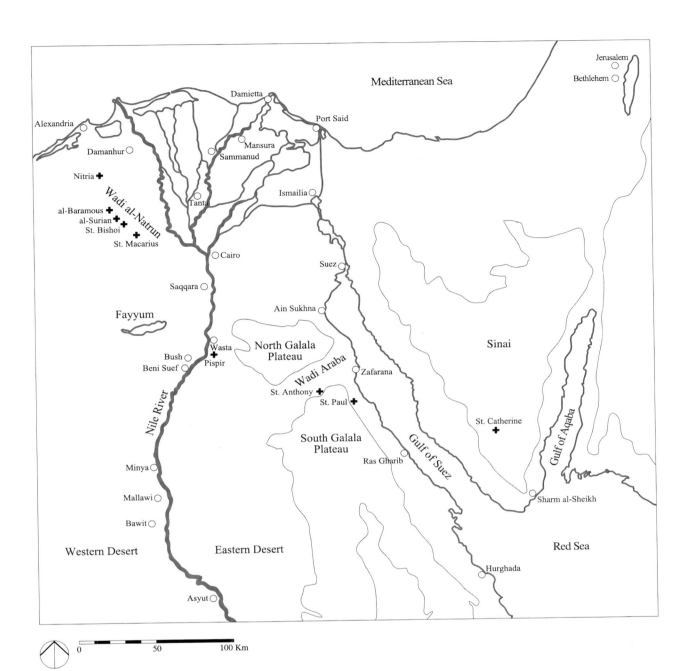

FIGURE 8

Location map of the Monastery
of St. Paul.

FIGURE 9

Monastic garden in the Wadi al-
Dayr, looking east toward the keep,
the Church of St. Michael and St.
John, and modern cells on top
of the limestone shelf. ADP/SP 10
S1127 97.

Flash floods not only cut and shaped the wadi but also coated it with a thick deposit of *tafl,* the Arabic word for potter's clay, washed down from the mountain. The tafl is composed of clay, limestone particles, and other sediment of the desert that forms a natural mortar when mixed with water. The buildup of tafl in the wadi next to the spring of St. Paul is in places more than three meters thick. Although it forms a rocklike substance, the tafl is very soft, making it ideal for digging small caves along the side of the ridge. The cave of Paul sits within this escarpment. It is believed to have originally consisted of two or more small, interconnected chambers that now form part of the subterranean section of the Church of St. Paul. Two of these rock-cut rooms currently serve as a *haykal,* or sanctuary, dedicated to the saint (H on the plan in fig. 10) and a shrine (G) containing a cenotaph that marks the presumed site of his grave (fig. 10).

Paul's cave is the nucleus and spiritual heart of the monastery. Possibly serving as a shrine in late antiquity, the monks transformed it substantially in the thirteenth century, shaping it into a two-sanctuary church. This process involved excavating a more spacious cave in order to create a nave (D) and an entrance narthex (F), as well as the construction of a new domed haykal (E) against the ridge. Early in the eighteenth century, the monks further enlarged the Cave Church by erecting three domed chambers (A, B, C) along its northern side. The easternmost room (C) functions as a third sanctuary. The cave of Paul thus evolved into one of the most unusual churches in Egypt. Part of the building is cut into the ridge, while the later chambers were built as extensions into the floodplain of the wadi. The subterranean portion has low ceilings, but spacious domes surmount the medieval and early modern additions (fig. 11).

The main communal buildings of the monastery are clustered on the limestone shelf directly above Paul's cave. They form a tight architectural ensemble that includes a church dedicated to St. Mercurius, a refectory and kitchen, two mills, and a massive stone keep. The medieval entrance of the Cave Church is in the same upper area. It comprises a series of rock-cut steps, descending to the cave below, that are now enclosed within the overlapping Church of St. Mercurius. These structures, along with the Cave Church, constitute the historic core of the monastery (fig. 12).

High walls, roughly made of stones from the desert, surround the monastic compound. They form an irregular rectangle enclosing about 15,000 square meters (figs. 13–15).[18] The garden takes up approximately a third of the area, and the shelf south of the wadi occupies the remaining space. Most of the buildings of the complex are found on

D6 Christ, 1291/1292

D7 Angel, 1291/1292

D8 Decorative motif, 1291/1292

D9 Unidentified saint, first half of the thirteenth century

D10 Gold ring on a blue field, above fragmentary remains of a painting, 1291/1292

D11 Maximus, 1712/1713

D12 Domitius, 1712/1713

D13 Angel carrying a child (Uriel and John the Baptist?), 1291/1292

D14 Massacre of the Innocents, 1291/1292

D15 Magi before Herod, 1291/1292

D16 Two Prophets (Isaiah and Micah?), 1291/1292

D17 Lost portion of the Infancy of Christ cycle (Nativity?), 1291/1292

D18 Moses the Black, 1712/1713

D19 Virgin and Christ child with two cherubim, 1712/1713

HAYKAL OF ST. ANTONY

E1 Cherub, 1291/1292

E2 Mark the Evangelist (?), 1291/1292

E3 Luke the Evangelist, 1291/1292

E4 John the Evangelist, 1291/1292

E5 Angel, 1291/1292

E6 Virgin Mary, the Christ child, and an angel, first half of the thirteenth century

E7 Annunciation: Gabriel, first half of the thirteenth century

E8 Annunciation: house or fountain building, first half of the thirteenth century

E9 Annunciation: Virgin Mary, first half of the thirteenth century

E10 Christ in Majesty with the four living creatures, 1291/1292

E11 Dated Coptic inscription, 1291/1292

E12 Angel, 1291/1292

E13 Stephen, first half of the thirteenth century and 1291/1292

E14 Unfinished painting of an architectural structure (?), 1291/1292

E15 Cherub, 1291/1292

CORRIDOR

F1 Arsenius, 1291/1292

F2 Unidentified cycle: Domed church (?), 1291/1292

F3 Unidentified cycle: Portion of a saint's nimbus, 1291/1292

F4 Unidentified cycle: Female saint, 1291/1292

F5 John, 1712/1713

F6 Arsenius, 1712/1713

F7 Abib, 1712/1713

F8 Apollo, 1712/1713

F9 Unidentified Saint (John the Little?) 1712/1713

F10 Shenoute, 1291/1292

F11 Diminutive king (Emperor Theodosius?), 1291/1292

F12 John, 1291/1292

F13 Red band with no inscription, uncertain date

F14 Moses the Black/Samuel of Qalamun, 1712/1713

F15 Unidentified saint, 1712/1713

SHRINE OF ST. PAUL

G1 Unidentified saint, 1291/1292

G2 Fragmentary remains of a painting (part of D10), 1291/1292

G3 Macarius, 1712/1713

G4 Haykal screen of St. Paul, uncertain date

G5 Cenotaph of St. Paul

FIGURE 11 BELOW LEFT

Cave Church, the Church of St.
Mercurius, and the refectory,
north-south section looking east,
1930–1931. Whittemore expedition,
DR14. Courtesy of Dumbarton
Oaks, Washington, D.C.

FIGURE 12 TOP RIGHT

Historic core of the Monastery of
St. Paul, looking southwest toward
the Cave Church (bottom right),
the Church of St. Mercurius (bot-
tom left), the keep (center), and the
Church of St. Michael and St. John
(center left). ADP/SP 6 S1134 97.

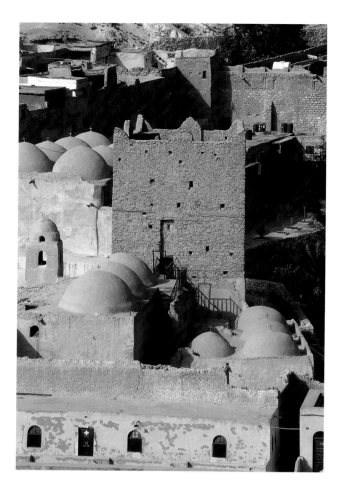

this limestone ridge, including the historic core, the modern
cells of monks, and a third church, dedicated to St. Michael
the Archangel and St. John the Baptist. The spring of Paul
was not originally within the compound, perhaps as a pru-
dent courtesy to neighboring bedouin. By the twentieth
century the monks had extended the walls of the monastery
to enclose the spring, but they left a secondary source of
water available outside the walls.

Antony, Jerome, and the *Life of Paul*

There are no towns near the Monastery of St. Paul, only the
lighthouse station at Zafarana, about forty kilometers to the
north. The closest settlement has always been the Monastery
of St. Antony on the other side of the plateau. Antony's
hermitage, like that of Paul, was a cave near a natural spring.
The monasteries of St. Antony and St. Paul eventually grew
around these fountains in the desert. The two communities
are only about twenty-five kilometers apart, but they are
separated by the Galala al-Qibliya, the Mount Qulzum
of the classical tradition.[19] Antony is said to have crossed
this desert terrain in his search for Paul. It is an arduous
trip that requires almost two days of hiking. An easier but
longer route of eighty-six kilometers involves circling the
northern face of the plateau and then heading south along
the coast until reaching the Wadi al-Dayr.[20]

　　In Jerome's account, Antony discovered Paul at the
end of his long career as a desert anchorite. A number of
the contributors to this volume make detailed reference to
the life of Antony, and the ensuing overview is designed to
orient the reader. It follows the *Vita Antonii,* attributed to
Athanasius, the powerful bishop of Alexandria, which pro-
vides a literary rather than a historical model for Antony's
life and the origins of monasticism.[21] According to Atha-

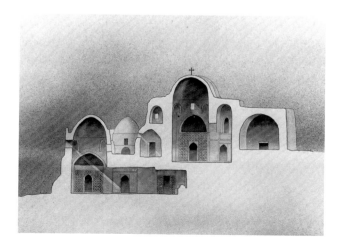

nasius, Antony became a hermit as a young man. At first he
lived outside his village, but in time he moved farther away
from the society of the Nile valley, until eventually with-
drawing into the desert.[22] For nearly twenty years Antony
lived in an abandoned fort at Pispir on a ridge overlooking
the eastern bank of the Nile.[23] The site, near the modern
city of al-Wasta, was known as Antony's Outer Mountain
because of its location on the outskirts of the desert.

　　At the age of fifty-five Antony emerged from his seclu-
sion and began teaching his method of Christian asceticism.
While maintaining his own practice he now instructed a
number of followers, who lived in cells clustered around
the Outer Mountain.[24] This simple federation of hermits is
often regarded as the first Christian monastic community.[25]
In about 313, Antony withdrew from his followers, seeking
greater solitude in the inner desert. Traveling with bedouin
guides, he followed the Wadi al-'Araba across the Eastern
Desert toward the Gulf of Suez. After three days the party
reached a natural spring at the base of Mount Qulzum.[26]
Here, at his Inner Mountain, Antony spent the last forty
years of his life. He continued to direct his community
at Pispir, as well as to communicate with other monastic
groups that were inspired by his example, but for the most
part Antony lived alone in his cave set high in the cliff face

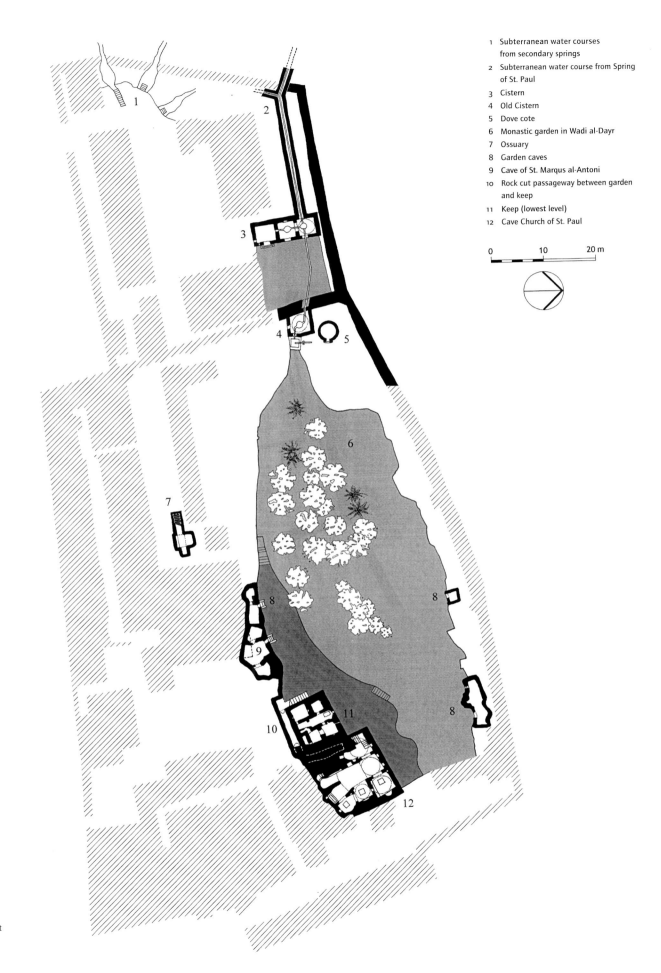

1 Subterranean water courses
 from secondary springs
2 Subterranean water course from Spring
 of St. Paul
3 Cistern
4 Old Cistern
5 Dove cote
6 Monastic garden in Wadi al-Dayr
7 Ossuary
8 Garden caves
9 Cave of St. Marqus al-Antoni
10 Rock cut passageway between garden
 and keep
11 Keep (lowest level)
12 Cave Church of St. Paul

0 10 20 m

FIGURE 13

Plan of the Monastery of St. Paul at
wadi level.

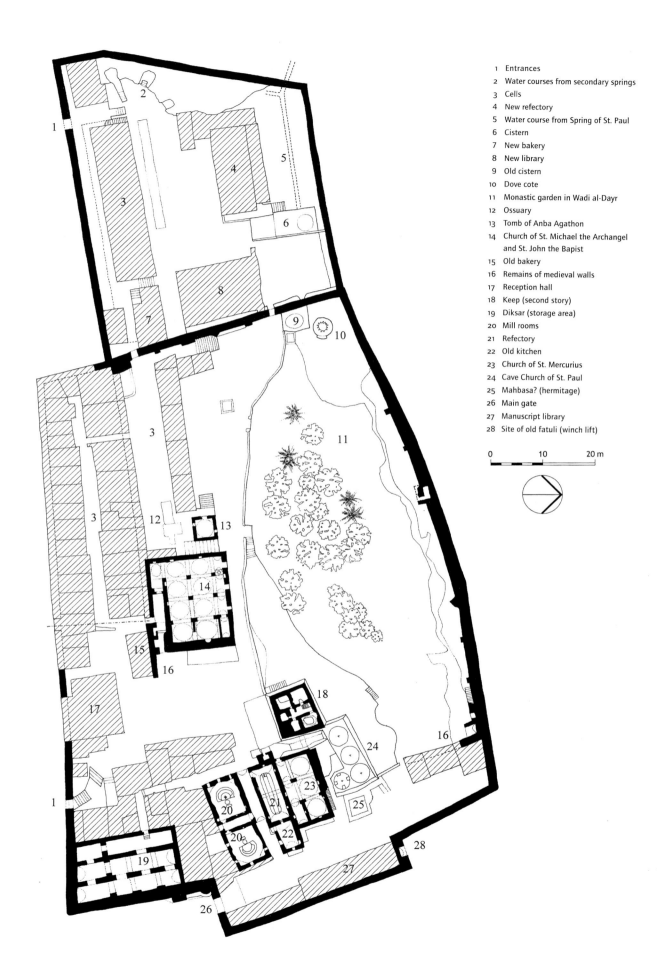

1 Entrances
2 Water courses from secondary springs
3 Cells
4 New refectory
5 Water course from Spring of St. Paul
6 Cistern
7 New bakery
8 New library
9 Old cistern
10 Dove cote
11 Monastic garden in Wadi al-Dayr
12 Ossuary
13 Tomb of Anba Agathon
14 Church of St. Michael the Archangel
 and St. John the Bapist
15 Old bakery
16 Remains of medieval walls
17 Reception hall
18 Keep (second story)
19 Diksar (storage area)
20 Mill rooms
21 Refectory
22 Old kitchen
23 Church of St. Mercurius
24 Cave Church of St. Paul
25 Mahbasa? (hermitage)
26 Main gate
27 Manuscript library
28 Site of old fatuli (winch lift)

0 10 20 m

FIGURE 14

Plan of the Monastery of St. Paul
at entry level.

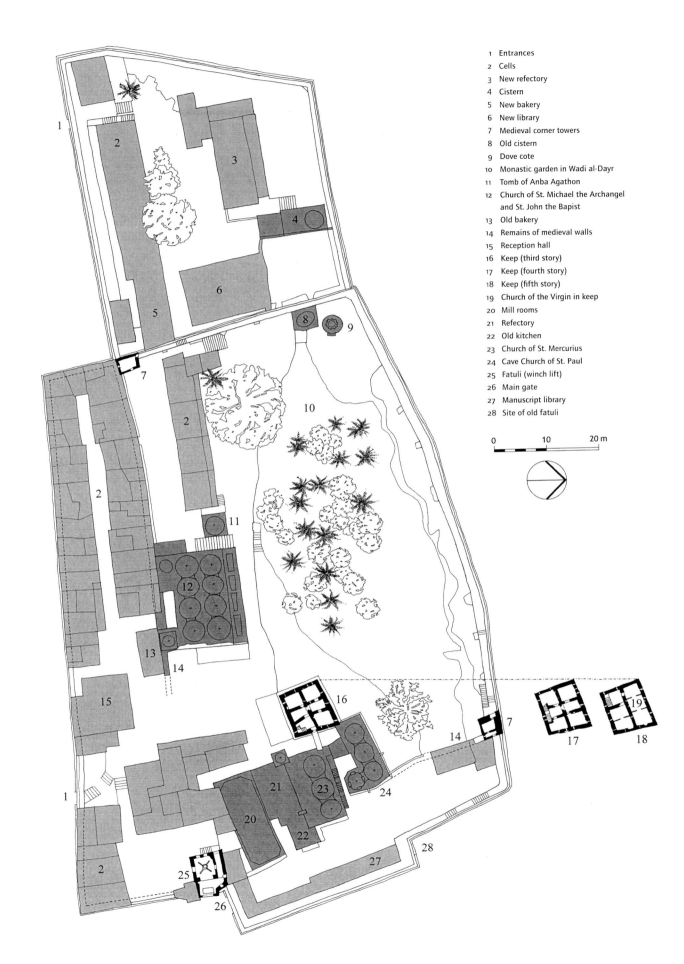

1 Entrances
2 Cells
3 New refectory
4 Cistern
5 New bakery
6 New library
7 Medieval corner towers
8 Old cistern
9 Dove cote
10 Monastic garden in Wadi al-Dayr
11 Tomb of Anba Agathon
12 Church of St. Michael the Archangel
 and St. John the Bapist
13 Old bakery
14 Remains of medieval walls
15 Reception hall
16 Keep (third story)
17 Keep (fourth story)
18 Keep (fifth story)
19 Church of the Virgin in keep
20 Mill rooms
21 Refectory
22 Old kitchen
23 Church of St. Mercurius
24 Cave Church of St. Paul
25 Fatuli (winch lift)
26 Main gate
27 Manuscript library
28 Site of old fatuli

0 10 20 m

FIGURE 15

Plan of the Monastery of St. Paul
at roof level.

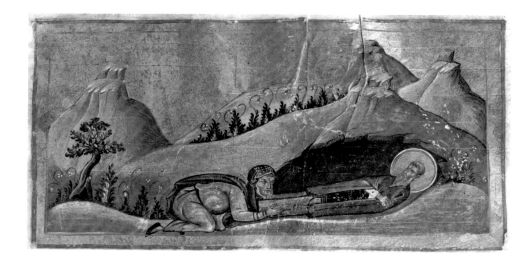

of the Galala plateau.[27] In the decade following Antony's death in circa 356, his hermitage at the Inner Mountain became a second Antonine monastery.[28]

The *Life of Antony* would forever elevate the saint above his anchoritic peers. Written in Greek soon after Antony's death, it became one of the most influential books of late antiquity. Athanasius presented Antony as a spiritual hero and holy exemplar of the ascetic life. In clearly defined stages, he outlined the steps taken by the saint in his quest for perfection. Athanasius thus provided both a narrative biography and a practical manual for those who wished to imitate Antony.[29] In addition, he included sermons, miracle stories, accounts of debates with pagans and heretics, and of course the temptations of Satan.[30] The *Life of Antony* was an immediate sensation. Its success established Antony as the father of monasticism throughout the Christian world.[31]

An early reader of the *Life* was the young Jerome, who developed a lifelong commitment to Christian asceticism and the propagation of monasticism in the Latin west.[32] His first attempt at a monastic community consisted of a circle of like-minded friends in northern Italy. When the group broke up, some of the members traveled east to see the monks of Egypt and Syria with their own eyes. Jerome went to Antioch in 374, where he spent five years with his friend Evagrius, who had recently translated the *Life of Antony* into Latin. While in Syria, Jerome lived among hermits in the desert of Chalcis east of Antioch.[33] The experiment in asceticism proved unsuccessful, but Jerome produced one of his earliest works, the *Life of Paul*, at this time.[34]

The *Vita Pauli* is a short biography written in Latin that is clearly intended as a corrective preface to the *Life of Antony*. Jerome asserted that while Antony may have been the inspiration for desert monasticism, he was not the first

anchorite to inhabit the desert. That distinction goes to a "certain Paul of Thebes, [who] was the originator of the practice, though not of the name."[35] Jerome briefly narrated the life of Paul until the hermit discovered the spring in the desert, then passed over his long years of solitude with the remark, "As to how he lived during the middle years of his life and what attacks of Satan he endured, no one knows anything for certain."[36]

Most of the text concerns Antony's pilgrimage to Paul, inspired by a dream "that there was someone else further into the desert interior who was far better than him and whom he ought to go and visit."[37] When Antony reached Paul's cave, a raven brought a loaf of bread that served as their common meal. Paul remarked that every day for sixty years he had received half a loaf from the bird, but that God had doubled the rations in honor of Antony's arrival. Paul then announced his coming death and requested as a shroud the cloak given to Antony by Athanasius, a gift mentioned in the *Life of Antony*.[38] Returning to his cell, Antony again crossed the mountain, only to set out immediately with the cloak for Paul. Upon reaching the cave, Antony found Paul's lifeless body still in a position of prayer. Having no tools, Antony was unable to bury the hermit until two lions of the desert dug the grave for him. Antony then returned again to his cell, acknowledging the spiritual superiority of Paul the Hermit.

Jerome's account of Antony discovering Paul in the Egyptian desert firmly linked the two saints in Christian imagination. In the Latin west, the work was widely read. European pilgrims began visiting the cave of Paul in Jerome's own lifetime. By the Middle Ages, Antony and Paul had come to personify the Egyptian origins of monasticism.[39] The veneration of Paul in the western tradition is largely due to the prominence of Jerome, the translator of the Vulgate Bible and one of the four early doctors of the Catholic Church. Subsequent mentions of Paul the Hermit by Latin authors are dependent on Jerome, as are the earliest western medieval depictions of the saint.[40]

The popularity of the *Vita Pauli* in the eastern tradition is perhaps more surprising. The Orthodox Churches do not particularly honor Jerome, but his *Life of Paul* seems to have found a wide audience in the Christian east. Soon after it was published, Jerome's story was translated into Greek.[41] This version then inspired an abbreviated Greek account that became the source of eventual Coptic, Syriac, Ethiopic, and Arabic versions.[42] Readers of these translations probably cared nothing for Jerome but were eager for more information about the great Antony. The discovery

of Paul in the desert became a popular episode in his legend. By the tenth century, Paul was well enough known in Byzantium to be included in the *Metaphrastic Menolgion* and the *Synaxarion of Constantinople* (fig. 16).[43] Today, the Greek, Russian, Armenian, Coptic, and other Orthodox churches venerate Paul the Hermit.[44]

Despite Jerome's claim that Egyptian monks first told him the story of Paul, no evidence has survived of a separate version of the saint's life that is not dependent on Jerome's Latin text.[45] The Coptic recension, for instance, follows Jerome closely.[46] Nevertheless, the later Arabic rendition deviates from Jerome in a number of ways. According to this version, and a parallel report by the fifteenth-century historian al-Maqrizi, Paul was a native of Alexandria, not Thebes, as Jerome has it.[47] The change of origin would place him at the center of the Decian persecution in the capital city rather than in remote Upper Egypt. The Arabic account, however, does not mention a persecution. Instead, Paul was convinced of the futility of human desires by a family dispute over money, combined with a chance encounter with a funeral procession. The unspecified chronology in this version allows for a possible reduction in the life span of 113 years attributed to Paul by Jerome, as do subtle changes in the narrative.[48] For example, in the Arabic recension, Paul told Antony that a raven had brought him bread for twenty-four years, compared to the sixty years reported in the Latin version.[49] The monks of the Monastery of St. Paul currently include these variations in their own accounts of Paul, but they also extend the age of the saint to 115 when he was found by Antony.[50]

Late Antique Pilgrimage to the Cave of Paul

The renown of Antony and the other desert fathers inspired pilgrims in late antiquity to include Egypt in their itineraries of holy places. Both lay and ascetic travelers longed to see the living successors of Antony in a country reputed to be "bursting with monks."[51] In 374, Rufinus, a friend and later enemy of Jerome, traveled to Egypt in the company of his patron, Melania the Elder, a pious Roman aristocrat. He visited Antony's Outer Mountain and the Monastery of Macarius the Great at Scetis, the modern Wadi al-Natrun.[52] Most of his time was spent at Nitria, the community founded by Amoun, which Rufinus called the best known of all the monasteries of Egypt.[53] Macarius and Amoun were both regarded as disciples of Antony.[54] Their monastic settlements in the desert skirting the Nile delta, southeast of Alexandria, produced some of the best known of the desert fathers. Much of the monastic wisdom collected in

Apophthegmata Patrum (Sayings of the Fathers) derives from the monks of Nitria and Scetis.[55] In the second half of the fourth century, Basil the Great, Palladius, and John Cassian also spent time among the monks of Egypt.[56] Their enthusiasm would help foster the spread of monasticism throughout the lands of the Roman Empire.

Jerome visited Egypt in circa 385, about ten years after writing the *Vita Pauli*.[57] It is unlikely that he went to the Monastery of St. Antony, but Jerome did include an account of such a pilgrimage in his *Life of Hilarion,* written in Bethlehem a few years later.[58] The geographical details are convincing enough to suggest that Jerome at least spoke with someone who had been to the Inner Mountain. Unfortunately, he did not mention an excursion to the hermitage of Paul. Other western pilgrims, however, certainly made the additional journey. In about 400, a friend of Sulpicius Severus named Postumianus traveled to the Holy Land and met Jerome in Bethlehem. He then went to Egypt, where he visited the two monasteries of Antony and "that place in which the most blessed Paul, the first of the eremites, had his abode."[59] This brief passage is the earliest account of a pilgrimage to the site of the Monastery of St. Paul.

In late antiquity, most travelers interested in the hermitages associated with Antony and Paul would first sail up the Nile to the monastery at Pispir. One pilgrim described Antony's Outer Mountain on the eastern bank as "overhanging the river, a most awesome place with high crags, and we visited the monks who lived there in caves."[60] At Pispir, they were probably provided with a monastic escort for the second, more difficult, leg of their journey to the Inner Mountain. Jerome told of a deacon "who kept dromedaries which were hired, on account of the scarcity of water in the desert, to carry travelers who wished to visit [the mountain of] Antony."[61] Many pilgrims probably walked accompanied by guides with a camel carrying food and water. Antony is said to have traveled in this manner when he periodically left the Inner Mountain to visit the community at Pispir.[62]

The pilgrims would have followed the Wadi al-ʿAraba, the ancient trade route linking the Nile at the Fayyum with the Gulf of Suez. "After three days' journey through the waste and terrible desert they at length came to a very high mountain . . . extending for about a mile, with gushing springs among its spurs."[63] Here, at the northern face of the South Galala plateau was the site of Antony's hermitage. In Jerome's account, two monks lived there, one of whom had attended Antony in his old age. He also mentioned an oasis of palm trees, Antony's garden, and his cave.[64]

More intrepid pilgrims, who wished to continue on to the spring of Paul, required another guide and enough water to cross the plateau. A medieval western traveler, writing at the end of the fourteenth century, called it a "hard and painful day's travel; and, in our opinion, of all the trips that a pilgrim can take overseas, one would never find a road so desolate and strange as the road from the Abbey of Saint Antony to [the Abbey of] Saint Paul."[65] Nine hundred years earlier, however, Postumianus made no mention of a monastic community at the site. Instead, he gave a detailed account of a hermit in Sinai, indicating great interest in such ascetics and suggesting that he did not encounter similar anchorites near the spring of Paul.[66]

It is unlikely that early Latin pilgrims, such as Postumianus, played a significant role in the discovery of the spring associated with Paul, or in the subsequent settlement of the site. The bedouin must have known the location for countless generations. A medieval tradition has Miriam, the sister of Moses, bathing here before the parting of the Red Sea.[67] The Antonine monks were no doubt equally aware of this other source of water in the desert at an early date, and perhaps the more determined of them had already established cells nearby. What is less certain is to what extent western pilgrims may have encouraged the identification of the spring they visited in the desert as the one belonging to Jerome's Paul. All that can be said for certain is that the spring was a focus of western pilgrimage at least as early as it was an Egyptian monastery.

The Earliest Monastic Settlement at the Site of Paul's Hermitage

Western pilgrims had identified the location of Paul's desert hermitage by the beginning of the fifth century. It would be another eight hundred years, however, before a monastery was reported at the site.[68] During this long period, monks and pilgrims likely transformed the cave of the hermit into a shrine through devotional and perhaps also liturgical use. Although there are no precise dates for the early history of the Monastery of St. Paul, it is possible to suggest a hypothetical sequence for the growth of the monastic compound. A loosely structured group of anchorites living in caves or other simple shelters in the vicinity of Paul's spring probably formed the original settlement. The monks could have easily created cells by cutting small caves into the tafl coating the sides of the wadi. A number of similar caves are preserved opening on to what is now the monastic garden. The monks of St. Paul's currently believe one of them to be the cell of Marqus al-Antuni, a fourteenth-century saint. It has three small rooms carved

into the tafl. The monastic community has recently made the cell of Marqus a chapel with an altar in one of the rooms. The cave of Paul may have resembled this later cave-shrine before being enlarged into a church.

Following the pattern of documented practice elsewhere, the monks would have gathered together once or twice a week for religious services and communal meals.[69] The cave of Paul almost certainly functioned as their chapel, and the monks probably had a simple refectory nearby. Eventually, they constructed a tower as a place of refuge in times of danger. Most Coptic desert monasteries contain prominent rectangular keeps. According to monastic tradition, the monks of the Wadi al-Natrun built them as early as the fifth century following repeated attacks by nomads.[70] Jerome constructed one for his monastery in Bethlehem at about the same time.[71] It is not known when the monks of St. Paul's erected a keep, but the isolation of the settlements may have required protective measures at an early date. The original structure was considerably smaller than the current keep of the monastery, but it seems to occupy the same location adjacent to the cave of Paul on the shelf overlooking the wadi.[72]

The semi-anchoritic settlement of late antiquity probably consisted of little more than a keep, a refectory, and the cells of the monks arranged around the cave of St. Paul. It may have retained this austere simplicity for centuries. The monks no doubt cultivated the bed of the wadi as a garden, but they probably relied on the Monastery of St. Antony for most of their supplies. At some point, however, the minimally protected community of hermits fortified their terrain with an enclosure wall. We do not know when the walls were built, but the monks of the Wadi al-Natrun erected similar fortifications in the ninth century.[73] It is also unclear when the cave of Paul became a church. The first dateable evidence for this transformation, in the form of wall paintings, is from the thirteenth century.

The Medieval Monastery of St. Paul

The *History of the Churches and Monasteries,* an Arabic survey compiled in Egypt between the late twelfth and early thirteenth centuries, included short sections on the two monasteries of St. Antony, and one dedicated to St. Paul.[74] This is the earliest known reference to a monastery at the site of Paul's hermitage. Of the three communities the author provided the most details about the Monastery of St. Antony at the Inner Mountain. He described it as being fortified with a keep and outer walls. Within the compound the cells of "many" monks overlooked a large garden containing fruit trees, vegetable patches, and a vineyard. "There is nothing

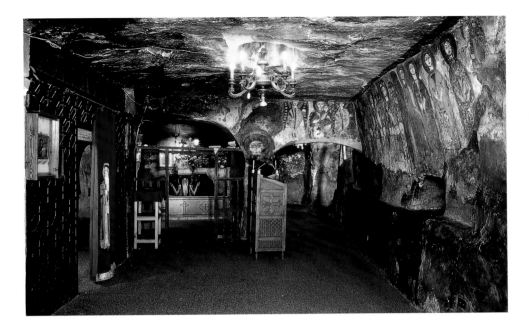

FIGURE 17

Central nave before conservation,
looking south toward the Shrine
of St. Paul and the corridor. The
Haykal of St. Antony is on the left.
ADP/SP 6 S153 01.

like it among the other monasteries inhabited by Egyptian monks."[75] The author also noted the wealth of the monastery. It possessed "many endowments and possessions at Misr" (Old Cairo) and "property and gardens also in Itfih," an agricultural region near Pispir.[76]

He referred to the monastery at the Outer Mountain, "upon the bank of the blessed Nile," as Dayr al-Jummayza, a regional place name.[77] The monastery was inhabited by thirty monks and contained a keep, a garden, a mill, and a winepress.[78] One of its chief functions seems to have been supervising the estates of the community, and ensuring that provisions were sent to the larger Monastery of St. Antony at the Red Sea.[79] A later Coptic source called it Dayr al-Badla (Monastery of the Exchange) because one exchanged a Nile boat here for a camel on the journey to the Inner Mountain.[80]

The author's brief account of the Monastery of St. Paul described the geographical setting but provided no details of its architectural development. He did make it clear, however, that at this point in time the monks were dependent on the Monastery of St. Antony. "Monks in priest's orders and deacons come from the monastery of the great Saint Antony to the monastery [of St. Paul] to celebrate the liturgy in it by turns."[81] The author depicted the Monastery of St. Antony in much the same way as its premodern core appears today, but to what extent the Monastery of St. Paul resembled its larger neighbor at this time is unknown. It may have been a simple cluster of cells around the cave of Paul; or it could have already been walled and more formalized. The community's reliance on the Monastery of St. Antony for priests, however, suggests that the settlement was still extremely small.

By an interesting coincidence, the earliest archaeological and art historical evidence for the growth of the monas-

tery also dates from this period. It appears that soon after the compilation of the *History of the Churches and Monasteries*, the population of the Monastery of St. Paul had grown sufficiently to require a more substantial church. The cave of Paul formed the core of the new structure. Two of its original rooms now functioned as the Haykal of St. Paul, and a shrine containing the saint's cenotaph (see fig. 10). The medieval monks, or their laborers, also excavated to the north, creating a rock-cut nave that nearly doubled the subterranean space of Paul's cave. When removing the tafl, they tried to give all the rooms as uniform an appearance as possible. Jean Coppin, visiting in 1638, remarked that the church resembled a building rather than a cave or grotto, likely due to the regularity of the shaped space.[82] The monks constructed a fourth room, a domed sanctuary now dedicated to St. Antony, as a built, rather than carved, extension into the wadi. It abuts the side of the ridge, and opens onto the east side of the nave (fig. 17). One entered the medieval church by way of a staircase descending from the upper shelf to an underground, rock-cut corridor that feeds into the nave from the south. This narrow room probably served as a narthex.

The monastic community also hired a professional artist to paint the first iconographic program in the enlarged church. The remains of his work survive beneath the dome of the Haykal of St. Antony (fig. 18). As Paul van Moorsel has shown, the paintings can be assigned on stylistic grounds to the first half of the thirteenth century and thus provide an approximate date for the expansion of the medieval Cave Church.[83] In the eastern niche of the sanctuary, behind the central altar, the artist placed an enthroned Virgin Mary holding the Christ child in her lap. Enough survives to indicate that she was flanked by angels, but much of the composition is lost.[84] Immediately above the niche he depicted the Annunciation, and on the adjacent north wall a group of standing saints, among whom van Moorsel identified John the Evangelist.[85]

By building a domed sanctuary in the Cave Church, the monks at St. Paul's adhered to contemporary trends in medieval Coptic religious architecture. A major structural change of the period was a shift from wooden roofs to brick vaulting.[86] In the twelfth and thirteenth centuries, numerous Coptic churches were modified in this manner, including those in the Wadi al-Natrun.[87] At the Monastery of St. Antony, the monks enlarged the Church of St. Antony by adding three new sanctuaries, each one surmounted by a dome. They also replaced the earlier wooden roof over the nave with two more domes.[88] Following the reconstruction of their churches, medieval monastic officials often hired

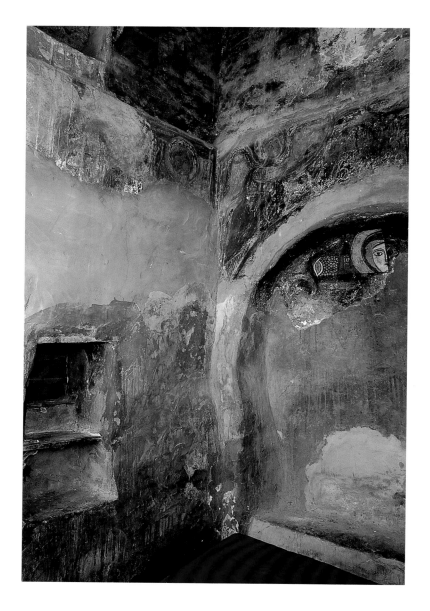

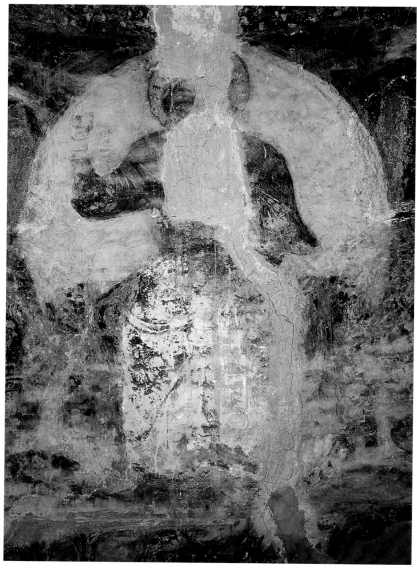

FIGURE 18 LEFT

Haykal of St. Antony, after the test
cleaning of the Virgin Mary in 1999.
ADP/SP 6 S179 01.

FIGURE 19 RIGHT

Christ in Majesty (E10), 1291/1292,
before conservation. ADP/SP
4 S181 01.

professional painters to create new iconographic programs.
A number of such teams have been identified as active in
thirteenth-century Egypt. They appear not only to have
worked in churches, but to have produced icons and illu-
minated manuscripts as well.[89] The best documented team
is that of Theodore, the master painter responsible for an
extensive program in the Church of St. Antony, dated by
inscriptions to 1232/1233 (AM 949).[90]

The principal monastic churches of the monasteries
of St. Antony and St. Paul, therefore, were both enlarged
and painted in the first half of the thirteenth century. Van
Moorsel asserted that the Monastery of St. Paul followed
the artistic and architectural lead of its larger neighbor, and
that the expansion of the Cave Church must have occurred
after 1233.[91] It also seems possible that the need for a more

substantial place of worship caused the monks of St. Paul
to expand and paint the Cave Church a decade or more
before Theodore was active at the Monastery of St. Antony.
In either case, Theodore and the first medieval painter at the
Cave Church appear to have been near contemporaries.

Less than a hundred years later, a second artist was
employed to expand the iconographic program in the Cave
Church.[92] In the Haykal of St. Antony, he placed a Christ
in Majesty, surrounded by the four living creatures of the
Apocalypse and two angels, on the eastern shell of the dome
directly above the work of the first medieval painter (fig.
19). The second artist's enthroned Christ forms a double
composition with the earlier Virgin and Christ child in the
lower niche. The same iconographic arrangement is a popu-
lar one in Coptic art and is found in the central sanctuary

FIGURE 20

Church of St. Mercurius (left), the

keep, and the Cave Church (lower

right), 1931. Whittemore expedi-

tion, B47. Courtesy of Dumbarton

Oaks, Washington, D.C.

at the Church of St. Antony.[93] The second painter seems to have been hired to complete a similar composition in the Cave Church.

Although the low ceilings and limited space of the medieval Cave Church precluded the elaborate iconography employed by Theodore in the Church of St. Antony, the second medieval painter may have incorporated Paul in his program. He painted a number of prominent monastic saints in the entrance corridor.[94] Only a few of these figures survive, and these only partially, but it is conceivable that the painter included Paul in his row of standing saints. On the other hand, van Moorsel suggested that this artist depicted both Antony and Paul on the original north wall of the church, which was demolished at the beginning of the eighteenth century.[95]

In Theodore's program, Paul is painted next to Antony at the head of a procession of desert fathers that circles the eastern nave.[96] A more abbreviated version of the same cycle is found in the thirteenth-century Church of the Virgin at the Monastery of al-Baramus in the Wadi al-Natrun. Here, Paul takes pride of place before Antony and a small group of desert fathers closely associated with the monastery, including Macarius the Great.[97] The hermit is also shown with Antony in a twelfth-century painting in the Monastery of St. Macarius in the Wadi al-Natrun.[98] The prominence of Paul in the painted churches of the Wadi al-Natrun and the Inner Mountain indicates the great renown of the saint in medieval Egypt.

The transformation of Paul's cave into a church marks a major turning point in the history of the Monastery of St. Paul. The presence of a painted church, as opposed to a cave shrine, implies a substantial increase in the monastic population, as well as a change in the social organization of the medieval community. The settlement may have remained a simple desert hermitage for centuries, but the commissioning of two separate painters to work in the Cave Church in the thirteenth century suggests that it had become the fortified compound that it remains today. A century later, Ogier d'Anglure made a pilgrimage to the Holy Land that included a visit to the monastery. The account of his trip records "at least sixty resident brothers" living in an abbey, "shut up in good walls, high and thick, quite like a fortress except that there is no moat outside."[99] The Monastery of St. Paul still resembles Ogier's description.

The medieval journey to the Monastery of St. Paul remained much the same as it had for pilgrims of late antiquity. Starting in Cairo, the Ogier party hired boats to carry them to the Outer Mountain, which they called St. Antony-on-the-Nile. The trip took "two good days of sail-

ing, even when there is a favorable wind."[100] They encountered thirty monks living in a monastery "tightly enclosed with walls in the manner of a fort."[101] The complex included a keep, a large garden, and a beautiful little church. After a short stay the party set out across the Eastern Desert for the Inner Mountain. Traveling with camels, they reached St. Antony-of-the-Desert on the fourth day. Ogier described the monastery as having high walls, beautiful dwellings for a hundred or more monks, a very inspiring church, and a hostel for pilgrims. "As for the garden, it is a lovely sight... green with trees and plants that greatly delight you when you see them in such a barren place."[102]

Finally, Ogier and his companions traversed the Galala plateau to the Monastery of St. Paul. "And in traveling this road, one must cross a mountain... of such great height that it seemed to us to be even more difficult than Mount Sinai."[103] Upon reaching the monastery around midnight, the pilgrims were served hot meals, and then attended mass in the Cave Church until dawn. "In this abbey there is a beautiful little chapel which is down several steps below a rock; here dwelt Saint Paul while he did his penance, for at that time there was no dwelling other than the rock."[104] The account of the journey is concluded by the observation that the three monasteries, "that is to say, of St. Antony-on-the-Nile, and of St. Paul and St. Antony... all come under the authority of one abbot, and seem to be all one [community]."[105]

Ogier did not describe the interior of the medieval Monastery of St. Paul apart from calling it a "beautiful place, well and tidily arranged."[106] The surviving physical evidence also provides little information about the architectural layout of the medieval compound. We can only speculate on the size of the walled enclosure and the distribution of buildings within it. Many of the structures that now constitute the historic core of the monastery were probably already present in an earlier form during the medieval period. The keep, refectory, and at least one of the mills (all common

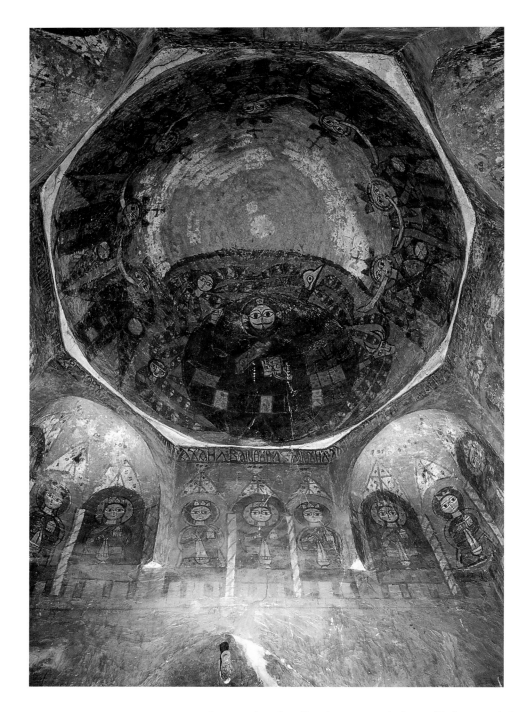

important in Egypt.[107] His information, however, was out of date. By the sixteenth century, the era of medieval prosperity at the Monastery of St. Paul had ended. The monasteries of St. Antony and St. Paul were both abandoned in about 1485 after a continuous occupancy lasting more than a millennium.[108] The Coptic patriarch Gabriel VII (1525–1568) repopulated the Monastery of St. Antony, but a similar effort at St. Paul's proved a failure.[109] By the end of the century, the monastery was again deserted. It would remain in ruins for more than a hundred years.[110]

The Modern Monastery of St. Paul

The Coptic patriarch John XVI (1676–1718) initiated a new era of prominence for the Monastery of St. Paul at the beginning of the eighteenth century.[111] Laborers and artisans, sent by the patriarch, repaired the walls, heightened the keep to its current dimensions, and built a mill and probably the refectory (fig. 20).[112] They also enlarged the Cave Church by adding three domed rooms along the northern side of the building, which introduced a new entrance narthex, an extension of the medieval nave, and a third sanctuary dedicated to the Twenty-Four Elders of the Apocalypse (see fig. 10). According to the foundation inscription in the dome of the narthex, the enlargement of the church was completed in 1712/1713 (AM 1429).

That same year, one of the monks created a new iconographic program in the Cave Church. The monk told Claude Sicard, a French traveler visiting St. Paul's in 1716, that he was a self-taught painter, something Sicard thought obvious from his work.[113] Yet, despite his technical limitations, the monk-painter produced an ambitious, and at times monumental, series of sacred images that extends throughout most of the church. In the three new rooms he painted equestrian martyrs, monastic saints, angels, and the twenty-four elders of the Apocalypse surrounding Christ in Majesty (fig. 21).[114] When working in the older parts of the church, the monk-painter either preserved the medieval images untouched or repainted the same iconographic subjects, often retaining the original medieval inscriptions.[115] Although his self-taught style is rarely praised by western visitors, the monk created the most prominent iconographic program surviving in the Cave Church.

The monastic compound of today has changed remarkably little since the eighteenth century. John XVI established the architectural arrangement of most of the historic core in its current form. The earliest known plan of the monastery, produced for Sicard, shows the enlarged keep and multiple domes covering the Cave Church, as well as a mill room and a cluster of cells along the southern wall.[116]

elements in other Coptic monasteries) very likely occupied their current positions on the shelf above the Cave Church. These communal buildings would have been essential to the wellbeing of the large monastic population recorded by Ogier. However, his estimate of sixty monks is almost certainly an exaggeration; the spring of Paul could not have sustained such a large number. But even the presence of half that many monks would indicate a flourishing community at St. Paul's at the end of the fourteenth century.

In 1526, Leo Africanus, the Moroccan geographer and convert to Catholicism, identified the monasteries of Antony, Macarius, and Paul the Hermit as the three most

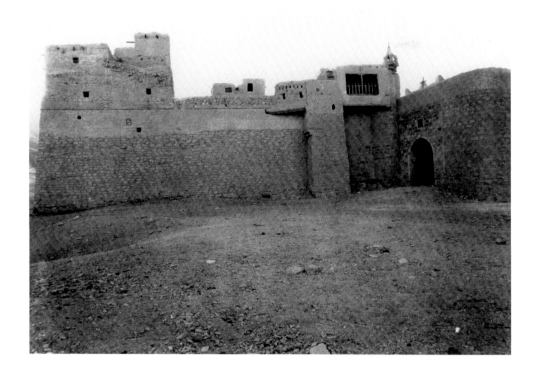

During the course of the century, two more churches were built in the monastery. Patriarch John XVII (1726–1745), a former monk of St. Paul's, consecrated the Church of St. Michael the Archangel and St. John the Baptist.[117] The multidomed building, situated on the limestone shelf to the west of the keep, overlooks the monastic garden. In 1780/1781 (AM 1497), Ibrahim al-Jawhari, the greatest Coptic notable of the period, sponsored the construction of the Church of St. Mercurius.[118] It is adjacent to the keep and refectory, immediately above the rock-cut portions of the Cave Church. An earlier structure may have once occupied this site, but the church now obscures almost all trace of any medieval building.

As a security precaution, the eighteenth-century compound did not have a ground-level entrance. The Monastery of St. Antony also shared this architectural feature in the early modern period. Visitors rang a bell to announce their arrival. The monks then opened a trap door in a projecting room on top of the walls and a lowered a rope to haul them up (fig. 22). The monks currently refer to the rope lift as a *fatuli,* a word of uncertain origin. It is operated by a large windlass in the upper room that a single man can turn (fig. 23).

Monks would greet visitors emerging from the fatuli tower in a small reception court in the southeast corner of the compound (fig. 24). The court gave access, on the north side, to the main public buildings in the monastery: the mills, refectory, and kitchen, and the churches of St. Mercurius and St. Paul. The court also forms the ceiling of a vaulted ground-level storage area known as the *diksar,*

Coptic for magazine or larder.[119] Deliveries of grain from the monastery's agricultural estates in the Nile valley were hoisted to the top of walls by monks turning the windlass of the fatuli. They then poured the grain into a chute leading to a storage bin in the lower diksar. The community used a smaller rope lift next to the fatuli to provide bedouin outside the walls with supplies.

The fatuli was still in operation at the beginning of the twentieth century, when Agnes Smith Lewis and her sister Margaret Dunlop Gibson became the first women known to have visited the Monastery of St. Paul. They traveled by camel, following the traditional route across the desert, and camped beneath the walls. "Next morning we found we had not been misinformed as to the mode of entrance into the convent. . . . Through [a] trap-door a thick cable rope is raised or lowered by means of a great wooden windlass. . . . Large iron hooks attached by small ropes to the great cable were fastened round [a monk's] waist, and he held firmly to the cable with his hands while he was being drawn up, pushing himself away from the wall with his feet as he rose."[120] Lewis and Gibson devised a more modest means of access, using rope netting folded into the form of a basket and lined with a quilt. "I was made to kneel on this, the rope netting being roughly sewn round my waist. I closed my eyes, and a minute later opened them, to find a dozen monks, in a state of great delight, standing ready to help me out. . . . Then about thirty monks fell into their places in a procession, carrying candles, crosses, and banners; a bell was pealed, a cymbal tinkled, and we marched behind them, along narrow winding paths between cells of unburnt bricks,

to the church, where we found some chairs placed for us in the choir."[121] After a two-hour service, the monks took Lewis and Gibson on a short tour of the monastery that included the bakery, library, and garden, before escorting them back to the fatuli.

The visit of the sisters may have broken an all-male tradition of sixteen hundred years, but their account of their journey differs little from that of Ogier d'Anglure, written six centuries earlier. The method of reaching the monastery had remained the same, as had the extreme physical isolation of the community. Within a few decades, however, travel options would begin to change dramatically. In 1930 Thomas Whittemore led an expedition of the Byzantine Institute of America in Ford automobiles across the desert to the Red Sea monasteries, escorted by soldiers of the Egyptian camel corps.[122] The same year, Johann Georg, a son of the king of Saxony, took a ship from Suez to Zafarana, from where he hired camels to St. Paul's.[123] The monastery continued to be difficult to reach, but modern technology was making the journey much easier.

The Whittemore expedition included a professional photographer named Kazazian, who thoroughly documented the Monastery of St. Paul.[124] His black-and-white images are among the first visual record of the interior of the compound. Kazazian photographed the walls, churches,

mills, refectory, keep, and garden, as well as newer structures, including a street of cells and a reception hall along the south wall. His photographs also indicate that the monks had enclosed the spring of St. Paul within the compound by building a western extension of the walls. Many of these additions to the monastery probably date to the eighteenth and nineteenth centuries, but one change recorded by Kazazian was more recent. A few years before the Whittemore expedition, the monks of St. Paul's added a large gate to the outer wall, immediately next to the fatuli, as well as a small door in the south wall near the monastic reception hall.[125] They no doubt continued using the fatuli for grain deliveries, but visitors could now enter the monastery at ground-level.

The 1946 completion of the coastal road from Suez to Ras Gharib reduced travel time from Cairo to the Monastery of St. Paul to about six hours by automobile.[126] Two years later, the monks constructed a guest house at the monastery, the first major structure built outside the walls.[127] St. Paul's had never been so accessible, but the community of monks remained isolated. After the 1967 Arab-Israeli war, the Red Sea coast became a restricted military zone for a decade. At the beginning of that period, the monastery had one truck that brought supplies from Bush, in the Nile valley, only four times a year. By the mid-1970s the deliveries had

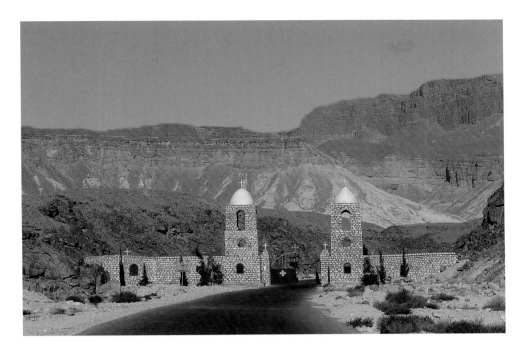

FIGURE 25

Modern outer gate of the enlarged monastic enclosure. ADP/SP

7 S1123 97.

increased to once a month. At about the same time, the monks replaced the eighteenth-century mills with a modern version powered by a generator. The monastic community would wait until the 1980s before paving a road through the Wadi al-Dayr, and introducing electricity into the compound.[128] Before the monks initiated these last changes, van Moorsel and a team of specialists spent two seasons studying the paintings and inscriptions in the Cave Church on behalf of the Institut français d'archéologie oriental.[129] Among van Moorsel's many important discoveries was the identification of two medieval painters active in the church.[130] Unfortunately, the publication of this first intensive study of the Cave Church was delayed until 2002, three years after van Moorsel's untimely death.

In 1985, when van Moorsel worked in the church, the still remote Monastery of St. Paul was on the verge of a new period of expansion. That year, tanker trucks began delivering drinking water to the compound. For the first time in its long history the monastery was no longer dependent exclusively on the spring of Paul. Over the next fifteen years the community increased from forty monks to an unprecedented seventy monks living in the compound.[131] The dramatic growth in the population also saw the expansion of the monastery outside the walls. Today, workshops, guest quarters, pilgrim centers, and tree-lined neighborhoods of monastic cells fill the surrounding desert. The monks have installed running water in all of the buildings, as well as electricity. A new outer gate now defines the beginning of the monastic enclosure at the mouth of the Wadi al-Dayr (fig. 25). The original walled compound has become merely the core of a much larger desert settlement.

The Monastery of St. Paul is no longer cut off from the rest of Egypt. Both Egyptians and foreign tourists frequent the Red Sea coast, now a popular summer resort area. Four-lane desert highways ensure that it takes only about three hours to drive from Cairo to the monastery. On weekends, hundreds of Coptic pilgrims from all over the country arrive in tour buses. During important Christian feasts, their numbers increase to the thousands.[132] Fifty years ago the Monastery of St. Paul was an outpost in the desert; today it has become one of the most accessible Coptic sites in Egypt.

During this period of remarkable change, ARCE became involved with the community at the Monastery of St. Paul thanks to generous funding by USAID. Between 1997 and 1999, Michael Jones supervised the conservation of the refectory, mill rooms, and portions of the outer walls, as well as the photodocumentation of the monastery by Patrick Godeau and the publication of a guide book.[133] In 2001, Adriano Luzi and Luigi De Cesaris began their four-year campaign to conserve the Cave Church and its wall paintings, again under the direction of Jones. This book is the result of six years of conservation work by ARCE at the Monastery of St. Paul (fig. 26).

Studying the Monastery of St. Paul: Past, Present, and Future

The ARCE-USAID involvement in the documentation and conservation of the Monastery of St. Paul was certainly not the first expression of western interest in the site, as I have mentioned above. Van Moorsel wrote the most substantial publication on the monastery, focusing principally on documenting the paintings in the Cave Church. That book includes a short architectural study by Peter Grossmann, a survey of the paintings by van Moorsel, and drawings and watercolors of the images and inscriptions by Pierre-Henry Laferrière.[134] However, as is unfortunately still often the case in Coptic studies, no multidisciplinary, in-depth publication such as this book had ever been produced. The scholars and specialists contributing to this volume present various facets of the complex phenomenon that is the Monastery of St. Paul. The generative impulse for that community and for this project is, of course, Paul the Hermit, for whom we have no physical remains or hard historical data. Nevertheless, belief in Paul and the desire to use him as a model for imitation have survived for almost two millennia, compelling pilgrims, monks, visitors, and scholars to visit, live near, build on, and otherwise embellish the site of the cave associated with the saint.

The contributions to this book are separated into two parts. The first examines the textual sources for the life of Paul and the history of the monastery dedicated to his memory. Stephen J. Davis begins with a study of Jerome's

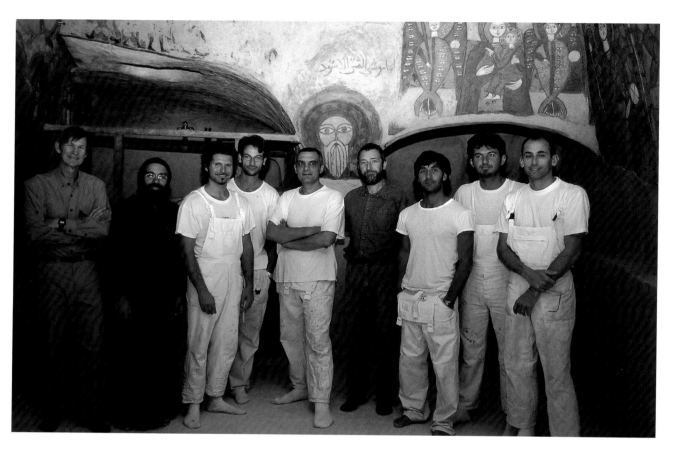

Vita Pauli, the earliest known written biography of Paul the Hermit. Davis demonstrates that Jerome carefully constructed his account of Antony's discovery of Paul in order to appeal to an educated Roman audience, suspicious of Christian asceticism. His *Vita Pauli* became one of the most important texts in the promotion and subsequent spread of monasticism in western Europe. It also inspired western pilgrims in late antiquity to seek out the hermitage of Paul in the Eastern Desert of Egypt.

These pilgrim accounts also serve as the earliest sources for the history of the Monastery of St. Paul, which Mark Swanson explores. Although the historical data concerning the monastery is extremely limited, Swanson places what is known within the wider context of the history of the Coptic Church and people, amplifying our perspective on the site considerably. Two periods in particular stand out in his study, the thirteenth and eighteenth centuries, which were both times of relative prosperity for the Copts that corresponded to the production of the wall paintings in the Cave Church.

Alastair Hamilton charts a parallel account of the history of the Monastery of St. Paul from the vantage point of western pilgrims, missionaries, and scholars. These travelers supplied much of the known information about St. Paul's between the late fourteenth and the early twentieth centuries. Hamilton describes the numerous motives driving these western travelers to visit the remote monastery, as well as their response to the monks and other Copts they met in Egypt. He thus expands our understanding of the networks of connections between East and West begun by Davis.

Febe Armanios provides a closer examination of the eighteenth-century revival of Coptic society, during which time not only was the Monastery of St. Paul repopulated, but three of its monks were elevated to the patriarchal throne. Viewing events largely from Cairo rather than from the monastery, Armanios traces the rise of a secular elite within Coptic society that owed its position of wealth and authority to the patronage of the Muslim military lords of Egypt. These Christian leaders infused funding into the Coptic community by building and repairing churches throughout the country, including the Cave Church. They also ensured the election of the three consecutive patriarchs from St. Paul's in the eighteenth century, demonstrating their strong ties to the saint and his monastery.

Gawdat Gabra concludes the first part of the book with important new discoveries from the manuscript library at the Monastery of St. Paul. He has located new Arabic-language sources for the medieval and eighteenth-century history of the monastery that he presents in the original and in translation. Although Gabra was allowed only limited access to the library, he nevertheless managed to identify and copy numerous key passages that throw new light on the

obscure history of St. Paul's. His discoveries, as well as his generosity in sharing his findings with the other contributors, have greatly expanded the scope of this book.

In Part Two, the Cave Church of St. Paul takes center stage. Art historians, archaeologists, conservators, and historians consider the material traces of devotion to Paul, expressed in multiple phases of building, painting, and writing inscriptions. Peter Sheehan presents archaeological evidence for the development of the church from its origins as a hermit's cave through its medieval and early modern enlargements. He also considers the growth of the monastery around Paul's hermitage, especially the churches and community buildings constructed on the limestone shelf above the cave, and the sequence of walls that enclosed the settlement.

Two chapters address the ARCE conservation of the Cave Church. Michael Jones describes the steps taken to conserve and protect both the interior and exterior of the building. He also gives an account of the earlier ARCE campaign to conserve the refectory and mill rooms of the monastery. Luigi De Cesaris and Alberto Sucato explain the process of conserving the three phases of wall paintings in the Cave Church from the initial test cleanings to the final presentation. They further outline the sequence of plaster layers found in the church upon which the different painting stages were executed. This information is vital for understanding the architectural and art historical development of the Cave Church.

Elizabeth Bolman devotes separate chapters to the two phases of medieval paintings in the church, both of which date to the thirteenth century. By examining the artistic style and iconography of the two programs, she considers their raison d'être in the contexts of the monastery, and of the period in which they were produced. As mentioned above, professional artists were particularly active painting Coptic churches in the thirteenth century. Through her study of the two phases of work in the Cave Church, which are separated by approximately sixty years, Bolman addresses important aspects of the character and trajectory of Coptic art in one of its richest eras.

The most unexpected and perhaps the most exciting material examined in this long story of devotion to Paul is from the eighteenth century. In addition to editing the book, I contribute a close investigation of the wall paintings in the Cave Church produced in 1712/1713 by one of the monks of the recently repopulated monastery. In two chapters I explore not only the iconography and style of the paintings, but also situate them at the beginning of an explosive but little known new age for Coptic art and cul-

ture. As with so many of the contributions to this book, my chapters draw on the work of others, especially that of Swanson, Gabra, and Armanios, for the political and social background of the eighteenth-century paintings.

In the final chapter, Gabra provides a new, postconservation reading of all of the inscriptions in the church, which are reproduced in the original Coptic and Arabic, along with translations. His new reading of the date of the second medieval painter, and his identification of the epigraphist of the eighteenth-century program (the latter based on his work in the monastic library) are major discoveries that Bolman and I depend on for our art historical analyses.

Patrick Godeau is responsible for most of the photographs in the book. His photo documentation of the Monastery of St. Paul and the Cave Church, carried out between 1997 and 2005, is a unique record not only of the cleaning of the wall paintings in the church but also of the remarkable growth of the monastic compound in the early years of the twenty-first century. Nicholas Warner produced the meticulous architectural drawings of the monastery and church that form an appendix to this volume, as well as illustrate a number of chapters. Sergio Tagliacozzi and Maria Antonietta Gorini supplied the graphic documentation of the wall painting conservation. Only a small portion of their extensive survey, made on behalf of Luigi De Cesaris, has been included as chapter illustrations.[135]

The current study of the Cave Church at the Monastery of St. Paul proves how rich and varied are the subjects of Coptic history, art, architecture, and archaeology. Such was the complexity of the material we encountered during the course of the ARCE conservation project that the scope of this volume increased considerably during its preparation. Nevertheless, much remains to be done at the Monastery of St. Paul and other Coptic sites in Egypt. Significant areas of study, most notably the manuscript library at St. Paul's, still need intensive exploration. I hope that future scholars will build on our efforts, as we have on those of Jules Leroy, Paul van Moorsel, Peter Grossmann, and other pioneering Coptologists.

PAUL THE HERMIT AND HIS MONASTERY

Generation, Imitation, and Reception

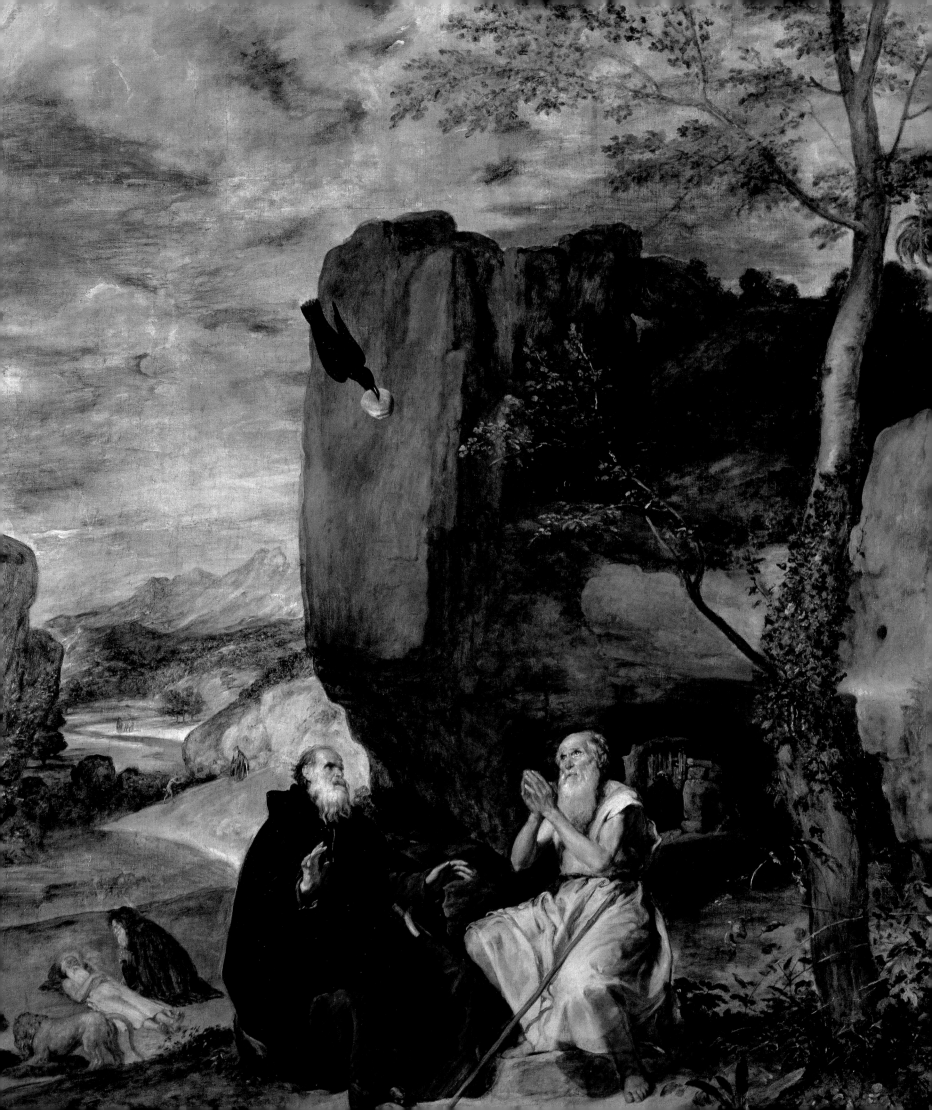

CHAPTER 1

JEROME'S *LIFE OF PAUL* AND THE PROMOTION OF EGYPTIAN MONASTICISM IN THE WEST

In the Prado Museum in Madrid, a painting by the Spanish artist Diego Velázquez (1599–1660) depicts the legendary meeting of the Egyptian saints Antony and Paul from Jerome's fourth-century *Vita Pauli* (fig. 1.1).[1] Panoramic in scene and scope (257 × 188 cm), the large oil on canvas shows Antony and Paul seated in the foreground in front of a landscape of rocky outcroppings, mountainous peaks, and tree-lined valleys. Antony, seated at left, is dressed in a hooded black cowl over a long-sleeved brown monastic robe. The T-shaped handle of his walking stick rests on his left thigh, and both of his hands are raised in mute wonderment. Paul is barefoot and dressed in a light-colored and rough yet almost diaphanous frock, belted at the waist. His own staff, propped on his lap and fully visible, is straight-hewn and simple. His eyes are slightly raised, as if gazing to heaven, and he holds his hands together before his face in a gesture of prayer. Above the two figures an overcast sky looms, its clouds marbled in texture; and a raven descends with a loaf of bread in his beak, a sufficient supper for these famous ascetics.[2] Behind the two central figures the surprisingly abundant landscape is populated by other scenes from the *Life of Paul*—visual vignettes designed to fill out the sequence of events surrounding this meeting between Paul and Antony.[3]

By the river that meanders through the valley in the distance (to the upper left of the main figures), Velázquez has depicted the first scene in miniature: Antony's encounter with a hippocentaur—"a creature that was half man and half horse"—near the beginning of his journey to find Paul's cave in the desert (*VP* 7).[4] As the valley rises toward the central figures and the viewer, one can descry a second scene in which Antony, dark-robed and standing in front of a rock face, is approached from the left by another figure, its arms outstretched. Here, Velázquez renders Antony's encounter later that same day with a faun, or satyr: "He saw in the rocky valley a man of no great height, with a hooked nose, his forehead sprouting sharp horns, the lower part of whose body ended in goats' feet" (*VP* 8).[5]

The third scene is that of Antony's arrival at Paul's cell on the third day of his journey. Through the mouth of the cave at the base of the large rock outcropping (immediately behind and to the right of the main scene in the foreground), one sees the figure of Antony knocking on the door of Paul's cell and entreating the hermit to receive him as a visitor. According to Jerome's account, "Antony fell down in front of this door and continued to beg to be allowed in until it was the sixth hour of the day or even later" (*VP* 9).[6]

The central event depicted in the foreground, Antony's encounter and conversation with the blessed Paul, represents then the fourth scene in the narrative sequence of the painting (*VP* 10–12). During their meeting, Paul speaks of his imminent death and bids Antony to go home to fetch an appropriate burial shroud: "I beg you to go back…and bring me the cloak which bishop Athanasius gave you and wrap it around my poor body."[7]

Finally, in the near background at the lower right of the painting, one finds the fifth and final scene in the visual narrative, the burial of Paul. Antony kneels, praying, over Paul's prostrate body, while two lions dig his grave with their paws. In Jerome's vita, even though Antony

hurriedly returns to Paul's cave with the cloak, he arrives to find that that monk has already gone to his rest. The end of the story tells how Antony "wrapped Paul's body up and brought it outside, singing hymns and psalms according to Christian tradition," and then buried him with the help of the two lions (*VP* 15–16).[8]

This magisterial painting provides a vivid example of how one western artist has reinterpreted the *Life of Paul* by visually conflating the geography and chronology of Jerome's account. Through a spatial and temporal reconfiguring of the narrative sequence, this early modern Spanish painter inexorably draws the viewer's attention to the moment of Antony's encounter with Paul.[9]

In ancient biographical legend, in the geography of Egyptian monasticism and pilgrimage, as well as in their reception as ascetic heroes in western visual art, Paul and Antony have always been inextricably intertwined. In Jerome's original vita from the late fourth century (ca. 375–376), the Latin church father self-consciously frames his narration of Paul's life story in relation to the well-known accounts that were circulating about Antony in both Greek and Latin—especially Athanasius of Alexandria's immensely popular *Life of Antony* (ca. 357).[10] Indeed, a full ten out of the eighteen chapters in Jerome's *Life of Paul* (chapters 7–16) focus on the person of Antony and his two journeys to see Paul at his monastic cave. By the end of the fourth century, Christian pilgrims on their way to the Sinai peninsula had begun visiting the monastic sites associated with Antony and Paul along the Red Sea coast as part of their itinerary of holy places. One pilgrim from around the turn of the fifth century reports visiting "two monasteries of St. Antony" and the "place in which the most blessed Paul, the first of the eremites, had his abode."[11]

The popularity of Paul and Antony in late antiquity was due in large part to their joint reputation as the pioneers of Egyptian monasticism. The early fifth-century monk John Cassian lauds them as the "originators (*principes*) of this profession."[12] Cassian's language echoes that of Jerome himself, who, in composing the *Life of Paul*, explicitly raised the question of "which monk was the first to inhabit the desert." In doing so, he sought to counter the prevailing opinion that Antony alone was the "first to undertake this way of life," asserting instead that even Antony's own disciples recognize Paul of Thebes as "the originator (*princeps*) of the practice . . . of the solitary life."[13]

And yet the early association of these two figures was not simply the product of early Christians' historical interest in monastic origins. From the beginning it had been part of a larger cultural and ecclesiastical strategy designed to promote Egyptian monasticism in the Latin-speaking world. In this chapter I will investigate two primary ancient contexts for the promotion of monastic values and the legacy of Paul of Thebes in the Latin West: Jerome's literary production of Paul's vita, and late antique pilgrimage practice to Paul's monastic cave near the Red Sea.

In the case of Jerome I will show how he sought—by means of allusions to Virgil, the Bible, and the *Life of Antony*—to portray Paul as an epic, biblical, and monastic hero for his friends and literary patrons in the West. Through the use of such texts Jerome constructs a monastic geography in which the heroic asceticism of the desert periphery is contrasted with (and serves as an implicit critique of) the conventional social mores of urban centers like Rome and Alexandria.[14] In the case of late antique pilgrimage practice, I will explore how early Christian travel accounts further promoted Egyptian monasticism in the West by effectively "re-mapping" the cave of Paul onto a biblical and extra-biblical landscape of holy places. In the process, an "exotic" (peripheral) pilgrimage destination in the Egyptian desert was domesticated—recast as part of a familiar network of sacred sites—for a highly literate western readership.

Finally, as something of a postscript to this study, I return to the legacy of Paul in early modern western art and reflect further on how the late antique and early medieval promotion of Paul as a monastic saint, and the concomitant construal of Egyptian desert landscapes as arenas for sacred encounters, bore fruit in the visual imagination of later European artists (see figs. 1.2–1.9).

Jerome's *Life of Paul*: Intertextuality and the Promotion of Egyptian Monasticism in the Latin-Speaking West

JEROME AND HIS AUDIENCE

With regard to Jerome's *Life of Paul,* both the date and place of composition are uncertain, although most scholars believe that Jerome wrote the work during the late 370s, either during his ascetic retreat in the Syrian desert or immediately afterward, during his time in the city of Antioch.[15] Having grown up on the northern Italian frontier in the vicinity of Aquileia, and having received his education in Rome, Jerome was intimately acquainted with Latin culture. By the year 375 or 376, however, Jerome had decided to leave his home territory and to withdraw to the desert of Chalcis in Syria. In the Syrian wilderness

he enthusiastically took up a life of solitude. Writing to his friend Heliodorus, who had entered the desert with Jerome but soon decided to return to his hometown of Aquileia, Jerome wrote, "O desert, bright with the flowers of Christ! O solitude whence come the stones of which, in the Apocalypse, the city of the great king is built! O wilderness, gladdened with God's especial presence! What keeps you in the world, my brother, you who are above the world? How long shall gloomy roofs oppress you? How long shall smoky cities immure you?"[16]

However, despite Jerome's self-proclaimed zeal for the desert and scorn for city life, his own initial foray into the life of solitude did not last very long. After little more than a year or two he relocated to Antioch, where he resided until 380. The *Life of Paul* was probably written either during his brief stint in the desert or (perhaps more likely) during his subsequent period in the Syrian capital.[17]

What is certain is that Jerome composed the work with a western, Latin-speaking audience in mind. One of its earliest recipients was the centenarian Paul of Concordia, prominent among Jerome's literary patrons in northern Italy. In a letter addressed to this patron, Jerome lavishes praise upon Paul for his continued health in his old age (a tangible sign of his piety), and requests copies of several Latin works: the commentaries of Fortunatian, the *History* of Aurelius Victor (for its account of the persecutors), and the letters of Novatian (in order to learn how to combat his schismatic teaching). In exchange, Jerome sent along with his letter a copy of his recently written vita on Paul of Thebes: "In the mean time I have sent to you, that is to say, to Paul the aged, a Paul that is older still." His letter also came with the promise of other vitae to come, "which if the Holy Spirit shall breathe favorably, shall sail across the sea to you with all kinds of eastern merchandise."[18]

From these epistolary remarks, one observes how the composition and distribution of Jerome's *Vita Pauli* were framed by the social and economic conventions of literary patronage in the late Roman Empire: the production of saints' vitae became a commodity of exchange. Thus, in his communication with Paul of Concordia, Jerome seeks to secure an economic transaction in which the *Life of Paul*, a kind of "eastern merchandise," is exchanged for specific forms of western literary patronage. Furthermore, by highlighting the mimetic connections between his literary patron and the saintly subject of the vita—the two Pauls shared the same name and exceeded one hundred years in age—Jerome in fact reveals something about the hoped-for effect his hagiographical work would have upon

its readers. Paul of Thebes is put forward as a model for pious imitation, and the readers of the *Life* are enjoined to assimilate themselves to his ascetic virtues, just as is already the case with his Italian namesake, Paul of Concordia.

Of course, Paul of Concordia was not the only ancient recipient or reader of Jerome's *Life of Paul*. Within a decade or two the work had been disseminated widely among Latin readers in the West.[19] The earliest readers of the *Life* would undoubtedly have been, like Paul of Concordia, among Jerome's friends in Italy, many of whom were members of the Roman elite. Jerome's cultivation of an aristocratic network of friends and supporters in the late fourth century has been amply documented and commented upon in recent scholarship.[20] Among this circle of friends, social bonds were formed at the intersection of late Roman male friendship, shared social class, and educational and literary training.[21]

Evidence within the *Life of Paul* reflects Jerome's concern with addressing an audience composed of the urban elite in Rome and other Italian city centers. Indeed, at the end of the *Life*, he addresses a Roman aristocratic audience directly, using Paul's example to offer a sharp critique of their dependence on luxury:

> At the end of this little work I would like to ask those who own so much land that they do not know it all, those who cover their homes in marble, those who thread the wealth of whole estates on to one string, 'What did this old man ever lack, naked as he was? You drink from jeweled cups but he was satisfied with the cupped hands that nature had given him. You weave gold into your tunics but he did not even have the shabbiest garment belonging to your slave. But then, paradise lies open to him, poor as he was, while hell will welcome you in your golden clothes. He was clothed with Christ despite his nakedness: you who are dressed in silks have lost the garment of Christ. Paul who lies covered in the vilest dust will rise again in glory: heavy stone tombs press down upon you, you who will burn together with your wealth. Have a care, I ask you, for yourselves, have a care at least for the riches you love. Why do you wrap your dead in cloths of gold? Why does your ostentation not cease amidst the grief and tears? Or are the corpses of the rich unable to rot except in clothes of silk?'[22]

Earlier in the *Life of Paul*, this final censure of upper-class Romans' preoccupation with material luxuries is presaged in Jerome's lament, "But to what does the accursed greed for gold not drive the hearts of men?"—a line taken

directly from Virgil's *Aeneid*.[23] Here, in quoting the famous Latin epic, Jerome significantly echoes Virgil's own critical attitude toward the urban aristocracy of Rome.[24] Thus, even as he seeks to appeal to the sensibilities of the literati by frequently employing an elevated Latin style, with diction interspersed with poetic terms and phrases that belie his claim to "have taken great pains to bring my language down to the level of the simpler sort,"[25] Jerome presents Paul's life (and his own) as a sharp critique of Roman aristocratic values and as a model of an alternative vocation for those who (like Paul) were "wealthy" and "highly educated."[26]

Intertextuality and the Study of Jerome's *Life of Paul*

In discussing the literary sophistication of Jerome's composition—most notably, his extensive allusions to Latin works by Virgil, Cicero, and Horace—some scholars have characterized the writer as exhibiting the passive or almost unconscious reminiscences of a writer steeped in a classical education.[27] It is true that the well-educated Jerome was able to draw on a reservoir of knowledge in calling to mind relevant passages from classical (as well as biblical and other early Christian) sources and in finding ways to integrate such references into the *Life of Paul* and his other hagiographical writings. What has not been adequately acknowledged, however, is the way that Jerome's literary allusions functioned as dynamic intertextual strategies designed to appeal to a particular Roman readership and to promote the monastic life among Romans who enjoyed a high educational, social, and economic status.[28]

The term "intertextuality" has had a range of applications in the study of historical texts.[29] At one end of the spectrum, among those simply concerned with the ways that authors use source material, "intertextuality" refers to the conscious (or semiconscious) reappropriation of various earlier texts in the production of new literary documents.[30] How and when a writer cites or alludes to previous sources, and what those sources are, says something not only about his or her reading habits and thematic concerns, but also about the way that textual authority was constructed for that particular writer. At the other end of the spectrum, among historians with an interest in poststructuralist theory, intertextuality more broadly describes a philosophy of how language functions as a constantly shifting, interreferential system. According to this perspective, texts are neither homogeneous nor autonomous in structure, but rather are necessarily composed of multiple layers—bits and pieces—drawn from previous discourses.[31] One commonly used analogy for this post-structuralist understanding of linguistic intertextuality is the image of a fabric woven together from strands of various hues;[32] another is that of a complex musical fugue, the apparently seamless product of many different melody lines interlaced in the performance.[33]

These two ways of defining intertextuality really reflect two different kinds of questions being posed of the texts being studied. In the first case, the questions being asked center on the agency of the author as interpreter of earlier sources, and on how such sources were redeployed for specific theological and/or social ends. In the second case, the questions being asked direct attention, on a discursive level, to how these reappropriated texts intersect with each other—how they sometimes compete and collide—in the production of new textual discourses.

In my study of the *Life of Paul*, I ask both kinds of questions. On the one hand, I want to note the ways that Jerome, as author, used classical, biblical, and early Christian sources in the presentation of Paul as a model of virtue. In doing so, Jerome was following the conventions of other ancient biographers who commonly drew on narrative models as a means of emphasizing the exemplary character and ethos of the biographical subject.[34] On the other hand, I also want to observe how the intersection of epic, biblical, and monastic models in the *Life of Paul* produced in the end not so much a cohesive narrative portrait of an individual hero, but rather a discursive topography—a "landscape" and an "inscape"[35]—that made the remote desert (as portrayed by Jerome) imaginatively accessible to a Roman urban audience.

The Presentation of Paul as a Biblical and Monastic Hero

In the *Life of Paul,* Jerome makes extensive allusions to biblical texts, as well as to other early Christian literature (especially the *Life of Antony*), in presenting Paul as a monastic model for his readers.[36] In chapter thirteen of the vita, Antony returns home after his first journey to Paul's cave and he is asked by two disciples, "Where have you been all this time, Father?" In reply, he proclaims, "I have seen Elijah, I have seen John in the desert and now I have seen Paul in paradise."[37] In placing these words on the lips of Antony, Jerome evokes a set of biblical figures and stories that were commonly reinterpreted and applied to descriptions of the monastic life in late antiquity.

The desert landscape in which Paul practices his asceticism is likened to paradise—the Garden of Eden from Genesis 2. Once lost to humankind through the sin of Adam and Eve (Genesis 3), Eden is thought to be "regained"

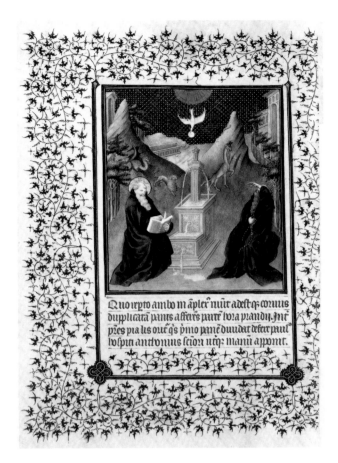

FIGURE 1.2

Antony and Paul fed by a dove next to a fountain in the desert, 1405–1408/1409. Pol, Jean, and Herman de Limbourg (active ca. 1399–1416). *Belles Heures of Jean, Duke of Berry*, folio 192v. The Cloisters Collection, 1954 (54.1.1), The Metropolitan Museum of Art, New York.

through the monastic pursuit of virtue.[38] This theme echoes throughout the corpus of monastic tales preserved from the early Christian era. In many of these stories, devout travelers tell of how they found the desert blooming around the caves and cells of holy men and women. Thus, in *History of the Monks of Egypt*, the monk Patermuthius relates how he had been "transported physically to paradise" and had "eaten the fruits of paradise." As proof of his visit, he brought back to his disciples a "large choice fig" from the garden.[39] In another story from the same collection, Macarius, a younger contemporary of Antony, embarks on a pilgrimage through the desert to find a "copy of the true paradise" planted by two other monks. He arrives to find a garden, guarded by demons, with huge fruit trees and "three large springs." After staying seven days, he returns home and shows his monastic compatriots the fruit he had gathered as proof of his visit.[40] Finally, in the *Life of Onnophrius,* a story of Paphnutius' journey deeper and deeper into the desert to find the hermit Onnophrius, the traveler encounters a succession of mini-Edens. First, he encounters Abba Timothy, a naked solitary who lives with the animals and is depicted as Adam restored to paradise.[41] Timothy's attainment of a paradisiacal lifestyle—fed by a spring and a date palm bearing fruit all year round—is depicted as an undoing of his earlier sexual sin with a female monk.[42] Later, after having encountered Onnophrius and

other monastic denizens of the desert, Paphnutius arrives at his own personal paradise. Seeing a well of water and a vast grove of fruit-bearing trees—date palms, citron, pomegranate, fig, apple, grape, nectarine, as well as sweet-smelling myrtle—he proclaims in wonderment, "Is this God's paradise?"[43] Therefore, Antony's reference to seeing Paul in paradise would have resonated deeply among its late antique and early medieval readers, conjuring in their minds an imaginative desert landscape peopled by such monastic heroes.[44]

Antony's words place the hermit Paul in such a landscape, along with Elijah and John the Baptist, two biblical figures often interpreted in the early church as prominent prophetic forerunners of early Christian monks. Indeed, Jerome highlights the monastic "pedigree" of Elijah and John in the prologue to the *Life of Paul*. In discussing the origins of monasticism, he writes, "Some, going back further into the past, have ascribed the beginning to the blessed Elijah and to John; of these, Elijah seems to us to have been more than a monk, while John seems to have started to prophesy before he was born."[45] In a similar vein, Athanasius of Alexandria also identifies Elijah and John the Baptist as spiritual models for Christian ascetics both in his treatise *On Virginity* and in his *Life of Antony.*[46] In the aforementioned *Life of Onnophrius,* the saint tells his visitor Paphnutius about how, as a youth, he had learned the ascetic vocation ("received spiritual formation") from monks in Upper Egypt who instructed him frequently about the lives of Elijah the Tishbite and John the Baptist.[47]

In the case of Jerome's *Life of Paul*, there are other narrative details that reinforce the saint's association with Elijah as a biblical archetype. In chapter ten, as Paul and Antony were conversing, "they noticed a raven land on the branch of a tree: it then flew gently and placed a whole loaf of bread in front of them as they watched in amazement" (fig. 1.2).[48] This scene of divine provision would have reminded biblically literate readers of the story of Elijah in 1 Kings 17:4–6, where God commands ravens to feed the prophet by the Wadi Cherith: "The ravens brought him bread and meat in the morning, and bread and meat in the evening; and he drank from the wadi." By incorporating this story element into his narrative description of Paul and Antony's encounter, Jerome casts Paul and his visitor as recipients of God-given sustenance, just like their predecessor Elijah.

Later, in chapter fourteen, when Antony in a vision sees "Paul among the hosts of angels, among the choirs of prophets and apostles, shining with a dazzling white-

ness and ascending on high," the language of description recalls Elijah's ascent to heaven in a fiery whirlwind, witnessed by the prophet Elisha in 2 Kings 2:11. Among ancient readers, the scene also would have evoked the story of Christ's transfiguration in the Gospels, where Jesus' face "shone like the sun, and his clothes became dazzling white" (Matthew 17:2; compare Mark 9:3 and Luke 9:29). In each of the three Gospels that relate this story, Christ's transformation is followed immediately by the appearance of Elijah and Moses, who converse with Jesus.[49] In Matthew and Mark, Jesus then offers his disciples commentary on his relation to Elijah; in the case of Luke, the evangelist simply emphasizes that Elijah, like Jesus, appeared to the disciples "in glory."[50] Once again, Jerome overlays his representation of Paul with evocative, visual images drawn from the pages of Scripture. Here, Paul's visual association with the exalted Elijah and the transfigured Christ further underscores Jerome's aim of presenting the monk as the embodiment of a transformed humanity, and the desert as both a paradise on earth and a door to heaven.[51]

The *Life of Antony* also serves as a crucial intertext in the *Life of Paul*. Shortly before Jerome composed his spiritual "biography" of Paul, Athanasius' expansive Greek vita on Antony's life and teachings had been translated into Latin by Jerome's close friend Evagrius of Antioch.[52] Evagrius, an influential and high-ranking member of Antiochene society who had entered the priesthood, met Jerome in northern Italy. Later he hosted Jerome during his time in Antioch, and he provided personal and material support for Jerome during his short-lived retreat to the Syrian desert. It was either during their time together in Italy, or in Antioch, that Evagrius completed his translation and dedicated it to Innocentius (a mutual friend and literary patron of both Jerome and Evagrius).[53] When Jerome notes that "an account of Antony has been recorded in both Greek *and Latin*" (emphasis added), he is probably referring to Evagrius' translation.[54]

In the *Life of Paul*, the narrative pairing of Paul and Antony allows Jerome to negotiate for Paul a privileged place in the pantheon of Egyptian monastic heroes. This discursive method is evident from the opening lines of the prologue, in which Jerome defends the claim that Paul (and not Antony) was the true "originator" of Egyptian monasticism. And yet, in constructing the relationship between the two figures throughout the remainder of the *Life*, the author sustains a delicate balance between an atmosphere of mutual aid and a spirit of friendly rivalry, a mix of cooperation and competition in the pursuit of virtue.

It may seem odd that almost all the action of the plot in the *Life of Paul* is in fact performed by Antony. It is Antony who sets off through the desert in search of Paul and meets with various mythical creatures on the way, and it is Antony who rushes home to fetch the cloak of the bishop Athanasius and then returns only to find Paul already dead. Indeed, as readers, we encounter Paul most often through Antony's eyes (the primary exception being chapters four through six, the account of Paul's early calling to the monastic life). Given this preponderant narrative focus on Antony, the *Vita Pauli* would seem to be presented almost as if it were a "lost chapter" in the *Vita Antonii*, an unrecorded episode in Antony's series of ascetic adventures. In one instance, Jerome's account specifically adopts the language of the *Life of Antony* in its Latin translation. When Paul flees to the mountains to wait out the persecutions, he is said to have been "making a virtue of necessity" (*necessitatem in voluntatem vertit*); Antony advocates the same ethic to his disciples in his vita: "Why then do we not make a virtue of necessity?" (*cur ergo non facimus de necessitate virtutem*).[55] Various other narrative details in the *Life of Paul* also mirror Evagrius' translation of Athanasius. Paul and Antony both experience the death of their parents prior to becoming monks,[56] both view their caves as gifts given by God and depend on date palms for sustenance,[57] and both were thought to have been carried to heaven by angels after their deaths.[58]

And yet there are ways in which Jerome's *Life of Paul* specifically seeks to renegotiate charismatic authority and subtly claims precedence over Athanasius' work.[59] First, Jerome does so by portraying Antony's journey into the desert to see Paul as a pilgrimage leading to an encounter with one more perfect than himself: "During the night while he was asleep it was revealed to him that there was someone else further into the desert interior who was far better than him and whom he ought to go and visit."[60] Second, when Antony does stumble upon Paul's cave, his words put himself in the position of a supplicant in the Gospels seeking Christ: "I have sought you and I have found you: I knock that it may be opened to me."[61] The holy Paul's identification with Christ is reinforced later when he displays an uncommon ability to foresee his own death.[62] Third, the description of Paul's final request that Antony return home to fetch the mantle of Athanasius effectively rewrites one detail of Athanasius' original *Life of Antony*. At the end of that work, a dying Antony tells his monastic disciples that Athanasius had given him the cloak on which he was lying, and instructs them to return

it to the Alexandrian bishop.[63] In the *Life of Paul,* which narrates events that are supposed to have taken place earlier in Antony's life, a dying Paul asks Antony to bring the cloak and wrap his corpse in it for burial: "I beg you to go back…and bring me the cloak which the bishop Athanasius gave you and wrap it around my poor body." This Antony does, even though his action betrays the narrative logic established by Athanasius himself in the *Life of Antony.* Here, in rewriting one aspect of Athanasius' plot, Jerome transfers the blessing of the Alexandrian bishop, and the title of original Egyptian monk, over to Paul.

Each of these examples shows how Jerome, in composing his vita, relied heavily on the *Life of Antony* as a crucial source, but at the same time reworked certain borrowed elements for new discursive and social ends. One oft-noted divergence in the portrayal of Paul—his educational background—vividly illustrates how Jerome adapted his characterization of Paul to address the concerns of an aristocratic Roman (that is, western, Latin-speaking) audience. While Antony, despite being the son of "well-born" parents, is openly described as illiterate (a fact that Athanasius celebrates as a sign of his removal from worldly concerns), Paul is characterized as both "wealthy" and "highly educated in both Greek and Egyptian letters" (*litteris tam Graecis quam Aegyptiacis apprime eruditus*).[64] In presenting Paul in such terms, Jerome was carefully crafting an Egyptian monastic hero who reflected his audience's rarefied set of aesthetic values, as well as his own. (Among the lettered Roman aristocracy, the rigorous excesses of unlearned monks were sometimes likened to the uncouth practices of Cynic philosophers and therefore viewed with suspicion.) Indeed, one wonders here to what extent the presentation of Paul as a monastic hero in fact coincides with Jerome's own literary presentation of himself to an audience that preferred their ascetic friends to be stamped with a suitable social and intellectual pedigree.[65]

The Egyptian Desert as an Epic Landscape: Monastic Heroes on a Virgilian Terrain

In the year 384, less than ten years after his experience in the desert of Chalcis (Syria), Jerome wrote a letter to his friend Eustochium in which he recounted a vision he had experienced while suffering a fever during that period of ascetic retreat. According to Jerome, he was brought before the judgment seat and was accused by God of being a "follower of Cicero and not of Christ" because of his inordinate love for classical Latin literature. As a result, he swore an oath that he would never again own or read "worldly books."[66] Writing to Eustochium, he reiterates this stance, asking, "How can Horace go with the psalter, Virgil with the gospels, Cicero with the apostle?"[67]

However, despite his self-professed diametrical opposition to the use of such Latin writers, Jerome's writings throughout his career (both before and after the alleged vision) are peppered with liberal allusions and quotations from that same corpus.[68] The *Life of Paul* is no exception. Virgil's writings, in particular, serve as an important reservoir of language, themes, and images for Jerome's hagiography.[69] Here, I want to concentrate especially on Jerome's use of the *Aeneid* as an intertext. By means of carefully placed allusions to Virgil's masterwork, Jerome sought to recast Paul and Antony in terms familiar to his classically educated Roman audience—as heroic figures who inhabit an epic landscape.[70]

The presentation of Paul as a hero in the tradition of Aeneas and his companions is epitomized in his encounter with Antony at the entrance of the cave in chapter nine of the *Vita Pauli.* Having arrived at the door of Paul's cell, Antony "fell down in front of the door and continued to beg to be allowed in," vowing to die right there if he was not able to see the hermit. Jerome then describes how Antony, while waiting for a sign from Paul, "persisted while thinking of these things, and remained transfixed" (*talia perstabat memorans, fixusque manebat*).[71] These words are taken verbatim from the deathbed speech of Aeneas' father in book two of the *Aeneid.*[72] The very next line introduces Paul's reply to the entreaties of his visitor: "In response the hero spoke a few words thus" (*atque ei responsum paucis ita reddidit heros*). This phrase is a nearly direct quotation from book six of Virgil's epic, when Aeneas' companion Musaeus replies to the speech of the Sibyl.[73] By applying this Virgilian discourse to Paul, Jerome explicitly marks the Egyptian Christian monk as an epic hero. Indeed, the rhetorical effect of these consecutive references to the *Aeneid* is to draw both Paul and Antony vicariously into the heroic retinue of the legendary Aeneas.

This epic characterization of Paul and Antony is supported in other places by more subtle allusions to Virgil's work. At several points after Paul's death, Antony's actions are likened to those of Aeneas himself. As he pondered how to bury Paul's body without a spade, "his thoughts were in turmoil" (*fluctuans itaque vario mentis aestu*), just as was the case for Aeneas (*vario…fluctuat aestu*) in his battle with Metiscus in book twelve of the *Aeneid.*[74] Shortly thereafter, Antony is described as "dutiful" or "devoted" (*pius*) for making Paul's burial mound according

to custom (*tumulum ex more posuit* [alt. *composuit*]), just as Aeneas was called pius for having raised a burial mound (*composito tumuli*) for his nurse Caieta in book seven of the *Aeneid*.[75]

The scattershot nature of these allusions to Virgil's *Aeneid*—their seemingly random extraction from various unrelated parts of the epic text—has been dismissed by one reader as a "triviality" (*Spielerei*) in Jerome's narrative.[76] Another scholar has characterized these allusions merely as instinctive "reminiscences," mute vestiges of a highly influential Latin education.[77] I think that these readings fail to recognize the important and dynamic role such allusions play in the *Life of Paul*. Clearly, in terms of characterization, the parts do not add up to the sum total one might expect: these disparate allusions do not combine to create a consistent or coherent portrait of either Paul or Antony as an Aeneas in Christian monastic dress. Instead, one is faced with a series of "small scenic arrangements"—a verbal skein of Virgilian echoes—that functions "kaleidoscopically" to construct a shifting hagiographical portrait of a saint (or, in this case, two).[78] However, in the end, I would argue that Jerome's dalliance with Virgil is not primarily designed to create a unified characterization of Paul (or of Antony) but rather is designed to produce what I would describe as an epic ethos or atmosphere—a linguistic terrain in which such characters move and have their being.

In this context, one begins to recognize key ways in which the Egyptian desert itself is marked intertextually as an epic landscape in the *Life of Paul*.[79] First, certain features of the desert topography are described in poetic language drawn from Virgil's writings, and from works later found to be falsely attributed to him. For instance, details in the setting of Paul's cave (*spelunca*)—the "hollow mountain" (*exesum montem*) out of which it is carved, and the "spreading branches" (*patulis diffusa ramis*) that cover its entrance—are reminiscent of poetic descriptions of natural scenes in his *Georgics* and the Pseudo-Virgilian *Culex*.[80] In the *Aeneid* itself, caves pockmark the terrain of Aeneas' travels. In book six, a "cavern" (*antrum*) serves as home to the Sibyl and her oracles, and a "deep cave" (*spelunca alta*), guarded by centaurs, marks the door to the underworld.[81] In book eight, after Aeneas arrives in Italy, King Evander shows him where there was once a cave where Hercules slew Cacus, son of Vulcan and the warder of Hell.[82] For Latin readers reared on Virgil's verse, Paul's cave in the desert would have recalled these other examples, where holes in the earth served as the setting for heroic action and epic storytelling.

Second, and more significantly, this same desert terrain is populated by mythical creatures and wild animals that are also found roaming the epic landscape of the *Aeneid*. On his long journey through the desert to see the hermit Paul, Antony encounters first a hippocentaur (half man, half horse) and then a satyr, or faun (half man, half goat) (fig. 1.3).[83] Later, a she-wolf guides him to the opening of Paul's cave,[84] and, after Antony prepares Paul's body for burial, two lions appear out of the inner desert to help dig his grave.[85]

In the *Aeneid* and in other ancient Greek and Latin literature, centaurs and satyrs are typically denizens of the wilderness, "boundary beings" who patrol the remote borders of the civilized world.[86] Thus, in Virgil's poetry, centaurs are known as guardians of the underworld and "cloud-born" dwellers of mountain peaks and thicketed forests,[87] and satyrs (or fauns) are said to reside in rustic "woodlands."[88] In Roman ritual and in the Latin biblical tradition, satyrs were also associated with caves and deserts. A Roman festival called the Lupercalia (February 15) was dedicated to the Roman god Faunus. At this festival, Roman youths dressed in goat skins would gather at a cave below the western corner of the Palatine hill.[89] In the Vulgate, the Latin translation of the Bible that traces back to Jerome himself, satyrs are closely associated with wild beasts and demons of the desert. The original Hebrew text of Isaiah 13:21 (a commentary on the devastation of Babylon) speaks about "wild beasts who inhabit the desert" (*tsiyyîm*) and prophesies that "*seʿîrim* shall dance there." Jerome's translation of the Hebrew word "*seʿîrim*" ("he-goats" or "goat demons") with the Latin word *pilosi* ("hairy ones") was influential over later understandings of these ambivalent figures as satyrs.[90]

As feral animals, lions and wolves shared a similar reputation for ferocity and for inhabiting the wilderness periphery in the ancient world. In the *Aeneid*, soldiers in the heat of battle are frequently compared to raging lions and wolves, and their hides or skulls are worn as war regalia.[91] Lions and wolves belong not to the civilized world but are usually found in mountain regions, on remote islands, or in caves.[92] On at least two occasions in Virgil's epic, lions and wolves share with centaurs and satyrs a liminal existence as hybrid creatures. When Aeneas hears the "angry growls of lions" and "huge wolfish shapes howling" on Circe's island, we are told that these creatures were humans whom Circe had robbed of their human form and "had clothed in the features and frames of beasts."[93] Earlier in the story we read of "Scylla in her vast cavern, and of the rocks that echo with her sea-green hounds." The cave-

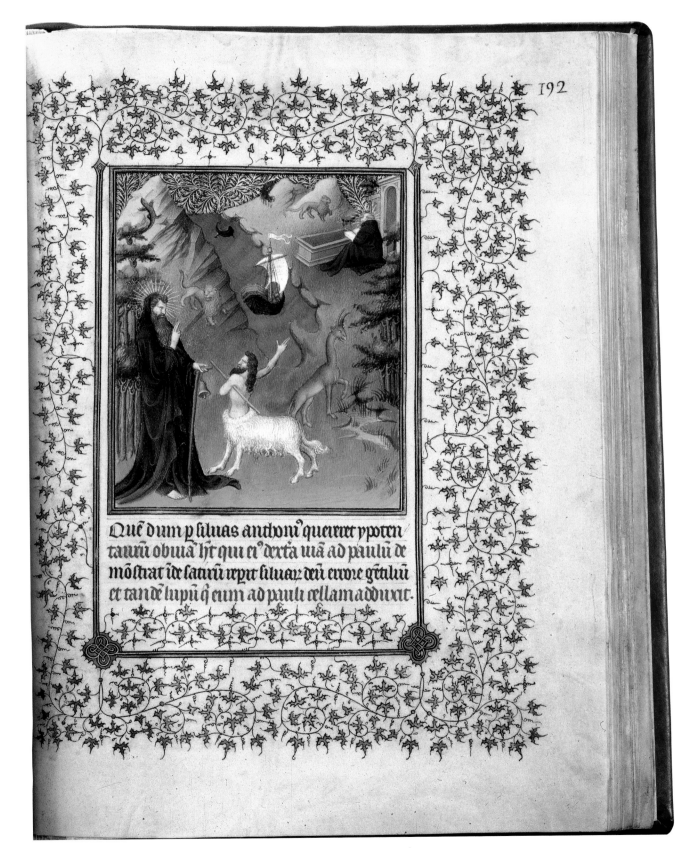

FIGURE 1.3

Antony directed by a centaur,
1405–1408/1409. Pol, Jean, and
Herman de Limbourg (active ca.
1399–1416). *Belles Heures of Jean,
Duke of Berry*, folio 192r. The
Cloisters Collection, 1954 (54.1.1),
The Metropolitan Museum of Art,
New York.

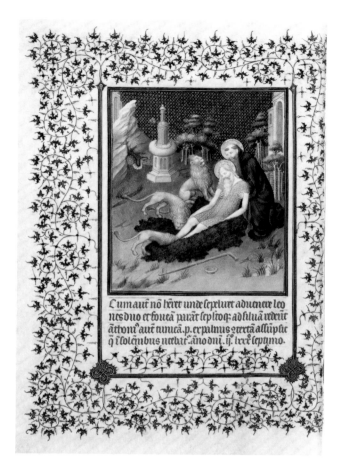

FIGURE 1.4

Lions help Antony bury Paul, 1405–
1408/1409. Pol, Jean, and Herman
de Limbourg (active ca. 1399–1416).
Belles Heures of Jean, Duke of Berry,
folio 193v. The Cloisters Collection,
1954 (54.1.1), The Metropolitan
Museum of Art, New York.

dwelling Scylla herself is described as misshapen: "Above
she is of human form, down to the waist a fair-bosomed
maiden; below, she is a sea dragon of monstrous frame,
with dolphins' tails joined to a belly of wolves."[94] For Latin
readers of the *Life of Paul* with echoes of Virgil in their
minds, the wolves and lions that Antony encounters in the
vicinity of Paul's cave (like the images of the centaur and
the satyr) would have reinforced the Egyptian desert's as-
sociation with liminality and hybridity, a threatening and
fantastical border zone filled with hairy wild beasts and
hairy wild (monastic) men.

And yet in the desert that Antony traverses and in
which Paul resides, these seemingly forbidding wild crea-
tures are curiously tamed and transformed by their en-
counters with holy men. Indeed, in their interactions with
Antony they act as providential guides and even commu-
nicate their shared belief in the gospel. Despite the fact
that the centaur approaches Antony with "some kind of
barbaric grunt" made through "bristling lips," Jerome em-
phasizes that the creature desired to engage in "friendly
communication." And even as Jerome speculates whether
such a monstrous creature was a contrivance of the devil,
in the end the centaur proves to be a divinely sent guide
whose mute hand signal accurately "indicate[s] the route
that Antony was seeking."[95] Later, the she-wolf plays a sim-

ilar beneficent role, silently leading Antony to the mouth
of Paul's cave.[96]

Both the satyr and the two lions in the story notice-
ably embody human characteristics and participate with
Antony in proclaiming the Christian gospel. The satyr,
described as a *homunculus* ("a man of no great height"),
acts as a peaceful emissary and provides Antony with sus-
tenance: "This animal brought him the fruits of the date
palm to eat on his journey, as pledges of peace." Far from
its typical association with unrestrained bestial sexuality,
here the satyr identifies closely with humankind—"I am
a mortal creature" (*mortalis ego sum*)—and actually pro-
claims Christ as Lord: "We know He came once for the
salvation of the world, and His sound has gone out over
the whole earth."[97] The satyr's confession of faith echoes
Psalm 19:4 (cf. Romans 10:8) and causes the aged traveler
Antony to shed tears of joy. At the end of the *Life of Paul,*
the two lions that help Antony dig Paul's grave express
their devotion to the deceased monk, "roaring loudly as if
to show that in their own way they were lamenting as best
they could." After excavating a hole for the burial, they
prostrate themselves before Antony and lick his hands
and feet (fig. 1.4). When Antony then realizes that they are
asking him for a blessing, he marvels that "dumb animals,
too, were able to understand that there was a God."[98]

The portrayal of these notoriously wild creatures as
docile and benevolent serves an important function with-
in Jerome's narrative. They show how the desert has been
transformed and reclaimed by a Christian monastic pres-
ence. In the process, the periphery of the civilized world is
made imaginatively accessible to Jerome's Roman readers.
At the same time, Egyptian monks, formerly viewed by ur-
bane Romans as uncultured "wild men" of the desert, are
shown to be civilizing agents who are to be both supported
and emulated.

One final detail epitomizes the way that Jerome used
Virgil and other ancient Roman traditions in re-present-
ing Egyptian monasticism to a Latin-speaking audience.
For Latin readers, the presence of a she-wolf at the cave
of Paul would have recalled the legend of Romulus and
Remus, the two brothers who were raised by wolves and
grew up to found the city of Rome. Virgil makes reference
to this legend twice in the *Aeneid.* In book one, Saturn
foretells to Venus the prehistory of Rome, ending with
an account of how "Romulus, proud in the tawny hide of
the she-wolf, his nurse, shall take up the line, and found
the walls of Mars and call the people Romans after his
own name."[99] Later, in book eight, Venus brings Aeneas
a shield on which was depicted "the story of Italy and the

triumphs of Rome."[100] Prominent among the scenes was one of "the mother wolf lying stretched out in the green cave of Mars; around her teats the twin boys hung playing, and suckled their dam without fear; with shapely neck bent back, she fondled them by turns, and moulded their limbs by fear."[101] In light of the audience of the *Vita Pauli*, it is not a coincidence that Jerome locates his monastic hero in a cave conspicuously tended by a she-wolf: here, Paul is depicted intertextually as a Christian Romulus—as an Egyptian monastic hero who is imbued with an illustrious Italian pedigree, and whose ascetic lifestyle is presented as an implicit critique of Roman aristocratic luxuries and as an inspirational model for his literate Latin readership.[102]

Early Christian Pilgrimage and the Cave of Paul

The production and transmission of saints' *Lives* was not the only way that Egyptian monasticism was promoted in the West. Pilgrimage—and the writing of travel accounts of pilgrims' visits to holy persons and places—provided another venue for the popularization of monastic sites among a Latin-speaking reading public.

After Emperor Constantine's imperial patronage of the "holy places" (*loca sancta*) and his building of monumental churches in Jerusalem and Bethlehem in the early 330s, the number of Christian pilgrims to these places increased dramatically throughout the rest of the fourth century.[103] Many of the early pilgrims who traveled to and from Palestine and the Sinai peninsula included a side trip into Egypt as part of their itinerary. The goal of this devotional detour was to visit Egyptian monasteries and to see first-hand the famous holy men and women of the desert. Upon their return to their homeland, the pilgrims would regale their friends with stories about monastic exploits that they had witnessed, or that others had related to them during their journey. Some of these pilgrims even recorded travelogues (or "itineraries") that detailed their adventures for posterity, and that served as an effective form of "advertising" for Egyptian ascetic piety in the West.[104]

These travelogues were not comprehensive in scope, nor were they merely straightforward, clinical accounts of where the pilgrims went and what they did on their long journeys. Instead, such pilgrimage narratives were often spare in detail or selective in focus, emphasizing certain topographical features and personal encounters while providing little or no information about other aspects of the journey. The informational gaps in these accounts, as well as their areas of descriptive density, tell the historian something important about the ways that pilgrims perceived their own activity and about the construction of

sacred space in late antiquity. In reading these accounts one quickly becomes aware of how early Christian pilgrims' perception of holy places was, in fact, informed by a host of personal and interpretive factors, including (most notably) the reading of biblical and other authoritative texts. Thus, when pilgrims to Palestine imagined the barren landscape they traversed to be populated by events and persons from the history of the Israelite prophets and patriarchs, or when visitors to the Egyptian desert viewed it as a verdant paradise, they were, in a sense, cognitively "mapping" the landscape according to a set of textual (and not just actual) coordinates.[105] As a result, early Christian pilgrimage itineraries were profoundly intertextual creations—textual maps of devotional practice, with other texts serving as the key to their relief. It was through the literary production of such documents that holy places were demarcated and defined in late antiquity.

Two ancient sources give us information about early Christian pilgrimage related to Paul of Thebes. The first is Sulpicius Severus' *Dialogues*, written around the year 400 in Gaul (modern-day France).[106] The second is the *Itinerary* of the Piacenza Pilgrim, a travelogue written by an anonymous Italian in about 570.[107] In both instances the pilgrims' reports seem to be so scant that they scarcely deserve notice. For example, the sixth-century pilgrim from Piacenza, the more expansive of the two sources, simply mentions that he and his companions "traveled through the desert to the cave (*spelunca*) of Paul, called Qubba in Syriac, and to this day there is a stream (*fons*) there giving water."[108] By comparison, Sulpicius Severus' earlier (and more succinct) account merely refers to the site as the "place in which the most blessed Paul, the first of the eremites, had his abode."[109]

However, appearances can be deceiving. In what follows, I will show that Sulpicius Severus, in fact, provides modern historians with valuable information about how some early Christian pilgrims perceived the Egyptian monastic landscape through an intertextual lens—especially in light of crucial themes and metaphors drawn from the *Life of Paul*. Through such interpretive strategies writers like Sulpicius Severus plotted the cave of Paul onto the larger Christian map of loca sancta.

The *Dialogues* of Sulpicius Severus are actually framed as a "tria-logue," a three-way conversation between the author, an unnamed friend from Gaul, and a man named Postumianus who has just returned from a pilgrimage to monastic territories in the eastern Mediterranean. In the first *Dialogue*, Postumianus happily agrees to narrate his recent travels to his two listeners; in the

second and third *Dialogues,* Sulpicius Severus and his Gallic friend reciprocate with stories of miracles performed by their patron saint and monastic hero, Martin of Tours.[110] Thus, Sulpicius Severus' work is not a conventional travelogue. And yet, while the author clearly displayed literary craftsmanship in composing the *Dialogues,* he probably based Postumianus' discourse (at least in part) on an actual report from a late fourth-century pilgrim.

Midway through this discourse, after having recalled some of his experiences in Palestine and among the monks of Egypt, Postumianus relates how he "visited two monasteries of St. Antony, which are at the present day occupied by his disciples," before making a brief sojourn at the hermitage of Paul—"that place in which the most blessed Paul, the first of the eremites, had his abode."[111] A social historian might make two basic, but important, observations about this brief account. First, only twenty-five years after the publication of Jerome's original vita we encounter evidence that a site reputed to be Paul's monastic cell—presumably a cave—was already localized within pilgrimage practice along the Red Sea coastline. Indeed, immediately after mentioning his visit to Paul's cell, Postumianus describes how he "saw the Red Sea" before journeying on to visit Mount Sinai.[112] (Almost two centuries later, the Piacenza Pilgrim would approach Paul's cave from the opposite direction, first traveling through the Sinai and then skirting the Red Sea on his way westward toward the Nile valley.)

Second, we see here how, from its very inception, pilgrimage related to Paul seems to have been integrally connected with Antonine monasticism in the region. This should not be surprising: monastic communities regularly provided an institutional support network for early Christian pilgrimage practice. Monks often served as local guides, and monasteries and convents provided places of rest and sustenance for weary travelers. The fourth-century pilgrim Egeria describes how when she visited Mount Sinai virtually "all the monks who lived near the mountain" came out to meet her: some provided her with fruit grown in their gardens as pilgrimage "blessings," while others accompanied her down the mountain and "point[ed] things out" to her.[113] In the sixth century, the Piacenza Pilgrim would also remark on the "crowd of monks and hermits" who greeted him and his companions as they approached the holy mountain.[114] The monks at the "two monasteries of Saint Antony," and perhaps individual anchorites in the vicinity of Paul's cell, would have played a similar role as hosts and guides for pilgrims seeking the legendary cave of the hermit.[115] Here, Posthumianus' brief report confirms the vital social connection between monastic practice and Egyptian pilgrimage in the late fourth century.

At first glance, Postumianus' visit to Paul's cell might seem to be an insignificant (almost parenthetical) episode in his discourse. Indeed, he mentions it in passing, as though it had been merely a simple stopover on his way to Mount Sinai (even though the journey to Paul's cell via the monasteries of St. Antony would have required a five- or six-day trek through the desert). However, to focus solely on the brevity of this episode would be to underestimate its narrative significance in the *Dialogues.* Indeed, the larger context strongly suggests that the author used Jerome's *Life of Paul* as a literary point of reference in reinterpreting Egyptian desert monasticism for his Latin readership. Even before describing his experiences in Egypt, Postumianus spends three full chapters describing his six-month stay with Jerome at his monastery in Bethlehem, most notably lauding Jerome's learnedness and defending his orthodoxy against the criticisms of his detractors: "I shall indeed be surprised if he [Jerome] is not well known to you also by means of the works which he has written, since he is, in fact, read the whole world over."[116]

This special attention given to Jerome early in the first *Dialogue* was not simply an example of ancient approbatory rhetoric, for by emphasizing the ubiquity of Jerome's works, Postumianus' discourse was priming attentive readers for further allusions to his writings. In this context, the events leading up to Postumianus' stopover at Paul's cave take on added significance. After traveling from Palestine to Egypt, Postumianus immediately headed up the Nile to witness the life of monks in the Thebaid (Upper Egypt). There he stayed in a *coenobium* (a monastic community), listened to tales told by the monks, and made short excursions to hermits living in the area. What is striking about Postumianus' account of his time in the Thebaid, however, is the way that his own stories recycle a constellation of themes from the *Life of Paul.*

First, his host, the abbot, tells him about a time when he visited a revered hermit and bread was provided "from heaven." As in the case of Paul and Antony, "both broke the heaven-sent bread with exceeding joy."[117] Then Postumianus tells of how he journeyed inland to visit an old monk who dwelled at the foot of the valley cliffs. When the two walk to gather fruit from a palm tree at a distance of two miles, they encounter a lion that eats out of the monk's hand "as readily as any domestic animal could have done."[118] Two chapters later, Postumianus relates another monk's encounter with a lioness who offers him an animal skin in gratitude for healing her blind cubs.[119]

Finally, in the middle of these two lion tales, Postumianus inserts a story about his own visit with a solitary who had a she-wolf as a valued companion: the wolf's genuine contrition after stealing a loaf of bread earns the monk's forgiveness and causes Postumianus to celebrate the fact that "wild beasts acknowledge [Christ's] majesty."[120]

It is not a coincidence that these episodes, which highlight divine provision in the wilderness and the taming of lions and wolves in the presence of holy men, immediately precede Postumianus' account of his visit to the cell of Paul. This pilgrimage narrative (couched in the literary form of a dialogue) shows yet another instance of an early Christian Latin author using intertextual methods—in this case, a series of allusions to Jerome's *Life of Paul*—in an attempt to civilize and reclaim the Egyptian desert margin for a western audience and to promote monastic sites as preferred destinations for pious travelers.

For Sulpicius Severus, the *Lives* of saints served as a valuable currency of exchange in his literary patronage of monastic causes. At the end of Postumianus' discourse, Sulpicius Severus responds to him by comparing the exploits of Egyptian monks to those of the famous Gallic saint Martin of Tours: "If you remind us that the savagery of wild beasts was conquered by, and yielded to, the anchorites, Martin, for his part, was accustomed to keep in check both the fury of wild beasts and the poison of serpents."[121] This comparison functions as an effective segue into the subsequent two *Dialogues*, which focus the reader's attention on the virtues of Martin. Even more important, however, it also shows how the author used two competing (and yet complementary) hagiographical models—not only the *Life of Paul*, but also Sulpicius Severus' own *Life of Martin*—to "translate" and reinterpret Egyptian monastic practices for a western audience.

Conclusion and Postscript: Visualizing Paul of Thebes' Legacy in the West

In this chapter, I have concentrated on the way that Paul and Egyptian desert monasticism were promoted by Latin authors as models for western piety in late antiquity. This was in large part a literary enterprise, accomplished through the publication of hagiographical vitae and pilgrimage narratives. Such works were given their distinctive texture by the interweaving of prior texts and discourses. Thus, Jerome, in his *Life of Paul*, variously draws on the biblical stories of Elijah and John the Baptist, the *Life of Antony*, and even Virgil's *Aeneid* in presenting Paul as a monastic hero, and in defining (and domesticating) the Egyptian desert as an epic terrain for the performance

of ascetic virtue. The travelogues of late antique pilgrims went further in localizing devotion to Paul and in situating his pilgrimage site within a larger itinerary of Christian "holy places." Indeed, in Sulpicius Severus' *Dialogues*, we have seen how Jerome's *Life of Paul* itself was used as a narrative template in popularizing the Egyptian desert as a privileged locus of monastic pilgrimage.

The representational strategies employed by Jerome and his successors proved to be successful not only in establishing Paul as an ascetic role model, but also in helping shape the character and self-perception of the monastic movement in western Europe. Within twenty years of Jerome's death, John Cassian, who "more than anyone brought Egypt to the West,"[122] was already citing Paul as the cofounder of the monastic life as he composed works designed to regulate the practices of monks living in southern Gaul.[123] The *Dialogues* of Sulpicius Severus show how the biography of Martin of Tours, the legendary father of western monasticism, was distinctly framed in terms of Egyptian monastic archetypes.

The reception of Paul and Antony as ascetic "icons" in western visual art provides a further context in which to measure the scope and success of such hagiographical-monastic discourses.[124] As mentioned at the beginning of this study, the Spanish painter Diego Velázquez used selected vignettes from the *Life of Paul* to give imaginative contours to the Egyptian desert landscape: through the visual movement of his painting he sought to make that distant place (and its exemplary virtues) present to his seventeenth-century western patrons (see fig. 1.1). However, among medieval and early modern European artists, Velázquez was not the only one to reinterpret the figures of Paul and Antony in a visual medium. On the north face of the Ruthwell Cross in Dumfriesshire, Scotland (ca. first half of the eighth century), one finds a relief of the two Egyptian saints breaking bread amid other biblical scenes connected with trials experienced in the desert, including Christ among the Beasts (recalling his forty days in the wilderness) and the Holy Family's Flight into Egypt (fig. 1.5).[125] This scene of meal fellowship, with its eucharistic overtones, also appears in sculpted form on a number of Irish High Crosses dating to the ninth century.[126] The association of the bread brought to the two ascetics by the raven with the eucharist is made explicit with the addition of a chalice in some of the Irish depictions, a feature that does not appear in Jerome's account of the meal.[127]

In the twelfth-century basilica at Vézelay, the expansive Romanesque sculptural program includes two depictions of Paul and Antony: the breaking of bread, and the

FIGURE 1.5

Antony and Paul break bread (second panel from bottom), Ruthwell Cross, Dumfriesshire, Scotland, ca. first half of eighth century.

burial of Paul by Antony assisted by two lions.[128] Several frescoes depicting narrative scenes from this story have survived in the narthex of the eleventh-century Church of Sant'Angelo in Formis.[129] One of the clearest and best preserved shows the two saints holding the bread between them, in front of a palm tree.[130] The appearance of these scenes in sculpture, in Britain, Ireland, and France, as well as in fresco, in Italy, has prompted Peter Harbison to suggest that a relatively standard cycle of depictions of the two saints existed in the early medieval period.[131] They remained popular. Around the year 1435 an anonymous Italian master from Osservanza anticipated Velázquez's later iconographic method of combining different narrative scenes from the *Life of Paul* in one painting. A single panel of his now-dispersed polyptych on the life of Antony features the two Egyptian saints embracing outside Paul's cave in the foreground, with two smaller scenes from Antony's journey to find Paul in the background (fig. 1.6).

By the fourteenth century Paul of Thebes had become associated with the iconographic cycle of Jerome himself. One remarkable example of Renaissance book illumination—the *Belles Heures* (1405–1409) of Jean, Duke of Berry—includes twelve full-page miniatures on the life of Jerome painted by the accomplished Limbourg brothers,

followed by six miniatures on the life of Paul, and two on the temptations and death of Antony (see figs. 1.2–1.4).[132] The appearance of lions in scenes connected with both Jerome and Paul underscores the vital visual connection between the two figures.[133] Indeed, by the seventeenth century, contemporaries of Velázquez, such as the painter Anthony Van Dyck, had begun portraying Jerome as a desert hermit in the image of his alter ego Paul.[134] In several early Van Dyck paintings Jerome is depicted as a partially naked old man sitting outside a cave in the wilderness, with a lion reclining at his feet (fig. 1.7).[135]

In this art, one cannot help but note how the life of Paul continued to be juxtaposed to, and conflated with, an assortment of other images drawn from the Bible, patristic sources, and the cult of the saints. A final example from the early modern period demonstrates very well the complexity and creativity of this intertextual legacy bequeathed by Jerome. In the early sixteenth century, almost eighty-five years before the birth of Velázquez, a German painter named Mathis von Aschaffenburg—alias Matthias Grünewald—completed his magnum opus, the *Isenheim Altarpiece* (ca. 1515). The iconographic program of this altarpiece notably incorporated a scene of the famous meeting between Antony and Paul amid images from the Gospels and the *Life of Antony,* as well as portraits of several patron saints popular in the West—Sebastian, Augustine, Antony (two more times), and Jerome himself.[136]

The altarpiece is structured as a triptych that opens in three successive panels. In its fully open state, the original sculpted shrine of the altar is visible: Antony stands in the center with Augustine and Sebastian on each side, and Christ and the twelve apostles below. On the left and right of this central sculpture, the inner wings painted by Master Mathis display the scenes of Antony's meeting with Paul and his temptations in the desert (figs. 1.8 and 1.9).

The Isenheim painting, *Saint Antony Visits Saint Paul the Hermit,* shows the two hermits seated in the foreground, facing each other. While Antony wears a finely sewn gray mantle with a mauve hood, Paul is dressed in a rough tunic of plaited palm leaves.[137] In the background, the landscape is depicted as an idyllic wood rendered in a surreal, almost impressionistic style. A date palm standing before the mouth of Paul's cave provides a lone but unmistakable example of desert flora.[138] Above the two figures, the raven descends with a piece of bread in its beak; between the seated monks, a wild stag grazes peacefully.[139]

In this sixteenth-century altar program, we once again find these two Egyptian saints together, inextricably linked in the western visual imagination. Their connection

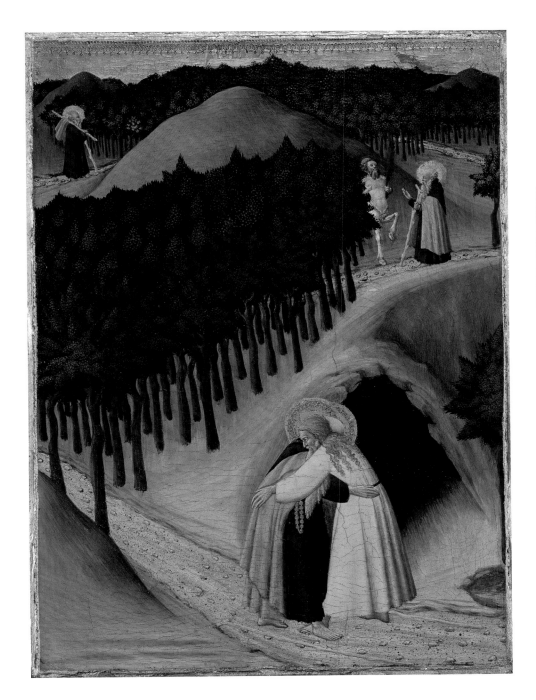

FIGURE 1.6 ABOVE LEFT

The Meeting of Saint Antony and Saint Paul, ca. 1430–1435. Master of the Osservanza (Sano di Pietro?). Samuel H. Kress Collection, 1939.1.293, National Gallery of Art, Washington, D.C.

FIGURE 1.7 ABOVE RIGHT

Saint Jerome, 1625–1627. Anthony van Dyck (1599–1641). Staatliche Kunstsammlungen, Dresden.

FIGURE 1.8

*Saint Antony Visits Saint Paul the
Hermit*, panel from the Isenheim
Altar, ca. 1515. Matthias Grünewald
(1455–1528). Musée d'Unterlinden,
Colmar.

FIGURE 1.9

The Temptation of Saint Antony,
panel from the Isenheim Altar,
ca. 1515. Matthias Grünewald
(1455–1528). Musée d'Unterlinden,
Colmar.

At the same time, the relative position of different scenes in the triptych and the rendering of bodily gestures work together to underscore Paul's familiar associations with ascetic virtue and sacred encounter. With the altarpiece fully open, *Saint Antony Visits Saint Paul the Hermit* folds over the panel with the Annunciation, another scene of providential visitation. The "gestural repertory" of the painting suggests further connections. Paul sits and gestures toward Antony, his palm up and his index finger extended toward his visitor in greeting (see fig. 1.8). The orientation of his arm and hand significantly replicates not only the posture of the angel who visits Mary in the Annunciation scene, but also that of John the Baptist, the forerunner of the desert ascetics, who stands next to Antony and points toward the crucified Christ on the face of the closed altarpiece.[142]

As in the other iconographic examples I have cited, so too in the *Isenheim Altarpiece*'s "complex choreography of communication,"[143] one sees compelling visual traces of familiar late antique discourses—discourses in which Paul is presented as a prophetic heir and a monastic icon, and in which his desert cave is transfigured into a paradise filled with divinely provisioned gifts and wild animals who are tamed in the presence of holy men. Ultimately, it was through such a multilayered, kaleidoscopic range of representational strategies that writers and artists— from Jerome and Sulpicius Severus, to Master Mathis and Diego Velázquez—promoted and popularized the image of Egyptian monasticism in the Christian West.

with each other, and with the other figures on the altarpiece, is highlighted by a study of the social setting of the altarpiece, its structural layout, and the depiction of bodily gestures in individual scenes.

Master Mathis' paintings on the altarpiece were commissioned for the hospital chapel of the monastery dedicated to St. Antony in the town of Isenheim (located in Alsace in northeastern France).[140] In the sixteenth century, the monastery was a pilgrimage destination for those seeking relief from assorted ailments, including a disease similar to the plague called the "feu d'Antoine," or the "Antoniusfeuer"—Saint Antony's fire. Since the founding of the Hospitallers of St. Antony in Europe around the end of the eleventh century (ca. 1095), Antony had garnered a widespread reputation as a healing saint. Thus, in the *Isenheim Altarpiece* panel, one finds Paul effectively linked with Antony as a holy figure endowed with healing power: their shared association with the gift of healing is visually reinforced by the artist's depiction of medicinal herbs around the two monks in their scene of meeting.[141]

CHAPTER 2

THE MONASTERY OF ST. PAUL IN HISTORICAL CONTEXT

In 2004, the monks of the Monastery of St. Paul published a small book entitled *The Preserved Secret* (*al-Sirr al-maktum*).[1] The title refers, in the first place, to the life of St. Paul the Hermit himself, who, as the booklet recounts, spent ninety anonymous years in the wilderness before St. Antony was led to meet him.[2] Even after his encounter with the younger anchorite, Paul died alone, and, in accordance with Paul's desire, his burial place was kept secret. By extension, the title refers to the monastery that preserves and honors the place and the memory of Paul's ascetic endeavors; for much of its history it has shared in the quiet mystery of the saint and his undemonstrative and unsung pursuit of holiness (fig. 2.1).

Western scholars concur that there is much that is simply unknown about the history of the monastery. "Extremely bare" is how one diligent chronicler of Egyptian monasticism, already in 1961, characterized the field of datable facts;[3] those that exist can readily be summarized in a list of a page or two.[4] The purpose of this chapter is not simply to reproduce lists that have been published before, but to place the data that we do possess in the context of the history of the Egyptian Church as a whole. If we read the data at our disposal alertly, I believe that we can see ways in which the fortunes of the Monastery of St. Paul have mirrored those of the Coptic Orthodox Church (and Egyptian society) as a whole; identify periods in which the monastery assumed special significance; and discern certain characteristic roles played by the monastery throughout its history. At least we can make the attempt—all the while remembering the paucity of our evidence and respecting the mystery that is at the heart of the monastery's identity.

The Beginnings

The beginnings of the site as a place of pilgrimage and of monastic life are particularly wrapped in mystery. According to the *Dialogues* of Sulpicius Severus (from about 404), Sulpicius' friend Postumianus visited "two monasteries of St. Antony," presumably that at Pispir in the Nile valley (the Outer Mountain), as well as the celebrated desert convent (the Inner Mountain), and then "even went to the place in which the very blessed Paul, the first hermit, used to live."[5] The notice affirms the antiquity of "the place" of St. Paul as part of a pilgrimage itinerary associated with St. Antony,[6] and many future visitors would follow the route leading from the Monastery of St. Antony at Pispir to his monastery in the Eastern Desert to the Monastery of St. Paul.[7]

Early visitors to the cave of St. Paul may well have included Christians from a variety of cultural and linguistic backgrounds. Postumianus was a Latin speaker who had read Jerome's *Life of Paul*. A simpler Greek recension of the *Life* was in circulation by, at the latest, sometime in the sixth century,[8] as was a Syriac version based on it.[9] The story of St. Paul would have been known, then, to monks and pious laypeople throughout the sixth-century Christian world; it is not hard to imagine that many of them might have been drawn to visit his cave. It is part of the mystery surrounding "the place" that, to the best of our knowledge, only one other late antique pilgrim has left us a record of his visit: the anonymous pilgrim from Piacenza who visited the site sometime in the 560s while on his way from Mount Sinai to the Nile valley. After reaching Clysma (Suez), he and his companions "traveled through the desert to the cave of Paul, called Qubba in Syriac, and to this

day there is a stream there giving water."[10] The significance of the visit to this pilgrim is clear from the fact that it represents a major detour in his travel between well-known pilgrimage sites (from Mount Sinai by way of Clysma on to Memphis and thence to the then-thriving pilgrimage center of St. Menas in Mareotis, southwest of Alexandria). And the pilgrim's note is at least suggestive of the catholic appeal of the site: a *Latin* pilgrim makes the cave of St. Paul—for which he has learned the *Syriac* name—a stop after visiting the *Greek* stronghold of Mount Sinai.

Were there monks at the site at the time of the Piacenza Pilgrim's visit? At this point we have no proof that there were, but it is difficult to imagine that the place was unoccupied if it were indeed a regular stop on pilgrims' itineraries. It is much easier to imagine the existence of a semi-anchoritic community, closely associated with (and regularly supplied by) that of St. Antony's, in which monks inhabited caves—both those occurring naturally and those dug out of the soft limestone tafl on either side of the wadi (astride which the present-day monastery is found)—gathering on Saturday night at the cave of St. Paul for prayer culminating in the celebration of the Eucharist, and providing hospitality (thence the need for supplies) and serving as guides to visitors.[11] At the monastery today one regularly hears the assertion that the keep (in its original form) was built during the reign of the emperor Justinian (527–565). While there is no proof of this, neither is there any reason to reject the idea out of hand.[12] Perhaps the slight link that the Piacenza Pilgrim's report makes between Mount Sinai and the cave of St. Paul as successive stops in a pilgrimage itinerary suggests that some modest degree of fortification at the cave could be contemporary with the conversion of the Monastery of St. Catherine at Mount Sinai into a veritable fortress.[13]

In the meantime, the fame of St. Paul appears to have been spreading throughout the Egyptian Church. At least this is the conclusion to which we must come if we accept the early date of a fragment, preserved in Paris, of a *Life* of the Coptic patriarch Benjamin (623–662).[14] The fragment tells how Benjamin entered a church (perhaps at the Monastery of St. Macarius?) in order to celebrate the liturgy, and was greeted by the figures portrayed in a program of wall paintings, who gave forth sweet-smelling oil and sang praises to God. On one side of the church were the painted figures of great patriarchs of Alexandria: Mark, Peter Martyr, Athanasius (pictured riding a cherub with his friend Liberius of Rome), Cyril, and Dioscorus. To the other side stood the great monastic founders: Antony, Pachomius, Macarius...and Paul. The text's editor believes that the account may well have been written by patriarch Agathon (662–677), Benjamin's disciple and successor. If this is the case, then we have a seventh-century witness to the esteem in which Paul was held within the Egyptian Church[15]—and an indication that the place of his long ascetic endeavors—like the places associated with Antony, Pachomius, or Macarius—would surely have been held in great honor, occupied by monks, and visited by pilgrims.[16]

The Rise of the Coptic Orthodox Church from the Fifth to the Twelfth Century

The list of patriarchs just mentioned points to the complexity of the history of the Egyptian Church. Western Christendom is well acquainted with the figures of Mark the Evangelist; Peter of Alexandria, martyred during the Great Persecution; Athanasius, the great protagonist of Nicene Orthodoxy, and his (mostly) staunch defender, Pope Liberius; and the impassioned theologian Cyril of Alexandria. Dioscorus, on the other hand, to say nothing of the seventh-century patriarchs Benjamin and Agathon, is not so well known—or is remembered in much of the Christian world as a "heretic." It may, therefore, be useful to sketch the history of the Egyptian Church from the fifth through the twelfth centuries—a period for which we know practically nothing about what we assume was the shrine, pilgrimage destination, and monastic settlement of St. Paul.

A critical moment for the history of the Egyptian Church came in the mid-fifth century, when most Egyptian bishops, led by Patriarch Dioscorus of Alexandria, found themselves on the "losing" side of what the Byzantine and Roman Churches would regard as the Fourth Ecumenical Council at Chalcedon (in 451).[17] The matter in controversy was largely—or so it seems in long retrospect—one of terminology: a quest for the appropriate language with which to describe the mystery of the one Lord Jesus Christ, confessed by nearly all parties to the dispute as simultaneously truly divine and truly human. The Chalcedonian Definition, which proposed to speak of this divine/human simultaneity by describing Christ as existing "in *two* natures," was rejected by Dioscorus and his followers, who remained loyal to a characteristic formulation of the great Cyril of Alexandria: "*one* incarnate nature of the Word." Dioscorus was deposed by the council and sent into exile, opening a period of struggle between Chalcedonian two-nature believers and conservative Cyrillian one-nature believers that consumed theological and church-political energies for the better part of the next two centuries.[18] Byzantine emperors, concerned for religious

FIGURE 2.2

Severus of Antioch and Dioscorus
of Alexandria, 1232/1233. Church
of St. Antony, Monastery of St.
Antony. ADP/SA 11S 98.

unity within their realm, sponsored negotiations, attempts at compromise, and periods of truce; in the end, however, their prestige remained staked to the Chalcedonian Definition, and they periodically resorted to coercion in order to enforce it. Over the course of the sixth century, the opponents of that Definition in Egypt and Syria elaborated their theological position (as seen especially in the writings of Severus, patriarch of Antioch) and began to set up their own anti-Chalcedonian hierarchy (as seen especially in the organizational work of Jacob Baradaeus, metropolitan of Edessa).[19] The ecclesiastical struggle reached a point of special intensity in Egypt on the eve of the Arab conquest: the anti-Chalcedonian patriarch Benjamin (623–662) was forced to flee from Alexandria to the monasteries of Upper Egypt so as to evade the agents of the imperially imposed and supported Chalcedonian patriarch Cyrus (appointed in 631).

The Chalcedonian/anti-Chalcedonian struggle was to a degree "resolved" by the Arab conquests of the East-

ern Byzantine provinces, including Egypt and Syria, largely achieved during the caliphate of ʿUmar ibn al-Khattab (634–644). Thus only a very few years after the death of the Prophet Muhammad in 632, the anti-Chalcedonian strongholds of Egypt and Syria came to be part of the *Dar al-Islam*, in which the apparatus of Byzantine ecclesiastical coercion no longer had any sway. The Arab conqueror of Egypt, ʿAmr ibn al-ʿAs, recalled patriarch Benjamin from his hiding place and restored him to authority; Benjamin, his successor Agathon (662–680), and subsequent patriarchs were to lead a church that commanded the loyalty of the majority (though not all) of Egypt's Christians, but did so within the "new world order" of the Islamic caliphate.[20] With the stabilization of this community of Egyptian Christians (Arabic *qibt*) loyal to the heritage of Cyril, Dioscorus, and Severus of Antioch, and who preserved a distinctive Egyptian Christian identity within the Dar al-Islam, a new chapter opens in the history of Egyptian Christianity. In this new chapter, the term Coptic Orthodox Church becomes a useful label for the community just described: it is Coptic in its specifically Egyptian character (and in its investment in the Coptic language as a marker of identity) and self-described as Orthodox in its commitment to the moderate anti-Chalcedonian heritage of Dioscorus and Severus of Antioch (fig. 2.2).

Egyptian Christians coped as best they could with the new situation—including the frequently onerous tax demands of the Arab authorities. They kept alive the memory of their saints and martyrs and continued to perform pilgrimage to their shrines.[21] The desert monasteries, in particular the Monastery of St. Macarius in the Wadi al-Natrun, increased in importance under Islamic rule; they helped anchor and define an Egyptian "sacred geography" that provided grounding for a specifically Christian culture that tenaciously survived, despite the political authority of the Arabs and the steady spread of their Arabic language and Islamic beliefs.[22] From time to time that sacred geography would suffer grievous blows, as, for example, when the great pilgrimage to the Shrine of St. Menas at Mareotis was cut off in the 860s, with the shrine itself soon beginning a decline into near oblivion.[23] All the same, the Egyptian "sacred geography" was capable of renewal: new pilgrimage sites could arise, as may be seen in the gradual development of a detailed itinerary of the stations of the Holy Family during their sojourn in Egypt.[24]

The Muslim governors of Egypt made their headquarters in the environs of what is now Cairo, with the result that structures of authority within the church began to tilt away from Alexandria toward the new center

of power. Indeed, turmoil in Alexandria in the second decade of the ninth century drove the patriarchal residence into the Delta, until, in the eleventh century, that residence came to be established in or near Cairo.[25] The class of Christian lay notables (the archons or arakhina), many of them well-connected financial administrators in the service of Muslim officials, frequently provided political and financial support to the ecclesiastical hierarchy, as well as leadership in times of weakness. While Coptic Orthodox Church history records occasional examples of the arakhina becoming sources of rivalry to the ecclesiastical hierarchy, they were also, with great regularity, sources of revitalization and renewal.

To a great degree, the fortunes of the Coptic Orthodox community reflected the fortunes of Egypt as a whole. The civil strife that characterized much of ninth-century ʿAbbasid Egypt, for example, is mirrored in a "crisis of cohesion"[26] within the church that also appears to coincide with a period of rapid conversion to Islam. By contrast, during the prosperous days of the early Fatimid period—and thanks to generally favorable policies toward Christians—the Christian community got along relatively well. (The exception was the persecution unleashed by the decidedly strange Fatimid caliph al-Hakim bi-ʿAmr Allah, 996–1020.) Later, with the decay of the Fatimid state and the Crusader incursions of the twelfth century, the community again suffered. And yet it stood on the brink of a major cultural revival—one in which the Shrine of St. Paul would make its reappearance after its centuries-long silence.

The Thirteenth Century

It is near the dawn of the thirteenth century of the Common Era that we hear, for the first time, mention of a *monastery* of St. Paul. In the Arabic *History of the Churches and Monasteries,* a composite text assembled between 1160 and 1220, we find the following notice: "Within the desert is the monastery of St. Paul. It stands on the bank of the Salt Sea, and between it and the monastery of Al-Jummaizah there is a journey of two days through the desert. Monks in priest's orders and deacons come from the monastery of the great Saint Anthony to the monastery to celebrate the liturgy in it by turns. It stands in the Wâdî ʾl-ʿArabah, near the pool of Miriam; and it is near Mount Sinai, but divided from it by the passage over the Salt Sea."[27]

In some respects this report is disappointing. The corresponding notice for the Monastery of St. Antony gives considerable detail about the physical layout of the monastery, including its church, garden, keep, cells, and fortified wall; it is inhabited by "many" monks.[28] As for the Monastery of al-Jummayza, or the Monastery of St. Antony-on-the-Nile, the *History of the Churches and Monasteries* mentions the keep, garden, mill, and winepress; it is inhabited by thirty monks.[29] For the Monastery of St. Paul, however, we can assume from the *History's* notice only that there was a place to celebrate the liturgy—which was done regularly by priests and deacons coming from the Monastery of St. Antony. While this notice affirms both the close connection of the Monastery of St. Paul to that of St. Antony's, as well as the veneration of St. Paul that would induce monks to undertake the difficult trek between the two monasteries on a regular basis, it tells us little about any structures at the monastery or the community of monks gathered about the cave of St. Paul; presumably this community was small and dependent upon the much larger Monastery of St. Antony.

The thirteenth century, however, would see a remarkable flowering of Coptic culture—a flowering in which the Monastery of St. Paul would share.[30] That such a flowering should have taken place is in some ways counterintuitive. The previous century is marked by the rapid decline of the Coptic church in the Delta[31] and by a rapid loss in competence in the Coptic language throughout the community.[32] The beginning of Ayyubid rule toward the twelfth century's end replaced the mostly tolerant sectarian Shiʿism of the Fatimid rulers with the assertive Sunnism of the great Salah al-Din (Saladin) al-Ayyubi and his successors. Furthermore, the early thirteenth century would witness a crisis in the institution of the Coptic Orthodox patriarchate, including a vacancy in the position from 1216 to 1235; since only the patriarch can consecrate bishops, the entire ecclesiastical hierarchy suffered severe attrition.[33]

While the hierarchy may have suffered crisis, Coptic lay notables (the arakhina) had succeeded by the early thirteenth century in reestablishing their indispensable roles as financial administrators to the Ayyubid rulers, who were making Cairo into the political and cultural center of the Islamic world. Wealthy Copts competed with one another and with their Muslim counterparts in bestowing patronage, and even Copts with modest means donated to pious projects—enabling extraordinary talent to flower in ecclesiastical art and literature. While the artists, craftsmen, and writers delved deeply into their specifically Coptic heritage, there is also a catholicity about their work, a "universalist and interconfessional cultural orientation,"[34] and a willingness to accept that "a kind of 'osmosis'" from outside Egypt "still belongs to its own heritage."[35] The literary revival, it must be stressed, took place in the Arabic

language, and here Coptic Orthodox writers had a profound debt to the Arabic Christian library that had already been created in Palestine, Syria, and Iraq, by members of all the different Christological communions or "denominations" of the day.[36]

The finest available example of flowering in the *visual* arts is undoubtedly the painted program of Theodore and his team at the principal church in the Monastery of St. Antony, dated to 1232/1233;[37] four dedicatory inscriptions provide a list of at least thirty-three donors who supported and financed the work.[38] Such thirteenth-century inscriptions have not been preserved at the Cave Church of St. Paul, but one may assume that the expansion of the church and successive programs of decoration that took place throughout the century (to the program of 1291/1292) were similarly subscribed—perhaps, in the case of the first painted program, by some of the same individuals whose names are recorded on the wall at the Church of St. Antony.

For many students of Coptic history, the thirteenth-century *literary* renaissance is symbolized by the Awlad al-ʿAssal, four brothers who were near the center of the Coptic community's intellectual (and church-political) life for much of the middle third of the century.[39] Born into a wealthy family that had held important posts in succeeding Muslim administrations for generations, one brother, al-Amjad, was a high-ranking civil servant who financed his family's activities, while the other three were fully engaged in Arabic-language literary endeavors. Al-Muʾtaman is remembered especially for his theological encyclopedia, the *Compilation of the Fundamentals of Religion* (*Majmuʿ ʿusul al-din*);[40] al-Asʿad is responsible for an elegant Arabic translation of the Gospels (complete with critical apparatus documenting the readings found in existing translations);[41] while al-Safi's work ranges from apologetic tracts to a major collection of canon law.[42]

One friend and client of the al-ʿAssal brothers was a learned monk, priest, and scribe named Gabriel, a former monk of the Monastery of St. Antony who, if our sources are to be believed, would later spend time at both the Monastery of St. Antony and that of St. Paul. According to the Ethiopian synaxarion (in which he is revered as a saint), the monk Gabriel had gone from the Monastery of St. Antony to Jerusalem to serve for a time as priest at the Church of the Resurrection, before returning to the Muʿallaqa (Hanging) Church in Old Cairo where he was "copying the holy Books of the Holy Church."[43] Coptic historians and scattered manuscript notices dating from 1249 to 1271 give us some details as to his activities.[44] We

know, for example, that he enjoyed the patronage of al-Amjad ibn al-ʿAssal, whose son he tutored; in fact, Gabriel wrote in 1257 that he had lived in al-Amjad's houses in Damascus and in Cairo for ten years.[45] Throughout this period Gabriel copied manuscripts and participated in the family's projects: for example, he copied a Copto-Arabic biblical manuscript used by al-Asʿad in the production of his critical Arabic translation of the Gospels,[46] and he also made a copy of al-Safi's compendium of canon law.[47] One of Gabriel's volumes, a bilingual New Testament, was copied from an original made by one of the great Coptic linguists of the age, Bishop John of Samannud, for the use of another great scholar of the day and friend of the al-ʿAssal brothers, the historian and theologian Abu Shakir ibn al-Rahib.[48]

Gabriel was the favored candidate of al-Amjad ibn al-ʿAssal and many of the Coptic notables of Cairo (al-Qahira) in the patriarchal election of 1262, which ended in deadlock. Despite a solemn drawing of lots that should have decided the election in Gabriel's favor, it was his rival John ibn Saʿid al-Sukkari (favored by the notables of Old Cairo or Misr) who was enthroned as Pope John VII.[49] According to the Ethiopian synaxarion, Gabriel withdrew to the Monastery of St. Antony;[50] and according to a story in an Ethiopic collection of Marian miracles, he made his way even farther from the center of Egyptian life, to the Monastery of St. Paul.[51] There, according to the Ethiopic text, he spent three years in ascetic endeavor…and in copying a very large book. Remarkably, this was not a Copto-Arabic work but rather the Arabic translation of a Greek florilegium, which in the sixteenth century was in turn translated into Ethiopic.[52]

It may be worth continuing with the miracle story.[53] Gabriel endowed the book that he had copied to the Monastery of St. Antony in perpetuity, and sent it to that monastery with a monk who led one of the donkeys belonging to the Monastery of St. Paul, one large and strong enough to carry the book. The monk, however, was waylaid by bedouin, who stole the donkey, the book, and even the monk's monastic habit. Informed of this, Gabriel hurried to the monastery church, threw himself down before the image of the Virgin, and swore that he would not eat, drink, or leave her image until she showed her power and recovered the book. After three days, the Virgin spoke to Gabriel with reassurances, both about his book and about his future as patriarch, and the next day the donkey, book, and habit were brought to the Monastery of St. Antony by a mysterious figure who vanished when the gate of the monastery was opened. The monks, amazed, hurried to

FIGURE 2.3

Virgin Mary (E6), first half of
the thirteenth century. ADP/SP 2
S249 05.

send the donkey back to the Monastery of St. Paul with the news (and with a load of food supplies grown at the monastery).

Later that same year, the story continues, a delegation arrived at the monastery with the intention of bringing Gabriel back to Cairo to be patriarch. He at first resisted their request. As he spent the night in prayer before the image of the Virgin, however, she once again spoke to him, assuring him that it was the will of her beloved son that he be restored to the patriarchal throne.

While few of the details of this story can be corroborated from Egyptian sources, it does have a number of features that ring true and that, at the very least, show how the Monastery of St. Paul was pictured by Ethiopian monks (some of whom undoubtedly paid the monastery a visit).[54] The monastery, according to this story set in the 1260s, is a small place, subordinate to the Monastery of St. Antony and dependent upon it for supplies; monks lead loaded donkeys between the monasteries, and sometimes suffer at the hands of bedouin. It is, significantly, a suitable place for withdrawal from the center of Egyptian life, nearly (but not quite entirely) off the map and out of mind. And despite its modest size and its distance from Cairo, the monastery shares in the thirteenth-century cultural flowering of the Copts: a precious manuscript may be produced there by a well-connected scribe of cosmopolitan outlook; the blessed Virgin looks down from wall paintings in the church. One can readily imagine the monk Gabriel prostrate before the image (now beautifully restored) of the enthroned Mother of God in the lower zone of the Haykal of St. Antony (fig. 2.3).

Two other thirteenth-century pieces of evidence should be considered before we move on. First, the library of the Coptic Patriarchate possesses two volumes (of what was probably once a three-volume set) of the Arabic translation—by a Syrian Melkite!—of St. John Chrysostom's homilies on the Gospel of Matthew.[55] They were copied at the Monastery of St. Paul and are dated 18 Baramhat AM 947 (March 14, 1231).[56] It appears that the once-and-future patriarch Gabriel was not the first to copy a book of Greek/Melkite provenance at the monastery. In fact, one is led to wonder whether at the time there were contacts between the Monastery of St. Paul and that of St. Catherine at Mount Sinai that included the sharing of books.

Another witness to the monastery's life in the thirteenth century is a long note in a Syriac manuscript, now in the British Library, that has been translated as follows: "Let the Syrian brethren who come after us to this monastery know that in the Convent of Abba Paulus, beside

the Monastery of Mar Antonius, which belonged to the Syrians like this [the Monastery of the Syrians], there are many Syriac books still. But because of what was to come [?] the Syrians were driven thence: the Egyptians took it, but…there is none to examine them and release it from their hands."[57]

A frequently repeated suggestion is that the troubles alluded to here should be dated to 1235–1245, but this seems little more than a guess.[58] Still, the note reinforces the suggestion made earlier that Syriac-speaking monks would have had good reason to be interested in the site; some appear to have settled there. Perhaps even more significantly, this notice is our earliest reference to a *collection* of books at the Monastery of St. Paul. In any event, the thirteenth century provides us with some evidence—if slight—both for book production and book preservation at the monastery. That the books in question should be Arabic translations of Greek works on the one hand, and Syriac volumes on the other, is by no means out of keeping with what we know of the intellectual life of the Coptic Orthodox Church in the thirteenth century, with its cosmopolitan horizons.

The Fourteenth and Early Fifteenth Centuries

The Ayyubid rulers under whom the Copts had come to thrive were succeeded by the Mamluks in 1250, and while the Coptic cultural renaissance continued unabated for a few decades, life soon became much more difficult for the community. The *History of the Patriarchs* reports that already during the first period of the pontificate of John VII (1262–1268), the sultan al-Malik al-Zahir Baybars threatened to burn all the Christians; he was dissuaded from this course of action, but a fine of 50,000 dinars was imposed on the patriarch.[59] Under John's rival Gabriel III (1268–1271), sumptuary laws designed to mark off the Christian and Jewish *dhimmis* (non-Muslims living under Islamic rule) and keep them "in their place" (including the wearing of blue and yellow turbans, respectively) were imposed.[60] Both the arbitrary arrest and fining of the patriarch and the imposition of sumptuary laws became a regular feature of Coptic life under Mamluk rule; Copts suffered both from the tyranny and avarice of individual Mamluk sultans and amirs as well as from the scapegoating dynamics of mobs fired up by anti-dhimmi propaganda, often against the background of general suffering caused by political instability, war (against Crusaders, Mongols, and Timur-i Lang), periodic crop failure leading to hyperinflation (for example, in 1295, 1347, 1374, and 1404), and epidemics (including twenty major outbreaks of bubonic

or pneumonic plague occurring between 1347 and 1517).[61]

On a number of separate occasions Mamluk governments adopted measures not only to enforce the sumptuary laws but also to compel Copts serving in governmental departments to convert to Islam; the most prominent were the measures of 1293, 1301, 1321, and 1354.[62] Each of these measures was accompanied by mob violence; in an orgy of destruction in 1321, sixty churches were destroyed in Egypt, eleven of them in Cairo. While sumptuary laws tended to fall out of effect shortly after their enactment, the sequence of measures did have irreversible effects: churches were destroyed and not rebuilt; Coptic wealth, including the endowments that supported churches and monasteries, was confiscated; publicly celebrated Coptic festivals were suppressed; and the leading Coptic civil servants converted to Islam in order to keep their positions. While many of these conversions appear to have been quite nominal in the earlier years of the fourteenth century, with many newly converted Muslim administrators leading Christian households and maintaining strong ties with the Christian community,[63] the measures of 1354 were designed to ensure that the Coptic *musalima,* as these converts were known, behaved and were socialized as pious Muslims.[64] The year 1354 has plausibly been proposed as a "turning-point in Egyptian religious history," a point at which many Copts may have perceived that their future, and that of their families, would best be secured by joining the Muslim community.[65]

The trauma suffered by the Coptic community in the mid-fourteenth century (due to factors such as the arrival of the Black Death in 1347 and the anti-dhimmi measures of 1354) is mirrored in what is known of the monasteries of Scetis (the Wadi Habib or Wadi al-Natrun). These monasteries, in particular the Monastery of St. Macarius, had continuously served as a refuge and center of spiritual energy for the Coptic Orthodox Church throughout the Islamic period.[66] They appear to have been flourishing through the year 1346—and then our sources fall silent. When the silence is broken, nearly a century later, the monasteries are ruined or inhabited by only a handful of monks.[67]

It is against this background that we must interpret the notices that come to us concerning the Monastery of St. Paul in the fourteenth and early fifteenth centuries. We discover that as the monasteries of Scetis were falling into ruin, the Red Sea monasteries—St. Antony in particular, but with St. Paul playing its characteristic supporting role—came to new prominence as centers of vitality in the church. The greatest saint of the age was probably Marqus

al-Antuni (1295/6–1386), that is, Mark of the Monastery of St. Antony.[68] He received his monastic training, however, at the Monastery of St. Paul (fig. 2.4).

The *Life* of Marqus al-Antuni is preserved in a number of manuscripts, including an important one in the library of the Monastery of St. Paul.[69] From it we learn that Marqus, as a young man of twenty-three, sought to become a monk at the Monastery of St. Antony.[70] "By the providence of God, our father the *hegumenos* Anba Rafaʾil al-Naʿnaʿi was living there in those days. When he saw the young man he rejoiced greatly over him, began to instruct him for a few days, and sent him to the Monastery of St. Paul to live in solitude there, because the young man did not yet have a beard. The intention of the above-mentioned hegumenos was that he live in solitude there and not mix with anyone of the community at all until his beard was full, as was the custom."[71]

Marqus spent six years at the Monastery of St. Paul, and the pages of his *Life* give us something of a portrait of the monastery in those days (ca. 1319–1325). Closely related to the larger Monastery of St. Antony, it was a place of great solitude inhabited by a small group of experienced ascetics who could be entrusted with the supervision of a young and promising monk. In addition, there were hermits living outside the monastery.[72] The text mentions the monastery garden, beside which Marqus dug himself a "tomb" in which he practiced fasting (and which pilgrims to the monastery may visit today) (fig. 2.5).[73] The monastery was surrounded by a wall, upon which one could walk and watch.[74] The monks used to gather at table, although Marqus, who became known for his powers of fasting, did not join them.[75] There were a variety of chores to be done; Marqus later told his disciples of being sent out into the wilderness with a camel (to which he fed his provisions!) to gather firewood.[76] Marqus' practice of fasting finally led to his stay at the Monastery of St. Paul being cut short: the senior monks, alarmed that their young charge was not eating, sent him back—with difficulty—to the Monastery of St. Antony.[77]

The *Life* (properly speaking) of Marqus al-Antuni is followed, as is typical in Copto-Arabic hagiography, by a set of *Wonders* worked by or involving the saint, here thirty-four in number. While most of these have to do with the mature monk at the Monastery of St. Antony (datable events range from 1365, when Marqus was nearly seventy, to his death in 1386),[78] the fourth wonder describes Marqus' clairvoyance even as a novice at the Monastery of St. Paul.[79] A man in the employ of the sultan al-Malik al-Nasir Muhammad ibn Qalawun (third reign, 1310–1341)

had withdrawn from his position and become a monk at the Monastery of St. Paul. The sultan sent a high-ranking search party after him. Marqus foresaw its arrival at the monastery sufficiently early as to send to the "large monastery" for the supplies necessary for hospitality, and so precisely as to know when to prepare food and to heat water for washing the feet of the guests, who arrived suffering from hunger and cold. We never learn what happened to the runaway. But the incident fits well into the context of the times, perhaps especially into the period of troubles following the riots of 1321. And, as was the case in the story of Gabriel III, the Monastery of St. Paul emerges as a place of refuge far from the center of Egyptian life—almost, but not quite, out of the reach of central authority.

While Marqus never served as superior of the Monastery of St. Antony, he became the spiritual father to many monks, priests, and lay people—men and women—of the era. Two saintly figures to whom Marqus served as mentor and inspiration were the hegumenos Ibrahim al-Fani (d. 1396)[80] and the priest Matta, who became the greatest of the late medieval patriarchs, Matthew I (1378–1408).[81] A reading of Marqus' *Life* (including the *Wonders*) makes it clear that he not only served the church as mentor and as a model of ascetic endeavor and merciful pastoral care, he also was deeply engaged in the church's struggle to respond to the processes of Islamization that had gained momentum since 1354.[82] Marqus maintained good relationships with some of the leading Coptic musalima;[83] encouraged Copts whose religious identity had been compromised to embrace the monastic life or to live out their Christian faith openly in the world;[84] and provided guidance and support to male and female disciples who later participated in the wave of voluntary martyrdom that was a startling feature of Matthew's patriarchate.[85]

According to the *Life* of Marqus, there were more than one hundred monks at the Monastery of St. Antony at the time of his death in 1386.[86] This important note is corroborated by Ogier d'Anglure.[87] Having visited the churches of Cairo, and having taken note of the extensive work of charity by the Coptic patriarch (Matthew), Ogier visited the three Antonine monasteries late in 1395. The three, he observed, were under a single abbot: St. Antony-on-the-Nile ("a good thirty brothers"), St. Antony-in-the-desert ("a hundred or more brothers"), and St. Paul ("at least sixty resident brothers").[88] These numbers are astonishing, especially when we note that it is only a few years later, in 1413, that a witness informs us that the Monastery of the Syrians in the Wadi al-Natrun was inhabited by a single monk.[89]

FIGURE 2.4

Icon of Marqus al-Antuni, 1768/1769 (AH 1182), by Ibrahim al-Nasikh (active ca. 1742–1780). Monastery of St. Antony. ADP/SA 93 97.

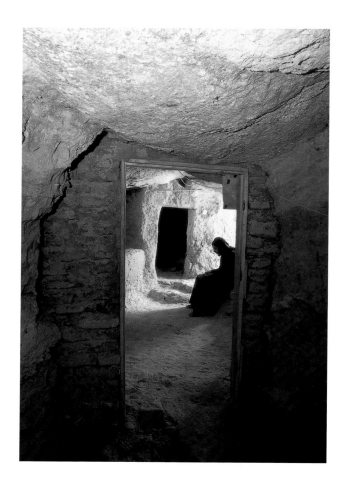

At the end of the fourteenth century, then, the monasteries of St. Antony and of St. Paul were flourishing. In his visit to the Monastery of St. Paul, Ogier noted its enclosure walls, high and thick like a fortress, its beautiful Cave Church with the tomb of the saint, its garden and water supply.[90] He made a special mention of the monks' hospitality to visitors: "They gave us very good cheer, received us most sweetly and benignly, and quickly brought us such provisions of food as God had lent them. And it must have been around midnight when we entered and came to the door of this abbey, yet these good brothers nearly all got up and were diligent in serving us, and brought us hot meats as though each one of them were to be paid a hundred ducats."[91]

An additional indication of the liveliness of the Monastery of St. Paul at this time comes from the realm of manuscript studies: in 1392/1393 (AM 1109) a monk of St. Paul made a copy of an Arabic collection of thirty discourses of St. Gregory Nazianzen, using a manuscript that had been written by a certain monk Zachariah of St. Antony. (The St. Paul manuscript, in its turn, was the basis for a seventeenth-century manuscript now preserved as Paris, B.N. syr. 191.)[92] This is a fairly sophisticated text; it is hard to imagine a library possessing such a book without possessing many others.

In terms of numbers, the monasteries of St. Antony and of St. Paul appear to have reached a high point during the patriarchate of Matthew I. The few notices that we possess from the fifteenth century indicate a slow decline of the Red Sea monasteries. In 1421 the traveler and diplomat Ghillebert de Lannoy visited the monasteries, reporting that there were fifty monks at St. Antony, and that St. Paul was subordinate to it; he also mentions the bedouin ("Indiciens") who came to the monastery for water.[93] Ghillebert may have left his name scratched into the west wall of the Cave Church.[94] Less than twenty years later, al-Maqrizi's description of the Monastery of St. Paul tells the story of its founder, mentions its spring and the garden, and does not mention monks at all.[95] Even if the Red Sea monasteries were in slow decline by the mid-fifteenth century, they continued to play an important role in the life of the church. When in 1440 patriarch John XI (1427–1452) needed a trusted envoy to send to the Council of Florence to negotiate the possibility of church union with the Roman Catholics, he turned to the priest Andrea, superior of the Monastery of St. Antony and, presumably, of St. Paul as well.[96]

Late Medieval Decline from the Mid-Fifteenth Century to Circa 1700

After its high point (in terms of numbers, at least) at the end of the fourteenth century, in the fifteenth century the Monastery of St. Paul slipped back into obscurity. This is not entirely surprising. If the embattled Coptic community of the late fourteenth century had been illuminated by a burst of holiness personified by Marqus al-Antuni, Ibrahim al-Fani, the patriarch Matthew, and the lay ascetic Furayj, known as Anba Ruways (d. 1404), they had all passed on by 1408, and the brilliance they had provided faded away. The process of Islamization of the society had not been halted, and the Coptic community found itself increasingly marginalized and impoverished. Matthew's successor as patriarch, Gabriel V (1409–1427), is remembered for traveling throughout the country on foot, seeking donations for the church. The great historian of the period, al-Maqrizi, commented that he had never encountered a patriarch so debased.[97]

It is important to remember that, even during the days of Marqus al-Antuni at the monasteries of St. Antony and St. Paul, existence in the Red Sea wilderness was a fragile affair. Marqus' *Life* reminds us that the monasteries were dependent on caravans bringing grain and other supplies from the Nile valley. In times of dearth and hyperinflation, hunger could drive monks back to the irrigated

land (despite Marqus' emphatic counsel that it was better for a monk to die of hunger in his monastery).[98] We are also reminded of the troublesome presence of bedouin, ready to steal anything of use or value, especially in times of want.[99]

The manuscript Vatican Copt. 9, which was written by the priest Gabriel (before he became patriarch Gabriel III) and bequeathed to the Monastery of St. Antony, contains a handwritten note by the patriarch John XIII (1484–1524) on its first folio. He notes that the manuscript was written at a time "when the monastery was inhabited by monks; now it is empty, deprived of inhabitants. The bedouin pillaged it. This manuscript was taken from the hands of the bedouins who took it with the booty." The note, which goes on solemnly to abrogate Gabriel's bequest-statement, is dated April 30, 1506.[100]

While John's notice refers specifically to the Monastery of St. Antony, it is frequently reported that both it and the Monastery of St. Paul were sacked by bedouin and depopulated in 1484; this sack is often imagined as a bloody affair.[101] However, neither the date nor the extreme violence are certain. As for the date, the witness of a Franciscan visitor points to about 1505 as the date for the definitive depopulation of the Monastery of St. Antony (which adds poignancy to Patriarch John's lament in 1506).[102] As for the reason for the depopulation, it is not hard to imagine that poverty and hunger had caused the number of monks to dwindle almost to the vanishing point, making it easy for bedouin to penetrate the monastery walls and make off with anything of value (if only for burning).[103] In any event, the Antonine monasteries (St. Antony, St. Paul, and Dayr al-Maymun at Pispir) did not remain uninhabited for long, as patriarch Gabriel VII (1525–1568) saw to their repair and repopulation, as well as the development of their *waqf* properties.[104] The situation of the Monastery of St. Paul remained precarious, however. Coptic historians report that bedouin of the Bani 'Atiya looted the Monastery of St. Paul, killing one of the monks and scattering the others;[105] Patriarch Gabriel responded with renewed efforts to repopulate the monastery.[106]

The monastery was indeed functioning in the 1550s, if we believe the account of the martyrdom of Yuhanna al-Numrusi, preserved in a manuscript in Paris.[107] Yuhanna, the son of Christian parents, was taken from his family as a child and raised as a Muslim. When his father Yusuf succeeded in reclaiming him they were forced to flee from the authorities, and they found a place of refuge at the very edge of the civilized world: the Monastery of St. Paul. Yusuf eventually became superior of the monastery. As for Yuhanna, upon reaching the age of twenty-one he traveled to Cairo, made confession of his Christian faith, and was executed for apostasy on February 22, 1562.[108]

Within decades, however, the monastery was once again abandoned.[109] Notices in the monastery library tell us that the monastery lay in ruin for more than a hundred years (that is, at least for the whole of the seventeenth century), and that its name was in danger of disappearance.[110] Another source, however, affirms that monks of St. Antony came to the monastery once a year to celebrate the liturgy in the monastery's keep.[111]

Most of the notices that we possess concerning the Monastery of St. Paul in the seventeenth century come from Europeans. Jean Coppin visited the monastery in 1638, setting out from the Monastery of St. Antony, inhabited at that time by twenty-two monks. He insisted on making the visit, despite dangers including potentially violent encounters with bedouin. He found the monastery abandoned but showing traces of bedouin encampments. The walls of the monastery were ruined, and the wall paintings in the church had been deliberately scratched.[112]

Some years later, we hear of a Franciscan monk who had been living at the Monastery of St. Antony in order to perfect his Arabic. In 1665 he came to Cairo with a written offer, as he understood it, for the Franciscans to occupy the Monastery of St. Paul; the Franciscans, however, lacked the personnel to take up the offer.[113] Antonius Gonzales' report on the state of the monastery is interesting: "Presently, it is not inhabited; Coptic religious… had occupied it in the past, but they had to abandon it because of poverty. It is still intact, except that there no longer are any windows or doors."[114] Presumably, the windows and doors of the monastery had been carried off, perhaps for fuel. But if the monastery had been abandoned because of poverty, new patrons would soon be found who would once again enable life at the monastery.

Eighteenth-Century Restoration

The poverty of the Coptic Orthodox Church in the sixteenth and seventeenth centuries was, to a certain extent, a reflection of Egypt's backwater status after the Ottoman conquest of 1517. Changes in the later seventeenth century, however, would soon lead to more propitious times for the Coptic community.[115] Power was decentralized: local authorities and heads of military households in Egypt gained in authority, often taking decisions without reference to Istanbul, while the official representative of the Ottoman state, the Pasha, became more and more a figurehead. As the local beys and regimental officers gained in authority,

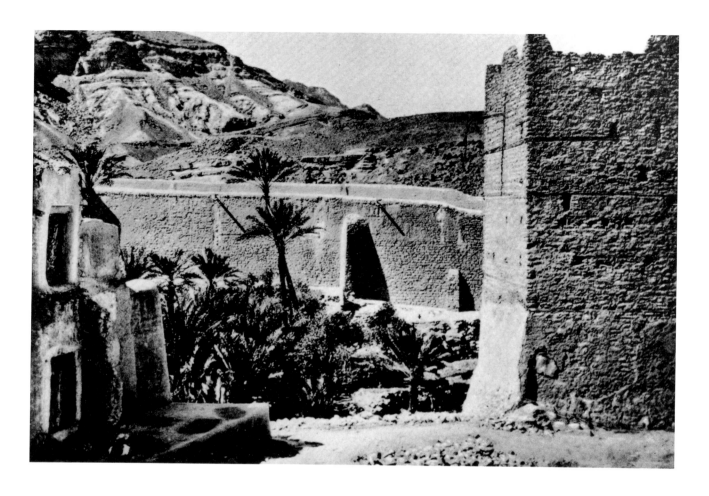

FIGURE 2.6

Medieval south wall, garden,
and the keep, which was enlarged
to its current height in the early
eighteenth century, 1930. Johann
Georg Herzog zu Sachsen.

a new class of Coptic notables (arakhina) thrived as their *mubashirun* (privy secretaries) and financial administrators. Unlike the Coptic musalima of the fourteenth and fifteenth centuries, these Copts maintained their close connection to their church, upon which they bestowed lavish patronage as they gained in wealth and influence. In the course of the eighteenth century, in fact, all the churches of Cairo, as well as all the inhabited monasteries, were recipients of their patronage in the form of restoration, new building and decoration, new endowments for their upkeep in perpetuity, as well as icon writing[116] and manuscript copying.[117]

The eighteenth century witnessed the reconstruction, repopulation, and development of the Monastery of St. Paul: pious building projects at the monastery spanned the century, from its initial reconstruction in 1701–1705 to the building of the Church of St. Mercurius in 1780/1781. In a sense, this work of reconstruction and revival of the Monastery of St. Paul may be seen as a particular instance of a process seen in churches and monasteries throughout the century, throughout Egypt. At the same time, the Monastery of St. Paul appears to occupy something of a special place in the eighteenth-century revival: the ambi-

tious project of restoring the Monastery of St. Paul to life at the beginning of the century may be seen as among the first fruits of the community's grasp of new possibilities, while the revived monastery itself made significant contributions to the course of the revival, with consequences for the life of the Coptic Orthodox Church as a whole.

The restoration of the monastery appears to have taken place as a result of the initiative of Patriarch John XVI (1676–1718), who had been a monk of the Monastery of St. Antony, in consultation with the superior of that monastery, the hegumenos Mark;[118] we also note that the patriarch had a close relationship with the greatest archon of the day, the *mu'allim* Jirjis Abu Mansur al-Tukhi.[119] Consultations between 1700 and 1702 led to major reconstruction work in which the walls and keep were repaired, the church fitted with screens, and a new mill installed (figs. 2.6 and 2.7).[120]

In April 1705 a great procession set out from Cairo: the patriarch, with all that was required for the final fitting out of the church and celebration of the liturgy, was accompanied by two leading clerics from the patriarchate, as well as several of the leading arakhina, among them the "great archon" Jirjis Abu Mansur al-Tukhi. They made

FIGURE 2.7

Haykal screen of the Twenty-Four Elders donated by John XVI in 1705; repaired in 1950. The painting on the right is of Marqus al-Antuni (B10), 1712/1713. ADP/SP 3 S243 O5.

their way to the Monastery of St. Antony, where they were joined by monks and priests from the monastery. Having arrived at the Monastery of St. Paul, they were joined by other arakhina, notably "the blessed" mu'allim Lutfallah Abu Yusuf. In a lengthy liturgical celebration that stretched through Saturday night and deep into the afternoon of Sunday, 18 Bashans,[121] the patriarch consecrated the monastery church (with its haykals, altars, vessels, and icons). After the completion of the communion, the congregation took the blessing of the tomb of St. Paul, and then went on to consecrate the Church of St. Mark (the location of which is open to speculation).[122] The great celebration concluded with the liturgy of Monday morning, followed by a visit to the monastery's holy places.[123]

The consecration of the monastery's churches complete, the patriarch appointed the priest Bishara as superior of the monastery; and, in a move that gave the monastery much greater autonomy than it had experienced for much of its history, provided it with its own endowment lands (waqf), separate from those of the Monastery of St. Antony.[124]

A number of other projects were undertaken in the few years that followed the reestablishment of the monas-

tery; in several of them, the active hand of Patriarch John is apparent. He, for example, provided for a sanctuary screen for the Chapel of the Virgin in the monastery's keep (figs. 2.8 and 2.9). Made by the monk Jadallah al-Kharrat, the screen is dated AM 1425 (1708/1709). Furthermore, the patriarch saw to the reconstitution of the monastery's library, as may be seen from his characteristic waqf-statement in many manuscripts.[125] In 1709/1710 the monastery was damaged by flood, as the wadi that it straddles became a riverbed and the flood-control channels that had been created around the monastery failed to divert the water, which breached the walls. With great toil, the monks—who had grown to a group of ten from the initial group of five—were able to rebuild the walls better than before.[126] Scattered notices inform us of continued growth after that: Claude Granger found fourteen monks in the monastery when he visited in 1730, while in 1737 Pococke reported that there were twenty-five monks there—a figure that remained quite stable over the next two centuries and more.[127]

The major role played by the arakhina in the initial reconstruction of the monastery is apparent from the accounts of the solemn consecration of its churches. Furthermore, the names of leading members of the arakhina

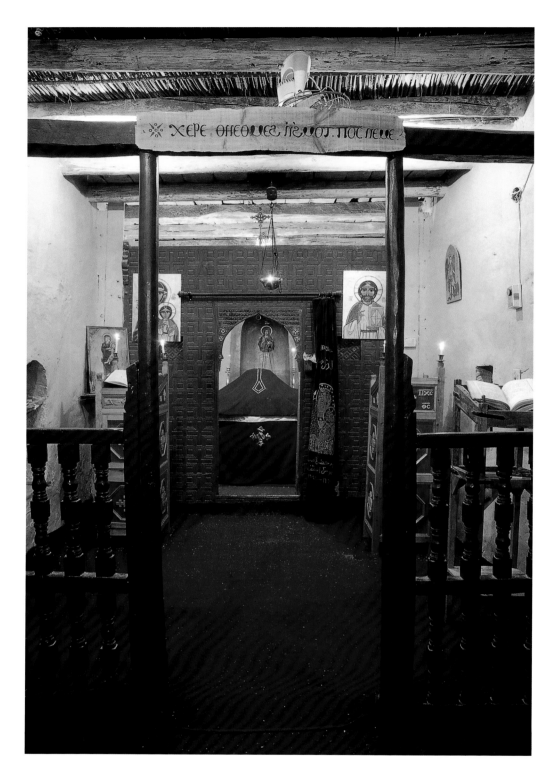

FIGURE 2.8

Chapel of the Virgin Mary on the
fifth floor of the keep. ADP/SP 1
s1135 97.

are recorded in various places throughout the monastery. The expansion and decoration of the Cave Church in 1712/1713 was sponsored, according to an inscription in the Dome of the Martyrs, by the patriarch John XVI, "the teacher Georgios and the teacher Pity-of-God."[128] "The teacher Georgios" is surely the great lay leader of the Coptic community in his time, al-muʿallim Jirjis Abu Mansur al-Tukhi (d. 1718), who had played a major role in the reestablishment of the monastery and who was also responsible for the repair of churches in Cairo, while "the teacher Pity-of-God" is Jirjis' successor as lay leader of the community, al-muʿallim Lutfallah ("Kindness-of-God") Abu Yusuf (d. 1720), who along with Jirjis had been present for the consecration of 1705. Lutfallah's successor was al-muʿallim Jirjis Abu Yusuf al-Suruji (d. 1737), "the amir of his community"; his name is recorded along with Lutfallah's in the dedicatory inscription of the Church of St. Michael the Archangel and St. John the Baptist, dated to 1732 (when the monk Michael was superior of the monastery) (fig. 2.10). Perhaps the most powerful of the Coptic arakhina was the muʿallim Ibrahim al-Jawhari (d. 1795), "the sultan of the Copts," who was responsible, as a dedicatory inscription points out,[129] for the building of the Church of St. Mercurius in 1780/1781.[130]

Something of a special relationship between the arakhina (who, in this period, were playing a leading role in the choice of patriarch)[131] and the monks of the newly re-vived Monastery of St. Paul may be seen in the fact that the three patriarchs after John XVI were all selected from among the monks of the monastery. Peter VI (1718–1726) had been, as the priest Murjan, a monk of the Monastery of St. Antony and later superior at the Monastery of St. Paul. The muʿallim Lutfallah Abu Yusuf, whose wife was the niece of Patriarch John XVI, took the leading role in securing his election.[132] Peter was succeeded by John XVII (1726–1745), previously the monk and priest ʿAbd al-Sayyid al-Mallawani at the Monastery of St. Paul. One of the original five monks chosen to repopulate the monastery,[133] he was a scribe and very possibly the leader of the monastic team responsible for the new painted program in the Cave Church.[134] He was followed in the patriarchate by Mark VII (1745–1769), who had been the monk and priest Simʿan at the monasteries of St. Antony and St. Paul.[135]

One young Copt who came into the orbit of Patriarch John XVII was a nephew of the abbess of the Convent of St. Theodore the General at Harat al-Rum, probably orphaned at an early age, named Ibrahim ibn Simʿan ibn Ghubriyal (d. 1785).[136] Under the name Ibrahim al-Nasikh ("the Copyist"), he would come to be celebrated as "one

of the symbols of Coptic culture in that age."[137] While Ibrahim was a particularly expert scribe, not just a copyist but a very well-read editor of texts, his fame perhaps rests more on the many icons he wrote, both by himself and with his partner Yuhanna al-Armani.[138] It is worth pointing out, however, that the young Ibrahim first comes to our notice as a member of the party that solemnly set out from Cairo in 1732 for the consecration of the new Church of St. Michael the Archangel and St. John the Baptist at the Monastery of St. Paul, including the patriarch John XVII and the great archon Jirjis Abu Yusuf al-Suruji; Ibrahim's record of the proceedings is now in the monastery library.[139] Perhaps it is no accident that the greatest Coptic icon-writer of the mid-eighteenth century had visited the Monastery of St. Paul, and had worked with the patriarch who may once have taken a leading role in painting its principal church.[140]

For much of the eighteenth century, then, the Monastery of St. Paul loomed large in the imagination and patronage of lay leaders of the Coptic Orthodox Church, in the experience and formation of its ecclesiastical leaders, and possibly also in the background of its artists. In terms of artistic technique, there is a wide divide between, say, the paintings of the equestrian saints in the Cave Church and the many icons of the same equestrian saints written by Ibrahim al-Nasikh; still, the connections between them—in terms of example and mentoring, of common imagination and theme, of patterns of patronage—may be stronger than one might assume at first glance.[141]

The Monastery in Modern Egypt from Circa 1800 to the Present

The story of the monastery in the past two hundred years lies beyond the scope of the art historical study that is the heart of this book. In any event, to tell it properly would require much careful research in the libraries of the mon-

asteries of St. Paul and St. Antony, as well as in collections of archival materials in Cairo. Still, a few brief observations may be useful.

Visitors' accounts from the eighteenth through the twentieth centuries give a remarkably stable figure for the number of monks at the monastery: from 1737 to 1956, the figure ranges from twenty-five to about thirty (fig. 2.11.)[142] When in 1897 Patriarch Cyril V (1874–1927) decided to raise the superiors of the four principal monasteries to episcopal dignity, the Monastery of St. Paul was among them, its superior becoming Anba Arsaniyus I (1897–1924).[143] This marks the clear independence of the Monastery of St. Paul from that of St. Antony, although the effective autonomy of the monastery had probably already been established. Bishop Arsaniyus is remembered for having developed the monastery's agricultural properties at Bush, in the Nile valley, where the monastery has a dependency to the present day.[144] The monastery's connection to a monastic establishment in agricultural land, once represented by the link with the Monastery of St. Antony at Pispir, continues in a new form.

Leaders for the entire church continue to be drawn from the monastery; *The Preserved Secret* gives a list of eleven bishops chosen from the ranks of the monks between 1797 and 1993.[145] Just as significantly, the Coptic Orthodox faithful look to the monastery for examples of life led in faith. I know of five booklets published in recent years that celebrate the lives of monks who have recently died, and materials are being gathered for others.[146] And, of course, the faithful come to hear counsel from and to receive the blessing of monks living at the monastery today.[147]

Along the way we have come across several hints of the importance of manuscript production in the monastery's life. While a study of such production in the modern period must await a close examination of the monastery's collections of manuscripts, it is possible to say that the

FIGURE 2.11

Monks of St. Paul outside the western mill room, 1930. Whittemore expedition, A99. Courtesy of Dumbarton Oaks, Washington, D.C.

FIGURE 2.12.

Colophon from Mingana Christian Arabic 52. "This blessed book, entitled *The Book of Eustathius [Ustath] the Monk,* in four parts, was completed on Tuesday, 24 Misra in the Year of the Martyrs 1592 [August 17, 1876], by its lowly scribe Marqus, one of the monks of the Monastery of the great and righteous Saint Anba Bula. He asks all who read in it to pray for him for the forgiveness of his sins." Translated by M. Swanson. Courtesy of the Mingana Collection, University of Birmingham, U.K.

reconstitution and expansion of the monastery's library that began early in the eighteenth century and continued throughout the nineteenth contributed to the preservation of works of great importance to the Coptic Orthodox Church. For example, of the ten manuscripts utilized by the editor of the modern edition of the theological encyclopedia of al-Mu'taman ibn al-'Assal, three come from the Monastery of St. Paul.[148] Of five existing manuscripts of the important ninth-century *Book of Eustathius the Monk,* two were copied at the monastery (fig. 2.12).[149] And it was a particularly active mid-nineteenth century copyist at the monastery, the hegumenos Shanuda, who restored an important thirteenth-century manuscript utilized in the modern publication of the *History of the Patriarchs.*[150]

We have noted that the monastery has long served as a place of withdrawal, of retreat and exile. This role has continued into the modern period: Bishop Yuhannis of al-Buhayra—later patriarch John XIX (1927–1942)—was exiled to the monastery for a time (1892) in the course of struggles between the Coptic hierarchy and the lay Community Council;[151] his successor as patriarch, Macarius III (1944–1945), when embroiled in a similar dispute, withdrew to the monastery for a time in 1944.[152]

The days when monks took two days to reach the monastery from Cairo, spending the night in the streets

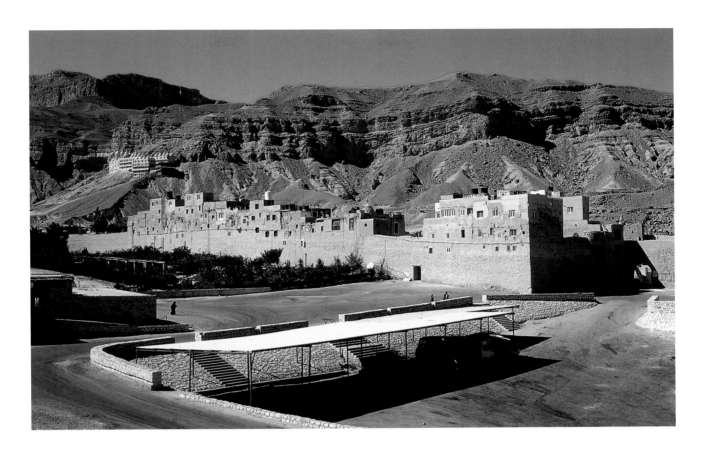

FIGURE 2.13

Modern parking lot and exterior garden at the Monastery of St. Paul, 2004. EG 2 S33 04.

of Suez; are still present in living memory.[153] Today the trip takes less than four hours, much of it by four-lane toll road. Buses full of Coptic pilgrims regularly reach the monastery; visitors from around the world, guidebook in hand,[154] stop by for a visit; guest facilities have been greatly expanded (fig. 2.13). And yet the monastery still offers visitors not only a hospitable welcome but a sense of being well off the beaten track. In a loud and assertive world, the Monastery of St. Paul preserves its modesty and its secrets: the secrets of the monastery's story, inaccessible to any amount of historical research; the secrets of its founder, who spent so many anonymous years in that place; and the secrets of the mysterious ways of God, whose praises the monks sing without ceasing.

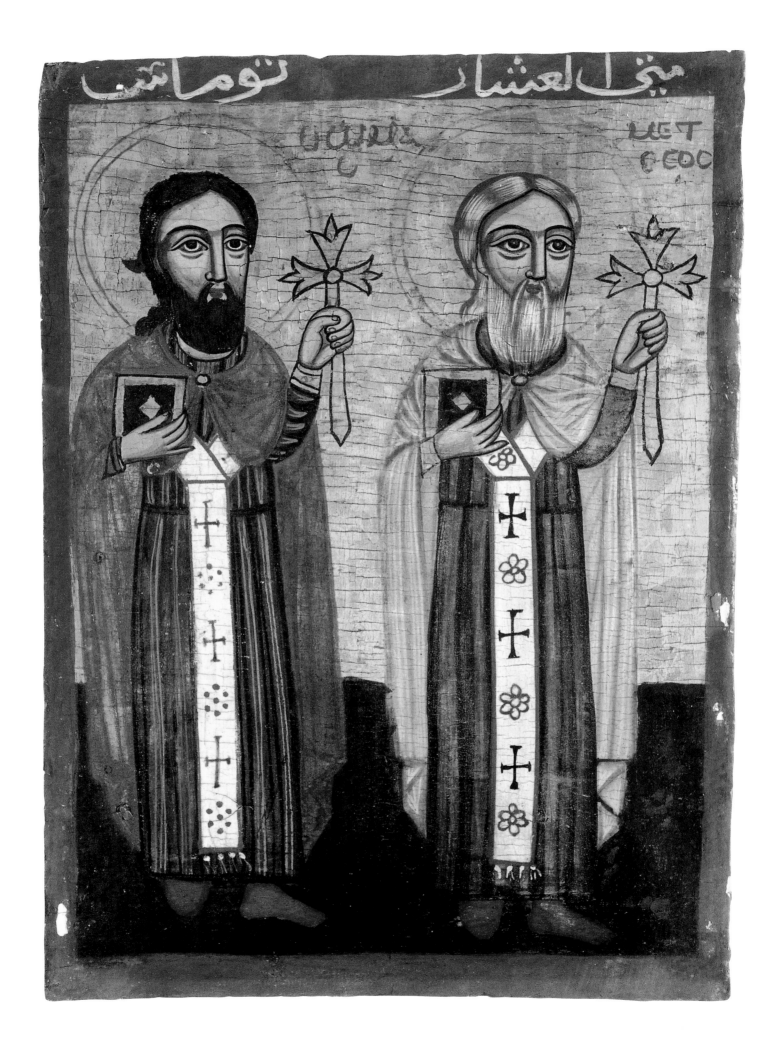

CHAPTER 3

PATRIARCHS, ARCHONS, AND THE EIGHTEENTH-CENTURY RESURGENCE OF THE COPTIC COMMUNITY

Recent investigations into what one scholar calls the middle period of Ottoman rule in Egypt have begun to paint a dynamic picture of Coptic Christians in the eighteenth century, specifically depicting a Cairene community that was vibrant, active, and occasionally caught up in volatile relationships with the surrounding Muslim and non-Muslim populace.[1] New research has shown, both explicitly and implicitly, that the eighteenth century was a period of social, communal, and religious renewal for the Copts.[2] Indeed, there appears to have been an unmistakable and increased interest in church and monastic renovations, artistic development (especially the creation of icons and illuminated manuscripts), as well as in reviving traditional Coptic rites (fig. 3.1).[3] The fruits of such a revival can be seen in, among other projects, the restoration and repopulation of the Monastery of St. Paul. The fact that Copts attained prominent economic positions in this period has been long known, but explanations for such a distinct cultural revival have yet to be fully explored.

My task in this chapter is to discuss the historical context for this emerging revival, which arguably shaped the course of Coptic history in the nineteenth and twentieth centuries. In the first section, I will evaluate the ways in which Coptic lay leaders, known as archons (Arabic: arkhun, pl. arakhina) were intimately tied to Egypt's most important political and economic actors in the late seventeenth and eighteenth centuries, and how their relationship to these grandees allowed them to achieve positions of great prominence and wealth. Archon is the ancient Greek word for official, magistrate, or ruler. Since the early Islamic conquests of Egypt in the seventh century, however, it has been often used to refer to influential Coptic notables.

In this context, the term came to signify a "lay member of the Coptic Church who through long years of experience and dedication to the church has earned honored status as a leading member of the Coptic community."[4] Archons were often called muʿallim—a polite title meaning "teacher" or "elder" bestowed on Christians and Jews in Egypt.[5] Second, I will examine in more detail the extent of the Coptic resurgence under the guidance and benevolence of influential and wealthy archons during the reign of four Coptic patriarchs (1676–1768), three of whom came from the Monastery of St. Paul. Here the nature of the changing relationship between patriarchs and archons, archons and other archons, and archons and Muslim leaders will be investigated, with a consideration of the ways that Coptic lay and clerical leaders dealt with external challenges and internal priorities. The conclusion will highlight that, in the period under study, archons became bolder in defending and managing communal matters, in part through their support of substantial restoration projects. Moreover, they utilized their close ties to Egyptian power holders in order to solidify their authority within the community vis-à-vis the patriarchs.

Historical Background: The Rise of Coptic Archons in Ottoman Egypt

The rise of a wealthy cadre of Coptic leaders in the late seventeenth and early eighteenth centuries is related to broader trends within Egyptian society, especially the ascent of military households in Ottoman Egypt that usurped political power from the Istanbul-appointed governors. Many Copts were affiliated with these households and benefited from their growing power and riches. Elite households in

FIGURE 3.2

Citadel of Cairo from the south, ca. 1799. The Burg al-Muqattam, the large tower on the right, was the headquarters of the Janissary regiment in the Citadel. Bibliothèque Nationale de France, Paris.

Egypt, which included those of the Ottoman governor, salaried officials, local grandees, and military officers, proliferated in this period and were in general modeled after the sultan's household in Istanbul. While, as Jane Hathaway notes, the household was a fluid entity that was "continuously evolving, expanding through marriages and mergers or breaking up,"[6] typically it was made up of a grandee's "entourage of slaves, domestic servants, wives and concubines, bodyguards, and assorted clients who gathered in the palatial houses that many of them owned."[7] Many of the prominent household heads were officers in the Ottoman military regiments stationed in Egypt, especially the Janissaries (known locally as Mustahfazan [Guardians][8] and the 'Azaban (Bachelors), who were both quartered in the Citadel of Cairo (fig. 3.2).[9]

On conquering Egypt in 1517, the Ottomans retained the division of the land into thirteen subprovinces that had been employed by the Mamluk sultanate. Initially, salaried officials paid by the central treasury collected taxes either in cash or grain. By the early seventeenth century, the Ottomans reorganized the collection of taxes under a system known as *iltizam* (tax-farming), with a *multazim* acting as the tax-farmer.[10] Local notables were able "to bid at auction (*muzayada*) for the right to collect the taxes of a given subprovince, district, village, or urban property or enterprise. In this fashion, virtually every significant office, from customs director to the governor of Egypt, came

to consist of a tax-farm."[11] The Ottoman Porte deemed it more expedient to sell iltizams to the highest bidders, who would in turn make upfront payments to the central government while retaining the right to extort taxes from the local populace.

Among the most valuable and prestigious iltizams were the thirteen subprovincial governorships held by officials bearing the rank of sanjak beyi or bey. Collectively known as the beylicate,[12] these men eventually "secured important administrative and military positions at all levels of the Ottoman regime in Egypt, including several key positions on the great diwan [governor's council] of Cairo itself."[13] The origins of some of these power holders was the *mamluk* system, a type of elite military slavery whereby recruits were usually purchased from the region of the Caucasus to join a local grandee's household, given military training, and eventually manumitted. Other beys, however, were Ottoman officials, Muslim converts from Bosnia, and freeborn Turks from Anatolia. The beylicate of the seventeenth century was not therefore a simple throwback to the former Mamluk regime.[14]

However, certain administrative changes in the early seventeenth century all but assured the emergence of a diverse group of local Egyptian power holders, in addition to the beys. Egypt was by far the Ottoman Empire's richest province in the seventeenth and eighteenth centuries; thus the right to collect taxes was coveted by all the local

elites.[15] As will be discussed below, the ability to collect taxes depended, to a great extent, on the expertise of Coptic bureaucrats who had traditionally served as financial agents (*mubashirs*), accountants (*muhasibs*), and scribes (*katibs*)—all key posts in the tax-collection structure. In this way, the Coptic archons who served in these jobs became intimately familiar with the factionalism and rivalry that was developing between various beys and military officers.

The iltizam system revolutionized the ways in which military officers could increase their control of tax revenues and thereby strengthen their political and military authority. By offering multazim positions to the highest bidder rather than passing it down to the beys (the traditional power holders of the sixteenth and early seventeenth centuries), jurisdiction over Egypt's lucrative rural tax-farms now fell into the hands of both beys and soldiery.[16] Ultimately, these local grandees gained control over most Egyptian affairs, while the Ottoman-appointed governors, who were rotated frequently, had limited stakes in local politics and were often confined to the walls of the Citadel of Cairo.

With the decline of Ottoman authority and a seeming power vacuum at the center of government in the seventeenth century, the Egyptian ruling classes battled for control of the province, and the beylicate split into two factions: the Fiqariyya and the Qasimiyya. The origins of this factionalism is beyond the scope of this study and has been well addressed by other scholars[17] However, it is significant to note that this rivalry affected the Egyptian social, political, military, and economic scene roughly from 1640 to 1730. This period was dominated by a series of feuds between altering coalitions of beys and regimental officers. At first, the Fiqariyya-Qasimiyya split was most apparent in the ranks of the beylicate, but the rising tide of dissent among the beys throughout the seventeenth century, in addition to the abovementioned fiscal changes, opened the door for the increased power of the Ottoman military regiments.[18] Soon the Fiqariyya-Qasimiyya clash engulfed the most powerful officer corps as well, namely the Janissaries and the 'Azaban, and culminated in the crisis of 1711, when the Fiqariyya coalition supported the Janissaries in a bloody struggle against the Qasimiyya-backed 'Azaban. The Qasimiyya-'Azaban coalition won this battle due to internal strife among its opponents, but the victorious Qasimiyya ultimately broke into smaller factions, leaving a major void in the Egyptian political scene. The Qasimiyya would reorganize themselves and annihilate the Fiqariyya in 1730.[19]

By the early eighteenth century, the center of political authority had begun to shift from the ranks of the beys to members of the Janissary corps, the wealthiest and most powerful of the Ottoman military regiments. The traditional corps leaders, the *aghas* (commanders), had by this time been effectively displaced by their lieutenants, the *katkhudas*.[20] During the late seventeenth and early eighteenth centuries, this executive position was frequently dominated by the leaders of a rising faction, the Qazdaghlis, who used this post to gain more clients and augment their household. In this period, many Janissary officers—specifically the Qazdaghlis—became wealthy mostly by asserting control over customs taxes at Egypt's Mediterranean and Red Sea ports and over the profitable coffee and spice trade.[21] However, the Ottoman Porte's introduction of the hereditary tax farm, or *malikane,* "made rural tax farms [traditionally held by beys] an even more secure source of revenue; consequently, Janissary officers intensified their efforts to obtain them."[22] Qazdaghli leaders, for example, realized that the progressively unstable coffee trade would not sustain their household's wealth and power and began to encroach upon the prerogatives of the beylicate.[23] Thus the first half of the eighteenth century is a period in which alliances were staged, broken, and redeveloped to generate ways for a number of military officers, particularly from the Janissary corps, to assert control over the beylicate and over those stable rural tax farms. Qazdaghli leaders used a combination of negotiation and intimidation, through their household's vast network of patron-client relations, to advance a number of their personal mamluks to the beylicate. By the midcentury the Qazdaghli household "that had evolved within and came to dominate the Janissary regiment infiltrated and came to dominate the beylicate."[24]

In this context, complex relations emerged between the Qazdaghli household and the Jalfi faction, which was based in the second most powerful military regiment, the 'Azab corps. The Jalfi household, a lesser "shadow" of the Janissary-based Qazdaghlis, attempted to maintain a neutral posture, often acting as mediators to the frequent tensions and conflicts that plagued the various military corps in the early to mid-eighteenth century.[25] By 1748, however, the household leader Ridwan Katkhuda al-Jalfi (d. 1756) had joined the Qazdaghli leader Ibrahim Katkhuda (d. 1754) in forming a duumvirate (1748–1754) that controlled Egypt's central government. Not only was their power rooted in the military regiments, Ibrahim al-Qazdaghli and Ridwan al-Jalfi also dominated the beylicate by promoting their personal mamluks to its ranks.[26] As Hathaway writes, "in filling the beylicate with their clients, Ibrahim [al-Qazdaghli] and Ridwan [al-Jalfi] proved themselves

the most successful, though hardly the only, regimental officers to infiltrate the beylicate. Clearly [they] had determined that the future of Egypt's military leadership lay in the beylicate."[27]

For the rest of the eighteenth century, the power of the Qazdaghli household was based in the beylicate, while the Ottoman regiments were reduced to adjunct status.[28] One of Ibrahim al-Qazdaghli's mamluks, the ruthless 'Ali Bey al-Kabir (1765–1773), "brought this Qazdaghli hegemony to its peak by killing or exiling all his rivals from competing households. In 1768 he went so far as to assert his independence from the Ottoman sultan, minting coins and having the Friday public sermon (*khutba*) in his name."[29] Some scholars regard 'Ali Bey as the founder of a neo-Mamluk beylicate[30] that was disrupted only by the French Occupation (1798–1801) and finally annihilated by Muhammad 'Ali in 1811 at the "massacre of the mamluks" within the Citadel of Cairo.[31]

For centuries, Copts had been indispensable to various local power holders in Egypt. While military factions fought over the lucrative Egyptian revenues, Coptic Christians were becoming essential to the grandees and officers because of their experience in tax collection and financial administration. Copts were valued for their longstanding experience in the financial sector and for their trustworthiness; according to Daniel Crecelius, "Having the implicit trust of their patrons, [Copts] managed the private affairs and knew the most intimate secrets of the houses they faithfully served."[32] One of the positions held by Copts, especially in the eighteenth century, was that of mubashir. The title initially referred to the clerical staff of the Ottoman financial administration.[33] Illustrative of how Copts had become well trusted by Muslim leaders, these mubashirs kept registers on revenues and expenditures in a special Arabic script that "made it incomprehensible to all but those especially initiated into the secrets of its formation and use."[34] In the era of household dominance as discussed above, Copts also served as the mubashirs for the leading military grandees, representing their patrons in business transactions and overseeing their administrative affairs. Similarly, another position in which Copts were well represented was in the *muhasiba,* or accounting department, of the Egyptian treasury, whose functions included distributing pensions to those entitled to revenues derived from the *jizya* tax imposed on non-Muslims in Egypt.[35] Additionally, Christian katibs staffed multiple parts of the Egyptian administrative structure, ranging from participating in cadastral surveys to filling various ranks of the Egyptian treasury. The Copts' extensive experience was essential in tasks such as land surveying and the annual measurement of the Nile, a practice carried out since ancient times.[36] Gradually, throughout the Ottoman period and especially by the late seventeenth century, many rose to influential posts as a result of their close connections to the military households.

Within the Coptic community, those few individuals who attained eminent positions in the political and economic power structure became respected and admired by their co-religionists, for in a sense they formed a conduit between ordinary Copts, who were for the most part marginalized from the Egyptian political system, and the center of power. Most Copts, in this period, were peasants, and some worked in specialized trades as goldsmiths and moneychangers. The most successful Copts attained the title of archon, a term, as discussed above, which has roots in ancient Greek times. Following the Islamic conquest of Egypt the word attained new importance for Copts, as it came to denote those Coptic laymen—secular leaders—whose wealth, connections, and authority were vital in supporting a Christian community that had gradually, over centuries, shifted from being the dominant cultural and demographic force in Egypt to a small minority.

In seventeenth- and eighteenth-century Ottoman Egypt, archons held important administrative posts, and they used their influence to enlist other Copts and to apprentice them into similar positions. This was a common practice in the Ottoman bureaucratic structure, on the whole, as Carter Findley has remarked with reference to the imperial scribal structure in Istanbul: "Recruitment [into the scribal system] through familial or other personal connections is a trait of both the guild tradition and the model of patrimonial household."[37] As will be discussed shortly, some archons were promoted to distinguished professional posts, which allowed them to become among the most entrusted members of the military households.

While Michael Winter argues that, in general, Jews served the households of Janissaries and Copts served individual beys, my discussion here will indicate that many Copts were employed in the households of regimental officers and only a few worked for beys.[38] The close relationship between archons and the governing establishment was evident in their domination of certain bureaucratic positions. Around the year 1704, the archon Yuhanna Abu Masri held the title of *kabir al-mubashirin* ("greatest of the mubashirs") and *ra'is al-arakhina* ("head of the archons").[39] Although our sources are unclear about the

exact meaning of these titles and are unspecific about Abu Masri's employer,[40] we know that he was a mubashir at the Egyptian *Khazina al-Amira* (Imperial Treasury), specifically within the subdivision known as the *Diwan al-Ruzname*.[41] The treasury administered the collection of taxes and stored the cash assets of the Ottoman Porte in Egypt; hence Abu Masri's position was relatively high ranking in the Egyptian financial system.[42] Until the early seventeenth century, posts within the Imperial Treasury were held by representatives sent by the Ottoman sultan. However, as major political changes swept Egypt in the seventeenth and eighteenth centuries, the Egyptian regimental officers and beys attained the right to appoint their own loyal recruits, many of whom were Copts, to those positions.[43]

Jirjis Abu Mansur al-Tukhi (d. 1718), who followed Abu Masri as the leading archon, held another influential position as *ra'is al-kuttab* (chief scribe).[44] He was in the service of Murad Katkhuda Mustahfazan, the top Janissary officer in Egypt, so he was likely chief scribe in Murad Katkhuda's household. Jirjis Abu Mansur's successor, the archon Lutfallah Abu Yusuf (d. 1720), was a mubashir for another leading Janissary officer, Muhammad Katkhuda Mustahfazan.[45] At the same time, an archon named Mercurius Ibrahim al-Fayyumi worked as mubashir for 'Uthman Bey Dhu'l-Fiqar, a member of the beylicate and the *amir al-hajj* (leader of the pilgrimage to Mecca), an enormously influential position in Ottoman Egypt.[46] In our present survey, Mercurius appears to be the only archon who worked for a bey; as noted above, this point contradicts Michael Winter's assertion that Copts primarily worked for beys. While little is known about Mercurius al-Fayyumi, his patron was one of the most influential political and military leaders in Egypt.[47] 'Uthman Bey, a rival of the Qazdaghlis for power, was defeated in 1743, driven out of Egypt, and lived out the remainder of his life in Istanbul, where he died in 1776.[48]

Another archon, Jirjis Abu Yusuf al-Suruji (d. 1737), who later assumed the post of leading archon, was a mubashir for 'Uthman Katkhuda al-Qazdaghli (d. 1736), the head of the Qazdaghli faction within the Janissary corps. 'Uthman Katkhuda took control of the Qazdaghlis in 1716, and under his jurisdiction the faction became the most powerful household in Egypt and a rival of the beylicate for control of lucrative rural tax farms.[49] Jirjis' brother Yuhanna Yusuf al-Suruji was also a mubashir for 'Uthman Katkhuda and then for 'Abd al-Rahman Katkhuda al-Qazdaghli (d. 1776). Yuhanna's boss, 'Abd al-Rahman, who had inherited the fortunes of the aforementioned 'Uthman

Katkhuda, was one of the most powerful grandees in the mid-eighteenth century.[50] He eschewed direct involvement in politics, however, preferring to devote his enormous wealth to building and repairing pious Muslim foundations throughout Cairo.[51] Following Jirjis al-Suruji, the subsequent leading archon and head of the Coptic community was Nayruz Abu Nawwar Ghattas (d. 1759). From 1730 to 1737 he served as a mubashir for 'Ali Katkhuda al-Jalfi (d. 1739),[52] and then he was employed by the influential Ridwan Katkhuda al-Jalfi until 1740.[53] As discussed above, the Jalfi household dominated the 'Azab regiment at the same time that the Qazdaghlis were running the Janissary corps. Perhaps his proximity to such leading political figures made Nayruz the ideal advocate for his community during a crisis in 1734, when many impoverished Copts were arrested for failing to pay the *jawali* taxes.[54]

The employment patterns of famous Coptic archons in the mid- to late eighteenth centuries illustrate their continual influence within their community and in Egyptian society: al-mu'allim Rizqallah al-Badawi (d. 1770) was the mubashir of the Diwan al-Ruzname, and most importantly the direct advisor to 'Ali Bey al-Kabir, the powerful Qazdaghli ruler of Egypt during this period. Aside from his administrative duties, Rizqallah al-Badawi reportedly served as 'Ali Bey's astrologer and as his personal confidant. His closeness to 'Ali Bey was disdained by grandees who felt humiliated not only because they were forced to exalt a Copt but were also obliged to give Rizqallah a gift before making any requests.[55] When Rizqallah died, his successor and protégé, Ibrahim al-Jawhari (d. 1795), became the leader of the archons. Ibrahim learned the scribal profession through his work in the service of a local grandee and then for two Coptic patriarchs, Mark VII (1745–1769) and John XVIII (1769–1796).[56] His preeminence came after the fall of his predecessor Rizqallah al-Badawi and the eventual ascendancy of the Qazdaghli duumvirs Ibrahim Bey (d. 1816) and Murad Bey (d. 1801), the mamluks of 'Ali Bey and the future opponents of Bonaparte. Al-Jawhari was particularly favored by Ibrahim Bey, who made him mubashir—manager and administrator—of his properties and finances. According to Harold Motzki, al-Jawhari was "the de facto chief of the supreme revenue office in Ottoman Egypt. He was also the director of the corporation of tax collectors and state scribes, who administered the finances of the whole country."[57] Ibrahim al-Jawhari was known, among Muslims and Copts, for his generosity. Moreover, he helped restore and renovate numerous Coptic churches and monasteries and also patronized the copying of manuscripts.[58] Upon

Ibrahim's death, his brother, Jirjis (d. 1810), continued this philanthropic tradition and financed the completion of a new patriarchal headquarters in the Azbakiyya district of Cairo. Jirjis al-Jawhari also retained his administrative posts during the short-lived French occupation of Egypt and then briefly in the service of Muhammad ʿAli (1805–1848), although his influence under the latter waned considerably and he died in relative dishonor.[59] Today, in the Coptic Church, Ibrahim and his brother Jirjis are considered to be saints.[60]

From this discussion we can discern how archons became wealthy and influential servants of Egypt's local military elites for well over a century, from the late seventeenth to the early nineteenth century. The archons' ascent occurred, in part, as they became literally and figuratively closer to the center of power and could be considered part of the "entourages" of influential households.[61] The intimate bonds that formed between the elite patrons and the archons may have extended beyond professional relations. It appears that some archons may have attempted to and were fairly successful in emulating the lifestyles of their patrons. For instance, there are allusions from various Coptic Church histories that throughout the Ottoman era, archons may have practiced polygamy, much as their Muslim counterparts did. Moreover, Coptic archons were benefactors of numerous building projects and patrons of a major artistic and literary revival. Thus it is not farfetched

to imagine that a successful archon likely controlled his own "entourage of slaves, domestic servants, bodyguards, and assorted clients who collected at his place of residence," much as did his Muslim benefactor. A glimpse of this possibility can be discerned from the Egyptian chronicler al-Jabarti's eulogy of Jirjis al-Jawhari. Al-Jabarti wrote that Jirjis built a lavish residence in Cairo that was later occupied by the Egyptian ruler Muhammad ʿAli, and adds that outside Jirjis' personal residence stood a group of "guards and servants."[62]

In the early part of the eighteenth century, several high-ranking military officers and grandees began to construct extravagant homes in elite neighborhoods of the Egyptian capital, such as the southern shore of Birkat (Pond) al-Azbakiyya on the western outskirts of Cairo. By midcentury, the area was dominated by the houses of the Qazdaghlis and their allies.[63] ʿUthman Katkhuda al-Qazdaghli, for example, constructed a residential complex containing a mosque, a public bath, a *sabil-kuttab* (water fountain and school), stables, and a number of shops overlooking what is today Opera Square. Only the mosque, completed in 1734, still stands in this once elite neighborhood.[64] At the end of the century, "the houses of the leading Qazdaghli grandees had displaced the governor's council in the citadel as loci of political power."[65] Historically, the northern shore of the Azbakiyya (al-Maqs) was a more humble neighborhood dominated by Copts. But in

the second half of the eighteenth century, notable Coptic archons would also build residences in this area, arguably to be closer to the households of their influential patrons (fig. 3.3). Doris Behrens-Abouseif pointed out that the Jawhari brothers alone, by the end of the eighteenth century, owned 167 properties—mostly houses and shops—in the posh Azbakiyya neighborhood.[66]

Patriarchs, Archons, and Communal Revival

In Chapter 2 of this volume, Mark Swanson shows that John XVI's restoration of the Monastery of St. Paul was one of numerous architectural projects undertaken by the patriarch and the leading archons in the late seventeenth and early eighteenth centuries. Their efforts appear to have inspired similar future projects in the Coptic community. This building activity was made possible due to the economic vibrancy experienced by Coptic laymen through their ties to military households in Egypt.[67] Despite a tumultuous political scene in eighteenth-century Egypt and the precarious economic changes, Coptic archons in Cairo appear to have been consistently generous in their contributions and in supporting various cultural projects. Many of these projects, whether in the architectural, literary, or artistic fields, were initiated by archons rather than by patriarchs. For example, in 1732 Jirjis Abu Yusuf al-Suruji instigated and financed the construction of the Church of St. Michael the Archangel and St. John the Baptist at the Monastery of St. Paul, albeit with the full blessing of John XVII.[68] These endeavors were costly, time consuming, and at times daring. Yet the commitment on the part of the archons is consistent with trends established since the seventeenth century, when most of the significant functions of the clerical leaders, including the election of a Coptic patriarch, as well as the payment of the *jizya* tax, had been taken over by influential laymen. The archons controlled nearly every facet affecting community life, which forced the Coptic patriarchs to become both dependent upon and weary of these powerful laymen.[69]

In the period under study we witness the continuing influence of archons over the choice of Coptic patriarchs, a role that they had habitually adopted since the seventeenth century. John XVI was selected by a group of archons who journeyed to the Monastery of St. Anthony, seeking a leader from among the monks.[70] Jirjis Abu Mansur al-Tukhi appears to have traveled to the monastery with an idea about the likely candidate. The next patriarch, Peter VI (1718–1726), was directly selected by the top archon Lutfallah Abu Yusuf, whereby the monk-turned-patriarch was

"kidnapped" from the Monastery of St. Paul, brought to Cairo in chains, and consecrated at the Church St. Mercurius. Similarly, John XVII (1726–1745) and Mark VII (1745–1769) appear to have been preselected by the archons, as they too were both taken from the Monastery of St. Paul and named patriarchs without the formality of a search committee.[71] The "taking" of monks from their monasteries was part of a ritual that dates to at least late antiquity, a ritual intended to highlight the unassuming nature of the patriarch-elect.[72]

The process by which these patriarchs were selected is illustrative of the relations that existed between patriarchs and archons during this period. Without a doubt, the ties between archons and patriarchs, and between various archons, would mold the Coptic revival in the late seventeenth and early eighteenth centuries. Within this context, kinship and geographic ties influenced the nature of their relationship. For instance, the town of Tukh al-Nasara in the Delta province of Minufiyya appears to have served as a nucleus for the rise of influential families and networks, from whose ranks would emerge influential lay and clerical leaders. It is perhaps no coincidence that patriarchs Matthew III (1634–1649), Matthew IV (1660–1675), and John XVI, as well as the archons Dawud al-Tukhi and his prominent nephew Jirjis Abu Mansur al-Tukhi, were all from this town and that their families were likely associated through friendship and marriage. Much as officers and grandees used intermarriage to form new alliances between military households, the leading archons adopted a similar strategy intended to solidify ties among their families and also to foster ties with patriarchal families. Two known examples pinpoint this tendency: The great archon Lutfallah Abu Yusuf was married to John XVI's niece, hinting at his close interference in selecting John XVI's successor, Peter VI.[73] Muʿallim Lutfallah's sister later married an archon by the name of al-muʿallim Jirjis Abu Shihata.[74] In fact, Abu Shihata most likely strategized this marriage arrangement in hopes of paying off his enormous debts.

As William Lyster writes in Chapter 11, the ties between the archons and the patriarchs are perhaps most evident in the figure of Patriarch John XVI. Lyster notes that, as a layman, John XVI was "an archon in the making." Ibrahim al-Tukhi, as he was known before he was consecrated, abandoned a lucrative career as a tax farmer, instead choosing a life of seclusion in the Monastery of St. Anthony.[75] Ibrahim's former ties to wealthy archon families in Cairo possibly led to his selection as patriarch, most likely by Jirjis Abu Mansur al-Tukhi; thus John XVI's Tukhi

origins may have also facilitated his upward mobility. The situation of mutual interdependence between patriarchs and archons became more visible when John XVI "proved particularly adept at using the wealth and influence of the archons for the benefit of the Coptic community. He placed the supervision of churches in their hands...[and the] archons not only had the resources to ensure the success of their building projects, but also the political clout to deflect governmental opposition."[76] Hence we see how in the early part of his reign, John XVI solidified his ties with the archon community by transferring the role of "supervisors for the churches" (nazirs)[77] from the hands of the artisan community to the archons.[78] John XVI paid special attention to the office of nazir, ensuring that supervision of monastic and church holdings was well-managed and maintained. This strategy appears to have inaugurated the revival of church building in the Coptic community, as the patriarch delegated the management of these large-scale projects to the wealthy and influential ranks of the archons. On the one hand, as a previously rising Coptic official, the patriarch fully appreciated the scope of archon power in this period and thus solicited their influence and resources to launch the revival. On the other hand, John XVI may have been selected by the archon leaders, who recognized that under this patriarch's tenure they could (and would) be successful at consolidating their authority over the Coptic community, in part through their patronage of a communal revival.

The reign of John XVI inaugurated the revival of Coptic building activity but was also indicative of the extent to which these projects could take place throughout the eighteenth century. Indeed, the renovation of numerous churches would enrage some Muslim leaders, and under John XVI they wrought the ire of the Ottoman governor Kara Muhammad Pasha (1699–1704), who attempted to bring an end to the Coptic resurgence. However, due to their positions of influence, the Coptic archons, "who were undertaking the service of the great of Egypt," were able to pursue their projects despite the governor's opposition.[79] In general, Christians and Jews living under Islamic law were legally forbidden from constructing or rebuilding their houses of worship, although many scholars argue that the traditional laws prohibiting the restoration or building of churches, as well as restricting the ringing of church bells, ritual processions, and the display of crosses, banners, and icons, were, in general, inconsistently applied.[80] The Ottoman period appears to have been one of modest recovery for the Copts, and despite general restrictions, community leaders were able to spearhead numerous building projects throughout the eighteenth century. As will be discussed shortly, Coptic leaders were regularly able to attain firmans (imperial decrees) in order to carry out their projects. Moreover, Islamic restrictions against public processions were habitually, and sometimes successfully, challenged by Copts. Winter argued that Coptic willingness to oppose authority is due to the fact that Copts were more numerous and powerful than any other non-Muslim group in Egypt. He also remarked that "a recurrent accusation against the Christians in official [Ottoman and Egyptian] documents was that they dared to flaunt their religion and its symbols, drinking wine, sounding the wooden clappers loudly as a call to prayer and so forth, allegations that were never made against the Jews."[81] This boldness of Coptic leaders is most visible during the reign of John XVI. In the year 1678, John XVI renovated the patriarchal residence, which he dedicated to the Glorious Resurrection, in the Cairene neighborhood of Harit al-Rum.[82] For several years, as the History of the Patriarchs reported, John XVI "consecrated a number of churches in Cairo and the rif [rural areas], after their repair, and, also, he consecrated metropolitans and bishops and priests and deacons."[83] In 1705, the patriarch consecrated the newly renovated Monastery of St. Paul, following the departure of the aforementioned Ottoman governor, Kara Muhammad Pasha, who had been antagonistic toward the Coptic community.

We can see during this period the patriarch's increasing dependence on the archons in leading major communal affairs. For instance, acting in his capacity as nazir, in the year 1689 the archon Lutfallah Abu Yusuf traveled to Istanbul to present the Ottoman sultan with lavish gifts and to ask that the money generated from the patriarchate's waqf would be exempt from taxation, a request which was allegedly granted.[84] The archon, Jirjis Abu Mansur al-Tukhi, took special care of the new patriarchal headquarters. When Jirjis Abu Mansur's only son died, he moved his residence to Harit al-Rum so that he could live in proximity to the Church of the Virgin Mary, for which he had been appointed nazir. He also restored the Church of St. George (the Upper Church) at Harit al-Rum, and when John XVI saw his talent for management, he appointed him the nazir for the Church of the Virgin in Old Cairo, know as al-Mu'allaqa, which he also renovated, including the refurbishment of its library.[85] Moreover, Jirjis was a well-known philanthropist. It is reported that each Sunday, after prayers ended, he welcomed the congregants and the poor for a meal at his home, and on feast days he would hold great celebrations for the Christian masses.

The collaboration between John XVI and Coptic archons was visible not only in the restoration of buildings but also in the revival of vital rituals in the Coptic community, and in particular the resumption of the pilgrimage to Jerusalem. Available documents do not allow us to track the timetable of Coptic pilgrimage to Jerusalem, so we are uncertain as to the date of the last pilgrimage prior to the early eighteenth century.[86] But we do know that Jirjis Abu Mansur initiated a pilgrimage in 1709.[87] On Christmas Eve of the previous year, he informed the patriarch of his intent to make the pilgrimage. Jirjis Abu Mansur sent detailed instructions to the patriarch, asking him to write letters to all Coptic bishops, informing them of the trip and asking the community for contributions. Shortly thereafter, community leaders were mobilized: a number of archons volunteered to offer their expertise and financial help in making the preparations. According to the manuscripts, the archon Karamallah Abu Fulayfil had learned from past pilgrimages which provisions needed to be gathered, and the archon Lutfallah Abu Yusuf devised plans for the journey. Moreover, Lutfallah Abu Yusuf volunteered to gather supplies for the trip, specifically to furnish the liturgical instruments used for the ceremonial blessing of the Church of the Holy Sepulchre. In a gesture illustrating the relatively positive relations between Coptic archons and local leaders, Lutfallah Abu Yusuf also obtained a firman from the Ottoman governor of Egypt, Husayn Pasha (1707–1710), an order that ensured the safety of the patriarch and the caravan. But in acknowledging the true power holders in Egypt, he also secured letters from various regimental officers and beys in Cairo, which were addressed to the custodians of different fortresses along the road, as well as to bedouin leaders.[88] It took Lutfallah Abu Yusuf nearly two and a half months to gather all of the necessary provisions, and ultimately, as described in MS Liturgy 128, this was a very successful pilgrimage.[89]

We observe that a similar procedure was followed earlier, in 1703, for the preparation of the holy mayrun, the oil used in anointing and in ceremonies of consecration in the Coptic Church.[90] As also revealed in the same manuscript in the Coptic Museum, Jirjis Abu Mansur al-Tukhi led the revival of this long forgotten and costly ritual, which had not been carried out since 1461. It was performed by Coptic notables, with the reported presence of Muslim leaders; the patriarch consecrated this mixture of spices, oil, and perfumes at the patriarchal headquarters in Harit al-Rum.[91]

Ultimately, the close collaboration between the patriarch and the leading archons of his day can be seen in their commemoration in the foundation inscription in the

Cave Church at the Monastery of St. Paul, which records the names of John XVI, Jirjis Abu Mansur al-Tukhi, and Lutfallah Abu Yusuf.[92] The affiliation between John XVI and Jirjis Abu Mansur was durable and prolific, and, in that regard, their likely death from the plague in 1718 is a poignant ending to their partnership. In effect, the rebuilding of the patriarchal headquarters in Cairo and the revival of the Monastery of St. Paul as led by John XVI and several Coptic archons, as well as the reinstitution of integral church rituals, appear to have become a model for revitalization projects of later Coptic patriarchs and notables.

The subsequent patriarch Peter VI (1718–1726), originally named Murjan, had been a monk at the Monastery of St. Paul, along with his successor John XVII. As discussed above, the patriarch-elect was brought to Cairo in the traditional chains under the orders of the Cairene archons. During his reign Peter VI faced some external challenges, namely from the Catholic missionary movement.[93] However, in dealing with a perceived rise in moral laxity within the Coptic community, perhaps as motivated by the Catholic presence, the patriarch was able to solicit the support of Muslim leaders in attaining a firman on his right to enforce Coptic laws on marriage and divorce.[94] During Peter VI's reign, moreover, the archon Lutfallah Abu Yusuf funded numerous renovation projects, including the rebuilding of the Church of St. Michael the Archangel in southern Cairo, known today as al-Malak a-Qibli, and the Church of St. Menas in Cairo. The latter church was in desperate need of repair, and the *History of the Patriarchs* indicated that before the renovation "they were not able to enter through the door of the choir in the daytime, except with a taper and he [Lutfallah] (re)constructed it and (re)built it as a great light church, and he built in it cells for the poor and others."[95] He also financed the restoration of the Church of St. Menas at Fumm al-Khalij, Cairo.[96] Allegedly, Lutfallah's considerable undertakings and influence within the community led to his murder by envious foes in the year 1720.[97] Al-mu'allim Mercurius Ibrahim al-Fayyumi, mentioned above as a client of 'Uthman Bey Dhu'l-Fiqar, renovated the Church of the Virgin in 'Adawiyya, south of Cairo, along with its neighboring monastery, and was made nazir over that church during this same period.[98]

The reign of John XVII (1726–1745), formerly the monk 'Abd al-Sayyid al-Mallawani recruited from the Monastery of St. Paul, was long, eventful, and at times quite tense. Early in his reign, on Easter eve in 1728, a fire broke out at the recently renovated Church of the Virgin in Harit al-Rum at the Patriarchal Headquarters, and an investiga-

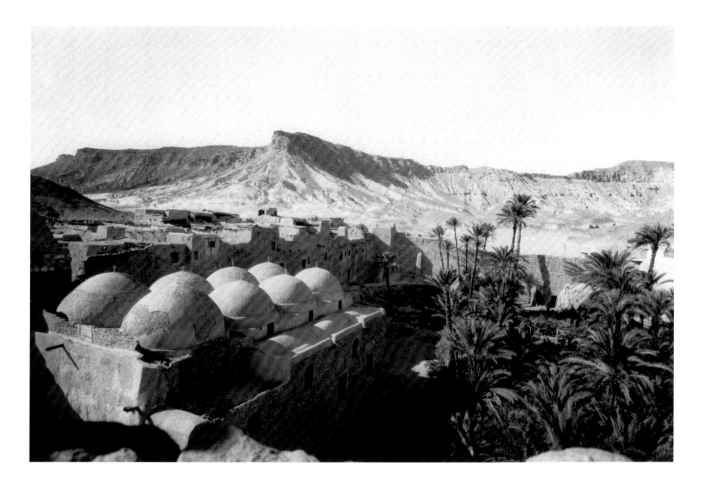

FIGURE 3.4

Church of St. Michael the
Archangel and St. John the Baptist,
1931. Whittemore expedition, B100.
Courtesy of Dumbarton Oaks,
Washington, D.C.

tion by the Ottoman governor and his soldiers revealed
that most of the church was burned and looted.[99] Such in-
cidents indicate popular discontent with the Coptic revival
during this period. Yet, Coptic notables continued their
building projects. In particular, Jirjis Abu Yusuf al-Suruji,
the successor of Lutfallah Abu Yusuf as the leading archon,
spent a great deal of his personal funds restoring churches
and monasteries. In 1732, he sponsored the construction
of the Church of St. Michael the Archangel and St. John
the Baptist, at the Monastery of St. Paul with the full bless-
ings of the patriarch. The foundation inscription on the
central haykal screen of the new church commemorated
the close relationship between John XVII, Jirjis Abu Yusuf
al-Suruji, and the late mu'allim Lutfallah (fig. 3.4; see fig.
2.9). Jirjis al-Suruji's generosity was often compared with
that of his predecessor to the extent that this inscription
refers to him as "al-mu'allim Jirjis Yusuf [who is] known as
the deceased mu'allim Lutfallah." Jirjis' brother, Yuhanna
al-Suruji, was equally benevolent. Having benefited from
his patron 'Uthman Katkhuda's authority and prestige, Yu-
hanna was a prominent archon and was appointed nazir
over the Monastery of St. Anthony.[100] Nayruz Abu Nawwar
Ghattas led the Coptic community after the death of Jirjis
al-Suruji in 1737. He was also a nazir over several Coptic

churches and monasteries that he spent a great deal of his
personal income on maintaining.[101]

In 1734, a Coptic protest took place against the ex-
cesses of new imperial taxes that again emphasized the
important role played by the archons during the reign
of John XVII. Their interference ultimately saved the
most vulnerable members of the community from severe
hardship. Winter notes that "in [AH] 1147/1734 an impe-
rial decree arrived from Istanbul concerning the poll
tax....The new taxes were so much higher that some 1,000
Christians demonstrated in protest. When the procession
reached the Rumayla Square, it was attacked by soldiers
who beat the Christians, killing two of them; the others
dispersed" (fig. 3.5).[102] As indicated above, due to wide-
spread famine and crop failure, many Copts had failed to
meet the new taxes. They were saved through the interven-
tion of Coptic archons, including Nayruz Abu Nawwar,
Rizqallah al-Badawi, Banub al-Ziftawi, and others.[103]
Nayruz Abu Nawwar likely utilized his connections to the
Jalfi military household to intervene on behalf of those af-
fected by the harsh provisions.

However, despite their influence with the leading fig-
ures in Egyptian political and military circles, Copts still
faced obstacles in executing renovation projects. In 1739 a

venerable Muslim religious leader, Shaykh al-Damanhuri, was prompted to write a treatise on the legality of Christians building new churches. He wrote his text as a result of a "query addressed to [him] by an ingenious notable for a statement on the legal status of the churches in Old and New Cairo.... The reason for the query on this subject was that, in the Muslim year 1151 [1738/1739], the dhimmis began the construction of a church in Cairo, in the neighborhood of Hin Street, causing a great agitation among Muslims." Al-Damanhuri explains that "I learned of the rise of this deplorable affair, and that in this community no longer is the prophetic injunction heeded to deter the infidels, the enemies of the faith, from their goal."[104] In eighteenth-century Ottoman Egypt, and despite numerous successes, Copts could still be held liable under strict interpretations of Islamic law.

The reign of Mark VII (1745–1768), the last of the St. Paul patriarchs, illustrates even more vividly the increasing power of Coptic archons over the patriarchs, on the one hand, and their occasionally precarious relationship to Muslim religious and military authorities, on the other. In 1751, as recounted by al-Jabarti, an attempt at organizing a pilgrimage to Jerusalem took place.[105] The renowned community leader Nayruz Abu Nawwar undertook this organizational challenge. Nayruz approached the Shaykh of

al-Azhar, ʿAbdallah al-Shubrawi, informing him of the intended pilgrimage and giving him a gift of 1000 dinars. The Shaykh granted him a *fatwa* declaring that the Copts were not to be hindered from making their pilgrimage. When it came time for the trip, the Copts formed a great procession and marched with their women and children through town. However, as news of this commotion spread to Muslim religious leaders, al-Shubrawi was confronted by other religious leaders who implicated him and warned of how the populace would react to the idea of a Christian pilgrimage procession imitating the Muslim *hajj* caravan. Subsequently, al-Shubrawi announced to the public that they were free to loot the caravan. Thus the people in neighborhoods near al-Azhar mosque gathered around the Copts, stoned them, beat them with sticks and whips, stole their belongings, and even plundered a nearby church.

This failed undertaking illustrates not only the influence of archons in that they were able to acquire a fatwa for making the pilgrimage, but it also reveals the limits of their ability to protect the interests of the Coptic community when the situation turned dire. Perhaps the pilgrimage fiasco of 1751 encouraged Mark VII to exert greater patriarchal control at the expense of these powerful Coptic laymen. The *History of the Patriarchs* makes a cursory but equally significant observation about the tensions over communal

FIGURE 3.5

Citadel of Cairo and Rumayla Square from the west, ca. 1799. The Bab al-ʿAzab, the large gate on the center left, was the headquarters of the ʿAzab regiment in the Citadel. Bibliothèque Nationale de France, Paris.

leadership between Patriarch Mark VII and the archons, in a tone that perhaps recalls the more tranquil patriarchate of John XVI. We are told that "the father, the mentioned deceased patriarch [d. 1768], endured in these days intimidations, the number of which is not to be counted; sometimes from behind and sometimes from perverse disloyal people, and if we were to explain to you, the explanation would be drawn out."[106] Between 1759 and 1770, and following the headship of al-muʿallim Nayruz Abu Nawwar, the leader of the archons was the enormously influential Muʿallim Rizqallah al-Badawi. Little is known about the relationship between Mark VII and Rizqallah, but one could envision scenarios that may have led to tensions between the two men. As discussed above, Rizqallah was one of the closest advisors to ʿAli Bey al-Kabir, the effective ruler of Egypt from 1755 to 1773. Rizqallah's influence in Egyptian society likely reflects his eminence within the Coptic community, whereby he may have emerged as the true leader of the church. This possibly led to increased tensions between Rizqallah and the patriarch over the right to rule the church and community, tensions that may have been brewing between patriarchs and archons for decades. Other conflicts that could have negatively affected the patriarch's reign may have stemmed from new Coptic converts to Catholicism. Throughout the eighteenth century, several Coptic clergy (possibly up to thirty-eight) had secretly professed their allegiance to the Catholic faith but continued to serve their Coptic Orthodox congregations, and this likely undermined the patriarch's role in the community and resulted in internal hostilities and confrontations.[107]

The history of lay-clerical relations within the Coptic community has yet to be fully studied due to the paucity of sources. But we can discern that internal communal conflicts, whether between patriarchs and Coptic secular leaders, or between various clergymen, were not new phenomena in the eighteenth century. Indeed, some of the developments taking place by the mid-eighteenth century, as highlighted in the reign of Mark VII, reflect a trend whereby Coptic patriarchs attempted to reassert control over the community. By the mid-eighteenth century it was clear that patriarchs needed and depended upon the archons to retain their position and to spearhead a communal recovery. These laymen controlled nearly every facet affecting community life, be it social, cultural, or religious.

Even the priests bowed down to the demands of the powerful archons, a reality that one patriarch could not change: Patriarch Mark VIII (1796–1809), out of anger against the ongoing practice among Coptic archons of allowing their daughters to marry non-Coptic Christians, directed the blame upon those priests who conducted the wedding ceremonies rather than at the "culprits" who initiated the habits.[108]

An example from the seventeenth century suggests the ways that personal and legal matters, specifically the issue of polygamy, became a site for contention between patriarchs and laymen in the early modern period. According to an anecdote recounted by the historian Mansi Yuhanna, during the reign of Patriarch Mark V (1602–1618), Copts in the Delta region caused some communal friction by proclaiming their right to freely practice polygamy.[109] Indeed, during this dispute, the bishop of Damietta sided with the rebellious Copts and declared that polygamy was not against biblical teachings. As a consequence, Mark V wrote a declaration forbidding polygamy and excommunicating the bishop. A group of influential Copts, supporters of the bishop, disagreed with the patriarch's decision and allegedly conspired against him. They complained to the Ottoman governor of Egypt, who ordered the patriarch to be beaten until he was near death, and then had him imprisoned in the Tower of Alexandria. The bishop of Damietta and his supporters then convinced another monk to become the standing patriarch, and he announced that Copts could practice both divorce and polygamy. After a short time, the Copts of Cairo and Upper Egypt rebelled and convinced the Ottoman governor to return Mark V to his place. The pro-polygamy faction fought hard, but their patriarch finally abandoned his post. As discussed above, in another incident, Peter VI (1718–1726) successfully obtained permission to enforce Christian laws regarding marriage and divorce, presumably in retaliation against lay supremacy. Rising tensions between laymen and clergy are consistent with the trends established since the seventeenth century, when most of the significant clerical roles had been taken over by influential laymen. Lay-clerical tensions over control of Coptic communal life continued well into the nineteenth century, when the clergy began to make an active effort at "modernizing" the community and reforming seemingly outdated and corrupt practices.[110]

Conclusion

It appears that the archons well understood the numerous challenges that needed to be addressed before they attempted to proceed with communal projects, and with consolidating their control over the Coptic community. They were fully aware that the success of building churches or making pilgrimages depended in large part on an agreement between the Coptic and the Muslim authorities. The frequent negotiation and cooperation that we witnessed in the eighteenth century is in itself a surprising revelation in a society that was structured by laws specifically intended to curtail the public worship of Christian and Jewish minorities. Enterprising Coptic archons could not have advanced their endeavors without their ties to local military grandees in Egypt, and they usually sought the most effective Muslim patrons to aid them in their cause. Occasionally the Copts' vulnerability as non-Muslims was exemplified, as with the case of the pilgrimage of 1751, by a breakdown in the arrangement with their patrons.

More important, perhaps, the Coptic community was experiencing a shift in its leadership structure, one that paralleled the vibrant communal revival. By the mid-eighteenth century, patriarchs had become exceedingly dependent on the archons, who were well respected by the broader Coptic and Muslim community. From our discussion above we can see how patriarchs were often tested, time and again, when attempting to impose their rules on such powerful individuals. Although archons made positive contributions on the cultural and political scene, many of their personal habits would be viewed with disdain by religious leaders, who could not, out of fear and trepidation, directly criticize this behavior. Incidentally, and as I have noted in a different context, the late eighteenth century would become an era of retribution by Coptic patriarchs and bishops against the perceived influence of the lay community.[111] While they supported the archons' communal philanthropy—their restoration of churches and monasteries, and their sponsorship of artistic and cultural projects—later clergymen would find new means for couching their criticisms: preaching sermons that accused the lay community of moral corruption and laxity.

Views of the Convents of S.^t *Paul and* S.^t *Antony.*
To the Right Rev.^d Father in God NICHOLAS *Lord*
Bishop of EXETER.

CHAPTER 4

PILGRIMS, MISSIONARIES, AND SCHOLARS

WESTERN DESCRIPTIONS OF THE MONASTERY OF ST. PAUL

FROM THE LATE FOURTEENTH CENTURY TO THE EARLY TWENTIETH

CENTURY

In the late Middle Ages and the early modern period the Monastery of St. Paul was comparatively neglected by western travelers.[1] Regarded as a remote appendage of the Monastery of St. Antony, it seldom shared the attraction of the older and larger foundation. By the time Europeans had embarked on their long hunt for Coptic and Coptic-Arabic manuscripts in the seventeenth century, St. Paul's had long been abandoned. It consequently lacked the library which drew collectors to St. Antony's and the monasteries of the Wadi al-Natrun. Nevertheless, because of its connection with St. Antony's, and the legendary friendship between Antony and Paul so evocatively recounted by Jerome, it sometimes benefited from the glory of the larger monastery, while its spectacular setting would, in due course, become a goal in itself (fig. 4.1).[2]

The statements of those few travelers who recorded their visit to St. Paul's have been amply exploited by modern scholars. For anyone trying to reconstruct the history, as well as the appearance, of the monastery, they provide invaluable pieces in an intricate puzzle. But the reports and the visitors themselves also reflect various stages in European relations with Egypt. They illustrate the growing European acquaintance with the Coptic community and changing perceptions of the Copts, as well as the shifts in missionary policy, the quest for manuscripts and antiquities, and the scientific exploration of the country.

Prosperity to Destitution

One of the first medieval travelers to leave an account of the Monastery of St. Paul was Ogier d'Anglure from Champagne, who passed through Egypt on his way to the Holy Land in 1395. Like most of his contemporaries, he was stimulated to visit the monasteries on the Red Sea coast by what he knew of the lives of Antony and Paul. He was fascinated by the legend of the raven who provided them with bread and of the lions who helped to dig Paul's grave, and he introduced an element popular in late medieval iconography of St. Antony—the pig, which he describes as Antony's guide in his quest for Paul.[3] But while many medieval pilgrims regarded the Copts simply as guardians of the holy places, worthy of no more than a cursory glance, Ogier showed a greater interest in them. They were, he wrote, "Jacobite Christians," who were first circumcised and then baptized. They crossed themselves with the index finger of their right hand. Their liturgical rites differed from those in the West but resembled those of the "Christians of the land of Prester John."[4]

Such was the view of the Egyptian members of the Church of Alexandria at the time.[5] The term "Copt" was hardly ever used. It really started to gain currency only in the mid-sixteenth century, and even then did so slowly. "Jacobite," on the other hand, was used widely. This led to a certain confusion, since no distinction was made between the Egyptian members of the Church of Alexandria, the Ethiopian members of the same church, and the Syrian members of the Church of Antioch who rejected the Council of Chalcedon. The legend of Prester John, which emerged from one of the great literary hoaxes of the twelfth century, a letter supposedly addressed by a mysterious eastern potentate to the Byzantine emperor, made the issue still more complicated. The fictitious author, Prester John, who vaunted his power and his riches as well as his Christianity, claimed to be the ruler of the "three Indias." These were what is now the subcontinent of India, the East Indies, and

Ethiopia. On contemporary maps, however, Ethiopia was represented as stretching eastward from Africa, parallel to Mesopotamia and Persia. The land of Prester John was thus situated in the East rather than in the South, and even after cartographers had allowed Ethiopia to drop south into eastern Africa in the course of the fourteenth century, an association with India persisted, and the origins of the Copts were frequently sought in Asia.[6]

Despite the obvious differences between the Copts and the Christians of the West, Ogier d'Anglure was charmed by his reception at St. Paul's, where he proceeded after staying at St. Antony's, arriving on December 3. The monastery, he wrote, contained over sixty monks, and they welcomed him and his companions, getting up at midnight to let them in and providing them with an excellent hot meal. He admired "the fine walls, high and thick" and liked the "beautiful little chapel."[7] Of the medieval pilgrims Ogier provided by far the most detailed description of the monastery. The Burgundian diplomat and soldier Ghillebert de Lannoy, who also called on the monastery of St. Paul in 1422, was far more cursory, referring simply to the site of the building at the foot of the mountains, the spring issuing from the rock, its fortified appearance, its subjection to St. Antony's, and its garden of palm trees.[8]

More than two hundred years elapsed before another visitor from the West described the Monastery of St. Paul. By this time not only had the monastery been abandoned since the late sixteenth century, but European attitudes to the Copts had undergone deep changes. At the Council of Florence, held between 1438 and 1445, the papacy had endeavored to bring all the eastern Christian churches into communion with Rome. These included the Copts, who were represented by a small delegation led by the prior of the Monastery of St. Antony. The agreement reached by the eastern churches with Rome, however, was never ratified—in the eighteenth century Edward Gibbon would describe the eastern delegates as "unknown in the countries which they presumed to represent"—and the result was the gradual organization of a missionary movement whose members would pursue the delegates and their successors in a quest that would extend over the centuries.[9]

The first true mission to the Copts was composed of Jesuits, who set off in 1561.[10] Although the mission never achieved its purpose, it marked the beginning of a western interest in the Church of Alexandria, and the publication of the missionaries' reports, which appeared in the early years of the seventeenth century, served to familiarize Europeans with Egyptian Christianity. In 1622 Pope Gregory XV founded the *Congregatio de Propaganda Fide*, which would remain the principal coordinator of the Roman missionaries. In the seventeenth century, however, Egypt was no longer as interesting to the missionaries as it had once been. Ethiopia was considered of far greater importance. It was reportedly sympathetic to Catholicism—the emperors had been converted by the Jesuits in 1603 and 1620—but at the same time it was difficult and dangerous to reach, and its inhabitants held mysterious beliefs which the Europeans, Protestants as well as Catholics, were eager to explore. As a result, many of the missions stopped only briefly in Egypt on their way south, but they availed themselves of their stay to try to convert the Copts.[11]

By the late 1630s, moreover, there was a growing western interest in the Coptic language and in Coptic manuscripts. This was centered around the French antiquarian Nicolas Fabri de Peiresc, who was eager to obtain Coptic versions of the Bible that could be included in the great polyglot edition of the Scriptures being prepared in Paris at the time. But the study of Coptic also received a strong impulse from the appearance in 1636 of the first study of the language, the *Prodromus coptus sive aegyptiacus* by Peiresc's former protégé, the Jesuit Athanasius Kircher. Kircher presented Coptic as the key to the hieroglyphs and thus to an ancient Egyptian wisdom that was the source of all learning, and however harshly criticized Kircher may have been by fellow scholars, his ideas, sometimes outrageous and frequently original, exercised a formidable fascination throughout Europe.[12]

Jean Coppin, the first traveler in the seventeenth century to publish an account of his visit to the Monastery of St. Paul, had served as a cavalry officer in the early stages of what would later be known as the Thirty Years War, fighting in the French army against the Habsburgs. He then decided to travel and to become acquainted with the Ottoman Empire. He arrived in Egypt early in 1638 and, in March, made the pilgrimage to the Red Sea monasteries. He set off from Cairo with eight companions.[13] Four were laymen: three European merchants—Porte from Brignolles, Bayart from Marseilles, and Antonio from Messina, who spoke Arabic, Turkish, and Greek and served as interpreter—and an Arab guide. The four others were clerics: two Franciscan Recollects, one from Aix-en-Provence and the other from Naples, and two Capuchin missionaries, Pierre from Brittany, and Agathange de Vendôme. The man about whom we are best informed is Agathange de Vendôme. He, like so many other missionaries, was on his way to Ethiopia where, together with Cassien de Nantes, he would be executed shortly after his last meeting with Coppin. While he was in Egypt Agathange also acted as an agent for Peiresc,

and one of the reasons for his eagerness to visit St. Antony's was to inspect its collection of manuscripts.[14] Yet it was above all as a missionary that he traveled, and his principal aspiration was to win converts for Rome.

Agathange de Vendôme was one of the more enlightened missionaries.[15] He rejected the obtuse instructions of the *Propaganda Fide,* according to which Catholics were forbidden to consort with heretics. He wrote at length to the prefect of the *Propaganda,* Cardinal Antonio Barberini, pointing out the impossibility of imposing such measures on the members of a monastic community, and he was one of many missionaries to have doubts about the actual heresy of the Copts. The only error he could find in their liturgy, he wrote, was the invocation of two of the founders of monophysitism, Dioscorus, the patriarch of the Church of Alexandria at the time of the Council of Chalcedon, and the slightly later Severus of Antioch, who held a more moderate view of the one-nature theory. It would take little, he claimed somewhat optimistically, to win over the Copts and persuade them to drop the two names at divine service.[16] Agathange de Vendôme's hagiographers delighted in his success at converting the monks of St. Antony's to Catholicism, but in fact it seems most unlikely that more than a couple were so much as interested in his arguments, and even Coppin admitted that none of them abandoned the Church of Alexandria.[17]

Coppin and his companions sailed from Cairo to Beni Suef. This took four days, and, having collected camels and a bedouin guide on the east bank of the Nile, they arrived at St. Antony's three days later.[18] After spending three days exploring the monastery and the surrounding sites, Coppin decided to travel on to St. Paul's. Bayart, the merchant from Marseilles, and the Neapolitan Recollect preferred to remain at St. Antony's. The others joined Coppin. Although they were offered the chance of taking the relatively brief route on foot straight over the mountains, the travelers, with bread in their pockets and two bottles of wine, preferred to keep their camels and to take the longer way, even if they left their camels shortly before St. Paul's and crossed the remaining sandstone hills on foot. The monastery they discovered was abandoned. Coppin gave a detailed description of the walls with a large breach in them, of the subterranean vault once leading to the spring but almost entirely demolished, of the keep, which retained its brickwork, and above all of the Cave Church, some twelve feet underground and with twenty-three steps leading to it. In the church, and by the side of the steps, the visitors could just distinguish a number of wall paintings which the bedouin had disfigured with their spears.[19]

Despite its state of abandonment, the Cave Church seemed evocative enough for Agathange de Vendôme to celebrate mass and for Coppin to take communion. The travelers then visited the orchard—Coppin plucked a branch from an incense tree, which he used as a stick. They drank from the spring in the grotto, had a "sober repast" of bread in memory of the loaf given by a raven to the "two Solitary Saints," and admired the view of the Red Sea and the Sinai mountains. On their way back to St. Antony's they recollected scenes from Jerome's *Life of Paul* as they observed the plain where Antony encountered two "monsters," a centaur and a satyr, and where the satyr, with a human voice, testified to his knowledge of God. At St. Antony's, Coppin and Agathange de Vendôme left each other, the Capuchin preferring to remain and proselytize. They would meet in Cairo the following month.[20]

It was many years later that Coppin actually wrote the account of his travels, and even longer before it appeared in print. He returned to France in 1639 and traveled in Tunisia, Palestine, and Syria before going back to Egypt in 1643. In this time he gathered political and military information about the Ottoman Empire. When he was again in Egypt he acted for three years as French (and English) consul in Damietta. Once back in France, however, he entered a monastic order, joining the recently founded hermits of St. John the Baptist in Chaumont near Le Puy. In 1665 he left his monastery to present his notes on the strengths and the weaknesses of the Ottoman Empire to Louis XIV's secretary of state, the marquis de Louvois, and he went on to Rome in order to persuade the pope, Alexander VII, to lead a new crusade against the Turks.[21] He stayed there for two and a half years before returning once more to Chaumont, where he completed the work containing his description of Egypt, *Le Bouclier de l'Europe, ou la Guerre Sainte, contenant des avis politiques et Chrétiens, qui peuvent servir de lumière aux Rois et aux Souverains de la Chrêtienté, pour garantir leurs Estats des incursions des Turcs, et reprendre ceux qu'ils ont usurpé sur eux. Avec une relation de Voyages faits dans la Turquie, la Thébaide et la Barbarie.*[22] It was published in Lyons in 1686, some four years before Coppin's death.[23]

Coppin's work was an appeal to the rulers of Christian Europe to unite in a war against the Turks. In the course of his travels he had observed what he regarded as the more vulnerable aspects of the Turkish defenses, and he was convinced that, if the western princes could overcome their political and confessional disagreements, they would have little difficulty in regaining the territory the Christians had once lost to the Muslims.[24] Appeals of this kind were by no means uncommon. The Arabist Pierre Vattier had re-

peatedly urged the French king to "create a new France in those beautiful countries of the East" and, in 1666, strongly recommended the invasion and colonization of Egypt. The same desire was expressed by Leibniz six years later.[25] Coppin's book, however, appeared when his hopes seemed well on the way to being fulfilled. Three years earlier, in 1683, the Turks had suffered a decisive defeat at the gates of Vienna, and the Christian armies were at last advancing into the Ottoman Empire.

By the time Coppin wrote his book he was evidently ill-disposed toward the Copts. He described their religion as the "coarsest and most absurd of all those of the Christians separated from the Church of Rome and living under Turkish rule." They retained, he continued, numerous Judaic ceremonies, and they had adopted the heresies of Dioscorus and Eutyches. It was this same faith, he added, which had drawn the subjects of Prester John, whose patriarch resided in Ethiopia.[26] From a man who had spent more than five years in Egypt, who had liked the Copts he had met, and who had known Agathange de Vendôme, such misinformation is surprising. Living in his monastery, imbued with the precepts of orthodoxy, Coppin seems to have been pandering to traditional Catholic prejudices and to have adopted age-old western misconceptions, in circulation ever since the Church Councils of the fifth century, such as the identification of the Coptic one-nature doctrine with the teaching of Eutyches. But Coppin's account of the Church of Alexandria, coming as late as it did, had little effect on European perceptions of the Copts, since it had been preceded—and implicitly discredited—by Johann Michael Wansleben's *Histoire de l'Eglise d'Alexandrie* (1677), with its far more reliable description of Coptic beliefs and practices.[27]

Revival and Restoration

Deserted, partly in ruins, and difficult to reach, the Monastery of St. Paul still attracted few visitors, and no other Europeans seem to have recorded their impressions until efforts were being made to repopulate and restore the monastery in the early eighteenth century. In 1716 one of the most interesting foreign residents in Egypt, the Jesuit Claude Sicard, paid a visit to St. Paul's. Like Agathange de Vendôme, Sicard, who had arrived in Egypt in 1712 after spending six years in Syria, had originally hoped to travel on to Ethiopia, but the impossibility of doing so, proved by the fate of Agathange and later missionaries, led him to settle in Egypt and concentrate on studying and educating the Copts as well as on exploring the country.[28] The

fruits of Sicard's activities included maps of the Eastern Desert and of Cairo that were of unprecedented accuracy, and descriptions of ancient sites which are of value to archaeologists to this day. Also like Agathange de Vendôme, Sicard was in disagreement with the instructions issued by the *Propaganda Fide* in Rome. He wrote eloquently against the idea that Catholics should shun heretics, and for this the *Propaganda* never forgave him.[29] He was regarded, both in Rome and by the Reformed Franciscan missionaries in Egypt, as lax in his doctrine and following "*la strada larga*" (the broad path).[30]

Yet a missionary Sicard remained, and he had a true contempt for the Coptic Church and its beliefs.[31] He was astounded by the ignorance, hypocrisy, and superstition of the monks. He despised their xenophobia, and he was appalled by their incessant use of charms and their love of magical practices. At the same time, however, his more flexible attitude toward conversion, together with his intelligence and affability, meant that he was far more successful in converting individual Copts to Catholicism than were his predecessors. His technique was exhibited at Dayr al-Suryani in the Wadi al-Natrun. He there informed the monks that he was a Copt—indeed, that he was a far better Copt than they were—but, he added, a Copt who followed the true teaching of the Church of Alexandria, the pre-Chalcedonian doctrines of church fathers such as Cyril and Athanasius. He drew their attention to the orthodox statements contained in many of their manuscripts and tried to show how their church had been led astray since Chalcedon.[32] This was what convinced his most distinguished convert in Upper Egypt, Rafael Tuki from Girga, who would later settle in Rome and, with his many editions of Coptic liturgical texts as well as his Coptic grammar, make an immense contribution to Coptic studies.[33]

One of Sicard's many advantages as a missionary was his command of Arabic. When he visited St. Antony's and St. Paul's, moreover, he was accompanied by a native speaker of the language, the Maronite Yusuf ibn Sim'un al-Sim'ani, known in Italy as Giuseppe Simonio Assemani. If the first Jesuit mission to Egypt in the sixteenth century had been marred by an almost complete lack of communication between the missionaries and the Copts, this was no obstacle as far as Sicard was concerned. Yet there was one aspect of his mission to the Red Sea monasteries that reflected the oddly uninformed policy of the *Propaganda*, and this was the very presence of Assemani.

Giuseppe Simonio Assemani was born in Hasrun on Mount Lebanon. Thanks to his uncle, the bishop of Tripoli,

he had been sent to Rome in 1695 at the age of eight to study at the Maronite College founded in the late sixteenth century by Gregory XIII. When he finished his studies Assemani was appointed scriptor of the Vatican Library for Syriac and Arabic literature, and in 1715 the pope, Clement XI, dispatched him to Egypt to collect manuscripts, and also to approach and report on the Copts. He stayed from the summer of 1715 until January 1717. On his return he was nominated librarian of the Vatican. He was sent as papal legate to Mount Lebanon in 1735, and he paid a second visit to Egypt on his journey back to Rome in 1738. In Italy Assemani founded a dynasty. He was joined in Rome by other members of his numerous family, cousins and nephews who rose to distinguished posts in the scholarly and ecclesiastical hierarchy. He himself has gone down to history as the compiler of the first great catalogue of oriental manuscripts in the Vatican that contained invaluable information about eastern Christianity in general, but his literary output, which included translations, editions, and a variety of historical and theological works, was immense.[34]

For all his qualities as a scholar, Assemani was not an ideal emissary to the Copts. The idea, cherished in Rome, that eastern Christians might help to convert to Catholicism other eastern Christians from different churches, almost invariably proved mistaken, and took no account of the traditional rivalry between the churches of the East. It would emerge in the course of the eighteenth century that the various members of the Assemani family were far from being universally popular. Sicard's convert Tuki would inveigh against them and never failed to advise against their being used in missions to Egypt.[35] And even if the superiors of certain monasteries were prepared to sell him manuscripts behind the backs of the monks, Giuseppe Simonio Assemani was fast gaining a reputation among the Copts as an unscrupulous raider of monastic libraries.[36] So it may well have been Assemani's presence that prevented Sicard from making much headway with the monks of St. Paul's.

Sicard, as able a writer and a stylist as he was an antiquarian, produced a memorable description of the monastery. He set out from Old Cairo on May 23, 1716, with various objects in mind. One was to tread in the footsteps of Antony and Paul, and his entire account is filled with references to their lives. Another was to study Egyptian antiquities in the lower Thebaid. And a third was, as he said, to convert the principal monks to Catholicism in the hope that they would soon be emulated by other Copts. Yet he was urgently begged by the Coptic patriarch, John XVI, as well as by his Coptic friends and even by the Jesuit

Maronite Elia and by Assemani, not to broach any controversial points.[37]

The party, consisting of Sicard, Assemani, a Coptic priest, and a Coptic layman, followed the traditional route, sailing to Beni Suef (which they reached after two days) and then assembling guides and camels on the east bank of the Nile to pursue the three-day journey to St. Antony's. Sicard, an indefatigable traveler, decided to set off for St. Paul's the morning after his arrival. The prior of St. Antony's, Synnodius, tried to dissuade him, assuring him that no Frank had ever dared undertake the journey, that it was full of dangers, and that the local bedouin had just massacred some forty travelers from Beni Suef. Sicard, however, insisted, telling Synnodius that God would protect him and his traveling companions as they followed the "sacred footsteps of the holy Fathers." Synnodius yielded. He loaded Sicard's camels with bread, water, onions, a jar of sesame oil, a large fishing net, cooking utensils, and two sacks of flour with which the travelers could buy off the Arabs, and accompanied the party himself with two of his monks.[38]

Sicard and his companions left St. Antony's on May 29 at five o'clock in the afternoon. Sicard described in detail the geological formations and the colors of the route.[39] He chose the longer way, skirting the mountains with his camels, and pointed out that the direct path straight over the mountains could be covered in less than ten hours, while the more circuitous one took fifteen. Sicard also relived Jerome's description of the toil of Antony in search of his companion, marveling that it should have taken Antony ten and a half days to discover the hermit who was separated from him only by "the thickness of a rock."[40] As soon as they reached the coast, on May 30, Sicard and Assemani washed their hands and faces in the sea, recited the *Te Deum*, and set about collecting shells. At two o'clock in the afternoon Sicard, Assemani, and the two Copts who had accompanied them from Cairo left Synnodius and his monks on the beach and proceeded to St. Paul's, where they arrived between six and seven.[41]

The travelers found that the access to the monastery of St. Paul was the same as that to St. Antony's. They were hoisted by a pulley issuing from a trapdoor and welcomed by a dozen monks to whom Sicard seems to have taken an instant dislike.[42] The visitors were immediately submitted to the customary ceremony of being led to the church after being draped in a cloak and entrusted with a candle. When Sicard started to talk to one of the monks from Upper Egypt whose relatives he had met, the inmates of St. Paul's could hardly conceal their anxiety. Nevertheless, despite their

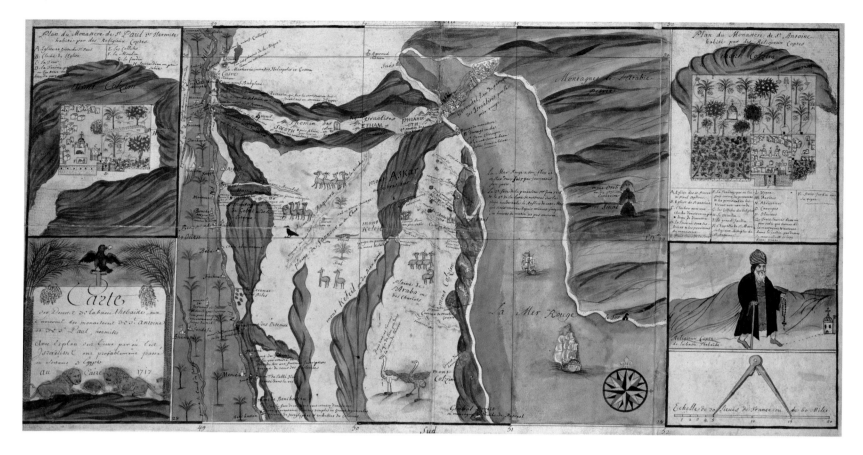

FIGURE 4.2

Map of Egypt with plans of the monasteries of St. Antony and St. Paul, 1717. Claude Sicard commissioned an Armenian artist to produce this plan after visiting the Red Sea monasteries in 1716. Bibliothèque Nationale de France, Paris, Section des Cartes et Plans. Rés. Ge. C. 5380.

promises to the patriarch, Sicard and Assemani were allowed to catechize the monks in public, and the monks pretended to agree with them and courteously praised their rhetorical gifts. As soon as their backs were turned, however, the monks warned each other to have nothing to do with the "thieving wolves," the subversive "enchanters" who had made their way into their monastery.[43] At this point Sicard and Assemani asked them if they would submit to the church and to describe what the church actually was. Their answers to the second question varied. Some said it was the Holy Virgin, others the New Jerusalem, still others baptism, the eucharist or the elect, or even their own bishops and doctors. Sicard reported their statements to demonstrate the boundless ignorance of the members of the Church of Alexandria.[44] On the next day, Whitsun, the visitors attended matins, mass at dawn, and a further religious service, after which, at about two in the afternoon, they left the monastery and returned to the coast.[45]

The monastery Sicard visited had been all but entirely restored after its period of abandonment. The Cave Church had been repaired and the walls decorated with "sacred stories coarsely painted." Sicard met the painter—could he, one wonders, have been the future patriarch John XVII?[46]—and

was informed that he had never been trained to paint, a fact, Sicard added, that was all too apparent from his work. The painter also told him that he had obtained his colors from the minerals on the surrounding heights.[47] Sicard described the monastery and made a sketch that was subsequently turned into an illustration by an Armenian artist (fig. 4.2).[48] It was, he wrote, a square building with a garden a third the size of that of St. Antony's and containing the same plants. A vault seventy yards long led to the spring—Sicard recalled Jerome's description of Paul, "that new Elias," having his thirst quenched there. The grotto where Paul and Antony first saw each other, recognizing one another miraculously and calling each other by name, was now part of the church and was furnished with a single altar, but the "tears of devotion which its sight should produce," he observed, "are stopped by the sad reflections which the present objects naturally call to mind."[49] Sicard and Assemani were shown the library, but, Sicard lamented, "the good books and the manuscripts have all been removed."[50]

Sicard's hostile attitude to the Copts seems to have softened with the passage of time. It was two years after his visit to St. Paul's, in 1718, that he first started to make converts in Upper Egypt and thus laid the basis of the Coptic

Catholic Church, which, from the 1730s on, would be organized mainly by the Reformed Franciscans.[51] Both Sicard and another Jesuit, Guillaume Dubernat, became increasingly sensitive to the problems of dealing with a church whose members had never received the scholastic training that would have been expected in Europe. This accounted for their inability to define "the church," as well as for a somewhat nebulous idea about what the sacraments were. Dubernat pointed out that if they were told what the sacraments were by a Roman Catholic, the Copts would agree that they too believed in them, but if simply asked to define the sacraments, they were incapable of doing so. Dubernat, however, decided that they should be given the benefit of the doubt and that their agreement with the Catholic definition should be accepted as a sign of orthodoxy.[52]

Sicard's description of the Red Sea monasteries, addressed to his fellow Jesuit Thomas Charles Fleuriau d'Armenonville in Brussels, was published in the fifth volume of the *Nouveaux mémoires des missions de la Compagnie de Jésus dans le Levant*, which came out in 1725. Because of his fine style, his immense knowledge, and the accuracy of his descriptions, his writings on Egypt remained unsurpassed for many years, and to them other travelers, such as Claude Granger and Richard Pococke, were profoundly indebted.

Claude Tourtechot, who wrote under the name of Claude Granger, was no missionary. By training he was a surgeon, and it was in that capacity that he first visited North Africa, sent by the Trinitarians to work in Tunis in 1721. In Tunis he met Pierre-Jean Pignon, the French consul, who became a close friend.[53] Granger returned to Paris, and there, working in the Jardin du Roi, he acquired some experience in chemistry, botany, and zoology. The decision to send Granger to Egypt together with Pignon, who had been appointed consul in Cairo at the end of 1729, was due to the influential secretary of state for naval affairs, Jean-Frédéric Phélypeaux de Pontchartrain, Comte de Maurepas, and his cousin, the royal librarian Jean-Paul Bignon who was notoriously sympathetic to the libertines and the ideas of the Enlightenment. They both wished to organize a scientific expedition that would "examine in Egypt those plants, animals and other things which could be of service to natural history,"[54] and Granger seemed perfectly equipped to lead it.

Granger arrived in Alexandria on July 18, 1730. On August 6 he was in Cairo, and on January 29 of the following year he set off for Upper Egypt. One of the most original aspects of his journey to the Red Sea monasteries was that he approached them from the south, facing an eight-day trek from Akhmim. First he went to the Monastery of St. Antony, and then he proceeded to St. Paul's (known by the Copts, he said, as the Monastery of the Tigers after Jerome's account of Paul's grave). He arrived on April 11 and stayed for one night. In the monastery he found fourteen monks—five priests, six clerics, and three lay brothers. He inspected the Cave Church and took measurements (32 feet long by 14 wide), commented adversely on the wall paintings, and copied the Coptic inscription on the framing arch leading to the Haykal of the Twenty-Four Elders. Granger, however, took the Sahidic Coptic to be Greek.[55] Although he would admit that St. Antony's and St. Paul's were the "least ugly" of the Egyptian monasteries,[56] he was dissatisfied by his visit, finding that there was nothing there "to satisfy anybody's curiosity, let alone a man of piety."[57] From St. Paul's he made his way back to Akhmim. After Egypt he explored Cyrenaica, Syria, and Mesopotamia, where he died in July 1737 on his way to Bassora. His notes were collected by Pignon and published in 1745.[58]

Granger helped himself freely to the work of Sicard. He had been shown his reports on Egypt by Pignon, who had been given them by Maurepas, and Granger's account of St. Antony's, as well as much of his report on St. Paul's, are taken almost verbatim from Sicard, even if Granger never mentions him by name.[59] To a large extent this is also true of the English traveler Richard Pococke, who was in Egypt in 1737 and 1738. Pococke never went to the Red Sea monasteries, but, in the first volume of his popular *Description of the East*, which appeared in 1743, he felt bound to describe them, and even to provide an illustration (see fig. 4.1). The illustration is taken from the one made by the Armenian artist for Sicard, a copy of which seems to have been available in Cairo, while Pococke's description—he claimed that the monastery contained twenty-five monks who followed a rule of particular austerity—is based on the observations of other contemporaries.[60]

Continuity and Change

The gradual accumulation of visitors to the Monastery of St. Paul in the nineteenth and twentieth centuries gives some idea of the extent to which it had been revived—artists, manuscript collectors, art historians, photographers, missionaries, and scientists all testified to its growing reputation as a site of interest and beauty, and, as time went by, they could profit from ever more practical and commodious means of transport. Yet their object frequently remained a quest for antiquity, a desire to follow Antony

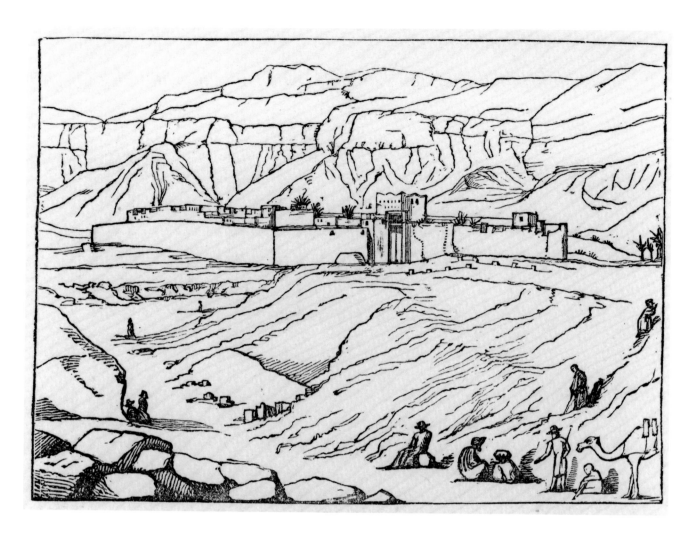

FIGURE 4.3

FIGURE 4.3

Monastery of St. Paul, ca. 1844.

Joseph Bonomi.

through the desert and to savor the atmosphere of a place that had once been frequented by Paul the Hermit.

Relations between Egypt and the West had been altered deeply by the Napoleonic invasion of 1798 and by the subsequent occupation of the country, and they changed still more after 1811 under the rule of Muhammad 'Ali Pasha. Muhammad 'Ali was particularly eager to appoint western technicians.[61] Ever larger numbers of Europeans settled in Cairo and explored the country; travel was safer than it had been in the past; and the Coptic monasteries became an increasingly popular goal. In March 1823 an English surveyor and geologist in the pasha's service, James Burton, called on St. Paul's in the course of his systematic investigation of the Eastern Desert. He was accompanied by one of his closest friends, with whom he shared lodgings in Cairo—John Gardner Wilkinson, who had arrived two years earlier in Egypt, where he would spend some twenty years and distinguish himself as an Egyptologist.[62] The two men, who had just been to St. Antony's and approached the Monastery of St. Paul from Zafarana on the coast, spent nine days there, arriving on the 17th and leaving on the 26th, and

using the monastery as a base from which to explore the outlying area. Burton took notes (which have remained unpublished),[63] and made a number of interesting sketches and paintings of the surrounding landscape, the walls, the streets, and the church,[64] while Wilkinson published his own record of their visit in 1832 in the second number of the *Journal of the Royal Geographical Society.*

The two accounts are almost identical. Wilkinson seems to have copied Burton's notes with no acknowledgment and thus confirmed contemporary fears that Burton's knowledge might be exploited by him.[65] The visitors were lavishly received. "They spread us carpets on a large Cairo map," wrote Wilkinson of the monks, "and the coffee, scented with cloves, was brought in handsome cups on silver stands. Pipes, too, of no inferior quality, were given us."[66] In the monastery churches Burton and Wilkinson observed "some pictures—one of St. Mark and another of St. Athanasius, (which seems to be of the Italian school), are the only two of any merit; the rest are grotesque representations of saints, dragons, miracles, and madonnas, painted on board by artists of Alexandria."[67] As for the Cave

FIGURE 4.4
Interior of the Church of St.
Michael the Archangel and St.
John the Baptist, ca. 1844. Joseph
Bonomi.

Church, "the walls are adorned with stiff old frescos."[68] The visitors were struck, moreover, by the presence of church bells (which they had also discovered at St. Antony's). At the time of their visit there were twenty-one inmates of the monastery, eighteen laymen and three brothers.[69] "The monks," wrote Wilkinson, "are Ichthyophagi, and go down in small parties to the sea, where a two days' fishing suffices to load a donkey, which they keep within their walls; rice, lentils, and bread, are their principal, if not their only other food."[70] But the two men did not take to the monks. The monastery, Wilkinson admitted, "is situated in a more picturesque spot than that of St. Antony, and has a much cleaner and neater appearance, owing to its having been recently repaired. The streets and houses are also laid out with some degree of regularity and order....The monks, too, appear cleaner and richer,—are better dressed and lodged, and possess more luxuries; in this alone, however, [they are] superior to the brothers of the other convent; being uncouth and even inhospitable,—ignorant, and consequently suspicious, and scarcely condescending to answer the usual questions of the traveller."[71] They were, Burton added, "more cunning than those of D. Antonios,"[72] but he and Wilkinson noted that, thanks to Muhammad 'Ali, caravans to the monastery were no longer attacked and the local bedouin no longer had the right to exact a tribute from the monks.[73]

A little later the artist Joseph Bonomi, a friend of both Burton and Wilkinson (some of whose works he would illustrate), visited the monastery. A pupil of John Flaxman and the son-in-law of John Martin, Bonomi had a lifelong interest in Egypt and Egyptology. He was in Egypt twice. He

first went as a salaried artist in the expedition led by Robert Hay, which set out in 1825 and traveled up the Nile to Abu Simbel. On this occasion Bonomi stayed until about 1834. His next visit was as a member of the even more important expedition of the Egyptologist Karl Richard Lepsius. He then remained in the country from 1842 to 1844.[74] It is not entirely clear when he was at St. Paul's, but his friend Samuel Sharpe included in the illustrated edition of his *History of Egypt* two woodcuts by him, one of the walls of the monastery and one of the interior of the Church of St. Michael the Archangel and St. John the Baptist, with the monks performing penitential prostrations (figs. 4.3 and 4.4).[75]

More than ten years after the exploration of the Monastery of St. Paul by Burton and Wilkinson, on December 23, 1834, the monks received what was probably the largest group of visitors they had ever seen, led by Marshal Auguste-Frédéric-Louis Visse de Marmont. Marmont had been one of the men closest to Napoleon. Once his aide-de-camp, he had served in nearly all his major campaigns—in Italy, Egypt, Germany, the Low Countries, Austria, Bohemia, Spain, and Dalmatia (where he was rewarded with the dukedom of Ragusa). But, inveigled by Talleyrand into negotiating with the emperor's enemies in 1814, he contributed to his fall, thereby winning the favor of the restored Bourbons. The Bourbons too turned against him in 1830, however, and accused him, unjustly, of treachery. Marmont consequently settled in Austria. He spent most of the remaining years of his life writing, defending his own reputation and blackening that of his numerous enemies.[76] But he also traveled, and on October 12, 1834, he landed in Alexandria to arrive in Cairo on the 27th. He was welcomed by Muhammad 'Ali and, above all, by his host, his former comrade at arms Colonel Joseph Sève, now known as Sulayman Pasha. Like Marmont, Sève had fought with Napoleon in Egypt. He returned there after the emperor's fall, converted to Islam, and was placed in charge of the instruction of Muhammad 'Ali's troops. Over the years he rose to become one of the most powerful men in the country, taking part in the Syrian campaign and holding the rank of second in command of the Egyptian army directly under the ruler's son Ibrahim. He was a pillar of the French colony in Cairo, and it was in his splendid mansion on the Nile that Marmont was invited to stay.[77]

Marmont went to the Monastery of St. Paul as he was returning from an expedition to Upper Egypt. He hoped to find a boat on the Red Sea coast and proceed to Suez, and consequently turned in to the desert at al-Minya. His traveling companions included two men who had been with him

since his departure from Vienna, Burun, a French friend, and the Italian count Savorgnan di Brazzà, an amateur painter, whose family would produce illustrious explorers later in the century.[78] He was also accompanied by a number of men he had met in Cairo—Lapi, the dragoman or interpreter of the Austrian consulate, a Bavarian doctor named Koch, and Yussuf Kiachef, another veteran of the Egyptian campaign who had converted to Islam and was responsible for mediating with local officials.[79] They were joined by an escort of fourteen bedouin and forty-five camels, and the journey from the Nile took twelve days.[80] At the monastery Marmont found thirty-five monks. Ten of them were priests, and only four of the ten were literate. The monastery, he wrote, was shabby; the library contained only thirteen books; and the monks amazed him by the ingenuousness of their questions.[81] Did the Europeans, they asked him, celebrate mass in the same way as they did? Were laymen allowed several legitimate wives at the same time whom they could divorce with no difficulty? Was the year divided into months and weeks consisting of seven days? And had the visitors read any prophecies about Christians being freed from Muslim rule?[82]

What was still more indicative of the revival of the monastery was that it should at last have started to draw manuscript collectors, even if the English archaeologist Greville Chester said he declined visiting St. Paul's when he was at St. Antony's, "as I was assured that not a single fragment of any ancient MS. had escaped the wreck of the eighty years of abandonment."[83] The Monastery of St. Paul was visited in 1838 by Henry Tattam, the greatest expert on Coptic in England and, at the time, rector of St. Cuthbert's in Bedford and Great Woolstone in Buckinghamshire. Tattam traveled with his niece, Miss Platt, and it was she who described the journey. They set out from Cairo on March 6, and, with six camels, two dromedaries, an Arab interpreter, five bedouin guides, and two servants, they took the unusual measure of crossing the desert directly from Cairo to the Red Sea and avoiding the passage up the Nile. The journey took a week. After stopping briefly at the Monastery of St. Antony, which Tattam visited, they pitched their tents on the coast. Tattam then left his niece and went inland to St. Paul's with his interpreter and two of the guides—it took him four hours—on March 14.

The description of the monastery by Tattam's niece, who did not see it for herself, is cursory. The buildings, we are told, were in better repair than those of St. Antony's, but the monks more isolated, even if they appeared "to have more comfort" and could occasionally obtain fish from the Red Sea. The library was what interested Tattam

most, and that he visited it proves that word was spreading that it might contain something worth seeing, however new it actually was. But Tattam was disappointed: "The monks here possess but few religious books, or did not choose to show more. They brought out a copy of St. John's Gospel in Coptic, and a copy of the Scriptures printed in Latin and Arabic, 4 vols folio."[84] This last work is the 1671 *Propaganda Fide* edition of the *Biblia Sacra Arabica*. In three volumes rather than four, it is still in the library. After seeing the books Tattam went straight back to the coast, to St. Antony's, and then to Suez.[85]

If Granger's inclusion of the Monastery of St. Paul in what was essentially a scientific expedition to Egypt can be seen as an effect of the European Enlightenment and Tattam's visit as yet another incident in the increasingly fashionable hunt for Coptic manuscripts, the visitors to the monastery in the nineteenth century also exemplified the changing face of western policies and of Egypt itself. One of the novelties of the nineteenth century was the vast expansion of the religious missions. From the sixteenth to the late eighteenth centuries the missionaries in Egypt had nearly all been Roman Catholic. The Protestant Moravian Brethren who came between 1752 and 1800 left little mark.[86] Since the missionaries provided extensive reports and had a far longer and more direct experience of the Copts than did most other residents in Egypt, the Copts, in both Catholic and Protestant Europe, were seen through their eyes, and Protestant writers were largely reliant on Catholic sources. In the nineteenth century this changed. The entire area of the Near and Middle East was infiltrated by missions from the whole of western Christendom. The Roman Catholic missions, in decline in the eighteenth century, were vigorously revived, with a quantity of new orders. And they were joined by Protestant missions—Anglicans, Evangelicals, and Presbyterians from England, Evangelicals and Presbyterians from America, Lutherans from Germany[87]—and by the Russian Orthodox.

By the end of the eighteenth century the Russians had made themselves out to be the protectors of the Greek Orthodox Church in the Ottoman Empire, fragile though their credentials were.[88] Their ambitions increased in the nineteenth century, and, like the Catholics and Protestants of an earlier period, they were eager to have a foothold in Ethiopia and in the Holy Land. In 1847, therefore, the archimandrite Porphyrios Uspensky set off for Jerusalem as head of the Russian mission,[89] but the objective of establishing a Russian presence in the city failed. Uspensky, nevertheless, retained a strong interest in the eastern Christians, and he was attracted by the idea of union with the great

monophysite churches, notably the Jacobites of Syria and the Copts, having concluded that the Copts could hardly be regarded as heretical, and that their beliefs were perfectly compatible with those of the Russian Church. At the same time he was keen to collect and inspect manuscripts—he was one of the first scholars to consult and describe the Codex Sinaiticus at the Monastery of St. Catherine, and the first to find the Euchologium Sinaiticum, two leaves of which he took back to Russia.[90] He paid a couple of visits to Egypt. In 1850 he called on the Monastery of St. Antony, whose prior, Dawud, then accompanied him to St. Paul's. Four years later Dawud would become Cyril IV, the most enterprising and enlightened Coptic patriarch of the nineteenth century, known as a pioneer of ecumenicism and for his readiness to open a dialogue with other churches. His official discussions with Uspensky, however, which started in 1860, were interrupted by his death in January of the following year.[91]

Uspensky was an observant visitor. In his account of St. Paul's he first described the relatively recent Church of St. Michael the Archangel and St. John the Baptist, with an inscription recording its construction on the orders of the patriarch John XVII in 1727 by the architect Abu Yusuf.[92] Its best decoration, he wrote, was an "icon of the Evangelist Mark, painted in Europe. The preacher of salvation in the land of Egypt is represented seated and in meditation. At his feet are two books in parchment bindings. In the background is a pyramid."[93] He then turned to the Cave Church. He copied the Coptic and Arabic inscriptions and transcribed the Coptic inscription around the base of the Dome of the Martyrs in the narthex, but was struck by the incapacity of the monks to understand it. Above the inscription, he continued, "are the names of the martyrs in Arabic.... The martyrs themselves are painted very badly." Most of the representations were so covered in soot as to be almost invisible. Uspensky could just distinguish the figures of saints on the stone iconostasis separating the sanctuary from the church, and, "behind the consecration table, high up on the wall...a full-size representation of the Saviour."[94] On the eastern wall of the chapel containing Paul's tomb he found a full-length representation of St. Paul, wearing a brown *chiton*, his arms uplifted, the raven bringing him a loaf and two lions licking his feet.[95] "The paintings on the walls of the Apocalyptic Church," he concluded, "are bad; the faces are ugly and even terrible."[96]

Scholarly Investigation

Another novelty of the nineteenth century was the network of railways established in Egypt from the 1850s on. To the

first line, from Cairo to Alexandria, was added a line from Cairo to Suez, and, in the 1860s under Khedive Isma'il, the journey to the monasteries of St. Antony and St. Paul was conveniently abridged by the railway from Cairo to Beni Suef. Nevertheless, despite the facilitations for tourism after the opening of the Suez Canal in 1869, the trek across the desert remained as challenging as it had ever been, and the explorer and naturalist Georg August Schweinfurth, who first visited St. Paul's in 1876, observed how few Europeans had in fact ventured to the Red Sea monasteries.[97] Schweinfurth's view is vindicated by the treatment of St. Paul's monastery in the increasingly popular guidebooks of Egypt. The standard English guide, later to be known as "Murray's guide" but first issued in 1847 as the *Hand-book for Travellers in Egypt*, was by John Gardner Wilkinson. Although he had visited it with Burton, Wilkinson mentions the monastery only briefly, and in the same breath as that of St. Antony, but gives no details about it.[98] And the German equivalent, by Karl Baedeker, was equally parsimonious in its information.[99]

By the time he went to St. Paul's himself Schweinfurth had established his reputation as one of the greatest explorers of his day. He had traveled over much of Egypt and the Sudan, and, in the African interior, he had made his most important discoveries—the river Welle and the Akka pygmies northwest of Lake Albert—besides gathering an abundance of new information about the Mangbetu cannibals. He had also founded the Egyptian Geographical Society in Cairo, where he had settled in 1875 and would stay intermittently until 1889.[100]

The description of the monasteries, by a man with a thorough knowledge of geology and natural history, is highly evocative, surpassing, for the first time, that of Sicard. Like his predecessors, Schweinfurth tells of the alternate routes from St. Antony's to St. Paul's—the shortcut, "accessible only to pedestrians and donkeys," over the mountains, which took nine hours, and the more circuitous way, which took sixteen.[101] The setting of the monastery made a unique impression on him—the barren rocks, uniformly gray but framed by white precipices, the palm trees in the deep ravines, the dark walls, and the deathly silence of the menacing cliffs.[102] He made an accurate sketch of St. Paul's seen from the east, showing the walls that, he said, had not been restored for many years, measuring some 455 meters and surrounding an area of one and a half hectares (fig. 4.5).[103]

On his first visit in 1876 Schweinfurth found twenty-three inmates inhabiting two parallel rows of buildings along the southern wall. The keep was in good condition,

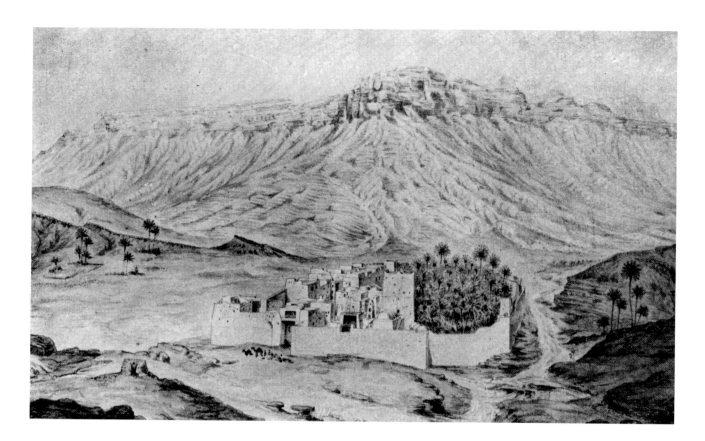

FIGURE 4.5

Monastery of St. Paul, 1876. Georg
Schweinfurth.

and the garden, which took up about a quarter of the mo-
nastic space, was rich in palm trees and other plants also
found at St. Antony's. The Cave Church seemed to Schwein-
furth to have been restored some two centuries earlier. The
paintings, he commented, were primitive, "grotesque cari-
catures," but it was clear to him that they covered far earlier
decorations that it would be well worth restoring "with the
aid of modern technique."[104] He remarked on the graffiti in
the cave and added information about the administration
and wealth of the monastery. It had, he said, lost much
of its land when the predecessor of the current bishop at
Bush converted to Islam and sold some of its property to
the government. Efforts, he added, were being made to re-
trieve it.

On later visits to St. Paul's, between 1876 and 1878,
Schweinfurth counted twenty-eight monks, most of whom
were very old. On the whole he liked them. He observed,
however, that, in emulation of the great Antony, the monks
seemed most reluctant ever to wash, and that their cells
were extraordinarily untidy (a feature already remarked
upon by Uspensky and one that would strike Michel Jul-
lien).[105] But, in the spirit of critical skepticism with which he
recounted the lives of Antony and Paul, he also thought the
monks had little future. They had long ceased to have either
a political or a religious significance, and they remained

isolated from the rest of the world and in the same state
of torpor and immobility that had characterized spiritual
matters in Egypt for centuries.[106]

The revival of Roman Catholic missionary activity in
the nineteenth century also affected the Society of Jesus.
Nearly all the members of the Society in Egypt in the eigh-
teenth century had died of the plague, and the house in
Cairo was closed with the dissolution of the order in 1773.[107]
It was not until 1879 that the Jesuits returned to Egypt, and
when they arrived they founded an educational establish-
ment, the Collège de la Sainte Famille. The next visitor who
wrote about the Monastery of St. Paul was Michel Jullien
from Lyons, who had arrived in Egypt in 1881 and had pur-
chased the ground on which the Collège de la Sainte Famille
stands to this day.[108] Treading most deliberately in the steps
of his great predecessor in Egypt, Claude Sicard, and with
Jerome's *Life of Paul* forever in mind, he set off from Cairo
on November 11, 1883, just over a year after British troops
had put an end to the 'Urabi revolution and occupied the
country. Jullien took the train to Beni Suef. He was accom-
panied by François Sogaro, the apostolic vicar for Central
Africa appointed for the Egyptian Sudan; Antun Morcos,
the apostolic visitor of the Catholic Copts; Luigi Korrat,
a coadjutor; and Sante Bonavia, an Italian architect who
lived in Cairo.[109]

The train journey from Cairo to Beni Suef lasted three hours, but then the visitors had to mount camels after obtaining permits from the bishops of St. Antony's and St. Paul's at Bush (for whom Jullien had a letter from the patriarch Cyril V). The permits were granted, and Jullien wrote a picturesque account of the journey across the desert. From the Monastery of St. Antony to that of St. Paul the company preferred the more circuitous road, and they were finally hoisted by ropes and greeted with the traditional procession and religious service. Jullien found that the monastery was inhabited by twenty-five monks—nine lay brothers and sixteen hiero-monks—one of whom was aged ninety. Antun Morcos managed to deliver a sermon in which he urged the inmates of the monastery to unite with the Church of Rome. According to Jullien the monks were impressed by his arguments. Some of them tried to speak to him alone, and he spent much of the night talking to them, but there is no evidence to suggest that any of them converted. Indeed, Jullien retained a low opinion of the Copts, who, he wrote, had no idea of mental prayer, were deaf to any exhortation, hardly ever took communion, and had hearts as empty, cold, and dilapidated as their churches.[110] Nevertheless, Jullien was generally pleased by St. Paul's—after failing to sleep in his cell he found that he slept very well in the open air. He drew a plan of the monastery, took measurements of the Cave Church, which he estimated at 9 square meters, but was disappointed by the coarseness of the wall paintings.[111] On the day after their arrival the visitors attended mass and set off on their return journey at noon. Jullien's account of the Red Sea monasteries was influential in the French-speaking world and was followed closely by Charles Beaugé, a French traveler who spent some twenty years in Asyut in Upper Egypt and who published an account of his experiences in 1923.[112]

Over twenty years after Jullien's expedition, in March 1908, St. Paul's received yet another party of missionaries. It was organized by Fortunato Vignozzi da Seano, the head of the Franciscan mission in Beni Suef, and by Gottfried Schilling, who was then the president of the Church of St. Joseph in Ismailia in Cairo and would subsequently represent the Custodians of the Holy Land in Washington. They were accompanied by another Franciscan missionary, Teodosio Somigli (who recorded their experiences in his biography of Vignozzi), and by a young archaeologist from Munich, August Schuler. Equipped with a camera, the travelers photographed Vignozzi being hoisted into the "only remaining monastery...without a gate."[113] The Franciscans made further efforts to win the inmates over to Rome, and, as on the occasion of Jullien's visit, discussions were held

with the monks for an entire night. In the end they were just as unsuccessful as the Jesuits, even if Somigli believed that the monks of St. Paul's seemed better disposed toward them than did those of St. Antony's.[114]

Despite the railway line to Beni Suef, the Monastery of St. Paul remained a challenge, and as such it was taken up by two exceptional English women in the first decade of the twentieth century. Agnes Smith Lewis and Margaret Dunlop Gibson were twins, identical and inseparable but with gifts that complemented one another—Lewis excelled in Syriac and Aramaic, and Gibson in Arabic. Frequent travelers to Egypt and the Middle East, they were rich and eccentric, known in Cambridge, where they lived in a neo-Gothic mansion, for their garden parties at which a piper would play on the lawn, and for owning one of the first motorcars in the city. As scholars they were highly respected. Lewis, who had once tried her hand as a novelist, had discovered the Syriac Codex Sinaiticus at St. Catherine's; she had acquired an interesting early Aramaic manuscript in Cairo that she gave to Cambridge University; and both sisters published valuable scholarly editions of early texts.[115] Yet even for these intrepid travelers, aged sixty at the time, St. Paul's posed a problem: it had never been entered by a woman. Well-connected and ready to take advantage of the British occupation of Egypt, they obtained a recommendation from the British consul general, Lord Cromer, and from the prime minister, Butrus Ghali Pasha, for the patriarch, Cyril V, who, in his turn, gave them letters for the bishops at Bush. They set out on February 18, 1904, and reached Bush by train. While they had no difficulties in obtaining a permit from the bishop of St. Antony's, they had more trouble in convincing Bishop Arsaniyus of St. Paul's. Finally, however, he agreed, and wrote that any of the monks who objected to their visit should be locked up together in one room.[116]

The twins set off across the desert with a Muslim cook, a Coptic waiter, and two bedouin guides, and they reached the Monastery of St. Antony on the 23rd. At 7:30 on the 26th they made for St. Paul's. They were at first appalled by the wall, which was fifty feet high, and by the windlass that would hoist them into the monastery, but, with the help of their traveling equipment, they managed to furnish a large padded basket and were pulled up in a decorous manner (figs. 4.6 and 4.7). They found thirty monks eagerly awaiting them, and, after the traditional procession and religious service, they were addressed by the prior in terms that stirred their patriotism. "Next came a eulogium on our beloved sovereign Queen Victoria," wrote Lewis, "and a lament over her death; then an expression of gratitude to

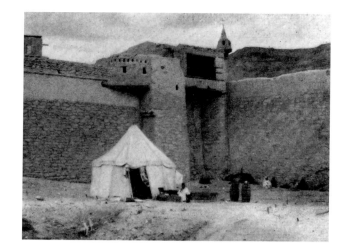

FIGURE 4.6
Tent of Agnes Lewis and Margaret
Gibson outside the walls of the
Monastery of St. Paul, 1904.

Lord Cromer, and to the noble English nation, for their deliverance of the Egyptians from Ahmed Arabi Pasha, for the works of irrigation, and for the establishment of schools, etc."[117] The two ladies inspected the bakery; Gibson took photographs of the monks; and they "examined their small store of manuscripts, which were similar in character to those at Deyr Antonius, only that one containing the sermons of St. Simeon the Stylite was on vellum." They had lunch prepared by their own cook, and were lowered down from the trapdoor.

The Smith twins, nicknamed the Giblews by their contemporaries, were scholars rather than missionaries. Nevertheless, they were committed Presbyterians. Their parents had been Presbyterians, Gibson's husband had once been a Presbyterian minister, and they contributed to the foundation of Westminster College in Cambridge, the Presbyterian theological college opened in 1897. They consequently took a strong interest in the primitive Coptic church and the remarkably successful efforts of the American Presbyterians to convert its members, even if they might have hoped for a more substantial English contribution. "The Coptic Church," wrote Lewis, "is now in a very critical position. To those who, like myself, have cherished the hope that she would rouse herself to feel the need of an educated ministry, well grounded in the Scriptures, and apt to teach, thus assimilating herself perhaps to the Protestant Church of England, it is a staggering reflection, and well-nigh a shattering of hope, to learn that all her bishops must be chosen from four of the monasteries which we visited."[118] Not only did Lewis regard the experience of the prospective bishops as far too limited to assist the church in any development, but she believed that the Copts themselves, self-indulgent, lazy, and excessively corpulent, were ill-equipped to guide it. "A change is impending," she concluded ominously. "Whether it will be in the direction of the Coptic Church

embracing in its own bosom the ideas of modern progress and assimilating itself more nearly to the pattern of the infant church which existed in the days of St. Mark, or whether it will become a mere empty shell of officialism and traditional ritual, the influences which affect it in the twentieth century will irrevocably decide."[119]

With his practical recommendations about the restoration of the wall paintings in the Cave Church, Schweinfurth can be regarded as the first visitor to encourage research into the artistic significance of the monastery itself. In February 1901 a group of eminent German scholars—the Byzantinist Josef Strzygowski; Bernhard Moritz, the Arabist and director of the Khedival Library in Cairo; and Carl Heinrich Becker, once professor of Semitic philology at Heidelberg and future minister of education and the arts in the Prussian cabinet—arrived at the Monastery of St. Paul to study the wall paintings and inscriptions.[120] Strzygowski was particularly interested in the equestrian martyrs for a study he was making on the iconography of St. George. Reproducing a photograph of the cupola over the narthex in the Cave Church taken by Becker, he gave a detailed description of every one of the martyrs—not only on the main cupola but also by the entrance and on the walls—in the *Zeitschrift für Ägyptische Sprache und Altertumskunde* of 1902–1903.[121] He also transmitted his copy of the inscription in the cupola, which dated the restoration of the church in 1713, to the Egyptologist Walter Wreszinski. Wreszinski published it, together with the names of the equestrians in Coptic and Arabic given him by Becker, in the same number of the same journal.[122]

Many years later another distinguished group of experts visited the monastery, its members availing themselves of an altogether new means of transport, the motorcar. In 1930 the American archaeologist Thomas Whittemore, the founder of the Byzantine Institute of America in Washington, D.C., led an expedition to the Red Sea monasteries and drove to St. Antony's in a convoy of Fords, accompanied by the epigraphist Alexandre Piankoff, the architect Oliver Barker, the photographer Kazazian, and the painter Netchetailov.[123] The reason for Whittemore's interest in the Red Sea monasteries was his desire to investigate Coptic art of the Middle Ages. He had found plenty of objects from an earlier period elsewhere, but in no other sites in Egypt had he discovered such a rich selection of paintings made between the twelfth and the fourteenth centuries. The meticulousness with which he and his collaborators examined the monasteries was unprecedented. Netchetailov made copies of the paintings, and Kazazian took photographs. "It is only now, for the first time," Whittemore wrote, "that these

monasteries have been carefully examined. No excavations have been undertaken, since they would involve damage to conventual buildings actually in use."[124] Whittemore spent most of his time in 1930 and 1931 at St. Antony's, so much richer in works of medieval art than St. Paul's. But he also worked at St. Paul's, which he reached by camel. Hardly any of the results of his expedition were actually printed. Nevertheless, seven of Kazazian's splendid photographs—views of the walls, gardens, the keep, a cell-lined street, the monks in their vestments after a religious service, and the equestrian saints in the dome of the Cave Church—were indeed published, on pages 14 and 15 of *The Illustrated London News* of July 4, 1931 (figs. 4.8–4.10).

At 10 o'clock in the morning on March 25, 1930, after a two-day stay at St. Paul's, as he was leaving the monastery in a small caravan and in the company of another "gentleman in European dress" (probably the photographer Kazazian), Whittemore first met the traveler with whom this survey must end, Johann Georg Herzog zu Sachsen.[125] The second son of the Saxon king George, and the brother of the last king of Saxony, Frederick Augustus III (who abdicated in 1918), Johann Georg, like the other members of his branch of the family, was a Roman Catholic. He and his slightly

younger brother Max had received a good education, first at the University of Freiburg, and then at Leipzig, where Max obtained a doctorate in 1892. Both brothers had always had a pronounced interest in eastern Christianity. Max, who had joined the priesthood, was committed to the idea of a union of the churches, and he would boldly maintain that the churches of the East had nothing heretical about them. He mastered Church Slavonic, Armenian, and Syriac and made a serious study of the liturgy, a subject in which he would hold a professorship at the Catholic University of Fribourg in Switzerland. Johann Georg was less single-minded. He was above all a collector of manuscripts, antiquities, and curios, with a good eye and a certain knowledge of art history, and he traveled to satisfy his somewhat eclectic curiosity. His main contributions to scholarship were his studies on the iconography of St. Spiridion, undertaken mainly in Corfu. Despite his sometimes inaccurate attributions, particularly where dating was concerned, the energy and enthusiasm with which he studied the Copts, along with his many publications, contributed to his reputation in the German world of learning and earned him an honorary doctorate at Leipzig and a *Festschrift* from the University of Freiburg.[126]

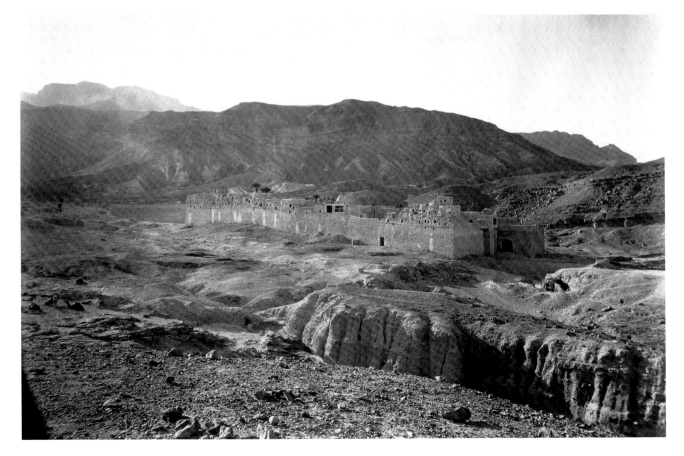

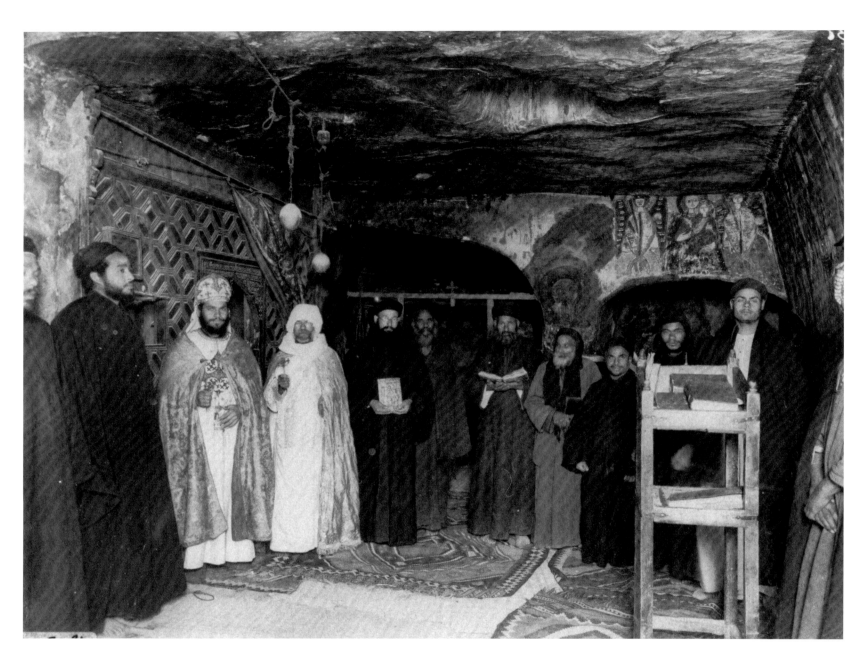

FIGURE 4.9

Monks in the Cave Church, 1931.

Whittemore expedition, B36.

Courtesy of Dumbarton Oaks,

Washington, D.C.

FIGURE 4.10
Street of cells, 1931. Whittemore
expedition, B29. Courtesy of
Dumbarton Oaks, Washington,
D.C.

FIGURE 4.11

Johann Georg outside the low gate
in the south wall, 1930. Johann
Georg Herzog zu Sachsen.

Johann Georg first visited Egypt in 1910 and then re-
turned repeatedly—in 1912, 1927, 1928, and 1930—visiting,
and describing, nearly all the Coptic sites. He had already
planned to go to the Red Sea monasteries in 1927 but had
given up the idea since nobody could give him any informa-
tion about the journey. Nevertheless, in the following year
he succeeded in driving to the Monastery of St. Antony.[127]
It was not until two years later, however, that he went to
St. Paul's.[128] Accompanied by a priest, the church and art
historian Joseph Sauer from Freiburg, and furnished with
a letter from the patriarch, John XIX, the duke left Cairo
at 3 o'clock in the afternoon on March 24 in a car belong-
ing to, and driven by, the owner of a travel agency. Trav-
eling at almost 60 kilometers per hour it took them two
hours and twenty-three minutes to reach the Hotel Belair
in Suez—Johann Georg, who had had a career in the army,
always made observations of military precision. At 9:30 that
evening the duke and Sauer, with a butler and an interpret-
er, took another car to Port Tawfik, at Suez, and boarded a
steamer. The duke spent an uncomfortable night on a sofa
in the saloon and, on the following morning, disembarked
in Zafarana, to be met by the coast guards, who provided
the party with camels and two Sudanese noncommissioned
officers as guides. They left the coast at 7:45, and at 12:15
they were at the monastery. Johann Georg noted a little

petulantly that he could easily have made the journey in
an hour by car and saved "strength and energy," but he did
admit that it would have been impossible to drive the car
into the monastery itself.[129]

After waiting outside the walls of the Monastery of
St. Paul, the visitors were finally admitted through the low
gate which, the duke wrote, had been made in 1927 (fig.
4.11). They were then welcomed with a toll of bells and
warmly received by the monks—the duke counted twenty
of them—and the hegumenos, to whom the duke gave the
patriarch's letter. Although the hegumenos wanted to pro-
long the reception ceremony, the duke prevailed on him
to show them around the monastery without further ado.
The library, the duke concluded, was hardly worthy of the
name, for none of the manuscripts in it was more than a
hundred years old.[130] Johann Georg followed Schweinfurth
in ascribing the eighteenth-century Church of St. Michael
and St. John the Baptist to the seventeenth century and
remarked on two icons, one representing Paul and Antony
with staffs in their hands—he dated it between 1600 and
1650—and one of the Madonna which he thought might be
fifty years earlier. The duke took the Cave Church to date
from the sixth or, at the latest, the seventh century, but he
realized that it had undergone severe renovation, the worst
of which was in the eighteenth century when a "large part

of the ceiling and the walls were daubed with truly hid-
eous frescos."[131] He quoted Schweinfurth but added that
the frescos of the equestrian saints in the front cupola were
about a hundred years earlier and of superior craftsman-
ship. There was another wall painting, he even said, which
was outstanding, representing St. Paul with a long robe and
a staff. He inspected it with a torch and dated it before 1000,
possibly as early as the seventh century.[132]

The duke was equally impressed by two icons, one
of the Madonna and child, which he dated to about 1500,
and one of Mary with Paul and Antony, which he found
particularly well painted and of unique iconographical im-
portance.[133] He also mentioned a bronze lectern in a dark
corner near the entrance, perhaps of the fourteenth or fif-
teenth century, resembling another he had seen in the Cop-
tic Museum in Cairo. He was less pleased by the Church
of St. Mercurius (fig. 4.12). After visiting the orchard and
appreciating the general state of the monastery, but only
seeing the keep from the outside, the visitors withdrew to
the recently built rest house, where they ate a lunch they
had brought with them and drank coffee prepared by the
monks. As they were leaving, the duke was given ten candles
as a present, and Sauer took a number of photographs of
both the monks and the monastery. When he arrived at the
coast, the duke, who was well over sixty, found that his legs

were so stiff that he could hardly walk, and when he board-
ed the boat he had to be hoisted in by his shoulders.[134]

The monastery Johann Georg visited was already
changing. The new gate, rather than the traditional wind-
lass, made it far easier to enter. The rest house, the extension
of which would be completed in 1948, entailed greater com-
fort for pilgrims and other visitors.[135] And Johann Georg's
regrets about not having had a car heralded the coast road
built in 1946 and the road inland to the monastery laid in
the 1980s. His conclusions, however, echoed those of travel-
ers over the centuries. He wrote that St. Paul's was by no
means the most interesting of the monasteries, but the site
was so spectacular and the monastery so suggestive that to
visit it was one of the most exciting moments of his many
journeys in Egypt.[136]

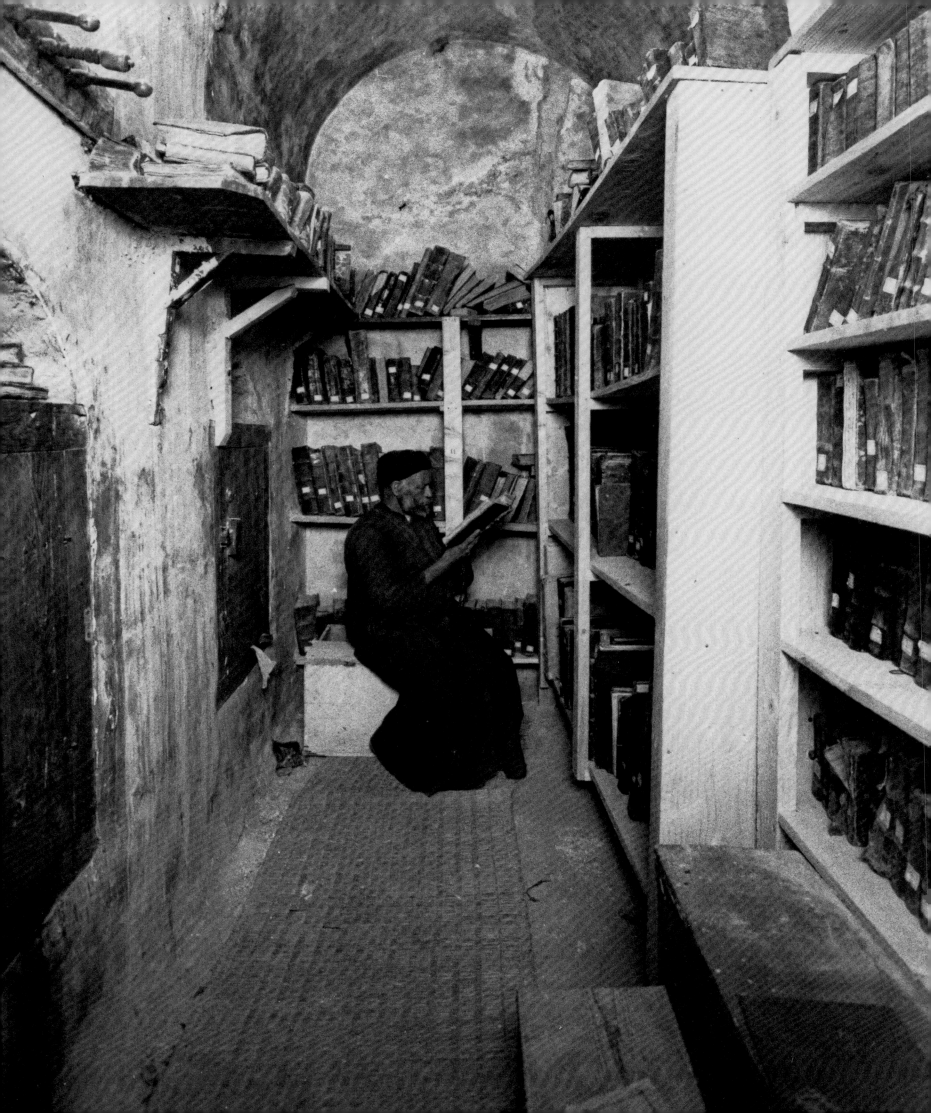

CHAPTER 5 NEW RESEARCH FROM THE LIBRARY OF THE MONASTERY OF ST. PAUL

Marqus Simaika was the first scholar to provide us with a useful description of the library of the Monastery of St. Paul. In 1932 he said it contained 122 biblical, 99 theological, 123 historical, 411 ecclesiastical (liturgical), and 9 miscellaneous manuscripts, for a total of 764. He stated that most of the manuscripts date to the seventeenth and eighteenth centuries, although the oldest date to the fourteenth century.[1] In 1981 the library possessed 891 manuscripts.[2] Magdi Guirguis has pointed out that half of the library's manuscripts were copied in the eighteenth century (figs. 5.1 and 5.2).[3]

The aim of this chapter is to present material from the library that sheds new light on the monastery's history while providing new material for analysis. Much work remains to be done; I was allowed only a few days in the library, working under very inconvenient circumstances. However, the following Arabic excerpts from a number of manuscripts are relevant to the current study of the Monastery of St. Paul.[4] In some cases my translations are not literal but are designed to be comprehensible to the general reader. The Arabic texts are reproduced as they are found; specialists will immediately recognize the errors in them.

The Life of Paul—in Arabic

Paul the Hermit is mainly known from Jerome's fourth-century *Vita Pauli*, written in Latin and then translated and abridged in a variety of languages. Many Arabic texts concerning the life of St. Paul have been preserved in Egyptian monasteries, churches, museums, and libraries. Unfortunately, none of them has been published, although they are mentioned in catalogues and other reference works.[5] The *Life of Paul* in Coptic was published as early as the nineteenth century.[6] Antoine Guillaumont and

K. H. Kuhn traced the origins of the Coptic and Arabic recensions, saying: "A *Life of Abba Paul, the Holy Anchorite,* published by E. Amélineau, has been preserved in Coptic. Amélineau thought that this Coptic Life was an original text that Jerome had simply adapted into Latin. In reality, it is clear that the Coptic text, the explicit of which bears the signature of Jerome, is a free translation of the Latin text. Nevertheless, the notes in two recensions, which the Arabic-Jacobite synaxarion devotes at 2 Amshir [February 9] to Paul of Thebes, present a few peculiarities. Paul is said not to be of Theban origin but a native of Alexandria, and the circumstances of his conversion are slightly different; but in substance this text appears to be dependent on the Coptic version of Jerome's book."[7] However, a special study is still necessary in order to trace the relationship between the Latin, Greek, Coptic, and Arabic texts on St. Paul.

The library of the Monastery of St. Paul possesses at least seven Arabic manuscripts, that include the *Life of*

FIGURE 5.1 LEFT

Library of the Monastery of St. Paul, 1931. Whittemore expedition, B27. Courtesy of Dumbarton Oaks, Washington, D.C.

FIGURE 5.2 ABOVE RIGHT

Manuscript library of the Monastery of St. Paul, 1997. ADP/SP 4 SI144 97.

Paul. They all range in date from the eighteenth to the twentieth centuries:

MS 39 (Hist.), ff. 63a–76b, AM 1457 (1740/1741)

MS 52 (Hist.), ff. 191a–204a, AM 1603 (1886/1887)

MS 80 (Hist.), ff. 1–17 (written on one side only), AM 1649 (1932/1933)

MS 136 (Hist.), ff. 121–45, eighteenth century (date unknown)

MS 148 (Hist.), ff. 1a–21a, twentieth century (date unknown)

MS 151 (Hist.), ff. 252–82, very modern (date unknown)

MS 152 (Hist.), ff. 1a–19b, eighteenth century (date unknown)

The study of these texts shows clearly that they were copied from the same text as the Arabic-Jacobite synaxarion.[8] They feature the same incipit:

قال كان فى ذلك الزمان قبل ان يظهر كثرة العباد
على الارض والجبال والبرارى خالية منهم وليس يلبسوا
شكل الصليب عليهم ولا كان ظهر اسم الرهبان وكان
بالا سكندرية رجل غنى لا يعرف كثرة ما له من الذهب
والفضة والثياب الفاخرة رزق ولدان اسما الكبير بطرس
والاخر بولس

He said: At that time—a time before many worshipers had appeared on earth, when the mountains and deserts were empty of them, when they did not wear the cross, and when the name of "monk" had not yet appeared—there was a rich man in Alexandria. Nobody knew the extent of his possessions of gold, silver, and luxurious clothing. He had two sons: the name of the elder was Butrus [Peter], and the other was Bulus [Paul].[9]

St. Marqus al-Antuni (CA. 1296–1386)

An interesting and unpublished Arabic text on Marqus al-Antuni, a Coptic saint of the Mamluk period, is preserved in the monastery library. Copied in AM 1416 (1699/1700), it bears the number 115 (History). The biography of the saint is followed by thirty-four wonders attributed to him. In spite of the hagiographical nature of the text, with its stories of miracles, it contains valuable historical information. For example, the Cypriot Crusade under the leadership of King Peter I of Cyprus, which resulted in the sack of Alexandria in 1365, found an echo in the life of Marqus (ff. 59a–b).[10]

According to the text of the manuscript, Marqus became a monk when he was twenty-three years old (ff. 8a–b) and lived nearly seventy years in the Monastery of St. Antony at the Red Sea (f. 3a). Soon after becoming a

monk he was sent to the Monastery of St. Paul, where he stayed six years. During that time Marqus lived in a cave (his "tomb") that is now a shrine dedicated to the saint (ff. 9a–b, 11a). He then returned to the Monastery of St. Antony, where he spent the rest of his life (f. 16b).

Marqus died in AM 1102, corresponding to 1385/1386 (f. 50a), at the age of ninety (f. 16a). Thus he was born in about 1296 and lived the greater part of his life in the fourteenth century. Three Coptic patriarchs are mentioned in the text as contemporaries of Marqus: Patriarch John—very probably John X (1363–1369) (f. 24b); Patriarch Gabriel IV (1370–1378) (f. 61b); and Gabriel'ssuccessor, Matthew I (1378–1409), known as Matthew the Poor or Matta al-Maskin (f. 89a). The Mamluk sultan Barquq (1382–1399) is also mentioned (ff. 28b–29a). Some of the thirty-four wonders attributed to Marqus are of special importance insofar as they reflect the suffering of the Christian community in Egypt in the late fourteenth century.

Texts Providing the Dates of Marqus al-Antuni

MARQUS' AGE WHEN HE BECAME A MONK (FF. 8A–B)

فلما اكمل من العمر ثلثة وعشرون سنه حينئذ
اشتاقت نفسه الى الرهبنه

When he was twenty-three years old, his soul longed for the monastic life.

MARQUS AT THE MONASTERY OF ST. PAUL (FF. 9A–B, 11A)

ومضى الى برية العظيم انطونيوس وكان بتدبير من
الله فى تلك الايام ابينا القمص انبا رافائيل
النعناعى مقيما هناك فلما نظر الى الشاب فرح به
جدا ثم اخذ فى تعليمه ايام قلائل وانفذه لدير
انبا بولا ينفرد هناك لان الشاب كان بغير لحيه...
فلما مضى الشاب الى هناك صار لا يخالط احدا من
الاخوه البته ... بل حفر لذاته هناك قبر بجانب
البستان وصار يصوم فى ذلك القبر يومين يومين
... وقد حكى لنا هذا الاب انه اقام بدير القديس
انبا بولا ستة سنين

He went to the desert of Antony the Great. According the will of God, our father the hegumenos Anba Rufa'il al-Na'na'i was residing there in those days. He looked at the young man and was very glad. He instructed him for a few days and dispatched him to the Monastery of St. Paul to withdraw there alone, because the young

man was beardless.…When the young man came to that place, he never mingled with a brother…but he dug a tomb for himself near the garden. He used to fast in that tomb for two days at a time.… That father told us that he lived six years in the Monastery of St. Paul.

LENGTH OF MARQUS' MONASTIC CAREER (F. 16B)

وثبت ساكن بالدير نحو سبعون سنه ولم يخرج عن
ديره يوم قط

He lived nearly seventy years in the monastery, and never left his monastery at all.

LENGTH OF MARQUS' LIFE (F. 16A)

وقد بلغ هذا الشيخ فى السن والكمال الى تسعين
سنه ما تعاظم على الرئيس يوما قط

This elder reached the age of ninety years and never behaved arrogantly toward the abbot.

MARQUS' DEATH (F. 50A)

وكانت نياحت هذا الشيخ فى الساعه السادسه من يوم
الاثنين الثامن من شهر ابيب سنة الف ومائه
واثنين للشهدا الاطهار

The death of that elder took place at the sixth hour on Monday, the eighth of Abib, in the year 1102 of the era of the Holy Martyrs [July 16, 1386].

Miscellaneous Events in the Life of Marqus

THE CYPRIOT CRUSADE AGAINST ALEXANDRIA IN 1365 (FF. 59A–60B)

ان فى دفعة هجموا طوائف من الافرنج على مدينة
الاسكندرية نهبوا اموالها وسبوا حريمها ثم تركوها
ومضوا وحصل على النصارى بسببهم بمصر من الامير
يلبغا كان فى تلك الايام ضيق كثير ثم ارسل رسلا الى
جميع الديار التى تحت سلطانه يطلب اموالهم
وتحصيل اوانيهم فلما بلغوا المرسلين الى دير ابينا
هذا الشيخ حينئذ الامير الذى معهم قبض على القس
متى الرئيس كان فى تلك الايام وعاقبه كثيرا فى طلب
المال ... حينئذ حنق منه هذا الشيخ وانتهر الامير
... وامر الجند ان يطلقوا القس متى ويضربوا
الشيخ عوضا منه ... اوثق هذا الشيخ والقس متى

وجماعة من الاخوه واخذ منطلق بهم الى مصر ثم ضيق
عليهم فى الطريق كثير بالجوع والعطش والمشي حفاة
فى البريه وكان هذا الشيخ كلما سال الامير ان
يسقيهم قليل ماء فلم يفعل بل بالكد دفع لهذا الشيخ
قليل ماء وحده فامتنع الشيخ من ذلك ولم يفعل ان
يشرب الماء وحده دون رفقائه بل طرح الماء امام
الامير وانتهره قايلا هوذا الرب الهنا يسقينا لانه
اكثر منك رحمة ثم رفع عينيه بحده الى السماء
فامطرت لهم مطرا كثيرا للوقت

It happened that groups of Franks attacked the city of Alexandria, pillaged it, took its women captive, then left it and went away. Because of them, great suffering came upon the Christians of Egypt at the hands of the amir Yalbugha. He sent his men to all the monasteries, seeking their money.…When they reached the monastery of our father the elder [Marqus], the amir, who was with them, took hold of the priest Matthew, who was the abbot at that time [he became Patriarch Matthew I in 1378], and punished him severely while asking for money.…Then that elder was angry and reproached the amir.…He [the amir] ordered the soldiers to release the priest Matthew and beat the elder instead of him.…He bound the hands of the elder and the priest Matthew together with the hands of a number of brothers, and started out with them for Misr [Old Cairo]. He greatly oppressed them with hunger, thirst, and walking barefoot in the desert. When that elder asked the amir to give them a little water he refused, but gave a little water only to that elder. The elder did not want to drink water alone without his companions, and threw the water down in front of the amir and reproached him, saying: "Behold, the Lord our God will let us drink, for He is more merciful than you." Then he lifted up his eyes to heaven, and at once a heavy rain fell.

THE ABANDONMENT OF MONASTERIES (FF. 17A–B)

كم من مرة كانت الديار تخلا من الرهبان لانقطاع
القمح عنهم وكان هذا الشيخ يغتذي بالحشيش
والماء ولا يرضى لنفسه ان يمضى الى الريف ابدا
وقد رايت هذا الشيخ يوصي كثير من اولاده قايلا خير
للراهب ان يدوخ ويقع يموت جوعا داخل ديره ولا
يمضى الى الريف ابدا

How often it happened that the monasteries were empty of monks because the wheat supply was cut off. That elder [Marqus] sustained himself with grass and water, and never permitted himself to go to al-rif [the cultivated land]. I have seen that elder commanding many of his sons, saying: "It is better for the monk to feel ill, fall down, and die of hunger inside his monastery, and never to go to al-rif."

THE MEDIEVAL MONK-PAINTER (F. 54A–B)

العجب الثاني من قبل انتقاله في دفعة خرج هذا الشيخ
الى الجبل جمع منه تراب اصفر وطين احمر ولون اخر
اخضر ثم احضرهم الى عند هذا الاخ المقدم ذكره
واشار له ان يصور وكان هذا الاخ لا يعرف صناعة
التصوير بالكليه فانار الله عيني قلبه حتى عرف صناعة
التصوير للوقت وكان لا يصنع شئ من التصاوير ويتم
عمله فيه الا من ذلك الطين

The second wonder that happened before his death:

Once that elder went out into the desert and there gathered yellow dust, red clay, and another color, green. Then he brought them to the aforementioned brother and asked him to paint. That brother did not know the art of painting at all, but God illuminated the eyes of his heart so that he at once knew the art of painting. He did not do any painting or complete his work without using that clay.

DANGER FROM THE BEDOUIN (FF. 54B–55A)

الثالث من عجائبه ان في دفعة ملا الشيطان قلب انسان
بدوي ان يهجم قلالي الاخوه واحدا بعد واحد وياخذ
جميع ما فيهم وكان بتدبير الله في احد القلالي عدة
الواح من الخشب قد ذهبهم بالذهب ذلك الاخ المصور
ليصور فيهم صورة هذا الشيخ فلما هجم البدوي القلالي
جميعهم وجاء الى تلك القلاية ليتسلق اليها
وياخذ ما فيها بسلا من الحائط ضربته في يده
اليمنى فانقلب من فوق الحائط الى اسفل

His third wonder:

Once Satan incited a bedouin to attack the cells of the brothers one by one and to take everything in them. According to the will of God, there were some wooden panels in one of the cells, which that brother the painter had gilded in order to paint them with the portrait of that elder [Marqus]. When that bedouin attacked all the cells and came to that very cell, climbing into it in order to take what was in it, behold, a viper came out of the wall and bit his right hand, and he was toppled from the top of the wall and fell to its bottom.

MARQUS AND THE PAINTING OF ST. SHENOUTE IN THE MONASTERY OF ST. ANTONY (F. 40B)

وفي دفعة رايت هذا الشيخ لام صورة القديس ابو شنوده
على رفضه الخطاه وقال لاولاده تعالوا بنا يا اولادي
نهرب عن صورة القديس ابو شنوده فانه كان يرفض الخطاه
كثيرا ويطرحهم الى الجحيم وهكذا اخذ هذا
الشيخ اولا ده ومضى هاربا عن صورة القديس ابو شنوده

وما كان قصد الشيخ بهذا الا يحقق لاولاده عظم امهاله
واشتياقه عليهم اكثر من امثاله القديسين الاولين

Once I saw that elder reproaching the portrait of Abu Shanuda [St. Shenoute] for rejecting sinners. And he said to his sons: "Come, my sons, let us flee from the portrait of Abu Shanuda, for he often rejected sinners and cast them into Hell." Thus that elder took his sons and went away hurriedly from the portrait of Abu Shanuda. The elder's intention in this was only to emphasize his great patience and kindness towards them, greater than that of earlier saints [fig. 5.3].

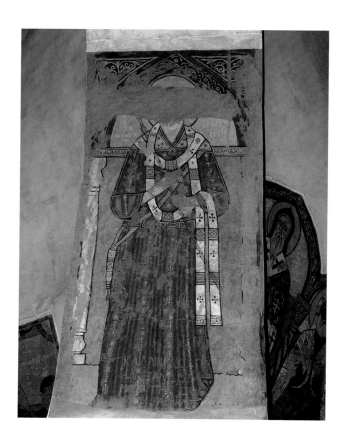

MARQUS AND THE EXAMPLE OF ST. PACHOMIUS (FF. 12A–B)

وكان اذا جلس مع الاخوه على المائده لا يجلس ابدا
الا والكتاب موضوع في حجره وكان في تارة يقرى
ويبكي قليلا وكانوا الاخوه اذا قصدوا يعرفوا ما سبب
بكاه على المائده كان يجيبهم قائلا هكذا سالوا الاخوه
ابينا باخوم عن سبب بكاه على المائده قال لهم
ما بكاني يا اولادي سوى عليكم اذ انا اكل خبزا فقط
وانتم تاكلوا هذا وهذا وهذا

He [Marqus] never sat with the brothers at table without having a book in his lap. Sometimes he read and wept a little. When the

brothers wanted to know the reason for his weeping at table, he answered them, saying: "The brothers asked our father Pachomius about the reason for his weeping at table." He said to them: "My sons, my weeping is only over you; for I eat only bread while you eat this, and this, and this."

The Eighteenth-Century Restoration and Repopulation of the Monastery of St. Paul

In about 1485, a hundred years after the death of St. Marqus, the Red Sea monasteries were abandoned. Patriarch Gabriel VII (1525–1568) repopulated both of them, but by the end of the sixteenth century, the Monastery of St. Paul was once again deserted.[11] It would remain abandoned for more than a hundred years. At the beginning of the eighteenth century, Patriarch John XVI (1676–1718) repopulated the monastery and financed its restoration with the help of the leading Coptic notables, the archons. Laborers sent from Cairo, assisted by monks from the Monastery of St. Antony, repaired the walls and keep, and enlarged the Cave Church. The patriarch provided the wooden screens for the church's sanctuaries, the liturgical vessels, as well as a mill for the benefit of the monks.[12] In AM 1421 (1705), the patriarch, in the company of the great archon Jirjis Abu Mansur al-Tukhi, consecrated the monastery and church. Work on the monastery continued for at least another decade, during which time the monks painted an iconographic program in the Cave Church, and John XVI donated numerous manuscripts to the monastic library.

At least three manuscripts in the monastic library, MS 38 (Lit.), MS 49 (Lit.), and MS 55 (Lit.), refer to the repopulation of the monastery during the patriarchate of John XVI.[13]

MS 38 (LIT.), AM 1424 (1707/1708)

وفي تلك الايام كان الدير الذى على شاطى بحر
القلزم خراب نحو ما يزيد عن ماية سنه بعد
عمارته من الاب البطريرك انبا غبريال الخامس
وتسعين لما عمر الدير الكبير وكاد ان يخفى
ذكره ويبطل اسمه لولا شا الله برحمته واذن
بعمارته ... وكان ذلك فى مدة رياسة الاب
السعيد الفاضل انبا يونس الثالث بعد مايه في
عداد البطاركة ... وكانت القدرة الا لهية
الخفية قبل ذلك حركت الاب الرييس ... مرقس
على الدير الكبير وسعى فى فتحه وترميمه

In those days the monastery [of St. Paul] that lies near the shore of Bahr al-Qulzum [the Red Sea] had been in ruin for more than one

hundred years after its reconstruction by the father Anba Gabriel [VII], the ninety-fifth patriarch, at the time that he reconstructed/repopulated the large monastery [of St. Antony]. Its reputation was about to disappear and its name about to fall into oblivion, had not God in his mercy willed and allowed its reconstruction/repopulation.... This took place during the pontificate of the blessed and eminent father Anba John [XVI], the one hundred and third in the number of the patriarchs.... The hidden divine power had already moved the father...Mark, abbot of the large monastery, to strive for its [the Monastery of St. Paul's] opening and restoration.

MS 49 (LIT.), AM 1421 (1704/1705)

كتب هذا الكتاب بدير ابينا القديس انبا بولا اول
السواح ...وكان عماره هذا الدير وتجديده فى سنة الف
واربعماية وعشرين للشهدا في رياسة ابينا السيد الاب
البطريرك انبا يوانس الثالث بعد الماية وفى رياسة ابينا
الحبر المعظم القمص مرقس ...وفي سنة الف واربعماية واحد
وعشرين حضر السيد الاب البطريرك بصحبة جماعة من
المصريين ...واراخنة وكرز هذا الدير فى ثاني
سنة العمارة وهذا الكتاب برسم هذا الدير

This book has been copied at the monastery of our father Anba Paul, the first hermit,...The reconstruction and renovation of this monastery took place in the year 1420 of the era of the Martyrs [1703/1704], during the pontificate of our father the patriarch Anba John, the one hundred and third patriarch, when our father the venerable hegumenos Mark was abbot....In 1421 [1705] the father, the patriarch, came accompanied by a group of Egyptians...and notables, and he consecrated this monastery in the second year of its reconstruction. This book is dedicated to this monastery.

Kamil Salih Nakhla has published more details about the consecration of the monastery in his Arabic study of the patriarchs, from which the following passage comes.[14]

وقد ظل دير الانبا بولا الاسكندري خرابا مدة مائة
وتسع عشرة سنة ...وكان من عادة الاباء الكهنة
بدير القديس انطونيوس ان يتوجهوا في كل عام
ومعهم المذبح واواني الخدمة فيقدسون في
الكنيسة التي في الجوسق ...عندما زار البابا
دير انطونيوس في سنة ١٤١٧ ش تكلم مع الاب المكرم
مرقس رئيس هذا الدير في شان تعمير دير القديس
بولا... وفي سنة ١٤١٨ ش توجه الاب مرقس المذكور
الى القلاية العامرة بمصر... وارسل له جانبا
من الاخشاب برسم العمارة ...ثم قام الرئيس
بصحبة بنائين وقطاع حجر واثنين من الفعلة واستصحبوا

معه من دير انطونيوس القمص تادرس والقس شنوده
وجماعة من الرهبان الاشداء وتوجهوا جميعا
الى دير القديس بولا وشرعوا في عمارة الدير فبنوا ما
قد تهدم من الاسوار والجوسق واخطروا البابا
بذلك فاهتم باحجبة الكنيسة وارسلها مع طاحون
وادوات اخرى للرهبان بصحبة النجارين فلما تم
تركيب الاحجبة والابواب ... جهز لهم سيادة البابا
اواني المذبح ... واحضرها ... سنة ١٤٢١ ش وفي
صحبته القمص سمعان خادم بيعة السيدة بحارة
الروم والقمص عبد المسيح كاتب القلاية والارخن
الكبير جرجس ابو منصور الطوخي والمعلم مكرم الله
فليفل والمعلم غبريال سليمان الابياري والمعلم سعد
الغمراوى ...لتكريز الكنيسة والمذابح ...وتباركوا
من مقبرة القديس بولس وكرزوا كنيسة انبا مرقس
...ثم قام البابا يوأنس بتعيين القس المكرم بشارة
رئيسا للدير واقام معه اربعة رهبان من دير
انطونيوس ...وقد فصل بين وقف هذا الدير ووقف
دير انطونيوس لضمان راحة الرهبان وعمار الدير

The Monastery of Anba Paul of Alexandria remained abandoned
for one hundred and nineteen years.... Every year it was the
custom of the monk-priests of the Monastery of St. Antony to go
[to the Monastery of St. Paul] with an altar and Eucharistic vessels,
and to celebrate the liturgy in the church of the keep. In AM 1417
[1700/1701] Pope John XVI visited the Monastery of St. Antony
and talked with Hegumenos Mark, the abbot of that monastery,
regarding the reconstruction of the Monastery of St. Paul.... In
AM 1418 [1701/1702] Father Marqus came to the papal residence
in Cairo...and the pope sent some wood for the [monastery's]
reconstruction.... The abbot [Marqus] set out in the company of
builders, stonecutters, and two laborers; Hegumenos Tadarus, the
priest Shanuda, and a number of strong monks from the Monastery
of St. Antony joined him; and they all headed for the Monastery
of St. Paul. They began to restore the monastery, rebuilt what had
been destroyed of the walls and the keep, and informed the pope of
the work. The pope provided for the wooden screens of the church's
sanctuary and sent them, along with a mill and other instruments
for the benefit of the monks, along with carpenters. After the
installation of the screens of the sanctuaries and the doors, the
pope readied the vessels of the altar.... He delivered them in
AM 1421 [1705], when, accompanied by Hegumenos Samʿan (priest
of the Church of the Virgin at Harat al-Rum), Hegumenos ʿAbd al-
Masih (clerk of the patriarch), the great archon Jirjis Abu Mansur
al-Tukhi, al-muʿallim Makramallah Fulayfal, al-muʿallim Ghubriyal
Sulayman al-Ibyari, and al-muʿallim Saʿd al-Ghamrawi, [he came
to the Monastery of St. Paul]...to consecrate the church and the

altars.... They then took the blessing of the tomb of St. Paul and
consecrated the Church of Anba Marqus.... The pope appointed
the venerable priest Bishara as abbot of the monastery, and ordered
four monks of the Monastery of St. Antony to be with him there....
The pope separated the waqf [endowment lands] of this monastery
from that of the Monastery of St. Antony to ensure the sustenance
of the monks and the population of this monastery.

Provision for the Monastery's Library

John XVI donated many manuscripts to the monastery soon
after its reconstruction and repopulation.[15] Some appear to
have been commissioned for the monks of St. Paul's, such
as MS 56 (Hist.), copied in AM 1420 (1703/1704) by Dawud,
priest of the church at Harat al-Rum. It is to be noted that
Harat al-Rum was the patriarchal residence of John XVI.
Other books may have come from the patriarchal library
in Cairo. In AM 1424 (1708) John XVI gave a three-volume
Latin-Arabic Bible to the monastery. It was published in
1671 by the Congregatio de Propaganda Fide, the princi-
pal coordinator of Roman Catholic missionaries. Claude
Sicard, one such missionary, visited St. Paul's in 1716. An
earlier Catholic mission to Egypt very likely presented this
Bible to John XVI, who in turn gave it to the Monastery
of St. Paul.

The reverse of the title page of the first volume of the
Latin-Arabic Bible features a waqf-formula of John XVI
confirming its endowment to the monastery (fig. 5.4)

بسم الله الرووف الرحيم
يا الله الخلاص
هذا الكتاب المبارك المتضمن خمسة اسفار التوراه
وسفر يشوع ابن نون وسفر راعوة واسفار الملوك
وقفا موبدا وحبسا مخلدا على دير القديس انبا بولا
فلا احد معه سلطان من قبل الرب سبحانه يخرجه من
الدير بوجه من وجوه التلاف وعلى بني الطاعه تحل
البركه والشكر لله دايما ابدا نسخ في اليوم
المبارك ثالث عشر شهر برموده ١٤٢٤ للشهدا

In the name of the compassionate and merciful God.

Salvation, O God.

This blessed book, which includes the five books of the Torah, the
book of Joshua the son of Nun, the book of Ruth, and the books
of the Kings, is an eternal and everlasting waqf to the Monastery
of St. Paul. No one has authority from the Lord (glory be to Him!)
to take it out of the monastery or to cause any damage to it at all;
may blessing come upon the sons of obedience! Thanks be to God
forever and ever! Written on the blessed day, the thirteenth of the
month of Barmudah, AM 1424 [April 8, 1708].

FIGURE 5.4

Waqf-formula of Patriarch John XVI, dated 1708, in the Propaganda Latin-Arabic Bible of 1671. Courtesy of the Monastery of St. Paul.

We find John XVI's solemn statement that the donated book has been granted as an inalienable bequest to the monastery in many manuscripts, including:

MS 115 (Hist.): AM 1417 (1700/1701)

MS 79 (Hist.): AM 1422 (1705/1706)

MS 24 (Hist.): AM 1424 (1707/1708)

MS 38 (Hist.): AM 1424 (1707/1708)

MS 102 (Hist.): AM 1424 (1707/1708)

MS 51 (Hist.): AM 1427 (1710/1711)

MS 42 (Hist.): AM 1431 (1714/1715)

Reference to More Books Provided by John XVI

MS 55 (HIST.), AM 1424 (1707/1708)

لما كان بتاريخ سنة الف واربعمايه واربعة وعشرين
للشهدا كان في ذلك الزمان دير العظيم في القديسين
اول السواح والشجعان المجاهد انبا بولا وذلك في
زمان رياسة ابينا الاب السعيد الفاضل انبا يوانس
وقد اهتم له بكتب كثيره وهذا من جملتهم واوقفهم
على الدير المذكور اعلاه وقفا موبدا وحبسا مخلدا
عمره الله بذكره على الدوام وادام الله السلامه من الان
وكل اوان

In the year AM 1424: The monastery of the great one among the saints, the first of hermits and heroes, the striver Anba Paul; during the pontificate of our blessed and honorable father Anba John. He provided many books for it, among them this [manuscript], and endowed them as an eternal and everlasting waqf to the monastery mentioned above; may God keep it populated and peaceful, now and at all times.

MS 55 (LIT.), AM 1424 (1707/1708)

وكان قبل تلك الايام الدير الذي على شاطى بحر القلزم
خراب نحو ما يزيد عن ماية سنة بعد عمارته من الاب
البطريرك انبا غبريال ٩٥ في عدد الابا البطاركة
لما عمر الدير الكبير وعن قليل كاد ان يخفي ذكره
ويبطل اسمه لولا شا الله برحمته واذن بعمارته ...
وكان ذلك في زمن رياسة الاب السعيد المكرم الفاضل
الجليل ابينا يونس انبا يونس الثالث في عدة الابا البطاركة
بعد المايه ادام الله سني حياته بالسلامة وكان يومئذ
متقلد على الكرسي ٣٢ سنة اهتم بهذا التذكار الحسن
لهذا الدير المبارك المذكور ومع كتب غيره

Before those days, the monastery [of St. Paul] that lies at the shore of Bahr al-Qulzum was in ruin for more than one hundred years after it had been repopulated by the father Anba Gabriel, the ninety-fifth patriarch, at the time that he repopulated the large monastery [of St. Antony]. Soon its reputation was about to disappear and its name was about to fall into oblivion, had God not willed through His mercy to allow its reconstruction/repopulation.... That took place in the pontificate of our father, the blessed, venerable, eminent, and honorable Anba John, the one hundred and third in the number of the fathers, the patriarchs. (May God extend the years of his life in peace!) At that time he had assumed the papal throne for thirty-two years. He provided for this goodly reminder [this manuscript] for this aforementioned blessed monastery, and other books as well.

The Flood of AM 1426 (1709/1710)

Although the Monastery of St. Paul is in the desert, every couple of decades torrential rains cause flash floods in the region. This manuscript provides an account of such a flood that occurred only six years after John XVI repopulated the monastery.

MS 47 (LIT.), AM 1422 [SIC.] (1705/1706)[16]

لما كان بتاريخ سنة الف واربعمايه وعشرين
للشهدا الاطهار رزقنا الله بركاتهم امين كان عمار
دير ابينا القديس انبا بولا اول السواح بعد ان
كان شاهق زمانا وعمر في سنة العشرين الى سادس
وعشرين سنة بعد الالف واربعمايه وفى سنة الف
واربعمايه ستة وعشرين حصلت سيول وامطار فى
البر والبحر وان السيول اخربت بلاد عامره
وجزاير انزلها السيل البحر وعم المطر والسيل
في كل موضع بحري وقبلي ومن جملة ذلك نزل
السيل على هذا الدير من الناحية الغربية روضين
متركبين على الدير واحد من بحري وواحد من قبلي

FIGURE 5.5

Illuminated pages of the Psalmody of 1715 (MS 368 Lit.). Notice ʿAbd al-Sayyid al-Mallawani's dotted sigmas. Courtesy of Father Yuhanna al-Anba Bula and the Monastery of St. Paul.

وصبوا الروضين على الصور الغربي فغلبوه ودخل
الما الدير وامتد الما الى القصر من بحري فاخذ
الما من عزمه المحبسة وفتح الصور الشرقي
وبقا الدير مفتوح من شرق ومن غرب فحصل عند
الرهبان انزعاج ...وبعد ذلك بمعونة الله ابننا
الصور افضل مما كان اولا لكن بعد تعب شديد
...فيا اباينا واخوتنا السكان بهذا الدير لا تغفلوا عن
هولاي الروضين وتتعاهدوهم دايما بالبنيان
والبحث والتشييد من اجل ما يندفع الما ويمتلك
الوطا وكنا سكان بهذا الدير عشرة رهبان في
زمان هذه التجربة

The reconstruction/repopulation of the monastery of our holy father Anba Paul, the first hermit, took place in 1420 of the era of the Holy Martyrs—may God grant us their blessings, Amen!—after being empty [correcting shahiq to shaghir] for a [long] time. It was reconstructed/repopulated between the years 1420 [1703/1704] and 1426 [1709/1710]. In the year 1426 there were floods and rains on land and sea. The flood ruined inhabited areas and submerged islands. The rain and flood prevailed everywhere, in the north and in the south. Among other things, the floodwater descended upon this monastery from the western side, where two dikes [rawdayn] were constructed in connection with the monastery, one at its northern

side and the other at its southern. The floodwaters overflowed the dikes and poured into the western wall, overcame it, and entered the monastery. The water reached the northern side of the keep and was so strong that it removed the hermitage [mahbasa] and made an opening in the eastern wall. The monastery [then] remained open on its eastern and western sides. The monks were troubled.... After that, by the help of God, we rebuilt the wall, better than it had been before, but after severe toil.... Fathers and brothers who dwell in this monastery! Do not neglect these dikes! Take care of them always by building, examining, and strengthening them, so that the water will not rush down into the lower part [of the monastery]. We were ten monks dwelling in this monastery at the time of that trial.

ʿAbd al-Sayyid al-Mallawani

One of the most important manuscripts for the history of the Cave Church is the holy psalmody, MS 368 (Lit.), which was copied in AM 1431 (1715) by the priest ʿAbd al-Sayyid al-Mallawani, one of the original five monks, who repopulated the Monastery of St. Paul. He later became Patriarch John XVII (1726–1745), the second of three consecutive monks of St. Paul's to occupy the throne of St. Mark. The most distinctive peculiarity of ʿAbd al-Sayyid's handwriting is his placement of a point in the middle of the Coptic letter sigma (C), as may be seen throughout the Coptic text of MS 368 (Lit.) (fig. 5.5). This same characteristic sigma is

also found in all the Coptic inscriptions of the eighteenth-century program in the Cave Church, leaving no doubt that ʿAbd al-Sayyid wrote these inscriptions as well. He is, therefore, the only person known by name to have been active in the painting of the church in AM 1429 (1712/1713).

The psalmody manuscript is written in two columns, Coptic and Arabic, and has a colophon (ff. 287b–288a) that reads (fig. 5.6):

تم وكملت بعون الله هذه الابصلموديه المقدسه في
اليوم الرابع والعشرين من مسرى سنه ١٤٣١ للشهدا
الاطهار كتبت بدير القديس انبا بولا الله يعمره الى
الابد امين ... والناقل العاجز المسكين الخاطي ... الذي لا
يستحق ان يدعا انسان الحقير عبد السيد الميلاواني
بالاسم قس لا بالعمل وهو احد رهبان دير القديس
انبا بولا اول السواح وهو يضرب المطانيه تحت
مواطي السادة الناظرين في هذه الاحرف والقارئين
فيها ان يصفحوا عن غلطاته

[The transcription] of this holy psalmody has been completed by the help of God on the twenty-fourth day of Mesore in the year 1431 of the era of the Holy Martyrs [August 17, 1715]. It has been copied in the Monastery of St. Anba Paul. May God keep it populated forever. Amen!…The incapable, poor, sinful…copyist, who does not deserve to be called a human being, the wretched one ʿAbd al-Sayyid al-Mallawani, a priest by name and not by deed, and one of the monks of the Monastery of St. Anba Paul, the first hermit, prostrates himself at the feet of those who behold and read this text [lit. "these letters"], [imploring them] to pardon his mistakes.

The Construction of the Church of St. Michael the Archangel and St. John the Baptist, AM 1448 (1732)

In 1732, the great archon Jirjis Abu Yusuf al-Suruji built a new church at the Monastery of St. Paul with the blessing of John XVII.[17] When the work was finished, the patriarch went to St. Paul's to consecrate the church in the company of Jirjis Abu Yusuf al-Suruji and other leading Coptic notables. An account of the construction and consecration is told in MS 117 (Hist.), ff. 147a–160b. The manuscript was written by the man who is well known to students of eighteenth-century Coptic iconography as Ibrahim al-Nasikh (the Scribe). Ibrahim had a long association with John XVII and, toward the end of the patriarch's reign, the scribe began painting icons with Yuhanna al-Armani from Jerusalem. Between about 1742 and 1783 their workshop was the most productive in Egypt.[18]

MS 117 (HIST.), FF. 147A–160B

انه كان الارخن المبجل ... المهتم بعمارة الاديره
والكنايس ... جرجس ابو يوسف الشهير بالمرحوم المعلم
لطف الله ... وحضر الى الدير المبارك ... دير القديس
العظيم انبا بولا اول السواح ... فبينما هو جايز
يتملا من المواضع المقدسة ففكر في قلبه بفكرة صالحه
ونيه خالصه على مكان حسن جدا في ناحية بستان الدير
المذكور من الوجه البحري ان يبنيه بيعه ... فلما
كان في سنة الف واربعمايه ثمانيه واربعين للشهدا
الاطهار حضر هذا الارخن المبارك ... الى القلاية البطريركية
... الى ابينا ... البطريرك انبا يوانس الخامس بعد
المايه وضرب له المطانوه وساله في بنا هذه الكنيسه المذكوره
فاجابه الى ذلك ... فاخذ بركة الاب وتوجه من عنده
وهو فرح ... فبعد ذلك احضر ابونا المكرم ... الراهب
ميخاييل ريس الدير المذكور الذي لانبا بولا وانفذ

احضر اليه جميع ما ينبغي من المون والاخشاب وغيره
كعادة عمارة البيع وارسل صحبته جماعه عمالين من
البنايين والنجارين ... وصاروا العمالين مجتهدين
في العمل والكد نهارا وليلا الى ان كملت على احسن
حال ... اراد الارخن المبارك ان يكرز البيعه المذكوره
فمضى الى الاب البطريرك واعلمه بذلك وسال من قدسه
الطاهر ان يمضى بصحبته ويكرزها بيده فاجابه الى
ذلك ... لانه كان متعبدا في هذا الدير قبل ان يصير
بطريركا ... واسماء الاراخنه المعلم تادرس اخو المرحوم
لطف الله والمعلم ضيف ابن يوحنا البيباري والمعلم غبريال
عبد المسيح المسرعي والمعلم ابراهيم ابن يوحنا بحارة
الروم والمعلم يوحنا الخواجه الدمشقي والمعلم ابراهيم
الخزايني بحارة الروم والمعلم يوسف والد المعلم
المذكور والمعلم موسى الرقاوي ابن خالته والمعلم
يعقوب ابن المعلم نصر الله اشعيا الطوخي والمعلم شلبي
الصايغ والمعلم جرجس الخياط والمعلم شنوده الصايغ
والحاج فهد وابنه عيد ... وفي ليلة السبت المبارك
الرابع والعشرون من بشنس دخول السيد ارض مصر لبس
الاب البطريرك حلة الكهنوت وشريكه الاب الاسقف وبدا
بعمل القداس في بيعة القديس العظيم انبا بولا بالمغارة
المقدسة ... فبعد ذلك قاموا جهزوا جميع ما يحتاج
اليه في عمل التكريز من الاواني وغيره واوقدوا القناديل
والشموع الكثيره الى ان حان الوقت فامر الاب البطريرك
بقراات البشاير والمزامير وايضا النبوات كما هو
مشروح في كتاب تكريز الكنايس ورش حيطان البيعه بالمياه
المقدسه وايضا الهياكل والمذابح وكذلك رشمها بالميرون
الطاهر ... والناقل المسكين ... الحقير ابراهيم
بالاسم شماس ... بدير حارة الروم بمصر المحروسة

The honorable archon...who provided for the construction of the monasteries and churches...al-muʿallim Jirjis Abu Yusuf [al-Suruji], known as [in association with] the late muʿallim Lutfallah...came to the blessed monastery of the great St. Paul...the first hermit.... While he was out walking, enjoying the holy places, a devout idea with a sincere intention took form in his heart: to build a church on a very beautiful spot, the northern side of which is beside the monastery's garden.... In AM 1448 [1731/1732] this

blessed archon...came to the patriarchal residence...to our father ...Patriarch Anba John, the one hundred and fifth [in the number of the patriarchs]. He prostrated himself before him and begged to be allowed to build this aforementioned church.[19] The patriarch agreed...and he [Jirjis] was blessed by the father and joyfully went his way.... After that he [Jirjis] brought our honorable father...the monk Michael, abbot of the aforementioned Monastery of St. Paul, and provided him with all the necessary provisions and wood, and anything else that the construction of churches customarily requires. He sent with him a number of laborers, builders, and carpenters.... The laborers were industrious in the work and toiled, day and night, until [the church] was completed in the most beautiful way.... The blessed archon wanted to consecrate the aforementioned church, so he went to the father the patriarch and informed him of his desire. He asked his Holiness to accompany him and to consecrate it by his own hand. He agreed...because he had been a worshiper [that is, a monk] in that monastery before he became patriarch.... The names of the archons [who accompanied the patriarch] are al-muʿallim Tadurus, brother of the late Lutfallah; al-muʿallim Dayf ibn Yuhanna al-Bibari; al-muʿallim Ghubriyal ʿAbd al-Masih al-Masraʿi; al-muʿallim Ibrahim ibn Yuhanna at Harat al-Rum; al-muʿallim Yuhanna al-Khawaja al-Dimashqi; al-muʿallim Ibrahim al-Khazaʾini at Harat al-Rum; al-muʿallim Yusuf, father of the afore-mentioned muʿallim; al-muʿallim Musa al-Raqawi, his cousin; al-muʿallim Yaʿqub, the son of al-muʿallim Nasrallah Ishaʿiya al-Tukhi; al-muʿallim Shalabi, the goldsmith; al-muʿallim Jirjis, the tailor; al-muʿallim Shanuda, the goldsmith; al-Hajj Fahd; and his son ʿId.... On the night of blessed Saturday, the twenty-fourth of Bashons [June 2, 1732, which was the commemoration of] the Entry of the Lord into the land of Egypt, the patriarch put on his liturgical vestment, and his partner, the father the bishop, as well. He started to celebrate the liturgy in the holy cave of the church of the great St. Anba Paul.... After that they rose and prepared all that was needed for the consecration, the vessels and other things. They lit many lamps and candles. When the time had come the father the patriarch commanded that the readings be read from the Gospels and the Psalms, and the prophecies as well, according to the book of the consecration of churches. He sprinkled the church walls with holy water, and the sanctuaries and the altars as well. He also made the sign of the cross on them with the holy mayrun.... The poor copyist is the wretched one Ibrahim, a deacon only by name...at the monastery of Harat al-Rum in Cairo.

Varia

NOTES FROM 1944, MS 117 (HIST.)

From September 18 to December 23, 1944, Patriarch Macarius III (1944–1945) was in retreat at the Monastery of St. Paul.[20] He stated that the bedouin used to come to the monastery seeking healing from St. Paul. The bedouin also enjoyed the monastery's acts of charity. Hegumenos Misak was the abbot of the monastery at that time.

NOTES FROM 1946, MS 726 (LIT.)

St. Paul and St. Antony appeared in a vision to Hegumenos Misak. The two saints urged him to encase the cenotaph of St. Paul with marble. This occurred in late March or early April 1946. Misak stated that Faruq, king of Egypt (1936–1952), visited the monastery.[21] Misak was consecrated bishop of the monastery on February 22, 1948, with the name Arsaniyus II.

SOME ABBOTS OF THE MONASTERY

MS 31 (Lit.), AM 1522 (1805/1806): Hegumenos ʿAbdu was the monastery's abbot.

MS 704 (Lit.), AM 1579 (1862/1863): Hegumenos Manqariyus was the monastery's abbot.

MS 144 (Lit.), AM 1612 (1895/1896): Hegumenos Yuʾannis was the monastery's abbot.

MS 705 (Lit.), AM 1616 (1899/1900): Arsanius I was the monastery's abbot.[22]

MS 762 (Lit.), AM 1655 (1938/1939): Hegumenos Misak (later Bishop Arsaniyus II) was the monastery's abbot.

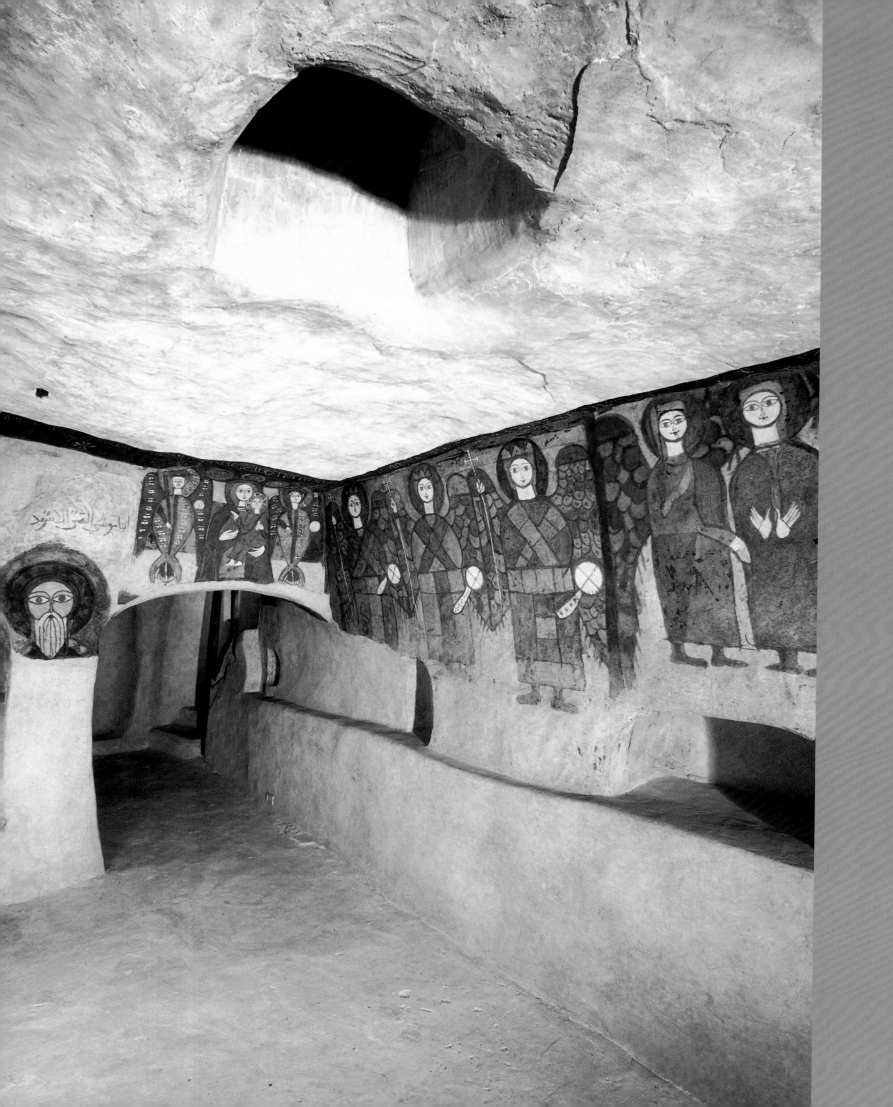

PART II

THE HERITAGE TRANSFORMED

The Cave Church of St. Paul

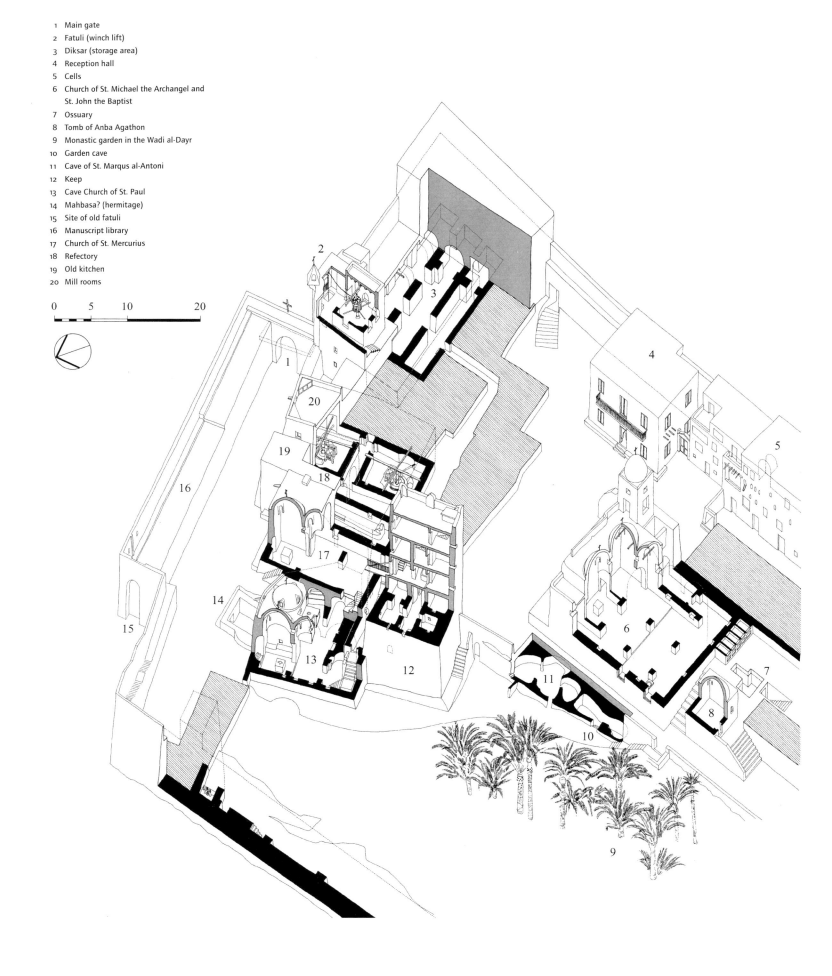

1 Main gate
2 Fatuli (winch lift)
3 Diksar (storage area)
4 Reception hall
5 Cells
6 Church of St. Michael the Archangel and
 St. John the Baptist
7 Ossuary
8 Tomb of Anba Agathon
9 Monastic garden in the Wadi al-Dayr
10 Garden cave
11 Cave of St. Marqus al-Antoni
12 Keep
13 Cave Church of St. Paul
14 Mahbasa? (hermitage)
15 Site of old fatuli
16 Manuscript library
17 Church of St. Mercurius
18 Refectory
19 Old kitchen
20 Mill rooms

0 5 10 20

Peter Sheehan

CHAPTER 6

NEW ARCHAEOLOGICAL EVIDENCE FOR THE ARCHITECTURAL DEVELOPMENT OF THE CAVE CHURCH

The unusual nature of the Cave Church created by its singular combination of built elements and hollowed-out caves defies a seamless inclusion into the architectural history of late antique and medieval Egypt. Perhaps in consequence of this, as well as the greater interest shown in the nearby Monastery of St. Antony, the development of the church over time has received little scholarly attention and only relatively brief descriptions, a situation that is in part also due to the fact that large areas of its medieval and later painted decoration were obscured by soot and more recently cement.[1] In the absence of unequivocal architectural forms through which to trace the development of the Cave Church, we have here relied on the primary source: the archaeological evidence of change and remodeling which survives within the church and which was revealed during the ARCE conservation project (fig. 6.1).

Our recent archaeological work has given a new insight into the fascinating development of the Cave Church, from its nucleus around the original cave dwelling and tomb of Paul the Hermit to its transformation into the richly decorated and deeply venerated medieval core at the center of religious life at the monastery. The historical development of the Cave Church presented here is largely based on the archaeological evidence preserved within the church, including the remains of medieval stone pavements revealed during conservation. These pavements and the contemporary construction of the Haykal of St. Antony are our primary indicators as to how the church was created in the thirteenth century around the cave containing the burial place and former dwelling of the saint. They also provide a context in which the medieval painting cycles and

their relationship to the liturgical and devotional space of the Cave Church can be considered.

The natural rock of which the church is largely composed has been constantly reshaped and transformed over the centuries. Any vision of the form and appearance of the original cave must be largely extrapolated from the evidence of the changes carried out during the medieval transformation and later. The thirteenth-century creation of the Cave Church also provides the starting point for our understanding of the extensive changes made in the rest of the monastery at the same time. Similarly, it provides the baseline from which we can chart the later eighteenth-century modifications to the church, notably the addition of the three large domed chambers along its northern edge and the addition of a new painted program by one of the monks of the monastery. As with the medieval transformation of the Cave Church and its relation to the wider monastery, these eighteenth-century changes were also part of a larger renovation project that has left a significant mark in the archaeological record, from which we can trace the outline of the subsequent postmedieval development of the monastery.

The Nature of the Archaeological Evidence

The Cave Church of St. Paul is composed of elements of three main phases of occupation or construction, and it has been divided by previous commentators into elements forming the "interior" of the cave and "exterior" elements built against it (fig. 6.2).[2] The earliest parts of the church derive from the original cave of the saint, which became in turn a shrine or chapel for the first monastic commu-

FIGURE 6.1

Axonometric drawing of the historic core of the Monastery of St. Paul.

109

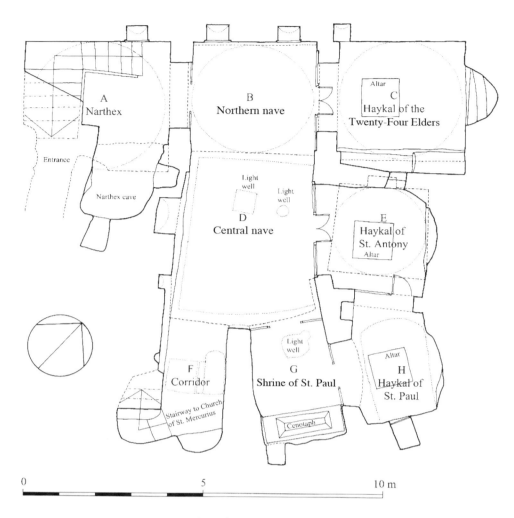

0 5 10 m

FIGURE 6.2

Plan of the Cave Church.

nity. The rock-cut rooms of the church include the present Haykal of St. Paul and the Shrine of St. Paul, containing his tomb, as well as the rectangular central nave and the corridor that leads to the stairs to the upper Church of St. Mercurius. It is not clear, however, whether or to what extent the latter two areas formed part of the original cave. The cave was transformed into the nucleus of the present church in the thirteenth century, at which time the Haykal of St. Antony was added to the east of an enlarged, rock-cut central nave. The rock-cut corridor became the narthex of the church at this time. It was reached by a flight of stairs from the top of the limestone shelf that forms the roof of most of the medieval Cave Church. At the beginning of the eighteenth century the church was modified and enlarged by the addition of three large square domed rooms on the north, consisting of the narthex, the northern nave, and the Haykal of the Twenty-Four Elders, constructed in an east-west direction along the front of the rock face of the hollowed-out cave. The main access was shifted to the stairway located in the first of these domed rooms that allow the three-meter descent to be made into the church from the narrow passage that now runs between the keep and the Church of St. Mercurius.

The construction of the Cave Church reflects both the natural topography of the site and the materials available for building. In the shallow valley running east from the natural spring of the monastery, deep layers of soft yellow limestone tafl alternate with narrower bands of hard limestone rock. This tafl is composed of compacted gravel, clay, and other lime-rich debris washed down the valley by flash floods over millions of years. These formations represent the genesis of the monastery, for it is within the softer tafl layers that the caves of the original monastic settlement were formed. Paul the Hermit and his followers utilized and extended the natural hollows eroded in these layers to create the earliest dwellings at the site. Subsequent builders carrying out modifications to the church also preferred to excavate within the tafl layers. They employed the same raw material for the bricks used to modify the natural topography, line the rough face of the quarried natural layers, and give architectural form to the cave.

Early in the course of the ARCE project we removed the modern cement layers covering the floors and much of the lower parts of the walls, and revealed the natural rock and tafl horizons from which the walls are formed. It was also clear that there was a distinction between these excavated natural layers and the same tafl reused in the form of bricks to fill in the natural hollows in the rock-cut walls. The ceiling and roof further illustrate the division of the Cave Church into natural and built elements. The roughly rounded ceilings of the haykal and the shrine of St. Paul are hollowed out of the tafl. In the central nave this hollowing-out and smoothing was carried out more regularly and carefully, until the band of hard limestone running over the church was reached, providing a more or less flat ceiling at its junction with the gentle inward slope of the tafl walls.[3]

Parts of the church were formed by combining both natural and built elements. The Haykal of St. Antony encloses the entrance to the original cave, and its dome is carried partly on piers of natural rock and tafl, and partly on walls specially constructed for this purpose. Similarly, the three large eighteenth-century domed rooms forming the north end of the Cave Church were built to utilize or abut the natural terrace edge.

Other major guides to the chronological development of the church are the surviving areas of earlier floors and the various layers of wall plaster. Our removal of the cement layers revealed paving stones from the thirteenth-century and hard plaster floors from the eighteenth-century expansions of the church. Most of the wall plaster layers can be correlated with periods of growth, primarily the three

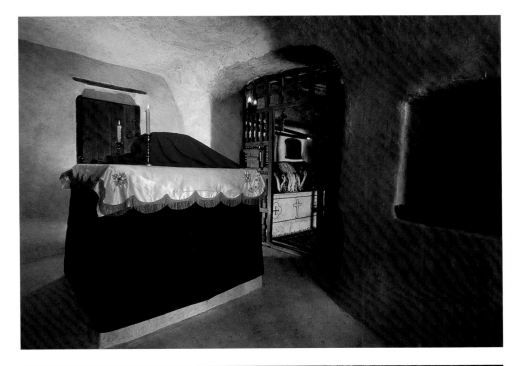

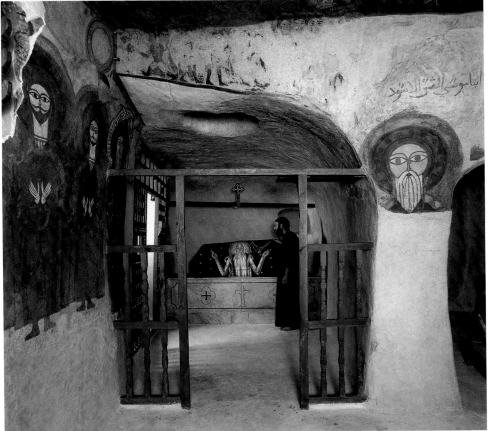

FIGURE 6.3 TOP

Haykal of St. Paul showing the
entrance to the Shrine of St. Paul.
ADP/SP 13 S247 05.

FIGURE 6.4 BOTTOM

Shrine of St. Paul looking south
from the central nave. ADP/SP 3
S212 5 05.

campaigns of mural painting, which are dated through a combination of inscriptions in the church, historical information, and art historical criteria to the first half of the thirteenth century, the late thirteenth century (1291/1292), and 1712/1713. The stratigraphic relationship between these plaster layers and the other features in the church thus provide a chronological framework within which the archaeological evidence can be examined.

Our work largely consisted of recording the key stratigraphic relationships revealed by the removal of the modern cement in the church. Our interpretation of the development of the Cave Church has largely been based on the evidence revealed during this process. The raw data to be considered included the uses of different and distinctive materials or building techniques in particular areas of the walls and floors, as well as the survival or partial survival of features that had been reused, modified, or plastered over. Much of this evidence for changes to the Cave Church over its lifetime has now once again been hidden by plaster and new flooring as part of the ARCE project to conserve the church.

The Original Appearance of the Cave of St. Paul and the Early Monastic Settlement

The earliest parts of the Cave Church are dug into the tafl beneath the limestone shelf that forms the ceiling of the church. What is less clear is which of these present rock-cut parts of the church can be identified with the original cave of the saint. Previous commentators have suggested that the core of the cave should be seen in the three rock-cut rooms now occupied by the haykal and shrine of St. Paul and the corridor. Paul van Moorsel, for example, suggested these rooms were given over, like the cave of Macarius the Great in the Wadi al-Natrun, to prayer, work, and to nightly rest (figs. 6.3–6.5).[4] However, there are several indications that only the first two of these rooms constituted the original cave and the subsequent shrine dedicated to St. Paul. In the first place, the later treatment of these rooms within the medieval church may be adduced as evidence of a special antiquity. It seems clear that monastic tradition has long associated these rock-cut chambers with the life of Paul the Hermit. One room functions as the sanctuary dedicated to the saint, and the other contains the assumed site of his burial.[5]

Archaeological evidence suggests that the original entrance to the cave of St. Paul was through the present passageway linking the haykals of St. Antony and St. Paul (fig. 6.6) This entrance was partially blocked in the thirteenth century by the construction of a pier for the arch that

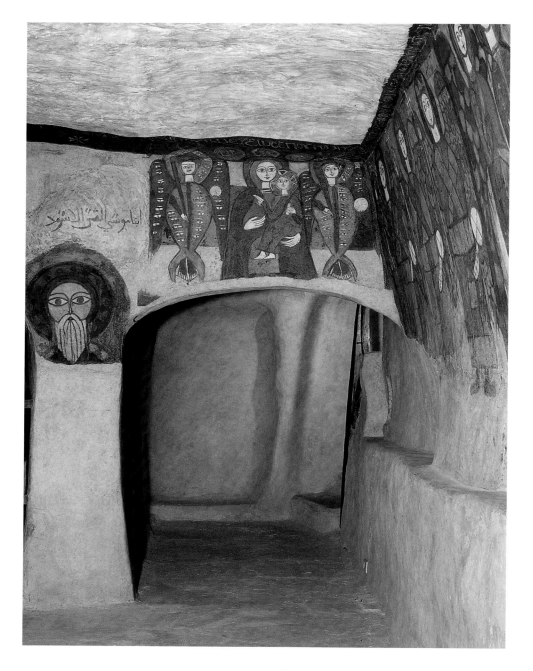

FIGURE 6.5

Corridor looking south from the
central nave. ADP/SP 12 S240 05.

limestone shelf, and although in its present form this re-
flects the changes of the thirteenth century, originally the
nave may have been not solid tafl but a large open space
under the rock shelf, around which a number of smaller
caves opened (fig. 6.7).[9]

If the present central nave was originally an open space,
then another part of the church may also have formed part
of the original cave. This is the undecorated shallow cave
at the foot of the present stairs in the eighteenth-century
narthex, below the Dome of the Martyrs (fig. 6.8). As will be
discussed below, we discovered that this narthex cave was
enclosed within the walls of the medieval Cave Church, just
like the haykal and shrine of St. Paul. Although no monastic
tradition survives concerning this hollowed-out area, its
incorporation within the medieval church suggests that it
may have been another cave hallowed by association with
the hermit and his early followers.

The Caves of the First Monastic Community

Recent work at the monastery has revealed a series of caves
dug into the tafl layer found just below the same limestone
shelf that runs along the southern edge of the monastery
garden and forms the ceiling of the Cave Church (fig. 6.9).
These cells begin to the west of the keep, and it is very likely
that the depth of accumulated soil in the monastery gar-
den has buried more of them further up the wadi toward
the spring. These caves were probably abutted by simple
enclosures or structures built against the outer face of the
rock.[10] Several cells can also be seen dug into the lower end
of the sandstone spur forming the northern edge of the
wadi, and it is again possible that more have been covered
by the buildup of soil. These caves, dug into both sides of
the wadi and watered by a spring at its western end, give us
some idea of the life of the early community, in which the
monks came together around the cave of the saint both for
worship and for mutual protection.

As with the origins of the cave of St. Paul, the nature
of these other caves, carved as they are from the tafl, means
that establishing the date they were first used, and the ex-
tent to which they may have been modified over time, is not
easy. The cave of St. Marqus al-Antuni provides a reveal-
ing example (fig. 6.10). The *Life* of this fourteenth-century
saint mentions that he too dug a "tomb" for himself in the
monastery garden in which to pray and fast.[11] The cave con-
tinues to be used and revered, but we do not know whether
its three rooms are all the work of Marqus or whether some
already existed before the fourteenth century or were added
after his time.

now separates the two haykals.[6] The original access to the
cave was therefore from the north, probably via a natural
path or gulley leading up the side of the wadi.[7] From the
first room, which is now the Haykal of St. Paul, another
opening led to an inner room of the cave, now the Shrine of
St. Paul, where the tomb of the saint is located.[8] The walls of
the shrine mean that access from here to the corridor would
have been possible only if part of what is now the central
nave was also included in the original cave. The nature of
the tafl and the limitations of the physical evidence com-
pel us to consider this and other possibilities regarding the
original configuration of the cave. For example, the central
nave has also been hollowed out from the tafl beneath the

FIGURE 6.6 RIGHT

Entrance to the Haykal of St. Paul from the Haykal of St. Antony. This passageway was the original entrance of the cave of Paul the Hermit. ADP/SP 2 S248 05.

FIGURE 6.7 BOTTOM RIGHT

Central nave looking south from the northern nave. Notice how the exposed limestone shelf has been carved to resemble an arch. ADP/SP 7 S240 05.

FIGURE 6.8 FAR RIGHT

Narthex cave. ADP/SP 17 S241 05.

FIGURE 6.9 BOTTOM FAR RIGHT

Cave of Marqus al-Antuni (bottom right) beneath the Church of St. Michael and St. John. ADP/SP 3 S238 05.

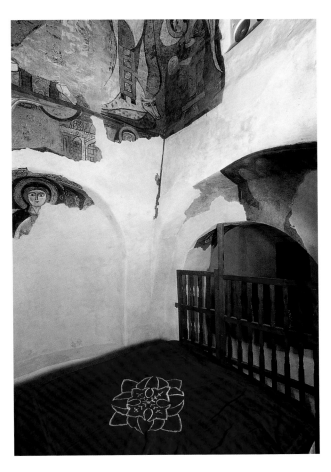

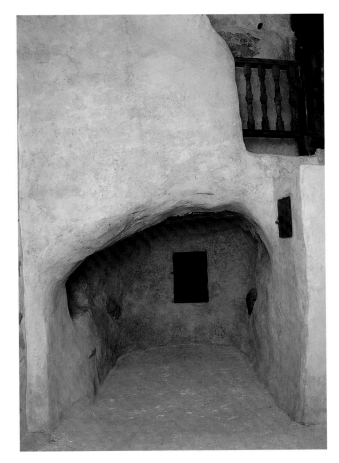

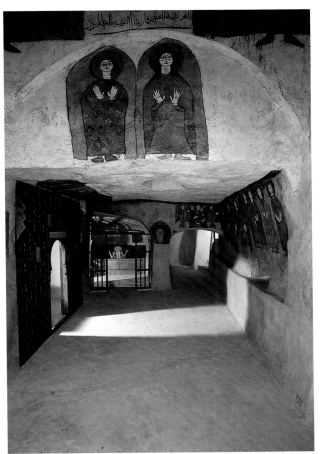

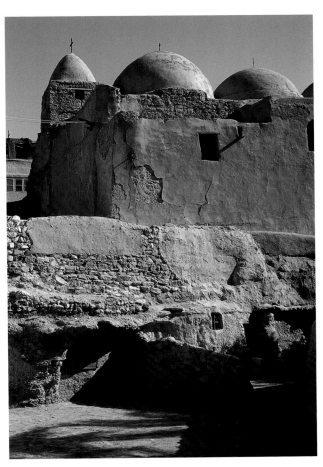

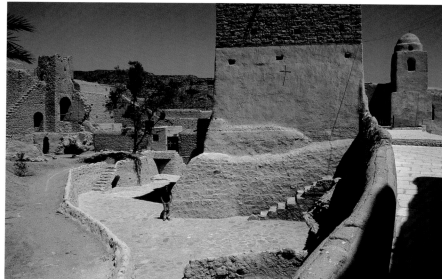

FIGURE 6.10 LEFT

Cave of Marqus al-Antuni. ADP/SP 11 S250 05.

FIGURE 6.11 RIGHT

Lower two stories of the keep, pre-eighteenth century, looking east. To the left is the northeast tower of the medieval walls and to the right is the bell tower of the Church of St. Mercurius. The lowered ground level is part of the ARCE drainage system installed to protect the keep and the Cave Church.

Early Fortifications

The desire to protect the early monks, who lived around the cave of St. Paul, first found expression in the construction of a defensive tower, or keep. Such towers are a feature of monasteries in Egypt from the fifth century onward, and they were a natural response to a declining ability of the central authorities to secure the fringes of the Byzantine empire. The Monastery of St. Catherine on Mount Sinai, for example, received its impressive fortifications from the Emperor Justinian during the sixth century.[12]

The keep was built to provide a refuge in times of danger, when the semi-anchoritic community of monks centered on the tomb of St. Paul still occupied caves in the side of the wadi. The earliest preserved phase in the architectural development of the monastery consists of the two lowest stories of the present keep, which survive below three upper stories added at the beginning of the eighteenth century (fig. 6.11). The level of the wadi floor in the area of the modern garden was at that time much lower than today, so the effective height of the north and west walls of the keep was greatly increased by its location along the southern edge of the wadi. It may be that the ground level on the other two sides was even artificially lowered to provide the same effect. The door, high in the north wall overlooking the wadi, was located so as to be accessible only by a rope or ladder, which could then rapidly be pulled up once all the monks were safely inside.[13] The similarities between the lowest two stories of the keep and the lower part of a ruined building that survives on the rock shelf over the Cave Church (in their materials, the use of simple vaulted rooms and painted plaster with basic

designs) suggest that the latter may also date from this first phase of construction. The two structures may even have been linked in a manner similar to the eighteenth-century drawbridge between the keep and the roof of the Church of St. Mercurius (fig. 6.12).[14]

Despite the sixth-century enclosure of the Monastery of St. Catherine in Sinai and the dating of the walls at Scetis to the ninth century, there seems little reason to ascribe this early date to the enclosure walls of St. Paul's.[15] Abu al-Makarim, the presumed author of the *History of the Churches and Monasteries*, notes that strong walls were in place at the Monastery of St. Antony by the end of the twelfth century but makes no mention of a similar arrangement at St. Paul's.[16] Instead, these walls almost certainly date from the thirteenth century, the time of the transformation of the cave of St. Paul into the Cave Church and the creation for the first time of an enclosed monastery.

The Thirteenth-Century Transformation of the Church of St. Paul and the Creation of the Walled Monastery

The archaeological evidence suggests that the thirteenth century saw the creation of the Monastery of St. Paul in the form we recognize today. The probable focus of this activity, and a rationale for the building of the monastery walls, was the construction and decoration of the medieval Cave Church around the tomb and cell of the saint. The date for the architectural changes within the church is provided by their integral relationship with the earliest paintings, which probably belong in the decade before or after those of the Church of St. Antony, at the Monastery

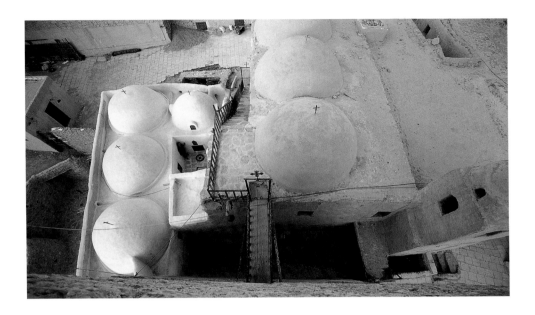

FIGURE 6.12 ABOVE

Cave Church (left) and the entrance passageway between the Church of St. Mercurius (center) and the keep (bottom). Note the drawbridge from the roof of St. Mercurius to the raised entrance of the keep. ADP/SP 3 S239 05.

FIGURE 6.13 RIGHT

Stairs in the corridor of the Cave Church leading to the Church of St. Mercurius. ADP/SP 3 S246 05.

of St. Antony, painted by the master painter Theodore and his team in 1232/1233. The creation of a sepulchral church around the tomb of the saint is paralleled by the tradition that places the tomb of Antony beneath the church of his monastery, a building which was also extensively modified in the thirteenth century.[17] The medieval changes to the Cave Church comprised the excavation or enlargement of the central nave to the north of the original cave, the construction of the Haykal of St. Antony, and the creation of a new entrance leading down into the church from the top of the rock shelf.

The Entrance to the Medieval Cave Church

The construction of the Haykal of St. Antony blocked the former opening from the wadi to the cave of St. Paul, necessitating a new entrance that would serve the newly created Cave Church. The medieval entrance consisted of stairs descending from the upper shelf to the rock-cut corridor. The lower part of the present stairs connecting the Cave Church and the Church of St. Mercurius are a survival of this medieval entrance. (fig. 6.13). The walls of the narrow stairwell are covered by the earliest medieval plaster layer, proving that this entrance was in existence from at least the first half of the thirteenth century and was not a later insertion, as was previously believed.[18] The present corridor thus served as the narthex of the medieval church, located between the foot of the stairs and the southern end of the nave. The truncated remains of a conical dome survive over the central part of the corridor. The dome was probably pierced to provide light and air for the narthex. The main plaster layers on the walls and ceilings are from the earliest

thirteenth-century phase, but the only medieval paintings in this room are the work of the second painter, active in 1291/1292. He created a series of monastic fathers, such as Arsenius and Moses the Black, an iconographic theme repeated in the eighteenth century, even though the location of the narthex was changed at that time.

The upper part of the stairs leading from St. Mercurius is a later eighteenth-century addition, dating from 1780/1781 when the medieval entrance to the Cave Church was enclosed within the upper church.[19] However, the plastered jamb of the original entrance to the narthex survives intact at the point where the present stairs turn to the west. The medieval doorway leading to these stairs also survives about midway along the passageway between the keep and the Church of St. Mercurius (fig. 6.14). This door was blocked during the eighteenth-century construction of the Church of St. Mercurius. Its presence shows that in the medieval period the bedrock over the Cave Church was occupied by other buildings. All this new evidence for the location of the entrance to the medieval church is explicitly confirmed by the account of Jean Coppin's visit in 1638 to the abandoned monastery. "The church, in the place where St.

FIGURE 6.14

Passageway to the eighteenth-century entrance of the Cave Church, between the keep (left) and the Church of St. Mercurius (right), after conservation. The remains of the medieval entrance of the Cave Church are on the lower right. ADP/SP 8 S239 05.

FIGURE 6.15 OPPOSITE

Archaeological plan of the Cave Church.

Paul of Thebes spent sixty years, is set twelve or thirteen feet below the ground and is reached by twenty-three steps; however, it is not a cavern or a cave, but a building made of walls with a man-made vault that shows no sign of weakness in any part. This church, which is not very big, is much longer than it is wide; the entrance is in the middle of one end of its length [l'entrée est au milieu d'une des extremitez de sa longeur]."[20]

The Medieval Construction of the Haykal of St. Antony

While the original cave associated with the life and burial place of the saint were incorporated into the medieval church, the close and dependent relationship of the Monastery of St. Paul with that of the great St. Antony was given architectural expression by the creation of the Haykal of St. Antony. This sanctuary was the location of the main altar of the medieval church, and the symbolism of the altar as the focal point of the church was enhanced by the three rows of windows in the sanctuary dome, providing the main source of natural light coming into the Cave Church. The haykal was created by building tafl brick walls and piers on stone foundations that abutted the shelf of

limestone that forms the ceiling of the nave. False arches cut into face of the rock were used to give the appearance of a regular architectural form to the base of the dome. The arch connecting the haykal with the central nave to the west was formed by simply leaving two upstanding piers of tafl beneath the rock shelf. The former entrance into the cave of the hermit was turned into an arch, springing on the east side from a pier carved out of the natural tafl, and on the west from a brick pier built against the former rock-cut edge of the earlier doorway.

The Stone Pavements of the Medieval Cave Church

We found that two distinct stone pavements were laid to complement the first phase of wall paintings in the Cave Church. The stone used in these pavements indicates a division of the medieval floor plan into two parts, essentially corresponding to the nave of the church on the one hand, and the sanctuary and khurus on the other (fig. 6.15).[21] Along the current west wall, an area over six meters long and one meter wide was paved with fine gray limestone blocks, forming the nave of the medieval church. What was probably a broad khurus, reserved for priests, lay to the east between the narrow nave and the sanctuaries. It is also possible that this space could have functioned as a kind of inner nave for the monks not engaged in the liturgy, with the relatively narrow limestone nave assigned to novices and the laity. In the khurus and within the Haykal of St. Antony, the thirteenth-century floor was a green and extremely friable metagraywacke siltstone known from a number of locations in the Eastern Desert, including the Wadi Hammamat (fig. 6.16).[22] The slightly higher level of the siltstone pavement in the haykal indicates that the distinction between it and the khurus was in relative elevation rather than in the material used. This stone may represent reused material from an ancient site brought to the monastery to create special floors within the khurus and the haykal. Although the stone is badly preserved, enough remains to suggest that the paving was laid as long, narrow stones. Large quantities of debris from this floor were also found in the fill beneath the flagged paving stones (likely a modern feature) of the northern nave and narthex, as well as a number of larger fragments that appear to have been deliberately reburied in the raised "bench" along the south wall of the Haykal of the Twenty-Four Elders.[23]

Careful cleaning and recording in the central nave and the Haykal of St. Antony showed that the arrangement of both the limestone and siltstone pavements is related to an earlier medieval altar, the vestiges of which are preserved

1 Site of original entrance to the cave of St. Paul
2 Haykal of St. Paul, showing current altar
3 Shrine of St. Paul, showing cenotaph
4 Corridor, showing stairs to Church of St. Mercurius
5 Haykal of St. Antony, showing current altar,
 foundations of medieval altar, and surviving
 medieval green paving stones
6 Central nave, showing surviving medieval paving stones
 dividing the room into two distinct areas
7 Haykal of Twenty-Four Elders
8 Northern nave, showing site of medieval
 northern wall
9 Narthex, showing eighteenth-century entrance
 stairway and site of medieval northern wall
10 Narthex cave, showing site of medieval entrance
 and walls
11 Passageway to eighteenth-century entrance to
 the Cave Church, showing original paving stones
12 Site of medieval entrance to Cave Church
13 Domed room tentatively identified as the mahbasa
 (hermitage)
14 Rock-cut passage from garden to keep

Keep

Church of St. Mercurius

Refectory

Old kitchen

Mill room

Mill room

0 5 10 m

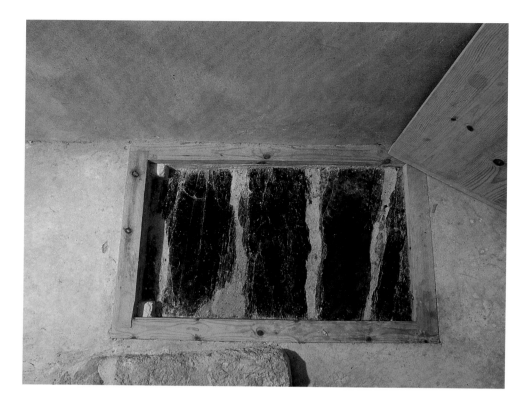

FIGURE 6.16

Surviving medieval paving stones in the Haykal of St. Antony. ADP/ SP 19 S247 05.

under the present altar. The green siltstone floor was laid around the altar, which was then plastered.[24] The three largest stones in the limestone pavement are aligned with this earlier altar, confirming that they represent the location of the principal entrance from the limestone-paved nave into the green siltstone-paved khurus. It is significant, too, that the deep openings cut into the rock ceiling of the nave to serve as light wells should be located over this entrance and along its axis toward the Haykal of St. Antony. Most important, the link between the layout of the stone floors and the medieval painted program is provided by the figure of the Virgin Mary preserved on the lowest part of the east wall of the haykal, which lies on the same alignment formed by the altar and the entrance from the nave.[25]

Access from the nave to the khurus was gained through a doorway in a screen that separated the two areas. The position of holes for the posts of this screen were noted both in the pavement of the church and in the face of the tafl wall that separates the Shrine of St. Paul from the corridor. Both the Haykal of St. Antony and the Shrine of St. Paul were probably separated from the khurus by further screens, although the medieval screens may have allowed much more inter-visibility between these two areas than the present versions. The wear marks on the stones at the southern end of the nave are consistent with this being the main access route from the medieval narthex. The unified relationship between the limestone floor of the nave, the opulent green siltstone floor of the khurus and haykal, the position of the altar, and the earliest preserved cycle

of wall painting all indicate that the medieval part of the Cave Church was essentially formed in the first half of the thirteenth century.

The northern edge of the medieval Cave Church was defined not by the edge of the limestone ceiling but by a wall at least one meter thick. When first exposed beneath the modern cement, the northern edge of the gray limestone pavement was overlain by the irregular limestone flagged paving found throughout much of the eighteenth-century extension to the church.[26] When the flagged floor was lifted, however, the limestone pavement was seen to extend a further meter to the north, where it neatly abuts the line of a robbed-out wall (parts of whose sandstone foundations remain) running east to west more or less through the middle of the current northern nave. During our archaeological investigations we also found some evidence of an earlier arrangement of simple plaster floors in the nave. These may represent the initial phase of the medieval church, before the painting cycles and the insertion of the fine stone floors, although, as discussed above, the possibility should not be discounted that the nave originally formed part of the primitive cave and that these floors are part of this earlier phase.

The stone floors extending all the way to the north wall of the medieval church also appear to clarify at least part of the rather puzzling description of the medieval church made by Coppin in 1638: "And its other side ends in three altars, arranged in the form of a cross in three hollows or little chapels. The one which is closest to the door, and which in consequence must be the main one, is located to the north; it is set back seven or eight feet and takes up a third of the width of the church; two walls forming a corner [*deux angles de mur*] divide the remaining space and form the head of the cross [*la tête de la Croix*]; the two other altars are set back in the same way to the east and the west and form its two arms. This holy place is illuminated by a single window which faces the rising sun [*qui regarde le lever du Soleil*]."[27]

The medieval division of the entire length of the church into nave and khurus revealed by the plan of the stone floors casts doubt on suggestions that there was an additional sanctuary at the northern end of the medieval church.[28] The three "enfoncements ou petites Chappelles" must rather be sought in the three existing rooms that opened off the central nave, namely the Haykal of St. Antony and the haykal and shrine of St. Paul. We have also seen from the previous part of Coppin's description that the medieval entrance to the church was "at one end of its length," so when he talks of the principal chapel being near-

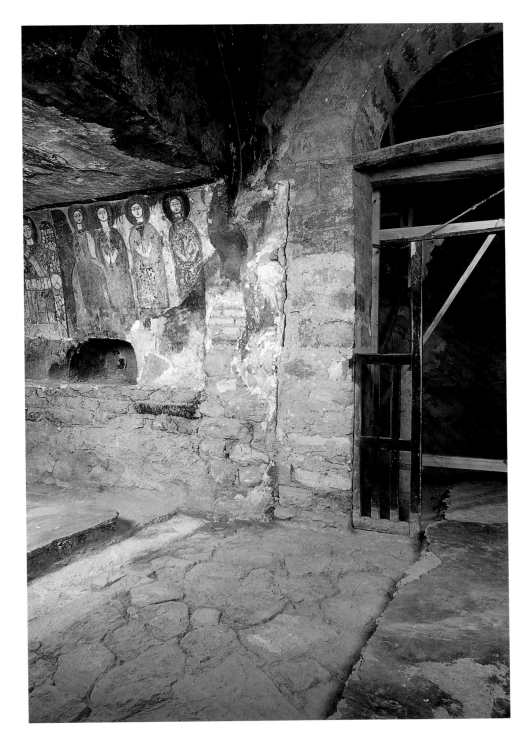

FIGURE 6.17

Northern nave after removal of the
cement, looking west toward the
narthex. The limestone weight-relieving
arch and flagged paving stones (center)
were added to the church in the mid-
twentieth century. The area of floor
to the right indicates the approximate
location of the medieval north wall.

ADP/SP 18 S1119 02.

est the entrance and taking up one-third of the width of the church, it seems clear that he can be referring only to the present Shrine of St. Paul. Given the L-shaped layout of the chapels, Coppin's likening of their arrangement to a cross is not entirely clear. However, he specified that the principal chapel formed "la tête de la Croix" of this arrangement and that it lay to the north. His orientation is based on an open window in the church that he identifies as facing eastward ("qui regarde le lever du Soleil"). The window in question could only be the one in the north wall of the Haykal of St. Antony that was blocked in the eighteenth century. Coppin, off by ninety degrees in his orientation, said the two other altars (which he described as the arms of the cross) lay to the east and the west—in other words, to the north and south. These rooms must be the haykals of St. Antony (north) and St. Paul (south). In this way the Shrine of St. Paul, set forward of the erroneous east-west line created by the two haykals and separated from them by "deux angles de mur," forms the rather notional head of the cross. Coppin's faulty orientation can easily be explained by his having just descended twenty-three steps into an unlit cave, probably without a compass. Similarly, his identification of an altar rather than a tomb in the Shrine of St. Paul does not rule out the identification of this as one of the chapels, since the church at the time of his visit had been abandoned for half a century or more and may have been in a state of some disrepair. He may also have mistaken the remains of a cenotaph in the shrine for those of an altar.

The north wall of the medieval Cave Church (and with it about one and a half meters of the northern end of the nave) was later demolished to make way for the domed chambers of the eighteenth-century extension. It therefore seems highly likely that the second medieval painting cycle originally continued farther to the north, especially since the "ghost" of a painted nimbus can be seen at the northern end of the surviving west wall of the medieval nave (fig. 6.17). It is possible, as has been suggested by van Moorsel, that the depictions of Paul and Antony on the north wall of the eighteenth-century extension of the nave replicate the earlier medieval iconography of the demolished north wall.[29]

We know that the small narthex cave was also included within the medieval church, for remains of the plastered wall forming the original northwest corner of the church survive below ground along the western edge of the cave. The cave appears to have been separated from the nave by an internal wall and was therefore probably entered through a doorway near the point now occupied by the southwest pier of the stone arch built (ca. 1950) to

119

FIGURE 6.18

North wall and northeast corner tower of the medieval monastic enclosure. ADP/SP 13 S1136 97.

support the original arch forming the western entrance of the northern nave.[30] The inclusion of the narthex cave in the medieval Cave Church and the low level of its plaster floor (below that of the earliest floors noted in the nave) also indicate that this cave may represent one of the oldest elements of the Cave Church.

The Walls and Buildings of the Thirteenth-Century Monastery

The creation of the Cave Church appears to have been accompanied by a major effort to provide the facilities for a substantial and permanent community of monks. The greatest task was the construction of the first walls around the monastery; these walls were almost certainly built in the thirteenth century. Supporting this view is the fact that the walls of the monastery are first mentioned in the following century.[31] The scope of the work required for the creation of the Cave Church and the other medieval buildings for which we have some archaeological evidence also fits with the building of the enclosure in the thirteenth century by a community large enough to require such a fortress and numerous enough to man its walls at times of attack.

The earlier core of the monastery—the caves, the original keep, and the garden—was enclosed by this first phase of the monastery walls. The walls are massive sandstone constructions raised further by a parapet wall of tafl bricks (fig. 6.18). The same light material was also used for two-story towers at the corners and in the center of the two long sides of the enclosure. The roughly rectangular circuit of this first enclosure is substantially smaller than that of the present walls of the monastery, although the position of the north wall remained unchanged and continued to be

utilized as the monastery expanded to the south and east in the postmedieval period. As a result of this expansion the south wall of the medieval monastery is now largely hidden by the eighteenth-century "Street of Cells" that abuts its outer face (see fig. 4.10). In this first enclosure, access to the monastery was probably through a gate in the center of the long south wall, immediately to the east of the current bell tower of the Church of St. Michael the Archangel and St. John the Baptist (fig. 6.19). The security provided by the number of monks would perhaps have allowed the use of a gate rather than the fatuli rope lift adopted in later times.

Much of the original circuit of these medieval walls survives intact, although the east wall and the southeast corner have largely disappeared, the west wall is largely rebuilt, and the south wall is thoroughly immured within later monastic cells on both sides. The surviving northeast corner tower and the fragment of the east wall adjoining it indicate that the line of the medieval east wall ran closer to the Cave Church, probably following the edge of the limestone shelf. The regular layout of the medieval enclosure shows that the present fatuli is actually built over the southeast corner tower. Coppin's description of 1638 reveals that the spring lay some thirty meters outside the medieval walls, although he speaks of a vaulted subterranean passage that once led to the spring but that even by his time was almost completely demolished.[32]

We know that other buildings of the medieval core stood over the roof of the Cave Church, for the west wall of the present Church of St. Mercurius lies over an earlier wall in which the doorway at the top of the steps leading to the medieval church is preserved. Other remains of buildings from this medieval phase probably also survive under the eighteenth-century Church of St. Michael and St. John and the current main courtyard of the monastery. They include a vaulted passage recently discovered beneath the terrace along the southern side of the keep, leading from the area of the garden caves to the medieval entrance of the Cave Church.

Eighteenth-Century Changes to the Cave Church

Between 1704 and 1713 the Cave Church underwent further enlargement and repair. Evidence from the nave shows that during this later renovation some of the ashy charcoal preparatory layer, which had been used as a foundation for the third medieval plaster layer, was dislodged and fell onto the floor of the church. We noted its presence in the gaps between the surviving medieval paving stones.[33] In the eighteenth-century, these gaps were roughly filled in with pieces of purple sandstone rubble, similar to that used in

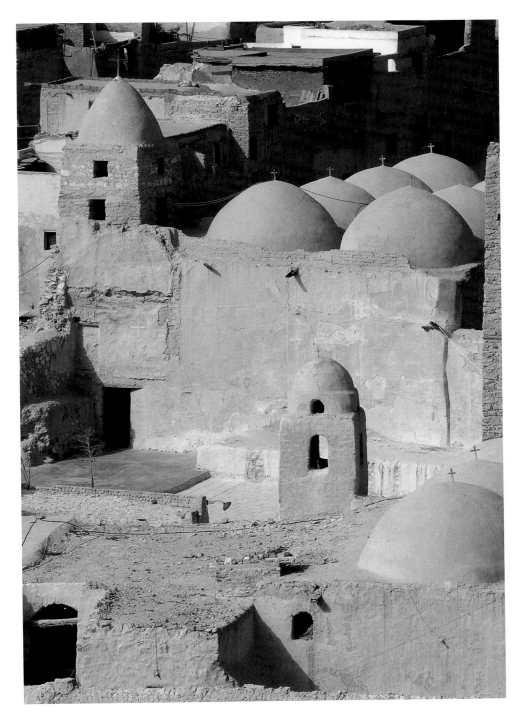

FIGURE 6.19

Vaulted passageway between
the mill rooms and the refectory
(bottom left), the Church of
St. Mercurius (bottom right),
Church of St. Michael and St.
John (middle), and the street of
cells, indicating the position of the
medieval south wall (top). ADP/SP
14 S1135 05.

the foundations for the piers of the newly constructed Hay-
kal of the Twenty-Four Elders. The floor was then leveled
with a layer of compacted tafl as preparation for a smooth
lime mortar that was then spread over the entire floor of
the nave.[34] This same combination of tafl and lime mortar
was also extended into the eighteenth-century rooms of
the church.

The major eighteenth-century change to the archi-
tecture of the medieval Cave Church was the addition of
the three domed chambers along its northern side. This
allowed the nave to be lengthened northward, and created

a new narthex and an additional sanctuary dedicated to
the twenty-four elders. Part of the new narthex was filled
by the stairs needed to link the lower level of the Cave
Church with that of the passageway that currently runs
between the Church of St. Mercurius and the keep.[35] The
narthex chamber is of clearly less formal construction than
the other two eighteenth-century domes. Unlike them, it
is founded partially on the rock of the upper shelf, while
the dome itself is carried on wooden beams laid across the
corners of the square base of the chamber, an arrangement
that is notably simpler than the squinches forming zones
of transition for the domes of the other two rooms. These
differences indicate that the eighteenth-century extension
of the Cave Church was not a single event but took place as
two distinct phases. Documents quoted by Gawdat Gabra
in Chapter 5 show that part of this extension was in place
by 1705, when the church was consecrated by John XVI.
On the other hand, the Coptic inscription in the Dome
of the Martyrs says that the "date of the construction of
this church is the year 1429 [1712/1713] of the holy martyrs,"
which makes it clear that the second and final stage of work
was the construction of the domed narthex that contained
the new entrance of the enlarged Cave Church.

Inside the church, the space for the northward exten-
sion was achieved by demolishing the original north wall
of the nave down to its foundations. Here we found a cir-
cular hole cut down through the remains of the medieval
wall, providing evidence for the presence of a ceramic *laqan*
basin, similar to that noted in the Church of St. Antony at
the Monastery of St. Antony.[36] The foundations of the new
north wall of the church were taken down to the limestone
bedrock beneath the floor of the Cave Church. The wall
supported the northern edges of the domes over the eight-
eenth-century nave and haykal, while three piers built in
a line adjacent to the limestone shelf and the north wall of
the Haykal of St. Antony supported the southern edges.
The piers are composed of purple sandstone foundations
with mud brick above.[37] The two piers at the southwest
and southeast corners of the northern nave were built only
to take the thrust of the east-west arches supporting the
dome, since the space between them is spanned by the solid
rock forming the ceiling of the original nave. The L-shaped
foundation pier at the southeast corner of the Haykal of the
Twenty-Four Elders, however, was constructed to receive
the thrust from two sides of the dome, because the stone
shelf does not extend that far to the east. In the northern
nave the exposed limestone shelf was carved and plastered
in the new scheme to look like another arch supporting the
dome (see fig. 6.7). Similarly, the outer face of the north

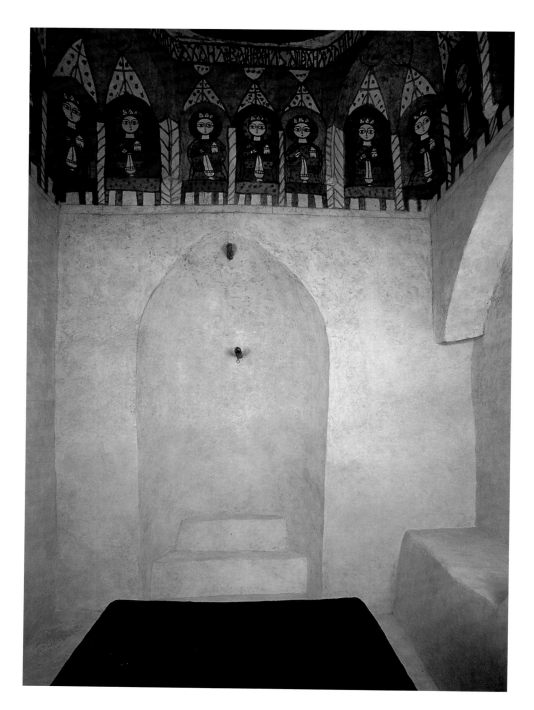

FIGURE 6.20

Haykal of the Twenty-Four Elders, looking east. ADP/SP 11 S249 05.

reconstruction using the large tafl bricks that are a distinctive architectural feature of this phase. Similar large tafl bricks and rubble were also used to repair the medieval west wall of the central nave. The lowest window in the north wall of the Haykal of St. Antony, which was blocked by the new Haykal of the Twenty-Four Elders, was also filled in with these same large tafl bricks.

Eighteenth-Century Changes to the Monastery

The enlargement of the Cave Church and the renewal of its painted decoration marked a conscious and sustained restoration of the monastery that continued throughout much of the eighteenth century. The extension of the monastic enclosure beyond the medieval south wall was stimulated by the continuing growth of the monastery and the need for more secure space in which to locate the monks' cells.[39] There were also more pressing circumstances to consider; for example, the rebuilding of at least parts of the west and east walls that were washed away during heavy rains in 1709/1710. The flood and the damage to the walls are explicitly mentioned in MS 47 (Lit.) in the monastery library, which states how the monks rebuilt the eastern wall "better than it had been before, but after severe toil." This document is particularly valuable in helping us to date the present east wall to the period between 1709 and 1717, the year it appears on a plan of the monastery made for Claude Sicard (fig. 6.21). The repairs currently visible in the west wall can probably also be dated to this period.[40]

Although the drawing by Sicard is a schematic combination of different plans and perspectival views, it is valuable for its depiction of several recognizable elements of the monastery landscape that were clearly in place by 1717. The enlarged keep is depicted with its distinctive battlements, a detail that places its reconstruction and the addition of its three uppermost stories to the first decades of the eighteenth century.[41] The inscription in the narthex dome records that work on the Cave Church was complete in 1712/1713, and the multi-domed "Eglise et Grote du St. Paul" is a prominent feature depicted on the plan by Sicard. The spring of the monastery is shown too, although to the north of the enclosure, not the west. A stream flows from its source in the neighboring hill into a large tank or basin just within the wall, from which a channel leads through the garden. A large plastered tank with a *shaduf* to lift water from it can still be seen in this location at the west end of the garden. Despite the schematic nature of the plan, the location of the ox-driven mill is broadly consistent with that of the present mill rooms of the monastery. It also in-

wall of the Haykal of St. Antony was shaved back to lie within the arch forming the southern edge of the Haykal of the Twenty-Four Elders (fig. 6.20).[38]

In the Haykal of St. Antony, repairs were made to a hole that had apparently been dug or had eroded through the lower central part of the apse in the east wall during the long years of abandonment. As part of these repairs the apse was thickened at ground level, and this rough reinforcement was extended around the inside of the north wall of the haykal. This in turn required the shifting of the altar southward to its present position, and thus its

FIGURE 6.21

Sicard's plan of the Monastery of
St. Paul, 1717 (detail of figure 4.2).
Bibliothèque Nationale de France,
Paris, Section des Cartes et Plans.
Rés. Ge. C. 5380.

dicates that the cells of the monks were scattered along the inside of the southern limit of the monastery, which, during this first phase of the reoccupation, was probably defined by the repaired thirteenth-century enclosure wall. Sicard does not of course show the Church of St. Michael and St. John, which we know was built in 1732 by Jirjis Abu Yusuf al-Suruji "on a beautiful spot, of which the northern side is at the monastery's garden."[42] The location of this church and a number of surviving topographical features suggest that it replaced buildings of the medieval monastery that had previously occupied the same beautiful spot.

The 1717 plan clearly shows the fatuli by which Sicard tells us he was hoisted into the monastery. It is significant, therefore, that our survey of the monastery walls revealed a right-angled corner toward the northern end of the east enclosure wall rebuilt, as suggested by the evidence of MS 47 (Lit.), in 1709/1710. The projecting platform preserved in this section of wall corresponds to Sicard's depiction of the fatuli, while its position on his plan in relation to the garden of the monastery makes a convincing case for this platform having been the location of the rope lift in use during the early years of St. Paul's reoccupation. However, Sicard's plan shows the extension of the east wall as recessed rather than projecting from its medieval position.

The loose arrangement of cells on Sicard's plan were in time replaced by a more orderly street of cells set within

a large southern extension of the thirteenth-century walls of the monastery. An important clue to the date of this enlargement of the interior area of the monastic enclosure is provided by an arched gateway (now blocked) in the center of this new south wall. Directly opposite this gateway a corresponding breach has been made through the thickness of the surviving medieval south wall, connecting to the passage that leads to the Church of St. Michael and St. John. The arch of the gateway shows that it is not a later insertion in the wall, and the route through this gate to the Church of St. Michael, via the breach in the medieval wall, suggests that it is probably either contemporary with or later than construction of the church in 1732. Since there is no archaeological or documentary evidence to indicate that the 1732 phase of activity produced anything other than the Church of St. Michael and St. John, it appears more likely that the enlarged southern enclosure belongs to the next documented phase of activity at the Monastery of St. Paul sponsored by Ibrahim al-Jawhari, in 1780/1781.

It was probably thanks to the patronage of this greatest of Coptic archons that the alimentary needs of the growing community were addressed by the construction, to the south of the Cave Church, of a block of buildings concerned with the storage, production, and consumption of the community's food. A second fatuli built over the southeast corner tower of the medieval enclosure allowed grain and other foodstuffs to be hoisted and then poured through a series of chutes into the great diksar, or vaulted storeroom (fig. 6.22). A passage led from here to the mill rooms and to the refectory of the monastery.

The archaeological evidence discussed by Michael Jones in Chapter 7 shows that the current pair of mill rooms were developed from a single earlier building, and the inscriptions on the beams of both mills indicate that this change formed part of the works carried out under the auspices of Ibrahim al-Jawhari in 1780/1781. As with the relationship between the arched doorway in the southern enclosure and the breach in the medieval wall, the expansion of the mill rooms and their integral relation to the construction of the diksar and the second fatuli could have been achieved only by demolishing parts of the medieval enclosure, which in turn could have taken place only after its replacement (the current south wall) had been built. Our knowledge of the scope of Ibrahim al-Jawhari's works at the Monastery of St. Paul had previously been confined to the construction or restoration of the Church of St. Mercurius commemorated by the inscription above its entrance (fig. 6.23). This consideration of the wider archaeological evidence from the monastery appears to show that the build-

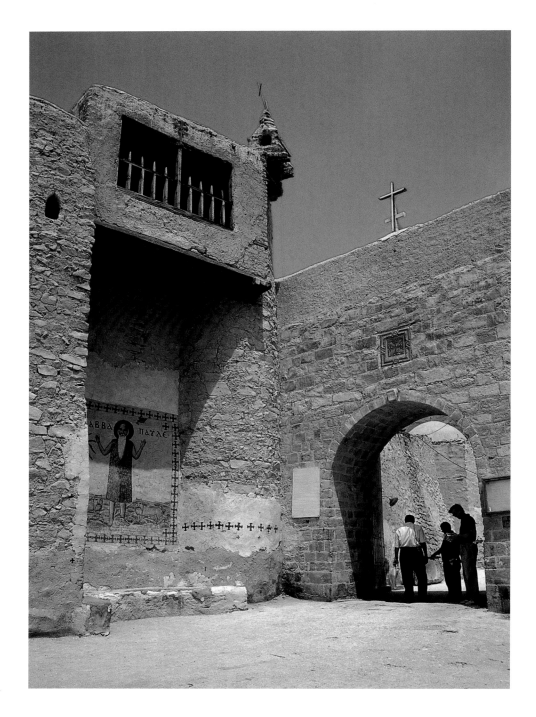

FIGURE 6.22

Fatuli and modern gate. EG 17

S534 95.

ing of the extended south wall, the diksar, and the second fatuli can also be ascribed to his good offices. Such a large program of works is consistent with our knowledge of the activities of Ibrahim al-Jawhari throughout Egypt, and of his stature within the Coptic community, in which he was known as "sultan of the Copts."[43]

The existence of a gate in the southern enclosure is perhaps more an indicator of the importance of the monastery to the Coptic Church of the eighteenth century than of a sense of physical security. As was the case at the Monastery of St. Antony, the gate was probably blocked and opened only for major supply caravans or important ecclesiastical visitors.[44] Thus it is not surprising that the gate does not feature in the accounts of European visitors like Agnes Smith Lewis in 1904, who entered and left the monastery via the fatuli and seems to have been unaware of the existence of any other means of access.[45]

Conclusion

The discovery of the stone pavements of the medieval church and their interrelationship with its architectural space and the first painted program has allowed us to share in the unified vision behind the creation of the medieval Cave Church and given us a glimpse into the minds of its creators. This picture has been completed by the identification of elements of the medieval church that were obscured or truncated by later events, such as the north wall of the church and the doorway at the top of the steps to the medieval narthex revealed in the passageway between the Church of St. Mercurius and the keep.

The scope and complexity of the vision contained within the Cave Church has in turn given us insights into related elements of contemporary medieval activity at the Monastery of St. Paul, such as the construction of the first enclosure and the vitality of the community within its walls. Observing and recording the sequences preserved within the walls of the monastery have also provided, if not conclusive proof of their date, then at least the beginnings of a clear relative sequence for the additions to and expansions of the monastery enclosure.

The fullness of the picture from the medieval period created by the combination of paintings and archaeology allows us to look backward to consider the probable form of the first cave shrine, and forward to view the impact of later changes. Supplementary evidence for the first community has been revealed in the caves of the monastery garden and their relationship to those forming the core of the Cave Church. The first steps away from the semi-anchoritic lifestyle and toward the creation of a more struc-

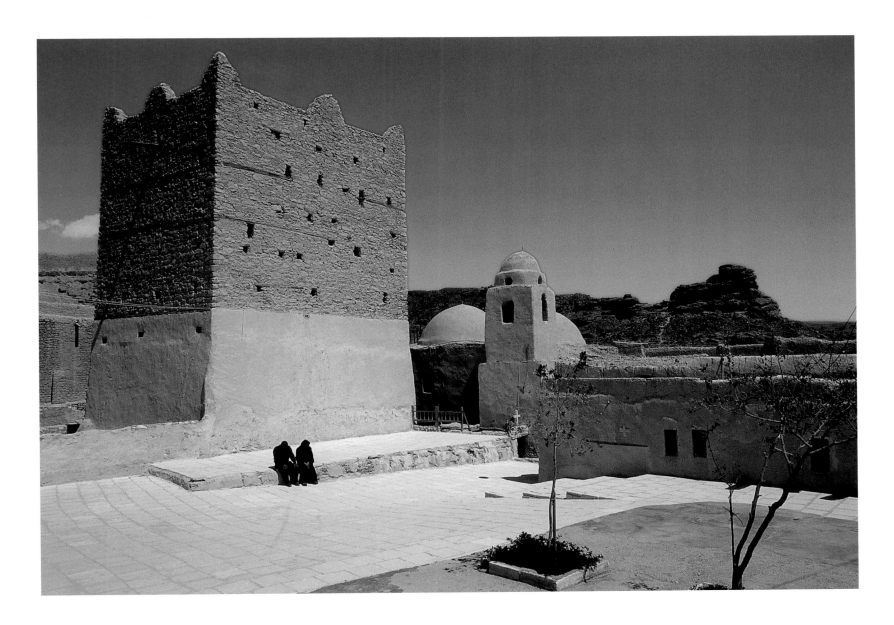

FIGURE 6.23
Keep and the Church of St.
Mercurius, looking northeast from
the central court of the monastery.
The refectory and mill rooms are
behind the low building on the
right. ADP/SP 14 SI133.97.

tured monastery are preserved in the lowest two stories of
the keep and perhaps in the remains of the building on the
rock shelf over the Cave Church.

To our earlier knowledge of the scope and character
of the eighteenth-century restoration of St. Paul's we can
now add archaeological evidence for the foundations of the
domes, the rebuilding of the altars, and the extensive re-
pairs that accompanied the renovation of the Cave Church.
During this same period the monks of the monastery cre-
ated an original iconographic program in the church. While
the unprofessional quality of much of this work provides
a revealing comparison with that of the medieval church,
the scope and intent of the undertaking reveal the strength
of continuity and tradition contained within the revived
community of the Monastery of St. Paul.

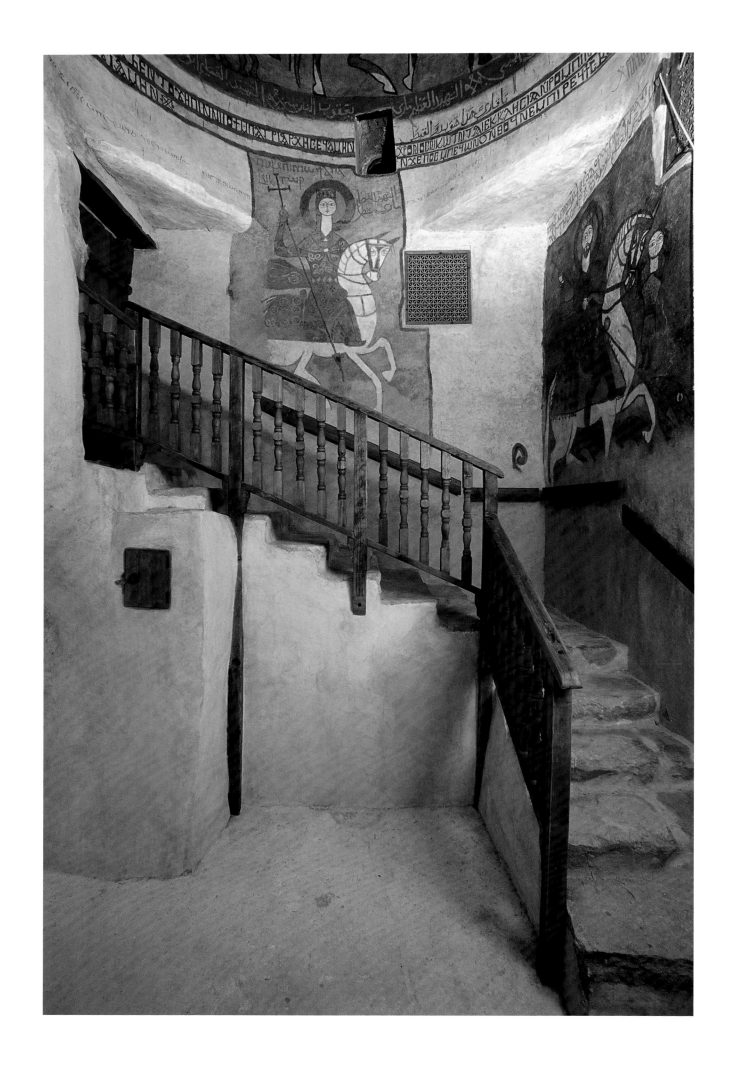

CHAPTER 7 THE CONSERVATION OF THE MILL BUILDING, REFECTORY, AND CAVE CHURCH

FIGURE 7.1

Narthex staircase after conservation.

ADP/SP 20 S240 05.

During the past thirty years the Monastery of St. Paul has undergone an extraordinary metamorphosis. The secluded desert monastery and ancient way of life described by travelers since at least the fourteenth century no longer exists. Improved roads connecting the region with Cairo, a pipeline bringing fresh water from the Nile valley, and the development of the Red Sea coast for tourism have brought the monastery into a new world. A truck carries water to the monastery daily, so the importance of the monastery spring, which was the only water source in the area, has declined. The population has grown from the traditional small community of about twenty-five monks to more than eighty monks and novices. Since the beginning of the twenty-first century, a building boom has overtaken the monastery, so that the ancient walled enclosure is now the "old town" within a new settlement spreading across the surrounding landscape. Nor has development been solely extramural. New buildings within the old enclosure rise three to four stories above the ramparts of the walls. Known in the monastery as Manhattan, these structures dominate the southeast corner beside the main entrance, altering considerably the character of the monastery and the prospect from the surrounding hills.

A steady increase in visitors and pilgrims has accompanied these developments. The distinction between the two groups—the first mostly foreign tourists or residents of Egypt, and the second the Coptic faithful from parishes throughout the country—illustrates the duality of the monastery's mission: combining hospitality with the spiritual life. Members of the first group wish to be placed in a significant context by seeing historical monuments and hearing them described with a recognizable narrative. The pilgrims come to participate in the liturgical life with the monks of St. Paul's and to experience a renewal of their spiritual commitment by being at such a holy place. The two groups may appear to contrast starkly, although there are shared agendas; some foreign churches organize day trips from Cairo, and many of the Coptic pilgrims are interested in their heritage and in the history of the monastery, requesting tours from the monks. Thus the monastery has entered the cultural tourism marketplace.

In response to these conditions, a project carried out in two phases by the American Research Center in Egypt was designed with both the monastery's residents and its visitors in mind. Its purpose was to preserve vulnerable ancient structures and to make them more accessible and understandable. There were three principal aims: the conservation and preservation of the old refectory and the mill building (1997–1999); the conservation and preservation of the Cave Church of St. Paul, including the wall paintings (2001–2005); and, throughout, a photographic documentation of our work at St. Paul's. We also conducted an archaeological study of the historic core of the monastery that significantly enlarged the scope of the project, especially with regard to the Cave Church. The results of that study, as well as an account of the conservation of the wall paintings in the church are presented elsewhere in this volume. This chapter describes the historic buildings and the architectural conservation carried out in both phases of the project (fig. 7.1).

The Mill Building and Refectory

The preservation of this cluster of historic buildings is important for the integrity of the monastery and its present-

FIGURE 7.2

Refectory of the Monastery
of St. Paul, 1931. Whittemore
expedition, B53. Courtesy of
Dumbarton Oaks, Washington,
D.C.

FIGURE 7.3 OPPOSITE

Plan of the historic core of the
Monastery of St. Paul.

day community, which sees these structures as important
reminders of a vanished asceticism that modern monks
should aim to emulate. The mills have been in disuse since
1973, and the original kitchen and refectory were replaced
some fifty years ago, but there are still monks alive who
can remember the traditional life and who can describe the
mills in use.[1] Bread has always been of immense significance
in the life of the monks. It is required for the Eucharist,
celebrated daily in one of the monastic churches, and for
centuries it was a major staple of the monks' diet. Until
fairly recently the community would gather in the refectory
every Sunday after the liturgy to participate in a communal
meal, known as the *agape* (brotherly love) (fig. 7.2).

In the days when the monastery relied on its own re-
sources, annual camel caravans from the monastery's farms
near Beni Suef brought large quantities of wheat at harvest
time in May. The sacks were hoisted to the top of the walls
by the fatuli rope lift and the wheat emptied into a chute
leading to the lower diksar, where it was stored for the year
(see figs. 14 and 15). Close to the diksar is the mill building,
a flat-roofed rectangular structure containing two mills
in separate rooms divided by a vaulted corridor. The mill
building is separated from the old refectory and kitchen by
an east-west passage, part of which is covered with a bar-
rel vault. The refectory is another rectangular room, also

roofed with a barrel vault. It abuts the Church of St. Mer-
curius, which in turn gives direct access to the innermost
part of the Cave Church of St. Paul.

The following description uses an arbitrary north
based on the assumption that the altars in the churches
are on their east sides, although the real alignment of the
buildings, including the churches, is actually northeast to
southwest, as shown on the plan (fig. 7.3).

THE MILL BUILDING

The mill building is constructed in a vernacular style
using traditional materials obtained both locally and from
the Nile valley. The walls are built of a combination of sand-
stone blocks and sun-dried mud bricks made from tafl,
the buff-colored clay occurring in the surrounding wadis,
which is also the basis for the mortars and plasters on the
walls, roofs, and floors. The sandstone was quarried locally
from the hill outside the northeast corner of the monastery
enclosure. The roofing materials comprise palm logs, grass
mats, palm frond ribs (*jarid*), and tafl.

The building contains two mill rooms. An arched
entrance in the middle of the north wall gives access to a
central north-south corridor, which exits the building by
another doorway at the far end, into what was once a small
courtyard leading from the diksar. At the southern end of
the corridor, two facing doorways lead directly into the mill
rooms: one to the east and the other to the west. Each room
houses an animal-driven flour mill of a kind once common
in Egypt, which can be traced back to at least the eighteenth
century.[2] These examples, still in working order, together
with an identical pair at the Monastery of St. Antony, are
rare artifacts of an earlier age. By the early twentieth cen-
tury the mills in the Wadi al-Natrun monasteries had been
dismantled and the useful timber recycled (fig. 7.4).[3]

The walls of the eastern room, the earliest of the
two mill rooms, show three building phases. Initially, the
room was constructed of roughly hewn sandstone masonry,
which survives only in the north, south, and east walls. The
stones of the east wall are preserved to roof level, but those
of the north and south walls have been partially removed,
causing the walls to slope downward unevenly toward the
western end of the room. These stone walls belong to an
earlier structure that was apparently already ruined before
being reconstructed as the present eastern mill room dur-
ing the second building phase. At that time the damaged
walls were built up to roof level in mud brick. Although
the walls are all plastered, the contours of the stone and
brick are clearly discernible. The lower stone sections of
the walls formed three sides of the original building on the

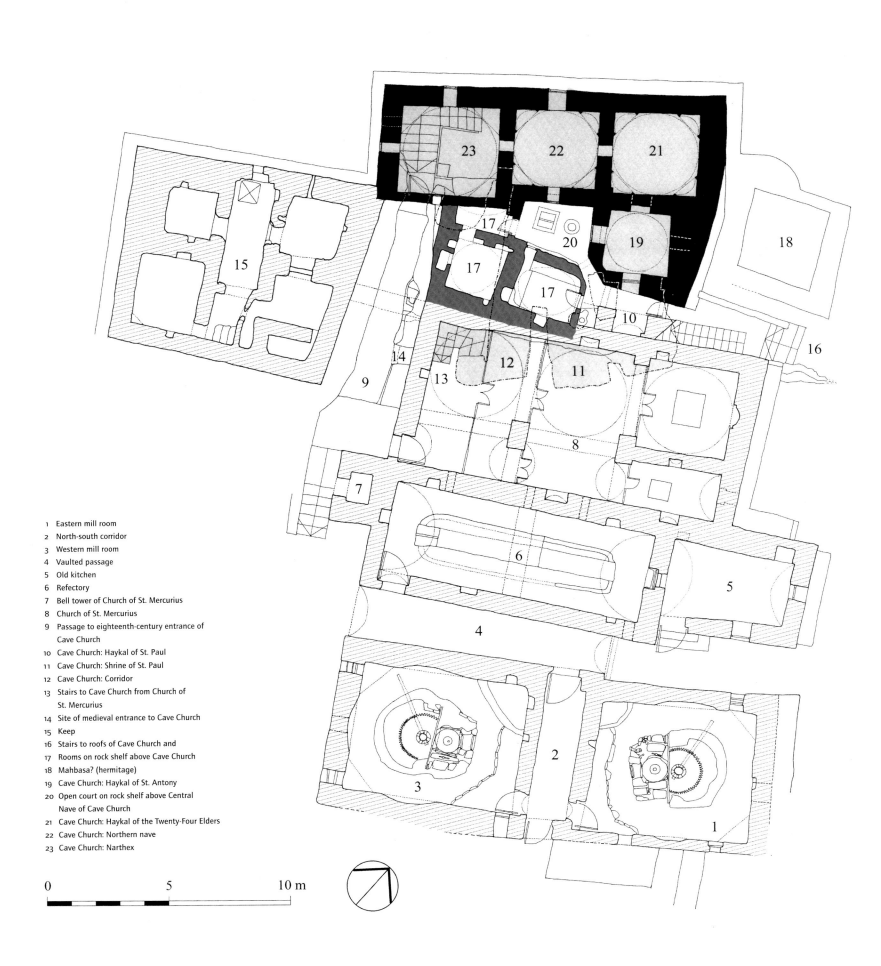

1 Eastern mill room

2 North-south corridor

3 Western mill room

4 Vaulted passage

5 Old kitchen

6 Refectory

7 Bell tower of Church of St. Mercurius

8 Church of St. Mercurius

9 Passage to eighteenth-century entrance of
 Cave Church

10 Cave Church: Haykal of St. Paul

11 Cave Church: Shrine of St. Paul

12 Cave Church: Corridor

13 Stairs to Cave Church from Church of
 St. Mercurius

14 Site of medieval entrance to Cave Church

15 Keep

16 Stairs to roofs of Cave Church and

17 Rooms on rock shelf above Cave Church

18 Mahbasa? (hermitage)

19 Cave Church: Haykal of St. Antony

20 Open court on rock shelf above Central
 Nave of Cave Church

21 Cave Church: Haykal of the Twenty-Four Elders

22 Cave Church: Northern nave

23 Cave Church: Narthex

0 5 10 m

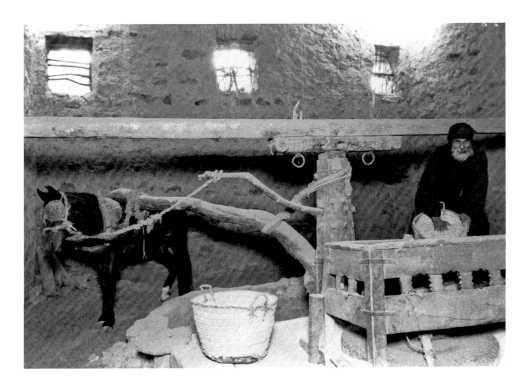

FIGURE 7.4
Western mill room, 1931.
Whittemore expedition, B55.
Courtesy of Dumbarton Oaks,
Washington, D.C.

site. The west wall, however, is built entirely of mud brick and is aligned differently. It belongs to the second, repair phase, when the western mill room and the connecting north-south corridor were also created. Later, in the final phase, the mud brick in the upper northeast corner of the eastern mill room was repaired. The supporting buttress now covering all the original exterior of the east wall may have been built at the same time.

The flat ceiling of the eastern mill room is constructed of palm logs, wooden rafters, matting, and jarid supported on two massive timber poles that rest on corbels in the north and south walls. On the south side these poles extend through the wall to the outside, where they are supported again on a corbel. Many old timbers are reused in the roof, including rafters, which bear cuts in the wood unconnected with their present use, and the two lateral supporting poles, which were formerly ships' masts. Three windows are positioned in the north and south walls almost at roof level. A modern building constructed outside now blocks one of the windows in the south wall. A window in the stone portion of the east wall belongs to phase one and was damaged prior to the mud-brick rebuilding of phase two, when it was blocked with mud bricks; later still, perhaps during the final phase, it was covered by the buttress on the outside of the wall. In the northwest corner of the room a small area is sectioned off for keeping grain while grinding was in progress. There are lamp niches in the east and west walls.

Various artifacts have been collected here. The largest and most conspicuous is a canoe with a pair of oars and a

boat hook, used by monks for fishing when the sea was a major source of food for the monastery. Among the other objects are a wooden screw press for olives, storage jars made of pottery, and various broken elements from old mills, including a wooden central shaft and the middle part of a spur wheel.

The western mill room was constructed in the second architectural phase, along with the west wall of the eastern mill room, and the corridor dividing the two mills. It seems to have been built onto the west end of the earlier stone building, incorporating part of its stone south wall. The other walls are of neatly coursed mud brick. This suggests that there may have been only one mill room originally, rather larger than either of the present ones, and that this arrangement was later changed to the present layout.[4] There are four windows, one high up in the older stone-built section of the south wall just inside the door, identical to those in the south wall of the eastern mill room, and three in the west wall. The northeast corner of the room is sectioned off, like the opposite corner in the eastern mill room. Among the objects collected here are three large ceramic storage jars with woven palm-frond jackets (the kind once used for storing cheese) and a broken quartzite bed stone from a mill (fig. 7.5).

THE MILLS

Each room contains an identical flour mill installed in a sunken horseshoe-shaped pit, roughly in the middle of the room. The open part of the pit contains the driving machinery, made of timber with metal bracing. In the center is an upright wooden shaft acting as the pivot. Crossbeams holding the shaft in place extend from the top of the shaft to the walls of the room. The vertical shaft is fitted with a pole for harnessing a horse, which drove the mill by walking around the room. The pole is the maximum length permitted by the width of the room, and bays in the walls increase the turning space for the horse. In the bottom of the pit, the base of the vertical shaft is attached to a horizontal wooden spur wheel, which drove a lantern gear under the millstones. A vertical spindle forms the axle of the lantern gear, and this protrudes upward, passing through a hole in the center of the bed stone and into a hole in the center of the grinding stone, where it is fixed in place. The bed stone is a massive quartzite slab set into a recess in the squared-off side of the pit where it is supported on a timber frame.[5] It has a convex upper surface and a raised lip around the outer edge with a small groove cut through the center of the lip on one side. The grinding stone, which rests on top of the bed stone, is made from a circular, dish-shaped slab of

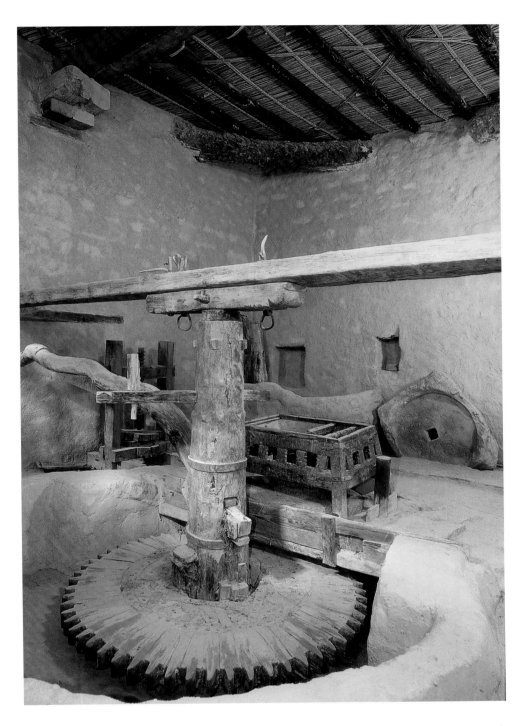

it into the hole in the central boss on the upper surface of the grinding stone. The hopper in the eastern mill room is a typical example of its kind, carved on one side with elaborate geometric patterns and an inscribed panel commemorating a group of individuals who may have been the donors and the carpenters.

بركات ابن حبش

نصرالله ابن حبش

اولاد زكارس الفلاحين

Barakat, son of Habash
Nasrallah, son of Habash
The sons of Zakaris, the farmers.

A pit on one side of the pavement allowed a basket to be inserted to collect the flour and also provided access to the lantern gear for maintenance. The bed stone and grinding stone could be separated for cleaning, as well as adjusted to provide different grades of flour, by means of a lever that raised and lowered the grinding stone.

Both mills have an inscribed wooden beam facing the doorway of the room, inset between the top of the shaft and the crossbeams. In the eastern mill room the inscription reads:

وكان المهتم في هذه العمارة المعلم ابراهيم جوهري

وكان أيامه ريس القس...

عبده في العزبة ش...

وكان مشيد العمارة عازر وكان نجار المعلم نخلة السويفي

أذكر يارب عبدك بن بشارة النجار

The one who was interested in this building was the Master Ibrahim Jawhari, who in those days was the supervisor of the priests…'Abdu on the farm…[?] The builder of this building, Azzar, was the carpenter of the Master Nakhla al-Suwayfi. Remember O Lord your servant, the son of Bishara the carpenter.

The text mentions the benefactor Ibrahim al-Jawhari, the carpenter, whose full name must have been Azzar ibn Bishara, and Nakhl al-Suwaifi, another late eighteenth-century archon.[7] The lacuna in the text was caused when a section was cut out of the beam to fit over the pivot block of the present mill shaft, suggesting that the inscribed beam was reused in its present position.

The inscription in the western mill room reads:

وكان تاريخ عمل هذه العمارة سنة [١٤٩٧]

The date of the work on this building was [the] year [AM] 1497.

FIGURE 7.5

Western mill room after conservation. ADP/SP 9 S147 99.

vesicular basalt.[6] The carved upper surface is concave with a protruding round boss in the center. The lantern gear and bed stone are concealed under the grinding stone, which is surrounded by a stone pavement creating a working surface for the miller.

The grain was fed through a wooden table hopper, which stood on the stone pavement and straddled the grinding stone. As the mill turned, it set up a shaking motion that caused the grain to fall steadily into a shovel-shaped wooden chute tied under the hopper, thus guiding

While no names are mentioned, the date 1780/1781 (written in *epakt* numerals) is important for linking the installation of the mill with the works of Ibrahim al-Jawhari, who built (or restored) the Church of St. Mecurius in the same year.[8] These inscriptions may not date the present mills precisely, as both probably have been dismantled and reconstructed since they were first erected, with the inscribed commemorative beams reincorporated. Nevertheless, the inscriptions refer to a major period of renovation at the monastery in the late eighteenth century, which seems to have included the installation of a pair of mills, probably of the same kind as those still here.

The absolute chronology of the mills and the mill building is uncertain because the documentation begins late in the monastery's known history. The original stone building may have been built to house the mill, installed circa 1703–1705, when the monastery was being restored under Patriarch John XVI.[9] If this is the case, the second mud-brick phase, which divided the building into two rooms with the corridor, could belong to the intervention of Ibrahim al-Jawhari in 1780/1781. This is plausible because the inscriptions on both mills record this event, and the two rooms were clearly designed for mills of this kind. However, if this is correct, it is hard to imagine why the stone building should have been so damaged after fewer than seventy years, unless it was partly demolished on purpose. Another interpretation might present this earliest structure as the ruins of a medieval building whose remains were renovated in mud brick to form the present building in the early eighteenth century. Ibrahim al-Jawhari's mills could have been installed inside this building later in the same century, and repairs to the walls could have been done at any time afterward. A fourth, adjacent building phase was the construction of the vault over the east-west passage between the mill building and the old refectory.

THE VAULTED PASSAGE

The north wall of the western mill room forms the south side of the east-west vaulted passage, while the south wall of the old refectory forms the opposite side. The passage connects a lower, eastern courtyard (now just within the main gate of the compound) with the upper, central courtyard of the monastery. The entrance to the mill building is just inside the east end of the vault, and the refectory door is on the right near the upper, west end. At the east end, two wooden beams span the arch between the mill building and the refectory. The upper beam, a rough log from an acacia tree, is a structural member inserted when the upper sections of the mill building wall and the refec-

tory wall were built. The lower beam is a section of reused timber inserted later as the lintel for a door that once closed off the lower end of the passageway and eastern courtyard from the rest of the monastery.

Both sides of the passage are reinforced with sandstone blocks, 40 centimeters thick and set in tafl mortar, that were added for support when the vault was constructed. This indicates that the vault was built after the mill building and refectory. The lower, more vulnerable surfaces are coated in successive layers of thick lime plaster mixed with tafl and sandstone chips. Above this level the tafl plaster is coarser and applied in large lumps smeared by hand over the stones. The vault is also built of coursed sandstone masonry faced with the same coarse plaster as the upper parts of the walls.

THE OLD KITCHEN AND REFECTORY

These two rooms now form a single structure, although the building styles and the different alignments suggest that they developed into their present form at different times. The kitchen, at the east end of the corridor opposite the eastern mill room, was converted into an office in the 1980s and is now completely plastered and painted inside, with no original features visible. The walls are of sandstone masonry, similar in style and alignment to the north wall of the eastern mill room. The east wall of the kitchen is supported by a sandstone buttress that covers the lower part of the original outer face. Above the top of the buttress the wall contains a single large rectangular window. A chimney, built of neatly coursed sandstone blocks with a mud-brick coping, remained intact on the roof until 1995, when it was partly removed so that its stone could be used in new building work.

The refectory abuts the west side of the kitchen. The walls are built of evenly coursed sandstone masonry. The exterior of the south wall is thickly plastered on the lower surfaces, with coarser plaster higher up, matching the opposite wall of the mill building. The west wall, facing the central courtyard of the monastery, has a large arched window fitted with reused wooden bars. The northern edge of the window is partly obscured by the later bell tower, built in the space between the window and the entrance to the Church of St. Mercurius, at the top of the steps leading to the Cave Church. The north wall of the refectory is the south wall of the upper church.

The interior of the refectory is a plain, rectangular room with a barrel-vaulted ceiling supported in the center by an arch. A low hatch in the east wall now filled with modern limestone blocking originally connected with the

FIGURE 7.6

Refectory after conservation.

EG 17 S33 04.

ern end. At the west end there is a V-shaped, stone lectern built into the table from which a monk would read during meals. Today the table is covered by a variety of domestic items, from cooking utensils and wooden eating bowls to a coffee grinder, ceramic storage vessels, and a whiskey jar from Belfast (fig. 7.6).

Conservation of the Mill Building and Refectory

An architectural conservation project was carried out in the refectory and mill building between December 2, 1997, and May 2, 1998. The buildings were architecturally sound, with only superficial cracks in the masonry and slight damage caused by neglect in the years since they fell out of use. The walls of both buildings, the vaulted ceiling of the refectory, and the vaulted passageway between them had been patched with cement and festooned with electric wires, many of them not in use. It was important to engage the monks for whom the monastery is home, and to be aware during the work that throughout the centuries the monastic community had always found its own solutions for maintenance and repairs. Conservation was implemented by El-Dahan and Farid Engineering Consultants, Ltd., directed by Rami el-Dahan and managed on site by Karem el-Dahan, with a team of workmen from Abusir (near Cairo) and Fayyum. Their strategy was to "apply an architectural language that restores the place not only physically, but also preserves it spiritually."[10]

THE MILL BUILDING

The eastern mill room was in good condition and required only minimal treatment. The walls and floor were cleaned, and excess electrical wiring was removed. The western mill room was more complex. The roof had collapsed during the 1980s and had been replaced by planks supported on a steel girder covered with a cement screed. Not only was this new roof completely incompatible with the character of the historic structure, but also the weight of the materials, particularly the steel girder, threatened to compromise the mud-brick walls.

The objects stored in the room were removed and scaffolding was erected. The modern roof was removed and a new one constructed based on the traditional materials and techniques employed to build the surviving roof in the eastern mill room. Two massive crossbeams of seasoned conifer timber were placed on two wooden corbels on the north and south walls. Double pairs of wooden rafters were laid over the crossbeams, resting on the tops of the east and west walls. Jarid strips, laced together with palm fiber string, were spread over the rafters to support a layer of

old kitchen. Two small rectangular windows high up in the north wall, level with the spring of the vault, open into the Church of St. Mercurius. The room is almost filled by a long table in the form of a solid, tafl-plastered brick bench. The table is in two parts, a narrow eastern section and a wider western section; the latter appears to be an enlargement of the original table. The low sitting bench along both sides of the eastern part does not continue against the western section; this section could have been for serving food rather than for eating, which might have been confined to the east-

mats. At this stage a modern addition was included in the form of plastic sheeting to prevent seepage in the event of rain. Then, returning to traditional methods, a layer of tafl mortar 5 centimeters thick was spread over the plastic, and the outer surface was finished with a layer of thin sandstone tiles. The roof was given a 5 percent slope to a wooden gutter on the east wall of the mill building to prevent ponding of rainwater.

The exterior work on the roof was extended to include the whole of the building. A modern outer cement screed was removed from the roof of the eastern mill room and a layer of plastic sheeting spread over the original jarid. This was then covered with new tafl mortar and sandstone tiles in the same sequence as the new roof over the western mill room. The original skylights in the four corners of the building were open, and the damage caused by rainwater and dust was evident on the inside walls. New wooden frames fitted with single windowpanes were constructed to cover the openings in the form of a *malqaf,* the traditional ventilator on Egyptian roofs.

THE VAULTED PASSAGE

The walls and vault were cleaned and the cement patching removed. New plaster was added to the surface, and the stones on the upper parts of the walls and vault were repointed using a mixture of tafl and sand. The electrical wiring that was still in use was fixed and concealed.

THE REFECTORY

One deep crack and several smaller fissures were visible running the entire length of the vaulted ceiling of the refectory. The crack was found to be filled with dust and cobwebs accumulated over a long period, and it was concluded that the crack was old and inactive. Following the standard response of minimum intervention, only the widest cracks were grouted with tafl mortar. The walls were also treated. Defunct electrical fittings and wires were removed, and cracks were grouted with the same mortar used in the vault. Sandstone paving slabs were laid to protect the earth floor.

A new lighting system was installed. Because the integrity of the sandstone walls was a major concern, no electrical conduits were inserted into the walls. Instead, cables were buried in the earth floor, and four floor lights were installed. A wooden box was fitted to the wall inside the door to contain the light switches.

The wooden door and frame were cleaned and numerous rusty nails used in the past to attach decorations were removed. The original woodwork had survived intact, so the only modern addition required was a new lock in the traditional style of a sliding wooden bolt running between brackets on the door into a slot in the doorpost.

As this first phase of the project came to an end, further conservation work at the Monastery of St. Paul was being planned, although it would be another two and a half years before it could begin. The important results of the conservation work then under way at the Monastery of St. Antony provided a catalyst for a similar project at the Cave Church of St. Paul. The traditional connection between the two monasteries, as well as their parallel histories, meant that the conservation of the Cave Church was a logical continuation of the successful work at the Church of St. Antony.

Description of the Cave Church

The Cave Church lies at the spiritual and historic core of the monastery. It is one of the most venerated sites in Christian Egypt, visited by large numbers of pilgrims and tourists. The hermitage of St. Paul, from which the church evolved, was originally a natural or man-made cave in the north-facing escarpment of the wadi now occupied by the monastery garden. By the mid-thirteenth century, and possibly even earlier, it had been transformed into a church. The original cave was expanded to include a rock-cut nave and a narrow entrance corridor that probably served as a narthex. In addition, a domed haykal was built, rather than excavated, against the original entrance of the cave along the side of the wadi. This sanctuary is now dedicated to St. Antony. The medieval Cave Church was painted in at least two stages during the thirteenth century with figurative scenes, some of which survive.

A further, more extensive remodeling took place at the beginning of the eighteenth century on the orders of Patriarch John XVI following a long period of abandonment and ruin. It was then that the church took on its present appearance, incorporating what had survived from the medieval period and extending the church further into the garden wadi by adding three stone-built domed rooms on its north side. This eighteenth-century building is more substantial, and although still modest, it was conceived on a grander scale than any of the preceding elements of the church. The renewal involved a new cycle of paintings on the interior walls, dated by a Coptic inscription to 1712/1713. At the same time, some of the more damaged medieval paintings were refreshed while others were left untouched.

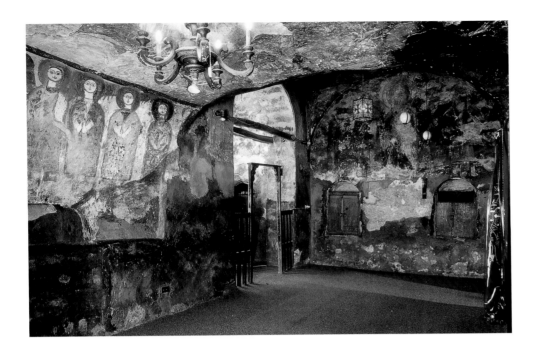

FIGURE 7.7

Central nave looking toward the
northern nave and the entrance to
the narthex, before conservation.

ADP/SP 25 SS1 99.

Conservation and Preservation of the Cave Church

In February 1999, when the ARCE conservation work at the
Monastery of St. Antony was drawing to a close, Adriano
Luzi and Luigi De Cesaris spent four days doing cleaning
tests in the Cave Church. They focused on examples from
the three phases of painting in the church that were al-
most completely obscured by the blackened surfaces of the
walls. These tests revealed paintings of great historical sig-
nificance. When the project was finally launched in 2001, its
aims were to clean and conserve the interior of the church,
to carry out architectural conservation where required, and
to record and document archaeologically the historical de-
velopment of the church. Father Sarapamon al-Anba Bula
and Father Tomas al-Anba Bula of the monastery worked
with the team throughout the project. Logistical support
and accommodation, together with specialized technical
assistance from carpenters, stonemasons, plasterers, build-
ers, and electricians, were provided by the monastery. The
timber scaffolding, cut to size and erected throughout the
church, was made in the monastery workshop.

The preliminary work during the winter of 2001–2002
was the documentation of existing conditions. This in-
volved an architectural and archaeological survey by Peter
Sheehan and the complete photographic documentation
of both the interior and exterior by Patrick Godeau. Over
the course of the project Sheehan and Godeau continued
to record and document the work until the completely con-
served church was comprehensively photographed again
in May 2005.

In this preliminary phase, Conor Power carried out
a structural stability survey in February 2001.[11] This sur-
vey was advised because two prominent faults, resulting in
cracks in the masonry, were apparent in the church. One,
visible only internally, went straight across the center of the
domes and arches of the three eighteenth-century rooms on
the north side of the church. The other, visible both inside
and out, ran through the dome and down the east wall
of the Haykal of St. Antony. Two supporting stone arches
had been inserted under the eighteenth-century arches in
about 1951, certainly in response to the perceived instability,
while the other crack had been filled with mud plaster sev-
eral times much longer ago.[12] The heavy salt efflorescence
on the walls of both the rock-cut rooms and those built
into the wadi indicated a long and serious history of mois-
ture infiltration that had led to weakening of the walls and
foundations on the north side, causing subsidence. In the
sandstone walls of the eighteenth-century rooms salt had
crystallized and hardened within the mortar and sandstone
blocks to such an extent that it had become part of the
actual fabric of the wall itself.

The source of the moisture affecting the walls was
twofold. Seepage from the adjacent garden was partly to
blame, and another and rather more insidious side effect
was related to ill-advised repairs and precautions taken
after the church was flooded in 1966 and 1971 following
torrential rains and flash floods.[13] As the walls dried out
they began to crumble, and in response the monks added
layers of hard, resistant Portland cement to the floor and
walls, up to the preserved level of the paintings throughout
the church (figs. 7.7 and 7.8). The cement sealed the sur-
faces, trapping moisture inside the walls and causing it to
migrate higher up, where salt crystallized on the exposed
surfaces, often around the edges of the paintings. Further
damage occurred behind the cement as infiltration from
the outside continued and the natural tafl of the cave walls
softened. The exteriors of the roof and domes had also been
partly covered in cement, as had the pavement and side
walls of the approach to the church between the keep and
the Church of St. Mercurius (fig. 7.9). Termites, attracted
by the heightened humidity in the floor, demolished the
modern banisters against the eighteenth-century entrance
stairs but spared all the seasoned timbers in the church.

The church was slowly suffocating inside its imperme-
able casing, so removing the cement was a vital first step.
Once exposed, the walls started to breathe again (figs. 7.10
and 7.11). The results were impressive for several differ-
ent reasons. The drying process was in some places almost

FIGURE 7.8 RIGHT
Narthex stairway before conser-
vation. ADP/SP 17 S158 01.

FIGURE 7.9 BELOW RIGHT
Passageway to the eighteenth-
century entrance of the Cave
Church, between the keep (left)
and the Church of St. Mercurius
(right), before conservation. ADP/
SP 7 S151 01.

FIGURE 7.10 FAR RIGHT
Narthex stairway after removal of
the cement. ADP/SP 4 S191 02.

FIGURE 7.11 BELOW FAR RIGHT
Eastern apse of the Haykal of
St. Antony after removal of the
cement. ADP/SP 11 S1193 02.

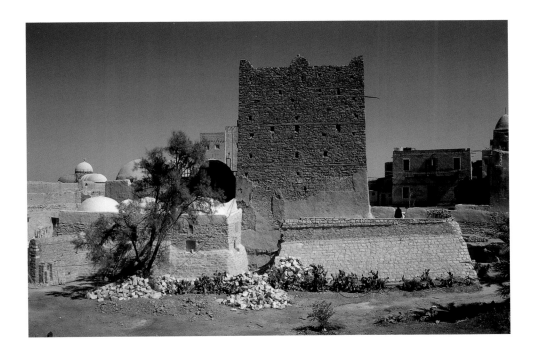

FIGURE 7.12

Cave Church and keep from the garden, looking south, during conservation.

tangibly quick, while other parts were slower to show improvement. It was thus possible to map high-risk areas. For the archaeologist, the bare walls and floors provided a rare opportunity to examine the structural composition and historical development of the church, and to record the evolution from rock-cut cave to eighteenth-century church. Combining archaeological information with conservators' observations on the plaster layers and with the art historical assessment, particularly the dating of the paintings, allowed researchers to connect the different strands of the project.

To find a solution for the problems caused by moisture inside the church, attention was turned to the monastery garden. Here date palms, olives, *nabq* (Ziziphus jujuba), and pomegranates grow, and two crops of vegetables are produced annually.[14] The soil is a mixture of compost and Nile clay brought over the years by pilgrims as donations to the monastery, spread over a bed of rubbish deposited for drainage. When it was excavated, the rubbish beside the church and keep was found to be of recent origin, with pieces of newspapers dating from the 1940s to the 1970s and "Black Cat" matchboxes common during the same period. By 2001 this accumulation had risen to more than two meters against the outside of the north wall of the church (fig. 7.12). To remedy this situation, a major drainage project was implemented from November 2003 to April 2005 under the direction of Father Maximous El-Anthony. A channel four meters wide was excavated against the foundations of the church wall through the garden soil and underlying debris to the natural wadi floor. At this level, an ancient drain was discovered, possibly dating to the early eighteenth cen-

tury, when the north wall of the church was constructed. This ran from the lower, east end of the garden, under the eastern courtyard of the monastery, and to the exterior of the monastery enclosure wall.

Further alterations were made to the sides of the keep, where a terrace of limestone blocks set in cement covering a rubble core had been built against the rock foundation and lower walls. This terrace was removed, and the keep, which was also suffering from moisture infiltration, was exposed and isolated from the surrounding soil. A tamarisk tree growing close to the church, which appears in Whitemore's 1930–1931 photographs, was protected and preserved (fig. 7.13).[15]

The north side of the channel was lined with a red-brick retaining wall constructed with internal cavities to allow rainwater to run into a drain in the floor. A layer of crushed sandstone pieces bedded in tafl was spread over the drain. The red-brick sides and the floor were then covered with a sandstone facing set in tafl and lime mortar. The result is both functional and aesthetically pleasing. A new storm drain isolates the keep and the church from the serious threat of damage from humidity and flash flooding. The materials and design of the mitigation measures are wholly compatible with the traditional architecture of the monastery.

Further work outside the church involved the removal of a rough stone *mastaba* against the east side of the Haykal of St. Antony. Beneath the mastaba the remains of a room were found, partly hewn from the natural rock and partly built of rough stones, short lengths of palm logs, and mud bricks. The room was filled with a compressed and fairly homogenous deposit of ash and organic rubbish, much of it apparently originating from the garden and animal pens. The interior walls and floor of the room were smoothly covered in tafl plaster. The walls were preserved to their full height against the wall of the church, where the springing of a vault showed that the room had originally been roofed with a dome. Access must have been from above, as there was no sign of a doorway in any of the walls. This feature, combined with its position in a constricted space between the medieval eastern enclosure wall of the monastery and the outside wall of the Cave Church, suggests a very particular kind of function, perhaps as a secluded cell or storeroom. Gawdat Gabra has suggested that this room might be identified with the *mahbasa*, or hermitage, mentioned in an account of a severe flood at the monastery in 1709/1710 (see Chapter 5). The force of the water was so great "that it removed the mahbasa and made an opening in the eastern wall."[16]

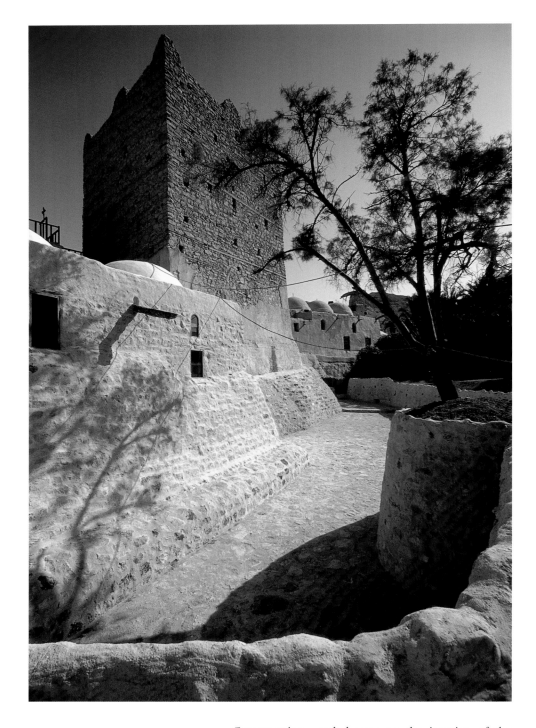

FIGURE 7.13

Cave Church and keep from the garden, looking west toward the Church of St. Michael and St. John, after conservation. The tree photographed by the Whittemore expedition is on the right. ADP/SP 4 S238 05.

stairwell below were seriously abraded. The crack in the domes and arches was easily grouted. The original *mash-rabiyya* window grills were removed for cleaning and re-installed at the end of the project (fig. 7.14.) The other two eighteenth-century rooms—the north part of the nave and the Haykal of the Twenty-Four Elders—also proved relatively straightforward to clean and conserve.

In the Haykal of St. Antony, however, a more complex pattern emerged, requiring skillful and imaginative treatment. This room is divided structurally into a lower square room containing the altar with a dome above. The lower section comprises three walls partly built in mud brick and partly hewn from natural tafl, and the fourth side is open to the nave but partitioned by the wooden screen. The east and north walls were painted by the first medieval artist, who was probably active in the church soon after the room was constructed. The dome was originally built with three tiers of windows and was undecorated. At the end of the thirteenth century, the second medieval artist added a large painting of the Christ in Majesty flanked by archangels on the eastern shell of the dome, and in order to accommodate it several windows had to be filled in. Other windows were left open and survived with their gypsum grills either complete or partially preserved, although they had been blocked from the outside. Sometime later the dome cracked and moisture penetrated the eastern window blockings, creating large lacunae in the painting where the paint layer has fallen away.

The archway between this haykal and the adjacent Haykal of St. Paul had been coated in modern lead-based gloss paint. When this was removed, the head of a thirteenth-century painting of St. Stephen was revealed. The ceilings of the haykal and shrine of St. Paul were also covered in gloss paint, originally white but now blackened like the surfaces it covered. No paintings were found in this haykal, and only the rough, preliminary outlines of paintings were uncovered in one corner of the Shrine of St. Paul. The walls had been severely damaged by prolonged moisture and salt action, and extensive replastering with tafl and lime plaster was required.

At the same time as the paintings were being conserved, a parallel series of structural interventions began both inside and out, employing a team of local workmen hired by the monastery and supervised by Father Maximous El-Anthony. The exterior of the roof was cleaned, layers of cement rendering were removed, the cracks were filled, and the dome over the altar of St. Antony was reinforced with two flying buttresses made of timber covered

Conservation work began on the interior of the church in February 2002 and continued until May 2005. The program included treatment of the plain, undecorated walls, as well as of the paintings, woodwork, marble, and icons. The first areas to be tackled were the Dome of the Martyrs over the eighteenth-century entrance stairs and the medieval Haykal of St. Antony. The paintings of the martyrs in the dome were found to be relatively intact, with most of their original paint preserved under a superficial layer of dust, although the three figures on the walls of the

FIGURE 7.14
Mashrabiyya window grill after
conservation. North wall, narthex.
ADP/SP 8 S1199 02.

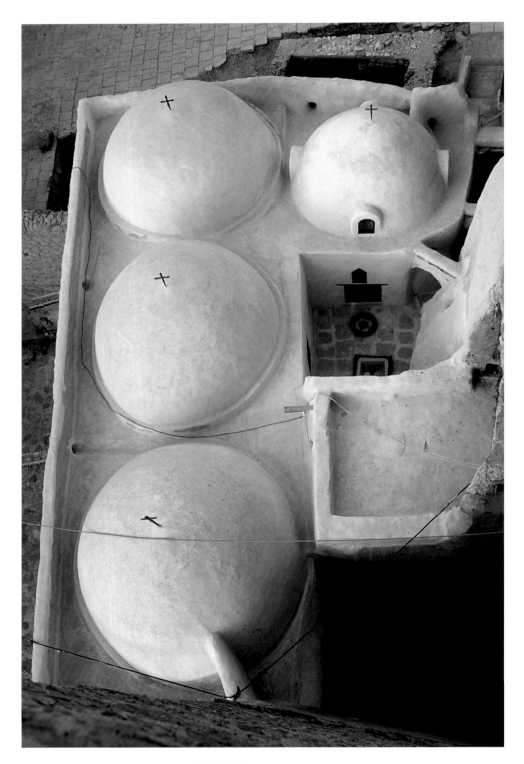

FIGURE 7.15

Domes of the Cave Church after
conservation. ADP/SP 6 S239 05.

with lime plaster (fig. 7.15). The windows in the dome were
opened where they would not interfere with the paintings
on the inner surface, and new frames and glass were fit-
ted. Inside, new gypsum window frames and grills were
made by Adriano Luzi working with Father Tomas al-Anba
Bula, and these were fitted into the surviving remains of the
originals to replicate the medieval arrangement around the
Christ in Majesty (fig. 7.16). The roof was replastered using
lime plaster, compatible with the traditional building mate-
rials, and a slope was added to guide rainwater toward new
gutters on the north and east sides, made in the traditional
way from hollowed-out palm logs. The north and east ex-
terior walls were cleaned and masonry joints pointed.

Completion of the interior required major repairs to
the lower segments of all the walls where cement had once
filled and covered deep cavities. Plaster mixed from locally
obtained tafl, sand, and gravel, identical to the plaster and
mortar used in the original construction, was used to fill the
damaged areas. The surface of the walls was finished with
a coat of lime plaster. In the course of this work, a serious
problem was encountered when the new, wet plaster reac-
tivated the residual salts in the walls, thus creating an en-
vironment in which the church was endangered by efforts
to preserve it. Eventually, after several sacrificial layers had
been applied and replaced in order to remove most of the
active salts, a balance was achieved, although monitoring
of humidity and salt action will remain important to the
maintenance of the church.

Decisions about how best to finish and present the
interior were often the result of prolonged discussions
involving the monks of the monastery, the conservation
team, and the project manager. One particular case, that
of the floor, serves to illustrate some of the issues involved.
Removal of the cement had lowered the floor to the medi-
eval pavements, some 15 to 20 centimeters below the late
twentieth-century level. These historically significant pave-
ments added authenticity and a traditional aesthetic, and
there were strong arguments in favor of preserving them as
the floor of the newly conserved church. However, equally
powerful voices opposed this idea, focusing on the relative
fragility of the different kinds of stones used in the floor and
the vulnerability of the surviving evidence for early screens
and entrances. These early floors are also very uneven and
would be difficult to stand on barefoot during long ser-
vices. Rather than risk future leveling work using inap-
propriate materials such as cement, another solution had
to be found. Eventually it was decided that after complete
archaeological recording, the floor would be covered by
a modern lime plaster floor corresponding in appearance

FIGURE 7.16
Adriano Luzi, Father Tomas al-
Anba Bula, and Father Sarapamon
al-Anba Bula in the central nave
preparing new stucco window grills
for the Haykal of St. Antony.
EG 7 s6 02.

and texture to the finish on the walls. The surface would respect the contours of the natural rock floor of the cave by taking its level from it and would extend at a single grade throughout the church. The lime plaster is porous enough to allow evaporation but is also very durable. The original floors are preserved under the new surface, covered with a layer of sand to mark the transition between the medieval and the modern.

When the floor of the nave had been lowered, the screens which close the haykals of St. Antony and the Twenty-Four Elders were also lowered. These screens were installed in 1950 and 1951 to replace the original eighteenth-century screens, which Thomas Whittemore recorded in situ in 1930–1931.[17] When the old screens were dismantled, original pieces of carved wooden inlay and the row of icons fitted on the top of each one were incorporated into the new screens, but the eighteenth-century dedicatory inscriptions carved on wooden panels and inset over the doors were removed and kept in storage. After considerable debate, it was decided to display them on the fronts of the screens above the inscriptions recording the renewal in 1950 and 1951, thereby celebrating both the old and the new screens together.

Conclusion

The three buildings included in this conservation project were selected because they were the most vulnerable elements remaining of the premodern monastic settlement, where it is possible to see how the medieval structures were incorporated into the eighteenth-century revival. The refectory and mill building were slowly deteriorating through neglect and structural failure. The collapsed roof in the western mill room demonstrated clearly the need for urgent intervention. Work here focused attention on the need to record and preserve this sort of vernacular architecture while it is still in working order and while there are still members of the community who can describe the life of the monastery before modernization.

The Cave Church was threatened by ill-advised repairs, such as the cement rendering applied some thirty-five years ago, and moisture seeping through the walls and floors. The wall paintings inside the church were not only obscured by dirt on the visible surfaces, but they were also endangered by the weakened walls. By dealing with the causes of deterioration, particularly reinstating the old drainage channel in the garden, the life of the Cave Church has been prolonged and the heart of the monastery strengthened. The cleaned and lightened interior, with the two medieval skylights reopened in the nave ceiling, is in dramatic contrast with the former interior gloom. A much greater sense of space, enhanced by the lower floor level, replaces the previous heavy impression of the low ceiling and darkened walls. Cleaning and publishing the wall paintings, and studying them in their architectural context, has contributed again to the increasing corpus of newly discovered Coptic art.

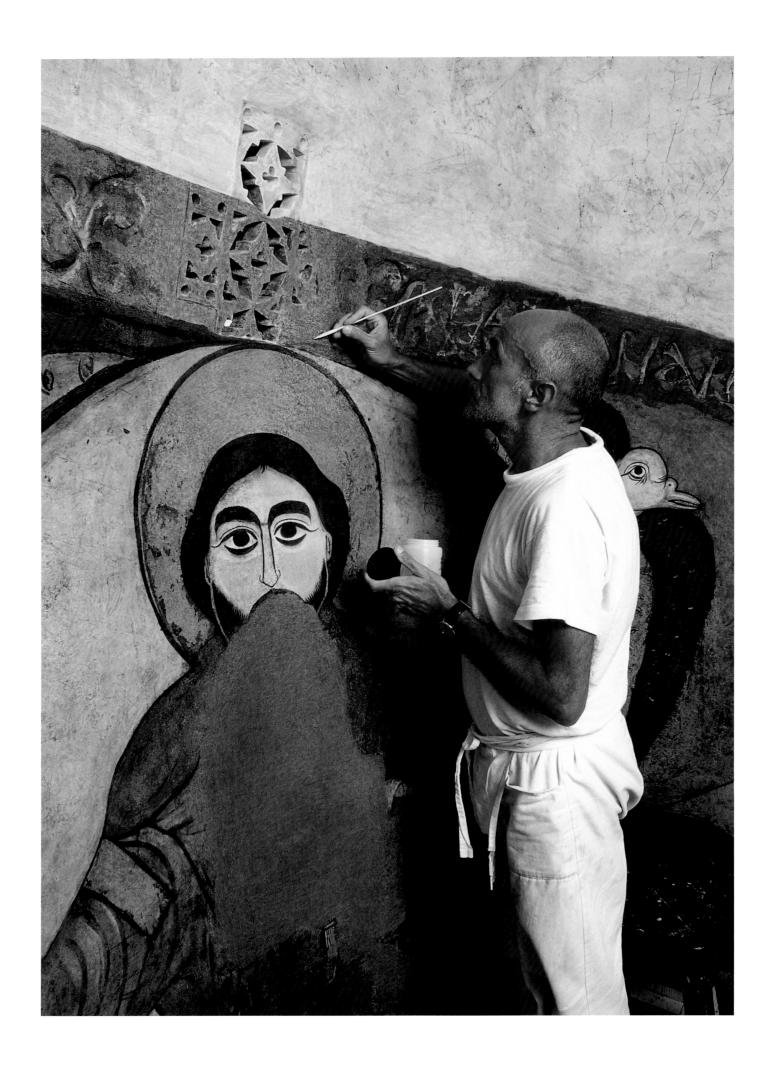

CHAPTER 8

CONSERVATION OF THE WALL PAINTINGS
IN THE CHURCH OF ST. PAUL

Introduction by Luigi De Cesaris

My colleague Adriano Luzi and I began working in Egypt in 1987, when we were invited to take part in the Nefertari Tomb Project, directed by Paolo and Laura Mora on behalf of the Getty Conservation Institute. Paolo Mora was chief conservator of the Istituto Centrale del Restauro (ICR) in Rome, and Laura Mora was a teacher and conservator on the staff of ICR. Together they helped pioneer a systematic, interdisciplinary approach to the conservation of works of art that has had worldwide impact.[1]

Our first encounter with medieval Coptic wall paintings took place between 1996 and 1999 at the Monastery of St. Antony. We had been asked by ARCE to clean and conserve the thirteenth-century wall paintings in the principal church of the monastery, dedicated to St. Antony.[2] The paintings were covered with soot and other deposits, which obscured all but a shadowy outline of their subjects. By the end of the conservation project we had revealed an extensive iconographic cycle, dated 1232/1233, painted in a distinctively Coptic style, as well as a somewhat later cycle by two artists, one trained in a Byzantine manner, the other in a decorative mode characteristic of the Muslim world.

Before we completed our work in the Church of St. Antony, Michael Jones of ARCE asked us to visit the Cave Church at the nearby Monastery of St. Paul with an eye to the conservation of its wall paintings. Luzi and I immediately realized that the building was more complex than the Church of St. Antony, where the building and painting phases dated primarily to the thirteenth century. The Church of St. Paul, on the other hand, comprises rock-cut chambers, reflecting its origins as a late antique hermit's cave, as well as built additions in the form of medieval and eighteenth-century domed rooms. The cycles of wall paintings are equally diverse, consisting of two medieval phases and a phase from the first quarter of the eighteenth century.

Although the Cave Church suffered from many of the same problems we encountered at the Church of St. Antony, its walls, plaster layers, and paintings were much more damaged. The entire interior of the church was covered by thick residues formed by dust from the desert and smoke from oil lamps and burning incense. We observed other superimposed substances, such as spilled wax and oil, and vinyl paint. Modern attempts to repair the church had resulted in the floors and lower walls of every room being covered by cement, which trapped moisture in the walls and accelerated plaster detachment and the loss of cohesion of the pigments layer on the medieval and eighteenth-century paintings. Our task, therefore, was to clean and consolidate all of the paintings and the plaster layers, as well as to conserve much of the rest of the interior of the church. Our goal, based on the theories and practice of conservation developed by the Moras, is always to maintain the aesthetic unity of a building. For example, we respect even the most modern additions to a given structure, providing they do not damage the architectural whole.

Three years later, in 2002, we assembled a team of assistant conservators, who had worked with us at numerous sites over the years, including the Monastery of St. Antony. These colleagues contribute a combination of technical skills, hard work, and a strong sense of responsibility. Together we spent 365 days, divided into four yearly campaigns, working in the Cave Church. After our first campaign, Luzi tragically passed away, depriving the world of a genuine maestro (fig. 8.1). The memory of his professionalism, extraordinary natural talent, and deep love for

FIGURE 8.1

Adriano Luzi working on Christ in Majesty (E10). ADP/SP 20 S 195 02.

FIGURE 8.2

Alberto Sucato, Luigi De Cesaris, Gianluca Tancioni, Emiliano Ricchi, and Adriano Luzi in the Dome of the Martyrs. EG 19 S5 02.

conservation was an indispensable resource for me during the difficult period following his death. I express deep professional and personal gratitude to team members Emiliano Albanese, Diego Pistone, Emiliano Ricchi, and Gianluca Tancioni, and especially to Alberto Sucato, who deserves praise for his unswerving support (fig. 8.2; see fig. 26). The example of Luzi's devotion to conservation, as well as his generosity of spirit, inspired us while completing the project we began together at the Monastery of St. Paul.

Test Cleanings

In February 1999, Luzi and I conducted four test cleanings of the wall paintings in the Church of St. Paul in order to calculate the time needed for a full conservation project. In the course of this work it became apparent that a major task would be the removal of the thick deposits that had accumulated on the walls over the centuries. The most basic component of this coating was the light dust from the surrounding desert that covered every surface of the interior of the church. On its own this dust would not have adhered to the walls, but when mixed with carbon particles from the smoke of lamps, candles, and burning incense it became

a cohesive, greasy dust that formed a thick residue.[3] This mixture also penetrated pigments and plaster layers.

The density of these dark deposits varied in different areas of the church. The eighteenth-century paintings in the Dome of the Martyrs above the narthex were too high to be completely obscured by cohesive materials—the particles were too heavy to coat this area. The images of the equestrian saints in the interior of the dome were muted but still recognizable (fig. 8.3). In the central nave, however, the paintings on the walls and low ceiling were almost illegible. Indeed, it was often impossible to determine whether the deposits covered painted or unpainted plaster. We encountered similar conditions in the other subterranean rooms.

Areas of wall near ground level were exposed to the spill of oil from lamps, and to wax from burning candles. Both substances had formed thick black deposits on the east wall between the central nave and the Shrine of St. Paul, obscuring the eighteenth-century paintings (fig. 8.4). Another common problem was the buildup of a greasy residue caused by visitors touching the sacred images. Wide bands of these oil deposits were found whenever a painting was within reaching distance.

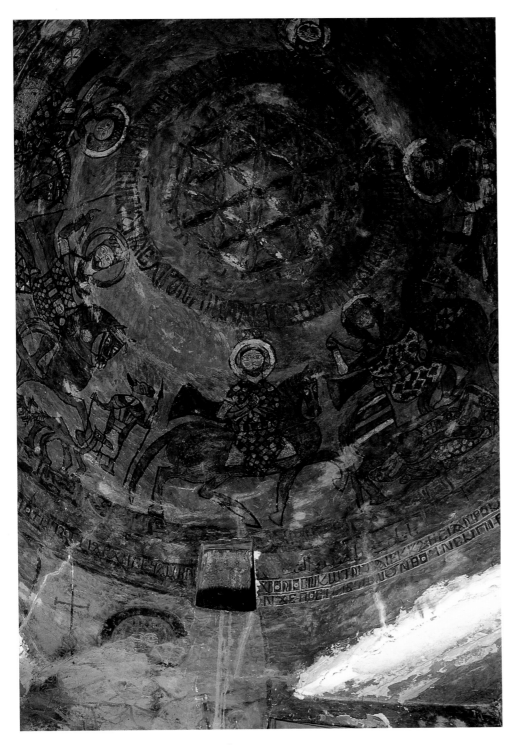

FIGURE 8.3

Dome of the Martyrs, before

conservation. ADP/SP 12 S154 01.

Our first test cleanings took about five days and concentrated on four paintings in the church: the Virgin Mary in the Haykal of St. Antony (see fig. 1); the angel carrying a child in the southeast corner of the ceiling of the central nave (fig. 8.5); Maximus on the east wall of the central nave, and Macarius the Great on the east wall of the Shrine of St. Paul (figs. 8.6). Each area represented a different period of painting. The Virgin was part of the earliest known pictorial cycle in the church associated with the first medieval master (ca. 1230); the flying angel was also medieval but was from the later second phase (1291/1292); while Maximus and Macarius were obviously the work of the monk-painter active in 1712/1713.

Tests such as the ones we completed in 1999 are normally carried out to determine how best to clean and conserve the paintings. They are also conducted at the beginning of each new stage of a project. A small rectangular area, known as a window, is chosen for the initial probe. The surface deposits are identified and removed as a first step. Our four test windows were all covered by exceptionally thick deposits, posing characteristic problems in the church as a whole. Once the cleaning was completed we were able to better examine the pictorial layer and clarify the problems confronting its conservation.

All the pictorial stages in the Church of St. Paul were executed on dry plaster. The pigments were fixed in a medium, generally a glue of animal protein, with which they were mixed prior to their application. The individual paints (composed of pigments and glues) from different periods form chemical compounds of varying degrees of stability. In the case of the Cave Church, the medieval paintings were more delicate than those from the eighteenth century, and needed a longer time to clean.

Even pigments from the same pictorial program have varying strengths and consistencies that require different cleaning and conservation methods. For example, the eighteenth-century yellow is very resilient and was cleaned with an ammonia carbonate solution applied with a brush over Japanese paper (fig. 8.7). If this method were used on the medieval programs, however, it would destroy the paintings. The eighteenth-century red, on the other hand, is much weaker, so that an acetone solution had to be applied manually to small areas, using cotton swabs for greater control. This method could not be employed on the green from the same period, which is more delicate still, as well as having a very rough surface. Instead, it required the application of the solvent on cotton balls pressed gently against the surface. By understanding the various pigments and their

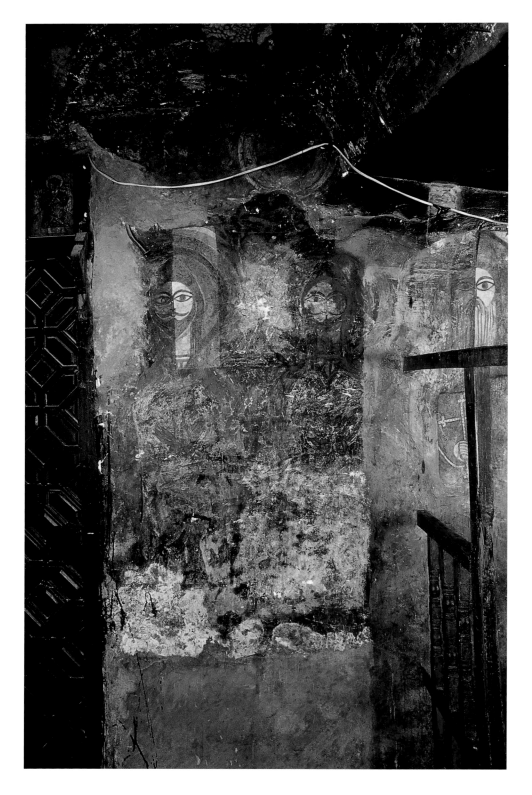

FIGURE 8.5

Angel carrying a child (D13) after
the first test cleaning. ADP/SP 15
S165 01.

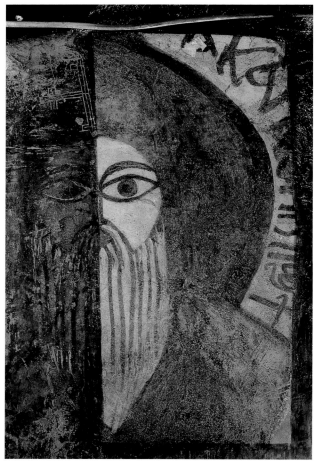

FIGURE 8.4

Maximus (D11), Domitius (D12),
and Macarius (G3) after the first
test cleanings in 1999. ADP/SP 12
S165 01.

FIGURE 8.6

Macarius (G3) after the first test cleaning.
ADP/SP 7 S150 99.

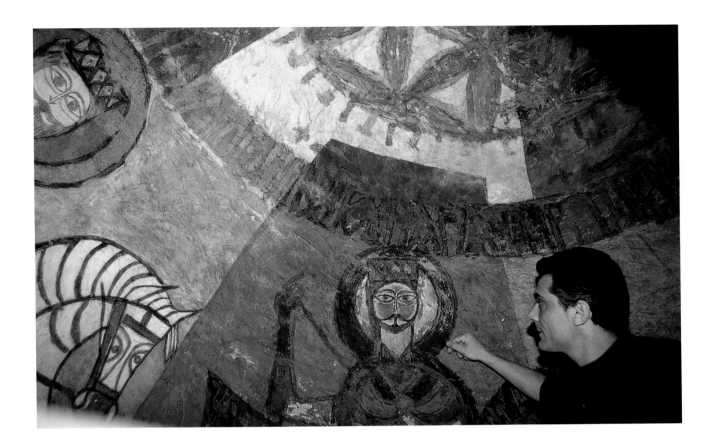

FIGURE 8.7
Luigi De Cesaris in the Dome of
the Martyrs, during conservation.
EG 8 S5 02.

adhesive media we calculated how best to conserve all of the paintings in the church.

After completing the initial tests we measured the interior surface of the building. Our goal was to determine the amount of wall space that was covered by painted and unpainted plaster. We estimated that a conservator working an eight-hour day could clean 40 square centimeters of a medieval painting, 70 square centimeters of one from the eighteenth century, or 1.5 square meters of unpainted plaster. Based on these calculations we worked out a plan whereby six conservators could complete the project in 365 days.

It was also apparent from our initial investigation that the Cave Church had suffered extensive damage from moisture. The location of the church in the bed of the wadi made the building particularly susceptible to water draining from the monastic garden, not to mention the rains and flash floods that periodically occur in the area. The resulting damage to the lower walls extended throughout the church but was particularly acute in the Haykal of St. Antony. Humidity, in one form or another, had destroyed large portions of the painted program of the first medieval master.

In the middle of the twentieth century the monastic community undertook widespread repairs to the church.

In the northern nave, they built relieving arches of irregular sandstone blocks joined by thick tafl mortar to reinforce the earlier arches leading to the narthex and the Haykal of the Twenty-Four Elders. This work seems to have been motivated by the appearance of a crack above the eighteenth-century arch on the eastern side of the room. In 1950 and 1951, the monks replaced the haykal screens of the sanctuaries of the Twenty-Four Elders and St. Antony, including the eighteenth-century inscriptions, due to damage from insects and moisture. During this same period, they also enclosed the cenotaph of St. Paul in marble.

A more pernicious intervention was the widespread use of Portland cement, which was applied thickly to the floors and damaged lower walls in the 1960s and early 1970s, to a height of at least a meter and a half, in all the rooms of the church (fig. 8.8). A thinner skin of cement was used to seal these repairs. The skin was "painted" along the edge of the cement encasement, where it met the exposed rendering of the upper walls. As a result, a continuous streak of cement wash was inadvertently formed on the lower plaster and paint layers throughout the church.

The cement created a waterproof barrier that kept the floors and lower walls continuously damp. Humidity could escape only by rising to the level of the absorbent plaster, carrying with it any soluble salts it encountered on the way.

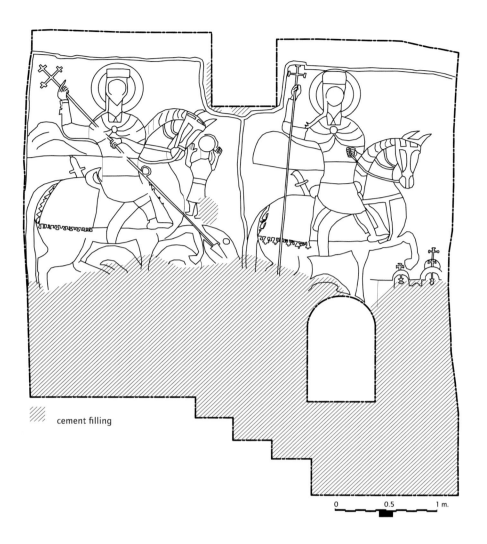

cement filling

0 0.5 1 m.

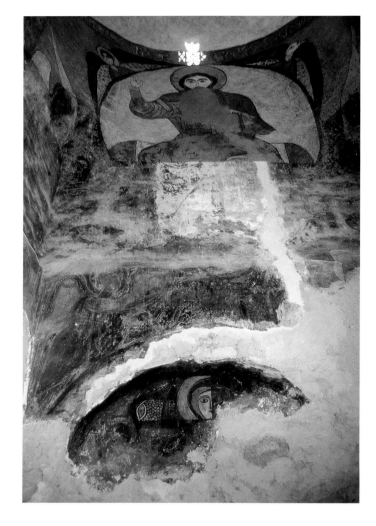

FIGURE 8.8 LEFT

Conservation record of Theodore
Stratelates (A2) and George (A3),
showing previous repairs.

FIGURE 8.9 RIGHT

Haykal of St. Antony during
conservation. The upper zone has
been completed and the scaffold-
ing removed in preparation for
work at the lower level.

As the water evaporated, deposits of salt formed on the sur-
face, seriously altering the cohesion of the paint and plaster
layers.[4] As a result, the removal of the cement in the church
was a priority for our first campaign.

Conservation of the Wall Paintings in the Cave Church

We began the campaign of 2002 in the Haykal of St. Antony
and the narthex in order to better understand the three
painters active in the church. The Haykal of St. Antony has
the best-preserved examples of the two medieval programs,
while the narthex contains one of the most ambitious com-
positions of the eighteenth-century monk-painter. The
team divided into groups that worked simultaneously in
the two rooms.

Our preferred method is to begin at the upper level
and proceed downward (fig. 8.9). The carpentry shop at the
monastery produced wooden scaffolding that supported
platforms at the level of the springing of domes above the
two rooms. Worktables served as additional platforms to
reach the highest levels. When we completed the work in

these upper regions, the scaffolding was removed, and we
continued in the lower zones. A similar approach was used in
the northern nave (second campaign, 2003) and the Haykal
of the Twenty-Four Elders (third campaign, 2004).

Later in the first campaign, part of the team moved
into the central nave. The rock-cut rooms of the church did
not require elaborate scaffolding; worktables served as plat-
forms when cleaning the ceilings and upper walls. During
the second and third campaigns, we concentrated on the
corridor and the shrine and haykal of St. Paul. By the end
of 2004 we had completed work on most of the paintings in
the church. This entailed the cleaning and consolidation of
the paint and plaster layers, and the aesthetic presentation
of the newly revealed images.

The technical steps employed when cleaning a paint-
ing are the same as those used in a test, but applied to the
entire surface of the wall. We begin by identifying and re-
moving the surface deposits. A universal problem in the
church was the buildup of greasy dust that covered every
surface to varying degrees. This form of deposit is removed

FIGURE 8.10

Alberto Sucato demonstrates the
technique of cleaning paint layers on
Maximus (D11). ADP/SP 16 S195 02.

by using different detergent surfactants (surface-active agents) mixed with water. Because water can weaken the glue of the pigment, about half of the solution is acetone to ensure quick evaporation. The paintings thus remain dry throughout the cleaning process. The solution is administered manually using cotton swabs on the surface area, millimeter by millimeter (fig. 8.10).

In parts of the church, the buildup of carbon particles was covered by wax and oil from candles and lamps, and oil from fingerprints. In the central nave, these deposits were so thick that the underlying paintings were almost completely obscured. Such deposits had to be removed before we could approach the more basic problem of greasy dust. Wax is usually treated first because the other substances are difficult to reach until it has been eliminated. Wax is inclined to darken and collect dust. It must be removed with care, because it is often difficult to tell what is underneath. Thin deposits were removed by applying a chlorite solvent, such as trichloroethylene, with cotton swabs. Thicker buildups required a similar technique, but the solvent was heated to about 50 degrees Celsius.

Oil is usually removed next. Unlike wax, which remains on the surface of the paint, oil penetrates it, causing it to dry and contract. The deposits on the east wall of the central nave were so thick in places that they had started to crack. The removal of oil required a mixture of polar and organic solvents. On very thick deposits, ammonia mixed with water (20 percent per liter) was applied first; lower layers of oil were then removed using amil acetate mixed with dimethylformamide. The process required multiple applications of the cleaning mixture. The solvent was first applied with a brush over Japanese paper, then over one or more sheets of tissue paper. Each application took between four and eight minutes, after which the solvent evaporated, and the process repeated. Every stage caused more oil to be absorbed into the paper. In some cases as a secondary stage, acetone was used with a brush over paper or applied with cotton swabs. Care was taken throughout the process to avoid using too much solvent, which would make the surface too wet. Thinner oil deposits, often caused by human touch, required a similar mixture of solvents used in various proportions. Unlike the treatment of thick oil, a purely chemical process in which the tissue paper absorbs the oil, thinner deposits were cleaned by applying the solution with cotton swabs.

We also encountered more localized problems in various parts of the church. In the northern nave and the corridor, for example, a vinyl resin in emulsion had been applied to the paintings as protection, probably during a

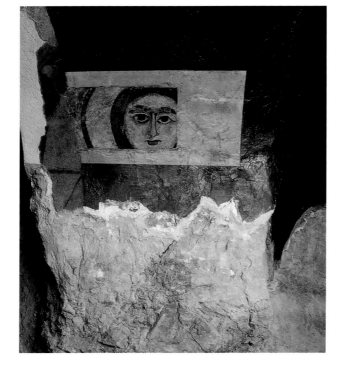

FIGURE 8.11

Stephen (E13) during conservation, showing the vinyl paint that covered the image. ADP/SP 12 S1207 02.

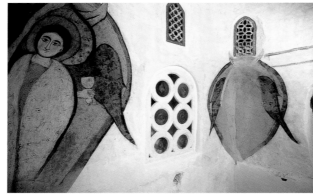

FIGURE 8.12

Cherubim (E15, E1), after conservation. Notice the restored window grills in the drum and shell of the dome. ADP/SP 11 S206 02.

FIGURE 8.13

Emiliano Albanese cleaning unpainted plaster on the exposed limestone shelf in the northern nave. EG 1 S61 02.

previous restoration effort. We removed the resin by alternating applications of an acetone mixture and a nitro solvent (thinner) brushed over Japanese paper.

The walls and ceilings of the hakyal and shrine of St. Paul and the passage leading to the Haykal of St. Antony were covered by a pale acrylic paint, seemingly to hide the deposits of oil and carbon residue. The paint overlapped the eighteenth-century images of Domitius and Moses the Black in the adjacent central nave, and completely obscured a medieval painting of Stephen that we rediscovered during the course of cleaning (fig. 8.11).[5] In order to remove this acrylic paint, a mixture of dimethylformamide and nitro solvents was brushed over tissue paper with a contact time of about ten minutes. As the acrylic paint was reduced to its lowest level, we employed pure thinner, alternating with an acetone solution, either over paper or using cotton swabs. Because of the highly toxic nature of the solutions used, the conservators wore gas masks and gloves during the operation, and extensively ventilated the area.

In the Haykal of St. Antony, the painting of a cherub in the northwest squinch was coated by run-off mud that had been carried by rainwater from an upper window (fig. 8.12). As part of the cleaning process, some of the dirt was dissolved using thin compresses lightly damped with water. A scalpel removed more stubborn particles. The last traces were cleaned using water mixed with acetone to ensure quick evaporation.

Throughout the church, the lower borders of the paintings were covered by a continuous streak of cement wash. Its removal required delicate cleaning with scalpels and abrasive tools. During this operation we were able to recover appreciable fragments of the original plaster and paint layers. New portions of the painted surface were discovered on both the east and west walls of the corridor, and along the lower margins of the equestrian saints on the walls of the narthex.[6]

Once these deposits had been successfully eliminated it was then possible to treat the paint layers themselves. Pigments that have absorbed dirt cannot be cleaned mechanically with cotton swabs. The first step is to brush acetone mixed with a small percentage of tensioattivo over Japanese paper, in order to weaken the dirt. Pure acetone is then applied to three or more sheets of tissue for the final cleaning. The paper compresses are always removed before they are fully dried so that they do not absorb any of the color. The procedure is repeated if necessary; some of the paintings in the Haykal of St. Antony required three treatments.

When cleaning the paintings it is important to ascertain the order in which the pigments were applied in each

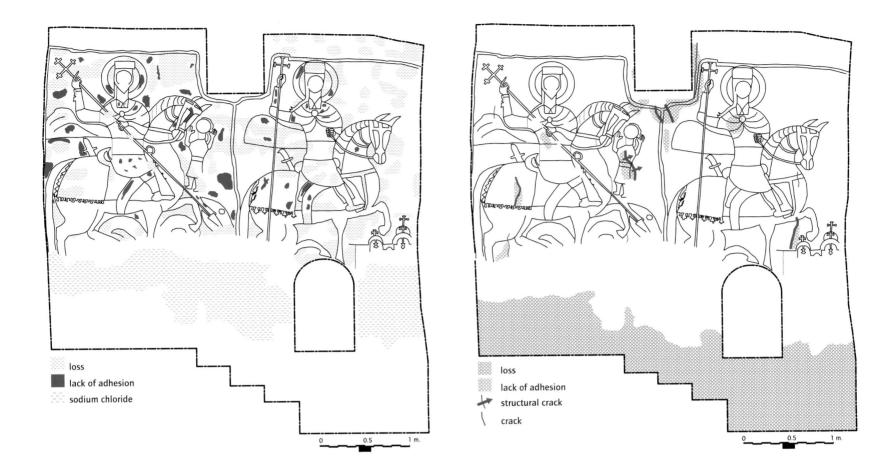

loss
lack of adhesion
sodium chloride

loss
lack of adhesion
structural crack
crack

0 0.5 1 m.

0 0.5 1 m.

FIGURE 8.14 LEFT

Conservation record of Theodore Stratelates (A2) and George (A3) showing the condition of the paint layers before conservation.

FIGURE 8.15 RIGHT

Conservation record of Theodore Stratelates (A2) and George (A3) showing the condition of the plaster layers before conservation.

composition. This chronology is particularly relevant to the medieval paintings in the church, which frequently consisted of large areas of a single color that were then embellished with details made of different pigments. The upper layers of paint are much weaker than the background color, and they needed to be cleaned first. Once that was done, we fixed the upper pigments using an acrylic resin solution, which protected them during the cleaning of the stronger background colors.[7] When the work was finished, we removed the fixing solution with acetone brushed onto tissue paper. We used a similar technique when treating paintings that needed to be cleaned in conjunction with plain plaster, such as inscriptions and framing lines.

Dirt deposits on unpainted plaster were removed by brushing an aqueous solution of ammonia carbonate (30 grams per liter) onto tissue paper placed on the surface (fig. 8.13). The tissue, often two or more layers, was kept wet for three to four minutes before it was removed. The last deposits were cleaned manually with a sponge and water. The action of the sponge followed the direction the spatula used in laying the plaster. Generally, this approach offers no danger to the plaster, but various safeguards were also used.

After the cleaning is complete the next concern is the physical consolidation of the paintings. If the pigment is

detaching or disintegrating, a fixative must be used. Two common problems we encountered in the church were the flaking of the paint layer and the powdering of the color due to surface abrasion or the weakening of the binding medium (fig. 8.14). Flaking is repaired by injecting an acrylic resin in emulsion between the paint and the underlying support.[8] In certain cases it was advisable to exercise slight pressure with a spatula, after first placing a sheet of silicone-coated paper over the surface. Powdering, or lack of color cohesion, required an acrylic resin solution, usually applied with a brush.[9] If the surface was too fragile, we used a spray whose pressure was low enough not to disturb any loose fragments of paint.[10] We try to carry out these operations after the cleaning of the paint and plaster layers to prevent dirt being fixed in place by the resin.

We also frequently found it necessary to consolidate the plaster layers. We discovered numerous places in the church where the rendering was detaching from the walls (fig. 8.15). In small areas, a minimum amount of an acrylic resin emulsion, sometimes with powdered calcium carbonate, was injected to restore the correct level of adhesion (fig. 8.16).[11] Larger areas of detachment—found, for example at various points on the west wall of the central nave—required the injection of a fluid grout.[12] Any holes or cracks

FIGURE 8.16

Emiliano Ricchi securing plaster detaching from the west wall of the corridor. ADP/SP 2 S250 05.

FIGURE 8.17

Christ in Majesty (E10) before conservation. ADP/SP 6 S149 99.

required this method of support. The plaster was detaching primarily due to problems arising from the cement repairs to the lower walls. When necessary, endangered sections were temporarily removed. We eventually replaced these fragments using a mortar made of sieved tafl, sandstone dust, and a small amount of gypsum. This same mortar was also used to repair cracks in the walls, domes, and ceilings. Under one loose piece of plaster taken from the east wall of the central nave, we found a medieval painting of the face of a saint (see fig. 8.10). Enough of the image is exposed to identify it as the work of the first medieval master. Because of the importance of the discovery, this particular plaster fragment was never replaced.

One of the last steps in the conservation process is the final presentation of the paintings, in particular the treatment of pigment loss. In areas where the colors have fallen away, the underlying rendering is exposed. These patches of newly cleaned white plaster affect the painted image by appearing optically *in front* of the pictorial plane. The areas of loss must be made to recede behind the image and serve as a uniform ground.[14] This is achieved by what we call the *acqua sporca* (dirty water) technique. A muddy gray color, with components of the surrounding hues, is employed in a reversible watercolor mixture. It gives the impression, from a distance, of belonging to the original color on the rendering. The areas of loss thus appear to recede, and the image recovers its coherence.[15] This technique also allows the viewer to distinguish easily between the original pigments and our interventions.

The final presentation of the paintings from the second medieval phase in the Haykal of St. Antony presented some special challenges. The two cherubim in the western squinches are each painted directly below a window in the dome (see fig. 8.12). The southern cherub is well preserved, but most of the northern image has been washed away by rainwater. After cleaning the damaged cherub we were able to conserve the faint traces of paint that had survived. Despite severe pigment loss, it is now possible to discern the outline of the composition.

The Christ in Majesty on the east side of dome had also suffered from humidity. The composition was painted over five windows in the dome that had been filled in and plastered over as part of the preparation for the second medieval phase of painting in the church. Moisture penetrating the sealed windows had caused extensive pigment loss to the face and chest of Christ (fig. 8.17). The damage was compounded by a crack in the dome that runs through the lower part of the image. We used the acqua sporca technique on the large gaps covering the body of Christ, but

in the plaster were first filled to prevent the adhesive from escaping. We took care to avoid completely filling the cavity with grout, which would be too heavy and could damage the rendering (plaster layer). Instead, we used a smaller amount to serve as a light bridge securing the plaster to the wall.

In more extreme cases of lack of adhesion, loose areas of plaster were held in place by Japanese paper and gauze, fixed with an acrylic resin, until they were consolidated.[13] The rendering in the apse of the Haykal of St. Antony that serves as the foundation for the painting of the Virgin Mary

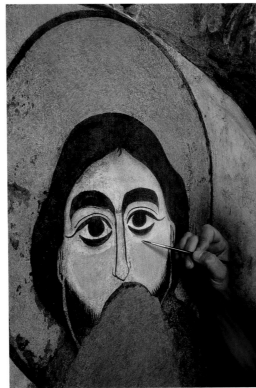

FIGURE 8.18 LEFT
Face of Christ after cleaning,
but before the addition of acqua
sporca and tratteggio. ADP/SP 11
S1194 02.

FIGURE 8.19 CENTER
Face of Christ after the application
of acqua sporca and during the
addition of tratteggio. ADP/SP 11
S60 02.

FIGURE 8.20. RIGHT
Emiliano Albanese cleaning the
haykal screen of St. Antony.

at the request of the monastic community we agreed to restore part of the face (fig. 8.18). Enough of the left side survived for us to reconstruct most of the upper right side using watercolors and the *tratteggio* technique, whereby the retouching is distinguished from the original by a system of thin vertical lines (fig. 8.19).[16] This pattern is not visible from a distance, but when close to the painting, one can immediately discern which areas are original and which have been reintegrated.

Despite requests from the monks, we chose not to restore the lower part of the face because we lacked adequate models for the mouth and beard. By chance, the other painting of Christ by the same artists in the central nave is damaged in precisely the same place. We avoid reintegration whenever possible, but when the images are part of a functioning church in an active monastery, we sometimes agreed to the monks' request to re-create a few important parts of the paintings. However, we do so only when we have original material for reference. Our interventions are always easily identifiable through the use of tratteggio, and all additions are completely reversible.[17]

While working in the Haykal of St. Antony we found that the shell of the dome was originally pierced by sixteen widows arranged in three superimposed registers.[18] Starting from the bottom there were four large arched windows, composed of five or six panes of circular glass in a stucco frame. The second level comprised eight windows of fretted

gypsum plaster forming two alternating geometric designs (see fig. 8.12). The third level had four windows also made of fretted gypsum plaster, but in the shape of crosses. The two upper registers did not seem to have employed glass.

Eleven of the windows had been plastered over at some point. The five on the east side of the dome were closed in about 1291/1292 for the painting of Christ in Majesty by the second medieval master. The lower window on the north side was filled with mud bricks in the early eighteenth century during the construction of the adjacent Haykal of the Twenty-Four Elders. The remaining windows seem to have been plastered over at a later date, perhaps in an effort to prevent further damage from rainwater. We removed the later covering wherever possible, most notably over the four cross-shaped windows of the upper register, which had been filled with a tafl mortar.

While cleaning the five open windows, we encountered the remains of their original stucco grills. Plaster fragments of the fretwork survived around the edges of the windows. In some cases, the complete outer frame was preserved. We also found pieces of colored glass at the base of the west window of the lowest register. By studying the surviving pieces we were able to identify the designs used to form the plaster grills at each level. It was thus possible to reconstruct ten of the windows. The new fretwork was made in molds produced at the monastery, and then finished using scalpels (see fig. 7.16).

153

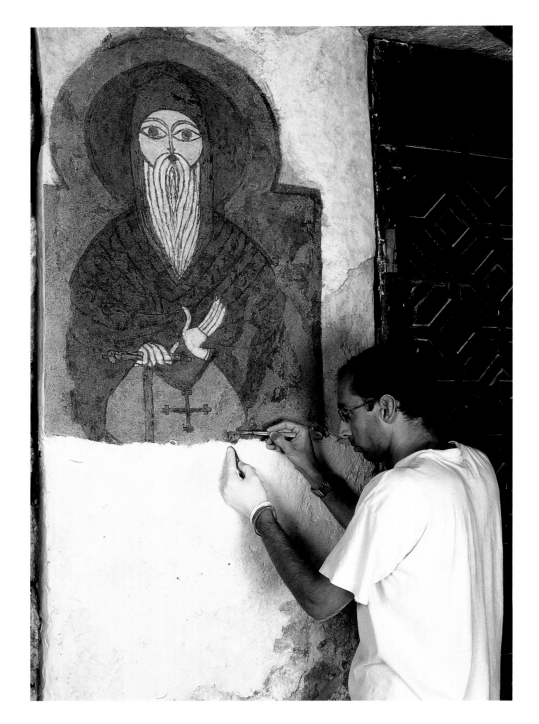

FIGURE 8.21

Gianluca Tancioni removing the cement wash on the painting of Marqus al-Antuni (B10). This process was carried out in conjunction with the cleaning of the paintings after removing the cement covering the walls. EG 2 S60 02.

During the course of our work, operations were also carried out on all the wooden elements in each room of the church. These included the haykal screens of the three sanctuaries and various other wooden barriers, latticework windows, the handrails of the staircases, suspended beams for holding lamps, and a series of built-in cupboards. When possible, we removed the wooden elements before cleaning them with a solution of ammonium carbonate (fig. 8.20).[19] They were then consolidated with an acrylic resin solution and restored to their rightful place, using a mor-

tar composed of sieved tafl, sandstone dust, and gypsum. According to inscriptions, the haykal screens of the Twenty-Four Elders and St. Antony were replaced in 1950 and 1951. We discovered, however, that many pieces had been reused from earlier screens dating from the beginning of the eighteenth century. At the end of the project, the original inscription panels from circa 1705 were repositioned above the modern inscriptions on the wooden walls of the screens (see fig. 2.7).

We attempted to complete work in each room before moving to the next phase. At the Cave Church this method was not always feasible because of the damaged state of the lower walls. At the beginning of the first campaign we removed about 1,500 kilos of thick cement from the walls and floors.[20] Underneath, we discovered deep losses in the fabric of the walls, especially in the medieval section of the church, where the tafl of the rock shelf was exposed (fig. 8.21). The damaged walls were too damp to be treated immediately. They needed a chance to dry before we could attempt repairs.

The delay provided the opportunity for an archaeological investigation of the original floor of the church carried out by Michael Jones and Peter Sheehan. It also allowed us time to study the composition of the medieval walls, and the different plaster layers applied to them. The long horizontal gaps clearly revealed a cross section of each wall that greatly facilitated our understanding of the architectural history of the church.

In the eighteenth-century rooms, the removal of the cement revealed extensive areas of original plaster that contained the presence of harmful salt. The problem was particularly acute along the lower parts of the northern walls of these rooms, which were exposed to runoff water from the monastic garden. Salt was also encountered in some areas of the medieval section of the church, but never in the same degree of concentration. When the salt reached a thickness of more than three millimeters, it was removed mechanically. We eliminated approximately fifty kilos of salt in this manner. Thinner layers were dissolved by spreading a cellulose paste made with distilled water on the wall for a period of two or three hours. In some cases this process was repeated after a few days.

During the second and third campaigns, once the lower walls had sufficiently dried and the salt was removed, the most substantial losses were filled with local sandstone and fragments of raw bricks bedded in with tafl mortar. We used these materials in imitation of the original building methods employed in the church. A roughly sieved tafl

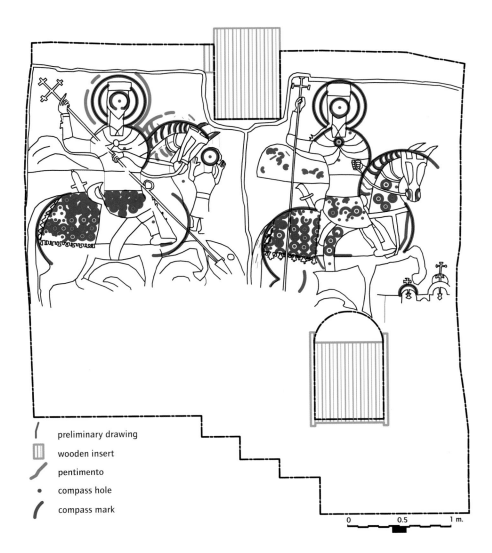

preliminary drawing
wooden insert
pentimento
compass hole
compass mark

0 0.5 1 m.

FIGURE 8.24

Conservation record of Theodore Stratelates (A2) and George (A3) showing the technique of the eighteenth-century painter.

leading to the Haykal of St. Paul (see fig. 6.6). On the eastern soffit of the same arch we rediscovered the painting of Stephen that the Whittemore expedition documented in 1931 but that was subsequently covered by a layer of vinyl paint (see fig. 8.11).[26] This figure appears to have been the work of the first master that the second later refreshed. Finally, we uncovered a long, narrow fragment of painted plaster running at the top of the east wall of the central nave and Shrine of St. Paul. Not enough survives to identify the subject, but its position on the third medieval plaster layer clearly indicates it is by the second painter, a point we will return to later. Although most of the new paintings from the second medieval phase we uncovered are fragmentary, many of them also appear unfinished. Apparently the artist originally planned to paint a more extensive program that for some reason he never completed.

The third cycle of paintings by the eighteenth-century monk is the most extensive program in the church, and it was the most legible before conservation. The style of the monk-painter is very distinctive. Circles made with a compass form the heads, halos, and upper bodies of his figures (fig. 8.24). At the center of each circle is a hole left in the plaster by the point of the compass. The round faces of the saints have large almond-shaped eyes that meet just above the mark of the compass. The other facial features are created with the economical use of thin lines of paint. When producing the bodies of his saints, the monk shows little concern for anatomical accuracy. The pigments of the eighteenth-century program are red and yellow, both of which appear to have been made from minerals obtained locally, as well as green, black, and brown, which are used more sparingly. The monk's palette rarely included white; instead, he preferred using the underlying plaster layers.[27] He frequently scraped paint off of the white plaster, especially while working on faces and hands, to ensure a degree of neatness and visibility. Almost all of his images have been corrected in this manner to some extent.

Van Moorsel identified Maximus and Domitius on the east wall of the central nave, but not the adjacent figure to the south (see fig. 8.4).[28] As mentioned above, these paintings were almost completely obscured by extremely thick deposits of oil, wax, and greasy dust. We chose this anonymous figure to be one of our first test cleanings. It became apparent almost immediately that the subject was Macarius. We uncovered an inscription in the saint's halo that contained his name (see fig. 8.6). Although this Coptic text was unknown to van Moorsel, it was still legible in 1931 when the Whittemore expedition photographed the painting.[29] During the course of our work we made a number of

will return to), his unusual chromatic range, his lack of systematic planning in the preparatory stage, and the character of his decorative details all make it reasonable to suppose that he was primarily experienced in the production of miniatures rather than wall paintings.

We uncovered previously unidentified portions of the second medieval program. On the west wall of the corridor we found a fragmentary cycle consisting of a domed church, a nimbus, and a female saint, possibly the Virgin Mary. Although the church appears unfinished and the middle saint is almost completely lost, the well-preserved head and face of the woman leaves no doubt that this is the work of the second master. In the Shrine of St. Paul we discovered a painting of a saint on the west wall. It survives as little more than an outline (again it may have been unfinished), but the framing arch is very similar to those used by the second master for Shenoute and John, in the corridor. We also uncovered other remains of his work. He placed what appears to be the preparatory stage of an architectural subject in the Haykal of St. Antony above the arched passageway

157

other discoveries relating to the eighteenth-century program. The removal of the cement and other later repairs, especially in the narthex and the corridor, revealed previously covered portions of the lower borders of the paintings. We found, for example, part of the face of a child within the coils of the dragon being impaled by the equestrian image of Theodore on the north wall of the narthex. This detail also appears in one of the Whittemore expedition's photographs, when both children still survived.[30] The dragon's tail extends in a curl onto the adjacent west wall to the left of the saint. This element, which was obscured by repairs made to a crack in the wall, is now separated from the rest of the monster's body due to the loss of the original underlying plaster layer.

The Coptic and Arabic inscriptions above the equestrian figure of George on the same north wall were painted in yellow on white plaster. Most of the inscriptions were illegible because the pigment had partially fallen away. A clear print of the lost letters remained, however, due to the surrounding areas having been blackened by carbon deposits. We fixed the negative impressions of the letters with an acrylic resin solution and restored the missing text using acqua sporca.

We also uncovered a preliminary inscription around the base of the dome of the narthex. It is painted in an irregular manner using a yellow pigment on the white plaster. The inscription has the same text as the more elaborate, two-lined Coptic inscription produced immediately above. It was obviously used by the painter as a model. Once the work was completed the earlier inscription was not removed. Instead, it was gradually hidden by the buildup of surface deposits.

In the Haykal of the Twenty-Four Elders we found a series of horizontal lines dividing the north wall below the springing of the dome. The lines were formed by the *battitura di filo* technique, whereby a string coated in carbon is stretched tightly along the wall and then plucked in order to leave a straight black line on the plaster. A similar system of lines was used in the drum of the dome when determining the space to be allotted to the row of enthroned elders of the Apocalypse. The presence of these lines on the north wall suggests that originally the monk-painter planned to expand the program in the dome of the haykal to the lower level of the room. If so, the project never progressed beyond this initial stage.

Plaster Layers

The earliest plaster layer (rendering one) in the church appears to be contemporary with the program of the first medieval master. All of his paintings are executed on this rendering. It is white in color with a particularly compact surface containing plant fibers. The plaster is similar in composition to the thirteenth-century rendering in the Church of St. Antony at the Monastery of St. Antony. This earliest phase seems to have been applied in all of the rooms of the medieval church. It is best preserved in the Haykal of St. Antony and in the corridor, where it is found covering the surfaces of both rooms. The first master used the rendering in the haykal when painting his enthroned Virgin, the Annunciation, and the four evangelists. The dome, however, was left unpainted, apart from some of the fretwork windows being decorated with red bands. There is no evidence that the painter worked on this plaster layer in the corridor. The first rendering is less well preserved in the central nave and the shrine and haykal of St. Paul, but enough survives to suggest that it was applied to the walls and probably the ceilings of each of these rooms.[31] In the central nave it is almost completely covered by subsequent layers of plaster. Nevertheless, we encountered the presence of the first rendering in this room in the two light wells in the ceiling, and under a fragment of eighteenth-century plaster on the east wall. It was on this portion of the first rendering that we found the face of a saint by the first master, as mentioned above. The face was roughened with a pick at some stage in order to improve the adhesion of a later plaster layer.

The second medieval layer of plaster (rendering two) is found only on the ceilings of the shrine and haykal of St. Paul. It was very roughly applied, which suggests that it was not intended as a surface for painting. The powdery nature of the underlying tafl may have caused the first plaster layer to detach from the ceilings of these rooms; it was then replaced by the second rendering. The repairs seem to have been carried out soon after the application of the original rendering. The image of Stephen in the vaulted passageway leading to the Haykal of St. Paul was painted on both the first and second plaster layers. The second master obviously retouched the painting, but it appears to have originally been part of the first medieval program. If this assessment is correct, both stages of rendering were in place when the first master worked in the church.

Sometime after the application of the first and second renderings, but apparently before the second master was active in 1291/1292, an elaborate new plaster layer (rendering three) was used to cover the walls and ceiling of the central nave. This rendering is found only in this one room, except where it extends onto the east wall of the shrine. It is composed of two layers: a light, adhesive mortar mixed with

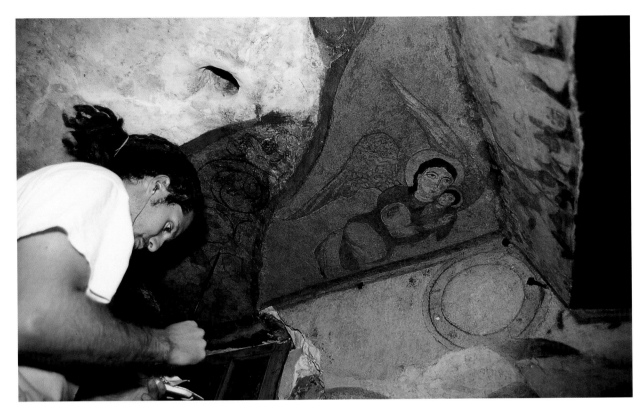

FIGURE 8.25

Paint and plaster layers on the
ceiling and walls of the southeast
corner of the central nave. The
painted arabesque (D8), 1291/1292,
is on rendering four (left, above
Alberto Sucato). The angel carry-
ing a child (D13), the gold ring on
a blue field (D10), and the Massacre
of the Innocents (D14), 1291/1292,
are painted on rendering three.

EG 22 S57 02.

ash or carbon supporting a thick white plaster with a slightly
gray tint.[32] This exceptionally thick rendering was probably
intended to provide a regular, flat surface throughout the
central nave. Along the upper east wall, between the Haykal
of St. Antony and the shrine, an additional layer was added
to bring the surface up to the same level as the rest of the
rendering in this area (see fig. 8.23).[33]

The third rendering represents a major renovation
of the central nave. It was also responsible for obscuring
any earlier paintings by the first master in the room. The
care taken in the application suggests that it may have been
intended for a new iconographic program. Such a proj-
ect, however, seems to have been delayed until 1291/1292,
by which time a number of other modifications had been
carried out in the church. The third rendering on the west
wall was sufficiently durable to be used by both the second
master and the eighteenth-century monk. The layer on the
ceiling, however, was less successful. Within what appears
to be a relatively short time, it had begun to fall or was
removed. Only two triangular segments are still preserved
in the eastern corners of the nave ceiling.

The ceiling was eventually repaired using a new ren-
dering made up almost exclusively of gypsum. This very
thin white plaster (rendering four) was applied following
the natural irregularities of the rock formation of the ceil-
ing. It slightly overlaps the two fragments of the preceding
rendering, but in general it respects them. This fourth layer
is found only on the ceiling of the central nave.

There were two more interventions in the church be-
fore the work of the second master. The first is a thin layer
of whitewash with a pronounced yellow tint that was ap-
plied to the southern arch in the Haykal of St. Antony and
to the walls and ceilings of the corridor, the shrine, and, less
certainly, the Haykal of St. Paul. In all cases it covers the
first medieval rendering. The purpose of this yellow wash
was most likely to refresh areas of the church blackened by
smoke and dust.[34] It may have been applied in advance of
the program of the second master, who used it extensively
as a foundation for his paintings.[35] The second intervention
(rendering five) is almost certainly contemporary with the
program of 1291/1292. Five windows on the east side of the
dome of the Haykal of St. Antony were filled and covered
with plaster, creating an uninterrupted surface for the en-
throned Christ painted by the second master. The plaster
layer is surprisingly rough, considering that it was intended
as a surface for painting.

A characteristic of the second master is that he made
use of existing plaster layers wherever possible. In the
Haykal of St. Antony he painted primarily on the first ren-
dering, except where the windows had been recently filled.
His Infancy of Christ cycle in the central nave overlaps the
third rendering on the south wall and the fourth rendering
of the ceiling. Part of the cycle, the angel carrying a child,
is painted on one of the surviving ceiling fragments from
rendering three (fig. 8.25). In the same room, he painted the
bust of Christ between two angels on the thin gypsum of

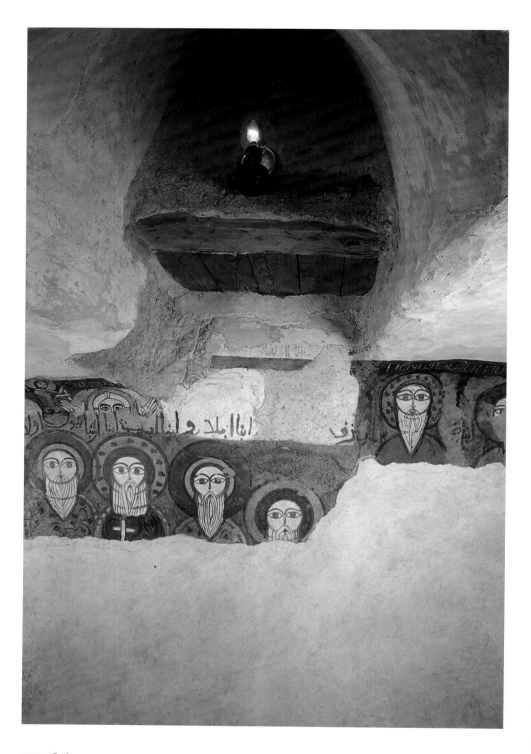

FIGURE 8.26

Paint and plaster layers on the east wall of the corridor: the saints from 1291/1292 (F10–F12) and 1712/1713 (F6–F9, F14, F15) are painted on the yellow wash applied to rendering one. The central red band (F13), of uncertain date, is on rendering six. The halo of Apollo (F8) is also partially painted on the sixth rendering. ADP/SP 4 S246 05.

the fourth plaster layer. It is noteworthy that the floral designs flanking the three figures have been made to conform to the irregular space of the ceiling caused by the remaining fragments from the third rendering. When working in the corridor and the Shrine of St. Paul, the second master painted on the coat of yellow wash applied over the first rendering. On the one occasion that a new plaster layer was required, in order to cover the windows in the Haykal of St. Antony, it was applied in an extremely irregular manner, especially considering that it was intended as the foundation of a painting. This lack of concern for a uniform wall surface is in marked contrast to the well prepared third plaster layer found in the central nave, and suggests that the second master lacked experience in producing murals.

The last medieval plaster layer in the church (rendering six) is only found in the corridor, where it was used to fill a depression in the center of the east wall. This area separates two groups of standing monastic saints from the program of the second master. The recess was roughly packed with thick tafl mortar, which was then pitted in order to provide greater adhesion for a thinner layer of pinkish-white plaster. Once the gap was bridged, a red band was painted, linking the earlier inscriptions above the two sets of saints (fig. 8.26). The sixth rendering and its red band do not seem to correspond with any other paint and plaster layers in the church. We can only suggest that they represent modifications made to the corridor sometime after the work of the second master, but before the enlargement of the church at the beginning of the eighteenth century.[36]

The seventh, and last, major rendering is contemporary with the program of the monk-painter of 1712/1713. It is a white plaster with a pink tint, containing a small amount of lime, applied in a smooth, regular manner to the interior walls of the three eighteenth-century rooms of the church, including the surfaces of the domes. The monk-painter worked directly on this rendering, except for one place in the north nave, where a second layer of very thin plaster was applied to the center of the north wall, between the recently completed paintings of Sarapion and Paul.[37] The monk painted the image of Antony on this second application. It seems likely that he was correcting a mistake in the painting, either the omission of Antony or some mishap in his original depiction.

The same eighteenth-century plaster is also found in all of the medieval rooms of the church, where it is used to fill losses in the earlier rendering.[38] In a number of cases the monk painted on the repairs. His three monastic saints

on the east wall between the central nave and the shrine are painted on the eighteenth-century plaster used to replace severe losses to the third rendering. The second master had worked on the exceptionally thick medieval plaster layer applied to this wall, but sometime after 1292 the rendering fell, taking most of the medieval paintings with it. The monk made no effort to bring the level of his repairs up to that of the surviving fragment of the third rendering. His paintings, therefore, are further recessed than the medieval plaster near the ceiling. The eighteenth-century plaster was applied directly over the painting of a saint on rendering one by the first master. This earliest plaster layer must have been partially exposed at that time by the loss to the medieval third rendering.

The monk also reused medieval plaster layers whenever possible. In the corridor, he painted a row of standing desert fathers directly over the earlier work of the second master. By chance or design, the monk respected the earlier inscription bands, as well as the remains of two saints at the northern end of the wall. A similar group from the second medieval program at the southern end of the corridor, however, he painted over. The ghost of a raised hand and traces of medieval color can be observed beneath the eighteenth-century painting of Samuel of Qalamun. The second master had placed a pair of standing saints at each end of the corridor. The monk-painter followed the same iconographic program but extended his figures to fill the entire east wall. He thus used the yellow wash over the first rendering, and the sixth rendering as the foundation for his row of saints. We encountered a similar situation on the west wall of the central nave, where the monk painted the three archangels and the three Hebrews in the fiery furnace on the plaster of rendering three. Once again he worked directly over the earlier program of the second master. We discovered fragmentary medieval pigments and the ghost of a nimbus under the eighteenth-century painting of the three Hebrews.

Studying the plaster layers in the Church of St. Paul greatly facilitated our understanding of the historical development of this complicated structure. By combining stylistic analysis with the physical evidence uncovered during the conservation process, we were able to associate the different pictorial phases with the plaster layers on which they were painted. We found seven stages of rendering that span a period of about five hundred years. Only three were major applications (one, three, and seven); the other four were used only in specific areas, often as repairs. During the same period there were three main stages of painting in the church. The programs of the first medieval master (ca. 1230) and the monk-painter (1712/1713) are contemporary with major stages of rendering (one and seven). The work of the second medieval master (1291/1292), however, is primarily executed on earlier plaster layers (especially the first, third, and fourth), although the rough fifth rendering used to cover the windows in the Haykal of St. Antony was almost certainly applied in preparation of his work.

In some areas of the church, the different pictorial phases can be identified based on the plaster layers on which they were painted. The clearest example is found on the east wall of the central nave, where the first master worked on the first rendering, the second master on the third, and the monk-painter on the seventh (see fig. 8.24). In a number of sections of the church, however, more than one artist used the same rendering. In particular, the eighteenth-century monk painted over the work of the second master in both the corridor and central nave. Fortunately, with only three phases of painting to consider we found it fairly easy to determine a preserved stratigraphy of superimposed paint layers.

But the practice of painting over earlier works without applying an intervening plaster layer raises certain possibilities regarding our chronological sequence of the pictorial phase in the church. One of the oddest features of that sequence is that the third plaster layer seems to have been prepared as the foundation for a cycle of paintings that was then apparently delayed until 1291/1292. Yet, it is conceivable that the third rendering was in fact painted by an unidentified medieval artist soon after it was added to the walls of the nave. Given the second master's conspicuous failure to apply a new rendering for his work, we cannot help but wonder if he may have painted over an earlier medieval phase in the central nave that was lost when the paintings of 1291/1292 were themselves covered in the eighteenth century. However, with no physical evidence for a third medieval painter, active sometime between the first and second masters, it seems best to dismiss this theoretical lost cycle as only an intriguing possibility. It does underscore the complexity of the situation in the Church of St. Paul, which is markedly different from what we found in the Church of St. Antony at the Monastery of St. Antony, where the layers of paint and plaster are straightforward and consistent.

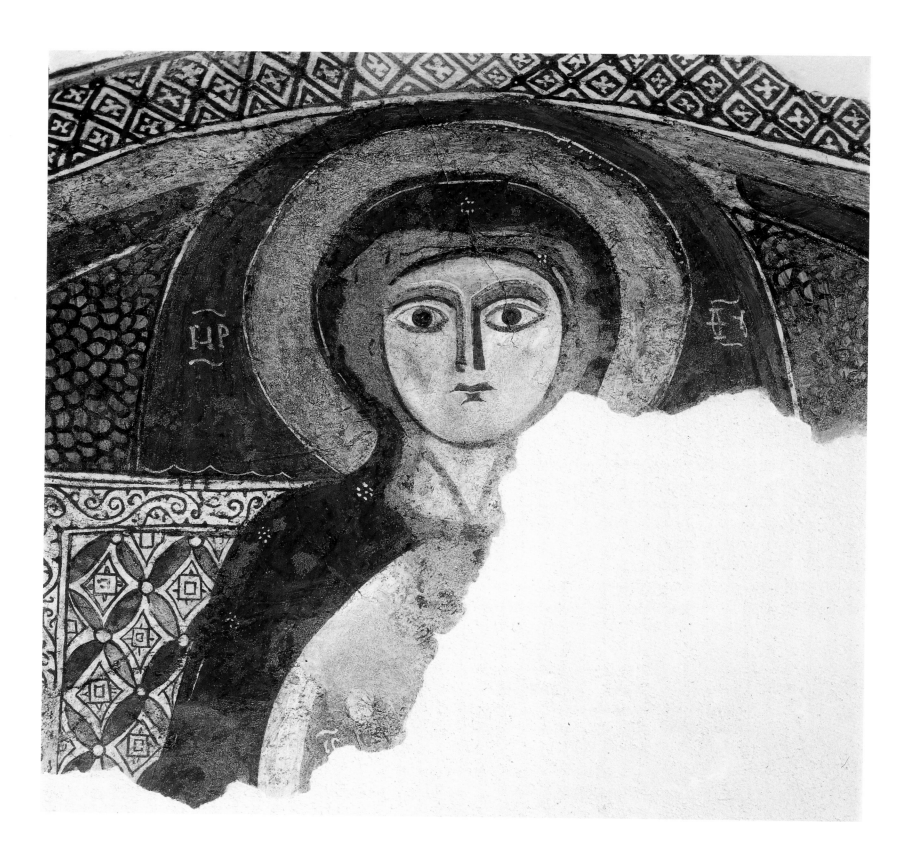

CHAPTER 9 — THE MEDIEVAL PAINTINGS IN THE CAVE CHURCH, PHASE ONE

CONTINUITY

The earliest evidence for painted decoration of any kind in the Cave Church of St. Paul dates to the thirteenth century, a period during which the Monastery of St. Paul flourished (fig. 9.1). We know from textual sources that pilgrims had been engaging in devotional practices at this location for many centuries. We have a far richer array of evidence enabling us to conclude that icons in various media and sizes were a standard part of late antique shrines. Even sites which were not linked to a saint were prepared for spiritual work in part with paintings—for example, the monastic oratories of the monasteries at Bawit and Saqqara—underscoring the central role of representational subject matter in devotional practice.[1] Texts about and remnants from important *loca sancta* within and beyond Egypt provide ample evidence for imagery, decoration, censers, and lamps, both monumental and small-scale, adorning such holy places.[2] Even solitary hermits without access to professional artists seem to have had a strong impulse to depict crosses, birds, boats, lamps, monograms, and other Christian symbols, and sometimes entire passages of significant texts, in their caves and rustic habitations.[3] Religious representations and texts functioned for their Christian audiences as tools for communication with the figures represented, as well as aids in Christians' efforts to find the path to salvation.[4] Additionally, in Chapter 2, Mark Swanson has observed textual evidence for an Egyptian painting of St. Paul described as early as the seventh century, in a monastic context, demonstrating the existence of images of this subject in a late antique setting. Therefore, despite the lack of evidence for late antique images in the Cave Church, we should nevertheless imagine religious depictions (informal or skilled) in both the Haykal of St. Paul and the Shrine of St. Paul by at least the fifth or sixth century.[5]

The reshaping of the cave shrine in the medieval period, and the modern application of cement in the Haykal of St. Paul, have contributed to the destruction of any such early imagery. Two small areas of medieval painting have survived at the outer (northern) end of the Shrine of St. Paul, on both the east and west walls, which I date on stylistic grounds to the later thirteenth-century program in the Cave Church. Irrespective of the paucity of material evidence in the Haykal of St. Paul and the shrine, I am confident that both late antique and medieval images in one or more media existed in these two spaces most closely associated with Paul.[6] The medieval paintings in the Cave Church should thus be understood as continuing a long tradition of using Christian imagery as a religious tool and to help constitute a site as holy.

Remains of two phases of thirteenth-century paintings have survived in the Cave Church. Even though neither program is complete or extensive, each provides an important opportunity to examine the complex character of Christian art in Egypt in this period. In this chapter and the next I consider these images from several points of view: as works of art, examined for their style and character; as iconographic subjects belonging to an established artistic tradition while forming ensembles unique to this church; and as participants in the performance of both individual and corporate devotions.

The Haykal of St. Antony

DESCRIPTION

The thirteenth-century modifications of the Cave Church included an additional haykal, now dedicated to St. Antony, and an expanded nave space to the north of the

FIGURE 9.1

Virgin Mary (E6), first half of the thirteenth century. ADP/SP 1 s250.05.

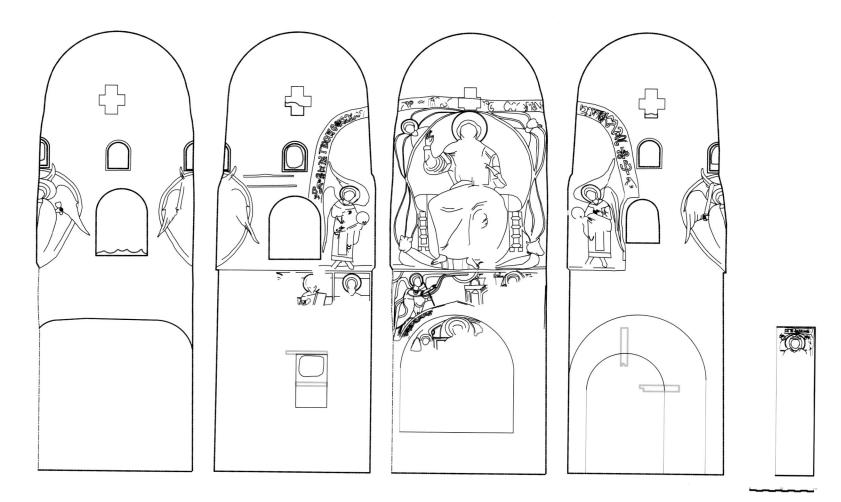

FIGURE 9.2

Conservation record of the two phases of medieval paintings in the Haykal of St. Antony.

original Shrine of St. Paul. The sanctuary space is tall and narrow, beginning at floor level as a cube and rising with awkward squinches to a smoothly rounded dome (fig. 9.2). In its earliest medieval phase, this space included paintings in the bottom half only. The upper zone was unpainted plaster pierced with three levels of windows made of stucco grills, creating a dynamic interplay of light and shadow as the sun moved across the sky (fig. 9.3). Fragments of all three types of openings remained at the start of conservation, making it possible to re-create, to a large extent, the original effect of the windows. The uppermost set of four windows are cross-shaped and fretted with a lacelike stucco, left completely white.[7] The middle set, originally eight in number, creates a sort of clerestory at the curved base of the dome. The stucco grills form various repeating patterns of crosses, eight-pointed stars, and other geometric motifs. A broad band of red paint now frames each of these windows, and thinner red lines trace their internal patterns. This paint could have been applied as part of the earliest phase of painting in this haykal, or as part of the second phase, as both painters used similar red pigments. Three windows in this group were blocked as part of the second phase of

medieval painting, in 1291/1292. The lowest set of windows, in the drum of the dome, was filled with clear glass roundels in stucco frames. Two of these four are currently filled in, and two have been restored. The multiple patterns of light and shadow, with their varied cross patterns, travel around what is essentially a simple space, making it considerably more visually complex.

The paintings in the bottom half of this space have survived in a fragmentary state. The lowest two meters or so of the images have disappeared because of flooding and the application of cement to the walls. This area would certainly have included the lower parts of the bodies of saints now poorly preserved on the north wall. It may also have been painted with imitation marble, or perhaps a solid band of color. The most compelling painting of this earlier medieval phase is that of the Virgin Mary and Christ child, flanked by what were once two archangels, in the shallow niche of the east wall. Above this is a partially preserved Annunciation, on the spandrels of the arch framing the niche (fig. 9.4). Remnants of standing saints on the north wall show that originally there was a continuous row of these figures. The division between the western end of the

FIGURE 9.3

Conserved windows grills in the dome of the Haykal of St. Antony. The black square next to the upper window is an area of uncleaned plaster, indicating the state of the dome prior to conservation. It was removed later in the project. ADP/SP 1 SI194.02.

sanctuary and the nave is established by a tall, postmedieval wooden screen and would likely have been filled with something very similar when this addition to the Cave Church was built in the first half of the thirteenth century.[8] The extent of the west wall in this lower zone of the sanctuary was therefore restricted to a narrow, unpainted frame. The south wall is also minimal in its expanse at this level, being pierced with an arched opening that provides the connection between this haykal and the sanctuary of St. Paul, directly to the south. The current altar is a modification of the first altar in this space, which was placed slightly more to the north and therefore centered on the niche and the painting of the Virgin Mary and Christ child. The original floor of the sanctuary was covered with a greenish stone, providing a dark, rich, coloristic contrast to the light-filled white dome above.[9]

Only the upper section of the composition of the Virgin and child remains. She sits frontally, on a throne, holding before herself the child in an oval, often called a *clipeus* (shield) or *mandorla* (body halo). It is an iconographic type usually identified as the Virgin *Nikopoios* (victory-maker).[10] Only part of the white-bordered oval with the child survives, but one can still discern a blue background,

part of an inscription, and traces of red and encaustic green pigments. Abbreviated inscriptions give Mary the standard title of Mother of God (*Meter Theou*). She stares directly at the viewer with an uncompromisingly serious expression (fig. 9.5). Her large eyes and pronounced pupils add a sense of otherworldliness to her gaze. The strong red lines at the base of her eyebrow and delineating her nose and lips, and even enhancing her pupils, add to the intense spirituality of her face. This redness is repeated again in her *maphorion* (the garment covering her head and shoulders), and in a red arch framing her face that rises above the back of the throne. The painter has embellished her mantle only with small groups of white dots, usually in clusters of seven (one in the middle surrounded by six others). The throne back is densely patterned, as are the angels' wings and their clothing. The elaborate chair back has a diagonal design suggesting luxurious padded quilting, with decorated borders that were presumably meant to suggest a carved wooden frame. The surviving face of the angel at the viewer's left exhibits a much more benign facial expression than does Mary, with smaller eyes that lack the intensity of those of the Virgin.

Two patterned bands establish the transition between the enthroned Virgin and child, and the Annunciation above. A red diaper pattern, featuring white crosses within diamonds, spans the inner edge of the niche. A pleated ribbon pattern in red, white, and green marks the outer edge and rises to a point that is slightly off center. Above, on the left, Gabriel, the angel of the Annunciation, fills the spandrel, reaching out to the Virgin with his right hand (fig. 9.6). The green encaustic of his wings and most of the blue background, and possibly other centrally placed iconographic features, have almost completely disappeared. A half circle still extends down from the upper red border of this painting, and whatever was in its interior is also now missing. On the right side of the composition, most of a domed architectural structure, the upper two-thirds of the Virgin's face, the dove of the Holy Spirit, and a few small decorative remnants have survived. The archangel and Mary are named, and part of the text of the angel's salutation has also survived. While Gabriel and Mary are turned toward each other, they make no eye contact.

On the north wall, the remains of three standing saints can now be discerned, postconservation. These haloed figures stand frontally within red-bordered frames, against poorly preserved backgrounds that were once blue at the top and bright green beginning just below shoulder level. John the Evangelist stands closest to the east wall and is identified by an inscription as: "John, the celibate evangelist" (fig. 9.7). The characteristic red highlights and

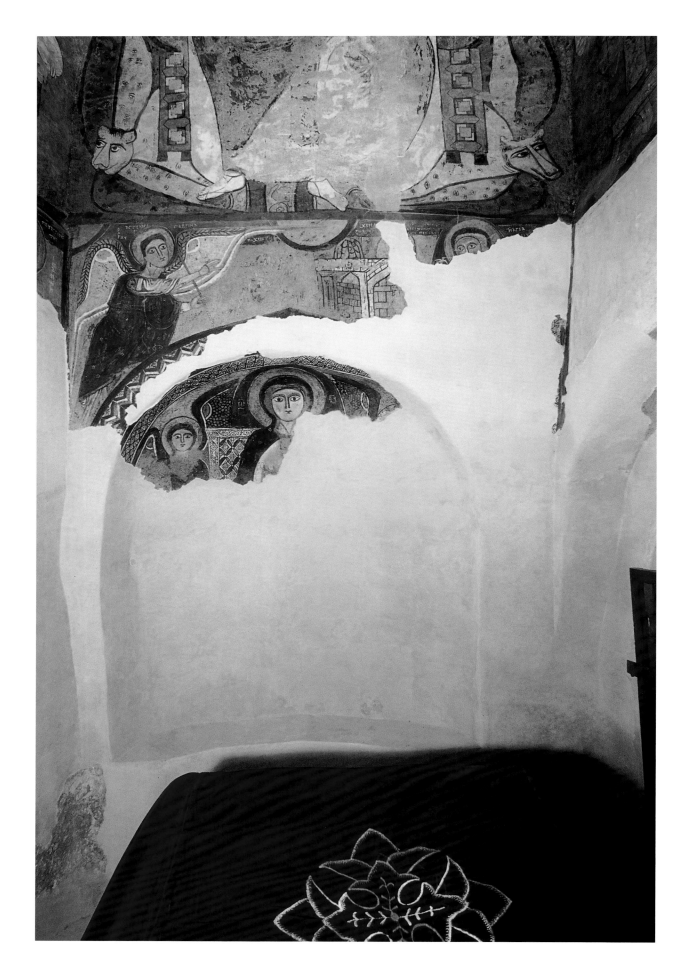

FIGURE 9.4

Enthroned Virgin Mary (E6) and
the Annunciation (E7–E9). ADP/SP
1 S248.05.

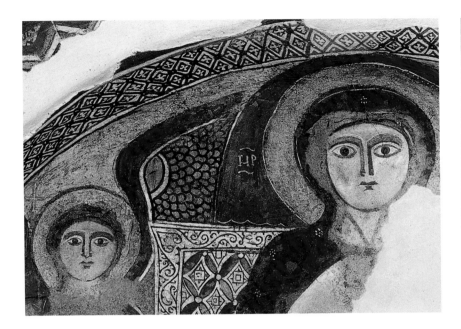

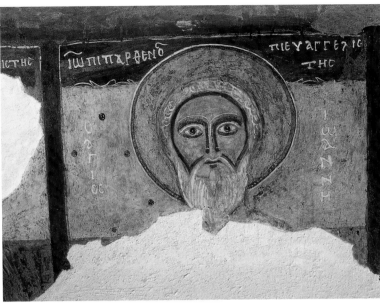

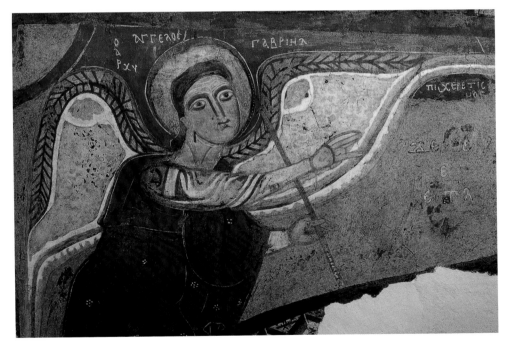

FIGURE 9.5 TOP LEFT
Virgin Mary holding the Christ
child in a clipeus or mandorla,
attended by an angel (E6). ADP/SP
214 S6 5 05.

FIGURE 9.7 TOP RIGHT
John the Evangelist (E4). ADP/SP
14 S206 02.

FIGURE 9.6 ABOVE
Angel of the Annunciation (E7).
ADP/SP 20 S206 02.

staring eyes appear here, too, but without the extreme intensity of the face of the enthroned Virgin Mary. Only the uppermost section of this painting, consisting of his white-haired head and bearded face, still exists. Moving to the viewer's left, the face of the next figure is largely obscured, but the upper section of his torso has survived, showing that he holds a book and apparently wears Episcopal dress. The remains of an inscription identify him as the evangelist Luke. Further left, only traces of a halo and the upper red frame remain of another depiction. This no doubt represented Mark. Certainly enough space existed here for all four evangelists, and it seems reasonable to assume that the artist included Matthew as well.

The east and north walls provided the greatest expanse for painting, and the question remains what else could have been depicted in the sanctuary. One might expect to see Antony and Paul, although they may have been located in the nave, next to the sanctuary entrance, as one finds them in the Monastery of St. Antony, or placed in the Haykal of St. Paul to the south. The characteristic red border survives on the south wall, framing the far eastern corner, suggesting that this surface was also painted, but the original thirteenth-century plaster surface has survived in this area, and, apart from the red border, it is unpainted. Given the remaining evidence, it is impossible to say what the artist intended for this zone.

STYLISTIC ANALYSIS AND DATING

The dating of the architectural addition of the Haykal of St. Antony in the Cave Church depends solely on that of the paintings in this lower region, and the only evidence

available for suggesting a time frame for the work of the first medieval artist is derived from an evaluation of style. While such analyses are still very general when considering late antique and early Byzantine art in Egypt, the situation with respect to medieval paintings is somewhat clearer. This fortuitous state, usually permitting the dating of medieval paintings to a span of a century at most, is largely due to the firm date provided by the inscriptions for most of the paintings in the Monastery of St. Antony.[11] Jules Leroy and Paul van Moorsel associated the paintings in the lower region of the Haykal of St. Antony (Monastery of St. Paul) with those in the Church of St. Antony (Monastery of St. Antony) of 1232/1233 by the artist Theodore, but without discussion.[12] As van Moorsel noted, the painter at the Monastery of St. Paul worked in a very closely related style to that used by Theodore at St. Antony's.[13] I concur with his opinion and, with the benefit of cleaned paintings at both sites, will take this opportunity to demonstrate it.

Parallels exist in the depiction of both ornamental elements and figural subjects. One is apparent, for example, in the folded ribbon motif embellishing the arch above the Virgin and child, and in the segmenting of pictorial fields with red borders. However, the red-framed pearl border so common at the Monastery of St. Antony, and in associated but likely earlier paintings at the Monastery of St. Macarius (Haykal of St. Mark, Wadi al-Natrun), appears nowhere in the surviving decorative scheme at St. Paul's.[14]

An evaluation of the relationship between the enthroned Virgin Mary at the Monastery of St. Paul and the same subject in the apse of the central haykal in the Church of St. Antony clarifies the situation with respect to figural and decorative paintings (figs. 9.8; see also figs. 9.1 and 9.4). In both representations the Virgin has a rounded face, clearly outlined, with reddish shading on the cheeks. Continuous lines delineate the eyebrows and nose in each painting, but Theodore typically used black or dark brown outlines, whereas the artist at St. Paul's avoided them in favor, usually, of red—a distinctive choice apparently unique to this painter. Also, the artist working in the Cave Church used broader strokes and white pigment to build up the bridge of the nose, and rendered the tip differently. The density of the shading between the eyebrow and eye is much heavier at St. Paul's. At the Monastery of St. Antony the eyes are somewhat longer and slightly less intense, but both share a similar shape and large, staring pupils. The mouths differ, in that curving lines frame pursed lips at St. Antony's, while at the Monastery of St. Paul the lower part of the mouth and suggestion of the

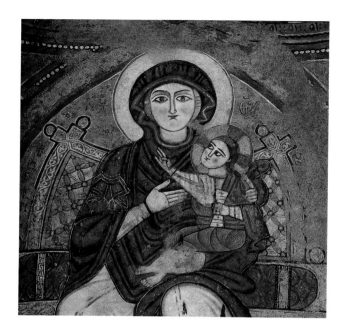

chin echo this format, yet the upper lip is fuller and more carefully shaped. At St. Antony's the articulation of the neck is sometimes conveyed with a large V shape, but never when showing the Virgin Mary.[15] At the Cave Church, this V appears prominently on the Virgin's neck. The handling of line in both cases is similar, with an even density, often inscribing simple curves and straight trajectories.

The decorative features framing the two images of the Virgin demonstrate the interesting ties between the two paintings while emphasizing the notable absence of exact similarities. The patterns on the backs of the two thrones are very similar, but not identical (fig. 9.9). Particularly, the decorative element found in the interstices of the diagonal pattern at St. Paul's does not exist anywhere in the paintings at the Monastery of St. Antony. The schematic design that borders the throne in the Cave Church painting, likely meant to suggest a leafy, undulating vine, is ubiquitous in the Monastery of St. Antony. Nevertheless, the same basic motif varies in significant ways at the two sites. In the Cave Church it is rendered with thin red lines on white. In the Monastery of St. Antony, thicker red lines adorn a golden-colored background. Similarities abound, but the same hand is never evident. A consideration of paintings belonging to the same general style at monasteries in Cairo and the Wadi al-Natrun does not yield a closer group of parallels.[16] This makes dating the earliest medieval phase of painting at St. Paul's to the same period as that of Theodore's work of 1232/1233 quite straightforward, but establishing whether the St. Paul artist worked before or after that date is impossible to determine.

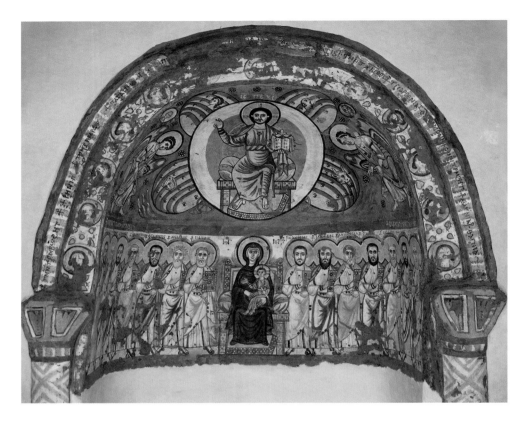

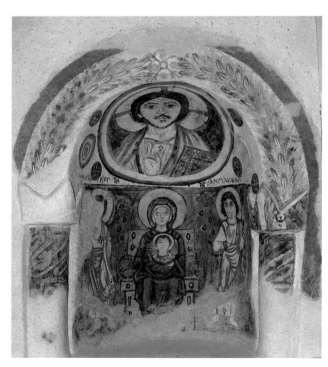

FIGURE 9.10 ABOVE

Christ in Majesty above the Virgin
and Christ child with apostles and
saints, sixth–seventh century, after
conservation. Room 6, Monastery
of Apa Apollo, Bawit, now in the
Coptic Museum, Cairo (inv. no.
7118).

FIGURE 9.11 RIGHT

Roundel bust of Christ above the
Virgin Mary holding a roundel
with the face of the Christ child,
sixth–seventh century, after
conservation. Cell 1723, Monastery
of Apa Jeremiah, Saqqara, now in
the Coptic Museum, Cairo (inv.
no. 7984).

Iconography: The Virgin and Christ Child

The enthroned Virgin and child make up one of the two
standard elements of a combination in Egyptian Christian
painting that first appeared in the sixth or seventh century
and continued with remarkable iconographic stability into
the thirteenth century. It was not unique to Egypt, but it
seems to have remained a common choice longer here than
elsewhere. This type, rendered in an enormous variety of
styles over the centuries, consists of an enthroned Christ
in Majesty in a mandorla supported by four incorporeal
living creatures and flanked by angels, above an image of
the Virgin and Christ child. In these images, and in others
of Mary and the Christ child alone, their presentation var-
ies, including, for example, the child seated on her lap, the
child nursing, and, as at St. Paul's, the child in a clipeus or
mandorla. The best-known early example of this common
two-level iconographic type comes from the Monastery of
Apa Apollo at Bawit (fig. 9.10).[17] It represents Christ en-
throned in majesty in an eternal realm in the upper zone.
Above, he manifests his divine nature, while below, where
he is shown as a child with the Virgin Mary, he is the in-
carnate *Logos,* or word of God.[18] A smaller painting from
a cell found at the Monastery of Apa Jeremiah at Saqqara
shows an abbreviated version of this scene, with busts of
Christ depicted in roundels—the adult Christ in the upper
level nicely paired with the Christ child in the lower one
(fig. 9.11). Another painting in a monastic cell, found at
Bawit but no longer surviving, showed a single zone only,
with the Virgin holding a clipeus or mandorla containing
the full body of the Christ child, flanked by angels.[19] The
version in the Cave Church most likely followed this model,
depicting the Virgin Mary holding a large oval framing the
entire body of the Christ child, as can be seen by the long
curve of the surviving part of the edge, which shows traces
of the child's right hand. Theodore used this iconographic
type when painting his second image of the Virgin in the
nave of the Church of St. Antony (fig. 9.12).

The fascinating depiction of the Virgin holding not
the child himself but an image of the child (in the tradi-
tion of the imperial depiction on a clipeus), or perhaps the
child's body halo, invites further analysis. This type is found
in late antique and Byzantine art, with many variations.[20]
Thomas Mathews has observed problems with interpreting
the oval as a shield, citing one example in a late antique
Armenian manuscript where the iconographer has inserted
this type into an Adoration of the Magi. Mathews noted
that the Magi visited the Christ child himself, not an im-
age of him, and plausibly argued for the significance of the
oval as "a radiance, a circle of light, a zone of glory."[21] An-

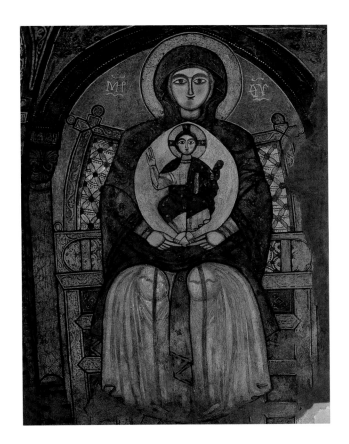

FIGURE 9.12

Virgin Mary holding the Christ
child in a clipeus or mandorla,
1232/1233. Church of St. Antony,
Monastery of St. Antony. ADP/SA
1999.

the presence of the windows. Apparently its absence caused some discomfort, because it was maintained for less than a century.

Iconography: The Annunciation

Depictions of the Annunciation feature with reasonable frequency in Egyptian Christian art beginning in late antiquity.[24] The earliest surviving example is the painting in the so-called Chapel of Peace at al-Bagawat (Kharga Oasis), where there still exists a beautifully reduced image of the subject, showing only the Virgin and the dove next to Noah's ark. A dove flies to the right, toward Noah, near the lower border of the image, while another dove approaches Mary from the opposite direction, directly above the first one.[25] Most artists have juxtaposed Gabriel and Mary tightly, although in many of these depictions the Virgin is positioned completely frontally, making no gesture toward the archangel, so their proximity does not suggest direct communication.[26] As van Moorsel has observed, this subject was not represented in the iconographic program at the Monastery of St. Antony at any time, and so the artist at the Monastery of St. Paul does not seem to have been copying from St. Antony's in this instance.[27] The St. Paul Annunciation represents an elaborate version of the subject, complete with a central fountain or building. However, a close precedent for this type of Annunciation, including its placement across an arch, can be found in the Wadi al-Natrun at the Monastery of St. Macarius (Haykal of St. Mark), probably dating to within fifty years or so of the Red Sea painting.[28] At this lower Egyptian site, and also at Bawit in a much earlier sixth- or seventh-century painting, the Annunciation is paired with the Nativity.[29] Interestingly, no trace of the Birth of Christ exists at St. Paul's, although it may well have been depicted nearby, as I will discuss in the following chapter.

other interpreter of the subject sees it as a depiction of the Christ child in the Virgin's womb, tying it to the notion, expressed by such early theologians as Cyril of Alexandria, that her womb was limitless, because a human female could not encompass God.[22] This possibility gains credence with the inclusion of the oval in two twelfth-century icons of the Annunciation.[23] One of these is now, and perhaps was from an early date, in the Monastery of St. Catherine on Mount Sinai, just across the Red Sea from the Monastery of St. Paul. Most likely the image in the Cave Church was meant to be seen in conjunction with the Annunciation just above it; the Annunciation showed the narrative events surrounding the incarnation, and the iconic image below expressed the paradox of Christ's existence within Mary's womb.

In the Haykal of St. Antony, in the Cave Church of St. Paul, the first medieval painter included the Virgin holding the image of the Christ child in an oval, as well as the unusual addition of the Annunciation, but not the standard Christ in Majesty. The upper region was, at that time, left white, with the regularly pierced windows in three tiers. As I will discuss in the next chapter, the later medieval painter transformed the upper area of the east wall and established the more common double-zoned format. The reasons for omitting the Christ in Majesty in the earlier painter's work may suggest that the two-zoned format was not as ubiquitous as we think, or that this choice was dictated by

The setting of the event near a fountain derives from the Apocrypha and not the canonical Gospels. Jules Leroy has pointed out that the depiction at the Monastery of St. Macarius fuses the two standard settings for the event: a fountain and the Virgin's house.[30] The St. Paul painter seems to have made the same choice, although because of significant damage to this area of the painting we cannot be certain (fig. 9.13). However, traces of a pattern at the far right might indicate a throne, an iconographical feature found in the Wadi al-Natrun example. The semicircle of red arching behind the Virgin's head is also the same in both images. At the Monastery of St. Macarius, a decorated roundel at the center holds the place filled in Byzantine art by a half circle and the hand or bust of God, while at

FIGURE 9.13

Annunciation, detail of the house
or fountain (E8). ADP/SA 3 S1207 02.

St. Paul's the painting is too damaged to reveal more than
a half circle. Oddly, no dove appears at the Monastery of
St. Macarius; perhaps it has been destroyed. The dove is
clearly visible and quite well preserved at the Monastery of
St. Paul (fig. 9.14).

The expansion of the Annunciation at St. Paul's de-
viates from the late antique tradition, but both its more
elaborate iconography and its positioning on an archway
find numerous parallels in Middle Byzantine art.[31] In the
depiction of the scene at the Cappella Palatina (Palermo)
of circa 1143, a half circle descends from the center top of
the field, from which extends the hand of God and a beam
of light. The light reaches from God's finger to the Virgin
Mary, and the dove is shown midway along it, facing Mary.
In a Middle Byzantine painting of the subject in the Church
of the Panagia Phorbiotissa at Asinou (Cyprus), a white
line travels from God in the central half circle to the dove,
but not beyond (fig. 9.15).[32] Oddly, in the St. Paul painting,
no evidence has survived for the beam of light extending
from the heavenly space to the dove, but a definite white
line reaches from the dove to Mary. At Asinou, Mary sits
on a throne in front of an elaborate architectural setting,
part of which houses a fountain.

Medieval Coptic artists, such as the first thirteenth-
century painter who worked in the Cave Church, may well
have drawn, at least initially, on Middle Byzantine examples
for this elaborate Annunciation type, including the dove,
the half circle denoting heaven with the hand of God, the
elaborate fountain building, and the placement of the scene
on an arch in the sanctuary.[33] The artist working in the
Cave Church may also have seen it in the Monastery of
St. Macarius, or in a manuscript. Theodore incorporated
Middle Byzantine elements into his paintings in the Mon-
astery of St. Antony, such as the image of Christ in Majesty
in the dome of the sanctuary.[34] Thirteenth-century Coptic
artists seem to have had access to examples of contempo-
rary Byzantine art. They would have seen some of it in its
architectural setting, not just in manuscript illuminations,
because the placement as well as the subject is sometimes
repeated.[35]

Erica Cruikshank Dodd sees such parallels spread over
a wide region (Sicily, Byzantium, Egypt, and, her focus,
Lebanon), all deriving from monumental art in Jerusalem.[36]
Artistic innovation at a holy site such as the Church of the
Annunciation in Nazareth would perhaps make more sense
in this instance if we were to follow Dodd's general model.
To my mind, however, the process of narration and its
pictorial and textual expression follow more complex and
elusive routes. Artists may have seen or heard about works
at sites other than those in the Holy Land. Also, the role of
smaller-scale media should not be underestimated. They
could have functioned both as loci of innovation and as
readily portable objects potentially interacting with a much
broader audience than would have been possible with fixed,
monumental art.

Iconography: The Evangelists

While Leroy and van Moorsel were able to discern with
clarity only the figure of John the Evangelist on the north
sanctuary wall and traces of additional paintings, more was
visible in the early twentieth century.[37] Happily, most of
these earlier remnants were uncovered during conserva-
tion (fig. 9.16). A photograph taken during Thomas Whit-
temore's trip to the monastery in 1930 or 1931 shows faint
but clearly identifiable depictions of three frontal, standing
figures in separately framed compartments (fig. 9.17). That
at the far right (east) shows John, and after conservation we
were able to identify the figure immediately to the west of
him as Luke. While in the Whittemore photograph John's
book is clearly apparent, and one sees evidence of three-
quarters of his standing figure, now nothing remains but
his head and the region around it. Evaluation of the iconog-

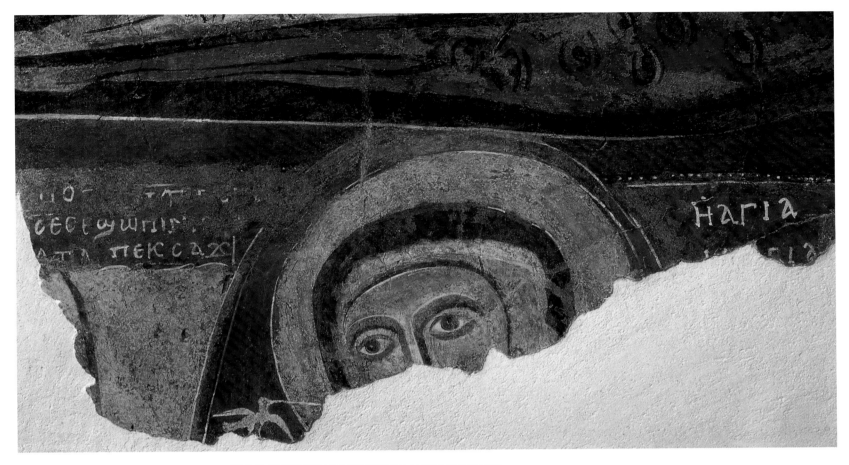

FIGURE 9.14 ABOVE
Virgin Mary of the Annunciation
(E9). ADP/SP 4 S207 02.

FIGURE 9.15 RIGHT
Annunciation, ca. 1350–1375,
Church of the Panagia Phorbio-
tissa, Asinou, Cyprus. Dumbarton
Oaks Field Committee Negative,
AS/B 67.81. Courtesy of Dumbarton
Oaks, Washington, D.C.

his halo, his beard, the upper part of his torso, his book, and sections of the framed background still exist. Traces of the standard red-bordered frame, and ample space on the wall, indicate that Luke and John were accompanied by Matthew and Mark.

Van Moorsel has pointed out the unusual placement of John the Evangelist, who is closest to the east wall. He suggested that perhaps John was the original patron saint of this haykal, and that additional standing figures to his left may have been apostles.[38] This explanation may account for John, but not for the presence of the other three. One early Egyptian representation of the evangelists has survived on the Freer Gospel covers, painted on wood in about the sixth century with two frontal evangelists on each side.[39] These images have an immediate relationship with the manuscript, as they are of the authors of the four Gospels, but their placement in the Haykal of St. Antony also has close ties to the first medieval painter's iconographic program. All of the evangelists testify to the divine and human aspects of Christ, while Matthew and Luke refer to or recount the Nativity, and Luke describes the Annunciation. So much of the visual expression of Christian Egypt has been destroyed over the centuries that we cannot know if this painting of all the evangelists standing together in

raphy of the evangelist Luke from the archival photograph causes difficulties, because a face, book, and torso are dimly visible, but they do not appear to relate more than generally to the placement of these elements in the postconservation painting. This suggests that overpainting existed on this surface, and that it did not survive the dual assaults of dampness from rain coming in the window above and moisture pushed upward from cement applied to the lower part of the wall after floods in 1966 and 1971. De Cesaris and Sucato found no overpainting in this area. The medieval layer showing Luke's face has been largely destroyed, but

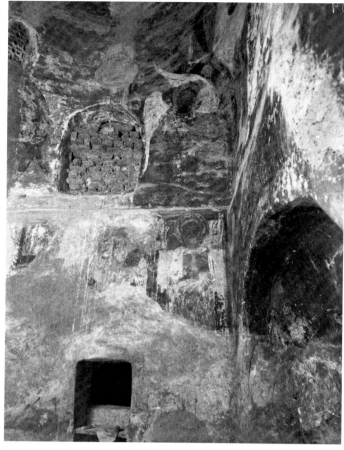

FIGURE 9.16

Evangelists (E2–E4) after conservation. ADP/SP 214 S1 5 05.

FIGURE 9.17

Evangelists, 1931, Whittemore expedition, B94. Courtesy of Dumbarton Oaks, Washington, D.C.

the Cave Church was really an unusual choice for its time. Certainly, full-figure representations of all four evangelists appear elsewhere in monumental Egyptian Christian art—for example, in the circa seventh- or eighth-century paintings in the so-called Red Monastery church near Sohag. In this instance they flank an enthroned Christ in Majesty, two on each side, in the southern semi-dome of the triconch sanctuary.[40] This expansive space provides far more opportunity for figural decoration than does the small sanctuary in the Monastery of St. Paul. In fact, the Haykal of St. Antony offered only two complete walls for painting. The west and south walls both have openings, and perhaps the first thirteenth-century artist was obliged to place all four of the evangelists together on the north wall because of these restrictions. Unusual subjects such as these once again underscore the vitality and flexibility of the iconographic tradition in the thirteenth century.

THE CENTRAL NAVE

Until the ARCE conservation project there was no evidence that the first medieval painter worked anywhere in the Cave Church except the Haykal of St. Antony. While consolidating the complex sequence of plaster layers in

the central nave, De Cesaris and his team removed a loose fragment of eighteenth-century plaster on the east wall (immediately to the south of the haykal screen), revealing the only indication that the creator of the first medieval phase worked in the nave (fig. 9.18). Beneath the detached section of later plaster is part of a face and the upper left corner of a red border that is painted on the earliest thirteenth-century layer, which is associated with the first medieval artist. The painter has framed a broad face with curly white hair. The dominant reddish and pink hues, the frontal face, the use of colored outlines to establish the facial features, and the color and width of the halo all tie this fragment to the better preserved works in the Haykal of St. Antony. Nevertheless, these remains are not in good enough condition to identify them unambiguously as being by the same hand.

Very likely, the subject in this area was a row of standing saints that was subsequently covered twice with later layers of plaster. The iconographic program in the Church of St. Antony, in the Monastery of St. Antony, includes rows of standing monastic saints in the eastern half of the nave. Interestingly, the subject of the eighteenth-century paintings that cover this portion of the first thirteenth-

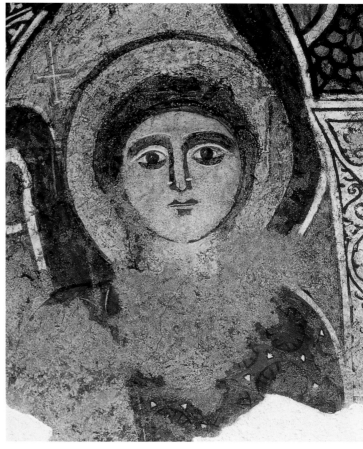

FIGURE 9.18
Face of a saint (D9), found under
the eighteenth-century plaster
layer. ADP/SP 6 S1192.02.

FIGURE 9.19
Angel (E6) attending the Virgin
Mary. ADP/SP 6 S1207 02.

century program is a row of three monastic saints, Maximus, Domitius, and Macarius the Great. William Lyster has considered the possibility that the first medieval artist's placement of standing saints on the east wall of the nave may have been repeated twice, once later in the thirteenth century, and once in the eighteenth. The second medieval artist was certainly active in this area of the church, but most of his paintings here were destroyed when the plaster he worked on fell from the walls at an unspecified date. Only a long painted fragment remains in place below the ceiling of the east wall, extending into the Shrine of St. Paul. Although little survives, Lyster identified two curved segments as possible red outlines of the halos of standing saints, suggesting that the second medieval painter may have reproduced the earlier subject, or expanded on it. The eighteenth-century self-taught painter could have in turn copied the figures rendered in 1291/1292, or, if the paintings were already lost, perhaps he noted the remains of the first medieval program revealed by the fallen medieval plaster, before covering it again with a new layer of plaster. While no further evidence of painting dating to the early thirteenth century is now visible in the nave, the recently uncovered face nevertheless indicates the possibility that

the earliest medieval artists may have covered the entire room with sacred images.

Conclusion

While van Moorsel and I have dated the first phase of medieval painting to circa 1232/1233 based on its similarity to Theodore's paintings in the Monastery of St. Antony, significant and interesting differences exist between the two painters and their images. Certainly, both artists worked within the parameters of a traditional Coptic mode. Aspects of this style, with its use of outlines and frontal representation, extend back to late antiquity. In the medieval period, artists manifest a flatter expression of it, with harder lines, a denser application of pigments, and a different palette.[41] Yet within this traditional Coptic style there was clearly some diversity. In the first place, no stylistic feature in the St. Paul paintings enables us to tie their creator directly to Theodore's team. Most notably, the distinctive choice by the St. Paul painter to omit black outlines in favor of broader strokes of red, white, and black sets his work apart (fig. 9.19).[42] He therefore seems to have been working independently of the major endeavor in the Church of St. Antony, although we cannot rule out

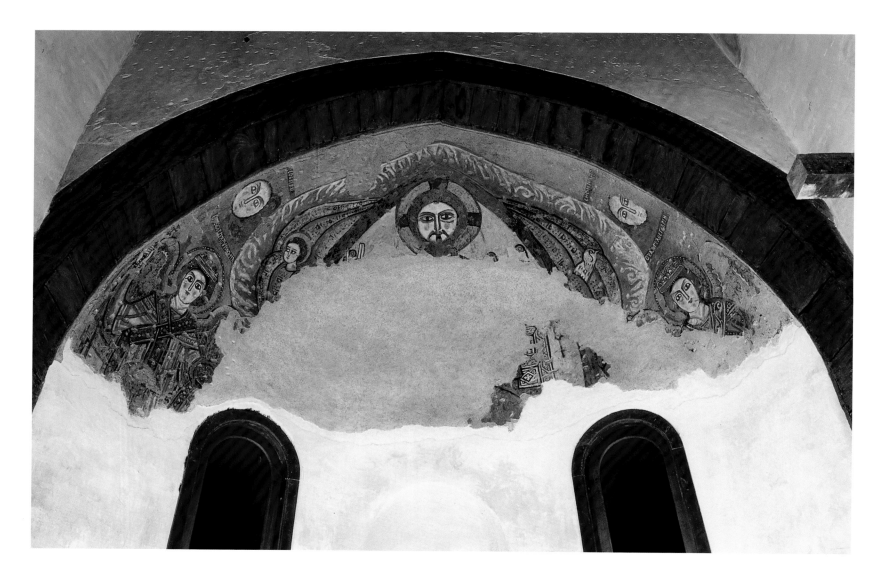

FIGURE 9.20

Newly discovered Christ in Majesty with the four living creatures and two archangels, ca. 1232. Church of St. Sergius and St. Bacchus (Abu Sarga), Old Cairo. Courtesy of Angela Jones and ARCE.

the possibility that he had a minor role at St. Antony's, or, indeed, that Theodore had a minor role at St. Paul's. Yet based on the surviving evidence, it is fully plausible that no direct connection existed between the two. Nothing enables us to place the St. Paul painter's work either before or after Theodore's, and the most we can say is that they have enough stylistic similarity to date the depictions in the Cave Church to the decades around 1232/1233. Van Moorsel has asserted that the St. Paul painter would have worked after Theodore because he could not imagine funds being paid for work at St. Paul's until the more important Church of St. Antony was decorated.[43] This is an interesting point, but it seems to me that we know too little of the circumstances of artistic production to draw this conclusion.

The widespread use of the general style evident at the monasteries of St. Paul and St. Antony has become clearer with the recent discoveries of two paintings in Old Cairo, at the Church of St. Sergius and St. Bacchus (Abu Sarga) (fig. 9.20) and at the Hanging Church (al-Muʿallaqa) (fig. 9.21).[44] These newly uncovered images have close ties to the paintings of the first medieval artist of the Cave Church, and of Theodore at St. Antony's, in addition to those at the Monastery of St. Macarius (Wadi al-Natrun) and the Monastery of St. Mercurius (Old Cairo).[45] Details of facial rendering, clothing, ornamental elements, and color scheme, and an overall similarity in the shaping and conception of form as a flat, typically outlined pattern, unite them into a common style dateable from about the mid-twelfth to well into the thirteenth century. The two recent finds also tell us something new about artistic production in Egypt, namely that urban ecclesiastical and remote monastic churches could be decorated in the same style, employing, at least in some cases, the same subject matter and perhaps even the same painters.

The paintings at the two Red Sea monasteries are much further apart iconographically than they are stylisti-

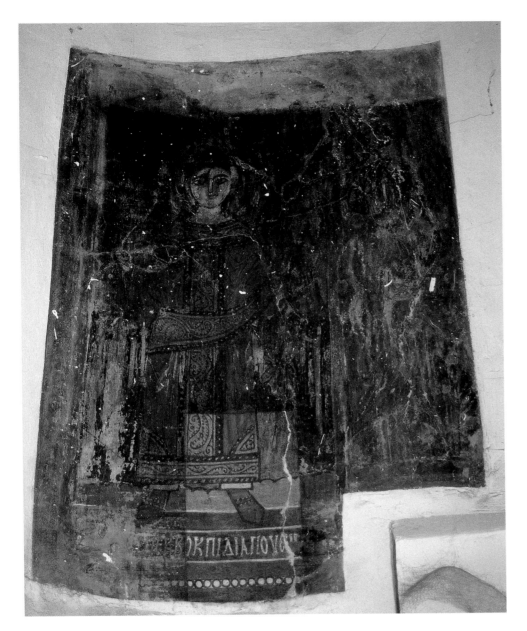

FIGURE 9.21

Angel, thirteenth century,

after a test cleaning by Luzi and

De Cesaris. Chapel of Thekla

Haymanot, Church of the Virgin

(al-Muʿallaqa), Old Cairo.

Courtesy of Father Maximous

El-Anthony.

cally. Only one of the precise subjects in the Cave Church is also found in the Monastery of St. Antony, and that is the Virgin holding the Christ child in a mandorla or clipeus, but its location is not the same. We have traces of a standing saint in the nave of the Cave Church but cannot tie it to the same subjects in the Church of St. Antony except generally, because we do not know which saint or saints the first St. Paul painter chose to represent. No feast cycle images appear in Theodore's program, making the Annunciation in the Cave Church stand out by comparison. And yet depictions of this subject have survived from late antiquity through the early thirteenth century in Egyptian Christian art. This provides us with a salutary lesson, namely that the thirteenth-century program in the Church of St. Antony, which is unique in being almost complete, shows us one impressive iconographic plan, but not the only one available to medieval Coptic painters. Theodore's work represents one option, and monuments with fewer paintings (for example, the first medieval phase of the Cave Church), or those which have not survived as well over the centuries (such as the paintings in the Monastery of St. Macarius), hint at what must have been a fantastic array of iconographic ensembles.

Mark Swanson has located a miracle story set in the 1260s, in the Cave Church at the Monastery of St. Paul, which reminds us that however much art historians emphasize style and iconography, the paintings were not made principally as works of art but were intended for devotional purposes. According to this narrative, the monk Gabriel sent a manuscript that he had just finished copying at the Monastery of St. Paul to the Monastery of St. Antony. Along with the donkey carrying the heavy book and other items, the precious volume was stolen by bedouin en route. When Gabriel heard this news he went to the church and threw himself in front of the image of the Virgin Mary, where he prayed for three days. The Virgin then spoke to Gabriel, promising the return of the manuscript and telling him that he would become patriarch. While of course we do not know for certain which image of the Virgin Mary was in the mind of the author of this miracle, we can readily imagine Gabriel directing his devotions to the intense and authoritative image of the Virgin Mary in the Haykal of St. Antony. The limited remains of paintings by the first thirteenth-century master make it impossible properly to address the meaning of his program and its connection to the liturgy. This medieval account fortuitously provides us with evidence for one specific role (among many) of the paintings in the Cave Church. For Gabriel they served as a vehicle for communication between those on earth and those in heaven.

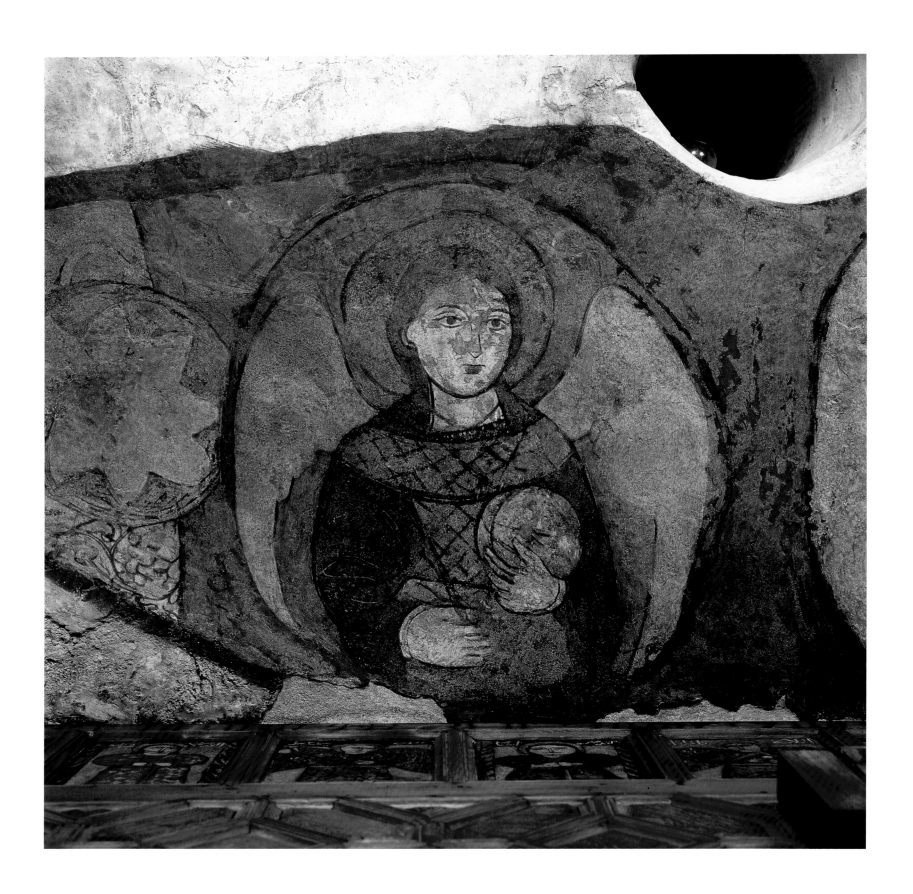

CHAPTER 10

THE MEDIEVAL PAINTINGS IN THE CAVE CHURCH, PHASE TWO

TRADITION AND TRANSFORMATION

Although often recognizable on the basis of stylistic and iconographic characteristics, Coptic art is a complex, not a monolithic, phenomenon. Even within a single time period, Egyptian Christian artists worked in several styles. Earlier generations of art historians have often attempted to use a simple model of stylistic decline with which to organize a heterogeneous body of material, forcing it into a pattern in which illusionism ranks high (Alexandrian Greek, sophisticated, early) and abstraction ranks low (ethnic Egyptian, uneducated, later).[1] We now know that the history of artistic production in Egypt is a far more interesting one than such a model suggests, and that it is not insulting to the local population. While certain iconographic elements were surprisingly stable over centuries, neither style nor iconography remained static. One of the most compelling periods in Coptic art is that of the thirteenth and early fourteenth centuries. The Christian community of Egypt manifested a cultural flourishing in Christian-Arabic literature, and also in impressive artistic creations in various media.[2] While much of this material has been lost, a surprising range of fascinating objects and monuments has survived, enabling us to obtain a glimpse of a rich and diverse visual world.[3] All the more startling then, is the fact that the fourteenth century seems to mark its end. This abrupt severing of centuries-long traditions in Egyptian Christian art coincides, as Mark Swanson explains so well in Chapter 2, with extended periods of plague, oppression, and impoverishment. The second phase of paintings in the Cave Church of St. Paul belongs to the period shortly before the break, and to some extent foreshadows it, as well as suggests the dynamic transformations in Coptic art in this period (fig. 10.1).

The Haykal of St. Antony

DESCRIPTION

In 1291/1292, less than a century after the construction of the Haykal of St. Antony and the first phase of painting, a second artist continued the visual embellishment of this space. He left untouched the existing paintings of the Virgin Mary, the Annunciation, and the evangelists in the lower zone of the sanctuary. To increase the amount of continuous wall space available, he filled in and plastered over the three tiers of windows on the eastern side of the dome. Inscribing a wide red arch with an inscription, he filled this irregular space with a massive Christ in Majesty (fig. 10.2). Seated on a throne, within a mandorla supported by the four incorporeal living creatures, he raises his right hand in blessing and holds a codex in his left. Standing angels flank this imposing figure (fig. 10.3). Six-winged angels inhabit the two squinches at the northwest and southwest corners, each brandishing a sword and a chalice. The angel in the northwest corner has been mostly destroyed, but enough remains of the wings and sword to suggest an iconography identical or very similar to the one at the southwest. The beginnings of another composition by the same painter are visible above the archway leading to the Haykal of St. Paul (south wall of the Haykal of St. Antony), but these initial elements seem never to have been finished, and not much more than the suggestion of two buildings is identifiable (fig. 10.4).

STYLISTIC ANALYSIS AND DATING

The long inscription enclosing the Christ in Majesty image includes a date that is especially valuable due

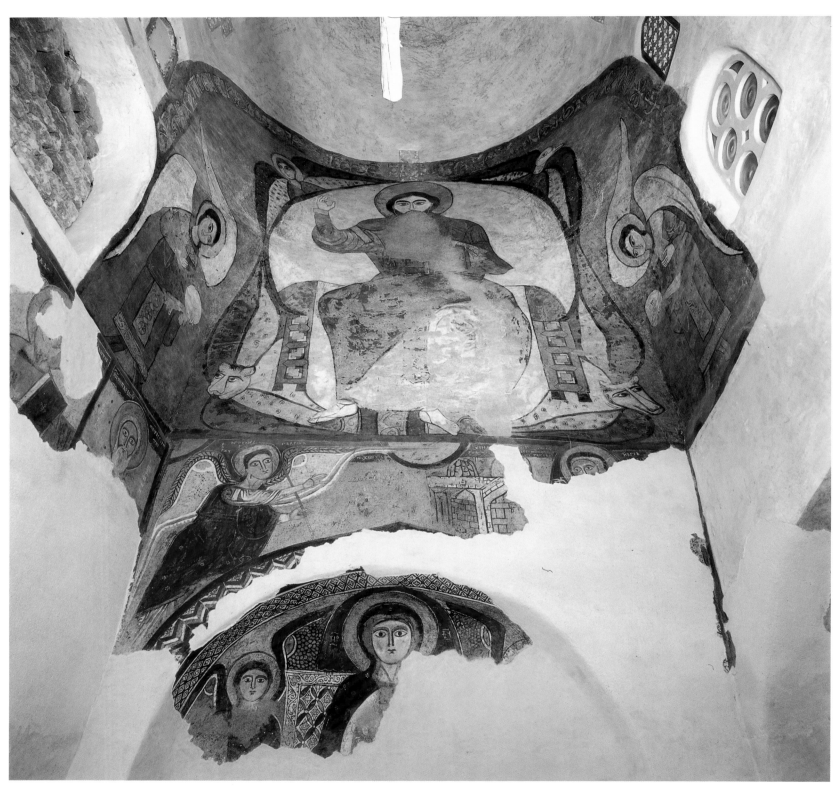

FIGURE 10.2

Christ in Majesty (E10), 1291/1292,
above the Annunciation (E7–E9)
and the Virgin Mary (E6), first half
of the thirteenth century. ADP/SP
214 S5 5 05.

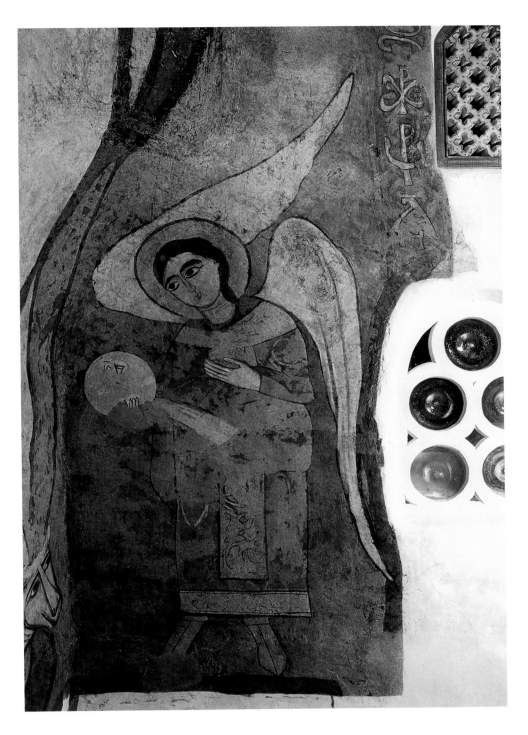

FIGURE 10.3 ABOVE LEFT
Angel (E12) flanking Christ in
Majesty. ADP/SP 2 S1205 02.

FIGURE 10.4 ABOVE RIGHT
Preparatory painting of an archi-
tectural subject (E14). ADP/SP 213
S2 5 05.

to its rarity in Coptic art. Paul van Moorsel read it, prior
to cleaning, as "the year of the martyrs 1050" (1333/1334).[4]
Gawdat Gabra has reread it, postconservation, as AM 1008
(1291/1292). This shortens the temporal distance between
the first and second phases of medieval painting in the Cave
Church by about four decades, a diminution with implica-
tions for Coptic art history.

More than any other feature, style distinguishes this
painting from the long tradition of antecedents in Coptic
art. When Adriano Luzi began conservation of the Christ
in Majesty, he observed that the artist had worked in a cal-
ligraphic style and identified certain methodological irregu-
larities in the execution of the painting. He suggested that
the artist had received training in manuscript illumination
rather than mural painting.[5] My analyses confirm Luzi's
initial hypothesis but also problematize it.[6] Luzi pointed
out that the rough application of a preparatory plaster layer
covering the filled-in windows did not follow the normal
practice of mural painters, which is to smooth the surface
of the wall before commencing work. He further observed
that the second medieval artist generally avoided this stage
altogether, preferring to use the preexisting plaster layers
in the church as the foundation for his paintings. Also, the sec-
ond medieval painter often used thin washes—for example,
a light turquoise blue rather than the dense paints and satu-
rated hues more commonly employed—suggesting again
that the artist was more at home creating smaller paintings,
such as miniatures or icons, and that he lacked experience
working on murals.[7]

Thin, sensitive black lines confidently build up the face
of Christ, which was more drawn than painted. Outlines

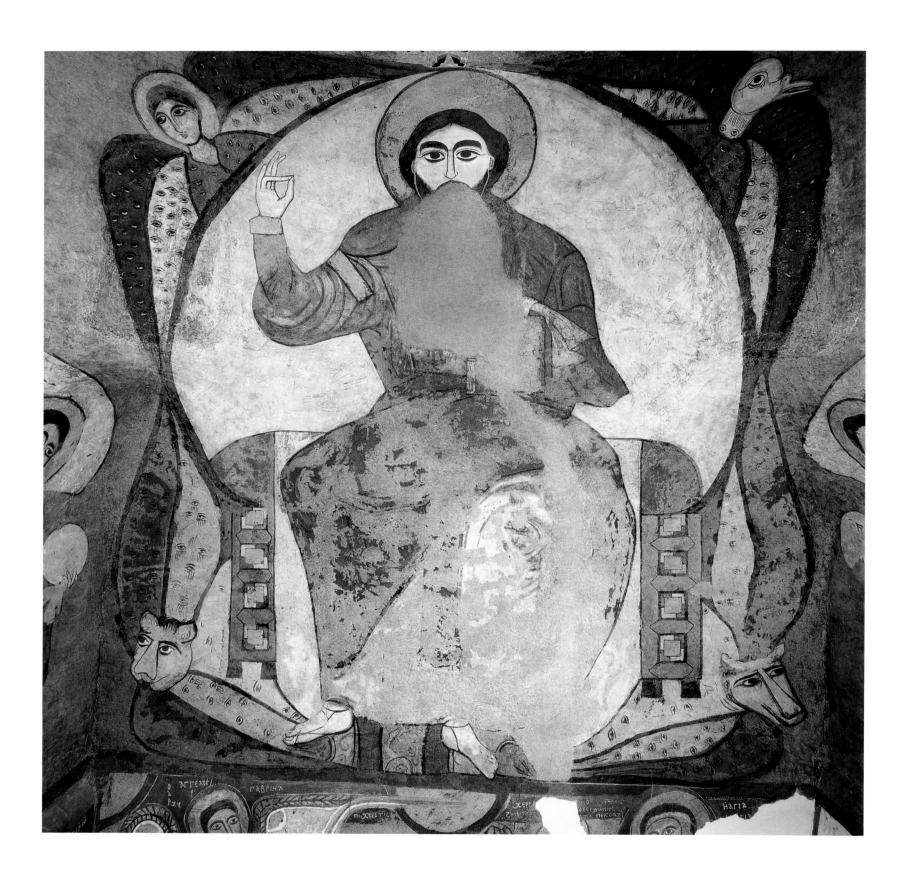

define Christ's left eye and his nose, with pink washes giving life to his complexion. The sweeping calligraphic lines of his eyes and eyebrows vary considerably in width and density, not always describing predictable trajectories, and demonstrate the artist's skill. The upper right section of his face, which was lost, has been re-created in tratteggio because of the importance of the subject and the location of these paintings in a living monastery.[8] The face is elegant and conveys personality. However, the rendering of the body shows considerably less confidence (fig. 10.5).[9] The shape of the head, with its encircling hair, is somewhat irregular, and the neck is too short—an impression that is aggravated when seen from below, as it must be without the use of a ladder or scaffolding. The torso and right arm seem completely flat and anatomically awkward, with a hand that is too small in comparison to the scale of the body. Attempts to suggest clothing folds are stylized and neither create coherent patterns nor effectively convey mass. The throne and cushion lack conviction as three-dimensional elements or as beautiful designs, and Christ's feet rest tentatively on a pillow. While the two flanking angels have elegant, curving wings and delicate, rounded faces, their bodies seem like uninventive paper cutouts, with large, two-dimensional feet. The ornamental panels on the loros hanging down the center of each of their robes are simple and imprecisely

drawn. These startling contrasts in the quality of rendering reinforce Luzi's assertion that this painter was not comfortable working on a monumental scale. Not only are figures in wall paintings considerably larger than those in manuscripts or on icons, but the point of view from which they are seen differs substantially. The artist creating large-scale murals must take into account distortions resulting from the low position of the spectator.

Observation of other parts of the second medieval phase of painting suggests that at least two hands were at work on the murals. In addition to the master artist who painted the commanding face of the Christ in Majesty, it seems likely that an assistant worked on the face of the incorporeal living being to Christ's upper right (the man-faced symbol of the evangelist Matthew) (fig. 10.6). The black lines follow the same general method for rendering facial features, but they are thicker and lack sensitivity. When contrasted to the face of Christ and that of the eagle-faced creature (associated with the evangelist John), both apparently done by the master painter with fluid and expressive lines, the difference in handling is evident (fig. 10.7). Although a distinct variation in the quality of the faces can be observed, it is not possible to tell which artist painted draperies and bodies.

I have not succeeded in locating a manuscript illu-

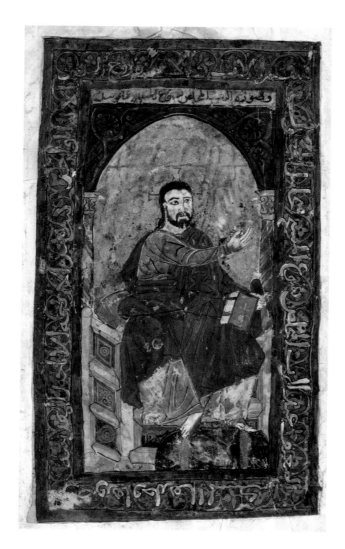

Byzantine elements.[12] The Damietta illuminations mark a transitional moment in which Arabic script on a vine scroll and leaf background boldly frame the composition in an Arabizing manner, while the gold background and attempts at a perspectival rendering of the throne show an appreciation for Byzantine sources.

The figure of Christ in the Damietta manuscript gestures to the four evangelists, originally shown on the opposite page in a folio now in the Freer Gallery in Washington.[13] His right arm reaches across his body and out to the four authors, who bow their heads slightly in acknowledgment. In contrast to figures in somewhat earlier Egyptian Christian illuminations, Christ's body conveys a suggestion of organic mass and physically coherent movement, and it rotates away from the viewer. He and the evangelists are drawn with a loose and sinuous line creating a dynamic effect that sets them apart from the style characteristic of the longstanding Coptic tradition, with its standard frontal depictions, dependence on outlining to suggest subjects, regularly inscribed lines, and saturated colors. The wide, embellished border inscription, and the smaller, simple one at the top of the composition, are in Arabic, not Coptic. The use of the text as a vital, decorative contribution to

mination that closely parallels the style of these paintings. Nevertheless, some of the sources of the lead artist's style can be at least generally identified within the milieu of the book arts. The 1179/1180 illumination of Christ in the Bibliothèque Nationale's Copte 13 (f. 2v), a gospel book created in Damietta, marks a distinct shift away from the traditional pictorial mode of Coptic manuscript illumination (fig. 10.8). These earlier Egyptian Christian works use line in a distinctive way, typically maintaining an even width and mapping out flat hieratic shapes and diagrams that convey the subjects of the paintings without suggesting that the surface of the folio (or wall, in the case of mural painting) is a window into space.[10] Creating an illusion of the material world did not interest these artists, who focused on rendering the spiritual world.[11] The Damietta artist drew both on newer artistic trends characteristic of the Dar al-Islam that were being produced and used by Muslims, Christians, and Jews, in secular and sacred contexts, and also on the polyglot eastern Mediterranean traditions of the period, which deployed Syrian, Crusader, and

FIGURE 10.10
Detail of the loros worn by the
angel (E5) to the left of Christ in
Majesty. ADP/SP 3 S204 02.

Copte 1) and the Coptic Museum (Cairo, Biblical MS 94), shows the fully confident realization of this shift to a new stylistic language, marrying fluid two-dimensional linear rendering to a lively figural style that clearly belongs to the thirteenth-century milieu of Arabic miniature painting (fig. 10.9).[15] These illuminations are also distinguishable from the Arab tradition by the addition of features drawn from the greater eastern Mediterranean realm—for example, gold backgrounds and the occasional perspectival rendering of isolated elements. With the exception of a few depictions of buildings or open books, three-dimensional space has no place in these scenes. The artist employed complicated arabesques and geometric patterns that are indistinguishable from those found in contemporary art in much of the Dar al-Islam.[16] One example is from a copy of the *Maqamat* ("Assemblies") of al-Hariri, a popular secular work often illustrated in the thirteenth-century Arab world. This manuscript, made in Syria circa 1275–1300, is now in the British Library (OR. 9718). It features nearly identical arabesques and designs to those used by the Coptic artist of 1249/1250.[17] In contrast, the second medieval painter at St. Paul's, active at more or less the same time as the creator of the London *Maqamat*, decorated the loros worn by the angel to our left of the Christ in Majesty with a simplified octagonal pattern that appears to be a poor attempt at duplicating the complex designs favored by manuscript illuminators of Egypt and Syria in the thirteenth century (fig. 10.10). It is interesting to note that the second painter seems to have been aware of these designs, perhaps from contemporary miniatures, but was not very competent when it came to reproducing them. In fact, while temporally closer to the 1249/1250 artist, his uneven handling of the figures, and his uncertain decorative motifs, remind one more of the late twelfth-century artist of the Damietta manuscript.

Medieval Christians, Jews, and Muslims in Egypt and the Middle East shared a compelling interest in a number of popular secular works, including not only the *Maqamat* of al-Hariri but also a text called *Kalila wa Dimna*. The latter work is a group of fables, often involving animals, written in Arabic by Ibn al-Muqaffaʿ in the mid-eighth century based on a Persian translation of a third-century Indian collection.[18] The earliest surviving illustrated manuscript of the Arabic version, now in the Bibliothèque Nationale in Paris, dates to circa 1200–1220 and was likely produced in Syria.[19] The second medieval artist of the Cave Church had a familiarity with the typical rendering of animals in *Kalila wa Dimna*, which he utilized in his depiction of the lion, ox, and eagle heads of the living creatures surrounding Christ in Majesty. While the circa 1200–1220 example

the illustration draws on the established Islamic tradition of illuminated Qurʾans, and monumental architectural inscriptions, the latter becoming especially prominent under the Fatimid caliphate of Egypt (969–1171).[14] The artist of the Damietta manuscript is not completely in command of the decorative motifs or the figural representation, as expressed by a certain unevenness in the lines and blurring in the application of color.

A later manuscript, a gospel book completed in Cairo in 1249/1250, now in the Institut Catholique (Paris, MS

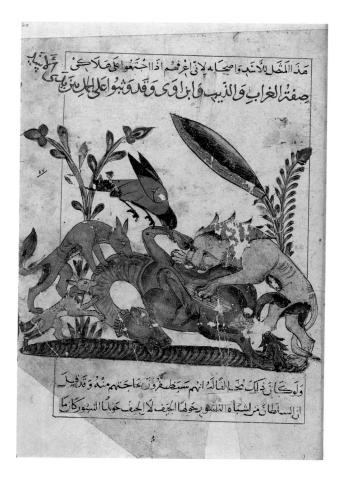

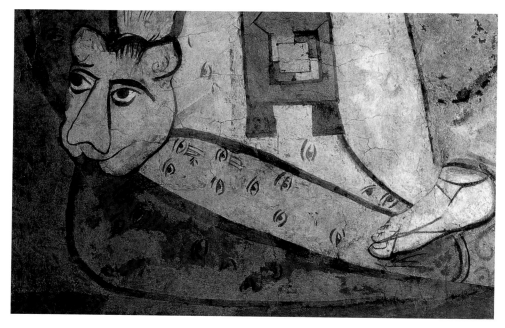

has some stylistic similarities to the three animal heads in the Cave Church, the more numerous fourteenth-century manuscripts provide closer parallels.[20] For example, several depictions of lions in a 1354 illustrated version, probably produced in Syria and now in the Bodleian Library at Oxford, follow the same format that we see in the Cave Church, with a three-quarter view, broad nose, bowed upper lips, and flattened, pointed ears with tufts of hair between them (figs. 10.11 and 10.12).[21] The eyes in many of the illuminations in this manuscript and others inscribe the same quick, circular shape with a sweeping calligraphic extension, as seen in the eye of the eagle in the wall painting.[22] Lucy-Anne Hunt has demonstrated a close connection in the thirteenth century between figural and ornamental styles in secular and Christian manuscript illuminations and other media.[23] That Coptic artists applied the animal subjects and styles used in *Kalila wa Dimna* to religious contexts is made apparent in some folios from the New Testament, in the Sahidic dialect of Coptic, originally from the White Monastery near Sohag but now in the Bibliothèque Nationale in Paris. These pages have been dated to the tenth century, but the style of the fish and birds is such that a circa thirteenth-century date is to my mind almost certain.[24] These connections to the paintings in the Haykal of St. Antony, in the Cave Church, help establish our understanding of the background of the second medieval painter, and his links to the manuscript arts. However, as I explore below, the question of his training is a complex one.

The prominent inscriptional banner arching over the large Christ in Majesty is rendered by a hand lacking in confidence. The size and outlines of the letters, as well as their coloration, are uneven. These uncertainties in execution may be another indication that the artist had training in the miniature arts, not in monumental wall painting. This inscription is nevertheless precious because of its date, and also because, like the band in the Damietta illumination, it belongs to a current preference for the production of large-scale decorative texts in public places.[25] As such, it is one more feature demonstrating the artist's familiarity with the visual language of the Dar al-Islam.

ICONOGRAPHY

In the haykal and perhaps other spaces in the church, the second medieval painter built on the iconographic framework provided by the first medieval painter. The first example of this, as observed by van Moorsel, is the depiction of Christ in Majesty.[26] A long tradition stands behind this subject, beginning in the early Byzantine period in Egypt. Monks commonly chose this type for their

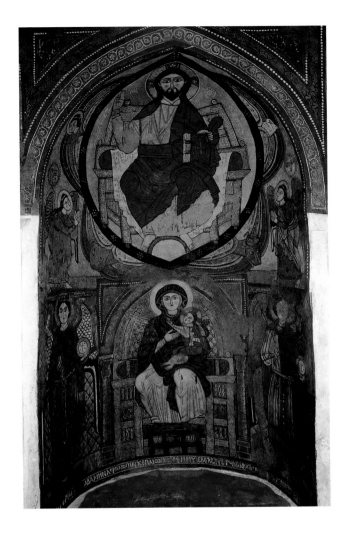

FIGURE 10.13

Christ in Majesty above the enthroned Virgin Mary holding the Christ child, 1232/1233. Church of St. Antony, Monastery of St. Antony. ADP/SA 6s 98.

monastic cells, oratories, public rooms, and likely also their churches. It is often set within an upper compositional zone and paired with a depiction of the Virgin and Christ child below it. The 1232/1233 program in the Monastery of St. Antony includes this two-zoned representation in the apse in the central sanctuary (fig. 10.13).[27] The second medieval artist of the Cave Church has painted the Christ in Majesty above the preexisting image of the Virgin and child, forming the familiar double-register composition. The basic iconographic elements for this subject in Egyptian Christian art are remarkably stable over time. However, the throne with its imitation woodwork inlays, the Byzantine dress of the angels, and the octagonal patterns on the loros, as well as other stylistic features, mark this painting as medieval and not late antique (contrast figs. 9.10 and 10.2).[28] What surprises the viewer familiar with this traditional depiction is the adaptation of the squinches and dome to mark out a space approximately, but somewhat inelegantly, evoking the normal apse. The first medieval program did not include the Christ in Majesty, but its appearance in the second phase of thirteenth-century work

in the church suggests that the earlier break with tradition may have caused a certain anxiety.

The significance of this double subject has been of persistent interest to art historians.[29] In his analysis of an account of a vision that took place circa 1000 by the priest Philotheos, van Moorsel has demonstrated that the Copts believed that the church apse, during the liturgy, functioned as the site of a theophany.[30] The paintings of 1291/1292 show just such a divine appearance: four incorporeal beings supporting an enthroned deity in a heavenly setting described in Old and New Testament visions (Ezekiel 1:4–28, Revelation 4:2–10). Another, somewhat later, Christian Egyptian author helps us to understand the force of this subject in the apse of a church. Ibn Kabar (d. 1324) wrote specifically about paintings in churches, and what their various iconographical features meant. "And when one represents him seated on a throne, carried by the four living creatures with six wings, it is because he is the Word of God who spoke to Moses and to the prophets, and whom Ezekiel saw in this form."[31] The same author addressed the significance of the pose of Christ's right hand, presenting not one but three opinions he had heard, but incorrectly describing the standard gesture. While he said that Christ touches his thumb to his little finger, in fact the typical image shows Christ's thumb touching his second-to-last finger. Ibn Kabar wrote that some people explained the gesture as one showing the conjunction of weakness and strength, while others said it represents Christ overcoming Satan, and yet others saw it as the sign of the coming of Christ six thousand years after the creation of Adam.[32] This range of options points out that the tradition is a heterogeneous one, constructed and reconstructed by artists, theologians, and their audiences. By this I do not mean to discount the relevance of Ibn Kabar's interpretation that the Christ in Majesty depicts the Word of God, but we should recognize that it is one facet of meaning in what is a multivalent image. Its significance is shaped by the images around it in the church, and no doubt by other factors, such as the moment in the liturgical calendar, the ritual being performed in a specific sanctuary, and the viewer.[33]

The later thirteenth-century paintings build on the depictions of the Annunciation and the Virgin Mary holding the Christ child in a mandorla or clipeus. Both of the subjects of the lower zone make a statement about the incarnation of Christ, emphasizing his entry into not only flesh but also time. The juxtaposition of the child Christ below, with the majestic, enthroned Christ as the Word of God above, was perhaps intended to convey the Copts' doctrinal view of Christ as having one nature composed

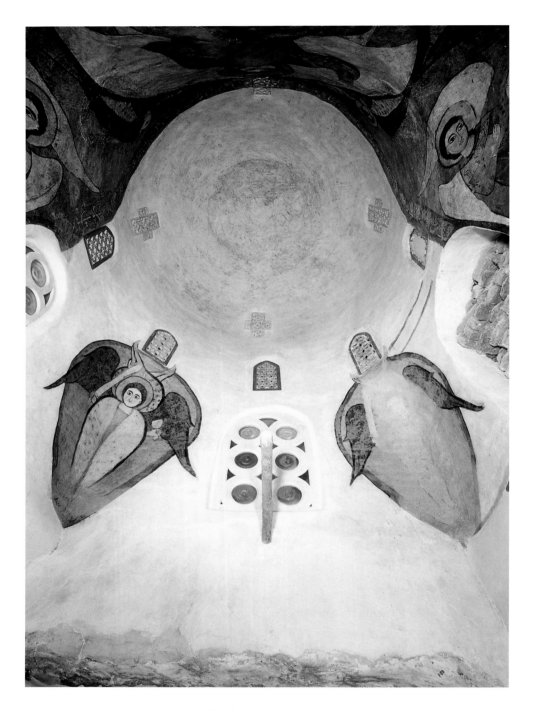

FIGURE 10.14

Cherubim (E15, E1). ADP/SP 14
s248 05.

the angel guarding Paradise, and the censer containing in-cense (standing in for prayers) that angels carry to heaven, thus accounting for their presence in the sanctuary in two meaningful ways.[37] The sword must also function as part of one of the principal tasks of this type of angel, namely protecting the throne of the Lord.[38]

Paintings of four similar celestial beings, dating to 1148/1149, are included beneath the squinches in the sanc-tuary of the church at the Dayr al-Fakhuri or Monastery of the Potter (also called the Monastery of St. Matthew) outside of Esna.[39] Two of them hold similar swords and censers, and the others each hold a sword and a *rhipidion*, which is a liturgical fan.[40] These fans, attested in liturgical use in the Byzantine world by the fourth century, are tra-ditionally decorated with the image of a six-winged cherub possessing the heads of the four living creatures.[41] By de-picting cherubim on rhipidia, these ritual fans take on the protective role of the celestial beings.[42] At least two of the six-winged figures at the Dayr al-Fakhuri also feature one of the animal heads of the apocalyptic living creatures next to their larger, human visages.[43]

Another clear reason for the presence of these angels in Coptic sanctuaries remains to be considered, namely the association between them and the cherubim who pro-tected the Ark of the Covenant in the Tabernacle (Exodus 25:18–22) and later in the Solomonic Temple (1 Kings 6:23–29). Writing in the thirteenth century on the reasons why Christians paint images in churches, and drawing on a long tradition of iconodule arguments, al- Muʾtaman al-ʿAssal listed first and foremost the fact that God ordered Moses to make cherubim in gold to cover the ark. He noted further that Solomon included representations of them in various media in the temple, particularly in the Holy of Holies.[44] In her insightful considerations of the significance of the sanctuary in the Coptic tradition, Gertrud van Loon has observed that "Coptic thought is rooted firmly in the Old Testament. This is not a new point of view but it cannot be stressed too strongly.... It can be argued that the haykal symbolizes three things at the same time. First it represents 'the Holy of Holies' of the Tabernacle which was ordered by God to house the law, the covenant between Him and His people. Secondly, it can be seen as the Temple, built by Solomon as the second house for the Ark of the Covenant. Thirdly it represents Jerusalem, the city.... Ultimately this room symbolizes the heavens, a new Jerusalem."[45]

In addition to the multiwinged cherubim facing the painting of Christ, and the two-winged angels worship-ping the enthroned figure, the second medieval painter also

of both human and divine elements. The emphasis on the incarnation in the lowest zone may have been greatest dur-ing the feast of the Nativity, while the higher image might well have read as a kind of ascension, at Easter.[34]

Across from the image of Christ in Majesty, painted in the western squinches, float two cherubim (or perhaps sera-phim) with six wings (fig. 10.14).[35] Each one holds a sword in the right hand and a cup-shaped object in the left hand. Van Moorsel has shown the vessel to be a particular type of incense burner.[36] He described the sword as belonging to

included in his vision of heaven the four living creatures described by Ezekiel and St. John. As mentioned above, they are shown surrounding and supporting the throne of Christ, which is one of the main functions of this form of celestial being.[46] A discourse read on the feast day of the four incorporeal beings, and written down in a late ninth-century Coptic manuscript, includes a series of references to intercession, the altar, and the priest celebrating the Eucharist that enhance our appreciation of the paintings in the sanctuary. The text is attributed to John Chrysostom (d. 407), who described the four creatures as having the privilege of accompanying and encircling God at all times. They "are as elevated as priests, for they are the first to praise God the Almighty," and they exist in a state of cease-less prayer.[47] Addressing John Chrysostom in a revelation, Christ explains that these beasts are "the ones who have existed with me, my Father, and the Holy Spirit since the beginning of the eons."[48] In a theme that runs throughout the discourse, John emphasized their intercessory powers, and their connection to the liturgy and salvation. "Whenever the sins of the children of humankind become many on the earth and their Father becomes angry so as to wipe out the world, the creatures exclaim, 'You are holy, you are holy, you are holy, O Lord of Hosts. O you without anger, do not be angry.'"[49]

The repetition three times of the word "holy," which is derived from the chants of the seraphim in Isaiah (6:2) and the four living creatures of Revelation (4:8), also recalls the Trisagion, spoken in the ceremony of the Eucharist.[50] In his introduction, John wrote: "But let us turn to the question which lies before us and find out whose this meal is and who invites the entire creation to this meal before us? It is Christ, whose holy body and true blood these are. Let us find out who has been invited to this feast which is spread out over the entire inhabited world."[51] The text continues with addresses to the hosts of beings who are invited to the feast. The four incorporeal beasts are described as working actively to assist the salvation of humans and other creatures, for example: "Whenever a human being sins, whether through fornication, defilement, blasphemy, stealing, murder, magic, or wizardry, one of the creatures, the human-faced one, cries out and urges Enoch the scribe of righteousness, 'Do not hurry to write down the sins of the children of humankind, but be patient a little and I will call the archangel Michael and he will implore the Father of mercy together with me.'"[52]

After listing additional examples of intercession for salvation, the author described Christ addressing the four creatures, saying: "I am the savior Jesus. I say to you in the truth of my Father: I will let every one who will give an offering in your name attend mass in the church of the first-born children, the Jerusalem of heaven, I will write their name in the book of life, I will let them lie down at the banquet of the thousand years and satisfy them with every good thing in my kingdom."[53]

Upon the conclusion of the revelation from Christ, John discussed the significance of the four creatures, noting their Old Testament types—for example, the seraph in Isaiah 6:6–7, which holds a burning coal to Isaiah's mouth, thereby removing his guilt and forgiving his sins. This example is also a type for the Eucharist. John informed deacons that they should model themselves on the four creatures during the celebration of the Eucharist, and also that: "the coal is the body of the Lord. The cherubs and seraphs are the deacons serving their Lord."[54] John pointed out to his audience the fact that these creatures recite the Trisagion to God: "This is what they sing to Him in a hymn of victory, 'You are holy, you are holy, you are holy, Lord of Hosts. The heavens and earth are filled with your holy glory.'"[55] This so-called victory hymn, another term for the Trisagion, is recited just before the bread of the Eucharist is blessed.[56] The medieval paintings in the Cave Church sanctuary would have engendered a complex series of associations and mimetic impulses in the knowledgeable viewer, such as the priests, deacons, and monks who spent so much of their lives in prayer and liturgical celebration.

The Central Nave

Paintings dating to the second medieval phase of work in the Cave Church survive in the central nave on parts of the ceiling and upper level of the south wall (fig. 10.15). While the large majority of the depictions now visible in the nave date to the early eighteenth century, evidence suggests that they often repeat the subjects, if not the style, of the second medieval painter's work. Despite the difficulty in seeing the paintings prior to their cleaning, van Moorsel initially observed this pattern, and conservation has made it clearer.[57] I will consider first the visible medieval paintings, and then turn to the evidence that this program originally extended further.

DESCRIPTION OF THE EASTERN CEILING PAINTINGS

The original stone shelf above the cave forms the low ceiling of the nave in front of the Haykal of St. Antony. Daylight enters this area through two medieval light wells (see fig. 6.2).[58] A postmedieval wooden screen now com-

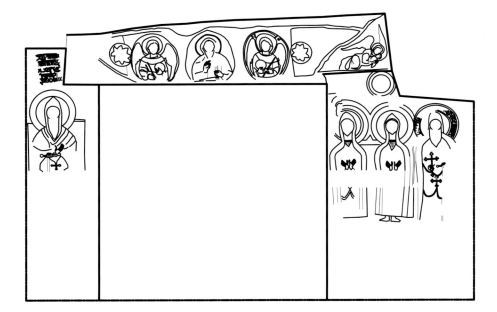

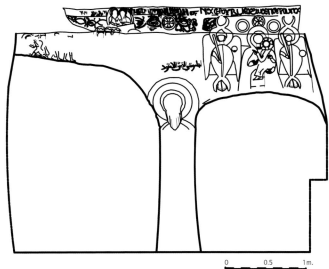

FIGURE 10.15

Conservation record of the east and south walls of the central nave, showing the paintings and inscriptions from 1291/1292 on the ceiling and upper walls.

pletely closes off the Haykal of St. Antony from the nave. At the entrance to the sanctuary, a broad painted band on the ceiling directly above the screen shows Christ flanked by two angels holding roundels (either orbs or the Eucharistic bread) and staffs (fig. 10.16).[59] The artist has set the bust-length figures in three ovals against a dark-red rectangle that is terminated by two irregularly shaped triangles, each filled with decorative motifs. This figural and ornamental band is applied to a very thin plaster layer, almost directly onto the stone of the ceiling, resulting in a rough and uneven effect. This plaster application seems to have already been in place well before the commencement of work by the second medieval painter.

EASTERN CEILING PAINTINGS: STYLISTIC ANALYSIS AND DATING

Several stylistic features show unequivocally that the second medieval painter created this ceiling band. His basic approach to figural representation as a two-dimensional linear rendering is manifested in this area above the haykal screen, as it is within the sanctuary (fig. 10.17). Precise parallels include the irregular shape of Christ's head, with its wide band of dark hair protruding at ear level; the blocky delineation of the ears; the confident, broad sweep of the eyebrows, tapering down to a sharp point at the outer end; the elegant, long eyes; the white complexion with a pink flush; the thin nose with its flared nostrils; and the full moustache and beard.[60]

Other features indicating the authorship of the ceiling band in the nave are the colors, including dark red, flat yellow, pale turquoise, steel blue, and bright white. The

two angels flanking Christ were conceived in a similarly graceful, calligraphic manner, with sweeping curves defining their faces, wings, and shoulders (see figs. 10.1 and 10.16). All lack a sense of material substance and mass, and convey a peaceful ethereality. These three figures rank among the most confident in this phase of painting.[61] Their bust-length format and greater control might indicate that the senior artist had experience painting icons. Panel paintings, while not usually employing roundels, often show only the head and upper part of the subject's body.

Each of the irregular triangles framing the ceiling band contains a vine and leaf pattern, as well as a single large flower set within a circle. They were not painted, however, in an identical manner. The vines on the northern side are much thicker than those employed on the south, and the flower transgresses the boundary of the central red rectangle. Unfortunately, the northern painting is damaged, making it difficult to determine the design, but the southern triangle is well preserved (fig. 10.18). Here the painter used very thin vines and small leaves, which he may have intended as a kind of arabesque. If so, the design is typically imprecise. He appears to have tried to imitate the rhythmic vine scrolls of the true arabesque, but without much success.[62] Once again, the painter seems to have been copying popular contemporary designs without the necessary training.

The most distinctive feature of the two vine and leaf ceiling patterns are the large flowers. They are reminiscent of the enormous flowering plants that appear in Arab miniature paintings in this period.[63] They were not only used in secular contexts, but also appeared in Christian manuscript

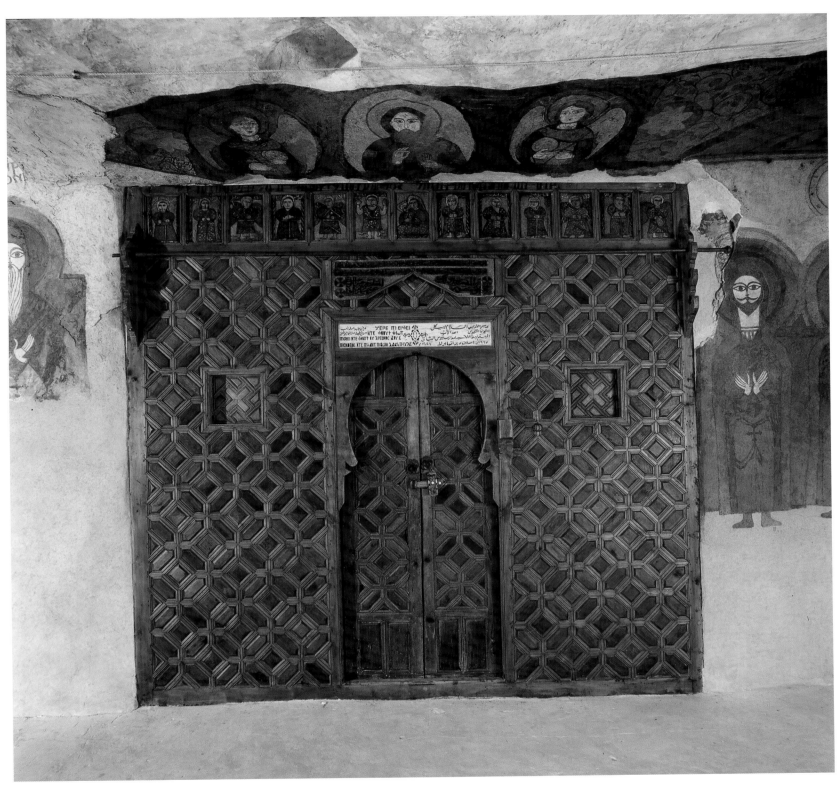

FIGURE 10.16

Roundel busts of Christ and two
angels with flanking ornamental
designs (D4–D8), on the ceiling
above the haykal screen of St.
Antony. ADP/SP 210 S8 5 05.

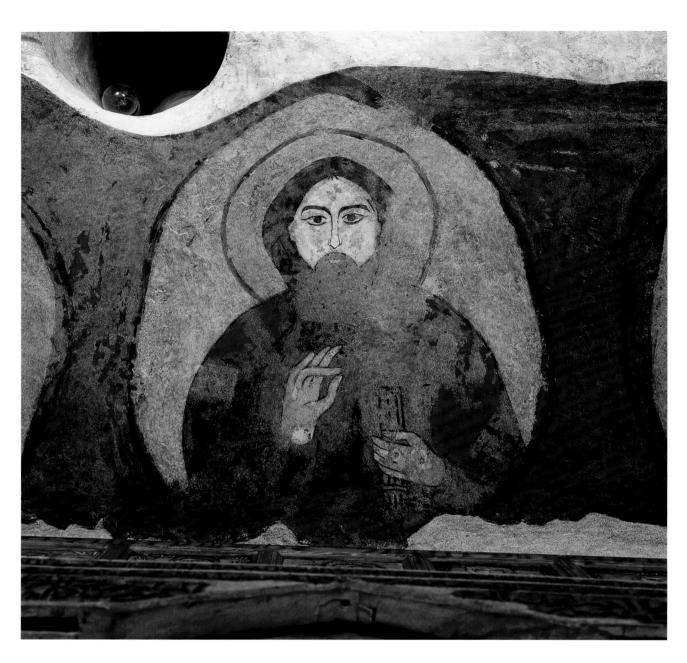

FIGURE 10.17
Bust of Christ (D6). ADP/SP 210 S2
5 05.

illuminations—for example, in scenes from the Gospels in the Damietta manuscript of 1179/1180.[64] Although the workmanship in the manuscript is considerably more precise than that of the second painter, the similarities between the two groups of flowers give more credence to the hypothesis that the St. Paul painter had experience as an illustrator of books.

EASTERN CEILING PAINTINGS: ICONOGRAPHY

The band above the haykal screen reproduces the main subject in the upper zone of the sanctuary, in a reduced format, with graceful bust-length roundels of Christ and two angels. In a sense, this band functions as the top of an icon screen, tilted forward and applied to the ceiling.[65]

It raises a question about interest in including depictions of Christ, saints, and angels at the top of the sanctuary screen in this period. While some tantalizing evidence exists in Egypt for the early placement of painted icons on screens or on high templon beams, by the medieval period the standard type seems to have included at most small wooden low-relief carvings of saints, set within and not on top of an opaque barrier.[66] The original medieval screen in the Cave Church would likely have been embellished with a carved and perhaps inlaid network of cross or star patterns, but no sacred paintings on wooden panels.[67] In the Cave Church, the representations on the ceiling above the medieval screen would have provided points of devotional focus for the viewer who was physically and also visually excluded

FIGURE 10.18
Bust of an angel (D7), arabesque
design (D8), an angel carrying
a child (D13), Massacre of the
Innocents (D14), the Magi before
Herod (D15), and two prophets
(D16), above Maximus (D11),
1712/1713. ADP/SP 209 S11 5 05.

from the sanctuary. Perhaps these paintings indicate that
more variation existed in the format of medieval screens
than otherwise seems to be the case.

THE NATIVITY CYCLE: DESCRIPTION, STYLISTIC
ANALYSIS, AND DATING

Paintings with similar colors, but somewhat less clear
stylistic features, extend along the southern end of the cen-
tral nave, filling the southeast corner and continuing along
the southern edge of the ceiling and upper part of the wall
(figs. 10.19 and 10.20; see figs. 10.15 and 10.18). In the cor-
ner, an angel clasps a small child to his breast, flying in an
indeterminate blue space. Fragmentary scenes at the top of

the south wall are primarily identifiable through an inscrip-
tion band at the edge of the ceiling. The broad ceiling band
consists of text running along the top, with a decorative
panel below it. The panel features ornamental designs on
a solid red background. At the far western end is a vine
and leaf pattern, followed by a simple arabesque framing
a medallion containing a cross. This section of the band
is executed fairly well, but the designs become progres-
sively less disciplined moving east. The overall irregularity
of most of these patterns is consistent with the painter's
lack of confidence in the rendering of designs expressed
elsewhere. The fragmentary Coptic inscription reads, from
left to right: "the young children (?) . . . The Magi, the kings

from the East. Herod." A roundel with two white-haired and bearded men, holding a tablet with the words "Jesus Christ [?] [B]ethleh[em]" interrupts the flow of the text.

The inscription along the ceiling and its ornamental features suggest with their colors and stylistic details that they were painted as part of the second medieval phase of work in the Cave Church. The same reds and blues are used as in the sanctuary inscription, although in the nave we see simpler, solid white letters and not black outlines of letters filled in with white. This band of text continues above the remnants of medieval paintings and extends well beyond them, along the south and west walls, over eighteenth-century murals. The medieval paintings of the south wall have suffered substantial damage and include numerous stylistic irregularities. They provide considerably less evidence for analysis than does the eastern ceiling band. The second medieval painter's composition seems also to have been repainted one or more times, making an evaluation of the medieval figural style in this area impossible.

THE NATIVITY CYCLE: ICONOGRAPHY

Unlike the iconic images above the haykal screen, the rest of the extant medieval scenes in the nave tell the story of Christ's infancy. Van Moorsel has proposed that the angel carrying the child in the southeast corner is Uriel, rescuing the young John the Baptist during the Massacre of the Innocents, in an iconographic motif known in Byzantine iconography but not elsewhere in Coptic art.[68] The *Protevangelium of James,* the most popular of the apocryphal infancy gospels, tells the story: "Elizabeth, when she heard that John was sought for, took him and went up into the hill-country. And she looked around [to see] where she could hide him, and there was no hiding-place. And Elizabeth groaned aloud and said: 'O mountain of God, receive me, a mother, with my child.'...And immediately the mountain was rent asunder and received her. And that mountain made a light to gleam for her; for an angel of the Lord was with them and protected them."[69] Elizabeth is not included in the paintings in the Cave Church, and the *Protevangelium* does not name the angel. However, given the Nativity theme of the scenes to the right of this painting, van Moorsel's identification of this image as the angel rescuing the young John seems most likely.

We can discern fragments of paintings of the Massacre of the Innocents, and the Magi before Herod, arranged from left to right after the corner image. These scenes are readily identifiable by the remains of soldiers, three men with crowns, the top of a halo, and the inscriptions above

them. My left-to-right description runs counter to the direction of the narrative told here, and in fact the spatial trajectory is more complicated still. The first medieval painter began the Nativity tale in the Haykal of St. Antony with the still surviving images of the incarnation, represented by the Annunciation and the Virgin Mary holding the Christ child in a clipeus or mandorla. The second painter continued the story in the nave. This practice of building on the subjects and meanings of works by an earlier artist can also be identified in the two thirteenth-century programs at the Monastery of St. Antony, but it is even more clearly apparent here because the paintings follow the same narrative thread.[70] The question remains whether a Nativity image existed in the medieval sanctuary as well, or possibly in the adjacent Haykal of St. Paul. A third option, and the one that I prefer, places the lost Nativity on the south wall of the nave, between the Virgin and Christ child with cherubim and the Magi before Herod (see figs. 10.15 and 10.20). According to my hypothesis, the story would be moving from right to left. This pattern of reading subjects and images follows the directional flow of Arabic and can be very clearly discerned in both thirteenth-century programs in the Monastery of St. Antony.[71] It does, however, conflict with the left-to-right movement of the Coptic text. The artist has overcome this problem by breaking up the textual narrative into short banners announcing the subjects below, and mapping them in a right-to-left directional sequence.

Although the area of the south wall that may have featured a condensed Nativity is now missing its medieval pigment, there is a cross medallion placed directly above this lacuna, as part of the decorative band. This symbol could mark the Nativity, standing in a long tradition of depictions of Christ's birth which include references to the passion.[72] The roundel with prophets above and slightly to the left of this blank area, separating the sections of text referring to the Magi before Herod and the Massacre of the Innocents, includes a reference to Bethlehem (fig. 10.21). According to the narrative, this painting seems logically tied to the hypothetical Nativity (below and to the right), and the fragmentary massacre (below and to the left). But it is not initially apparent why the meeting of the Magi and Herod is directly underneath it. Herod met the Magi in Jerusalem, although the birth of Christ and the massacre of the male children were both situated in Bethlehem. The answer may lie in the Gospel according to Matthew, which prominently includes two prophetic texts in the narration of the Nativity and arrival of the Magi. Quite possibly, these passages prompted the inclusion of two prophets in this

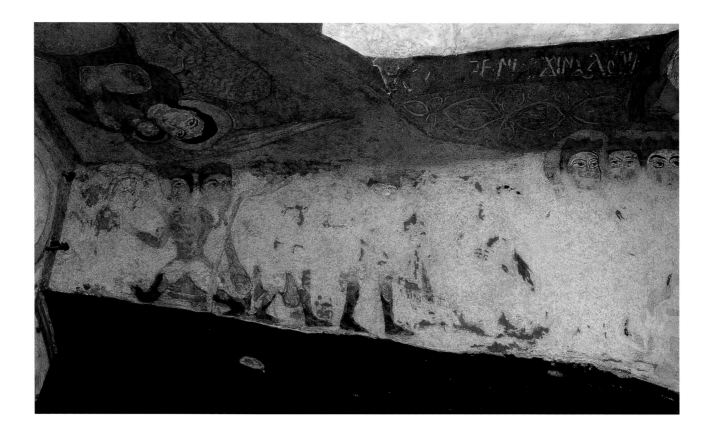

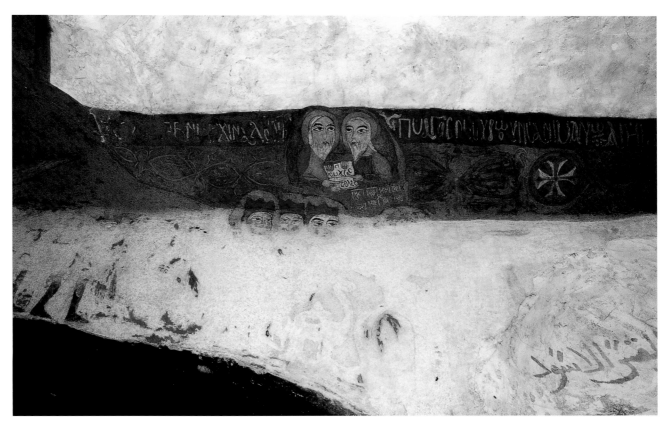

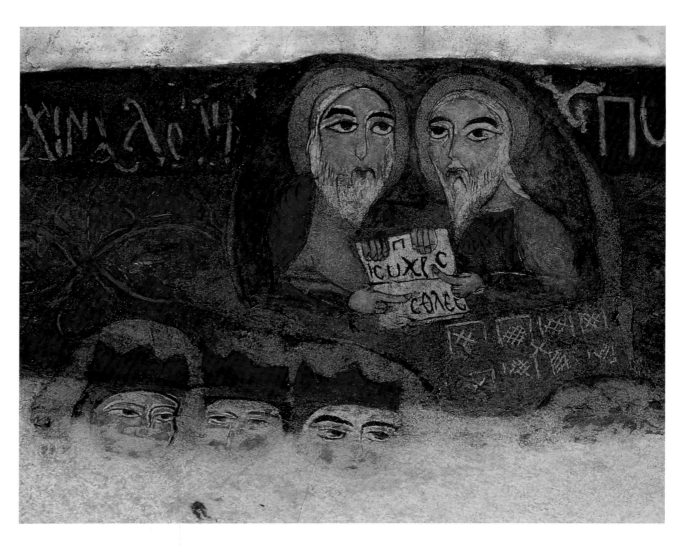

FIGURE 10.21

Prophets in a roundel (D16) above the Magi before Herod (D15). ADP/SP 14 S1201 02.

pictorial cycle. The first text, tied directly to the incarnation and birth, is Isaiah 7:14: "Behold, a virgin shall conceive and bear a son, and his name shall be called Emmanuel" (Matthew 1:23). The second passage recounts the arrival of the Magi in Jerusalem, which prompts Herod to inquire where the child would be born. His people tell him Bethlehem, and then quote a prophecy of Micah that from out of Bethlehem "shall come a ruler who will shepherd my people Israel" (Micah 5:2; Matthew 2:5–6). It seems likely that the two bust-length figures punctuating the inscriptional band were intended to represent Isaiah and Micah, and also to help situate the two flanking events that took place in Bethlehem, and the moment in Jerusalem when Herod learned of the Magi's quest.[73]

If this scenario for the location of the missing Nativity is correct, then the narrative thread begun in the sanctuary would be resumed here with the birth of Christ. It would continue to the left with scenes of the Magi telling Herod

about the newly born king of the Jews, and following that the murder of the young boys resulting from that meeting. The painting of the angel carrying a child, on a thick layer of plaster in the southeast corner of the nave, concludes the extant sequence with an abbreviation of the escape of John the Baptist, shown here without Elizabeth. The scenes from the early life of Christ may well have continued on the original north wall of this nave, destroyed in the eighteenth-century expansion of the Cave Church. Van Moorsel has suggested that medieval depictions of Paul and Antony would have been on this lost wall, which is certainly another very plausible scenario, and indeed the two ideas are not mutually exclusive.[74]

The closest parallels to the Cave Church Nativity cycle in subject and in the format of its presentation are the far earlier paintings in another cave adapted as a church, at Dayr Abu Hennis, near Malawi.[75] These have been variously dated to the sixth century and, less commonly, the late fifth

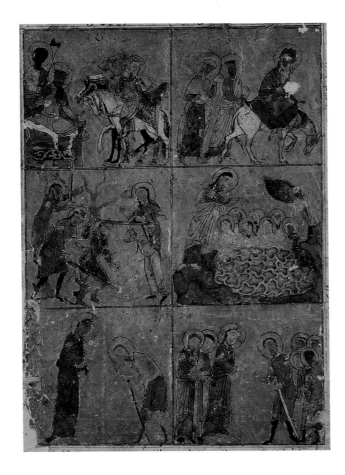

FIGURE 10.22

Magi before Herod, Flight to
Egypt, Massacre of the Innocents,
followed by scenes from Christ's
ministry, 1249/1250. Gospel MS 1,
f. 4v. Institut Catholique de Paris,
Bibliothèque de Fels.

century.[76] Some of the same scenes have been included in
both programs, although the representations at Dayr Abu
Hennis appear to have originally presented a more elabo-
rate narrative, with, for example, the Murder of Zacharias
and the Dream of Joseph. Since neither program is com-
plete, it is impossible to analyze their iconographic relation-
ship in any detail. Of interest, however, is the scene of the
Massacre of the Innocents, in which Herod is shown with
a halo. He sits in front of a building, watching the murder
of the young boys. At the Monastery of St. Paul, Herod is
also crowned and haloed. Chapel XXX in the Monastery of
Apa Apollo at Bawit, like Dayr Abu Hennis also late antique
in date, showed the Massacre on the north wall followed by
Elizabeth (not Uriel) holding John the Baptist.[77] The Magi
with Herod and the Massacre are included in twelfth- and
thirteenth-century gospel books. The 1179/1180 manuscript
from Damietta shows Herod on a backless seat, crowned
but without a halo, hurrying the Magi out the door with
his hands.[78] The elaborate scene of the Massacre includes
a basket of small heads and shows several decapitations in
process. Herod holds a sword and looks over the proceed-
ings.[79] This bloody event ends the short Nativity cycle at

the beginning of this manuscript, illustrating the Gospel of
Matthew.[80] Mark and John include no part of the infancy
narrative, while the Gospel of Luke provides us with an
Annunciation, among other scenes not found in Matthew,
but no Massacre. The illuminated codex of the Gospels of
1249/1250 begins its illustrations of the Book of Matthew
with a Nativity, and then, starting with folio 4v, shows the
Magi on horseback before Herod. All four are both crowned
and haloed. Following this scene on the same folio are the
Flight to Egypt, and the Massacre (fig. 10.22).[81] Once again
this violent event terminates the pictorial account of the
Nativity cycle in the Gospel of Matthew. None of these ab-
breviated cycles shows an illumination of an angel with a
child. In medieval depictions, Herod is represented both
with and without the traditional halo denoting authority,
and not divinity.[82] The Nativity cycle in the Cave Church
includes events from more than one gospel account, which
makes sense because the wall paintings are not tied to a
single text but express the larger narrative. The appearance
of Infancy scenes in medieval Egyptian monumental art
and manuscript illuminations suggests that this cycle was
a reasonably popular one for depiction.[83] It is also worth
observing that two of the medieval examples are miniatures
in illustrated Gospels. Conceivably, the second painter may
have produced similar miniatures, which later served as
models for his work in the Cave Church. The damaged state
of his Nativity cycle, however, makes further speculation
on this question impossible.

ECHOES OF MEDIEVAL PAINTINGS: DESCRIPTION
AND DATING

The eighteenth-century artist repainted three subjects
from the second medieval program in the nave, at the west
end of the south wall and on the west wall. The monk re-
sponsible for reworking the earlier images was evidently
guided by the surviving medieval inscriptions, and also
perhaps by medieval paintings that may have been visible
then. The inscriptions identify the three subjects as cheru-
bim praising Christ (far western end of the south wall), the
archangels Michael, Gabriel, and Raphael (west wall), and
the three Hebrews (west wall) (fig. 10.23).

Although the inscription on the south wall mentions
only Christ and cherubim, the eighteenth-century painting
depicts an enthroned Virgin and child flanked by cheru-
bim. This unusual juxtaposition was clearly derived from
the work of the second medieval painter. Roundels identi-
fying Mary as the Mother of God form part of the medieval
decorative band between the inscription and the images,

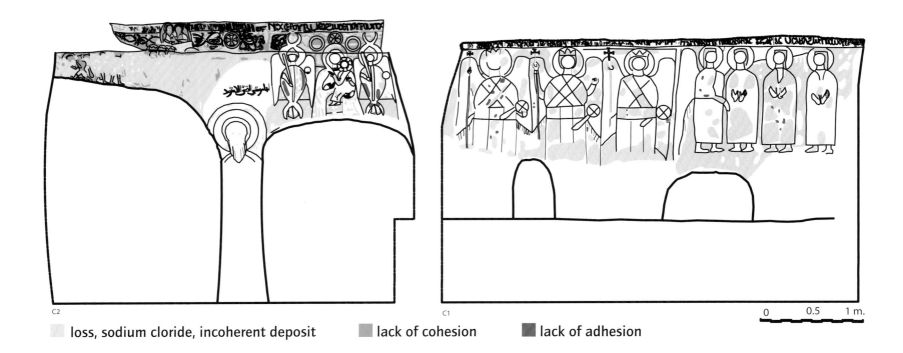

C2 C1 0 0.5 1 m.

■ loss, sodium cloride, incoherent deposit ■ lack of cohesion ■ lack of adhesion

FIGURE 10.23 ABOVE
Conservation record of the south and west walls of the central nave showing the re-created medieval paintings of the Virgin and Christ child with cherubim (D19), three archangels (D1), and the three Hebrews (D2).

FIGURE 10.24 RIGHT
Virgin and Christ child with cherubim (D19) and the three archangels (D1), 1712/1713, repainted images from 1291/1292. ADP/SP 209 S1 5 05.

leaving no doubt that the Virgin was part of the original composition (fig. 10.24).[84]

Certain stylistic features in the painting of the Virgin, Christ child, and cherubim, observed by De Cesaris, Sucato, and Lyster, indicate that the self-taught eighteenth-century painter modeled his version of this subject on the earlier one, or perhaps even copied it without any but a stylistic adaptation. The bodies of the four figures, for example, were not formed with a compass-drawn circle, presumably meaning that the later artist followed the medieval composition closely. Additionally, van Moorsel saw remnants of pigment that in his opinion belonged to a medieval phase underneath this later painting, which De Cesaris has since confirmed.[85] The self-taught painter also never repeated this depiction of a cherubim possessing one head and six wings, but this iconographic format is nearly identical to the medieval artist's handling of the cherubim in the Haykal of St. Antony (fig. 10.25).

The eighteenth-century paintings on the western nave wall are all located below the continuation of the medieval inscription band from the south wall. As van Moorsel observed, the subjects identified by these inscriptions clearly also existed in the medieval period and were repainted by the eighteenth-century artist.[86] They do not relate in a direct narrative way to the Nativity cycle but emphasize themes of protection and salvation. In their current, eighteenth-century state they provide valuable information about the medieval iconography of the nave. All data relating to the medieval style of these images have, of course, been lost.

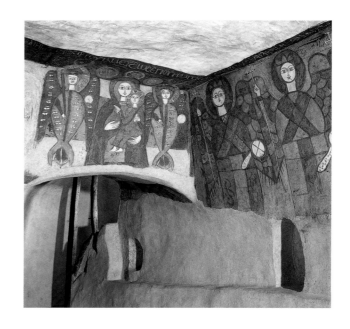

ECHOES OF MEDIEVAL PAINTINGS: ICONOGRAPHY

Two of the three subjects in the nave, which originally belonged to the second phase of medieval painting in the Cave Church, are unusual. The Virgin and child flanked by adoring angels is a ubiquitous subject, but including cherubim instead of the usual pair of archangels is not a standard choice. That the cherubim were part of the original medieval conception is made manifestly clear by the inscription: "The cherubim are praising the king, the Christ." This inscription suggests an image of Christ in Majesty surrounded by the heavenly host, similar to the painting in the

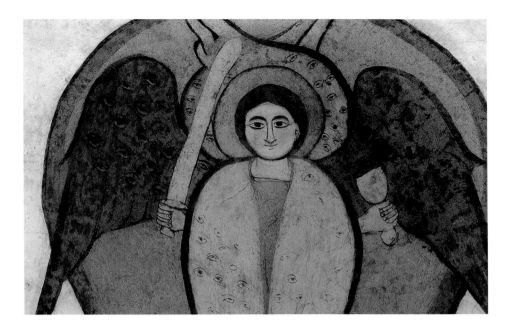

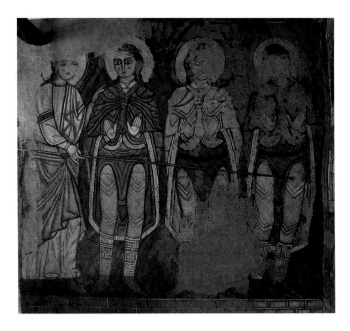

FIGURE 10.25 LEFT

Cherub (E15). ADP/SP 2 S1206 02.

FIGURE 10.26 RIGHT

Three Hebrews, 1232/1233. Church
of St. Antony, Monastery of St.
Antony. ADP/SA 1999.

Haykal of St. Antony. Instead, the subject is of the Virgin
and child with cherubim. Perhaps the artist intended to
represent the Incarnation in this scene, as a variation on
the earlier painting of Mary holding the Christ child in a
clipeus, shown in the central apse. If so, this iconic image
might express the same impulse to repeat the paintings hid-
den in the sanctuary considered above, for the benefit of
audiences in the nave.[87]

The painting of Michael, Gabriel, and Raphael on
the west wall also stands out as an inventive choice.
Archangels certainly figure prominently in wall paint-
ings, manuscript illuminations, and other media, but not
as an iconic trio. Again, the medieval inscription makes
their early inclusion in the Cave Church program appar-
ent: "Michael, the archangel; Gabriel, bearer of good...;
Raphael, the compassionate." While the grouping is unusu-
al, the eighteenth-century painter's frontal depiction of the
angels dressed in Byzantine court garb and holding a cross
staff in the right hand, and an orb, disc, or loaf in the left,
finds numerous parallels within and outside of medieval
Coptic art. One example is in the Monastery of the Martyrs
(Esna), where the identity of the long rounded elements
adjacent to the orbs in the Cave Church representation is
clarified. They are an eighteenth-century misinterpretation
of bunched fabric from each angel's cloak.[88]

Archangels appear in monumental church decoration
in such scenes as the Annunciation, and framing depic-
tions of Christ in Majesty, as in the Haykal of St. Antony
in the Cave Church. Within as well as outside of Egypt,
Christians constructed ways to make them the focus of
liturgical and individual devotion. People chose to dedicate
churches to them, have feasts honoring them, and write

homilies about them, including accounts of miracles they
performed.[89] The archangels provided protection and in-
terceded with God for the remission of sins.[90] These three
in particular were the "greatest of all the angelic host."[91]
It seems likely that the selection of these three archangels
was meant to have a Trinitarian symbolism, as was often
attributed to the three angels to whom Abraham offered
hospitality (Genesis 18:1–15).[92]

A far more standard subject for late antique and medi-
eval wall paintings, at least based on the surviving evidence,
is the Three Hebrews in the Fiery Furnace. The inscription
announces: "The angel of the lord. The three youths, Ana-
nias, Azarias, and Misael, praise the Lord and glorify him
forever." In their basic presentation, the second thirteenth-
century painter who worked in the Cave Church followed
one of the two standard models for this subject, also seen
in the Monastery of St. Antony (fig. 10.26), in which the
angel stands to the far left of the three youths.[93] The three
young men face the viewer and hold their hands in front of
their torsos in a gesture of prayer. They are standing within
the furnace of the Babylonian king Nebuchadnezzar, hav-
ing refused his order to worship a golden idol. The angel
protects them from the fire (Daniel 3).

Homilies, visual depictions, miracle accounts, and
magical papyri attest to the importance of the three young
men in Egypt.[94] Van Loon has shown that they functioned
as a type of Christ's sacrifice in the medieval period, and
thus of the Eucharist, making them an appropriate image
for sanctuaries, where one often finds them. Van Loon has
emphasized their significance, when included in a khurus,
as an image of the saved in paradise.[95] She has also con-
sidered evidence that the three young men functioned as

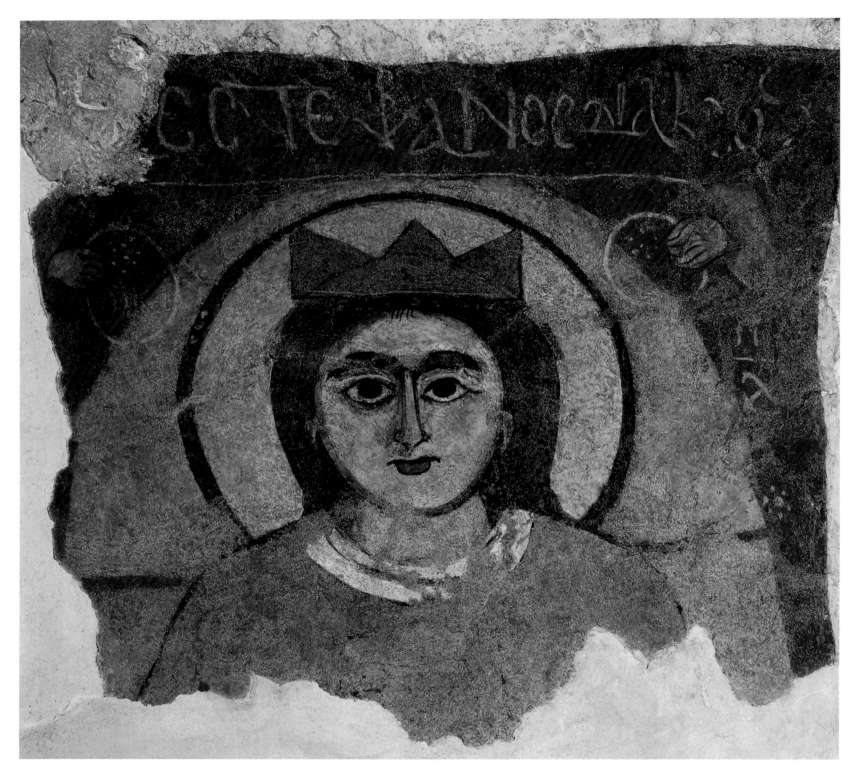

FIGURE 10.27

Stephen (E13). ADP/SP 212 S10 5 05.

examples of asceticism and martyrdom for the monks, a valence that would certainly be appropriate in the Cave Church.[96] A twelfth-century Coptic *Panegyric on the Three Children of Babylon* provides yet another possibility, and one that works particularly well adjacent to the three angels and the notion that they represent the Trinity. The anonymous homilist characterized the three youths as a "type of the Trinity, who confounded the contemptuous king

until he had acknowledged the Son of God, well before he became incarnate."[97] The author also recounted a miracle, according to which the furnace became a source of healing. When the youths left it, pure water came down into the furnace, causing it to run with water. As the sick who bathed in this water were healed of their physical ills, they lost their faith in demons and believed in the saints (the three youths) and in Christ.[98] Following this, Christ appeared to

200

the three young men, telling them that they would be saved and that "anyone who dedicates an oratory in their names, or gives alms in remembrance of them, or recounts their martyrdom" will have complete remission of sins and protection from the fires of hell. Further, those who call on Christ and invoke as well the names of the three youths "will be saved, whether it be on the water, or in any port, or from torments, or from illnesses."[99]

The second medieval artist working in the Cave Church painted the three Hebrews in a part of the church that is certainly neither the sanctuary nor the khurus. Peter Sheehan has observed evidence of a division between the eastern and western sections of this room, which would have made the westernmost area the medieval nave. The scale of the Cave Church is considerably smaller than that of the Church of St. Antony, providing limited space for paintings and perhaps necessitating the placement of the three Hebrews in what seems an uncharacteristic location. This western slice of the church was the most accessible, and perhaps this factor also motivated their position in the nave, in order to facilitate devotional activities. This particular painting would have resonated in multiple ways for the monastic viewer, depending on his thoughts and needs at any given time.

The Archway Between the Haykal of St. Antony and the Haykal of St. Paul

The Haykal of St. Paul, originally part of an eremitic cave, now functions as the southernmost of the three sanctuaries. It is fronted on the west by what was probably the second room of the cave, which now contains the saint's cenotaph, in the Shrine of St. Paul. As Sheehan has shown in Chapter 6, the original entrance to the cave was on the northern side of this sanctuary, through the passage that now leads to the Haykal of St. Antony. One painting remains in the archway between these two sanctuaries. The single extant image shows Stephen, the first martyr, identified by an inscription (fig. 10.27).

DESCRIPTION, STYLISTIC ANALYSIS, AND DATING

This painting of Stephen fits best within the stylistic and coloristic repertoire of the later thirteenth-century work. Features indicating such a dating include the inscription band at the top, which is nearly identical to those in the nave, the wide, curving eyebrows, the basic design of the nose, the full head of hair, and the distinctive blue. However, it also includes features consistent with the earlier medieval paintings, such as the white seven-dot pattern, the greater width of the figure's eyes, the red line underscoring

the brows, and the shape of the face. Luzi, who discovered the image of Stephen under a later paint layer, first identified the presence of both medieval styles in this one face. To make matters more complicated, elements of the face belong to neither medieval phase. For example, the nose, basically following the linear design used by the later thirteenth-century artist, nevertheless is rendered with a suggestion of modeling, and an unusual pink is applied on various parts of the martyr's face, distinctively closer to a magenta than the apricot-pink flesh colors used by the first medieval painter. Most likely, these additions were made by postmedieval artists, attempting to "refresh" what is physically a very accessible painting, so we see in this one image traces of at least three periods of painting and repainting.

ICONOGRAPHY

The placement of the first martyr, Stephen, in the archway between the two sanctuaries, is interesting, and is somewhat reminiscent of the location of a painting of the same saint in the north church in the Monastery of the Martyrs at Esna, dating to the twelfth century.[100] His liturgical appellation is included in the Cave Church in the inscriptions, which describe him as "Stephen, the deacon" and make reference to his martyrdom by drawing our attention to "the crown." At Esna, the full figure of Stephen fills one side of an arch, but in this instance it is the arch directly in front of the main sanctuary. The presence of another frontal depiction of this saint, in the Haykal of Benjamin at the Monastery of St. Macarius, Wadi al-Natrun, of about the ninth or tenth century, indicates that he was likely not an unusual choice for monumental paintings in medieval Egyptian churches.[101] Late antique ascetics and writers constructed a genealogical relationship between martyrs and monks, according to which the monks continued the work of the martyrs, and were also identified as soldiers of Christ.[102] In this program in the Cave Church of St. Paul, the prominent choice of the first martyr brings to mind the designations of Paul as the first hermit, and Antony as the father of monasticism (in other words, the first monastic leader), emphasizing this link between martyrs and monks.

Angelic hands hold out two circlets, indicating crowns of martyrdom, to the saint and he wears the traditional third. The three crowns are described in an Ethiopian source as paralleling in number the Holy Trinity and as symbolizing the saint's virginity, endurance, and martyrdom.[103] However, the crown on the martyr's head may be a later addition. The white dots at the lower right edge of the painting are likely the original depiction of the third

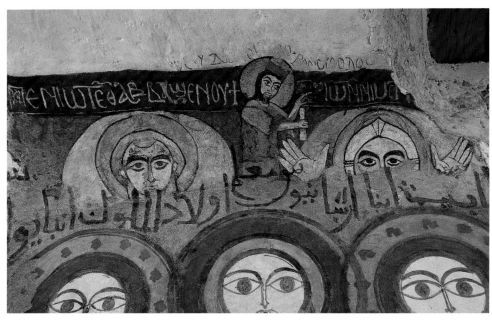

FIGURE 10.28 ABOVE
Traces of a saint (G1).

FIGURE 10.29 BELOW
Shenoute (F10), Emperor Theo-
dosius (?) (F11) and John (F12),
above John (F5), Arsenius
(F6), and Abib (F7), 1712/1713.
ADP/SP 211 S3 5 05.

"crown" as a circlet, like the two being offered to either side
of the saint's head. Unfortunately, only the head survives
of what was probably a full-length figure of Stephen. He
may have held a chalice and book, and have been dressed
in ecclesiastical garb, as is the case in the painting in the
Monastery of St. Macarius. The proximity to the site of the
celebration of the Eucharist makes such an iconographic
choice suitable for both paintings.

The Shrine of St. Paul

The walls of the shrine, like those of the Haykal of St.
Paul, were almost completely covered with cement, which
destroyed almost all traces of medieval paintings. Nev-
ertheless, on the west wall, at the southern entrance, De
Cesaris found the red outline of a frame surrounding a halo
of what was presumably a standing saint (fig. 10.28). One is
tempted to imagine that this frontal figure was Paul, due to
the significance of the shrine, but of course no such iden-
tification can be made. The dark red of the frame and the
mobility of its execution show that this painting belongs
to the second medieval phase. The east wall of the shrine
includes the continuation of some ambiguous remnants
that are also the work of the second medieval painter (see
fig. 8.23). One can still see the tops of what appear to be
red circles bridging the nave and the shrine, and while
there is certainly enough room here for standing saints
(as we see from the eighteenth-century monastic figures
painted below these medieval remnants), the evidence is
too limited for further speculation. We can now say with
certainty, however, that the second medieval artist worked
in the Shrine of St. Paul.

The Corridor: Description, Stylistic Analysis, and
Dating

The late thirteenth-century painter worked on both sides
of the corridor in the southwest corner of the Cave Church.
On each end of the east wall he placed a pair of monastic
saints: Shenoute and John to the north and Moses the Black
and possibly Pachomius to the south.[104] The two groups
were separated by what appears to have been an unpainted
area at the center of the wall, which is beneath a break in
the ceiling where there was once a small dome or light well
(see fig. 8.26). The eighteenth-century monk-painter of the
Cave Church repainted the southern pair of saints but pre-
served their medieval inscription band. Beneath the later
paint layer one can see the ghost of a raised right hand be-
longing to Moses. At the northern end of the wall the monk
painted a row of standing saints but placed them lower
on the wall, leaving about a third of a meter of the earlier

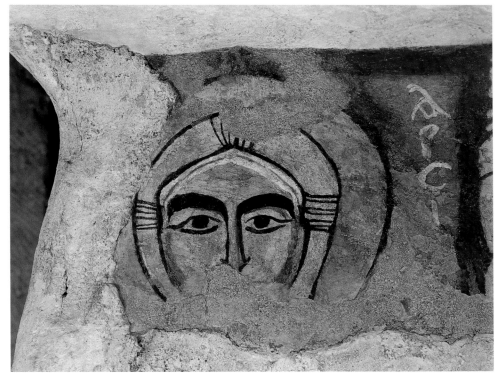

FIGURE 10.30 ABOVE

Arsenius (F1), a church (F2), a
lost saint (F3), and an unidentified
female saint (F4). ADP/SP 28 S10 5 05.

FIGURE 10.31 BELOW

Arsenius (F1). ADP/SP 211 S9 5 05.

subjects visible (fig. 10.29). Once again he preserved the red band of Coptic inscription. Both examples have the same distinctive white lettering as that found in the central nave. The partially surviving figures at the northern end have stylistic features characteristic of the second medieval artist's work, such as the thin outlining of the nose tipped with a V shape, the thick, arching eyebrows, and the flaring profile of the outer eye. The two figures stand below the inscription band, and within an unarticulated lighter red arcade, with a pale turquoise background that has largely disappeared. Of the first figure (at the far northern end), Shenoute, we see only his bare, haloed head. The next figure, identified as John, wears a monastic headdress and raises his hands in the orans position. Only his hands and the upper half of his head are visible. In a diminutive scale, inserted between these two heads, stands a figure gesturing to John and holding a scroll. In their original state, presumably the saints' entire bodies would have been visible.

An incomplete and also damaged painting dating to the second medieval phase faces these monastic saints (figs. 10.30–10.32). This western wall shows, at the far left, Arsenius, also with a monastic hood.[105] Only the upper two-thirds of his head, the right side of the inscription, and the red frame have survived. Immediately to the right (north), what appears to have been a narrative scene is still partially visible but was never finished. The outlines of a domed structure, presumably a church, are at the left. Next, one can still discern the top of a halo and an inscription reading "the saint." A haloed woman, wearing a maphorion, looks back toward the lost figure and the church. Too little survives to suggest the subject, but the unfinished building and inscription band show that this painting was not completed. The rendering of the female saint's head numbers among the more compelling of this artist's work.

The Corridor: Iconography

The fragmentary information available about the subjects in the corridor makes it impossible to form a clear picture of their specific iconographic rationale. Which, for example, of the several Johns is represented here? And who is the small figure addressing him? His identity is uncertain, but the absence of any trace of a cross nimbus, and the crown on his head, suggest that he may be one of the prophet kings, such as Solomon or David.[106] Gabra has proposed that the partial inscription, written more casually above the figure against the white plaster, might read: "Emperor Theodosius." The identity of John and of this crowned figure remain a mystery. Shenoute might be included here, as he is in the Monastery of St. Antony, as one of

the great founders of monasticism. Similarly, the incomplete narrative scene on the western corridor wall eludes identification.

However, one can address the choice to include standing saints, monastic and otherwise, on the east wall. It was a common one in late antique and medieval painting within and outside of Egypt. The eastern nave program in the Monastery of St. Antony provides the closest geographical parallel. The inclusion of monks functioned variously, as do all of the paintings in the church, here more specifically providing exemplars for imitation and reminders of the *Apophthegmata Patrum* (Sayings of the Fathers). Additionally, the saints could act as intercessors. As such, these depictions would have been foci for devotion by monastic viewers who had special relationships with the saints represented—for example, a monk with the saint's name.[107]

Conclusion: The Context of the Second Medieval Painter

Both the Cave Church and the Church of St. Antony were painted twice in the thirteenth century. What sets them apart are scale and, at least as regards the second phase of work at St. Paul's, quality.[108] Neither the scope of the second medieval program in the Cave Church nor the technical skills of the artist and his possible assistant rank with the best surviving art of Christian Egypt, although the paintings include some compelling visual passages. It should perhaps not surprise us that the monks from the large and more prominent Monastery of St. Antony, with the assistance of more than thirty patrons, would commission some of the best painters we know from the thirteenth century in Egypt to produce a monumental program. The remote and smaller Monastery of St. Paul also had building and painting projects in the thirteenth century, but the first ensemble is difficult to judge properly given its limited survival, and the quality of the second phase of painting falls short of that produced in the Monastery of St. Antony. Evaluating the significance of artistic quality in this period is challenging. Certainly a discussion of style should not obscure the fact that paintings of sacred images functioned as part of the spiritual life of the inhabitants of both monasteries, irrespective of the skill of the artist who rendered them.

I have commented elsewhere on the existence of at least four modes of painting during this period: 1) the continuation, with the integration of newer elements, of the heterogeneous but nevertheless recognizable Coptic tradition; 2) the current style of the Dar al-Islam, being formulated, practiced, and commissioned by people of all faiths; 3) a Byzantinizing style; and 4) a Syrian Christian style.[109]

The existence of two related monastic churches, each with two phases of painting dating to the thirteenth century, provides us with data for refining our understanding of the character of Egyptian Christian art in the thirteenth century. We are virtually certain that none of the artists who worked at the two Red Sea monasteries painted in both churches, meaning that we have evidence of four separate painters or teams of painters.[110]

The two medieval artists at the Monastery of St. Paul worked in the same century in which two very distinct teams created mural paintings in the Church of St. Antony. The master painter Theodore directed the first team at the Monastery of St. Antony in 1232/1233.[111] The second team was comprised of an ornamental and a figural master, who were active within a few decades before 1291/1292, the date in the inscription surrounding the Christ in Majesty in the Cave Church.[112] Theodore and his near contemporary, the first St. Paul painter, worked within the parameters of what I have characterized as a traditional Coptic mode. Aspects of this style, with its use of outlines and its preference for frontal representation, extend back to late antiquity. The medieval artists manifest a flatter expression of it, with harder lines, a denser application of pigments, and a different palette.[113] Within this traditional Coptic style diversity certainly existed. For example, Theodore delineated facial features with black or dark brown paint, whereas the first St. Paul painter used lines of variously colored paint, including red, to form noses and eyebrows. But the widespread use of this style within and outside of monastic contexts has become clearer with the very recent discoveries of two paintings in Old Cairo, at the Church of St. Sergius and St. Bacchus (Abu Sarga) and at the Hanging Church (al-Muʿallaqa) (see figs. 9.20 and 9.21).

While the visual work of the first medieval painter fits readily within an identifiable group, that of the second belongs easily in none of them. The endeavor to comprehend his sources and training has been a difficult one, compounded by the fact that so much of his program has been lost. The second medieval artist working in the Cave Church of St. Paul duplicated at least one traditional ornamental design found in the work of Theodore and that of the first medieval painter. Both of the earlier thirteenth-century painters employed an undulating vine and leaf pattern—for example, when decorating thrones, including that of the Virgin in the Haykal of St. Antony (see fig. 9.9). The second medieval artist placed the same design on the hems of the robes worn by the angels in the Haykal of St. Antony (see fig. 10.3). It is worth noting that his handling of this traditional vine and leaf pattern is considerably more successful

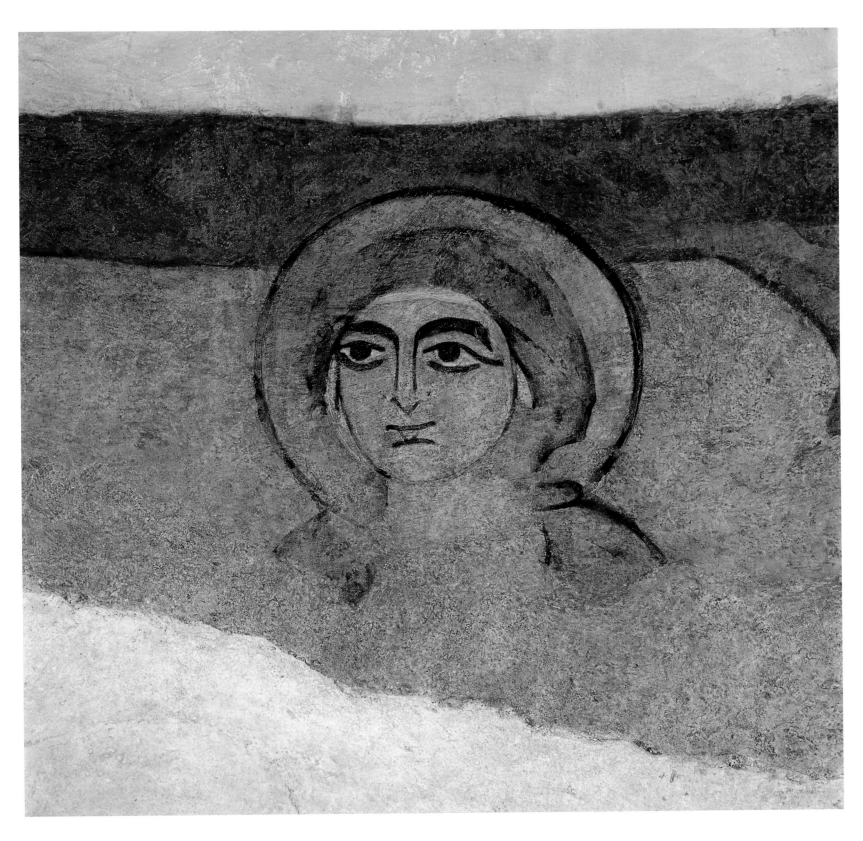

FIGURE 10.32

Unidentified female saint (F4).

ADP/SP 211 S10 5 05.

than are his attempts at reproducing contemporary designs of greater complexity. The St. Paul painter of 1291/1292 does not appear to have been at home with the new ornamental styles of this period. Unlike the artist of the gospel book of 1249/1250, he was unable to create the elaborate geometric designs and arabesques that are such a prominent feature of contemporary miniatures, metalwork, and architectural decoration. This lack of training in the ornamental styles popular in the Dar al-Islam is reminiscent of the less than completely confident handling of aspects of the Damietta manuscript, produced more than a century before, when such designs were still being developed and popularized.

The work of the second St. Paul painter is, therefore, clearly distinguishable from that of the ornamental master of St. Antony, who deployed a dazzling array of sophisticated designs and decorative inscriptional passages that are typical of the period. The ornamental master worked within a coherent and widespread visual language. Lyster has shown the connections between the khurus ceiling in the Church of St. Antony and those of contemporary palaces and wealthy homes in Cairo and elsewhere in the Islamic realm.[114] The second St. Paul painter obviously was familiar with this contemporary stylistic mode, but his clumsy attempts at reproducing the same complicated designs indicate that he did not have training in this tradition.

Although the artist of 1291/1292 shows some familiarity with these ornamental designs, the fluid linearity of his figural style has much closer links to the visual language of contemporary Arab miniature paintings, which is also found in a wide range of other media, including images of humans and animals on ceramics and metalwork. Based on the surviving evidence in the Cave Church, it is possible to speculate that he could have illustrated figures in both secular works such as *Kalila wa Dimna*, and religious texts, including copies of the Gospels. Unfortunately, the damaged state of his Nativity cycle makes comparisons with Coptic miniatures of similar biblical subjects almost impossible, but his painting of a female saint in the corridor would not be out of place, for example, in the gospel book produced in Damietta about a century earlier (fig. 10.32).[115] Some of the unevenness of his work may derive from a lack of familiarity with large-scale wall painting. However, his greater ability in the rendering of faces and torsos perhaps indicates that he (also?) worked as an icon painter.

Nor can he be comfortably linked to the work of the figural master of the second thirteenth-century team at St. Antony's, which shows ties to provincial Byzantine art.

The St. Paul painter incorporated certain iconographic elements that ultimately derived from Byzantium, in particular the court costumes worn by his angels in the Haykal of St. Antony, but he was not part of a clearly identifiable Byzantinizing stylistic tradition. How then should we characterize the second St. Paul painter? Except for an obvious lack of experience with mural painting, shown by a total disregard for a smooth preparatory layer and problems with scale, and suggestions of involvement with miniature and icon painting, his work fits neatly into no single stylistic category or technical practice.

A closer consideration of the political and economic conditions of the Copts at the end of the thirteenth century may help account for the unevenness of the second medieval painter's performance. All of the other teams of painters at the Red Sea monasteries were active during a flourishing of Egyptian Christian culture, when the Copts still enjoyed positions of wealth and prosperity within the predominantly Muslim society of Egypt. By 1291, however, the era of Mamluk oppression had already begun, and it must have affected Christian artistic production. The second St. Paul painter was active at the end of a ten-year period of persecution of the Copts by Sultan Qalawun.[116] In such an environment, the quality of training and professional life of the second painter may have declined dramatically from the days of Theodore and the first St. Paul painter. In particular, this period of oppression may well have foreshadowed the ultimate demise of the tradition of monumental Coptic wall painting in the fourteenth century. One persistent constraint imposed by the Muslim government during times of persecution was the prohibition on building or improving churches.[117] It may well have been difficult or impossible to undertake large-scale wall painting projects in the decade before the second medieval painter worked at the Monastery of St. Paul. A lack of opportunities for training and practice may account in part for his unusual work but does not fully explain it. While we can see the addition of this idiosyncratic mode of painting to the larger corpus as one more example of the richness and diversity of Coptic wall painting in the thirteenth century, it is likely more historically accurate to see it as pointing to the end of a period of wealth and intensive cultural production. It marks the termination of a tradition of wall painting stretching back to late antiquity.

Questions of style and iconography must be addressed at length in a study such as this one, due not only to the recent conservation of the church and our better ability to

appreciate the paintings in their cleaned state, but also because the field of Coptic art history is a young one and such traditional art historical subjects are still in need of consideration. However, function, and not artistic questions, motivated the patrons (whether they belonged to the monastery, clergy, or laity) who commissioned the paintings for the Cave Church. In a prominent way, religious images helped to construct and maintain a Christian identity within the larger aniconic Muslim setting of medieval Egypt. Most of our sources from the period addressed the question of religious images from the point of view of urban Cairo and the needs of the laity, but the issues had relevance for Christians everywhere in Egypt. These authors' very stance in defense of images indicates a context in which the subject required justification. They provide not just that, but also explanations of many of the ways in which images worked.[118] Medieval Egyptian Christian writers repeatedly cited Old and New Testament precedents, canonical and apocryphal, for using images—for example, God's instructions to Moses to create cherubim to protect the Ark of the Covenant, and Christ's gift to King Agbar of a cloth miraculously imprinted with his image.[119] We are told that in addition to using bright colors and dramatic subjects to entice the uninformed to engage with depictions of the saints and martyrs, these paintings elicited the viewer's curiosity and provoked questions. When the questions were answered by a knowledgeable person, the icons then provided an opportunity to teach people about their religion.[120] These authorities insisted on the point that icons provide access to the holy personage represented, and that the image itself was not the focus of the veneration.[121] Contact with that personage creates opportunities to ask for intercession with God, for forgiveness of sins. Images of the martyrs strengthen people's faith. The priest of the Hanging Church in Old Cairo, Ibn Kabar, wrote that Christians have an "obligation" to depict Christ in human form, as a reminder of his work on earth "from his miraculous birth to the time of his resurrection and ascension."[122]

Our understanding of the two phases of medieval paintings in the Cave Church at the Monastery of St. Paul is usefully informed by these assertions. We can see the paintings as basic to the construction of Christian identity in medieval Egypt. They exist not independently as works of art but as statements of faith and as vehicles for communication with sacred personages. They play a role in the viewer's desire for remission from sins, providing a method for contacting saints and requesting intercession. The in-clusion of the Nativity cycle, begun by the first medieval painter in the sanctuary, and continued in at least part of the nave during the second phase of thirteenth-century painting, had a specific purpose. According to Ibn Kabar, it fulfilled an obligation to show the reality of Christ's incarnation. The span of required depiction, as mapped out by this author, continues from the Annunciation to his resurrection and ascension.[123] We can interpret without difficulty the upper zone of painting in the Haykal of St. Antony, by the second artist, as completing the circle and showing Christ in heaven. Ascensions commonly depict precisely this setting, showing Christ in a mandorla carried by the four incorporeal living beings or angels, although in these scenes he is typically standing, not enthroned. The manuscript illumination of 1249/1250, produced in Cairo, exemplifies this iconographic type (see fig. 10.9).[124] The coherence of this narrative circle, mapped out by Ibn Kabar in words, and at least partially in images by both medieval painters, suggests that further depictions from the life of Christ might well have been included on the now lost north wall of the Cave Church. The extensive twelfth- and thirteenth-century manuscript illuminations of this cycle add credence to this hypothesis. Nevertheless, I do not mean to suggest that this Cairene priest, however influential, dictated the precise format of the medieval images in the Monastery of St. Paul.

The textual sources considered in this chapter make it clear that Christian paintings had multiple points of reference. The diversity of artistic production in medieval Egypt shows that this complexity was increased through the choice of varied subjects for churches. In the case of the Cave Church, this specific environment had strong eremitic and monastic resonances. Interestingly, the surviving medieval paintings have little in them that can be directly tied to Paul, except the choice of the first martyr, Stephen, as the figure connecting (visually and spatially) the haykal of the first hermit (Paul) and that of the first monk (Antony). This martyr figure and any others originally included would also have established at this site the genealogical connection between martyrs and monks that is so dominant in the nave paintings in the Monastery of St. Antony.[125] Presumably the lost paintings in the central nave, the Shrine of St. Paul, and possibly also in the Haykal of St. Paul would have expanded substantially on these themes, visually connecting the cycle of the incarnation and resurrection with the legacy of asceticism at the Cave Church.

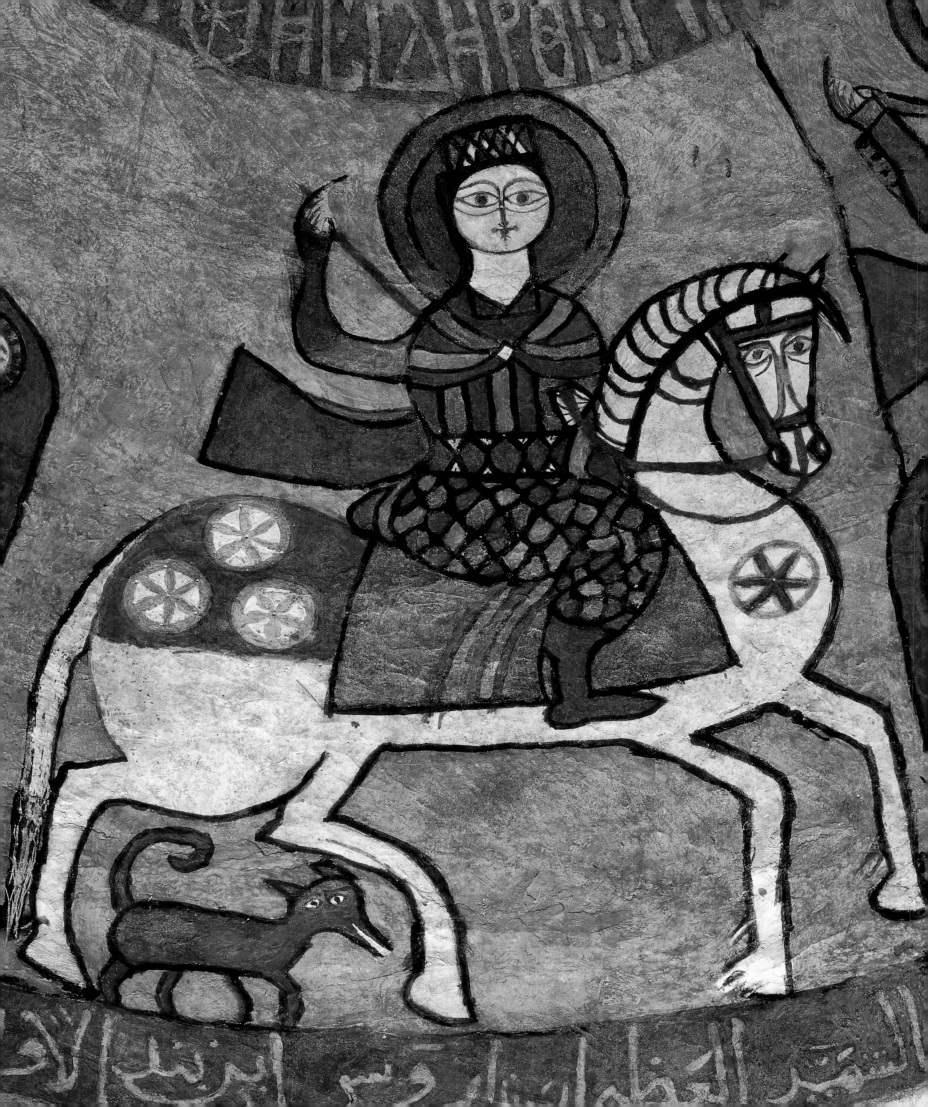

CHAPTER 11 REVIVING A LOST TRADITION

THE EIGHTEENTH-CENTURY PAINTINGS IN THE CAVE CHURCH,
CONTEXT AND ICONOGRAPHY

First Impressions

In 1716, Claude Sicard, a French Jesuit, visited the Monastery of St. Paul, which had been occupied for only a decade after a century of abandonment. He was taken to the Cave Church and shown the murals that one of the ten monks at the monastery had painted about three years earlier. Sicard was not impressed. "The walls, which have been recently repaired, are filled from the vault to the floor with sacred stories coarsely painted. Among which they did not forget that of the two tigers, who dug the grave of the saint. The painter-author of these devotional figures presented himself to us. He was a monk of the convent. He told us that he had never learned to paint, which was apparent from his work. He added that the neighboring hills had furnished him with different minerals from the earth: the green, the yellow, the red, the brown, the black and the other colors used in his painting" (fig. 11.1).[1]

Sicard's low opinion of the eighteenth-century paintings would be shared by practically every foreign visitor who wrote about the Cave Church for the next three centuries. In 1738, Claude Granger echoed Sicard's observations: "The walls [of the church] appear to have been repaired recently. There are painted on them, somewhat rudely, some sacred stories, and that of the tigers has not been forgotten."[2] In the middle of the nineteenth century, Porphyrius Uspensky was more outspoken about the quality of the paintings, especially those in the narthex and the Haykal of the Twenty-Four Elders of the Apocalypse. "The martyrs themselves are painted very badly. They are all on horseback.... The paintings on the walls of the Apocalyptic Church are bad; the faces are ugly and even terrible."[3]

A quarter of a century later, Georg Schweinfurth used the paintings to help determine the date of the modern enlargement of the Cave Church. He concluded that the "ancient church with the tomb of St. Paul was restored two hundred years ago, especially if one judges according to the extremely rough and barbaric wall-paintings.... Every wall of this very ancient holy place is covered with grotesque caricatures."[4] Michel Jullien, in an account of his visit in 1883, mentions the "peintures grossières."[5] Johann Georg, who visited St. Paul's in 1930, wrote that in the Cave Church "a large part of the ceiling and the walls were daubed with truly hideous frescos."[6]

Even twentieth-century scholars of Coptic art and culture could rarely muster a good word for the paintings in the Cave Church. Otto Meinardus began one of the earliest scholarly studies of the paintings with a prediction that was practically a plea for their destruction. "Undoubtedly, the day will come when the grotesque wall-paintings in the Church of St. Paul will give way either to new wall-paintings or to the restoration of the thirteenth-century wall-paintings, which are found beneath the eighteenth-century paintings."[7] The pioneering Coptic art historian Jules Leroy showed little interest in "les grossières peintures" in the Cave Church.[8] Paul van Moorsel complained that "these paintings are very disappointing for the visiting art historian. The journey to Saint Paul's is a long and tiring one and we can't help wondering why Pope John [XVI in 1712/1713] did not engage a more skillful painter."[9]

Such critical reactions are understandable if the paintings of the anonymous monk are judged by the standard of High Renaissance Italian art. Leonardo da Vinci wrote

FIGURE 11.1

Isidore (A10), 1712/1713. ADP/SP 167

S1 02.

209

FIGURE 11.2

Raphael (B3), 1712/1713. ADP/SP 177
S5 03.

help of a pair of compasses and then tried—rather unsuccessfully, alas—to give them some substance by painting them, or rather coloring them in, with garish hues. Thus, the feet of most of the saints are painted red!"[14] Otherwise, van Moorsel thought that the "working method of this painter . . . needs no lengthy discussion."[15]

The paintings of the anonymous monk do not conform to Renaissance artistic conventions, or to the traditions of Byzantine icon production, or even to the standards of medieval Coptic murals. The monk was a self-taught painter working in a style that does not belong to any recognizable artistic school. He created images using a set formula, whereby compass-drawn circles defined the head, halo, and upper body of each figure. The circumference of the circle forming the chest and shoulders then determined the width of the rectangular robes that most of the saints wear. The monk depicted arms as simple parallel lines, or sometimes omitted them altogether, in which case he placed the hands directly on the figure's chest. He worked with an extremely limited palette consisting primarily of red, yellow, and green that he alternated to produce what van Moorsel called the "kaleidoscopically colored garments" of his saints.[16] It is no wonder that eighteenth- and nineteenth-century travelers, such as Sicard, Uspensky, and Schweinfurth, found the monk's work in the Cave Church difficult to appreciate. He reduced the human form to an anatomical abstraction consisting of geometric shapes, and then painted his images in a few bright colors. A more contemporary audience at least has the benefit of a century of modernism in western art from which to consider the self-taught style of the monk-painter.

Modernists sought inspiration outside of the accepted canon of western art.[17] In particular, artists such as Picasso adopted a more "primitive" style from African tribal objects.[18] Although the use of the word "primitive" to describe nonwestern societies and their visual cultures has been justly criticized as ethnocentric and pejorative, Picasso meant it as a compliment when he said that "primitive sculpture has never been surpassed."[19] William Rubin has argued that the word should now be understood primarily as an art-historical designation: "That the derived term primitivism is ethnocentric is surely true—and logically so, for it refers not to the tribal arts in themselves, but to the Western interest in and reaction to them. Primitivism is thus an aspect of the history of modern art, not of tribal art."[20]

Primitivism is central to the character of much of western art produced in the first half of the twentieth century.[21] In his seminal study *Primitivism in Modern Art,* first published in 1938, Robert Goldwater included considerations

that a "perfect picture executed on the surface of some flat material should resemble the image in the mirror. Painters, you must therefore think of the mirror's image as your teacher, your guide to chiaroscuro and your mentor for the correct sizing of each object in the picture."[10] Uspensky clearly accepted Leonardo's definition of a perfect picture; he regarded an Italian oil painting of St. Mark as the "best icon" in the Monastery of St. Paul.[11] In contrast to the skillful use of perspective and chiaroscuro by the European artist, the work of the anonymous monk was "very badly painted."[12]

Schweinfurth was probably the first to describe one of the monk's most characteristic methods of depicting images. "The heads of the saints . . . as well as their halos are designed with the aid of a circle, and the eyes, the nose and the mouth are added with geometrical regularity" (fig. 11.2).[13] The painter also used a circle to form the upper body of each of his saints, as van Moorsel has observed. The anonymous monk "drew his figures mainly with the

FIGURE 11.3

Senecio, 1922. Paul Klee (1879–
1940). Kunstmuseum, Basel.
Courtesy of VG Bild-Kunst, Bonn.

art was consistent with a modernist re-evaluation of the notion of the primitive as a whole, so that, for example, a number of artists took a different view of children's art, certain types of amateur painting sometimes termed Sunday painting and the art of the mentally ill.[23]

The work of Paul Klee (1879–1940) has often been compared to the art of children. His paintings exhibit many of the features commonly attributed to the drawings of young children, including a diagrammatic simplicity of composition, and figures rendered geometrically.[24] But it is important to remember that Klee was a professional painter and theorist of modern art. His evocation of an untutored approach was as much a conscious construct as was his decision to reclaim the supposed spontaneity of the child or naïve artist.[25] In a recopied entry of his journal from 1909, Klee wrote: "If my works sometimes produce a primitive impression, this 'primitiveness' is explained by my discipline, which consists of reducing everything to a few steps. It is no more than economy; that is the ultimate professional awareness, which is to say the opposite of real primitiveness."[26]

Senecio, painted in 1922 when Klee was a teacher at the Staatliches Bauhaus in Weimer, depicts the bust of a man in a style similar to the work of the eighteenth-century monk (fig. 11.3).[27] There is no question of artistic influence linking the two painters; rather, Klee consciously adopted an assumed naïveté that happened to duplicate aspects of the self-taught style of the monk at the Monastery of St. Paul. Admirers of Klee praise the childlike playfulness of his work but, like the monk-painter, he also had his detractors. In 1937, after Hitler's seizure of power in Germany, seventeen works by Klee were included in the exhibition of Degenerate Art in Munich. Later the same year, the Nazis removed all modern art from state collections throughout the country, including more than a hundred paintings by Klee.[28]

Any similarities between the childlike style of Klee and the work of the monk-painter in the Cave Church are purely coincidental. The modernist trends of twentieth-century art offer little insight into the self-taught style of the eighteenth-century monk. Yet the emphasis on primitivism in the works of modern artists, such as Picasso and Klee, at least provides a twenty-first century audience with a frame of reference within which to consider and describe the Cave Church paintings in more positive terms than those used by Uspensky, Schweinfurth, and others. A century of modernism has conditioned our eyes to the possibility that simplified figures drawn with geometric shapes may be considerably more than grotesque caricatures.

of Fauvism, Cubism, German Expressionism, Dada, and Surrealism, as well as of the work of such abstract artists as Wassily Kandinsky.[22] Niru Ratnam has provided a concise explanation of the appeal of primitive art to members of the modernist avant-garde.

> Broadly speaking, western artists who drew upon primitive art did so in order to invest their own practice with attributes that they believed primitive art possessed. Key among these were simplicity, authenticity, a directness of expression, and a more instinctive nature in comparison with western art. It is important to note from the outset that these are not necessarily attributes that the makers of primitive art would have recognized; instead, these are values that modern artists read into those objects, and held up as guiding principles for alternative ways of making art in contrast to what they saw as a moribund, stifled and dry western academic tradition . . . This process of re-categorizing non-western objects as primitive

The monk-painter, however, almost certainly did not regard himself as an artist, but as a creator of devotional images. He did not intend his work simply to beautify the church but to introduce a living assembly of saints in the form of icons painted on the walls. The *Book of the Precious Pearl*, a fourteenth-century Arabic encyclopedia of the doctrines and customs of the Coptic Church, indicated one of the functions of such wall murals. "In the churches there should be painted images in color, depicting martyrs and saints whose lives are read to the people to urge believers to imitate their conduct."[29] The imitation of the saints is an important aspect of Coptic monastic life, but the paintings in the Cave Church were not intended solely as didactic role models.[30]

Medieval and modern sources describe the ceremony in which Coptic icons are consecrated to God in a ritual similar to the consecration of the altar and the eucharistic vessels.[31] Once the ritual is complete, the images, empowered by the Holy Spirit, become living manifestations of the saints, worthy of veneration. They are also potential vehicles for miracles. The saints may speak from the paintings, or even emerge from them to appear before the congregation.[32] The *History of the Patriarchs*, an Arabic biographical chronicle compiled over the centuries, contains a number of accounts of miraculous Coptic icons come to life.[33] In one story from the late eleventh century, a bedouin entered a church and began abusing a painting of George, only for the saint to appear and kill him on the spot.[34]

Sincerely petitioning the saints could also result in miraculous solutions to problems in the Coptic tradition. Mark Swanson, in his chapter on the history of the Monastery of St. Paul in this volume, tells of the future patriarch, Gabriel III (1268–1271), spending three days in prayer before a painting of the Virgin Mary, likely the one in the medieval sanctuary of the Cave Church. The Virgin eventually demonstrated her power by speaking to Gabriel with reassurances that his prayers had been answered. Nelly van Doorn observed that the miraculous power of icons is currently believed to stem from a combination of the consecration ritual, the authority of the individual saint, and the faith of the person asking for intervention.[35] Today, devout Copts, when entering a church, greet the saints by touching their images, and then kissing their fingers afterward. This practice is taught from childhood and is promoted by such contemporary Coptic religious leaders as the late Matta al-Miskin (Matthew the Poor) of the Monastery St. Macarius, in the Wadi al-Natrun.[36]

Greeting the saints through physical contact is a tradition that has endured for centuries. We have a western account of Coptic attitudes toward icons written by Johann Wansleben shortly before the painting of the eighteenth-century program in the Cave Church.[37] This observer remarked that the Copts expressed great veneration toward religious images: "They kiss them; they light them with candles and lamps. They have great faith that God works remarkable graces through the intermediary of such images; when they have problems they confide also in the images."[38] When Adriano Luzi and Luigi De Cesaris and their conservation team began cleaning the paintings in the Cave Church, they were first required to remove wide bands of dirt deposits that covered every image, where generations of believers had touched the paintings. With the completion of the conservation project, the current monks of the Monastery of St. Paul are faced with a dilemma: should the newly cleaned images be treated as museum pieces and protected from pilgrims, or should the traditional method of physically greeting the saints still be permitted, and even encouraged?

Behind this debate are conflicting interpretations of the nature and functions of the paintings. The western conservators and their sponsors have identified and treated the paintings as works of art. On the other hand, the community of monks, while recognizing the historical importance of the images, regards them primarily as icons to be venerated. Elizabeth Bolman has remarked on the paradox of the western visual tradition prizing illusionism without believing that a work of art possesses life, while in the Coptic tradition a spiritual presence is attributed to even the most nonnaturalistic of consecrated images.[39] Van Moorsel made a similar observation about modern Coptic visitors to the Cave Church: "When [pilgrims]—sometimes arriving in groups and often headed by a precentor with cymbals—descend singing from the narthex into the church, and make their way to the sepulchral room, they feel welcomed by all these martyrs and archangels, and it does not worry them that an unskilled painter depicted most of these saintly images. Pilgrims have their own standards. But so do present-day art historians and archaeologists."[40] In this particular case, however, the standards of the modern pilgrims appear to be same as those of the eighteenth-century creator of these sacred images: the artistic style of the paintings is less important than their spiritual presence. And at least this twenty-first-century art historian treats the images in the Cave Church as works of art, as well as historical evidence for devotion.

Sicard indicated that a single monk filled the Cave Church "from the vault to the floor with sacred stories," but it seems unlikely that such an ambitious enterprise

was the work of only one man.[41] Although the monk who spoke to Sicard may have been the principal painter of the project, he very likely enlisted the support of most or all of the members of the small community then residing at the monastery. He no doubt received further assistance from Patriarch John XVI, who had recently enlarged the church and may have initiated the painting project as well. Working on behalf of the pope, or at least with his blessing, the painter and his fellow monks clearly invested considerable energy and effort in the design and execution of this monumental undertaking.

The fact that the patriarch and the monastic community of St. Paul's entrusted a self-taught painter with the creation of the devotional images in the newly enlarged Cave Church indicates something very interesting about the state of Coptic art in the early eighteenth century. It appears that no living tradition of wall painting or professional icon production existed among the Copts at that time. As far as can be determined, teams of professional artists stopped painting churches in Egypt sometime in the fourteenth century.[42] Thereafter, the Copts no doubt continued venerating their existing murals, but they do not seem to have sponsored the creation of new ones. By painting the Cave Church in 1712/1713, the anonymous monk and his brethren revitalized an artistic tradition that had been dormant for centuries.

Renewing a Lost Tradition

The decline of the medieval tradition of Coptic painting seems to have been a consequence of the traumas suffered by the Christian community of Egypt in the mid-fourteenth century. Anti-Christian riots resulted in the destruction of churches throughout the country. The Mamluk government deplored mob violence but showed solidarity with popular opinion by enacting strict discriminatory measures against non-Muslims. Christian administrators and scribes lost their positions in government service, and many of the farmlands supporting churches and monasteries were confiscated. The major sources of revenue for Christian institutions were effectively eliminated.[43] Confronted with both physical and financial persecution, many Copts became Muslims. According to the fifteenth-century historian al-Maqrizi, "When the Christians' affliction grew great and their income small, they decided to embrace Islam. Thus, Islam spread among the Christians of Egypt."[44] The cumulative effect of discriminatory measures, the widespread conversion to Islam, and the larger demographic crisis brought on by the Black Death reduced the Coptic community to an impoverished minority.[45]

Professional painters were inevitably affected by the destruction of churches, the loss of patronage, and the dwindling Christian population. The Copts could no longer afford to build churches, much less to paint them. Some professional artists may have continued producing icons, but it is not clear for how long or in what quantity.[46] Under the Circassian Mamluks (1382–1517) the income of the Coptic community seems to have been too low to encourage much private patronage. Even the Coptic Church could offer little assistance; the patriarch was impoverished, and the numbers of monks were everywhere in decline.[47]

A few patriarchs sought to retrieve the sinking fortunes of their community. In 1517, the year the Ottoman Turks conquered Egypt, John XIII (1484–1524) consecrated three chapels in the keep of the Monastery of St. Macarius.[48] He even managed to procure the services of a painter, who created iconographic programs celebrating equestrian martyrs, the founders of Egyptian monasticism in the form of Paul the Hermit, Antony, and Pachomius, and the great anchorites of late antiquity.[49] The painter was not a Copt but a visiting monk from Ethiopia. It is telling that the last medieval paintings in one of the most important monasteries in Egypt were the work of a foreigner.[50]

During the Ottoman period (1517–1798) the fortunes of the Copts gradually improved thanks to their discovery of a new source of protection and patronage. By the seventeenth century, local military factions in Cairo were challenging the authority of the transient Ottoman governors sent from Istanbul.[51] The soldiers formed rival coalitions led by Mamluk beys and officers of the Ottoman regiments stationed in Egypt. As these military grandees gained greater control of the resources of the country, they began hiring Copts to manage their fiscal affairs.[52] A new class of Coptic notables, the archons, emerged, who enjoyed wealth, prestige, and political influence through their association with the military factions of Cairo. The archons employed a wide network of their fellow Christians as administrators, scribes, and tax collectors working on behalf of their Muslim patrons. With new access to wealth and protection, the Coptic community began to emerge from its medieval decline.[53]

The future patriarch John XVI (1676–1718) was in his youth an archon in the making.[54] As a tax farmer, he had the potential to acquire a fortune, but only at the expense of the taxpayers. The work appalled him, and he retired to the Monastery of St. Antony, where he became a monk and priest.[55] He may have withdrawn from the world, but he was not forgotten by the archons of Cairo. When Pope Matthew IV died in 1675, the archons led a delegation to

the Monastery of St. Antony and chose the former tax collector as the new patriarch.[56] John XVI proved particularly adept at using the wealth and influence of the archons for the benefit of the Coptic community. He placed the supervision of churches in their hands, and "they found what was necessary to be repaired and to be (re-)built in all the churches, and they were all zealous in good works and charity."[57] The archons not only had the resources to ensure the success of their building projects, but also the political clout to deflect official opposition. When the Ottoman governor Kara Muhammad Pasha (1699–1704) attempted to stop the flurry of church building, his decree was quashed without difficulty. Because the archons were in the "service of the great of Egypt . . . nothing happened at the holy places, and the Divine Liturgy did not cease on any day."[58] During Kara Muhammad's brief tenure as governor, John XVI embarked on the most ambitious project of his reign, the reestablishment of the Monastery of St. Paul. He sent artisans and laborers to repair the walls and keep, build a mill room, and enlarge the Cave Church by the addition of three domed rooms. A few monks from the Monastery of St. Antony assisted in the work, and eventually settled in the compound. In 1705, John XVI visited the repopulated monastery in the company of some of the greatest archons of the day, including Jirjis Abu Mansur al-Tukhi. While at St. Paul's, the patriarch consecrated the Cave Church and appointed a superior for the four monks in residence.[59]

Nothing indicates that the wave of church building at the turn of the eighteenth century was accompanied by a similar renewal of wall paintings. Under the Ottomans, Coptic artisans played an important role as builders and woodworkers.[60] The Christian community had the necessary skills to construct a church, providing the economic and political environment was favorable. The patriarchate of John XVI was a time of "calm, abundance, liberality and profit" when churches were being repaired, enlarged, and built throughout Egypt.[61] The tradition of wall painting, it seems, could not be resurrected so easily. After a hiatus of more than three hundred years, no teams of professional painters apparently existed within the Coptic community. The absence of professional artists active in Egypt at this time is indicated by the two haykal screens that John XVI and Jirjis Abu Mansur al-Tukhi donated to the Cave Church during their visit to the monastery. The character and style of the twenty-six icons that surmount the screens suggest that the patriarch and archon had access only to self-taught painters.[62]

We have no evidence indicating who conceived the idea to paint the Cave Church. Van Moorsel suggested that John XVI could not afford the services of a professional painter and therefore instructed a monk of the monastery to do the job, "in spite of his inexperience. And he did it out of obedience."[63] The patriarch had just returned from a pilgrimage to Jerusalem, where he would have seen monumental imagery in churches, such as the Holy Sepulcher, which may have inspired his decision to paint the Cave Church, as well as explain his lack of funds.[64] On the other hand, in a time of such prosperity John may have had sufficient money, but no access to professional painters for hire. Turning the project over to the monks of the monastery may have been the only practical option available.

It is also possible that the notion of painting the Cave Church originated in the Monastery of St. Paul. The monks themselves may have initiated the project after a local disaster damaged the church. In AM 1426 (1709/1710), a flash flood of unusual intensity washed through the compound, piercing the walls at the points of entry and exit.[65] The water reportedly reached the northern face of the keep, suggesting a stream three meters deep. It would have swamped the low-lying Cave Church. The flood may have destroyed most of the medieval paintings on the walls of the church. The water could have also briefly revealed the images behind the accumulated layers of soot with a sudden clarity before the paintings were lost.[66] The appearance of these images in a last moment of glory could have inspired the monks to restore the medieval paintings, and to extend the iconographic program into the new rooms of the enlarged church. Whatever their inspiration, the monks began the project two or three years later, allowing sufficient time for the walls to dry, and enabling all concerned to make the necessary preparations. During this same period the patriarch's laborers completed the enlargement of the Cave Church. They appear to have finished the Haykal of the Twenty-Four Elders, and possibly the northern nave, in time for the papal visit of 1705, but work on the narthex seems to have been delayed for six years. The foundation inscription in the dome records the "date of the construction of this church" as "the year 1429 of the holy martyrs," or 1712/1713.[67] This same date must also apply to the paintings of the eighteenth-century program in the Cave Church.

The ambitious plan to paint the Cave Church would most likely have required a team drawn from the ten monks residing in the monastery. The project consisted of two main components: first, designing the iconographic program, and second, painting it on the walls of the church. As those most familiar with the liturgical literature, the priests of the monastery very likely devised most of the program. Two are known by name: Murjan, the superior of the mon-

astery, and the scribe 'Abd al-Sayyid al-Mallawani. Both men would become Coptic patriarchs later in the century. 'Abd al-Sayyid al-Mallawani, however, appears to have played the more active role. Evidence for his involvement in the project is provided by a copy of the psalmody in the library at the Monastery of St. Paul that he transcribed in 1715, about two years after the monk-painter worked in the Cave Church.[68] The psalmody is a choir book containing the psalms and hymns to be sung in preparation for the liturgy.[69] 'Abd al-Sayyid transcribed his copy in Coptic with Arabic translations in the margins. Gawdat Gabra has observed that throughout the manuscript the scribe placed a point in the middle of the Coptic letter sigma(\mathbf{c}). This same distinctive peculiarity of 'Abd al-Sayyid's handwriting is also found in the Coptic inscriptions of the Cave Church, leaving little doubt that he was responsible for those as well. 'Abd al-Sayyid is therefore the only monk who can be positively identified as a member of the team that produced the eighteenth-century program. His Coptic inscription identifying George in the church is, significantly, a quote from the psalmody. The accompanying Arabic inscription follows the same formula, suggesting that it too is the work of the bilingual 'Abd al-Sayyid. The Arabic inscription identifying Abadir and Ira'i draws on the same source. Indeed, Gabra observed that the eighteenth-century program in the Cave Church appeared to be based on the sequence of doxologies praising the saints in the psalmody.[70] 'Abd al-Sayyid obviously knew and consulted this liturgical text two years before transcribing his personal copy.[71]

Although, 'Abd al-Sayyid can be identified as the epigraphist of the project, his reliance on the psalmody suggests a deeper involvement. As a priest and senior monk, he likely played a leading role in designing the iconographic program, and the psalmody was clearly one of his major liturgical sources. Other monks no doubt contributed to the task, including Murjan, and there may have been an ongoing discussion among the monastic community as to which saints to include. As I will demonstrate in the next chapter, evidence exists that in certain areas of the church the iconography was developed as work progressed, although much of the program seems to have followed a predetermined plan. 'Abd al-Sayyid may not have been the sole author of the eighteenth-century program, but in my opinion he played a leading role in its design. He must have also collaborated with the monk-painter. Indeed, it is impossible to determine whether the designer or the painter was responsible for individual iconographic details. In the following analysis of the eighteenth-century program I try to distinguish between 'Abd al-Sayyid's presumed role as organizer of the project and that of the monk-painter, who was in charge of executing the program on the walls of the church. The two monks appear to have worked so closely together that it is hard to avoid wondering whether they were not in fact one and the same man. Whether 'Abd al-Sayyid was also the monk-painter is a question to which I will return in the following chapter.

Designing the Iconographic Program

'Abd al-Sayyid al-Mallawani and his fellow monks knew the liturgical texts concerning the daily commemoration of the saints, which provided a well-defined list of angels, patriarchs, apostles, evangelists, martyrs, and monks.[72] The Coptic ecclesiastical calendar celebrates the feast of each saint with an account of his or her life read during the morning service.[73] The biographies are usually presented in the form of an encomium or a homily for the edification of the congregation.[74] In the fourteenth century, the lives of the Coptic martyrs and saints were compiled in a single volume, the synaxarion.[75] Other texts, including the great liturgy, difnar, and psalmody, also include brief citations of the saints.[76]

Martyrs and monks figure among the most prominent types of saints in the Coptic calendar. Both groups were closely associated with Egypt. According to the Coptic tradition, many of the greatest martyrs from the era of Roman persecution came from Egypt or were somehow connected to the land of the Nile. The hagiographic accounts, many set in the Great Persecution of the early fourth century, follow a cycle of torture, miracles, mass conversions, and execution.[77] By dying for their faith, the martyrs won eternal life and were believed capable of intervening on behalf of the faithful. After the Peace of the Church, persecution ended and the monastic movement took root in Egypt. Monks were perceived as the spiritual successors of the martyrs.[78] They too died metaphorically for love of Christ by adopting the angelic life of prayer and the pursuit of perfection.

The iconographic association of martyrs and monks in Coptic art is best illustrated by the murals of the master painter Theodore, active in 1232/1233 in the Church of St. Antony, at the Monastery of St. Antony. Theodore does not appear to have designed the program, which was likely the work of priests and patrons of the monastery, but as the leader of a team of professional painters, he was probably responsible for many of the iconographic details.[79] In the western nave, which contains the main entrance of the church, he depicted thirteen martyrs, most of them equestrian. These soldier-saints are popularly believed to protect churches and answer prayers. In the eastern nave, reserved

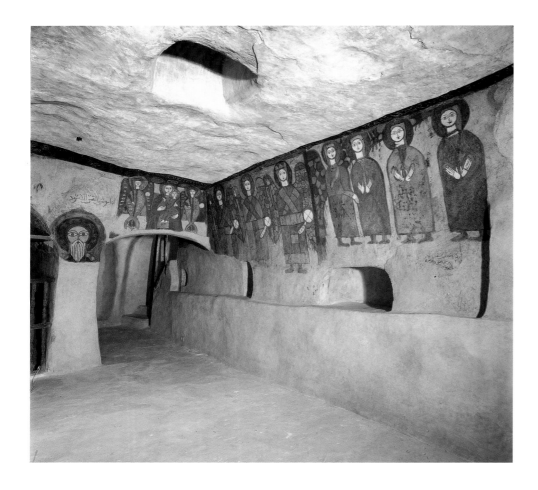

FIGURE 11.4

Moses the Black (D18), Virgin and Christ child with cherubim (D19), three archangels (D1), and three Hebrews (D2). ADP/SP 209 S5 5 05.

well preserved they left untouched. The most prominent area unaffected by the eighteenth-century program is the Haykal of St. Antony. In this room, the monastic team did not refresh the medieval images, even though they must have been damaged and obscured by thick deposits of soot. The same is true of the medieval paintings on the ceiling and upper south wall of the central nave. On the east wall of the corridor, the monk-painter carefully preserved the fragmentary faces of John and Shenoute above a group of similar monastic saints he added as part of the eighteenth-century program. At the other end of the same wall, however, two additional medieval figures were probably too damaged to save, and the monk painted over them, although he retained the earlier inscriptions. The legibility of an image seems to have determined the team's choice either to preserve or repaint the surviving portions of the medieval program. When thirteenth-century inscriptions identified the subjects of lost paintings, the monks respected the earlier iconography and produced new versions of the same images (fig. 11.4). Medieval inscriptions now describe eighteenth-century paintings of the Virgin and Christ child with cherubim, the archangels Michael, Gabriel, and Raphael, and an angel protecting the three Hebrews in the furnace of Babylon. Van Moorsel observed that the lost portion of the medieval program in the Cave Church can be largely reconstructed based on these later paintings.[83]

The Cycle of Martyrs

The monastic community's decision to extend the eighteenth-century program into the three domed chambers recently added to the Cave Church posed a greater iconographic challenge. The rooms had never been painted, which required the monks to devise new themes and subjects for these spaces. In the narthex, 'Abd al-Sayyid and his associates began their program with equestrian martyrs. They placed Victor at the top of the stairs, next to the eighteenth-century entrance, and Theodore Stratelates and George on the adjacent north wall overlooking the steps descending to the lower level. While above, they arranged Iskhirun of Qalin, James the Persian, Menas the Wonderworker, Julius of Aqfahs, Abadir, and Isidore in circular procession around the dome (fig. 11.5). Their use of soldier-saints to protect the entrance of the church has clear parallels with Theodore's program.[84] The monk-painter also seems to have copied the pose and basic dress of the horsemen from the medieval paintings at St. Antony's.[85] In both programs, the martyrs turn in their saddles to face the viewer with raised right arms. Each saint wears armor and a billowing cloak. Although the two sets of paintings

for the congregation of monks, Theodore painted twenty standing images of the founding fathers of Egyptian monasticism. Bolman has referred to this juxtaposition of martyrs and monks as a "genealogy of Egyptian monasticism in paint."[80] Not only does the program commemorate an exceptionally large number of Egyptian monastic saints, it also proclaims them as the spiritual successors of the great martyrs. This iconographic association is not unique to the work of Theodore, but his program provides the best preserved, and most extensive, Coptic example of this spiritual lineage.[81] By the eighteenth century, these paintings were covered in soot and had been partially repainted, but their iconographic plan could still be distinguished.[82] 'Abd al-Sayyid, who came from the Monastery of St. Antony, apparently studied these medieval paintings carefully and sometimes modeled his choices on the example set by the iconographer of Theodore's program, as I will explain in detail below.

One of the monks' original motives for painting the Cave Church in 1712/1713 may have been their desire to restore the medieval program. Generally, 'Abd al-Sayyid and his associates treated the thirteenth-century paintings in the church with great respect. Those sufficiently

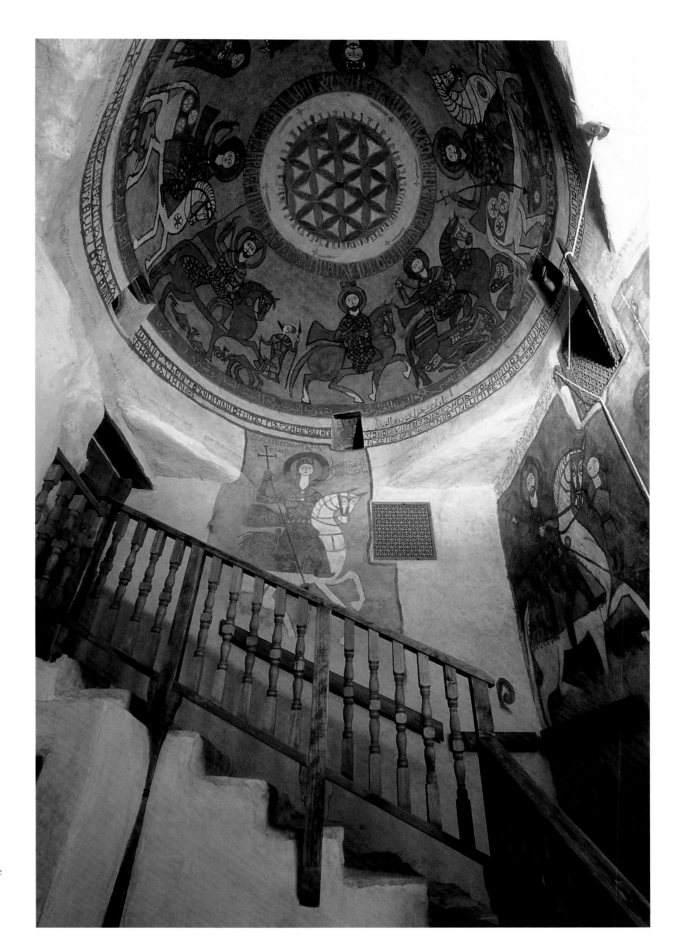

FIGURE 11.5

Dome of the Martyrs and staircase
of the narthex. ADP/SP 12 S241 05.

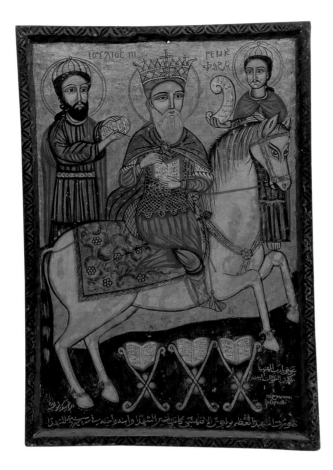

FIGURE 11.6

Icon of Julius of Aqfahs with
his brother and son, 1756/1757
(AM 1473), by Ibrahim al-Nasikh
(active ca. 1742–1743). Church of
St. Mercurius, Monastery of St.
Mercurius, Old Cairo. EG 9
s902 99.

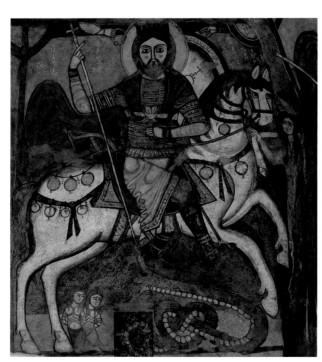

FIGURE 11.7

Theodore Stratelates, 1232/1233.
Church of St. Antony, Monastery
of St. Antony. ADP/SA 1999.

differ enormously in style, this iconographic pose is identical in both.

The martyrs depicted in the narthex are primarily associated with the Great Persecution inaugurated by Emperor Diocletian (285–305). The exceptions are George, a saint of uncertain date but exceptional popularity, and James the Persian, a more recent addition to the Coptic synaxarion adopted from the Church of Syria.[86] The remaining seven are all prominent in the Coptic narratives of Diocletian's persecution. Victor, Theodore Stratelates, Menas, and Iskhirun were soldiers who refused to sacrifice to the pagan gods and thereby made themselves enemies of the Roman state.[87] Abadir, the son of Basilides the General, and Isidore, the son of Panteleon, came from families of martyrs whose individual passions collectively form larger hagiographic cycles.[88] According to Coptic tradition, Julius of Aqfahs collected the relics of the saints and wrote their biographies before winning a martyr's crown himself.[89] Inscriptions on a Coptic icon by Ibrahim al-Nasikh, dated AM 1473 (1756/1757), inform the reader that Julius of Aqfahs and his family compiled the lives of James the Persian, Victor, Theodore Stratelates, and Menas, all of whom the monks of St. Paul's depicted together in the narthex (fig. 11.6).

'Abd al-Sayyid also employed an iconographic device in the narthex that he may have learned from studying the work of the painter Theodore. In the medieval program, the equestrian martyrs are shown with narrative scenes from their legends.[90] These secondary images are depicted on a smaller scale, but the figures usually interact with the larger saint. In the Church of St. Antony, Theodore included Theodore Stratelates, Victor, and George among his equestrians, the same three saints found on the walls of the narthex in the Cave Church. These medieval paintings will serve to illustrate the types of narrative scenes employed by Theodore. His painting of Theodore Stratelates celebrates the saint's most famous miracle, the rescue of two children from a dragon in response to their mother's prayers (fig. 11.7).[91] In the painting of Victor, he showed the saint again, but in a reduced size, enduring torture in two separate narratives.[92] Theodore depicted George twice in the Church of St. Antony, once in the nave and again in the khurus.[93] In both paintings, the saint protects a miniature church from desecration by spearing the wicked perpetrator. These episodes are probably accounts of posthumous interventions by George, when images of the saint miraculously came to life in times of need.[94]

'Abd al-Sayyid and the monk-painter also employed narrative elements when depicting their equestrian saints. The paintings of Theodore Stratelates and George include

FIGURE 11.8

Theodore Stratelates (A2) and
George (A3). ADP/SP 7 S241 05.

scenes identical to those used in the Church of St. Antony (fig. 11.8). Theodore Stratelates spears a serpent that has wrapped its coils around the children, while the beseeching mother stands to one side.[95] The composition is so similar to Theodore's that it is likely a direct copy. The narrative elements that the monks of St. Paul's used with George also follow the thirteenth-century paintings. George is shown defending a small church, although the enemy he spears has not survived. The painting of Victor, however, differs from Theodore's handling of the same subject. It does not include narrative details.[96]

The designer of the eighteenth-century program also used narrative elements in association with the six equestrians in the dome of the narthex, but he did not rely on the medieval iconography of the Church of St. Antony. Only one of his equestrians, Menas, is found in Theodore's program, and there he is depicted in a different mode (fig. 11.9). In the medieval painting, the saint rides above a small camel caravan shown transporting his remains.[97] According to the

legend, the camel carrying the relics refused to go farther, and on that spot the principal shrine of Menas was founded in Egypt.[98] The designer of the Cave Church program, however, followed a different narrative. Menas is shown as an equestrian subduing a trio of aquatic camel monsters (fig. 11.10). An encomium on the martyr, attributed to an early medieval Coptic patriarch, provides a more complete account of the story.[99] As the ship carrying the relics of the saint sailed for Egypt "there came out of the sea fearsome beasts with necks raised aloft and faces like those of camels. And they stretched their long necks into the ship, wishing to take the remains of the saint and also the lives of the men on board."[100] A miraculous fire emerging from the body of Menas drove the sea monsters beneath the waves. In the eighteenth-century program the narrative is reduced to a simple confrontation between the victorious Menas and camel-monsters of his legend.

'Abd al-Sayyid distinguished the other equestrians in the dome in a similar manner. James the Persian, also

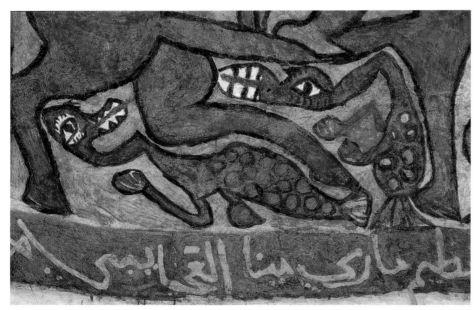

FIGURE 11.9 TOP

Menas (A7). ADP/SP 166 S6 02.

FIGURE 11.10 BOTTOM

Camel-monsters of Menas.

ADP/SP 3 S1189 02.

known as James the Sawn Asunder (al-Muqattaʿ), is legless and holds his right hand close to his chest (fig. 11.11). He was dismembered on order of the shah for abandoning the religion of the Persian court.[101] Abadir is accompanied by his sister Iraʾi, his traveling companion and fellow martyr (fig. 11.12). Smaller than her brother, she stands by his side. The Arabic inscription, however, acknowledges both siblings equally. The painting of Isidore includes a small dog beneath the saint's horse (see fig. 11.1). An inscription on a Coptic icon by Ibrahim al-Nasikh from AM 1461 (1744/1745) identifies it as the "dog that the martyr Isidore caused to speak."[102]

Next to the horse of Iskhirun, a man holding a spear attends a herd of camels (fig. 11.13). Ibrahim al-Nasikh later duplicated this detail almost exactly in two undated icons he painted of the saint.[103] The scene is from an account of a posthumous miracle of Iskhirun. A bedouin's camels were all barren, so he went to a famous church dedicated to the saint. Iskhirun had once miraculously transported this church from the town al-Qalin, in the Delta, to the village of al-Bihu, in Upper Egypt. The bedouin vowed to give the firstborn of every camel he owned to the Church of Iskhirun if the saint healed his herd. Iskhirun answered his prayers, and the bedouin fulfilled his vow faithfully for the rest of his life.[104]

The designer's handling of Julius of Aqfahs is somewhat surprising. The saint dispatches a monstrous fish (fig. 11.14). It is not clear why the "hagiographer of the martyrs" is here portrayed as a kind of dragon slayer. Perhaps the challenge of depicting the saint surrounded by his books, the iconographic solution used by Ibrahim al-Nasikh in his 1756/1757 icon of Julius, daunted the self-taught monk-painter (see fig. 11.6). Instead of providing scenes directly related to the life of the saint, the monks emphasized the more traditional role of the martyr as protector of the faithful and vanquisher of evil. A similar reliance on this typical iconographic model is found in the depiction of Cyriacus, the only equestrian painted in the northern nave. Only three years old when he suffered martyrdom with his mother, Julitta, Cyriacus nevertheless sits on horseback in the Cave Church program, spearing a dragon.[105] The age of the saint and the details of his life were obviously of less importance than the miraculous powers manifested by the heavenly martyr.

The monks compensated for the limited wall space in the narthex by placing the majority of the martyrs in the dome. It was a bold decision, something the master painter Theodore attempted only once in the Church of St. Antony, and indicates the confidence that the monastic team had

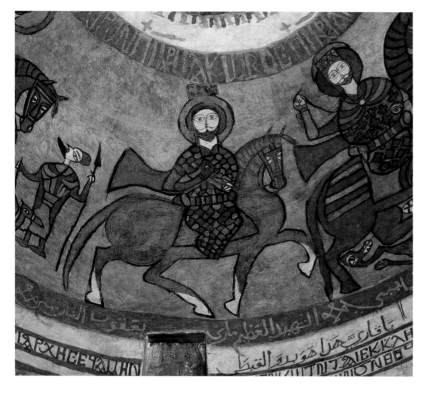

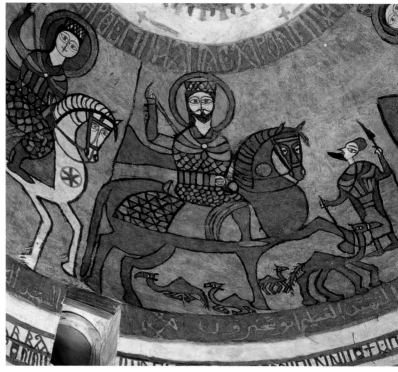

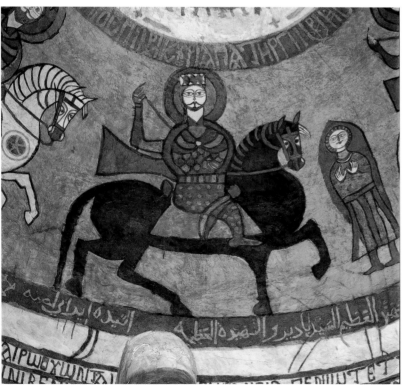

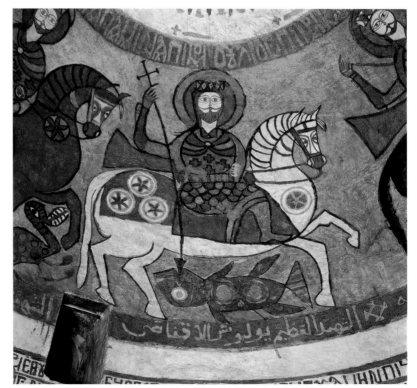

FIGURE 11.11 ABOVE, TOP

James the Persian (A6). ADP/SP 166
S4 02.

FIGURE 11.12 ABOVE, BOTTOM

Abadir and Iraʾi (A9). ADP/SP 166
S11 02.

FIGURE 11.13 ABOVE, TOP

Iskhirun of Qalin (A5). ADP/SP 166
S2 02.

FIGURE 11.14 ABOVE, BOTTOM

Julius of Aqfahs (A8). ADP/SP 166
S8 02.

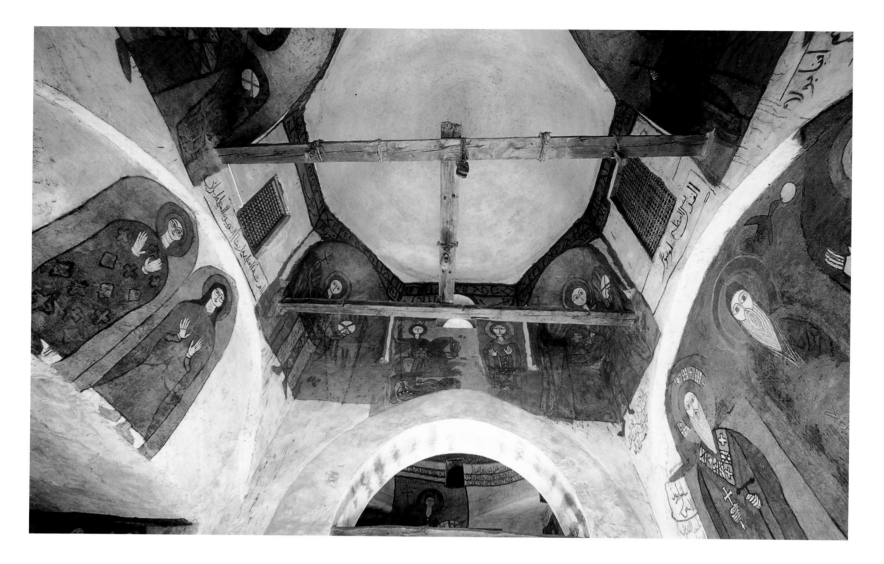

FIGURE 11.15

The northern nave looking west, showing Eirene (B12), Marina (B13), Suriel (B14), Cyriacus (B1), Julitta (B2), Raphael (B3), Sarapion (B4), and Antony (B5). ADP/SP 2 S244 05.

in its own ability.[106] The resulting Dome of the Martyrs is one of the most ambitious compositions in the eighteenth-century program. The circle of horsemen has been compared to a carousel of saints that appears to spin around the dome.[107] This impression could have been intentional on the part of the monks responsible for the program. A miracle from the time of Cyril III (1216–1243) recorded in the *History of the Patriarchs* may have provided their inspiration. According to this account, an enthroned figure appeared in the dome above the altar during the celebration of the liturgy in a local Coptic church. "Then there appeared at the back of all the dome riders on horses like the pictures of the saints which are in the churches, and they were turning about the dome, and the tails of their horses were swishing, and all of them, namely the people, witnessed them. And when they reached the throne, they bowed in greeting, and they passed by, and they continued thus up to the time of communion [when] they departed."[108]

Whether 'Abd al-Sayyid and his colleagues were familiar with this text is unknown, but their organization of

the martyrs in the Cave Church closely parallels the vision. In the narthex, six equestrians turn about the dome, while three others appear to descend the staircase heading toward the sanctuary. George, at the bottom of the stairs, is poised to pass through the arch into the northern nave.[109] Cyriacus, painted above the same arch but on the opposite side, has already made the transition. The child martyr on his diminutive horse appears to lead the parade of equestrians into the interior of the Cave Church. As mentioned earlier, Coptic paintings function as points of connection to the dynamic entities they represent. The visionary account of the equestrian procession takes a ubiquitous iconographic subject in Coptic churches, and brings it to life. It provides us with a possible reading of the paintings in the Dome of the Martyrs as an active parade of powerful figures, circling continuously within the dome and perhaps beyond it, within the church.

The stairway in the narthex leads down into the northern nave, which also has limited wall space suitable for painting. The room opens on three sides, connecting

FIGURE 11.16

John (F5), Arsenius (F6), Abib
(F7), Apollo (F8), John the Little
(?) (F9), Samuel of Qalamun (F14),
unidentified saint (F15), below
traces of medieval paintings from
1291/1292 (F10–F12). ADP/SP 6
s246 05.

with the narthex (west), the Haykal of the Twenty-Four Elders (east), and the central nave (south). Only the north wall provided an uninterrupted area for a large composition. Despite these drawbacks, the monks were able to include ten saints in the northern nave without extending their program into the dome, which remained unpainted (fig. 11.15). They chose martyrs, monks, and angels to fill the room, the three most common subjects in the eighteenth-century program. The cycle of martyrs that the designer of the program began in the narthex continues in the northern nave with Cyriacus and Julitta.[110] He assigned the images to the cramped area immediately above the arch leading to the narthex.[111] As mentioned above, the young saint is portrayed as an equestrian spearing a dragon, and his mother stands by his side. Eirene, the third martyr in the northern nave, is one of the two standing saints painted on the exposed rock shelf above the entrance to the central nave (see fig. 6.7). She was the daughter of a king named Licinius, whose miraculous deliveries from torture resulted in the conversion of thousands of onlookers.[112] Both Julitta and Eirene are shown standing with upraised hands and covered hair. They are not accompanied by narrative elements. The inclusion of these holy women is an unusual feature of the eighteenth-century program. Although the Coptic synaxarion records numerous female saints, they are rarely found in Coptic wall paintings from any period, apart from the Virgin Mary. Theodore, for example, painted the Virgin twice at the Church of St. Antony, but all the other saints in his program are male.[113] I will return to this point when examining the monastic saints in the Cave Church.

The Cycle of Monastic Saints

In the lower sections of the Cave Church, 'Abd al-Sayyid's iconographic theme shifted from martyrs to monks. In part he followed the example of the thirteenth-century paintings in the Cave Church. The second medieval painter, working at the Monastery of St. Paul in 1291/1292, had placed a pair of standing saints at each end of the east wall of the corridor. The surviving medieval inscriptions identify Shenoute, John, and Moses the Black. Van Moorsel suggested Pachomius as the possible fourth.[114] The artist also painted Arsenius on the opposite wall. The medieval iconography seems to have celebrated saints associated with both the cenobitic and anchoritic forms of Egyptian monasticism. Pachomius and Shenoute shaped communal forms of monasticism in the Nile valley, while John the Little (or perhaps John Kama), Moses, and Arsenius lived in the desert of Scetis (Wadi al-Natrun).[115] The designer of the eighteenth-century program respected the earlier iconog-

raphy in the corridor, but he did not reproduce it exactly. He increased the number of monastic saints to seven, and organized them into a single row that spanned the length of the east wall.

When choosing which saints to depict in the corridor, 'Abd al-Sayyid apparently disregarded the medieval Coptic inscriptions, which were nevertheless preserved, along with fragments of the earlier paintings (fig. 11.16).[116] As a result, two separate lists of saints are recorded on the east wall. Arabic inscriptions accompanying the later paintings record the names of John (Kama?), Arsenius, Abib, Apollo, and Samuel of Qalamun. No identification survives for two figures, but the diminutive saint next to Apollo is probably John the Little due to the considerably lower level of his head. All of these men were prominent monastic leaders of Bawit, the Fayyum, and the Wadi al-Natrun.[117] The designer duplicated John and Arsenius in his expanded program but assigned them different positions from those of the medieval paintings of the same figures. Both saints therefore were depicted twice in the corridor. The eighteenth-century monks also reproduced Moses the Black but moved his image to the central nave. 'Abd al-Sayyid and his brethren were obviously following the medieval program in the corridor to some extent, but they nevertheless expanded the earlier theme into a new iconographic ensemble.

The eighteenth-century paintings of Macarius, Maximus, and Domitius on the east wall of the central nave and shrine are not accompanied by medieval inscriptions. However, they seem to repeat a similar group of standing saints from the second medieval program (fig. 11.17).[118] If these paintings were only damaged in the flood of 1709/1710, the monks of St. Paul's may have known the identities of the images. It is just as likely that 'Abd al-Sayyid was forced

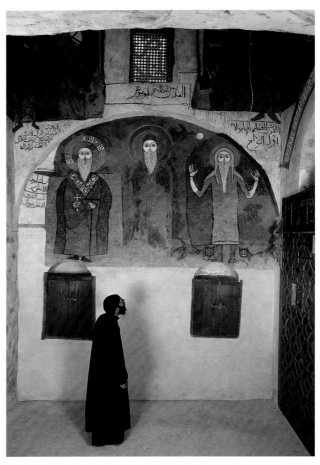

FIGURE 11.17

Maximus (D11), Domitius (D12),
and Macarius (G3). ADP/SP 10
S245 05.

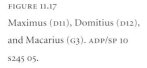

FIGURE 11.18

Sarapion (B4), Antony (B5), and
Paul the Hermit (B6). ADP/SP 10
S242 05.

to improvise at this point and chose Macarius the Great,
the founder of Scetis, and two of his most illustrious fol-
lowers, the so-called Little Strangers, to take the place of
the unknown medieval saints.[119] He then elaborated on the
medieval iconography by shifting Moses the Black, another
disciple of Macarius, from the corridor to the narrow south
wall of the central nave (see fig. 11.4). The lower portion
of this wall, separating the shrine from the corridor, does
not seem to have been painted in the thirteenth century.
By placing the figure of Moses here, the designer created
a bridge linking the two groups of monastic saints in the
corridor and central nave.

ʿAbd al-Sayyid also expanded his monastic cycle into
the northern nave. Standing images of Paul the Hermit,
Antony, and Sarapion hold pride of place on the north
wall (fig. 11.18). The initial plan envisioned only two saints,

almost certainly Antony and Paul. After the paintings were
completed, however, the monks decided to add Sarapion,
a disciple of Antony who became bishop of Tmuis, to the
composition.[120] Sufficient space existed between the two
images to include a third figure, but iconographic proto-
col dictated that Sarapion should follow Antony, just as
Antony followed Paul. The solution seems to have been
to rework the original Antony into the image of Sarapion
by introducing an ecclesiastical vestment over his monas-
tic tunic.[121] The monk-painter then added a new painting
of Antony as the central image.[122] The organization of the
three images from right to left indicates that Arabic was the
first language of the painter, the designer of the program,
and the intended audience. Van Moorsel suggested that
these paintings duplicate the thirteenth-century subjects
on the lost medieval north wall of the Cave Church.[123]
This wall was demolished as part of the eighteenth-century
expansion and, as a result, the medieval central nave now
opens directly onto the northern nave. It would certainly
be characteristic of the eighteenth-century designer to re-
create the destroyed paintings, especially if one of the im-
ages was that of the patron saint of the monastery. The
belated addition of Sarapion to the new north wall of the

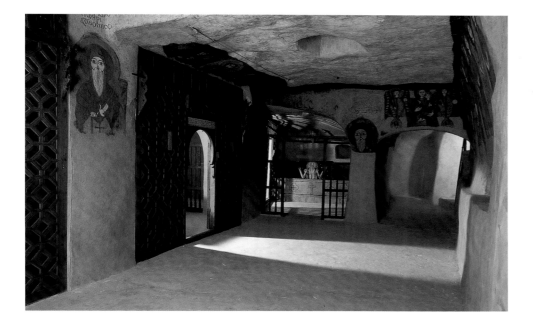

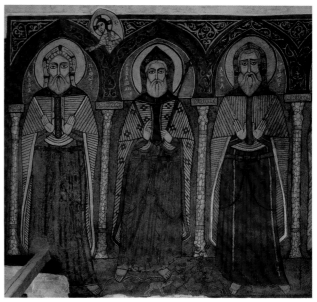

FIGURE 11.19 LEFT

Marqus al-Antuni (B10) at the far
left and Moses the Black (D18) on
the south wall of the central nave.
ADP/SP 4 S240 05.

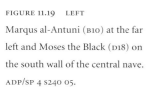

FIGURE 11.20 RIGHT

Pschoi, John the Little, and Sisoes,
1232/1233. Church of St. Antony,
Monastery of St. Antony. ADP/SA
1999.

church may indicate that he was not included in the medieval program, and that only Antony and Paul were copies of earlier paintings.

The designer introduced two less common monastic saints into his program. Marqus al-Antuni, a fourteenth-century monk associated with both the monasteries of St. Antony and St. Paul, occupies the narrow east wall between the two haykal screens, where the northern and central naves meet (fig. 11.19). 'Abd al-Sayyid no doubt added this medieval monk to the distinguished group of desert fathers found elsewhere in the Cave Church because of the local veneration of Marqus at both of the Red Sea monasteries, attested to by later icons (see fig. 2.4), a church in St. Antony's dedicated to the saint, and the association of one of the garden caves at St. Paul's with his cell. The designer's final monastic figure in the northern nave closed the cycle on an even more unexpected note. Next to Eirene, on the exposed rock above the entrance to the central nave, 'Abd al-Sayyid placed Marina, a woman who adopted male attire and entered a monastery (see figs. 6.7 and 11.15). She lived as monk for the rest of her life, and the secret of her sex was discovered only when her body was being prepared for burial.[124]

When depicting the monastic saints in the eighteenth-century program, the monk-painter employed two approaches. He painted Moses the Black and the desert fathers in the corridor with long beards, but he made no attempt to indicate a distinctive style of dress or otherwise specify who the images represented. Moses, for example, is depicted with the same white face as the other saints in this group. All of the other monastic figures in the Cave Church, however, the painter portrayed with a greater attention to iconographic detail. Paul wears a short tunic and

is accompanied by a raven carrying a loaf of bread and by the two lions that dug his grave. Paul is the only monastic saint shown with such narrative elements. Antony wears the traditional habit of a Coptic monk, which includes a tunic, hood, mantle, and outer cloak.[125] This costume is said to have been revealed to him by an angel, who ordered Antony to adopt it for himself and his followers.[126] He also wears a harness of leather bands, called an *analabos,* that crosses the saint's chest. It signifies the act of taking up the Cross and following Jesus, and it was worn by senior monks.[127] Antony's staff, which was no doubt originally tau-shaped, also seems to convey his monastic seniority.[128] These items of clothing are very close to those worn by the monastic saints in the thirteenth-century paintings of Theodore (fig. 11.20).

The monk-painter depicted all the rest of the monastic saints in the church wearing similar habits that include the analabos.[129] However, he introduced a few variations. Macarius and Sarapion each hold a tau-staff and a cross. The similarities in iconographic attributes are probably intentional if the painting of Sarapion was originally of Antony. According to the earlier phase of painting, the two great desert abbots were both portrayed holding the same symbols of authority. In contrast, Maximus and Domitius stand in the orans position with raised hands (see fig. 11.17). The brothers, believed to have been sons of a Roman emperor, became disciples of Macarius in Scetis and died in the desert. According to the *Apophthegmata Patrum,* Maximus had a beard when he arrived in Scetis, and Domitius was just beginning to grow one.[130] Lucien Regnault observed that this late antique account of the lives and sayings of the desert fathers remained popular in Egypt "either directly through the reading of the collection in Coptic or Arabic

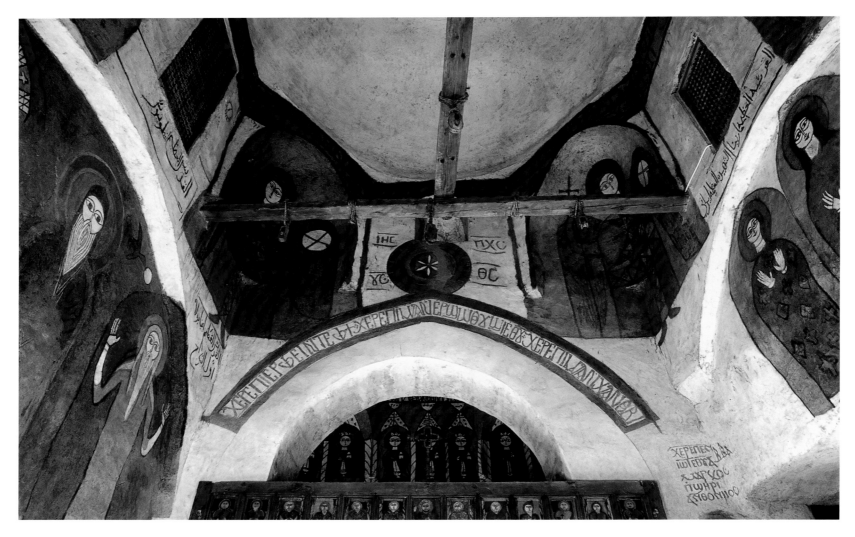

or indirectly through the place given to the holy monks of the apothegms in the liturgy."[131] 'Abd al-Sayyid and the monk-painter's close following of this physical description suggest their familiarity with the story. The Little Strangers are portrayed with short, dark beards, contrasting with the long, white beards worn by all the other desert fathers in the Cave Church with the obvious exception of Marina (see fig. 11.15). She stands in the orans position, wearing the monastic tunic, mantle, and analabos. The monk-painter, however, portrayed Marina with a full head of hair reaching beyond her shoulders. He thus identified her unmistakably as both a monk and a woman.

One of the most striking features of the Cave Church program is the inclusion of four holy women. The presence of Iraʾi and Julitta was possibly determined by their close connection to their male relatives, Abadir and Cyriacus. Iraʾi in particular is depicted almost as a smaller narrative character in the painting of her brothers in the Dome of the Martyrs. But 'Abd al-Sayyid and the monk-painter gave much greater prominence to the three woman saints in the

northern nave. Julitta is larger than her mounted son and was clearly being venerated as a saint in her own right. This observation applies even more to Eirene and Marina, whom the designer assigned the choice position in the northern nave opposite the paintings of Paul, Antony, and Sarapion. 'Abd al-Sayyid's incorporation of these woman saints into the Cave Church program is a surprising break with tradition. Nevertheless, the designer appears to have consciously concluded his cycles of monks and martyrs with female representatives of both groups.

The Cycle of Celestial Beings

Above the martyrs and monks in the northern nave 'Abd al-Sayyid placed the archangels Michael, Gabriel, Raphael, and Suriel in the four squinches supporting the dome, at the highest level of painting in the room (fig. 11.21; see fig. 11.15).[132] They appear to serve a protective function in much the same way as the equestrian saints do in the narthex. It is noteworthy that the second medieval artists painted Michael, Gabriel, and Raphael on the west wall of the cen-

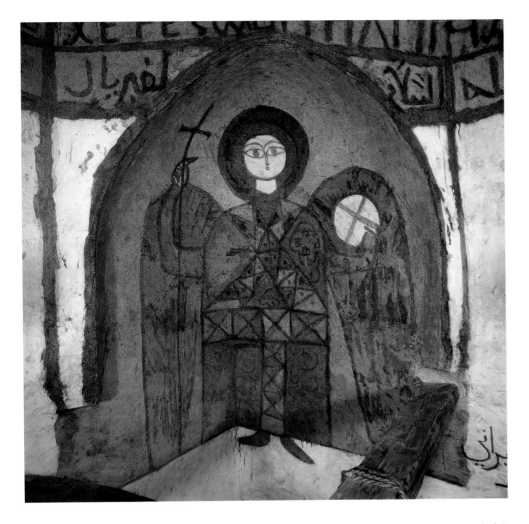

FIGURE 11.22

Gabriel (B11). ADP/SP 184 S4 03.

ally hold an orb and a cross on a long staff. This angelic costume, based on that of the emperor, was common in middle and late Byzantine art.[136] Henry Maguire observed that "archangels assume these imperial vestments in Byzantine art only when they accompany Christ or the Virgin in images of the *heavenly* court ... when the same archangels appear in *earthly* contexts where they are no longer part of the heavenly retinue, they usually change their attire, appearing in the antique tunic and himation."[137] The designer and painter of the eighteenth-century program apparently understood this peculiarity of angelic dress because the angel protecting the three Hebrews wears the noncourtly attire of tunic and cloak. The only other celestial beings in the program not wearing the loros are the two cherubim protecting the Virgin and Christ child in the central nave (see fig. 11.4). The monk-painter depicted them with three pairs of wings filled with eyes. The first pair covers their bodies, and the other two spread around their heads and shoulders. Small arms emerge from the wings holding swords and orbs. The painter's method of depicting cherubim is identical to that used by the second medieval artist in the Haykal of St. Antony.[138] Indeed, the earlier artist originally painted the Virgin and Christ child with cherubim in the central nave. When the eighteenth-century monk re-created the images he seems to have followed the surviving outline of the medieval figures very closely. Interestingly, he did not use this angelic form elsewhere in the church.

ʿAbd al-Sayyid and the monk-painter may have been familiar with the loros from icons of archangels that entered Egypt from other countries. However, they more likely knew of examples closer to hand in the Church of St. Antony. In Theodore's program angels rarely wear the loros, but four large paintings of archangels added to the church later in the thirteenth century offer exact parallels (fig. 11.23).[139] Michael and Gabriel, each wearing the loros and holding a crossed staff and an orb, were depicted twice on the soffits of the arches between the nave and the khurus, and between the nave and the annex. It is hard to believe that these highly visible Byzantine-inspired images did not encourage the creators of the eighteenth-century program to adopt the same costume for most of the angels in the Cave Church.

ʿAbd al-Sayyid conceivably understood angels as the ultimate stage of the spiritual genealogy at the heart of Theodore's program, and of monasticism itself. Monks, the successors of the martyrs, aspired to the ranks of the angelic host. In fact, the monastic vocation is called the "angelic life."[140] The Coptic monastic habit, or *schema*, was frequently referred to as the angelic costume.[141] Both of the

tral nave. The eighteenth-century monks re-created this subject during their renovation of medieval paintings in the Cave Church, but their placement of archangels in the northern nave formed part of their original program. ʿAbd al-Sayyid's duplication of these celestial beings was clearly intentional.[133] The medieval devotion to angels, which Bolman describes in the previous chapter, apparently still found regular and intensive expression in the eighteenth century. Michael, in particular, has a long history of veneration in Egypt.[134] Wansleben, for example, remarked on the special devotion the Copts felt for Michael in his late seventeenth-century account, including the unusual detail that the Copts possessed an icon of the archangel painted by St. Luke himself.[135] Twenty years after the monastic team painted the Cave Church, ʿAbd al-Sayyid, now Pope John XVII, consecrated a church dedicated to St. Michael at the Monastery of St. Paul.

The monk-painter usually depicted angels in the Cave Church wearing a multicolored band, called the loros, folded elaborately around a long tunic (fig. 11.22). They gener-

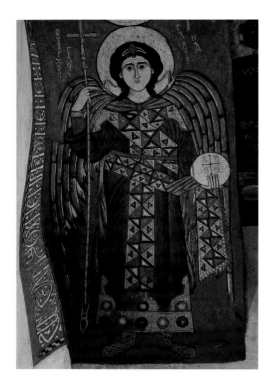

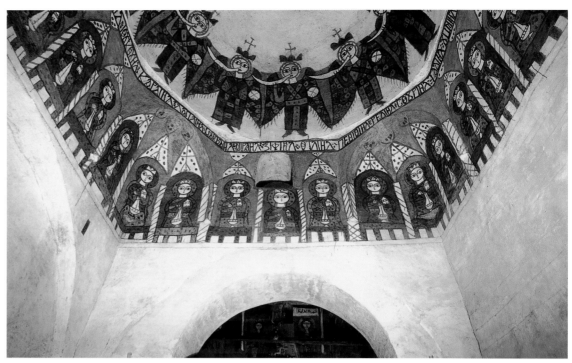

FIGURE 11.23 LEFT
Michael, thirteenth century.
Church of St. Antony, Monastery
of St. Antony. ADP/SA 1999.

FIGURE 11.24 RIGHT
Unpainted lower walls of the
Haykal of the Twenty-Four Elders.
A series of horizontal guide lines
on north wall (right) indicates
that the monastic team originally
intended to paint the lower level
of this room. ADP/SP 15 S249 05.

future patriarchs, Murjan and ʿAbd al-Sayyid, were said to
have been "clothed with the holy schema," which was also
described as the "angelic form," while they were monks at
the Monastery of St. Paul.[142] The Cave Church program of
1712/1713 was designed by monks for a monastic audience.
The iconographic selection of martyrs, monks, and angels
provided the congregation with appropriate role mod-
els, sources of inspiration, and means of communicating
directly with these heavenly beings.

ʿAbd al-Sayyid's program concludes monumentally in
the Haykal of the Twenty-Four Elders, the domed sanctu-
ary added to the Cave Church at the beginning of the eigh-
teenth century. Although the room offered abundant wall
space for paintings, the monks instead placed all the images
in the dome (fig. 11.24). Their dramatic composition cen-
ters on an enthroned Christ in Majesty, surrounded by the
four living creatures, who together occupy the eastern side.
Seven angels holding trumpets ring the rest of the dome.
Immediately below, in the lower drum, the twenty-four
elders sit around the room in the squinches and on the walls
supporting the dome. The ultimate iconographic source of
these paintings is the Revelation of St. John, but the medi-
eval programs in both the Cave Church and the Church of
St. Antony include very similar scenes, and indeed Christ
in Majesty is one of the most frequently depicted subjects
in Coptic art. In the adjacent sanctuary at the Cave Church,
dedicated to St. Antony, the second medieval painter placed
an enthroned Christ accompanied by the four living crea-
tures on the eastern side of the dome. The example at the

Monastery of St. Antony is somewhat closer, with the addi-
tion of the twenty-four elders also included in the sanctuary
program.[143]

ʿAbd al-Sayyid and the monk-painter may have fol-
lowed the example of the earlier paintings, but they did
not copy them exactly. The monastic team combined tra-
ditional iconographic elements but organized them into
an original composition (fig. 11.25). Their ambitious de-
sign took full advantage of the large dome covering the
sanctuary. Christ sits in majesty, surrounded by angels, as
if in the vault of heaven. The twenty-four elders form the
second celestial ring, emanating downward from the dome.
The composition has a visionary quality that suggests that
the designer and painter were as much inspired by reading
scriptures as by looking at medieval paintings. The fourth
chapter of the book of Revelation provided almost all of
the necessary iconographic elements, and ʿAbd al-Sayyid
appears to have followed it almost literally. "Immediately
I was in the Spirit; and behold, a throne set in heaven, and
One sat on the throne.... Around about the throne were
twenty-four thrones, and on the thrones I saw twenty-four
elders sitting, clothed in white robes; and they had crowns
of gold on their heads ... and in the midst of the throne, and
around the throne, were four living creatures full of eyes in
front and back. The first living creature was like a lion, and
the second living creature like a calf, and the third living
creature had a face like a man, and the fourth living creature
was like a flying eagle. The four living creatures, each having
six wings, were full of eyes around and within."[144]

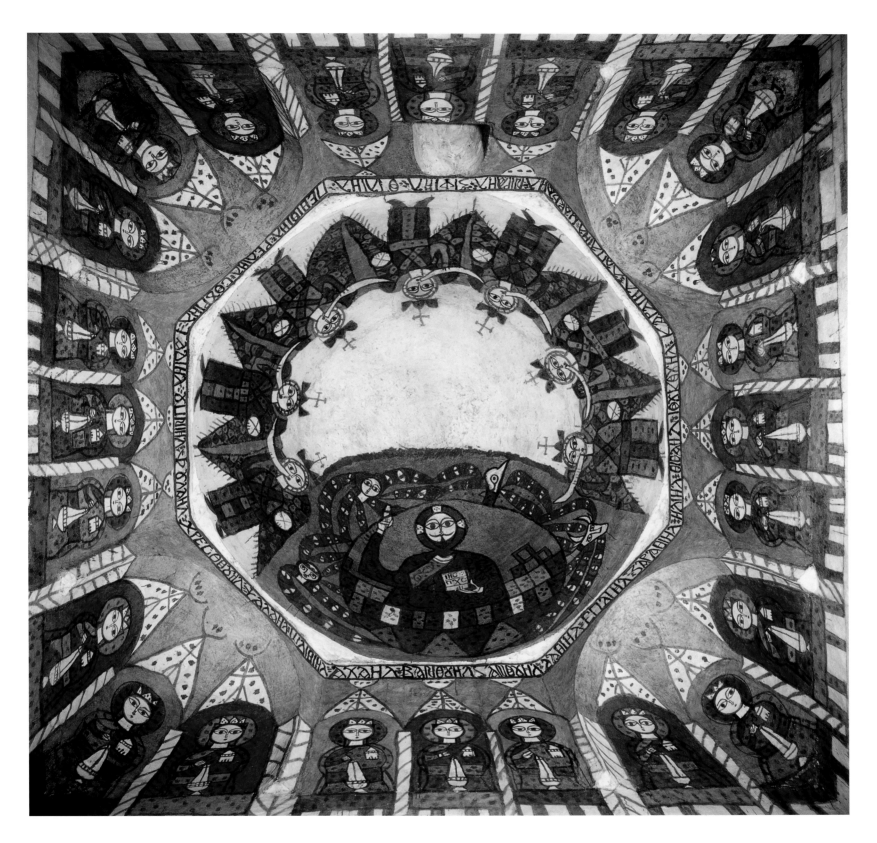

FIGURE 11.25

Christ in Majesty (c10), seven angels
with trumpets (c9) and the twenty-
four elders (c1–c8). ADP/SP 200 S11 04.

The seven angels with trumpets are the one iconographic element not found in the medieval paintings at the Red Sea monasteries. Van Moorsel commented that the subject is rare in Coptic art.[145] In this instance, ʿAbd al-Sayyid most likely relied on the Bible to complete his vision of heaven. In the eighth chapter of Revelation, after the opening of the seventh seal, St. John "saw the seven angels who stand before God, and to them were given seven trumpets."[146] The passage provides the perfect symbol for the angelic host assembled before the throne of God and allowed ʿAbd al-Sayyid to extend his theme of loros-wearing angels, found elsewhere in the Cave Church, into the Haykal of the Twenty-Four Elders.

The walls of the sanctuary were never painted, but evidence survives showing that the monks of St. Paul's planned to extend the program to the lower level of the room. During the course of conservation, De Cesaris and his team uncovered a series of horizontal lines on the north wall that the monks apparently intended as preparation for a new series of paintings.[147] The designer's intention will never be known, but the medieval programs in the two Red Sea monasteries suggest two possible alternatives. On the north wall of the adjacent Haykal of St. Antony, the first medieval artist painted the four evangelists. Theodore, on the other hand, employed patriarchs on the walls of the two side haykals at the Church of St. Antony.[148] The prospect that the designer intended to use patriarchs as the subject of this lower area raises some intriguing possibilities. In 1718, Murjan, the superior of the Monastery of St. Paul, became Pope Peter VI. Perhaps this event inspired a revival of the project, and the monks planned a series of paintings of Episcopal saints that were intended to honor the new patriarch. The only evidence for such an assumption is the later addition of Sarapion in the northern nave. This radical reworking of a completed painting is unique in the Cave Church program. The designer and painter devoted special attention to introducing Sarapion, the monk who became a bishop, to the company of Paul and Antony. It is possible they intended the image as the first in a cycle that was to be extended into the Haykal of the Twenty-Four Elders. Work on these paintings, however, never progressed beyond the black lines the monks placed on the north wall.

Conclusion

Van Moorsel remarked that the creator of the Cave Church program was aware of being part of an ancient tradition.[149] ʿAbd al-Sayyid al-Mallawani and his team certainly knew the medieval paintings in the Monastery of St. Antony, and they drew on them when designing the eighteenth-century Cave Church program. The martyrs in the narthex, the extended cycle of desert fathers in the nave and corridor, and the heavenly vision in the Haykal of the Twenty-Four Elders are all indebted to some extent to the program of Theodore.[150]

ʿAbd al-Sayyid and the monk-painter showed great ingenuity in adopting these medieval themes to the irregular interior of the Cave Church. They were almost able to duplicate the number of equestrians found in the larger Church of St. Antony by placing most of their martyrs in the dome of the narthex.[151] By distributing the desert fathers throughout the church, rather than concentrating them in a single room, as in Theodore's program, the monastic team managed to find space for thirteen monastic saints, compared to the twenty employed at the Church of St. Antony. They therefore successfully replicated the thirteenth-century "genealogy of Egyptian monasticism" in the enlarged Cave Church.

The selection of saints in the eighteenth-century program followed the medieval tradition less closely. ʿAbd al-Sayyid often relied on his own iconographic skills, or perhaps those of his monastic brethren, when choosing the sacred images to be depicted in the church. He introduced at least six monks not found in Theodore's program.[152] Sarapion, John (Kama?), Apollo, and Abib were revered fathers from late antiquity, but Marqus al-Antuni had not even been born when Theodore painted the Church of St. Antony. The inclusion of a fourteenth-century monastic saint is typical of the way ʿAbd al-Sayyid modified iconographic themes to give them greater relevance to an eighteenth-century audience. Personal devotion to a monastic father may well have played a significant role in the choice of this painted subject and others. In such a small community of monks, whoever selected the iconographic assembly would have known which saints were most important to members of the monastery.

The saints in the Dome of the Martyrs best illustrate 'Abd al-Sayyid's abilities as an iconographer. Only one of the martyrs is repeated from Theodore's program, and he is shown with a different narrative scene. All six are therefore based on sources other than the medieval paintings at the Red Sea monasteries. 'Abd al-Sayyid probably derived most of the iconographic details from liturgical texts, especially the various encomiums on the saints. He is known to have used the psalmody when working in the Cave Church, and he relied on the Bible when choosing the seven angels in the Haykal of the Twenty-Four Elders. There is evidence that he consulted the *Apophthegmata Patrum* when designing Maximus and Domitius in the central nave, and it is possible that his organization of the Dome of the Martyrs was inspired by a historical account of a medieval miracle. 'Abd al-Sayyid remained true to the medieval iconography at the monasteries of St. Antony and St. Paul, but he also drew on the living literary tradition of the Coptic community to create an original iconographic program.

'Abd al-Sayyid's decisions may have also been shaped by contemporary religious practice in Egypt, as well as the private devotional preferences of his monastic brethren. Most of the saints depicted in the Cave Church appear to have been particularly popular during the eighteenth century, judging by the evidence of later icons produced in the decades following the painting of the Cave Church. The workshop of Ibrahim al-Nasikh and Yuhanna al-Armani, active circa 1742–1783, created icons of almost all of the monks and martyrs in 'Abd al-Sayyid's program.[153] Pious benefactors often commissioned these paintings and donated them to important churches.[154] They provide some indication of which saints were especially venerated in eighteenth-century Egypt.

Certain martyrs and desert fathers seem to have enjoyed an enduring popularity. Theodore Stratelates, George, Victor, and Menas, who all appear in Theodore's program, were also painted by Ibrahim and Yuhanna.[155] The same is true of Paul, Antony, Macarius, Maximus, and Domitius.[156] The presence of these saints in the Cave Church may have been due to contemporary piety as much as the example of Theodore. Most of the saints not found in the medieval paintings at the Red Sea monasteries were also the sub-

jects of eighteenth-century icons. The school of Ibrahim and Yuhanna depicted James the Persian, Isidore, Iskhirun of Qalin, Julius of Aqfas, Cyriacus and Julitta, Apollo and Abib, and Marqus al-Antuni.[157] Clearly, all these saints had a special relevance to the Coptic community in the eighteenth century that may have guided 'Abd al-Sayyid in his selection of sacred images.

Four saints in the Cave Church appear neither in Theodore's program nor, as far as I know, as subjects of eighteenth-century icons. Eirene, Marina, Abadir, and his sister Ira'i do not seem to have commanded the same popular devotion as did the other saints in the Cave Church. Significantly, all of them are women except Abadir, who may well have been included in the program because of his sister. I have already observed that one of the most unusual features of the eighteenth-century iconographic program is the inclusion of these holy women. Female saints, although extremely rare in Coptic wall paintings, were portrayed in later eighteenth-century icons. Ibrahim al-Nasikh, for example, painted Julitta and her son Cyriacus, who also appear in the Cave Church. Eirene, Marina, Ira'i, and Abadir, however, do not seem to have been popular icon subjects. We can only speculate as to why 'Abd al-Sayyid included these saints in his program. Perhaps he was inspired by feelings of personal devotion, or maybe the women saints were intended as tributes to female relatives in holy orders. All that can be said with certainty is that this most unlikely of iconographic themes appears to have had personal significance for the designer of the eighteenth-century program.

A study of the iconography of the Cave Church paintings shows that 'Abd al-Sayyid and his team were aware of the ancient and medieval traditions of the Coptic Church from pictorial, textual and, no doubt, oral sources. They drew from them, demonstrating continuity with past artistic traditions and also a willingness to create new visual subjects. All of this is quite remarkable when one considers the long hiatus in monumental visual production in Egypt between the fourteenth and early eighteenth centuries.

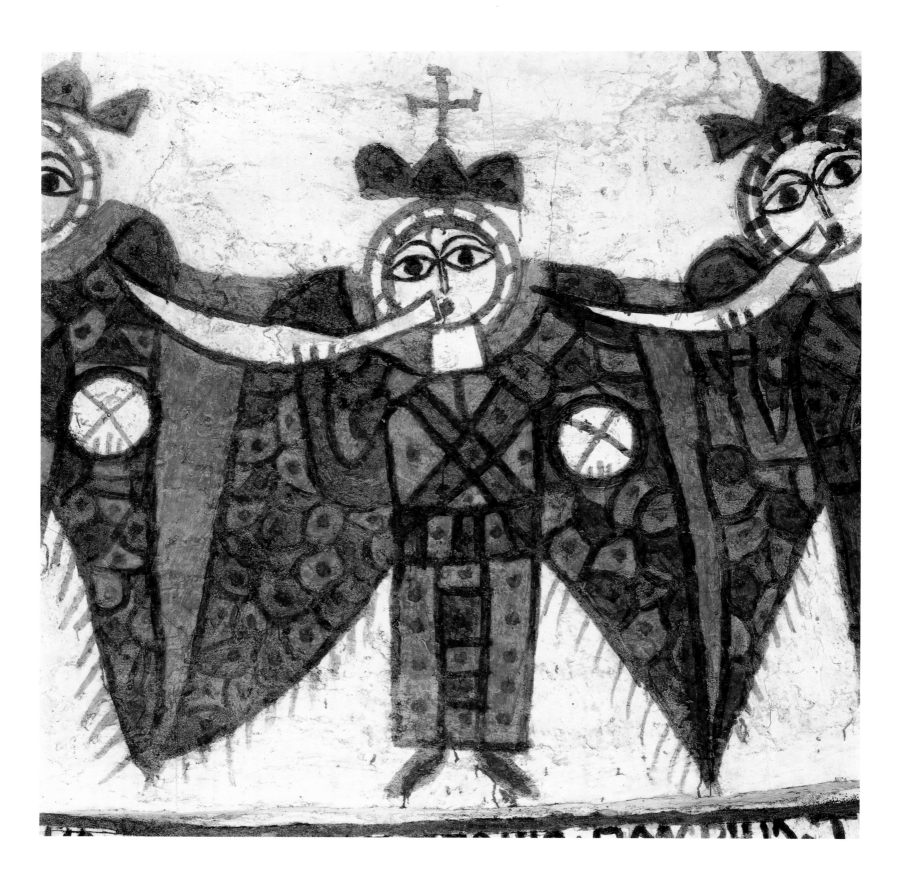

CHAPTER 12 RESHAPING A LOST TRADITION

THE EIGHTEENTH-CENTURY PAINTINGS IN THE CAVE CHURCH, STYLE AND TECHNIQUE

The eighteenth-century monks at the Monastery of St. Paul not only had to design an iconographic program for the Cave Church, they also faced the challenge of painting it. As demonstrated in the previous chapter, 'Abd al-Sayyid al-Mallawani, the future patriarch John XVII, played what was likely a decisive role in devising the iconography. He and his brethren envisioned more than eighty images, most of them almost life-sized, which were to be distributed throughout the church, often in areas difficult or impossible to reach without substantial scaffolding (fig. 12.1). It was an ambitious plan, especially for a team of monks with no experience producing wall paintings. In 1716, a few years after the completion of the project, Claude Sicard visited the monastery and met a monk he identified as the "painter-author" of the program.[1] He did not record the monk's name, but he repeated some of their conversation and provided the earliest known critique of the paintings. Modern scholars have never questioned Sicard's assertion that a single anonymous monk painted the Cave Church in 1712/1713. After the completion of the ARCE conservation project, I am convinced that there was indeed one dominant hand active in the church. I do not believe, however, that the monk-painter necessarily worked alone. We cannot say for certain how many monks may have been involved in the project, although it could hardly have been more than the ten monks then resident in the monastery. The ARCE conservation team at the Cave Church included five conservators, two or three assistants, and a carpenter to build and move the scaffolding. Theoretically, the task of painting the church in the first place could have employed as many people.

Careful examination of the paintings, evidence from conservation, and the identification of a unique illuminated manuscript in the monastery have enabled me to reconstruct much of the original working practice of the monk-painter. As explained in the previous chapter, these naïve paintings have been consistently misunderstood, and indeed maligned. In this chapter, I present evidence for the artistic procedures employed, and also link this program to the origin of the revival of Coptic religious painting later in the eighteenth century.

Before work began in the Cave Church, the principal painter devised a method of depicting saints that he used on all his sacred images. The basic technique consisted of compass-drawn circles to form heads, halos, and upper torsos. The monk painted the rest of the body freehand, following a standard design. Another preliminary step, likely requiring the help of an assistant, ensured that rows of figures were depicted in a uniform manner. The monk used a method known as battitura di filo, whereby a string coated in carbon residue is stretched across a wall and then plucked, leaving a faint line. A series of these horizontal lines served as a grid that determined the size and placement of each circle, as well as the length of the body and the position of the feet.[2] The technique left little to chance when positioning the initial image of each saint.

The use of the battitura di filo method to determine the location of the images on the walls of the church was possibly a modification of a similar technique employed by Coptic manuscript illuminators, in particular when they created ornamental chapter headings and large crosses composed of interlacing strap work. They based these de-

FIGURE 12.1

Angels with trumpets (C9). ADP/SP 198 S4 04.

FIGURE 12.2

Virgin Mary and Christ child,
Psalmody of 1715 (MS 368 Lit.).
Courtesy of Father Yuhanna
al-Anba Bula and the Monastery
of St. Paul.

signs on preliminary rows of dots that ensured the sym-metricality of the final patterns. ʿAbd al-Sayyid knew this technique. He employed it in the decoration of a copy of the psalmody he produced in 1715, now in the library at the Monastery of St. Paul.[3] The manuscript contains many common Coptic decorative motifs, including large crosses, chapter headings, decorative letters, animals and birds in the margins, and medallions filled with floral elements formed by a compass (see fig. 5.5).[4] Whether ʿAbd al-Sayyid produced these ornamental elements is unknown, but they belonged to the scribal tradition with which he was wholly familiar. It is possible that another monk with experience illuminating manuscripts assisted ʿAbd al-Sayyid in the cre-ation of the Psalmody of 1715. Samiha Abd El-Shaheed has observed that Coptic manuscripts of this period were often illuminated by someone other than the scribe.[5] Whether such a strict division of labor applied to the small monastic community at St. Paul's in 1715 is uncertain. ʿAbd al-Sayyid may have been both its scribe and illuminator, or he may have collaborated in the production of the psalmody.

The question of whether ʿAbd al-Sayyid worked alone or with a partner is of central importance for identifying the monk-painter of the Cave Church. The illuminator of the Psalmody of 1715 almost certainly played a primary role in painting the iconographic program of 1712/1713. He repeated a number of traditional decorative motifs in the manuscript that are found in the church, as well as includ-ed a series of miniature paintings that employ the same method of depicting images as used by the monk-painter. The most remarkable of these is a full-page miniature of the Virgin Mary with the Christ child (fig. 12.2). The Virgin's head, halo, and body are formed by concentric circles made with a compass. The image is almost completely abstract. The only anatomical details are the face, a neck joining the two groups of circles, and tiny arms holding the child. The facial features are identical to those used for all of the saints depicted in the Cave Church. Her radiating nimbus, formed by alternating stripes of red and green, also has parallels with the halos of Iraʾi in the narthex and the Christ child in the central nave. Even the wings of the tiny angels guarding the throne are decorated with overlapping ovals of alternating colors in the same style seen on the three arch-angels in central nave and the seven angels in the Haykal of the Twenty-Four Elders. In many ways, this painting demonstrates the technique used in the eighteenth-century program in its most elemental form. It could almost be a study for a wall painting that was never produced. A similar enthroned Virgin would not have been out of place in the

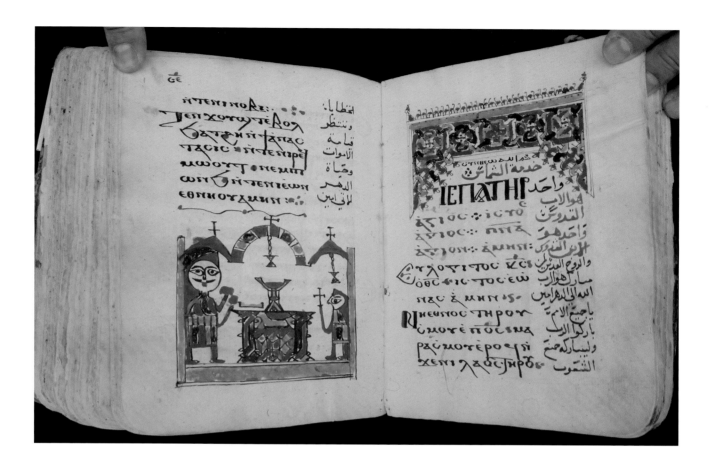

FIGURE 12.3

FIGURE 12.3

Priest and deacon celebrate the
liturgy in a church, Psalmody of
1715 (MS 368 Lit.). Courtesy of
Father Yuhanna al-Anba Bula and
the Monastery of St. Paul.

unpainted apse of the Haykal of the Twenty-Four Elders
(see fig. 6.20).

Another miniature in the Psalmody of 1715 is a half-
page illustration of a church, which is nearly identical to
the painting of the church being protected by George in the
narthex (figs. 12.3 and 12.4). Both buildings are shown in
outline with domes formed by a compass. The lower part
of the wall painting is damaged, but in the manuscript, a
priest celebrates the liturgy. His compass-drawn head, fa-
cial features, and the manner in which his body is depicted
all conform to the system employed in the Cave Church.
A deacon assisting during the ritual, in contrast, is drawn
completely freehand. This figure is shown in profile with a
single almond-shaped eye dominating his face. At least ten
other miniatures in the manuscript are similarly peopled,
usually with men engaged in secular activities. There ap-
pears to be no correlation between these paintings and the
text; rather, they seem to have been included for the sheer
joy in producing figures. The monk-painter had used the
same type of man as a narrative element in the Cave Church
program, as will be discussed below.

Evidence exists that these freehand paintings were
added to the manuscript at a slightly later stage of produc-
tion. The upper portion of one of the pages was originally

to feature an ornamental chapter heading (fig. 12.5). Rows
of dots outlining three crosses had already been prepared,
but the page was instead devoted to a miniature of a man
climbing a palm tree to collect dates. The reason for the
change in subject is unknown, but it is interesting that a
secular representation in a self-taught style was privileged
over the more conventional motifs of crosses and interlac-
ing strap work. It is possible that one monk, perhaps ʿAbd
al-Sayyid, was responsible for the traditional designs and
another added the figures, but it seems equally probable
that a single artist, trained as an illuminator of manuscripts,
had developed a more personal freehand method of depict-
ing images.

As Gawdat Gabra has demonstrated, ʿAbd al-Sayyid
was the epigraphist of the Cave Church project. I believe
that he was also the chief iconographer, and he may have
been the principal painter as well.[6] Although it is tempting
to suggest that ʿAbd al-Sayyid produced the eighteenth-
century program alone, no such assertion can be proven.
This future patriarch is the only monk known to have been
involved in the project, but that does not mean that he was
its "painter-author." It is just as likely, but equally difficult
to prove, that ʿAbd al-Sayyid and an unidentified monk-
painter cooperated on the Cave Church program and then

FIGURE 12.4

George protecting a church (A3).

ADP/SP 204 S11 5 05.

method by introducing subtle changes that when together can suggest a possible chronological sequence for the paintings. Such an approach is based on the assumption that the monk's style developed over the course of the project, but a number of other factors must also be taken into consideration. For example, the monk may have reverted to earlier stylistic modes when producing later paintings. External forces, such as difficult working conditions and time constraints, could plausibly account for changes in his technique. We cannot discount the possibility that one or more assistants participated in the creation of some of the images, thus explaining other variations. The following analysis of his style and working method will suggest a plausible sequence for the monk's paintings in the Cave Church, but other possibilities exist.

While conserving the Cave Church, Luigi De Cesaris found the only physical evidence for a chronology of the eighteenth-century paintings. He discovered a series of guidelines on the north wall of the Haykal of the Twenty-Four Elders indicating that the paintings in this room were never finished, and that the monk-painter likely worked here at the end of the project (see fig. 11.24).[7] De Cesaris also determined that the monk added the painting of Antony in the northern nave sometime after completing the other figures on the same wall (see fig. 11.18). He cites this as evidence for "different, consecutive painting phases within the same [eighteenth-century] cycle."[8] I agree with his interpretation, and, using stylistic evidence, I have identified a number of other paintings that I believe the monk produced during the same later phase. I will return to De Cesaris' discoveries after examining the paintings that the monk probably created earlier in the project.

Re-Creating the Medieval Paintings

The monk's restoration of the medieval images may comprise his earliest work in the Cave Church. The paintings of the Virgin and Christ child with cherubim, the three archangels, and the three Hebrews in the central nave, and at least two of the monastic saints in the corridor, were not original compositions but were based on the work of the second medieval artist, active in 1291/1292. The monk-painter probably knew the medieval subjects primarily from the surviving thirteenth-century Coptic inscriptions describing the earlier images, which he incorporated into his new paintings of the same figures. The monastic community may have also had a visual memory of the medieval images. A large flood at St. Paul's in 1709/1710 could have severely damaged the paintings only two or three years earlier.[9] I suggested in the previous chapter that the di-

produced an illuminated copy of the psalmody. For the sake of convenience, I will assume that the scribe and painter were separate monks, although it should be remembered that they may have been one and the same person.

In this chapter, I engage in a detailed examination of the monk-painter's style and means of production. Initially, I expected that this task would be a short one. Based on general similarities in working process visible throughout the church, I assumed that the monk followed a set method that varied very little from painting to painting. The more I examined the paintings, however, the more I saw variations in his technique. In fact, the monk experimented frequently with his working

FIGURE 12.5

Decorative medallion, a man
climbing a date palm, and prepara-
tion for an interlacing strap-work
design, Psalmody of 1715 (MS 368
Lit.). Courtesy of Father Yuhanna
al-Anba Bula and the Monastery
of St. Paul.

saster perhaps inspired the monks to re-create the paint-
ings, which in turn may have led to their extending the
iconographic program into the other rooms of the Cave
Church.

Because of the low ceilings, the monk-painter did not
require scaffolding when working in the central nave and
the corridor. Compared to other areas in the church, the
walls were among the easiest to reach, and it seems likely
that he first began painting in these rooms in part for that
reason. He probably reworked all of the medieval images
in the central nave at more or less the same time, but in the
corridor he appears to have begun with the two monastic
saints at the southern end of the east wall, and then added
the five other figures later in the project. The re-creation
of the medieval images may have been the first test of the
monk-painter's ability, as well as of his artistic method.
They also serve as an ideal introduction to his working
practice.

The Virgin and Christ child between two cherubim,
located above the entrance to the corridor, is the only ex-
ample in the eighteenth-century program of a thirteenth-
century image being overpainted according to medieval
stylistic principles, rather than re-created using the monk's
technique (fig. 12.6).[10] The medieval painting appears to
have been in good enough condition that the monk could
follow the outlines of the earlier figures when repainting.[11]

It is noteworthy that he did not use a compass when form-
ing the bodies. The artist carefully alternated the combina-
tion of pigments from figure to figure. For example, the
Virgin's mantle is red, and she wears a yellow undergar-
ment. The clothes of the Christ child are the same colors,
but in reverse. The monk designed all of his paintings with
a similar chromatic balance.

According to Sicard, the monk-painter said that his
colors came from the surrounding desert.[12] The sandstone
found in the vicinity of the Monastery of St. Paul is streaked
with layers of yellow and red in a wide variety of shades,
which could have been the source of the painter's two main
colors. He may have also used different types of clay, washed
down from the mountains, containing minerals such as
hydrated ferric oxide (for ocher yellow and red), iron ox-
ide (red), and copper oxide (green).[13] A passage from the
Life of Marqus al-Antuni, translated by Gabra in Chapter
5, tells how the fourteenth-century saint once "went out
into the desert and there gathered yellow dust, red clay, and
another color, green." He gave these pigments to a fellow
monk, a medieval self-taught painter, who thereafter "did
not do any painting or complete his work without using
that clay."[14] The monk-painter may have been inspired
by this story, which was copied in 1699/1700 (AM 1416)
and conceivably had been donated to the monastic library
before 1712/1713.[15]

FIGURE 12.6

Virgin and Christ child with
cherubim (D19). ADP/SP 5 S245 05.

The eighteenth-century artist did not have access to white paint, or chose not to use it, except on very rare occasions.[16] Instead, he relied on the underlying plaster layer to provide areas of white when needed. He formed the heads, hands, and feet of the Virgin and Christ child, for example, by leaving the underlying plaster exposed. The monk-painter's method of creating the heads of his figures remained constant throughout the eighteenth-century program. He formed the circle of the head by driving a nail into the plaster to serve as the point of a compass. Using a string tied to the nail and a paint brush, the monk established the diameter of the circle, which he outlined in yellow. The halo of the image consists of one or two larger concentric circles drawn from the same point. He then removed the nail, leaving a small hole at the center of all the faces of his saints.[17]

The monk almost always carefully cleaned the heads of his figures by scraping away drips and smudges, as well as portions of the original preparatory drawings.[18] This practice can be seen in the painting of the Virgin and child, where he removed the part of Christ's halo that overlapped the circle forming the Virgin's head. An excessively vigorous application of this method of cleaning and correction may have caused damage to the face of the eastern cherub.

The monk appears to have learned from the experience, as he did not repeat this error. He then applied the facial details, usually in yellow. They consist of large almond-shaped eyes that meet just above the central compass hole, eyebrows that form a continuous line with the two sides of a long, narrow nose, and a small mouth that is either carefully drawn or reduced to a single dot of red paint. He repeated this facial type with only minor modifications throughout the Cave Church. The monk also used the same template for the Virgin and the priest in the psalmody miniatures.

When re-creating the other medieval paintings in the corridor and central nave the monk relied completely on his own method of depiction. He likely began in the corridor at the far southern end of the east wall. Here, the second medieval artist had placed two monastic saints beneath identifying inscriptions in Coptic. The monk painted two saints of his own directly over these images (fig. 12.7).[19] He followed the positioning of the earlier figures closely, as can be seen by the ghost of a raised arm and hand that is still visible beneath the eighteenth-century paint layer. The monk incorporated the surviving medieval inscriptions into his new composition, suggesting that he intended them to refer to his new saints. Thus the eighteenth-century image identified by a later Arabic inscription as Samuel of Qalamun

seems to have originally represented Moses the Black, the desert father named in the medieval Coptic text.[20] Unfortunately, the name of the second figure has not survived in either the medieval Coptic or later Arabic inscriptions, but Paul van Moorsel asserted that the thirteenth-century text mentioned Pachomius.[21]

Moses/Samuel has a long beard formed by a triangular area of unpainted plaster highlighted with lines indicating strands of hair. The artist used this style of beard on almost all of his monastic saints, making it almost certain that the damaged anonymous saint had one as well. The monk again varied his color scheme, painting the halo of Moses/Samuel yellow and his body red, then alternating the same pigments on the adjacent figure. Although the current background is green, he initially framed these two saints within rectangular panels that repeated the color of each figure's body.[22] The addition of the green background indicates that the monk embellished these paintings at a later stage of the project. I believe he also added the series of large dots that decorate the halos at the same time. When first working in the corridor, he seems to have employed only large monochrome fields of pigment without additional painted decoration.

The artist made little advance calculation as to where to position these figures. When forming the circle of Moses/Samuel's head, he placed it too high and had to rework it at a lower level. The overlapping circles are still visible across the face and beard, as are the two marks of the compass within the face. The monk-painter took some effort to remove these corrections, but he did not do so in a comprehensive manner. The anonymous saint is almost completely lost, but we can discern from the remains that the monk placed this figure at a lower level than Moses/Samuel. He did not use guidelines when positioning the two saints, although he apparently intended them as a pair, united by the medieval inscriptions. The painter's failure to use a technique he applied consistently elsewhere in the church indicates that he produced these images at the start of the project. The simplicity of the design and color scheme, as well as the artist's failure to clean the plaster before adding the details of the beard, provide further evidence for an early date for these paintings.

In contrast, the monk designed the three archangels and the three Hebrews in the central nave with greater foresight (figs. 12.8 and 12.9). In both paintings he first divided the surface of the wall into horizontal registers using the battitura di filo technique, thus ensuring a standardized size for all the figures.[23] The monk used two concentric circles to form the head and surrounding halo of each image, but he followed slightly different methods when producing the bodies of the two groups. On the archangels the painter used circles that are about three times larger than the heads. He covered the lower curves of these balloon-like torsos with belts that he also used to determine the width of the

FIGURE 12.7

Moses the Black/Samuel of Qalamun (F14) and an unidentified saint (F15), beneath an inscription band from 1291/1292. ADP/SP 211 S7 5 05.

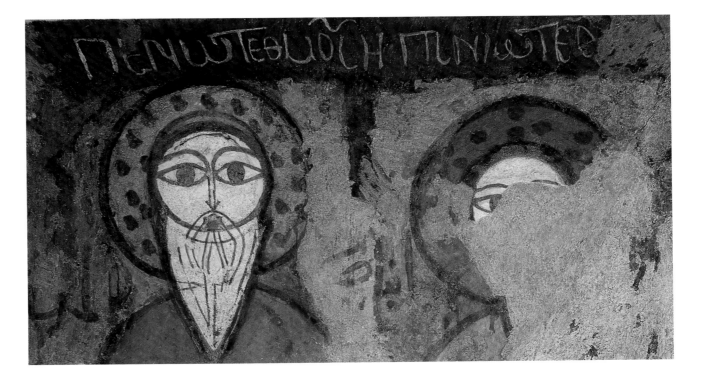

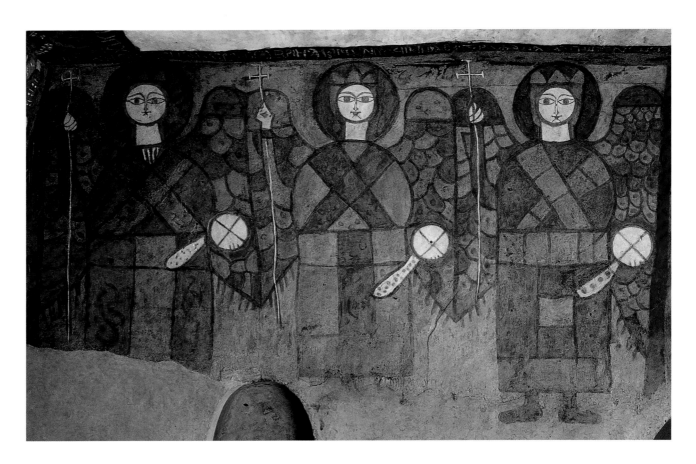

FIGURE 12.8

Michael, Gabriel, and Raphael (D1).

ADP/SP 9 S244 05.

rectangular skirts of the archangels' tunics. When painting the three Hebrews the monk reduced the diameter of the circles of the bodies by approximately a third. Instead of emphasizing a circular torso he used only the upper curve to indicate the shoulders, and then extended a straight line down on each side to the level of the feet. The resulting body is bullet-shaped, a design element that appears with frequency in the monk's work in the Cave Church. In particular, he used this type of body on his standing saints, but he returned to the circular torsos when depicting seated figures, such as the equestrians in the Dome of the Martyrs and the twenty-four elders in the sanctuary.

These two paintings also demonstrate the monk's principal methods of depicting arms and hands. Each archangel holds a staff in his right hand and an orb in his left.[24] The artist drew the right arms as narrow upturned loops with oval-shaped hands of exposed plaster. When depicting the left arms, however, he resorted to abstraction. Instead of showing a supporting limb he used three lines of yellow paint to indicate fingers holding each orb. The monk portrayed the three Hebrews in the orans position, with their palms held in front of them. He created the hands by outlining their shapes and then painting around them, leaving the white plaster exposed.[25] Each hand is carefully depicted, with the finger and other details clearly empha-

sized, in marked contrast to the simplified hands of the archangels. Although the monk-painter did not provide the Hebrews with arms, he nevertheless successfully conveys the impression that the figures stand in a position of prayer. He simplified the human form in this manner repeatedly.

The re-created medieval paintings in the central nave and corridor introduce most of the techniques used by the monk in the Cave Church. If these paintings were the earliest stage of the project, then by the time the artist completed the series he had perfected his method of depicting the human form as a skeleton of circles, and he had adopted gridlines to organize his more complicated compositions. In these paintings we see the two body types he used throughout the church, as well as his principal methods of depicting arms and hands. Also apparent is the monk's concern to alternate his limited palette so that each figure is colored differently. He painted most of these images employing only solid fields of colors, but with the three archangels the monk embellished the figures with dots and curving lines of the same color paint in darker tones. The monk employed this simple method of ornamentation throughout the program. According to my chronology, having established his distinctive style while reworking the medieval paintings, the monk then turn to the greater challenge of creating saints for an original iconographic program.

FIGURE 12.9
Three Hebrews protected by an
angel (D2). ADP/SP 13 S244 05.

The Narthex

The monastic team's decision to create a new series of
paintings in the dome of the narthex was an ambitious
leap no matter when it occurred during the course of the
project. The conception and execution of the parade of
equestrians in the Dome of the Martyrs was a major un-
dertaking compared to the relatively straightforward task
of painting the low vertical walls of the corridor and central
nave. ʿAbd al-Sayyid and the monk-painter clearly designed
these paintings, the first images a visitor encounters upon
entering the enlarged Cave Church, to be as impressive as
possible. The presence of the foundation inscription re-
cording the date of the project and naming the patriarch
and the two leading archons of the day underscores the
importance placed on the decoration of this entryway. The
inscription proclaims John XVI as the "one who provided
for this church." The passage signals the patriarch's role
in the renovation, enlargement, and consecration of the
building between 1703/1704 and 1712/1713, but it could also
be an acknowledgment of his support for the major en-
deavor of painting it.[26] The text then calls upon God to
protect John's life, along with those of Jirjis Abu Mansur
al-Tukhi and Lutfallah Abu Yusuf "and every Christ-lov-
ing archon."[27] These secular leaders of the Coptic commu-
nity were patrons of the Monastery of St. Paul, and they

very likely provided supplies necessary for the project—for
example, painting materials and lumber for scaffolding
necessary to reach the dome. The three men were no doubt
invited to the monastery to see the newly painted Cave
Church. A planned visit by the patriarch and the archons,
or their representatives, would explain the enormous effort
devoted to painting the narthex, which in my opinion was
intended as the showpiece of the project.

The monk-painter apparently had easy access to the
entire surface of the dome. He seems to have used the four
windows in the drum of the dome to carry crossbeams that
supported a platform about five meters above the floor.[28]
Initially, he made a false start. The monk drew the legs of a
horse freehand immediately above the level of the presumed
scaffolding platform. Upon evaluation, he must have found
the position of this preparatory image to be too low, so he
placed subsequent figures about half a meter higher in the
dome. The position of the horsemen was perhaps changed
to avoid the four windows that would have interfered
with the procession of finished images. The monk never
removed the outline of the first horse, which can be seen
beneath Abadir and Iraʾi, although he largely obscured the
drawing by painting over most of it (fig. 12.10).

After this tentative beginning, the monk-painter con-
tinued with greater success. He appears to have established

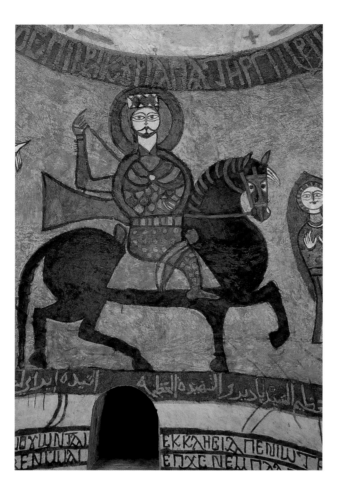

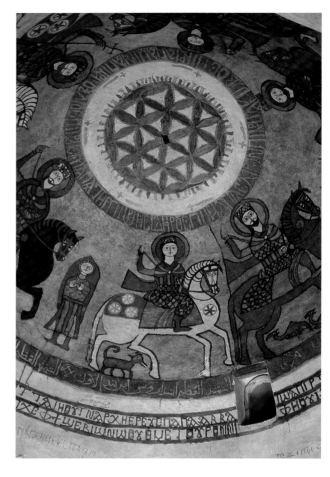

FIGURE 12.10 LEFT
Preparatory drawings of a horse
beneath Abadir and Iraʾi (A9).
ADP/SP 8 S1185 02.

FIGURE 12.11 RIGHT
Decorative medallion (A11) at the
apex of the Dome of the Martyrs.
ADP/SP 9 S198 02.

the different registers of decoration using a compass. Beginning at the apex of the dome, he drew a large central circle, which was developed into a medallion consisting of a series of overlapping circles and half circles, also drawn with a compass (fig. 12.11).[29] The design is identical to one in the Psalmody of 1715 and appears to be a standard part of the ornamental vocabulary of Coptic manuscript illuminators (fig. 12.12).[29] Its inclusion in the Cave Church indicates that the monk may have been a self-taught painter but that he was not without awareness of trends in manuscript decoration. He, or a member of the team, framed the central medallion with a circular band and placed a second one lower in the dome. ʿAbd al-Sayyid wrote the names of the martyrs in these bands, in Coptic above and Arabic below.[30] The monk-painter apparently used these inscription bands to help define the size of the equestrian martyrs. The upper one established the location of the saints' halos, while the lower indicated the placement of the horses' hooves.

The monk-painter designed all of the martyrs in the dome in a nearly identical manner.[31] He defined the heads with the usual circles and followed his regular practice in depicting the faces, but with the addition of short beards covering the lower curves of the circles. All of the equestrians have beards and thin moustaches, except for the youth-

ful Isidore. The beards vary in length, but none is as long as the beard worn by Moses/Samuel in the corridor. The monk provided the martyrs with round bodies resembling those of the three archangels in the central nave (fig. 12.13). The belts worn by each figure link the circle of the upper torso to a compass-drawn semicircle, forming the buttocks. The artist drew the thigh as a freehand diagonal extension of this semicircle, and he followed the same practice when defining the lower leg and foot. He also used circles to render the horses; they form the neck, chest, and rump (fig. 12.14).[32] The painter then joined the circles with freehand drawings of the heads, bellies, legs, and tails. Although the monk always showed a certain discomfort with the human form, he appears to have been quite confident when depicting horses. The heads and legs, in particular, are shown with a surprising suggestion of naturalism. Admittedly, a single pose is repeated with every horse, but it is one of the most anatomically accurate of the painter's compositions.[33]

The team of ʿAbd al-Sayyed and the monk-painter designed all but one of the equestrians in the Dome of the Martyrs with diminutive figures representing stories from their lives and miracles.[34] The exception is James the Persian, also known as the Sawn Asunder, whose legless body tells the story of his martyrdom. A number of these nar-

FIGURE 12.12 ABOVE

Decorative medallion, Psalmody of
1715 (MS 368 Lit.). Courtesy of
Father Yuhanna al-Anba Bula and
the Monastery of St. Paul.

FIGURE 12.13 RIGHT

Menas (A7). ADP/SP 5 S1189 02.

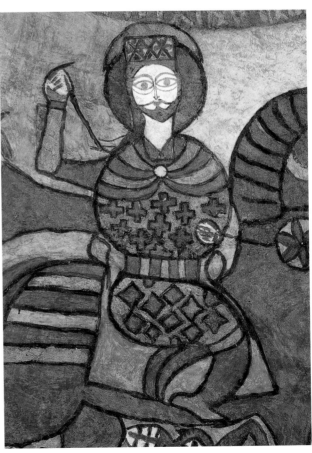

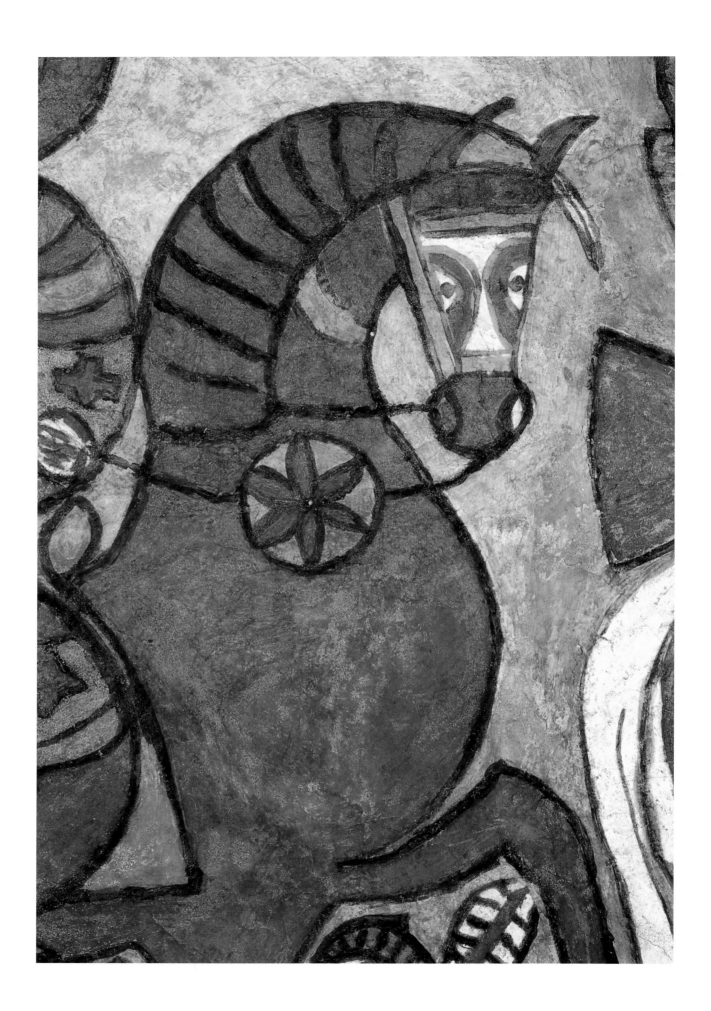

FIGURE 12.14

Horse of Menas (A7). ADP/SP 7

S1189 02.

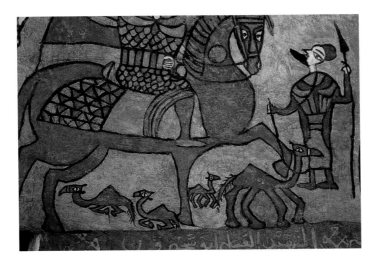

FIGURE 12.15

Camel herder next to Iskhirun of

Qalin (A5). ADP/SP 13 S1187 02.

FIGURE 12.16 RIGHT

Camel herder, birds, a decorative

medallion, and a cat and mouse,

Psalmody of 1715 (MS 368 Lit.).

Courtesy of Father Yuhanna al-

Anba Bula and the Monastery of

St. Paul.

rative figures have exact parallels in the miniatures in the Psalmody of 1715. When illuminating the manuscript, the monk painted his freehand figures in profile with jutting beards. They often wear red caps and striped robes and are usually engaged in secular occupations, including sailing a ship, catching a huge fish, tending camels, and harvesting dates (see fig. 12.5). The monk employed an identical figure in the Dome of the Martyrs to represent the bedouin follower of Iskhirun, whose camels are also duplicated in the manuscript (figs. 12.15 and 12.16). The monstrous fish speared by Julius of Aqfahs is similar to the one caught by a pipe-smoking fisherman in another miniature (figs. 12.17 and 12.18).

The monk paid special attention to the decoration of the figures in the Dome of the Martyrs. Nowhere else in the Cave Church did he invest as much time and energy as in this room, as is indicated by the vividly ornamented costumes worn by the martyrs. The monk obviously had a plentiful supply of paint and applied it in a considerably more elaborate manner than anywhere else in the church. Instead of employing his usual fields of solid color or randomly applied lines and dabs of paint, the monk decorated the bodies of the equestrians with an array of crosses, diamonds, circles, rectangles, and vertical bands. He covered three of the martyrs with an intricate scale-like pattern, perhaps representing armor. The monk put compass-drawn

Fish monster of Julius of Aqfahs
(A8). ADP/SP 19 S1189 02.

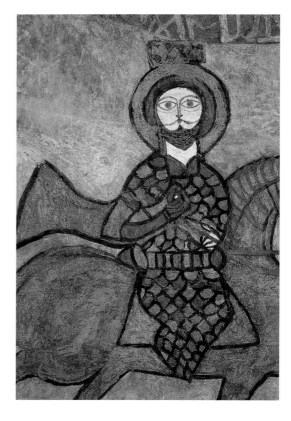

FIGURE 12.18 ABOVE LEFT
Pipe-smoking fisherman, Psalmody
of 1715 (MS 368 Lit.). Courtesy of
Father Yuhanna al-Anba Bula and the
Monastery of St. Paul.

FIGURE 12.19 ABOVE RIGHT
James the Persian (A6). ADP/SP 13
S1188 02.

medallions on the necks of some horses and large saddle
blankets that extend over their rumps, on others providing
additional areas for similar decorative motifs. The monk's
color scheme consists of the usual red, yellow, and green,
but with the introduction of brown and black, which could
be toned down to shades of gray. He employed black when
painting the horses of Abadir (black) and James (gray), but
he also used it to outline his figures, including the numer-
ous small fields of color that decorate their clothes, in what
must have been a remarkably time-consuming task. When
van Moorsel described the figures in the Cave Church as
dressed in "kaleidoscopically colored garments," he can
only have been referring to the Dome of the Martyrs.[35] For
reasons unknown, the artist never repeated such elaborate
ornamentation outside of the narthex.

The monk conceivably worked more or less alone
when re-creating the medieval paintings, but in the narthex
he seems to have had assistants. The scaffolding platform
was probably stable enough to hold a number of workers
at the same time. We know that ʿAbd al-Sayyid contributed
two inscriptions in the dome, and it is likely that one or more
other monks helped as well. The monk-painter may have
drawn each figure and painted the faces but shared the detail
work with his assistants. There certainly appear to be two
different hands responsible for the decorative designs used
on the martyrs. For example, a contrast is apparent between
the more elaborate scale-like pattern found on James the
Persian (fig. 12.19) and the simpler arrangement of crosses
and diamonds on Menas (see fig. 12.13). No matter how
many monks were active, however, it is obvious that a

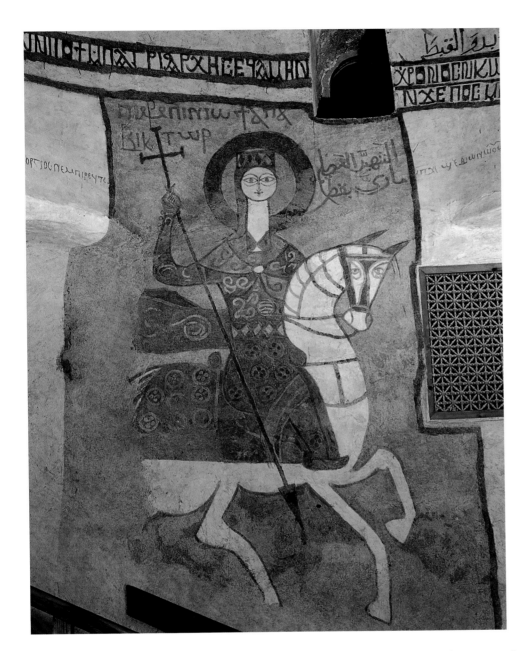

FIGURE 12.20

Victor (A1). ADP/SP 19 S240 05.

painting the final inscription.[36] This two-stages process is another indication of the care applied to painting the narthex. For the benefit of those with a less than perfect command of Coptic, he added an Arabic inscription indicating the start of the text: "O Reader: here begins the Coptic!"

After completing his work in the vault of the narthex, the monk painted three more equestrians on the walls of the stairwell.[37] They continue the sweeping motion of the circle in the dome, but in a lowering spiral as they descend, along with those entering the church, down the stairway. The artist depicted Victor, Theodore Stratelates, and George in the same style as the horsemen in the dome, but with a fluency that suggests that he was now completely comfortable with this type of image (fig. 12.20; see fig. 12.4). He probably also found painting on the flat walls of the stairwell more conducive to stylistic refinements than working from a platform on the curved surface of the dome. The main modification he employed with these three figures is in his handling of their bodies. Instead of forming a complete circle, the painter used only part of the curve to create the shoulders. He drew the rest of the torso freehand, making an attempt to suggest more than just a geometric shape. The right arm of each saint is convincingly connected to the shoulder, and instead of balloon-like bodies, the martyrs have clearly defined waists. Theodore Stratelates even has a functioning left arm that he uses in a double-handed motion to spear the dragon (fig. 12.21). When depicting these equestrians, the monk continued to depend on his technique, but he allowed himself greater freedom to apply his own skill as an artist. He experimented in this manner throughout the program and often incorporated the results into his stylistic repertoire. For example, the monk depicted James the Persian, in the Dome of the Martyrs, with a hint of a waist and a more articulated arm, and then developed this method further on the equestrians of the stairwell.

The monk also modified the decoration of the martyrs' clothes. He still applied it lavishly, but he used less complicated ornamental patterns and executed them with less precision. The painter placed greater emphasis on somewhat larger fields of monochrome that he generously embellished with curling lines of paint in different colors. He also painstakingly covered the legs and saddlecloths of the saints with small compass-drawn circles. Theodore Stratelates is adorned with almost fifty red and green circles produced in this manner. These changes in his style mark a shift away from the detailed ornamentation used in the Dome of the Martyrs. They may also indicate that he had fewer assistants when producing the lower equestrians. However, another monk may have undertaken the

great deal of time was devoted to producing the Dome of the Martyrs. Also indicative of the monastic team's attention to detail is the almost complete absence of paint drips and smudges throughout this elaborate composition. The monk-painter and ʿAbd al-Sayyid were usually extremely careful about removing such accidents before finishing their work.

ʿAbd al-Sayyid probably added the Coptic foundation inscription after the removal of the scaffolding. Its position is too low for him to have painted it from the presumed platform erected in the dome, but it is also too high to have been reached from the floor, so the monastic team must have provided a lower scaffolding. ʿAbd al-Sayyid found it necessary to write a faint preliminary copy of the text around the drum, which he then used as a guide when

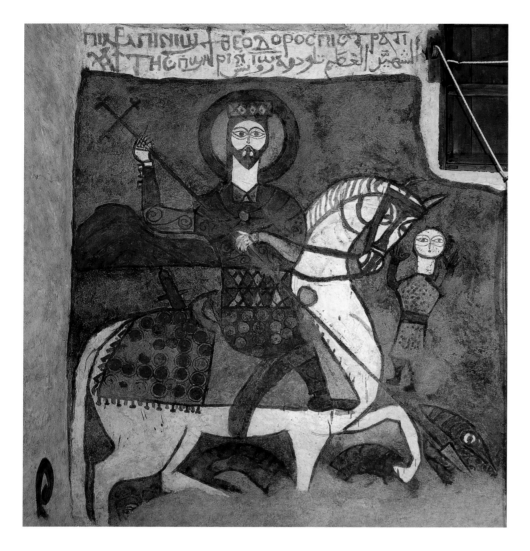

FIGURE 12.21

Theodore Stratelates (A2). ADP/SP 204 S10 5 05.

laborious task of producing and painting the numerous compass-formed circles, a decorative method found nowhere else in the church in this quantity.

We will never know how the original audience responded to the paintings in the narthex, but later visitors were generally most impressed with this portion of the eighteenth-century program. Johann Georg Herzog zu Sachsen, visiting the Monastery of St. Paul in 1930, regarded the superior craftsmanship of the Dome of the Martyrs as evidence that the images dated to a century earlier than the other modern paintings in the church.[38] Even van Moorsel, who rarely had a charitable word for the monk-painter, acknowledged that the horses of the equestrians were "skillfully done."[39]

The Northern Nave: Upper Zone

The sequence of paintings in the octagonal drum of the dome over the northern nave can be charted fairly confidently. The monastic team expanded the program in this room in three stages of activity. It is less clear whether these stages

were all part of a predetermined plan or whether the monks developed the iconography as the project progressed. ʿAbd al-Sayyid commenced the series with a Coptic inscription arched over the entrance to the Haykal of the Twenty-Four Elders (see fig. 11.21). The letters, red on a white ground, are well spaced and elegantly formed. ʿAbd al-Sayyid or a member of the team framed the inscription band very neatly in red. Immediately above the central point of the inscription, on the wall between the squinches, he or the monk-painter formed a decorative medallion flanked by the abbreviated formula "Jesus Christ, Son of God," written by ʿAbd al-Sayyid (fig. 12.22). This composition is reminiscent of an illuminated page in a Coptic manuscript (see figs. 12.5, 12.12, and 12.16).[40] Indeed, it would be repeated as one of a number of similar decorative pages of the Psalmody of 1715 (fig 12.23).

In the second stage, ʿAbd al-Sayyid painted Coptic and Arabic inscriptions, identifying Michael, Gabriel, Raphael, and Suriel, just below the springing of the dome, and the monk-painter rendered the four archangels in the squinches supporting the dome (see figs 11.15 and 11.21).[41] When working on Michael, the painter extended the tip of the southern wing and the yellow background framing the image to the edge of the inscription above the sanctuary entrance but no farther, indicating that he produced the archangels at a somewhat later stage of work.

We cannot say for certain how the monks reached the drum of the dome in the northern nave. ʿAbd al-Sayyid may have used the wooden beams currently spanning the room as the foundation for a platform from which he inscribed the names of the archangels.[42] However, the beams are too high to have served the monk-painter. The team must have used scaffolding that allowed them to paint nearly six meters above the floor of the church. Although the platform in the narthex appears to have been large and stable enough for a team of monks, the scaffolding in the northern nave may have been smaller and possibly not as stable, which could account for the less precise workmanship in this upper area. For example, ʿAbd al-Sayyid obviously intended the inscription over the sanctuary entrance to be neat and orderly, but when writing the names of the archangels higher in the drum, he used less decorative letters and placed them less regularly. He appears to have found working in the drum something of a challenge. The red lines framing the inscriptions and the hoods of the squinches were also applied very roughly, with a great deal of dripped paint left in place. Conceivably an assistant was responsible for this menial task.

FIGURE 12.22

Decorative medallion with abbreviated inscription, above the inscription (B9a) framing the entrance to the Hakyal of the Twenty-Four Elders. ADP/SP 19 S1218 03.

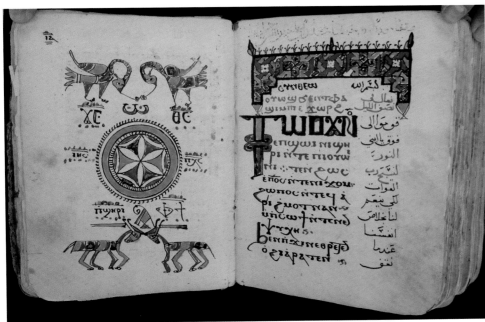

FIGURE 12.23

Decorative medallion with abbreviated inscription, Psalmody of 1715 (MS 368 Lit.). Courtesy of Father Yuhanna al-Anba Bula and the Monastery of St. Paul.

The monk-painter, working under the same conditions, formed the heads and double-ringed halos of the archangels using a compass, but he drew the shoulders freehand. The difficulty of placing the figures spanning the curved hoods of the squinches and the right angles of the corners probably made the effective use of a compass impossible. These figures appear to be among the painter's earliest attempts at deviating in this way from his normal practice.[43] As a result, the bodies are all of slightly different sizes. The monk experimented with two different positions. He placed Michael and Raphael straddling both walls of the corners, resulting in bodies of elephantine proportions, whereas he rendered Gabriel and Suriel occupying primarily a single wall (figs. 12.4 and 12.25; see fig. 11.22). These figures have less massive torsos, similar to those of the three Hebrews. The monk duplicated the basic costume and pose of the three archangels in the central nave but painted the loros bands using more elaborate triangular ornamentation, similar to the medieval models at the Monastery of St. Antony (see fig. 11.23). However, the design is not as elaborate as the related one decorating the saddlecloth of Iskhirun in the Dome of the Martyrs (see fig. 12.15). His handling of the wings differs from the technique he used when painting the other angels in the church. Instead of

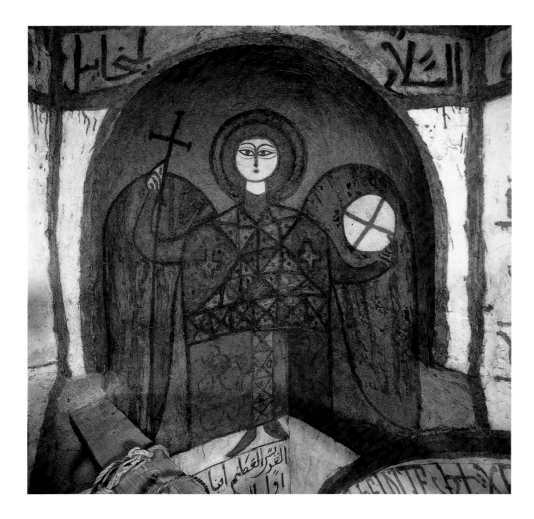

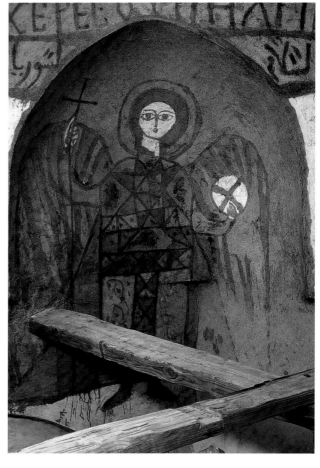

FIGURE 12.24 LEFT

Michael (B7). ADP/SP 174 S4 03.

FIGURE 12.25 RIGHT

Suriel (B14). ADP/SP 14 S1214 03.

using a series of overlapping ovals to indicate feathers, he applied alternating lines of his three main colors.

These paintings are the most puzzling in the eighteenth-century program. Their design follows the same format, but certain features are different in each figure. The heads and halos of the archangels, with the exception of Michael, are unexpectedly asymmetrical. They look as if the painter was forming a circle on a curved surface for the first time. The faces are subtly different. Michael, the most detailed of the four, has extremely narrow eyes, with extra lines placed above and below them. The monk used similar lines under the eyes of the equestrians in the narthex, but not between the eyes and eyebrows. He also colored the nose of the archangel red, perhaps as an attempt to make the face more legible from below. When working on Gabriel, the monk reverted to his standard facial model, which he followed when painting Raphael and Suriel. The facial details of these angels, however, are unusually irregular (see figs. 11.2 and 11.22).

These variations raise questions about the chronology of the paintings in the upper zone of the northern nave. The monastic team may have worked here after completing the narthex and were perhaps hampered by lower and less stable scaffolding. On the other hand, the northern nave could have been 'Abd al-Sayyid's and the monk-painter's first attempt at working in one of the vaults of the church. Both possibilities would explain the apparent difficulty they seem to have encountered there. Yet the painting of Michael is rendered with great assurance and precision. Perhaps it was the last archangel the monk created, by which time he had come to terms with working in the drum of the dome, but the discrepancies between the four figures, especially their slightly different faces, may suggest that more than one monk was involved. The presence of so many paint drips, in particular beneath Suriel, further indicates the hand of at least one assistant charged with painting the skirts of the tunics and the background colors. He may have been the same monk who carelessly framed the inscription bands naming the archangels.

After completing the archangels, the monk-painter depicted Cyriacus and Julitta above the arched entrance to the narthex, between the squinches occupied by Raphael

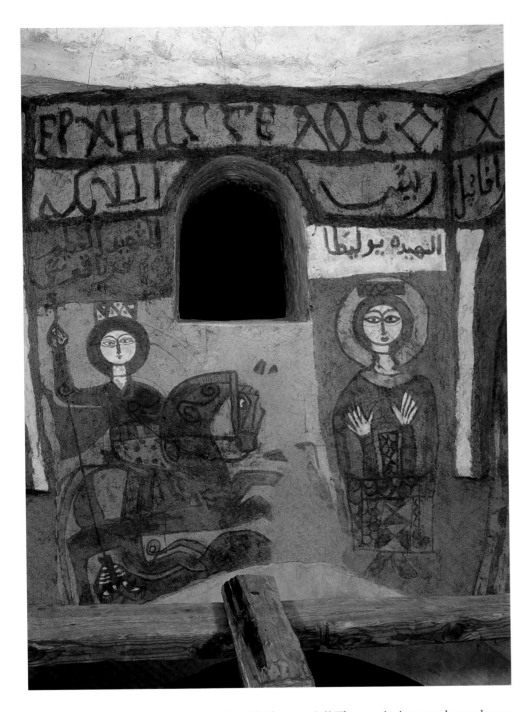

FIGURE 12.26

Cyriacus (B1) and Julitta (B2). ADP/
SP 6 S1213 03.

The painting of Cyriacus is an assured composition that is a smaller, simplified version of the equestrians in the narthex. The monk used a compass for the head and halo of the martyr and the neck of the horse but drew the rest of the figures freehand. The saint galloping over a dragon is particularly successful in both form and placement, which again indicates the artist's comfort depicting horses. This painting is similar enough to the other equestrians to make it impossible to determine whether it was created before or after the saints in the Dome of the Martyrs. Cyriacus, however, has one interesting similarity to the painting of Michael suggesting that the two figures were produced at the same time. Both images have facial features that include very narrow eyes, emphasized by lines above and below, and a nose accentuated in red that the monk employed only on these two saints.

In contrast to Cyriacus, the figure of Julitta is particularly awkward. She is depicted in one of the standard poses used in the church, with her hands held upright. Instead of leaving the arms to the imagination of the viewer, however, the painter showed them emerging from the saint's belt, an interesting experiment in depicting human anatomy that was not repeated in the eighteenth-century program. He provided each hand with five distinct fingers, but they are not as articulated as those of the three Hebrews. The color scheme is less balanced and the decoration lacking in precision compared to other examples of the monk-painter's work. The artist surrounded Julitta's face with two concentric circles: the first serves as a red maphorion and the second a yellow halo. He painted the maphorion in an extremely careless manner, placing the garment out of alignment with the saint's neck and then making what appears to have been a clumsy attempt at extending it down to Julitta's shoulders. Such inept workmanship, rare in the Cave Church, suggests that a less skillful assistant may have produced this image.

The Northern Nave: Lower Zone

The paintings of Sarapion, Paul the Hermit, Eirene, and Marina in the lower section of the nave seem to represent a distinct stage in the Cave Church program and one that apparently did not involve 'Abd al-Sayyid.[46] With the exception of Eirene, whose red tunic is embellished with green crosses and diamonds, the monk paid almost no attention to decorating the clothes of these figures, preferring to use large areas of solid color. He instead focused on developing his method of depicting standing saints, with remarkable results. Such experimentation may have been encouraged by the ease of accessibility of the lower walls in contrast to

and Suriel (fig. 12.26).[44] These paintings are located on a small expanse of wall that offers less than two square meters of surface. The medallion and abbreviated prayer over the eastern arch comfortably occupy a comparable area, but here the artist added an equestrian and a standing saint. Room to depict the two figures was further reduced by the addition of Arabic inscriptions above each one.[45] These are positioned as a third register of the bilingual inscriptions identifying Raphael and Suriel, indicating that the monk introduced Cyriacus and Julitta after the completion of the archangels.

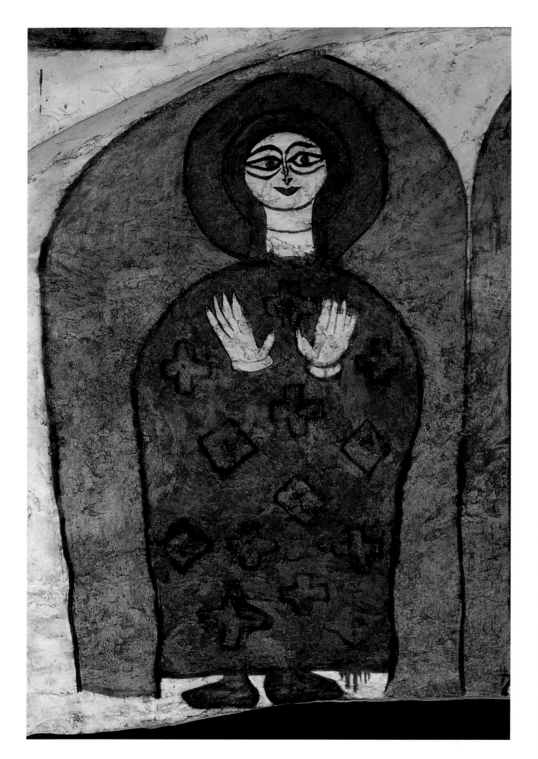

FIGURE 12.27

Eirene (B12). ADP/SP 17 S1220 03.

Hebrews in the central nave. The monk used the inner circle of Eirene's halo as a green maphorion. He (or an assistant) applied the same approach when depicting the head covering of Julitta, but here with much greater success. Otherwise, this painting shows little sign of the experimentation so apparent in the other figures of this group.

The monk provided the figure of Sarapion with a long white beard similar to that worn by Moses/Samuel in the corridor (fig. 12.28). In this instance, however, the painter removed the lower curves of the circles forming the head, double-ringed halo, and shoulders before adding the lines denoting the hair of the beard. These lines are more numerous than in the earlier example and were applied more systematically. More important, the monk varied his technique when working on the body of Sarapion. He formed the saint's torso using another large circle, but instead of depicting the same bulky body used for Eirene, he reduced the appearance of a wide girth by placing a narrower tunic, drawn freehand, within the confines of the circle. He then painted the outer curves red, indicating a cloak, an article of monastic dress found here probably for the first time. The artist continued to expand on this costume in subsequent paintings, refining and adding to the apparel worn by his monastic saints. As mentioned above, the monk added the figure of Antony to the north wall of the nave later in the project. Up until that time the figure now identified as Sarapion was most likely an earlier representation of Antony. The painter apparently modified the image by introducing the ecclesiastical vestment around the saint's shoulders in order to indicate the figure's new identity as the bishop of Tmius. The monk probably applied the crosses and hatched patterns to the halo during the same phase of work.

The monk experimented further when painting Marina (fig. 12.29). As a woman monk, she is dressed in a monastic costume similar to that of Sarapion. The artist again added a freehand drawing of the tunic within a large circle. However, he introduced an important stylistic refinement. Instead of indicating a cloak formed by the curves of the circle, the monk depicted a more elaborate mantle. It covers Marina's upper body but opens at the waist to reveal her flared tunic and to underscore the fact that she wears an analabos. The saint's hands are held upright and depicted with the same care as those of the three Hebrews. The painter also included yellow forearms. In contrast to the awkward attempt at adding arms to the figure of Julitta, these seem to emerge from within the mantle, causing it to fall open. The saint's face is also exceptional. The monk outlined her features in black, rather than the usual yellow,

the upper vault. Here the monk did not need scaffolding, only the equivalent of a high table.

The artist depicted Eirene (fig. 12.27) in a usual standing pose with armless hands held upright against her chest. He varied his technique somewhat by forming the body around an especially large circle. As a result the torso of the saint is considerably wider than those of the three

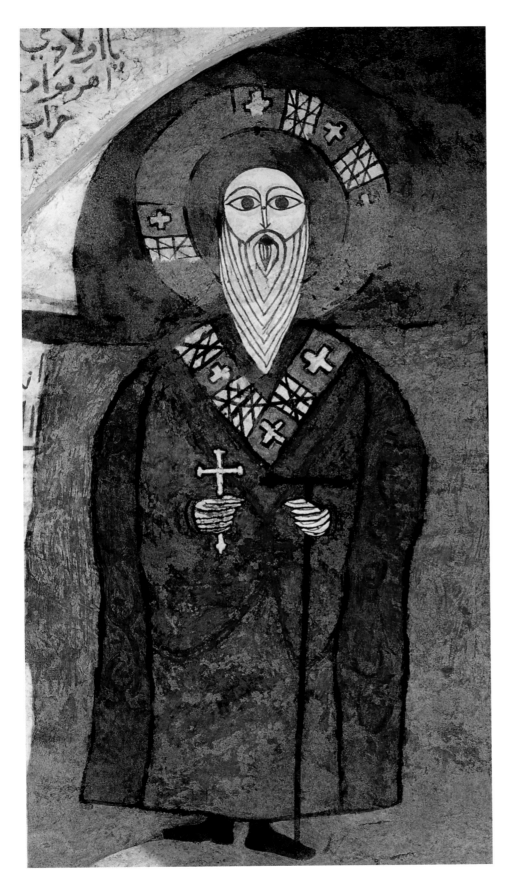

FIGURE 12.28

Sarapion (B4). ADP/SP 4 S1222 03.

and painted the mouth as large and surprisingly sensual. The most startling feature, however, is Marina's full head of black hair, which falls thickly around her shoulders. The overt femininity of the image, combined with the painter's stylistic innovations when depicting her monastic dress and rendering her arms, make Marina one of the most distinctive paintings in the eighteenth-century program.

The monk relied even more on his own skill as an artist when painting the patron saint of his monastery. Apart from using compass-drawn circles to form the head, a ring of hair, and the halo, he produced Paul the Hermit completely freehand, a remarkable indication of his growing confidence (fig. 12.30). Yet without a circle to guide him, the painter miscalculated the positions of the shoulders and had to redraw them at a slightly lower level. He portrayed the saint standing with his arms raised in the orans position. In the rest of the Cave Church the monk approximated this pose by placing hands directly in front of the body, but he depicted Paul's arms and hands with a noticeable attention to anatomical detail. He also provided the hermit with an appropriately thin body and short tunic, as well as Paul's iconographic symbols, a raven and two lions. The monk portrayed the lions as large domestic cats with arched backs and curling tails (fig. 12.31). They are red with black outlines, and their facial features have been emphasized by white strokes cut into the plaster. The monk seems to have enjoyed painting them, because he included similar cats in two miniatures in the Psalmody of 1715, one watching a mouse, and the other a large bird (see fig. 12.16). The painter's raven, however, is nothing like the colorful, flamboyant birds portrayed in the miniatures of the manuscript (see figs. 12.16 and 12.23). Instead, the monk created a dark red silhouette of a bird in flight carrying a compass-drawn loaf of white bread.

The paintings in the lower level of the northern nave are among the monk's most assured compositions. He created Eirene by closely adhering to his standard method, but with the other three figures he employed a more experimental approach, devising new ways of elaborating on one of his typical costumes, taking greater care when depicting human anatomy, and introducing surprising innovations, such as Marina's flowing hair. Compared to Eirene the figures of Sarapion, Marina, and Paul are considerably more complex compositions, making it seem possible that Eirene was painted primarily by an assistant. The monk may have drawn the circles forming the outline of the figure and painted the face, which closely resembles Maria's, and then have permitted another monk to complete the

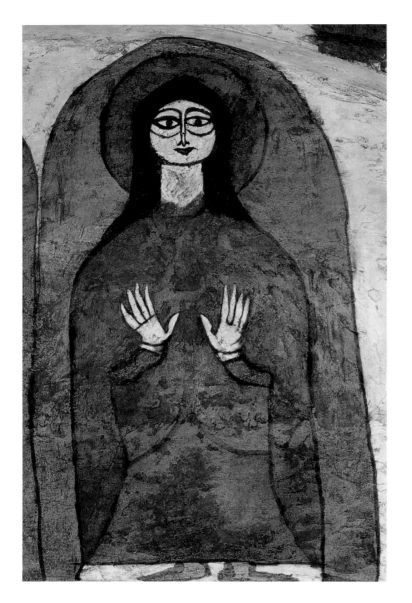

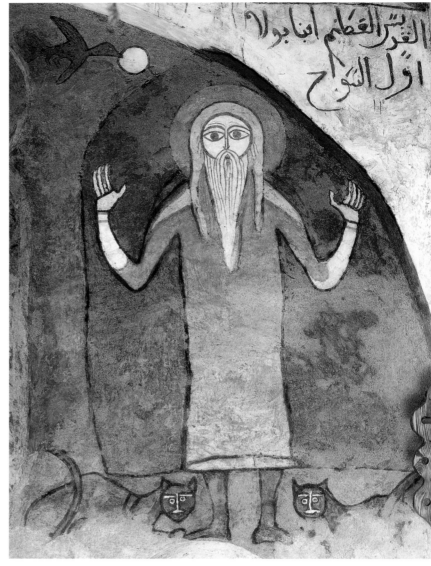

FIGURE 12.29
Marina (B13). ADP/SP 19 S1220 03.

FIGURE 12.30
Paul the Hermit (B6). ADP/SP 206
S7 5 05.

body. Eirene's unusually large round feet and her simpli-
fied hands, similar to those of Julitta, certainly appear be
the work of a different individual, as does the failure to
clean the paint dips from the hem of the figure's tunic.[47] It
is also noteworthy that this is the only painting in this series
that is decorated in a manner reminiscent of the Dome of
the Martyrs. Perhaps the assistant, when given the chance
to complete the body of Eirene, resorted to using crosses
and diamonds similar to those he had employed earlier on
Menas in the narthex (see fig. 12.13).[48]

The Haykal of the Twenty-Four Elders
The Haykal of the Twenty-Four Elders rivals the Dome of
the Martyrs as the monk-painter's most ambitious com-
position.[49] His depiction of Christ in Majesty attended
by a heavenly host of thirty-five celestial beings fills the

vault above the sanctuary (fig. 12.32). The monastic team
organized the images in two concentric rings, placing the
elders of the Apocalypse in the drum and the enthroned
Christ surrounded by angels in the shell of the dome. They
must have employed a very tall scaffolding to enable them
to reach the highest level of painting, about seven meters
above the floor. The monks do not seem to have encoun-
tered the same difficulty as they did when working in the
vault of the northern nave, even though they were painting
at the same or a higher level.[50] However, the artist appears
to have made the decision at the very beginning of this stage
to create most of the images in as simple a manner as pos-
sible. The program in the Haykal of the Twenty-Four Elders
is one of his most impressive compositions, but more for
the ambitious scope, careful organization, and complexity
of the overall design than for the individual details.

The monk started with the elders, judging by the evidence of paint drippings on the figures from above. He calculated the position of each one, organizing them into groups of three on the four walls and four squinches of the drum of the dome. The use of guidelines was essential in ensuring that he allotted all the images the same amount of space and made them of a uniform size. He depicted the elders on simple bench-like thrones, set within what appear to be niches surmounted by triangular canopies of unpainted plaster. Each elder has a round body with a belt covering the lower curve that resembles those of the three archangels in the central nave and the equestrians in the Dome of the Martyrs. The monk made no attempt to show the figures' legs or feet but suggested a seated position by reducing the length of their tunics. He also outlined the torso of each elder with an additional circle that forms a narrow outer cloak extending downward around the lower body. The painter used a larger version of this article of clothing when depicting Sarapion in the northern nave but seems to have developed this narrower style of cloak when working in the Haykal of the Twenty-Four Elders. The elders wear crowns and hold censers in their right hands and incense containers in their left. The artist formed these objects using unpainted plaster outlined in yellow. Uniquely among

them, Kardiel, in the southwest squinch, has a red crown. The artist possibly began with this figure and then decided that red was not distinct, especially when surrounded by red halos, and thereafter shifted to white.

The monk-painter duplicated the same image twenty-four times, using two alternating color combinations and modifying the formula only twice. The central elder on the west wall, Xiphiel, had to be placed at a slightly lower level because of a window opening onto the northern nave (fig. 12.33). Due to the limited space, the monk provided the figure with a more condensed body sitting on a throne with shorter legs. He was also obliged to dispense with the canopy above the throne, although the window can be seen as substitute. The second figure that required adjustment was Epdiel, the central image in the east squinch (fig. 12.34). Here the problem was caused by a mishap with the lower guideline indicating the position of the legs of the throne. It was extended around the drum, but when the two ends came together in southeast corner, the line was slightly out of position. As a result, the legs of the throne are of different lengths.[51]

Although the monk seems to have produced these images almost mechanically, with little sign of experimentation, he obviously spent time on each one. His depictions

FIGURE 12.31

Lion of Paul the Hermit. ADP/SP 5
S1223 03.

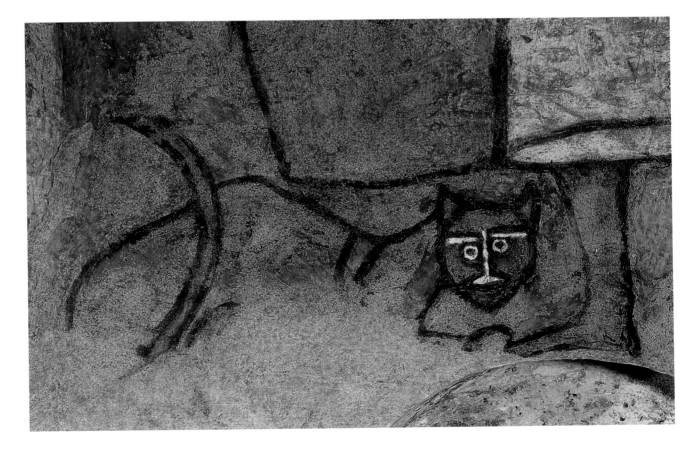

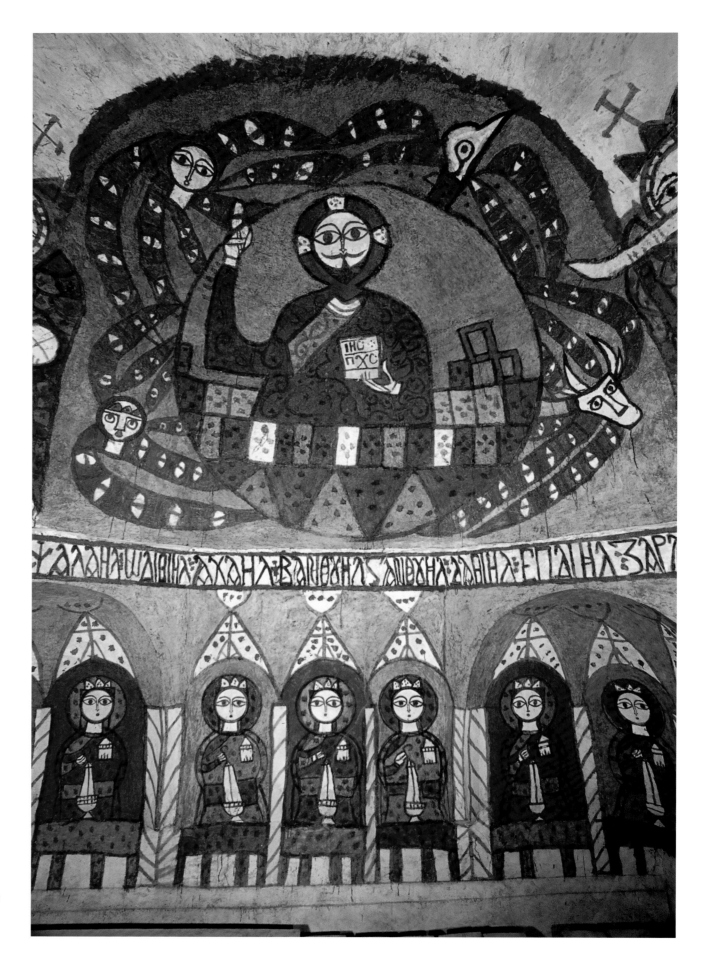

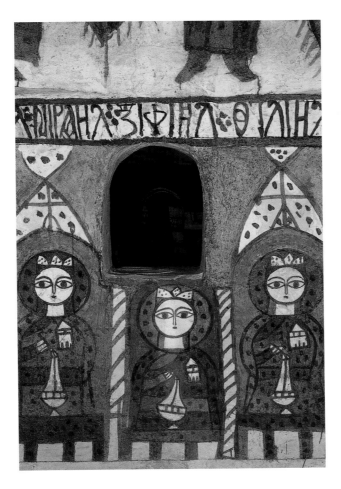

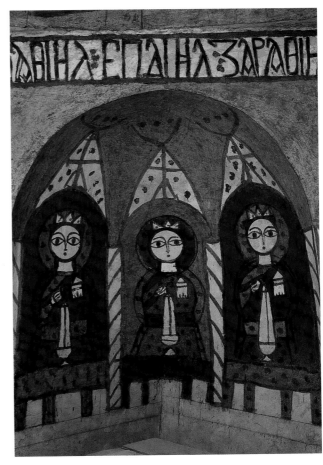

FIGURE 12.33 LEFT
Nirael, Xiphiel, and Otliel (C1).
ADP/SP 12 S1233 04.

FIGURE 12.34 RIGHT
Dathiel, Epdiel, and Zarathiel (C6).
ADP/SP 6 S1231 04.

of the censers held by the elders are detailed enough to be recognizable as a type still used in the Coptic Church today. He meticulously cleaned the faces of every elder by scraping away excess paint. The canopies above the thrones also received a surprising amount of attention. After completing a pattern of yellow lines within each one, the painter returned to every canopy and simplified the design to the current arrangement of a cross with three legs.[52] Someone then finished the decoration by applying red dabs of paint around the crosses in an incredibly sloppy manner. Similar red dots were also placed between the names of the elders in 'Abd al-Sayyid's otherwise carefully planned and executed Coptic inscription.[53] Again it is hard to avoid the conclusion that these dots are the work of a less careful assistant.

In the upper shell of the dome, the monk-painter probably first formed a large circle on the eastern side to serve as a mandorla for the enthroned Christ in Majesty. He placed the four living creatures around the circle and then framed the whole composition with an outer mandorla, flanked by seven angels with trumpets circling the dome. Apart from using compass-drawn circles for the heads and halos (and the orbs held by the angels) the monk painted all the figures in the dome freehand, again emphasizing his growing willingness to deviate from his artistic method. 'Abd al-Sayyid also participated at this upper level of the

haykal, inscribing the abbreviation of Jesus Christ on the book held by the enthroned figure.

The monk-painter seems to have encountered some difficulty at the very top of the dome. He applied the upper red border of the outer mandorla particularly roughly (fig. 12.35). The monk appears to have made it with a single sweep of the brush. This line is at the highest point of the dome, and one can imagine the painter struggling to reach it. After a first mostly successful attempt, he quit without further refinement. The difficulty of working high up in the dome also probably explains the fact that the seven angels are so covered in drips (fig. 12.36).[54] The monk corrected each figure to some degree, but the challenge seems to have been too much for him as drips accumulated wherever he worked. In a most uncharacteristic fashion, he even left paint drips on five of the angels' faces. Generally, I believe that most of the sloppy workmanship found in the program can be attributed to assistants, but in this instance the problem may have been that the scaffolding was too low for the painter to reach the top of the dome comfortably.

The series of guidelines on the north wall of the Haykal of the Twenty-Four Elders indicates that the painter intended to continue in the lower levels of the room, but for reasons unknown he never began work in this area. The fact that the program in the haykal was unfinished perhaps

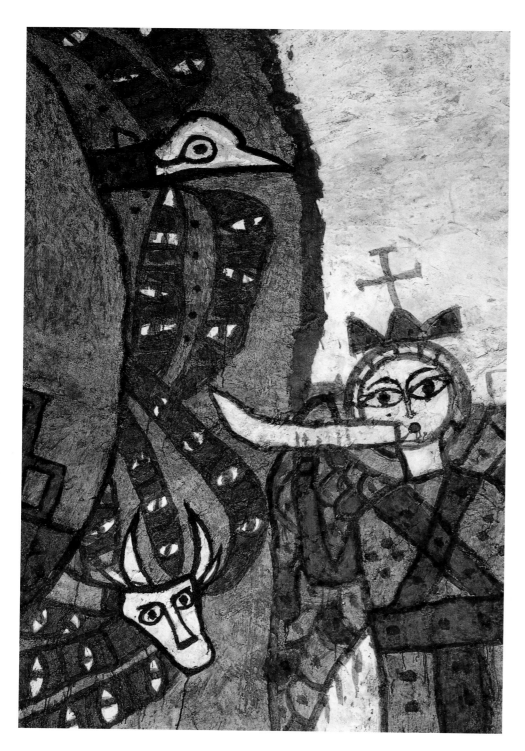

FIGURE 12.35

The eagle-headed and ox-headed
creatures (C10) with an angel (C9).

ADP/SP 20 S1226 04.

suggests that the figures in the dome represent the final stage of his work. Certainly these paintings are a breathtaking achievement in terms of both design and execution. The monk could conceivably have accomplished such an ambitious undertaking only after gaining the necessary experience and confidence working in other parts of the church. However, two groups of monastic saints remain to be examined. One I believe the monk painted after the haykal was completed, but I am less certain about the other group, the later standing saints in the corridor.

The Later Monastic Saints in the Corridor

As discussed above, the monk apparently painted the two monastic saints at the far southern end of the east wall of the corridor as part of his re-creation of the medieval images in the Cave Church. As with the other paintings in this early series, he placed these saints under the surviving medieval Coptic inscriptions that he probably intended to identify his new figures. Methodological features suggest that the monk eventually returned to the corridor and added five more figures resulting in a row of seven standing saints that now spans the east wall (fig. 12.37). The final group comprises, according to later Arabic inscriptions, John, Arsenius, Abib, Apollo, an unnamed saint (presumably John the Little), and the earlier figures of Samuel and Qalamun (or Moses the Black according to the Coptic inscription), and his anonymous companion.[55] The new images resemble the first two closely, but the monk painted them in a more elaborate and confident style. The saints' beards, depicted in detail, resemble those of Sarapion and Paul rather than the more sketchy versions worn by Moses/Samuel. He provided all five images with double-ringed halos, a feature that never appears in his re-creation of medieval paintings.[56] On two of the figures the monk ornamented the outer ring of the halos with dabs of paint. Similar dots decorate the halos of the twenty-four elders in a part of the church that I think the painter completed as the first phase of the project was coming to an end. The bodies of the saints have additional decoration, sometimes in two colors, whereas the monk painted Moses/Samuel in a monochrome red. He surrounded the upper body of each image with an additional circle representing a narrow outer cloak that is also worn by the elders, but not by the figure of Moses/Samuel. These stylistic features indicate that the painter created the five monastic saints on the northern half of the wall sometime after working on the initial two. Judging by their similarities to other paintings in the Cave Church, he probably created them late in the initial phase of the project.

Whenever the monk produced these later images, he did not initially conceive of them as a group of five, as varia-

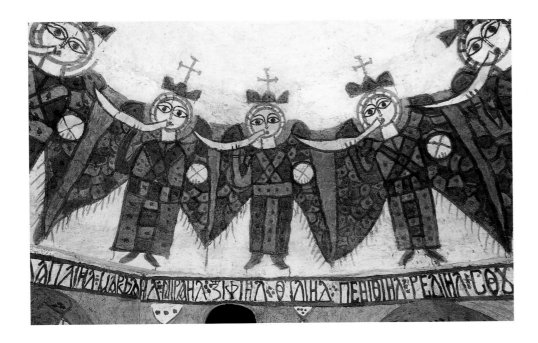

FIGURE 12.36 ABOVE

Angels with trumpets (C9). ADP/SP

15 S1228 04.

FIGURE 12.37 BELOW

John (F5), Arsenius (F6), Abib (F7),

Apollo (F8), John the Little (?)

(F9), Samuel of Qalamun (F14),

and an unidentified saint (F15),

below paintings from 1291/1292

(F10–F12). ADP/SP 5 S246 05.

tions in his working method indicate. Rather, he appears to have painted them in stages. Evidently he began with the figures now identified as John and Abib, at the northern end of the east wall (fig. 12.38). The monk-painter seems to have first planned to duplicate the two medieval images that partially survived at this end of the corridor, and thus complete the re-creation of the earlier iconography. It is likely that the medieval Coptic inscriptions naming John and Shenoute were intended to identify the new images. The faces of the medieval paintings, however, still partially survived. The monk had painted over the earlier images at the southern end of the wall, but here he preserved them. His two saints, now known as John and Abib, were placed beneath the medieval faces, creating a double row of saints under a single inscription band.

Perhaps the confusion of having four saints identified by only two names caused the painter to reconsider his plan and resolve to expand upon the medieval iconography, rather than merely to duplicate it. In the area between his two saints he placed a third figure, now known as Arsenius. Although he painted all three images at what appears to be about the same time, he clearly did not plan them as a group. He positioned John and Abib using guidelines, something he had not done when painting the earlier saints at the other end of the room. The monk then thought to add Arsenius. He positioned the figure without reference to the guidelines he used to form the other two saints. Such disregard for one of the foundations of his stylistic technique indicates that the monk painted these figures in two stages. In order to fit Arsenius into the available space, the monk positioned the head and body at a slightly higher level than that used for John and Abib. Nevertheless, the outer ring of the saint's halo overlaps those of his neighbors.

The monk-painter then probably added the final two images next to Abib. The first is identified by an Arabic inscription as Apollo, and his diminutive companion must be John the Little. The monk painted these saints in the same general style as the others, but I suggest that he introduced them after the program in the corridor had been revised and expanded. My evidence is that these two saints are not in alignment with the other figures, nor are the proportions of their faces and halos the same as either those of John and Abib or Arsenius.[57] The other rows of saints in the church, from the three archangels in the central nave to the twenty-four elders, the artist designed to be as uniform as possible. He clearly valued this quality when positioning his figures, and its absence here indicates that the monk did not apply his usual working method when painting this group of saints. These later images also signify that in this section of the church the monastic team did not design

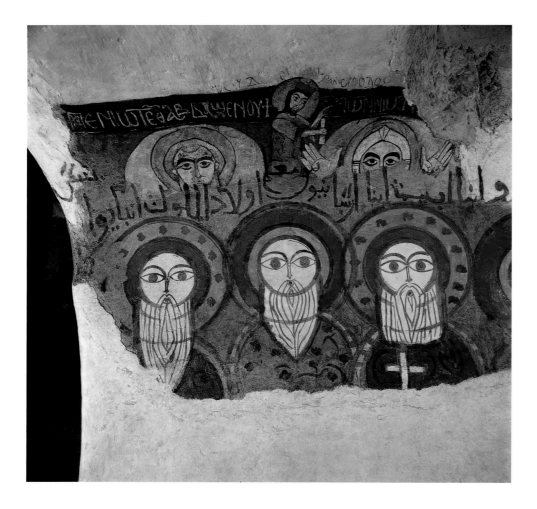

FIGURE 12.38
John (F5), Arsenius (F6), and
Abib (F7), below paintings from
1291/1292 (F10–F12). ADP/SP 211 S4
5 05.

before painting the details of the facial hair only in the corridor; none of the other monastic saints in the Cave Church include this distraction.

Although, this oversight might be blamed on an assistant, the paintings all appear to be the work of the monk-painter. It seems possible that his haste in creating these figures could have been caused by external factors. One feasible scenario is that he was trying to finish his work in time for a visit by church officials and archons from Cairo, who would have come to see the painted program in the Cave Church. According to this premise, the monk may have finished the corridor at practically the last minute. These hypothetical visitors would have found the Cave Church filled with sacred images extending from the domes of the eighteenth-century addition to the rock walls of the original cave. After their departure the monastic community may have regarded the painting of the church as finished. On the other hand, they were just as likely already preparing for the next stage of an ongoing project.

The Final Paintings: Monastic Saints in the Northern and Central Naves

De Cesaris observed that the monk-painter produced the Cave Church program in more than one phase of activity. I believe he concluded the first phase by painting the vault of the Haykal of the Twenty-Four Elders and the later monastic saints in the corridor. It is impossible to say how long the monk-painter waited before returning to work in the Cave Church, but he could have resumed the project almost immediately. The artist created all of his later figures using the same basic technique he employed throughout the program. His later stylistic innovations are rooted in his earlier experiments, especially on the standing saints in the northern nave. The painting of Marina, for example, anticipates much of the monk's later work. Despite the obvious continuity between the two phases, the monk made a stylistic change that clearly distinguishes one from the other. In the paintings examined so far, the artist's palette consisted primarily of bright red, yellow, and green. When working on his later paintings, however, he adopted darker shades of red, yellow, and brown. This chromatic shift, combined with the monk's evident mastery of his technique, indicates that he produced these paintings at a later date. It also suggests that there may have been a break between the two phases long enough to enable the painter to rethink his approach.

The monk's later images are of prominent desert fathers: Antony, Macarius, Moses the Black, Maximus, and Domitius, as well as the medieval father, Marqus al-

the iconography in advance but developed it as work progressed.[58] The monk concluded in the corridor by framing all seven saints within a green background that extends across the length of the wall. It was likely at this same time that he added dots to the halos of the two earliest saints at the southern end.

The painter seems to have produced these later figures in a hurry. The corridor provided the monk with the most accessible walls in the entire church. He did not need scaffolding or even a bench when painting in this small space and must have sat on the floor when working on the lower bodies of his saints. Yet, all of the paintings show signs of having been completed without the precise workmanship found in the haykal, or the experimentation evident in the lower northern nave. The painter overlooked the sorts of corrections that were usually of great concern to him. In particular, he did not remove most of the lower curves of the heads, double halos, and shoulders before adding the details of the beards. As a result all of the images in the corridor have stripes cutting across their beards, with the partial exception of the figure of Apollo, where the monk eliminated most of the lines. He failed to remove these lines

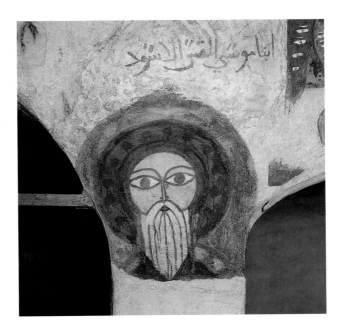

Antuni. They are located on the lower walls of the church, so the monk-painter was not troubled by scaffolding.[59] He had little wall space left, so he positioned his paintings wherever there was sufficient room for a standing figure. In the case of Antony he was obliged to create a new area by introducing the saint into an earlier painting. The monk seems to have had more time to devote to each image. Instead of producing a series of nearly identical figures, as he did in the Haykal of the Twenty-Four Elders and the corridor, the painter experimented with each of his later images. As a result, his final group of saints indicates a remarkable artistic development. There is also little evidence that the monk worked with an assistant at this stage.

It is difficult to determine when the monk painted Moses the Black (fig. 12.39).[60] The figure closely resembles the desert fathers in the corridor. The saint's lower body has not survived, but enough of the tunic is preserved to indicate that it was red with a narrow yellow cloak framing the shoulders. Although the single ringed halo of Moses is less elaborate than those of the saints in the corridor, it is decorated with carelessly applied dots. Both of these features link this painting to the work in the corridor and the Haykal of the Twenty-Four Elders. However, unlike the paintings of the desert fathers, the artist removed the curves of the circles forming Moses' head, halo, and shoulders from the area of the beard before adding the details of hair. This extra foresight indicates that he was not working under the same rushed conditions as when he produced the saints in the corridor.

His placement of Moses on the narrow wall separating the shrine from the corridor, an area that had never been painted, also seems in keeping with one of the monk's apparent motives for continuing the project, namely to cover as much of the Cave Church with sacred images as space allowed. His decision to paint Moses greater than life-size was probably determined by the unusual shape of the south wall, as was his choice to give the figure a large head and a very narrow body. Despite the awkward space, the monk's painting of Moses must have dominated the southern end of the nave before most of the body was lost.

At first glance, the figure of Macarius on the east wall of the shrine appears to be typical for the Cave Church (fig. 12.40).[61] Yet, on closer inspection, the painting shows clear signs that the monk was continuing to refine his technique. When working on Macarius the monk formed the upper body with two small concentric circles that define the tunic and cloak. In contrast, he had used a single large circle for both the tunic and cloak of Sarapion. As a result of these changes, Sarapion appears very bulky compared to the

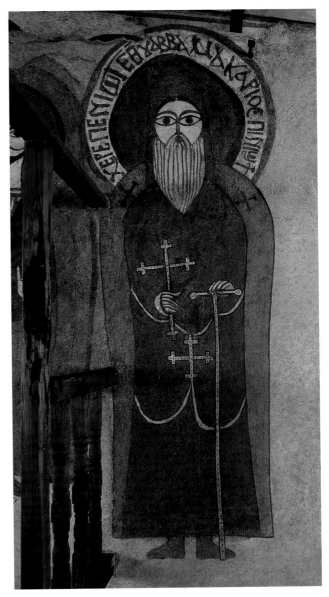

FIGURE 12.39 TOP RIGHT

Moses the Black (D18). ADP/SP 209 S9 5 05.

FIGURE 12.40 BELOW RIGHT

Macarius (G3). ADP/SP 212 S2 5 05.

261

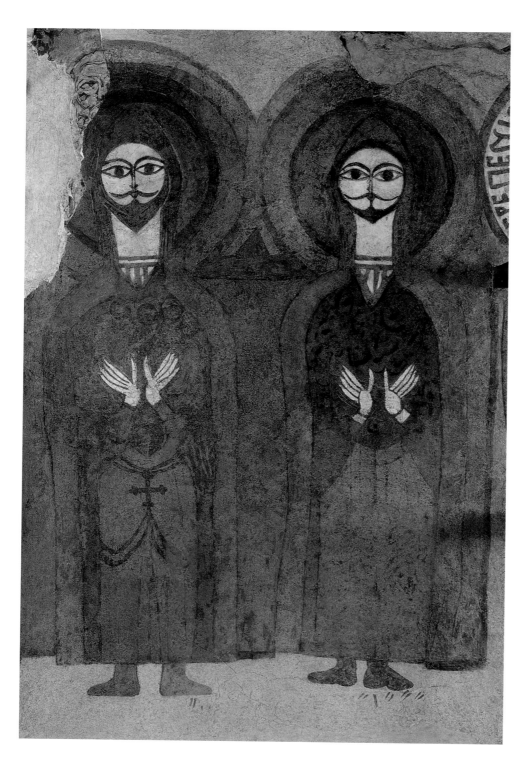

FIGURE 12.41

Maximus (D11) and Domitius (D12).

ADP/SP 210 S9 6 05.

taller and more slender Macarius. Instead of the bright green tunic and red cloak worn by Sarapion, Macarius is dressed in more somber tones of red and brown. The painter also introduced a new garment to Macarius' monastic costume. He covered his head with a typical Coptic monastic hood, drawn freehand, that extends down on each side of his face and beard. Previous monastic saints, from Sarapion to the monastic fathers in the corridor, all have bare heads, shown without hair.[62] The monk further experimented with the saint's halo, which is unique in the eighteenth-century program. The outer ring, instead of being filled with color, contains a circular Coptic inscription that reads: "Hail, our holy father Anba Macarius the Great." The text contains a dotted sigma, indicating that 'Abd al-Sayyid was still actively involved with the project at this stage.

The monk likely next chose to paint Maximus and Domitius on the east wall of the central nave, immediately next to Macarius (fig. 12.41).[63] He clearly intended to show the three desert fathers from the Wadi al-Natrun as a group, but one that was completed in two stages. Although the depiction of the two brothers are formed with guide lines, they are not in precise alignment with the earlier image. The monk painted their halos lower on the wall, probably to avoid the surviving medieval plaster levels just beneath the ceiling, and made their bodies less elongated, so that their feet are above the level used for Macarius. The discrepancy in size makes the two saints appear to be standing slightly behind the elder monk. It is possible that the monk was trying to achieve precisely this illustionistic effect.

The monk used the same narrow body type and darker palette on Maximus and Domitius that he had adopted for Macarius, but he further elaborated on the monastic costume. In addition to the hood, tunic, and cloak, the painter included a mantle covering the upper body. It is the same garment worn by Marina in the northern nave that also reveals the forearms of the saints. Perhaps the monk's most surprising development in this painting is an experiment with an illusionistic approach that portrays the body as more substantial than does his usual method of employing flat fields of color often decorated with randomly applied lines and dots of paint. Instead, he added a few vertical lines to the lower tunics of Maximus and Domitius that convey the outlines of their legs. These lines seem to be one of his earliest attempts at providing his images with some kind of physical definition. He also included a few tufts of grass beneath the feet of the saints, which is perhaps his only experiment with a landscape feature in his paintings.[64]

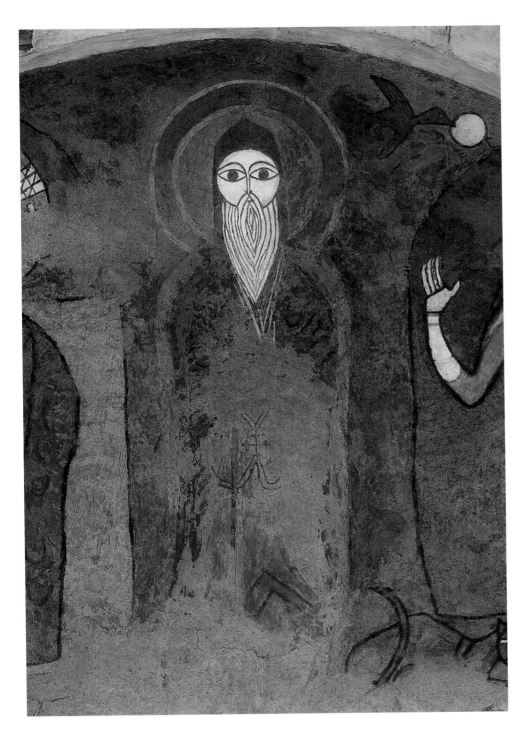

FIGURE 12.42

Antony (B5). ADP/SP 12 S1222 03.

The monk took particular care when producing the background for Maximus and Domitius. He surrounded each of their heads with a series of concentric circles, choosing for the innermost a red halo outlined in a darker red circle, which in turn is surrounded by two green circles, both with yellow outer rings. The green is then extended downward on both sides of the saints, filling a rectangular panel framed in red. Although we might see the multiple circles around the heads of the saints as an elaboration on the monk's earlier use of double-ringed halos, I think that he was trying for a different effect. The green circles framing the heads and red halos of Maximus and Domitius may indicate that the brothers are standing in an arcade. The artist reinforced this impression with a red triangular element inserted between the two groups of circles, which plausibly represents the capital of a green column supporting the arches. Whatever the monk's intention, he certainly spent more time on the background of this painting than on the roughly formed mandorlas surrounding saints that I believe he painted earlier, such as Paul, Sarapion, and Marina.

Stylistically, the painting of Antony appears to be the next in the series (fig. 12.42).[65] It is the only one that was certainly added to the program after the completion of the earlier paintings. The green background between the images of Sarapion and Paul was covered by a thin layer of plaster upon which the monk painted the new figure of Antony.[66] The monk did not have sufficient room for a mandorla, but he painted the outer edges of the new plaster layer green to blend with the earlier background. Antony's monastic dress follows that of Maximus and Domitius in both design and color scheme, although the monk reduced Antony's outer cloak to little more than a yellow outline around the body, which resembles an aureole as much as an article of clothing. The most important stylistic innovation in the painting is the monk's more elaborate use of dark lines to depict the folds in the material of the mantle and to provide the skirt of the tunic with a double triangular crease, generally indicating three dimensions. Such naturalistic details are a remarkable new departure in the work of the monk-painter.

The monk carried this stylistic innovation even further in his depiction of Marqus al-Antuni on the narrow east wall between the haykal screens in the northern and central naves (fig. 12.43).[67] This painting is arguably the monk's most fully realized sacred image. Marqus wears the same monastic costume as Antony, but the reduced outer cloak has now disappeared completely. The saint has

a single ringed halo that is about three times the size of his head. The circle forming his shoulders is larger than the halo by approximately a third. Throughout the project the monk used different proportions for the heads, halos, and upper bodies of his images. His painting of Marqus is a particularly interesting variation that comes much closer to depicting correct human anatomy than do many of the other figures in the Cave Church. He also conveys his new engagement with naturalism in his handling of the saint's mantle. Here the monk shows the folds in the material by using thinner, fainter, and more numerous lines than he had employed on the painting of Antony. The effect is less decorative but more naturalistic, and it indicates the painter's continuing experimentation with this quasi-illusionistic technique.

The monk concluded the painting by surrounding the saint with a green background panel that he clearly intended to suggest an apse or part of an arcade. It has a horseshoe-shaped hood resting upon a lower rectangular niche. The simplicity of the design combined with its careful execution makes this one of the monk-artist's most successful attempts at framing his sacred images. In fact, everything about this painting indicates that he had made a major breakthrough in both style and technical ability. Such a judgment is not dependent solely on the painter's use of naturalistic effects. I am not suggesting that the traces of illusionism in the monk's later paintings signify an improvement in his style. The superiority of the images from the second phase is the result of increased confidence and technical expertise, a greater attention to detail, and a more experimental approach that includes, but is not dependent on, the use of seminaturalistic details. I regard the image of Marqus as one of the monk's best paintings because of the carefully considered proportions, the elegance of its lines, and the balance of the color scheme. Johann Georg, visiting the monastery in 1930, shared my opinion. He was so impressed by the image that he attributed it to a medieval program or even to one from late antiquity. Most of other eighteenth-century paintings, however, he dismissed as "truly hideous frescoes."[68]

'Abd al-Sayyid produced what was probably his last Coptic inscription in the church directly above the painting of Marqus.[69] He divided it into five lines written in red on the white plaster: "Hail, our holy father Anba Marqus, son of Antony." The scribe repeated more or less the same formula he had used with Macarius. He miscalculated the positioning of the text and was obliged to conclude three of the lines on the adjacent wall. The eighteenth-century epigraphist used Coptic in the lower part of the church only twice, when identifying Macarius and Marqus. If my theory is correct that both date to the very end of the project, then 'Abd al-Sayyid maintained his involvement in the creation of the Cave Church program for its entire duration.

The Unrealized Paintings in the Haykal of the Twenty-Four Elders

The iconographer and painter clearly intended to extend the project onto the lower walls of the Haykal of the Twenty-Four Elders. The monk-painter marked the north wall with eleven parallel guidelines that he obviously intended as the first step in the creation of a row of standing saints (see fig. 11.24). The placement of the lines shows that he had already determined the size and proportions of the figures, and that 'Abd al-Sayyid had chosen the iconographic subject matter as well. The painter appears to have been on the verge of starting a new cycle of images, but before he could apply his compass to the first saint, something caused the cessation of the project. We can only regret that the monk, apparently at the height of his powers, was unable to add a possible row of patriarchs next to an enthroned Mother of God as the final iconographic component in the Haykal of the Twenty-Four Elders.[70]

The artist may have been unable to continue working due to illness, death, or any number of less tragic reasons. He worked in the Dome of the Martyrs in 1712/1713 and illustrated 'Abd al-Sayyid's psalmody in 1715. He could have produced his final series of monastic saints in the intervening years or even somewhat later. In my previous chapter I suggested that the decision to resume painting the church may have been connected to Murjan's elevation to the patriarchal throne in 1718. Although there is no evidence for such an assumption, it seems possible that the project was still going on five years after the completion of the Dome of the Martyrs.

The sudden departure of Murjan, who was taken to Cairo to become the next patriarch, is the only major change in the monastic community at this time about which we have information.[71] It is even possible that Murjan was himself the monk-painter, and that he was forced to abandon the project to become Pope Peter VI. A less spectacular explanation, but one that is perhaps more likely, is that the painter of the Cave Church was simply a monk at St. Paul's who stopped painting, for reasons unknown, sometime after 1715. If one of the monks in the monastery fell ill or died, it is conceivable that the event was never recorded.[72] We do not know enough about the

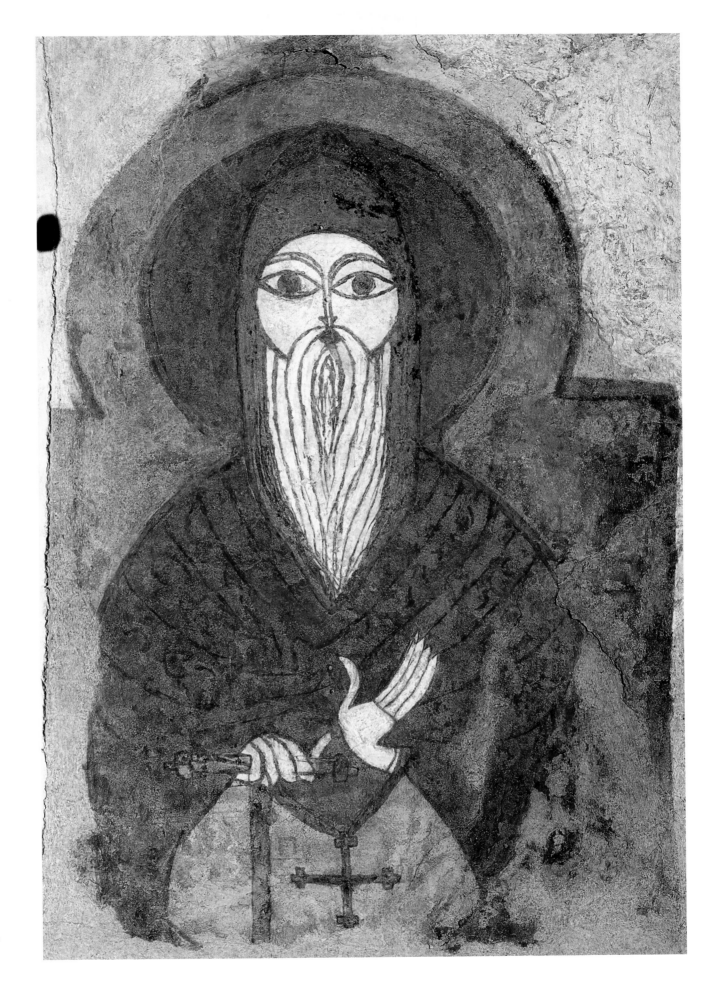

FIGURE 12.43

Marqus al-Antuni (B10). ADP/SP
207 S5 5 05.

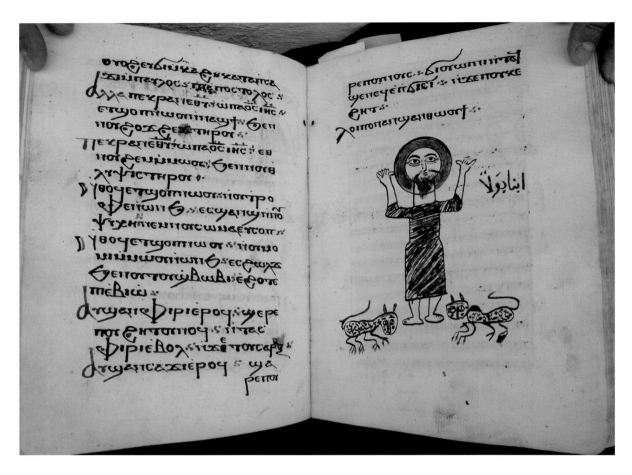

FIGURE 12.44

Paul the Hermit, early nineteenth-
century manuscript in the library of
the Monastery of St. Paul. Courtesy
of Father Yuhanna al-Anba Bula
and the Monastery of St. Paul.

individual members of the community in the first quarter
of the eighteenth century to provide explanations as to why
one anonymous monk stopped painting. ʿAbd al-Sayyid,
however, remained in the monastery for another eight years
before becoming the next patriarch. The fact that he spent
nearly a decade at the monastery without completing the
Cave Church program is probably the strongest evidence
that he was not the monk-painter. On the other hand, he
may have had new responsibilities brought on by Murjan's
departure that prevented his further involvement.

Conclusion: The Significance of the Cave Church Program

Most western scholars have regarded the eighteenth-cen-
tury paintings in the Cave Church as being not only bad art
but irrelevant to the development of Coptic art history. The
program's chief importance, according to van Moorsel, was
the evidence it provided of the lost medieval paintings in
the church.[73] One can understand this position. The naïve
style of the artist never inspired a school of painters, al-
though later monks at the Monastery of St. Paul did occa-
sionally copy it in manuscript miniatures (fig. 12.44).[74] The
tradition of creating monumental wall paintings in Egyp-

tian churches was not revitalized after the completion of the
Cave Church program. In fact, it was not until the twentieth
century that such wall paintings were once again widely
produced in Coptic churches.[75] In the eighteenth century,
most Coptic sacred art was generated in the more portable
form of icons.[76] The best-known school of icon painters of
the period, as well as the most prolific, was that of Ibrahim
al-Nasikh and Yuhanna al-Armani, who formed a partner-
ship a full thirty years after the completion of the Dome of
the Martyrs.[77] Even the location of the Cave Church paint-
ings in one of the most remote monasteries in Egypt adds
to the impression that the whole project was a bizarre folly,
albeit one inspired by unquestionable faith and determina-
tion. As for the monk-painter, van Moorsel spoke for many
when he asserted that he was clearly no artist.[78]

Ultimately, any aesthetic appraisal of the work of
the monk-painter must be based on personal taste. The
painter's own objective, however, was surely not to create
art but to fill the Cave Church with devotional images, a goal
he certainly fulfilled. As a producer of religious paintings he
was an unqualified success. His martyrs, monks, and angels
are easily identifiable. They are large and colorful enough to
be imposing, and provided with sufficient individual details

to give them special authority. The monk's figures may be categorized as naïve or even dismissed as grotesque caricatures, but they have a strong spiritual presence, which has once more been fully revealed by the conservation of the Cave Church. The cleaned paintings also indicate that the monk-painter was an artist of real talent with marked organizational skills, abundant self-confidence, and what appears to have been a strong reverence for sacred images. His self-taught style, however, is considerably less important than the fact that the Cave Church project was undertaken in the first place. By the early eighteenth century, no living tradition of wall painting had existed in Egypt for over three hundred years, while the production of icons seems to have been restricted to the work of pious amateurs. Yet at this same time a small group of monks at the Monastery of St. Paul devised an elaborate iconographic program and painted it on the walls of their church.

The reestablishment of the Monastery of St. Paul was the most notable of many building projects during the reign of John XVI. The new monastery had the support not only of the patriarch but also of the leading archons of Cairo, whose successors were to take an active interest in St. Paul's for the rest of the century. The monks chosen to populate the monastery appear to have been an exceptional group of men—witness the presence of Murjan, 'Abd al-Sayyid, and the monk-painter.[79] The Monastery of St. Paul was geographically isolated, but the residing monks were obviously closely connected to the religious and secular leadership of the Coptic community. Seen in this light, the painting of the Cave Church was certainly not the whim of a few monks relegated to a social backwater but the work of dedicated and influential members of the ecclesiastical hierarchy.

The creation of the iconographic program of 1712/1713 was possibly only the most ambitious, or best surviving, of a number of attempts to revitalize the then moribund tradition of Coptic sacred art.[80] Coptic churches are known to have possessed numerous paintings of saints before the reign of John XVI. Johann Wansleben, who was in Egypt three years prior to John's election, wrote that Coptic churches "have many images in the Greek style, panels of flat painting; and many of their churches are completely ornamented with stories, which, however, are represented very crudely."[81] Although this remark is open to interpretation, I think Wansleben was distinguishing between imported icons by professional workshops and locally produced icons painted by self-taught artists.[82] Mat Immerzeel has observed that icon production flourished in the seven-

teenth century among the Melkite Christians of Ottoman-controlled northern Syria.[83] The priest Yusuf al-Musawwir, or Joseph the Painter, founded the School of Aleppo that was active from at least 1645.[84] His atelier drew upon the icon tradition of Crete, which before its conquest by the Ottomans in 1699 was the "hub of a great intermingling of Western and Eastern Christian representations."[85]

Other workshops, active in Ottoman Palestine, specialized in producing icons for pilgrims visiting Jerusalem. One of the best document types of pilgrims' souvenirs is the *proskynetarion*, a map-icon of the Holy Land.[86] The earliest known example dates from 1704.[87] It is not inconceivable that the proskynetarion now displayed as an icon in the Church of the Holy Apostles at the Monastery of St. Antony was donated by John XVI following his pilgrimage to Jerusalem in 1709.[88] The lucrative pilgrimage market caused the local Palestinian icon industry to grow into one of the strongest in the region.[89] Many Coptic pilgrims appear to have donated icons purchased in Jerusalem to churches and monasteries. The icon collection of the Monastery of St. Paul includes a number of icons in a post-Byzantine style, many of which were probably produced in Jerusalem in the eighteenth and nineteenth centuries.[90]

The widespread construction of churches under John XVI, and the prevailing atmosphere of religious tolerance, must have resulted in an acute need for more icons throughout Egypt that local amateurs and foreign imports could not fill. According to current scholarly belief, the demand was only satisfied in the middle of the century by the workshop of Ibrahim al-Nasikh and Yuhanna al-Armani.[91] These painters often signed and dated their icons, which makes them stand out from the general confusion of anonymously produced works of this period. We know that Coptic icons were painted in the first half of the eighteenth century, but they were rarely signed or dated, which makes them difficult to place in a chronological sequence.[92]

Historical circumstances in the half century before the establishment of Ibrahim and Yuhanna's partnership warrant closer examination than they have thus far received, for an appreciation of the eighteenth-century revival of professional icon production in Egypt. In 1703, John XVI undertook the rituals necessary for preparing the holy mayrun, which had not been carried out for almost two and a half centuries.[93] Mayrun is the oil used in the Coptic Church to consecrate churches, altars, and—significantly—also icons.[94] Two years later the patriarch and Jirjis Abu Mansur al-Tukhi donated twenty-six icons to the Monastery of St. Paul that still surmount the two haykal screens they

installed in the Cave Church.[95] The icons are painted in a self-taught style by an artist who was nevertheless capable of producing a series of uniform and recognizable subjects (fig. 12.45). He worked in a technique that has similarities to that of the monk-painter, although he appears to have had a slightly better understanding of human anatomy, and a more refined repertoire of decorative motifs. His figures have round or oval heads resting on bulky, bullet-shaped bodies with projecting elbows. They usually place their hands in front of their torsos, and they display simplified feet emerging from beneath the hems of their long robes. The basic shape of each figure is close enough to the monk-painter's method of depicting standing saints to suggest that these icons were as much a source of inspiration to him as was the medieval program of Theodore at the Church of St. Antony.

The haykal screen icons of 1705 demonstrate the existence of Coptic painters of sacred images at the very beginning of the eighteenth century. They also confirm Wansleben's observation that Coptic churches, at that time, contained sacred images painted "very crudely." It is significant that even the patriarch had to rely on self-taught painters to provide icons for his personal commissions. Yet the rising demand for icons very likely led to the creation of proto-workshops even before the death of the patriarch in 1718. The Cave Church icons may even be the product of such an early establishment.[96]

John XVI was succeeded as patriarch by Murjan under the name of Peter VI (1718–1726), who in turn was followed by 'Abd al-Sayyid as John XVII (1726–1745).[97] Early in John XVII's reign a new church was built at the Monastery of St. Paul dedicated to St. Michael the Archangel and

St. John the Baptist. In 1732, the patriarch traveled to the monastery in the company of the great archon Jirjis Abu Yusuf al-Suruji in order to consecrate the church.[98] Their procession through the desert is reminiscent of the similar visit to St. Paul's undertaken by John XVI and Jirjis Abu Mansur al-Tukhi twenty-seven years before. The patriarch and archon followed the example of their predecessors by donating to the new church two haykal screens that are each surmounted by a row of seven icons.

These icons show a greater technical proficiency than the ones donated in 1705. Van Moorsel refers to them as "high-quality paintings," in contrast to the earlier eighteenth-century images found in the Cave Church.[99] The painter of the 1732 icons depicted seated apostles, in groups of two, above the screen of the Haykal of St. John the Baptist, and pairs of standing saints over the screen of St. Michael (fig. 12.46). The central images of the two rows depict the Baptism of Christ and the Virgin and Christ child (fig. 12.47). Father Pigol al-Souriany has identified the painter, thanks to a signed triptych of four monastic saints in the Monastery of the Syrians, where the artist refers to himself as "the humble Mattary."[100]

Van Moorsel and Immerzeel have noted that a great number of icons by Mattary are found throughout Egypt, "in the Coptic Museum, in several churches in Old Cairo, in both Red Sea Monasteries, and in all the Monasteries of the Wadi 'n Natrun, except (perhaps!) Baramous," as well as in other sites in Upper Egypt.[101] There can be little doubt that Mattary was a professional painter, perhaps associated with a workshop, who produced a wide range of icons for some of the most prominent churches and monasteries in Egypt. Van Moorsel and Immerzeel have suggested

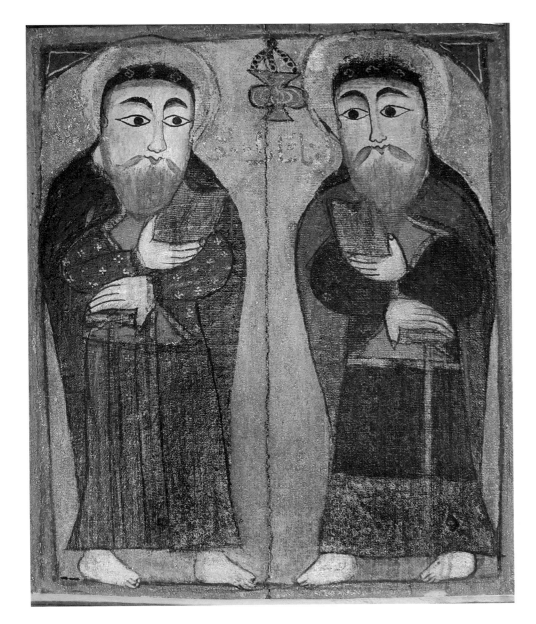

that Mattay was an Armenian, judging from his depiction of priests wearing the Armenian priestly headdress, the *vakkos*.[102] If so, he may have been from Jerusalem, which would make him a member of the same community as his younger contemporary, Yuhanna al-Armani al-Qudsi ("the Armenian of Jerusalem").[103] The presence of a foreign-trained professional artist in Egypt, circa 1732, would certainly explain what appears to be a leap in the development of icon production since the creation of those donated to the Cave Church in 1705. Compared to the earlier paintings, the works of Mattary and his possible school are more sophisticated in both style and iconographic content. His large icon of George, in the Monastery of St. Mercurius in Old Cairo, features narrative figures, as well as explanatory and dedicatory inscriptions in an elegant Arabic script placed in bands or cartouches (fig. 12.48). Mattary employed a much wider range of materials than were used in the earlier icons, including gold leaf for backgrounds and silver foil for details.[104] He also produced icons in varying sizes, presumably according to the requirements of his patrons. All of these features anticipate the paintings of Ibrahim al-Nasikh and Yuhanna al-Armani by at least a

FIGURE 12.46 ABOVE

Icon of two standing saints by
Mattary, 1732. Haykal screen of
St. Michael the Archangel, Church
of St. Michael and St. John,
Monastery of St. Paul.

FIGURE 12.47 RIGHT

Icon of the Virgin and Christ child
by Mattary, 1732, Haykal screen of
St. Michael the Archangel, Church
of St. Michael and St. John,
Monastery of St. Paul.

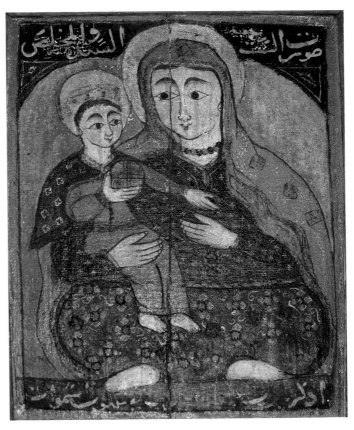

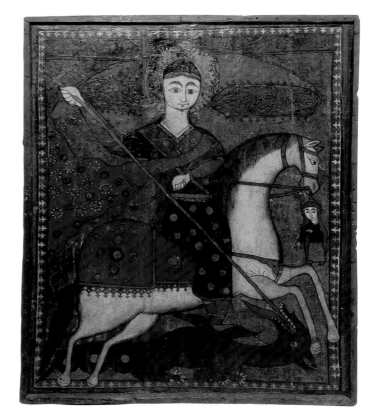

FIGURE 12.48

Icon of George by Mattary,
Church St. Mercurius, Monastery
of St. Mercurius, Old Cairo. EG 37
S901 99.

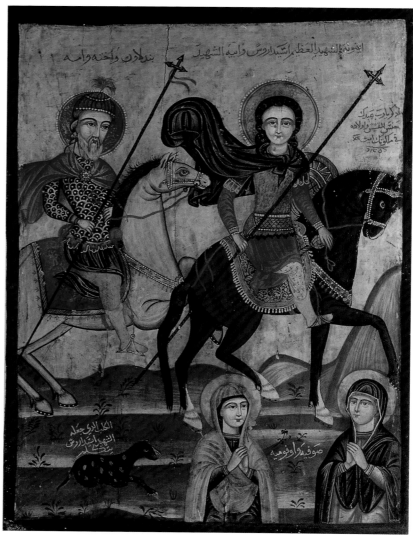

FIGURE 12.49

Icon of Isidore and his family of
martyrs by Ibrahim al-Nasikh and
Yuhanna al-Armani, 1744/1745 (AM
1461), Church of St. Menas, Fumm
al-Khalig, Cairo. The dog that
Isidore "caused to speak" is at the
lower left. EG 6 S927 99.

FIGURE 12.50

Dog of Isidore (A10). ADP/SP 11
S1186 02.

decade.[105] There is also evidence that Mattary illuminated manuscripts. Two miniatures of an equestrian Menas, in separate codices in the libraries of the monasteries of St. Macarius and of the Syrians, are clearly the work of Mattary or his school.[106] Such a prolific body of work further suggests the existence of a large and discerning clientele in the 1730s that we know included John XVII.

Mattary was presumably already active during the reign of John XVII's predecessor, Peter VI.[107] In a similar manner, the workshop of Ibrahim al-Nasikh and Yuhanna al-Armani was established late in the life of John XVII but enjoyed its greatest period of productivity during the reigns of Mark VII (1745–1769), the last of the St. Paul patriarchs, and his successor, John XVIII (1769–1796), a former monk of the Monastery of St. Antony. It should also be mentioned that a promising young scribe named Ibrahim al-Jawhari began his illustrious career working for both of these later patriarchs.[108] As the greatest of all archons, he always showed a special concern for the desert monasteries of St. Antony and St. Paul.[109]

Ibrahim al-Nasikh, "one of the symbols of Coptic culture," had a long association with John XVII, as Mark Swanson has demonstrated in Chapter 2.[110] He worked at Harat al-Rum, near the patriarchal compound, and is known to have been employed by the patriarch on a number of occasions. Ibrahim accompanied John XVII to the Monastery of St. Paul in 1732 and recorded the proceedings in a manuscript now in the monastic library.[111] During his visit Ibrahim must have seen the icons by Mattary, whom he may have known personally. More important, he would also have seen the paintings in the Cave Church, and perhaps heard stories of their creation from the patriarch himself.

Ten years later, in 1742, Ibrahim painted his first known icon with Yuhanna, by which time John XVII had only three years left to live. In the year of his death, the workshop of Ibrahim and Yuhanna produced an icon of Isidore and his family of martyrs that includes the talking dog from one of the saint's miracles (fig. 12.49). This is not a common iconographic motif, but it had been used in the Cave Church program thirty-two years before (fig. 12.50). Ibrahim conceivably copied the dog from the painting in the Dome of the Martyrs. He also appears to have followed the iconography of the Cave Church later in his career when he included the bedouin camel herder in two icons of Iskhirun (fig. 12.51).[112] This narrative detail, possibly first devised at the Monastery of St. Paul, became a standard

FIGURE 12.51

Icon of Iskhirun by Ibrahim
al-Nasikh, ca. 1742–1783, Church
St. Mercurius, Monastery of
St. Mercurius, Old Cairo. EG 5
S901 99.

element in icons of the saint until at least the nineteenth century.[113] The depiction of James the Persian without legs in the Cave Church also anticipates other eighteenth-century icons by the workshop of Ibrahim al-Nasikh and Yuhanna al-Armani. In one, the saint is shown whole, but his severed limbs are heaped beneath his horse (fig. 12.52).

'Abd al-Sayyid belonged to a select group of secular and religious leaders who nurtured the rebirth of Coptic

visual culture in the first half of the eighteenth century. As a monk he participated in the painting of the Cave Church; as patriarch he was a patron of icon painters in Egypt. After a life dedicated to the veneration of sacred images, it is unfortunate that John XVII died just as Coptic sacred art was entering one of its most productive periods. Perhaps Ibrahim's inclusion of Isidore's talking dog was an appropriate final tribute to the patriarch in the year of his

FIGURE 12.52

Icon of James the Persian
by Yuhanna al-Armani, ca. 1742–
1783, Church of the Virgin
(al-Muʿallaqa), Old Cairo. EG 32
S914 99.

death. The creation of the Cave Church program was a groundbreaking phase of a much wider quest for professionally produced sacred images in the Coptic community. The paintings of 1712/1713 were created by amateurs in what appears to have been almost a cultural vacuum. Yet, by the end of ʿAbd al-Sayyid's life, iconographic motifs from the Cave Church program were being quoted by a new generation of professional icon painters.

CHAPTER **13** THE COPTIC AND ARABIC INSCRIPTIONS
IN THE CAVE CHURCH

FIGURE 13.1

Coptic and Arabic inscriptions
in the drum and lower dome of
the narthex (A10b, A4c, A4, A4a),
1712/1713. ADP/SP 1 S1186 02.

The inscriptions in the Cave Church at the Monastery of
St. Paul were subjected to scholarly scrutiny as early as the
beginning of the last century.[1] In the second half of the
twentieth century, Otto Meinardus and Jules Leroy dealt
with some of the texts. Paul van Moorsel's publication of
the paintings of the Cave Church in 2002 included all the
Coptic and Arabic texts that he and his assistants could
discern.[2] Recent conservation campaigns in the church
by ARCE have made it possible to reexamine and collate
many of the previously published texts. The work has also
brought some new inscriptions to light (fig. 13.1).

The majority of the inscriptions in the Cave Church
date to the early eighteenth century, when three rooms,
the narthex (A), the northern nave (B), and the Haykal of
the Twenty-Four Elders (C), were added to the existing
structure along its northern side. At that time, the Cop-
tic and Arabic texts were inscribed by 'Abd al-Sayyid al-
Mallawani, a monk at the monastery who became Patriarch
John XVII (1726–1745). He can be identified as the writer
because a psalmody he copied, preserved in the library of
the monastery, shows the same peculiarities of his hand,
such as writing the Coptic letter sigma (**C**) with a point in
the middle of its opening.[3] This form occurs in a variety of
inscriptions on the walls—for example, in the double-lined
foundation inscription (A4) in the dome of the narthex and
the draft text of the same inscription (A4a). The dotted
sigma is also used in inscriptions associated with some of
the painted figures, such as the texts identifying Theodore
Stratelates (A2a) in the narthex, on the scroll held by Christ
in Majesty (C10a) in the Haykal of the Twenty-Four Elders,
and within the halo of Macarius (G3a) in the Shrine of St.
Paul.[4] Analysis of the eighteenth-century Coptic and Arabic

inscriptions clearly shows that the texts, as well the program
for the paintings, in the three rooms added to the church in
the eighteenth century are based on the psalmody.[5] Some
of the Coptic texts represent a translation from the Arabic,
such as the title "Master" and the personal name "Rahma-
tallah" (A4).

A number of Coptic and Arabic texts dating to the
mid-twentieth century are inscribed on the haykal screen of
the Twenty-Four Elders (B8a–b), the haykal screen of St.
Antony (D3a–b), and on the cenotaph of St. Paul (G5a–b).
The Coptic inscriptions of both the eighteenth and the
twentieth centuries are written in the Bohairic dialect, and
some epitomize artificial Coptic. This dialect, which be-
came the official ecclesiastical language beginning in the
eleventh century, had ceased to be a truly living language
scarcely a century thereafter. It survived in succeeding cen-
turies in monasteries as a religious language, and perhaps as
a means of communication within and between monaster-
ies, despite its artificiality. Therefore, it would serve little
purpose to discuss the grammar or orthography of these
inscriptions. The Arabic inscriptions also contain some
errors, which are not corrected below.

An asterisk designates the medieval Coptic inscrip-
tions in the earlier rooms of the church, the central nave
(D), the Haykal of St. Antony (E), the corridor (F) and
the Shrine of St. Paul (G). One of them (E11) contains the
date AM 1008 (1291/1292) (fig. 13.2). Van Moorsel read this
date as AM 1050 (1333/1334).[6] The dating system employed
is based on the principle of attaching numerical value to
letters of the Coptic alphabet.[7] For example, an ita (**H**)
represents the number 8; a ni (**N**) is 50; and an alpha (**Ⲁ**)
marked with two parallel supralinear strokes is used for

FIGURE 13.2

Detail of the date AM 1008 (1291/
1292) (E11). ADP/SP 5 S249 05.

1,000. The inscription in question was read by van Moorsel as ⲁ (with two strokes) plus ⲛ, or 1000 + 50 = AM 1050 (1333/1334). In his published drawing of this inscription, by Pierre-Henry Laferrière, the alpha is surmounted by two strokes and the ni is shown as the same size, positioned below.[8] After the cleaning of the inscription, however, it is clear that the alpha is surmounted by only one stroke, and the second number-letter is much smaller and has been squeezed between the legs of the alpha due to lack of space. Although the second number-letter is partially damaged, it can be confidently identified as an ita. The date, therefore, should be read as ⲁ (with one stroke) plus ⲏ, or 1000 + 8 = AM 1008 (1291/1292).

However, other Coptic inscriptions at the Monastery of St. Paul may be considerably older. Pierre du Bourguet published a photograph of a dated funerary text inscribed on a wall, which he read as AM 870 (1153/1154). Unfortunately, the reproduction of the photograph is not adequate to allow verification of the date. Nor did du Bourguet note its location within the monastery.[9] Most of the medieval inscriptions are very short, and a number of them are fragmentary. They usually identify the figures in the paintings. Three inscriptions found in the central nave and the Haykal of St. Antony are of a narrative character (D2a, D19c, E7a–b, E8a). The text above the painting of the Virgin Mary, the Christ child, and two cherubim (D19c), for example, reads "The cherubim are praising the king, the Christ." The fragmentary texts associated with the painting of the Annunciation (E7a–b, E8a) retell the story according to the Gospel of Luke. The person or persons who wrote the texts employed Bohairic but sometimes neglected to include one or more letters, as in the inscription above the three Hebrews (D2a), where the genitive ⲛ or ⲙ between ⲡⲁⲅⲅⲉⲗⲟⲥ (the angel) and ⲡⲟ̄ⲥ (the lord) is missing, and the letter ⲧ is omitted before ⲱⲟⲩ (glorify).

At least seven examples of medieval or early modern European graffiti are scratched into the lower part of west wall of the central nave (D1b), underneath the eighteenth-century paint layer depicting the archangels Michael, Gabriel, and Raphael. Georg Schweinfurth recorded one of these graffiti in the nineteenth century; subsequently a number of them were published by Meinardus in 1966. Detlev Kraack, who visited the site in 1993, has shown that none of the fragmentary inscriptions dealt with by Meinardus can be reconstructed to yield a legible text.[10] As both Meinardus and Kraack have pointed out, many European nobles visited Egypt in the fourteenth, fifteenth, and sixteenth centuries in connection with pilgrimages to the Holy Land.[11] Western pilgrims who visited the Monastery

of St. Paul were considerably fewer than those who made the journey to the Monastery of St. Antony at the same time.[12] The western graffiti in the Cave Church, including those recently discovered, are now available to specialists for study.

In the texts and the translations that follow, [square brackets] are used when it is necessary to indicate a lacuna where writing once existed; {curly brackets} surround letters or words omitted by the writer. Translations are rendered so as to be understandable for the general reader; specialists will easily recognize errors in the Coptic or Arabic inscriptions.

THE INSCRIPTIONS

Narthex

STAIRWELL

A1. Victor (west wall)[13]

A1a. ⲡⲓⲛⲓϣϯ ⲁⲡⲁ ⲃⲓⲕⲧⲱⲣ
The great martyr Apa Victor

A1b. الشهيد العظيم ماري بقطر
The great martyr St. Victor

A2. Theodore Stratelates (north wall)[14]

A2a. ⲡⲓⲛⲓϣϯ ⲑⲉⲟⲇⲟⲣⲟⲥ ⲡⲓⲥⲧⲣⲁⲧⲓⲗⲁⲧⲏⲥ ⲡϣⲏⲣⲓ ⲛ̄ⲓⲱⲁ

The great martyr Theodore Stratelates, son of John

A2b. الشهيد العظيم تاودوروس
The great martyr Theodore

A2c. Arabic graffito

اذكر يا [رب]

O [God], remember…

A3. George (north wall)[15]

A3a. ⲡⲓⲛⲓϣϯ ⲡⲁⲟ̅ⲥ̅ ⲡⲟⲩⲣⲟ ⲅⲉⲱⲣⲅⲓⲟⲥ
The great martyr, my master the king, George[16]

A3b. الشهيد العظيم سيدي الملك ماري جرجس
The great martyr, my lord the king, St. George,

DOME

A4. Foundation inscription (see fig. 13.1)
ⲭⲣⲟⲛⲟⲥ ⲛⲕⲱⲧ ⲛⲧⲁⲓⲉⲕⲕⲗⲏⲥⲓⲁ ⲛⲣⲟⲙⲡⲓ ⲛϣⲟ̅ⲩ̅ⲧⲕ̅ⲑ̅
ⲙⲡ̅ ⲉⲑ̅ⲩ̅ ⲉϥⲉⲥⲁϧⲛⲓ ⲙⲡⲟ̅ⲥ̅ ⲙⲡⲟⲩⲥⲙⲟⲩ ⲁⲙⲏⲛ
ⲡⲓϥⲁⲓⲣⲱⲟⲩϣ ⲛⲧⲁⲓⲉⲕⲕⲗⲏⲥⲓⲁ ⲡⲉⲛⲓⲱⲧ ⲉⲧⲧⲁⲓⲏⲟⲩⲧ

ⲛⲁⲣⲭⲏⲉⲣⲉⲩⲥ ⲡⲁⲡⲁ ⲁⲃⲃⲁ ⲓ̅ⲱ̅ⲁ̅ ⲡⲓⲣⲉ̅ⲧ̅ ϧⲉⲛ ⲧⲟⲩⲏⲡⲓ
ⲛⲛⲓⲟϯ ⲙⲡⲁⲧⲣⲓⲁⲣⲭⲏⲥ ⲉϥ ⲁⲙⲏⲛ ⲛⲍⲉ ⲡ̅ⲟ̅ⲥ̅ ⲙⲡⲉϥⲱⲛϧ
ⲛⲟⲟϥ ⲛⲉⲙ ⲡⲓⲣⲉϥϯⲥⲃⲱ ⲅⲉⲟⲣⲅⲓⲟⲥ ⲛⲉⲙ ⲡⲓⲣⲉϥϯⲥⲃⲱ
ⲟⲙⲉⲧⲛⲁⲏⲧ ⲙⲫϯ ⲛⲉⲙ ⲁⲣⲭⲱⲛ ⲛⲓⲃⲉⲛ ⲙⲙⲁⲓ ⲉⲡ̅ⲭ̅ⲥ̅ ⲛⲉⲙ
ⲡⲁⲗⲟⲥ ⲙⲡ̅ⲭ̅ⲥ̅ ⲫϯ ϣⲉⲃⲓⲟ ⲛⲱⲟⲩ ⲟⲙⲉⲧⲟⲩⲣⲟ ⲛ̄ⲓⲫⲏⲟⲩⲓ
ⲁⲙⲏⲛ

{The} date of the construction of this church is the year 1429 [1712/1713] of the Holy Martyrs; may God grant their blessing, amen. The one who provided for this church is our honorable father and high priest, Pope Anba John, the one hundred and third in the number of the fathers, the patriarchs, amen.[17] May God {protect} his life with the master Jirjis and the master Rahmatallah and every Christ-loving archon[18] and the people of Christ. May {God} recompense them {in} the kingdom of heaven.[19]

A4a. Preliminary foundation inscription (see fig. 13.1)
The same text as A4, except that a small part is covered by the figure of Victor.

A4b. Explanatory inscription (beneath A6–A7)

يا قاري هذا هو بدو القبطي

O Reader, here begins the Coptic!

A4c. Arabic graffito (beneath A10, see fig. 13.1)

اذكر يا رب عبدك الخاطي القمص عبد المسيح الانبا بولى
في ملكوتك

Remember, O Lord, your sinful slave, Hegumenos ʿAbd al-Masih of the Monastery of St. Paul in your kingdom.

A5. Iskhirun (Abiskhirun) of Qalin[20]

A5a. ⲡⲓⲙⲓ̈ ⲁⲡⲁ ⲥⲭⲣⲓⲟⲛ
The martyr Apa Iskhirun

A5b. الشهيد العظيم ابوسخيرون
The great martyr Abiskhirun

A6. James the Persian[21]

A6a. ⲡⲓⲙⲓ̈ ⲓⲁⲕⲱⲃⲟⲥ
The martyr James

A6b. الشهيد العظيم ماري يعقوب الفارسى
The great martyr St. James the Persian

A7. Menas[22]

A7a. ⲡⲓⲙⲓ̈ ⲁⲡⲁ ⲙⲓⲛⲁ
The martyr Apa Menas

A7b. الشهيد العظيم ماري مينا العجايبي
The great martyr St. Menas, the worker of miracles

A8. Julius of Aqfahs[23]

A8a. ⲠⲓⲘⲀ ⲒⲞⲨⲖⲒⲞⲤ

The martyr Julius

A8b. الشهيد العظيم يوليوس الاقفاصي

The great martyr Julius of Aqfhas

A9. Abadir and Ira'i[24]

A9a. ⲠⲓⲘⲀ ⲔⲨⲢⲒ ⲀⲠⲀⲦⲎⲢ

The martyr, Master Abadir

A9b. الشهيد العظيم السيد ابادير والشهيدة العظيمه السيده ايرايي اخته

The great martyr, the lord Abadir, and the great martyr, the lady Ira'i, his sister[25]

A10. Isidore

A10a. ⲠⲓⲘⲀ ⲎⲤⲒⲆⲎⲢⲞⲤ

The martyr Isidore

A10b. الشهيد العظيم اسيداروس ابن بندالاون

The great martyr Isidore, son of Bandalawn[26]

Northern Nave

WEST WALL

B1. Cyriacus[27]

B1a. الشهيد العظيم قرياقوس

The great martyr Cyriacus

B2. Julitta[28]

B2a. الشهيده يوليطا

The martyr Julitta

B3. Raphael (northwest squinch)[29]

B3a. ⲬⲈⲢⲈ ⲢⲀⲪⲀⲎⲀ ⲠⲒⲤⲀⲖⲠⲒⲤⲦⲎⲤ

Hail, Raphael, the trumpeter

B3b. السلام لرافائيل ريس الملايكه

Hail to Raphael, the archangel

NORTH WALL

B4. Sarapion

B4a. يا اولادي اهربوا من الداله لان سبب خراب نفس الراهب هو الضحك والداله

O my sons, flee familiarity, for the cause of the ruin of the monk's soul is laughter and familiarity.[30]

B4b. انبا سرابيون الاسقف

Anba Sarapion, the bishop

B4c. تلميذ القديس انطونيوس

Disciple of St. Antony

B5. Antony[31]

B5a. القديس العظيم {اذ}طونيوس

The great St. Antony

B5b. Inscription formed by mashrabiyya window grill

يا الله الخلاص

Salvation, O God!

B6. Paul the Hermit[32]

B6a. القديس العظيم انبا بولا اول السواح

The great St. Anba Paul, the first hermit

B7. Michael (northeast squinch)[33]

B7a. ⲬⲈⲢⲈ ⲘⲒⲬⲀⲎⲀ ⲠⲒⲚⲒϢϮ ⲠⲒⲈⲢⲬⲎⲀⲅⲅⲈⲖⲞⲤ

Hail, Michael, the great archangel

B7b. السلام لميخايل ريس الملايكه

Hail to Michael, the archangel

EAST WALL

B8. Haykal screen of the Twenty-Four Elders

B8a. Donor inscription (1950)

ⲬⲈⲢⲈ ⲠⲒⲈⲢⲪⲈⲒ ⲚⲦⲈ ⲪⲚⲞⲨϮ ⲪⲒⲰⲦ ⲠⲒϨⲎⲔⲒ ⲚⲦⲈ
ⲪϮ ⲞⲨ ⲀⲢⲤⲈⲚⲒⲞⲤ Ⲃ̄ ⲞⲨⲈⲠⲒⲤⲔⲞⲠⲞⲤ ⲚⲦⲈ ⲠⲒⲀⲂϨⲎⲦ:
ⲠⲒⲐⲘⲎⲒ ⲀⲂⲂⲀ ⲠⲀⲨⲀⲈ

Hail, the temple of God the father. The poor one before God, Arsaniyus II, bishop of the Monastery of the righteous Anba Paul.

B8b. Donor inscription (1950)

السلام لهيكل الله الاب برسم الاربعة وعشرين قسيس الروحيين المهتم بهذا الفقير لله ارسانيوس الثاني اسقف دير البار انبا بولا ١٦٦٦ ش ١٩٥٠ م عوض يا رب من له تعب الصانع المعلم نجيب واصف البوشي

Hail to the temple of God the father, dedicated to the twenty-four spiritual priests. The one who provided for this {screen} is the poor one before God, Arsaniyus II, bishop of the Monastery of Anba Paul: AM 1666, AD 1950. Compensate, O Lord, he who has toiled. The one who made it, Master Naguib Wassef of Bush.

B8c. Donor inscription (1705)

ارفعوا ايها الملوك ابوابكم إرتفعي ايتها الابواب الدهرية
ليدخل ملك المجد من هو ملك المجد الرب العزيز القوي هو
ملك المجد وذلك من اهتمام السيد الاب البطريرك ابينا انبا
يوانس ادام الله حياته والمخاديم الكرام المعلم جرجس
والمعلم لطف الله عوضهم يا رب امين

Lift up your doors, O you kings! And be lifted up, you everlasting doors!
And the king of glory shall come in. Who is the king of glory? The strong
and mighty Lord is the king of glory.[34] The patriarch, our father Anba John,
provided for this {haykal screen}. May God extend his life and that of the
honorable servants, the master Jirjis and the master Lutfallah. Compensate
them, O Lord! Amen.

B8d. Thirteen icons at top of haykal screen, nine origi-
nals (1705) and four modern replacements. Only
two original icons have legible inscriptions (listed
from north to south).

III. يعقوب ابن حلفه

James, son of Alphaeus

VIII. القديس...

Saint…

FIGURE 13.3
Donor inscriptions on the haykal
screen of St. Antony (D3a, D3b, D3c),
1705 and 1951. ADP/SP 2 S1194 05.

B9. Entrance of the Haykal of the Twenty-Four Elders[35]
ⲭⲉⲣⲉ ⲡⲓⲉⲣⲫⲉⲓ ⲛⲧⲉ ⲫϯ ⲭⲉⲣⲉ ⲡⲓⲙⲁ ⲛⲉⲣϣⲱⲟⲩϣⲓ
ⲉⲑⲩ ⲭⲉⲣⲉ ⲡⲓⲙⲁ ⲛ̀ⲭⲁⲛⲟⲃⲓ

Hail, the temple of God. Hail, the holy sanctuary. Hail, the place of
forgiveness.

B9a. Decorative medallion
ⲓ̅ⲏ̅ⲥ̅ ⲡ̅ⲭ̅ⲥ̅ ⲑ̅ⲥ̅ ⲟ̅ⲥ̅

Jesus Christ, Son of God

B10. Marqus al-Antuni[36]

B10a. ⲭⲉⲣⲉ ⲡⲉⲛⲓⲱⲧ ⲉⲑⲩ ⲁⲃⲃⲁ ⲙⲁⲣⲕⲟⲥ ⲡϣⲏⲣⲓ
ⲁⲛⲑⲟⲛⲓⲟⲥ

Hail, our holy father Anba Marqus, son of Antony

B11. Gabriel (southeast squinch)[37]

B11a. ⲭⲉⲣⲉ ⲅⲁⲃⲣⲓⲏⲗ ⲡⲓϥⲁⲓϣⲉⲛⲟⲩϥⲓ

Hail, Gabriel, bearer of good news

B11b. السلام لغبريال ريس الملايكه

Hail to Gabriel, the archangel

SOUTH WALL

B12. Eirene[38]

B12a. الشهيده العظيمه ايراني

The great martyr Eirene

B13. Marina[39]

B13a. القديس العظيمه مارينا

The great St. Marina

B14. Suriel (southwest squinch)[40]

B14a. ⲭⲉⲣⲉ ⲥⲟⲩⲣⲓⲏⲗ ⲡⲓⲉⲣⲭⲏⲁⲅⲅⲉⲗⲟⲥ

Hail, Suriel, the archangel

B14b. السلام لسوريال ريس الملايكه

Hail to Suriel, the archangel

Haykal of the Twenty-Four Elders[41]

DRUM OF DOME

C1. Three elders (west wall)

C1a. ⲛⲓⲣⲁⲏⲗ ⲝⲓⲫⲓⲏⲗ ⲟⲧⲗⲓⲏⲗ

Nirael, Xiphiel, Otliel

C2.	Three elders (northwest squinch)

C2a.	ⲡⲉⲑⲓⲑⲓⲏⲗ ⲣⲉⲇⲓⲏⲗ ⲥⲟⲩⲣⲓⲏⲗ

Pethithiel, Rediel, Suriel

C3.	Three elders (north wall)

C3a.	ⲧⲁⲇⲓⲏⲗ ⲩⲙⲛⲓⲏⲗ ⲫⲩⲗⲁⲏⲗ

Tadiel, Ymniel, Phylael

C4.	Three elders (northeast squinch)

C4a.	ⲭⲣⲉⲥⲑⲟⲩⲏⲗ ⲯⲁⲗⲁⲏⲗ ⲱⲇⲓⲑⲓⲏⲗ

Chresthouel, Psalael, Odithiel

C5.	Three elders (east wall)

C5a.	ⲁⲭⲁⲏⲗ ⲃⲁⲛⲟⲩⲏⲗ ⲅⲁⲛⲟⲩⲏⲗ

Akhael, Banouel, Ganouel

C6.	Three elders (southeast squinch)

C6a.	ⲇⲁⲑⲓⲏⲗ ⲉⲡⲇⲓⲏⲗ ⲍⲁⲣⲁⲑⲓⲏⲗ

Dathiel, Epdiel, Zarathiel

C7.	Three elders (south wall)

C7a.	ⲏⲇⲓⲏⲗ ⲑⲓⲑⲁⲏⲗ ⲓⲟⲩⲕⲟⲩⲏⲗ

Eliel, Thithael, Ioukouel

C8.	Three elders (southwest squinch)

C8a.	ⲕⲁⲣⲇⲓⲏⲗ ⲗⲁⲡⲇⲓⲏⲗ ⲙⲁⲣⲫⲁⲏⲗ

Kardiel, Lapdiel, Marphael

DOME

C10.	Christ in Majesty (fig. 13.4)

C10a.	ⲓⲏⲥ ⲡⲭⲥ

Jesus Christ

Central Nave

WEST WALL

D1.	Michael, Gabriel, and Raphael[42]

D1a.	ⲙⲓⲭⲁⲏⲗ ⲡⲓⲁⲣⲭⲏⲁⲅⲅⲉⲗⲟⲥ ⲅⲁⲃⲣⲓⲏⲗ ⲡⲓϥⲁⲓⲛⲟⲩϥⲓ…
ⲣⲁⲫⲁⲏⲗ ⲁⲗⲡϣ[ⲉ]ⲛϩⲏⲧ*

Michael, the archangel; Gabriel, bearer of good…; Raphael, the compassionate.

D1b.	Medieval or early modern European graffiti (fig. 13.5)

D2.	Three Hebrews[43]

D2a.	ⲡⲁⲅⲅⲉⲗⲟⲥ ⲡⲟⲥ ⲡⲓⲧ ⲁⲗⲟⲩ ⲁⲛⲁⲛⲓⲁⲥ ⲁⲍⲁⲣⲓⲁⲥ
ⲙⲓⲥⲁⲏⲗ ϩⲱⲥ ⲡⲟⲥ ⲱⲟⲩ ⲉⲣⲟϥ ϣⲁ ⲉⲛ[ⲉϩ]*

The angel of the Lord. The three youths, Ananias, Azarias, and Misael, praise the Lord and glorify him forever.

EAST WALL

D3.	Haykal screen of St. Antony

D3a.	Donor inscription (1951)
ⲭⲉⲣⲉ ⲡⲓⲉⲣⲫⲉⲓ ⲛⲧⲉ ⲫⲛⲟⲩϯ ⲫⲓⲱⲧ ⲡⲓϩⲏⲕⲓ ⲛⲧⲉ
ⲫⲛⲟⲩϯ ⲟⲩ ⲁⲣⲥⲉⲛⲓⲟⲥ ⲃ̅ ⲟⲩⲉⲡⲓⲥⲕⲟⲡⲟⲥ ⲛⲧⲉ
ⲡⲓⲁⲃⲏⲧ ⲡⲓⲑⲙⲏⲓ ⲁⲃⲃⲁ ⲡⲁⲩⲗⲉ

Hail, the temple of God, the father. The poor one before God Arsenius II, bishop of the Monastery of the righteous Anba Paul.

D3b.	Donor inscription (1951)

السلام لهيكل الله الاب برسم القديس العظيم الانبا
انطونيوس المهتم بهذا الفقير لله ارسانيوس
الثاني اسقف دير انبا بولا ١٦٦٧ ش ١٩٥١ م عوض
يا رب من له تعب الصانع المعلم نجيب واصف النجار
البوشي

Hail to the temple of God the father, dedicated to the great St. Anba Antony. The one who provided for this {screen} is the poor one before God, Arsaniyus II, bishop of the Monastery of Anba Paul: AM 1667, AD 1951. Compensate, O lord, he who has toiled! The one who made it, Master Naguib Wassef, the carpenter of Bush.

D3c.	Donor inscription (1705)

ارفعوا ايها الملوك ابوابكم ارتفعي ايتها
الابواب الدهرية ليدخل ملك المجد الرب القوي
هوملك المجد ادخل الى مذبح الله الاهي المبهج
لشبابي اشكرك وانا بكثرت رحمتك ادخل بيتك واسجد
نحو هيكل قدسك مما اهتم بعمل ذلك المعلم جرجس
الطوخي ابو منصور عوضه يا رب امين

Lift up your doors, O you kings! Be lifted up, you everlasting doors! And the king of glory shall come in. The mighty Lord is the king of glory.[44] I will come into the altar of God. My God, who gladdens my youth, I thank you.[45] In the multitude of your mercy I will come into your house and worship toward the temple of your holiness.[46] Master Jirjis al-Tukhi, the father of Mansur, provided for this {screen}. Compensate him, O Lord! Amen.

D3d.	Thirteen icons (1705), listed from north to south.

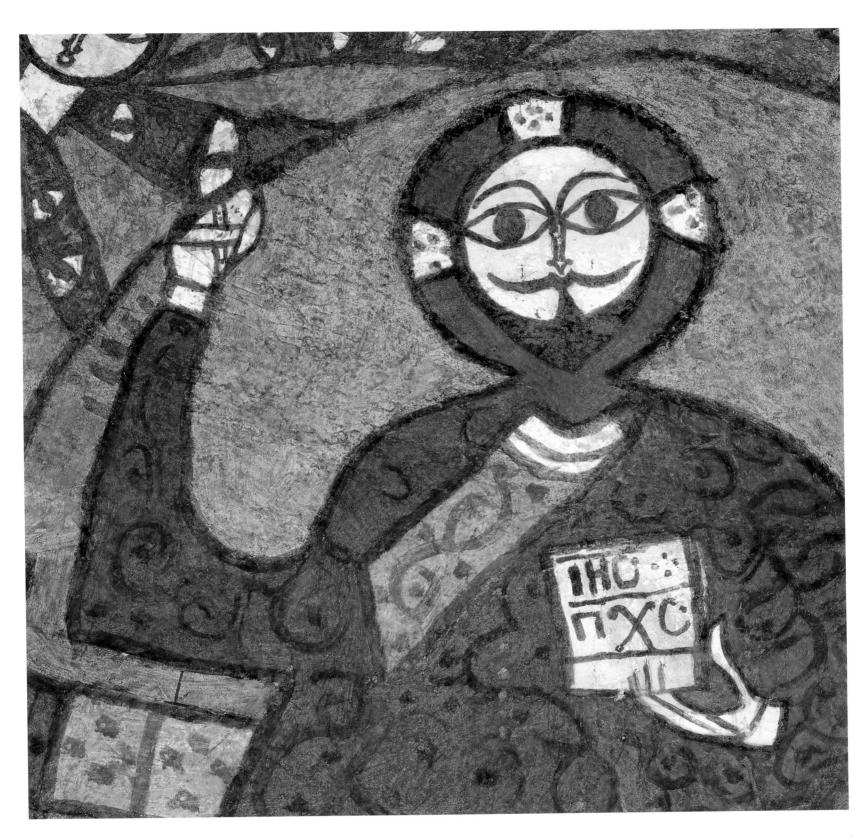

FIGURE 13.4

Book held by Christ in Majesty

(C10a), 1712/1713. ADP/SP 5 S192 04.

FIGURE 13.5

European graffiti (D1b), ca.
fifteenth or sixteenth century.
ADP/SP 4 S209 5 05.

I. القديس ابو مقار
St. Father Macarius

II. القديس انبا شنوده
St. Anba Shenoute

III. الملاك ميخاييل
The angel Michael

IV. القديس ابشاي
St. Pschoi

V. الملاك رافايل
The angel Raphael

VI. القديس انبا بولا
St. Anba Paul

VII. Virgin Mary and Christ child (no inscription)

VIII. القديس...
Saint...

IX. القديس انطونيوس
St. Antony

X. القديس انبا حنس
St. Anba John

XI. الملاك سوريال
The angel Suriel

XII. القديس انبا باخوم
St. Anba Pachomius

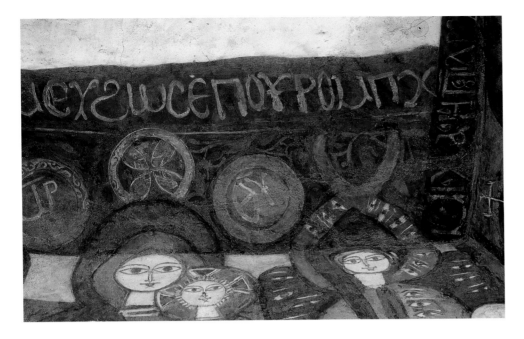

FIGURE 13.6

Inscriptions, 1291/1292, identifying the Virgin Mary (D19a) and Christ and the cherubim (D19b). ADP/SP 18 S1201 02.

XIII. الملاك غبريال

The angel Gabriel

XIIIa. The text that Gabriel bears

السلام لك يا ممتليه نعمه الرب معك روح القدس يحل عليك

Hail to you, you who are full of grace! The Lord is with you.[47]
The Holy Spirit will come upon you.[48]

SOUTH WALL

D14. Massacre of the Innocents

D14a. ... NҠ[OⲨ]ⲀI NⲀⲀ[ⲰOⲨI]*

...the young children [?]

D15. Three Magi before Herod[49]

D15a. ⲠⲘⲀⲄOⲤ NIOⲨⲢⲰOⲨ NⲤⲀNIⲘⲀNⳋⲀI NⲢⲰⲀH{Ⲥ}*

The Magi, the kings from the East. Herod

D16. Two prophets (Micah and Isaiah?)[50]

D16a. Scroll held by the prophets

ⲠICⲨ̄Ⲭ̄Ⲣ̄Ⲥ̄ ⲈⲐⲀⲈⳋ*

Jesus Christ [?] {B}ethleh{em}

D18. Moses the Black[51]

D18A. انبا موسى القس الاسود

Anba Moses the Black, the priest

D19. Virgin Mary and Christ child with two cherubim[52] (fig. 13.6)

D19a. ⲘⲢ̄ ⲐⲨ̄*

Mother of God

D19b. NIⲬⲈⲢOⲨB{I}Ⲙ ⲈⲨⲊ̅ⲰⲤ ⲈⲠOⲨⲢO ⲘⲠⲬ{Ⲥ}*

The cherubim are praising the king, the Christ

Haykal of St. Antony

NORTH WALL

E3. Luke the Evangelist

E3a. [O] ⲀⲄIOⲤ*

Saint [Luke]

E3b. ⳃOⲨⲔⲀⲤ [ⲠI ⲈⲨⲀⲄ]ⲄⲈⲀICⲦHⲤ*

Luke the Evangelist

E4. John the Evangelist[53]

E4a. O ⲀⲄIOⲤ IⲰⲀNNH{Ⲥ}*

St. John

E4b. Ⲓ̅Ⲱ̅ ⲠIⲠⲀⲢⲐⲈNO ⲠIⲈⲨⲀⲄⲄⲈⲀICⲦHⲤ*

John, the celibate evangelist

EAST WALL

E6. Virgin Mary and Christ child

E6a. ⲘⲢ̄ ⲐⲨ̄*

Mother of God

E6b. Ⲓ̅Ⲥ̅*

Jesus

E7. Annunciation: Gabriel[54]

E7a. O ⲀⲢⲬⲀⲄⲄⲈⲀOⲤ ⲄⲀⲂⲢIHⲀ*

The archangel Gabriel

E7b. ⲠIⲬⲈⲢⲈⲦICⲘOⲤ ... ⲀⲈ ... ⲤⲈ ... Ⲣ ... Ⲉ ... Ⲣ ... Ⲑ ... ⲦⲀ*

The Salutation ... [?]

E8. Annunciation: house or fountain[55]

E8a. ⲬⲈⲢⲈ Ⲑ[H] ...*

Hail thou...

ⳋHⲠI[Ⲉ ⲦⲂⲰⲔI NⲦⲈ ⳊⲤ ⲈⲤⲈⳋⲰⲠI NH[I Ⲕ]ⲀⲦⲀ ⲠⲈⲔⲤⲀⲀI*

Lo, [the handmaid of the Lo]rd! Let it be to [me acc]ording to thy word.

E9. Annunciation: Virgin Mary[56]

E9a. H ⲀⲄIⲀ Ⳙ[Ⲁ]ⲢIⲀ*

St. Mary

FIGURE 13.7
Annunciation inscription (E8a),
first half of the thirteenth century.
ADP/SP 18 S201 02.

E11. Inscription dating the second medieval painter
in the Cave Church (fig. 13.8; see fig. 13.2)

ⲡⲟⲥ ⲛⲑⲟⲕ ⲧⲟ ⲁⲃ…ⲑⲉⲱ ⲛⲁⲓ ϧⲁ ⲡⲉⲕⲗⲁⲟⲥ
ⲁϥⲍⲱⲕ ⲉⲃⲟⲗ ✣ ∦ ⲁⲏ*

Lord you are holy…God have pity on your people! Completed:
AM 1008 (1291/1292)[57]

E13. Stephen

E13a. ⲡ[ⲓⲭ]ⲗ[ⲟⲙ]*

The crown

E13b. ⲉⲥⲧⲉⲫⲁⲛⲟⲥ ⲁⲓⲁⲕⲟ[ⲛ]ⲟⲥ*

Stephen, the deacon

Corridor

F1. Arsenius[58]

F1a. ⲁⲣⲥⲓ[ⲛⲏⲟⲥ]*

Arse[nius]

F3. Unidentified narrative cycle

F3a. ⲟⲩⲁⲅⲓⲟⲥ*

Saint…

F5. John[59]

F5a. انبا يوانس

Anba John

F6. Arsenius[60]

F6a. انبا ارسانيوس معلم اولاد الملوك

Anba Arsenius, tutor of the king's children

F7. Abib[61]

F7a. وانبا ابيب

and Anba Abib

F8. Apollo[62]

F8a. انبا ابلا

Anba Apollo

F10. Shenoute[63]

F10a. ⲡⲉⲛⲓⲱⲧ ⲉ̄ⲑ̄ ⲁⲃⲃⲁ ϣⲉⲛⲟⲩϯ*

Our holy father Anba Shenoute

F11. Diminutive king

F11a. …ⲁⲉ…ⲟⲩⲣⲟ̣ⲑ̣ⲉ̣ⲟ̣ⲇⲟⲥ[ⲓⲟⲥ]*

…Emperor Theodosius [?][64]

F12. John[65]

F12a. ⲓ̄ⲱ̄ⲛ̄ ⲛⲓⲙⲉⲧ*

John…

F14. Moses the Black/Samuel of Qalamun[66]

F14a. ⲡⲉⲛ[ⲓ̣]ⲱⲧ ⲉ̄ⲑ̄ ⲙⲟⲩⲥⲏ*

Our holy father Moses[67]

F14b. انبا ص[مو نيل] المعترف

Anba S[amuel] the Confessor

F15. Unidentified saint[68]

F15a. ⲡⲉⲛⲓⲱⲧ ⲉ̄ⲑ̄*

Our holy father…

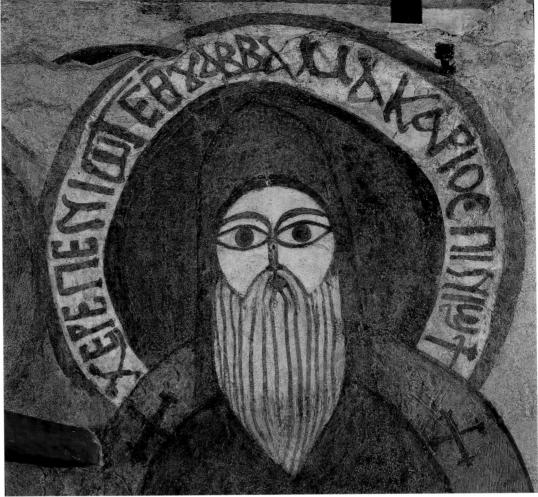

FIGURE 13.8 LEFT

Inscription (E11) with the date AM 1008 (1291/1292). ADP/SP 7 S1221 03.

FIGURE 13.9 RIGHT

Coptic inscription in the nimbus of Macarius (G3a), 1712/1713. ADP/ SP 1 S212 5 05.

Shrine of St. Paul

G3. Macarius (fig. 13.9)

G3a. ⲭⲉⲣⲉ ⲡⲉⲛⲓⲱⲧ ⲉⲑ̅ⲟ̅ⲩ̅ ⲁⲃⲃⲁ ⲙⲁⲕⲁⲣⲓⲟⲥ ⲡⲓⲛⲓϣϯ

Hail, our holy father Anba Macarius the Great

G5. Cenotaph of St. Paul

G5a. ⲙϩⲁⲩ ⲛⲧⲉ ⲡⲓⲁⲅⲓⲟⲥ ⲡⲓⲑⲙⲏⲓ ⲁⲃⲃⲁ ⲡⲁⲩⲗⲉ ⲡⲓⲣⲉⲙⲣⲁⲕⲟϯ ⲡⲓϣⲟⲣⲡ ⲛⲁⲛⲁⲭⲟⲩⲣⲓⲧⲏⲥ ⲉⲧⲁⲩⲙⲁⲥⲩ ⲉⲃⲟⲗ ϧⲉⲛ ⲧⲡⲟⲗⲓⲥ ⲛⲧⲉ ⲣⲁⲕⲟϯ ϧⲉⲛ ϯⲣⲟⲙⲡⲓ ⲙⲙⲁϩ ⲥ̅ⲕ̅ⲏ̅ ⲙⲙⲓⲥⲓ: ⲟⲩⲟϩ ⲁϥⲙⲧⲟⲛ ⲙⲙⲟϥ ⲉⲃⲟⲗ ϧⲉⲛ ϯⲣⲟⲙⲡⲓ ⲙⲙⲁϩ ⲧ̅ⲙ̅ⲅ̅ ⲙⲙⲓⲥⲓ

{The} tomb of the righteous Saint Anba Paul of Rakote [Alexandria], the first hermit, who was born in the city of Rakote in AD 228 and he went to his rest in AD 343.[69]

G5b.

قبر القديس البار انبا بولا الاسكندري أول
السواح ولد في مدينة الاسكندرية سنة ٢٢٨
وتنيح سنة ٣٤٣ ميلا دية
عمل في عهد رئاسة القمص ميساك الأبا
بولى المنشاوي في سنة ١٦٦٢ للشهداء وسنة
١٩٤٦ ميلادية القمص ابراهيم الأنبا بولى

The tomb of the righteous Saint Anba Paul of Alexandria, the first hermit, he was born in the city of Alexandria in AD 228 and he was dead in AD 343. Made [that is, the marble encasement for the cenotaph] during the reign of Hegumenos Misak of al-Minsha, abbot of the Monastery of St. Paul in AM 1662/AD 1946. Hegumenos Ibrahim of the Monastery of St. Paul

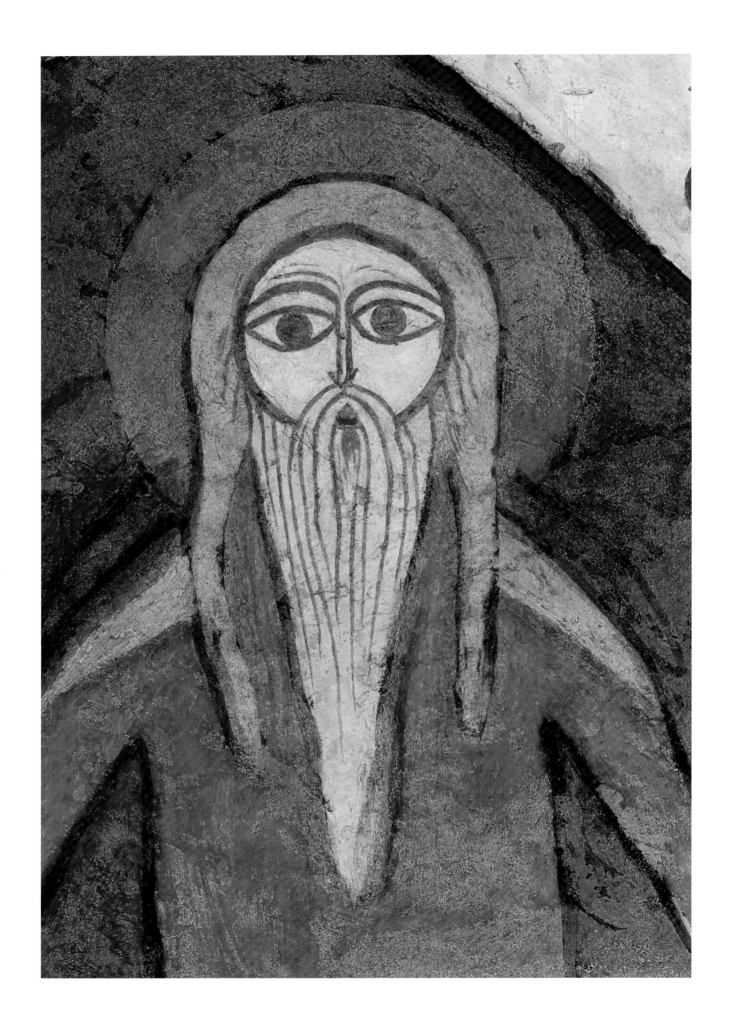

Conclusion

Jerome commented in the *Vita Pauli* that "no one knows anything for certain" about Paul the Hermit during his years of solitude in the desert (fig. 27).[1] The same observation also applies to the monastery dedicated to the saint for most of its long history. Circa 570, the Piacenza Pilgrim visited the cave of Paul but mentioned neither an organized shrine nor anchorites, although both were probably present at that time.[2] The brevity of the earliest known reference to a monastery at the site of Paul's hermitage, recorded in about 1200 in the *History of the Churches and Monasteries,* suggests that the author never actually went there.[3] More than a hundred years later, al-Maqrizi still had little to say about St. Paul's other than that it was deep in the desert.[4] Ogier d'Anglure, in 1395, provided the most detailed premodern account of the monastery but described only a walled compound containing a garden and a "beautiful little chapel…down several steps below a rock."[5] Ogier also indicated the major reason for the monastery's continuing obscurity. The journey to St. Paul's required "hard and painful" traveling through "desolate and strange" desert landscapes and over tall mountains "even more difficult [to cross] than Mount Sinai."[6] The challenge of reaching the remote monastery remained unchanged until the mid-twentieth century. Jerome, writing circa 391, mentioned the necessity of hiring camels to carry pilgrims across the "waste and terrible desert."[7] Fifteen hundred years later, Agnes Lewis and Margaret Gibson were still required to employ the same method of transportation.[8] The Whittemore expedition of 1930–1931 drove Ford automobiles across the roadless desert to the Monastery of St. Antony but could only reach St. Paul's on camelback. Alexandre Piankoff, a member of the expedition, described the journey as "cost-

ly and frequently even dangerous."[9] Paul van Moorsel referred to his trips to St. Paul's in 1984–1985 as "long and tiring" even though a road by then linked the monastery to Cairo.[10]

When ARCE began the first phase of its conservation project in 1997, the Monastery of St. Paul was still a "hidden mystery" in many respects.[11] Nevertheless, much had changed in the decade since van Moorsel's efforts to document the paintings in the Cave Church. Highways through the desert had made it possible to reach St. Paul's from Cairo in less than four hours.[12] The population of monks continued to grow as part of the wider monastic revival of the second half of the twentieth century.[13] The Coptic laity had embraced a new style of weekend pilgrimage to the monasteries of Egypt that transformed the relationship between the faithful and the monks, who have assumed a much greater pastoral role in the life of the community.[14] By the start of ARCE's conservation of the Cave Church, in 2002, St. Paul's was on the verge of a major period of expansion. In the four years of the project we witnessed the remarkable growth of the settlement outside of the walls of the fortified compound. During this short period the monks transformed the surrounding desert, perhaps not into a city, but certainly into a thriving village. These momentous changes have already rendered Patrick Godeau's initial phase of photo-documentation of the monastery, carried out between 1997 and 1999, as much a historical record as it is a contemporary survey.

One of the earliest buildings belonging to this recent expansion housed the spacious living quarters that the monks built for Adriano Luzi, Luigi De Cesaris, and their conservation team. The vaulted, self-contained dwelling is

FIGURE 27

Paul the Hermit (B6), 1712/1713.

ADP/SP 3 S1223 03.

287

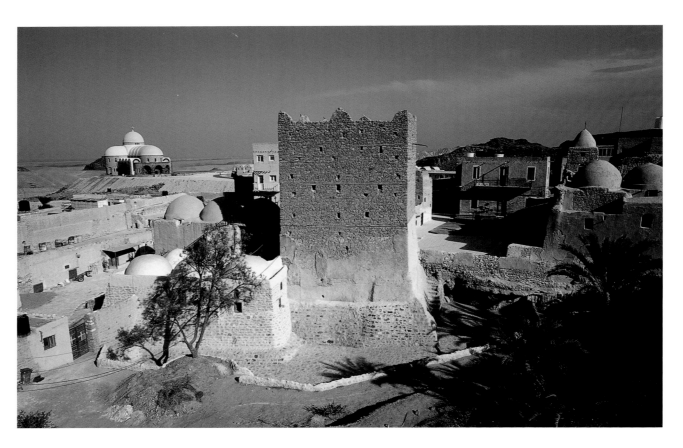

constructed on a hill overlooking the walled monastery. In
the other direction, the Gulf of Suez and the mountains of
Sinai are clearly visible. This hill is one of the few places at
St. Paul's where it is possible to contact the outside world
by cell phone. It is also adjacent to the huge, domed cathe-
dral that the monks are building in order to accommodate
the thousands of pilgrims who now come to celebrate the
feast of St. Paul and other religious holidays (fig. 28). The
conservators lived here for 365 days over a period of four
years. Other members of the larger project, including those
working on this book, also had the opportunity to spend
extended periods at the monastery in the same comfort-
able surroundings, made possible by the generosity of the
monastic community.

During the course of the ARCE conservation project,
the contributors to this book made many discoveries both
at the monastery and in research libraries. Little was known
about the history and physical development of St. Paul's,
other than that it was originally a hermit's cave that became
a late antique shrine, which in turn was transformed into a
monastery by at least the thirteenth century. After a period
of medieval prosperity, indicated by two separate cycles of
devotional paintings in the Cave Church, the monastery
declined and was eventually abandoned throughout the
seventeenth century. It was repopulated by John XVI (1676–
1718), who also enlarged the Cave Church and may have
instructed the small group of resident monks to paint it as

well. During the reign of John XVII (1726–1745) a church
dedicated to St. Michael the Archangel and St. John the
Baptist was added to compound, and in 1780/1781, Ibrahim
al-Jawhari, the greatest of the eighteenth-century Coptic
lay leaders, sponsored the construction of the Church of
St. Mercurius. The contributors have been able to expand
upon almost every phase of this sketchy historical outline.
In the following summary, I will integrate the most salient
findings to emerge from our work at the Monastery of St.
Paul, thematically setting aside both chronology and the se-
quence of the chapters in this book.

Michael Jones, who managed all phases of the ARCE
project at the monastery, outlines in his chapter the archi-
tectural conservation of the refectory, the two mill rooms,
and the Cave Church. His study of the mill rooms indicates
that they were constructed in phases. Originally there was
only a single mill in a one-room, limestone building. This
structure was likely constructed as part of John XVI's reno-
vation of the monastery, circa 1703–1705, which we know
from textual sources included the donation of a mill. At a
later date, a mud-brick western extension was added, di-
viding the building into two rooms separated by a vaulted
corridor. Both rooms were clearly designed for mills. Jones
notes that the rooms currently house animal-driven flour
mills of a kind common in eighteenth-century Egypt (fig.
29). The same type is illustrated as a typical Egyptian mill
in the Napoleonic *Description de l'Égypte.* Each mill has an

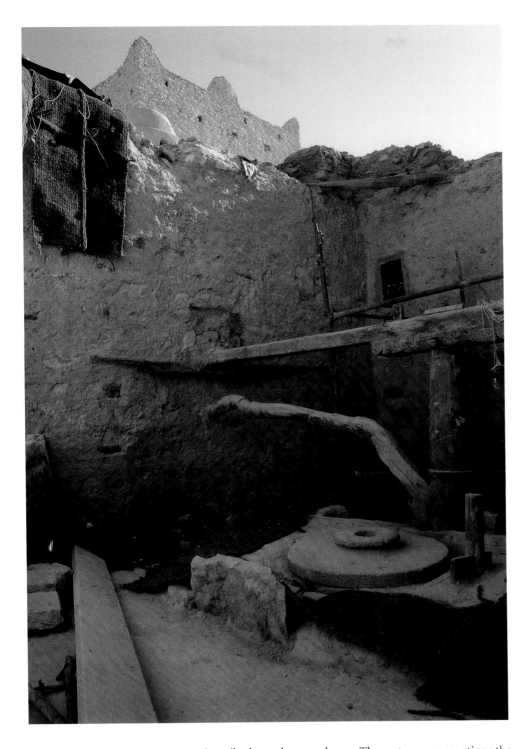

FIGURE 29

Western mill room during conservation.

inscribed wooden crossbeam. The eastern one mentions the benefactor Ibrahim al-Jawhari, the carpenter, and Nakhla al-Suwayfi, who was probably another patron of the monastery. The western mill inscription provides no names but records the date AM 1497 (1780/1781), the same year that Ibrahim al-Jawhari built the Church of St. Mercurius at St. Paul's. Jones' analysis of the mill rooms provides clear evidence of different building stages that likely correspond to the known interventions at the monastery initiated by both John XVI and Ibrahim al-Jawhari.

Peter Sheehan has further suggested that Ibrahim al-Jawhari was responsible for extending the south wall of the monastic enclosure to its current position. The medieval wall had originally abutted the Church of St. Michael and St. John, and portions survive within the fabric of later buildings. For example, the former southeast corner is the foundation of the present fatuli. Sheehan believes that this fatuli was also constructed during the 1780/1781 restoration of the monastery. It replaced a rope lift, probably dating from the first or second decade of the eighteenth century, the remains of which survive on the extension of the east wall. Ibrahim al-Jawhari obviously sponsored a major renovation of St. Paul's that seems to have included restoring the original eighteenth-century mill room of John XVI, as well as the construction of the western mill, the current fatuli, and the Church of St. Mercurius. If Sheehan's theory is correct, as seems almost certain, al-Jawhari also substantially increased the internal area of the monastic compound. This space, formed by the new south wall, now contains a street of cells, which until recently was the main residential section of the monastery. The cells can therefore be dated to 1780/1781 or later.

At the heart of the ARCE project was the conservation of the wall paintings in the Cave Church. Adriano Luzi, Luigi De Cesaris, and their team cleaned, conserved, and documented every square millimeter of the interior and effected an astonishingly dramatic transformation of the church and its paintings (fig. 30). They uncovered new medieval paintings by both of the thirteenth-century artists. The most important for our appreciation of the first medieval phase was the face of a saint on the east wall of the central nave. The conservators found it by accident under an eighteenth century plaster layer that was detaching from the wall. This painting proves that the first medieval program originally extended beyond the Haykal of St. Antony onto the walls of the nave. It is possible that other paintings by the same artist survive in this room, but if so, they are covered by plaster layers and the eighteenth-century iconographic program.

The conservators discovered new paintings from the later medieval phase, all of which the artist appears never to have finished. In the Haykal of St. Antony they found what may have been the preliminary stage of a painting of an architectural structure located over the arched passageway leading to the Haykal of St. Paul. On the west wall of the corridor they uncovered a possible narrative cycle involving at least two saints and a domed church. At the very end of the project, De Cesaris exposed the faint remains of a saint on the west wall of the Shrine of St. Paul. Elizabeth

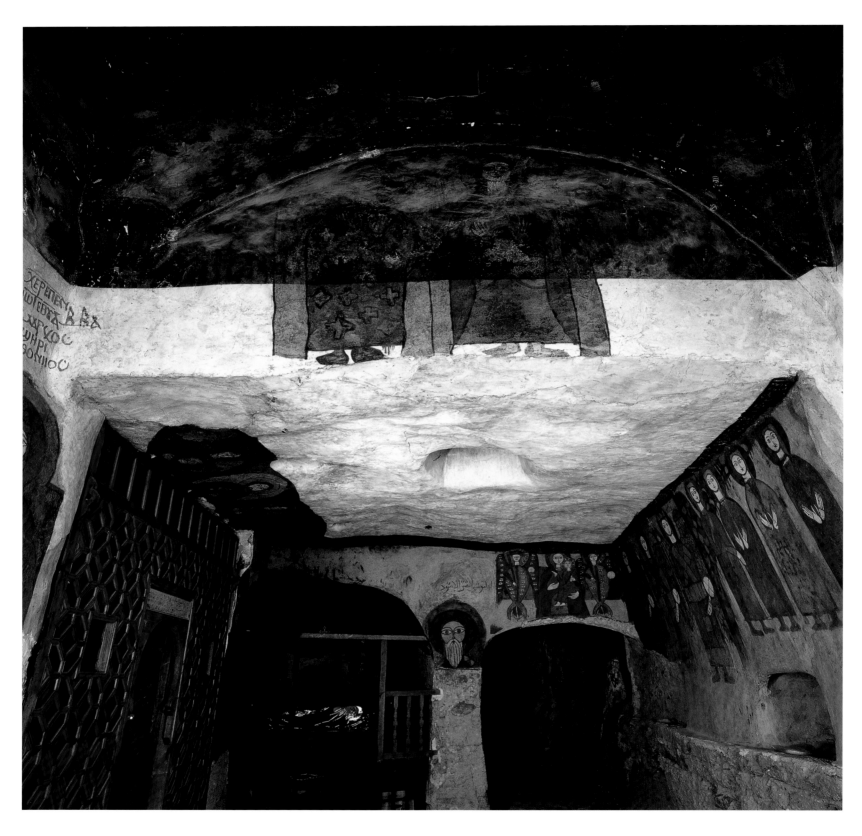

FIGURE 30

Northern nave and central nave
during conservation. ADP/SP 173
S3 02.

Bolman attributes all of these paintings, on stylistic grounds, to the artist of 1291/1292. The same painter was also responsible for a possible row of standing saints on the opposite wall. All that survives is a long, narrow fragment, featuring what may have been red circular borders for two halos, that runs along the top of the east wall joining the nave and the shrine. Thanks to these discoveries, we now know that the second medieval artists painted the east and west walls of both the corridor and the Shrine of St. Paul, and that he originally intended to create a more extensive program.

Although the identification of two phases of medieval paintings, first established by van Moorsel, is a relatively straightforward task, understanding the sequence of plaster layers in the Cave Church is an extremely complex one.[15] Luzi and De Cesaris found seven different applications, five of which can be dated to the thirteenth century. These plaster layers provide a secure chronological sequence, which, along with stylistic analysis, was vital for our dating of the newly discovered paintings. The plaster layers on the east wall of the central nave, for example, enable us to identify confidently the recently exposed face of a saint, on the first rendering, as the work of the first medieval painter, and assign the long, narrow painted fragment, on rendering three, to the second artist (see fig. 8.23).

The labor of Luzi, De Cesaris, and their team enabled Bolman, Gawdat Gabra, and me to view the paintings with completely new eyes. Instead of being obscured, sometimes completely, by deposits of soot, most of them are now as readily discernable as when they were first painted. My study of the working method of the eighteenth-century painter was possible only because of the newly cleaned state of the images, and the sensitive observations made by De Cesaris and Alberto Sucato during the course of the project. Gabra's redating of the work of the second medieval painter from AM 1050 (1333/1334) to AM 1008 (1291/1292) was also due to the new legibility of the inscription in the Haykal of St. Antony. Although only forty-two years separate the two readings, so few dated medieval Coptic wall paintings have survived that any change in their known chronology is of great significance. The four decades in question were also a time of upheaval for the Coptic community. The year 1290 marked a positive change in Mamluk policy toward the Copts, after a decade of repression under Sultan Qalawun.[16] The second medieval painter was active at a moment that seemed to herald a return to the more tolerant policies of the Fatimids and Ayyubids. The Coptic community, however, enjoyed only the briefest of reprieves before facing the collapse of their era of medieval prosperity.

One can readily distinguish the medieval section of the Cave Church from the eighteenth-century additions. The rock-cut rooms and the Haykal of St. Antony remain structurally the same as when they were formed in the thirteenth century. The principal area of uncertainty, prior to this project, was the location of the northern wall of the medieval building. This wall was demolished during the eighteenth-century expansion of the church, and all traces of it were covered by plaster floors and stone paving. De Cesaris and Sucato's removal of the modern cement applied to the floors and lower walls of the church provided a perfect opportunity for Sheehan to examine the original medieval floor level. He found the foundations of the north wall of the nave, which was constructed more than a meter beyond the rock-cut portion of the room. This location, which is now in the eighteenth-century northern nave, is farther to the north than we had expected. The medieval wall also extended to the west far enough to enclose the small cave, which is now adjacent to the stairs in the eighteenth-century narthex. The incorporation of this cave within the medieval church was unknown before the excavation. As Sheehan points out, it must have had a special significance for the thirteenth-century monks, and may even have been part of the original cave of Paul. We are now in a better position to answer a question posed by van Moorsel: What was the ground plan of the medieval Cave Church?[17]

Sheehan also found the remains of two types of medieval paving stones that divided the nave into distinct areas. The outermost, perhaps assigned to the monks of the monastery, was indicated by gray limestone blocks forming a narrow corridor, more than six meters long and one meter wide, along the west wall. The eastern side of the nave was paved in green siltstone. This area probably functioned as a khurus, reserved for priests. The division of the room into two areas was reinforced by some kind of wooden barrier placed between them. Sheehan found post holes in the pavement, and he speculates that the gap in the plaster layer immediately above the eighteenth-century painting of Moses the Black, in the south wall separating the shrine from the corridor, indicates the position of the screen's upper rail. The screen had a central opening in line with the entrance of the Haykal of St. Antony, indicated by extensive wear to the paving stones in this area. The green siltstone extended into the sanctuary, where it was used to pave the floor around the altar. Another screen with a central door almost certainly filled the entrance to the haykal.

The division of Coptic churches into areas of increasing exclusivity as one moves east toward the sanctuary is an architectural feature found in the medieval Church of St.

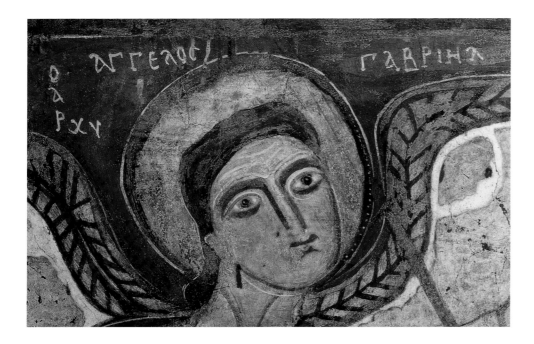

Antony, at the Monastery of St. Antony, and in the eight-eenth-century churches at St. Paul's, including the Chapel of the Virgin in the keep. That the medieval monks also adapted a similar division for the irregular space of the Cave Church is a fascinating new discovery. Sheehan further un-covered the remains of the medieval altar under the cur-rent altar in the Haykal of St. Antony. It was substantially smaller than the present one and occupied a slightly differ-ent position. The first medieval painter placed his image of the enthroned Virgin Mary, in the eastern apsidal niche, on the same alignment formed by this earlier altar and the entrance to the haykal from the nave. The current, larger altar is slightly to the south of the older one, and is not centered on the painting of the Virgin Mary.

Bolman's iconographic and functional analyses of the medieval paintings, such as the Virgin in the Haykal of St. Antony, address the numerous reasons for their inclusion in the Cave Church. She situates them in a historical en-vironment where the creation of devotional images was a demonstration of faith and religious identity for Christians. Contemporary medieval writings attest to this use, and to the multiple resonances that sacred depictions had for their intended viewers. Paintings both represent a holy subject and form a medium for contact between the saint and the viewer. They also make visible the spiritual realities present during the liturgy, shifting in their emphasis depending on the church calendar and the ritual action being performed. Bolman has explained the paintings as works of art, and also as dynamic players in the life of the church.

Her stylistic analyses of the two phases of medieval murals in the Cave Church enhance our understanding

not only of the paintings but also of the larger picture of artistic production in Egypt in this period. The first medi-eval artist worked in what Bolman has identified as a tra-ditional Coptic mode that appears to have been the style of a number of professional teams of painters active in Egypt in the first half of the thirteenth century (fig. 31). The best documented team of this period is that of Theodore, who was responsible for creating the large painted program in the Church of St. Antony in 1232/1233. Other newly found thirteenth-century murals in the Church of Abu Sarga and the Hanging Church, in Old Cairo, show close stylistic ties to the work of Theodore and the first artist at St. Paul's, indicating that these artists were employed in both the most central, ecclesiastical churches, as well as the most remote, monastic ones.

The second painter at St. Paul's is harder to classify (fig. 32). Active in 1291/1292, he was a near contemporary of the two artists responsible for painting the khurus vault in the Church of St. Antony less than fifty years after Theo-dore. One of these had ties to Byzantium and the other was trained in the decorative styles popular in the Islamic world. The artist at St. Paul's, however, worked in a dif-ferent mode altogether. Luzi indicated that he was not a professional mural painter, but more likely a creator of miniatures. Bolman has refined this observation by suggest-ing that he produced icons, as well as possibly contributing narrative scenes and depictions of animals to illuminated manuscripts. She notes that the artist was uncomfortable when working on a monumental scale and created his finest work, such as the angels on the ceiling of the central nave (see fig. 10.1), as smaller paintings that could easily also be rendered on wood as portable devotional images. The painter also produced narrative scenes in the Cave Church similar to ones in contemporary illuminated gospels books, and his depiction of the animal heads of the four living creatures of the Apocalypse likely derived from illustrated editions of collected fables. Just why the monks of St. Paul's hired such an artist to produce large-scale murals remains a mystery. The two later medieval painters at the Mon-astery of St. Antony indicate the remarkable diversity of artistic styles available in Egypt in the mid- to late thirteenth century, especially with the inclusion of Theodore and the first St. Paul artist a few decades earlier, but it is pos-sible that the ancient tradition of Coptic wall painting was already in decline by 1291/1292. In the following century it seems to have died out altogether.

Mark Swanson takes the few known, dateable facts associated with the Monastery of St. Paul and places them within the broad context of Coptic history. Drawing on

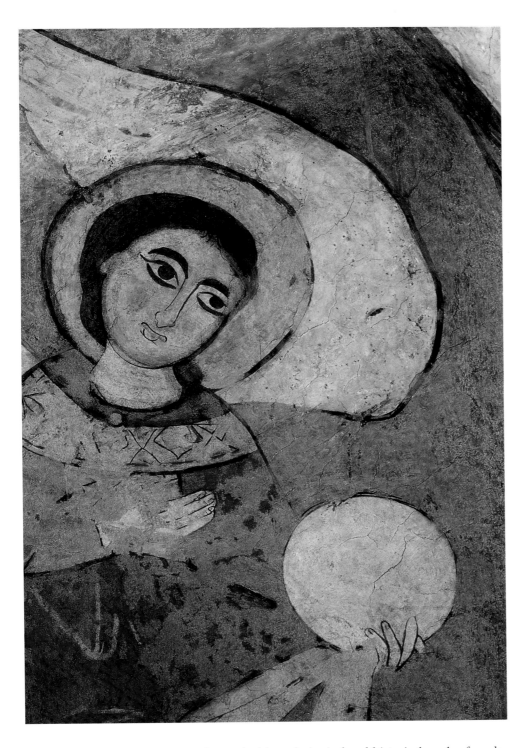

FIGURE 32

Angel (E5) attending Christ in Majesty, 1291/1292. ADP/SP 20 S1203 02.

plies. What emerges from Swanson's nuanced discussion is how closely connected the monastery was to the political, economic and cultural fortunes of the Coptic people, despite its physical isolation.

In the thirteenth century, the monks of St. Paul's shared in the literary and artistic achievements of their day. Swanson speculates that the monastery may have had a sizable library, where monks worked as copyists, during a period of great literary revival. The monks also had access to two professional painters in one of the most creative eras in Coptic art. Wealthy Christians, often government officials, were primarily responsible for donating books and scribal supplies, and for paying the wages of painters, but even Copts with modest means donated to pious projects, enabling extraordinary talent to flower in ecclesiastical art and literature, even in the secluded monastery dedicated to Paul the Hermit.

The rapid decline of the Coptic community in the fourteenth century brought an end to such generous patronage, and saw the collapse of major Christian institutions. Swanson observes that as the monasteries of the Wadi al-Natrun fell into ruin in this period, the Red Sea monasteries came to new prominence as centers of vitality in the church. Marqus al-Antuni (1295/6–1386), a monk of St. Antony's who trained at St. Paul's, perhaps best represents the role of both monasteries in the fourteenth century. Citing an edition of the *Life* of the saint in the monastic library, Swanson presents Marqus as a champion of traditional Christian and monastic practice in an age of decline, who set a heroic example for his beleaguered community. At a time when monasteries were being abandoned throughout Egypt, Marqus said it was better for a monk to die of hunger than to leave his monastery. He was also deeply engaged in the church's struggle against the widespread conversion to Islam among the Copts, even though he lived all his adult life deep in the Eastern Desert and "never left his monastery."[18] However, following the death of Marqus, the Monastery of St. Paul was also eventually abandoned for more than a century.

Swanson continues with a absorbing account of John XVI's repopulation of the monastery at the beginning of the eighteenth-century. In many ways the reestablishment of St. Paul's symbolized the start of the modern Coptic revival. John XVI paid close personal attention to reconstructing and developing St. Paul's. He repaired the walls, heightened the keep, installed a mill and enlarged the Cave Church. It was also during his reign that a team of monks from the monastery painted the church with what are almost certainly the first monumental Coptic murals to have been

Copto-Arabic ecclesiastical and historical works, foundation inscriptions, Ethiopian Marian miracles, Arabic lives of medieval saints, and contemporary Coptic hagiography, he presents the monastery as a key part of the sacred geography of Christian Egypt that helped to ensure the tenacious survival of Coptic identity. Although extremely remote, St. Paul's was never completely cut off from the rest of the world. Living in the barren desert, the monastic community depended on the Nile valley for food and sup-

created since the medieval period. The leading archons, the wealthy lay leaders of the community, assisted the patriarch in his ambitious undertaking. They and their successors took an active interest in the monastery for the entirety of the eighteenth century.

The archons owed their wealth and authority to their patrons, the leaders of the competing Muslim political factions in Cairo. They served as trusted officials in charge of managing the vast economic interests of these military households, especially as financial administrators and tax collectors. The importance of their positions within the ruling hierarchy gave the archons critical leeway when it came to undertaking large scale, and highly visible projects, which were often forbidden by law, such as repairing, enlarging and building churches. John XVI made the archons responsible for the upkeep of churches and monasteries, a duty they embraced enthusiastically. Their revitalization of Christian religious institutions, including the Monastery of St. Paul, marks the first physical expression of the eighteenth-century renaissance of the Coptic community. The patriarchs worked closely with the archons but these powerful lay leaders also effectively controlled the selection of popes, three of whom came from St. Paul's. The elevation of these three men to the throne of St. Mark in succession is another example of the paradoxical position that the monastery occupied in Coptic society. The monks chosen to repopulate St. Paul's appear to have been extremely capable individuals, apparently highly regarded by the archons, who were assigned to a physically isolated monastery, from which three of them were then called to be patriarchs. These men in turn played a significant role in guiding the course of the social, artistic, and religious renewal of their community.

Febe Armanios delves further into the political, social, and financial background of the rise of the archons and their dominant role in Coptic society during the reigns of the St. Paul patriarchs. The history of Ottoman Egypt is a relatively young field of study, and western scholars have focused primarily on the rival military households and their endemic struggles for supremacy.[19] Although great advances have been made in our understanding of the period, the role of the Copts in eighteenth-century Egypt has been largely ignored by these scholars. Jane Hathaway, for example, makes no mention of the Coptic archons in her otherwise excellent study on the rise of the Qazdaghli faction.[20] Armanios, however, demonstrates that most of the greatest archons of the period derived their wealth and power from serving precisely this military household. The fact that Copts attained prominent economic positions in

the eighteenth century has long been known, but explanations for such a distinct cultural revival have yet to be fully explored. Armanios utilizes the findings of both western and Egyptian scholars, and draws upon her own research in historical manuscripts at the Patriarchal Library in Cairo, to produce a groundbreaking study of the sociopolitical origins of the eighteenth-century Coptic renaissance.

Gabra provides illuminating new information on St. Paul's during this same period from the manuscript library of the monastery. Although he was granted only a few days for his work, Gawdat and his able assistant Samiha Abd El-Shaheed identified and copied extracts from a wide range of manuscripts in the collection. Gabra's generosity in sharing this material with the other contributors has greatly enriched this book. He found, for example, the *Life* of Marqus al-Antuni that Swanson uses so effectively when examining the medieval monastery. Most of the texts he uncovered, however, concern the history of St. Paul's during the eighteenth century. Gabra and Swanson studied the material independently, and, with Armanios, combined the new data with the findings of earlier scholars.

Gabra's discoveries in the manuscript library were of enormous value to the other members of the ARCE project as well. Sheehan and I both use Gabra's account of the flood of 1709/1710 in our chapters. Sheehan suggests that repairs to the east wall, damaged in the flood, resulted in the eastern extension of the monastic compound and the construction of the first fatuli rope lift. I believe that the same event may have washed away many of the medieval paintings in the Cave Church, inspiring the monks to repair the damage themselves by repainting the church. The account of the flood also mentions the destruction of a mahbasa (Arabic for hermitage), which may be the buried ruin uncovered during the conservation of the exterior of the Cave Church by Michael Jones and Father Maximous El-Anthony. The structure is a single square room that was once surmounted by a dome. It would have been impossible to provide even a hypothetical identification of the ruin but for Gabra's research.

The most important finding to emerge from the manuscript library at the Monastery of St. Paul was the identification of ʿAbd al-Sayyid al-Mallawani as the painter of the eighteenth-century inscriptions in the Cave Church. Previously, all that was known about the creation of the iconographic program of 1712/1713 was that it was the work of an anonymous monk of the monastery, who met Sicard in 1716.[21] While studying the library material, Gabra observed that the future John XVII used an unusual dotted sigma throughout the psalmody that he transcribed in 1715.

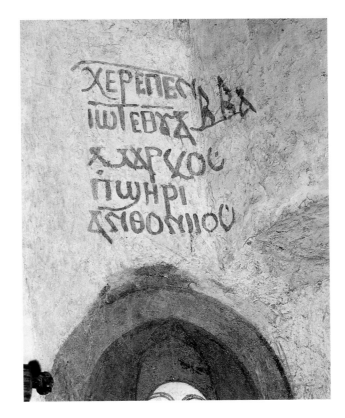

FIGURE 33

Inscription (B10a) by ʿAbd al-
Sayyid al-Mallawani identifying
Marqus al-Antuni, 1712/1713. ADP/
SP 14 S243 05.

FIGURE 34

Miniature of a man in a boat with
a diminutive crew, Psalmody of
1715 (MS 368 Lit.). Courtesy of
Father Yuhanna al-Anba Bula and
the Monastery of St. Paul.

The same distinctive sigma was employed two or three years earlier in all of the eighteenth-century Coptic inscriptions in the church (fig. 33). We can therefore now say that ʿAbd al-Sayyid al-Mallawani was at least partially responsible for painting the Cave Church.

I was also drawn to the Psalmody of 1715, independently of Gabra's investigation of the monastic library. One of the photographs taken by the Whittemore expedition is of an illuminated manuscript page featuring a man in a ship (fig. 34).[22] Precise stylistic parallels make it apparent that the image is by the same artist who painted the narrative figure of a bedouin camel herder in the Dome of the

Martyrs (see fig. 12.15). I took a copy of the photograph to Father Tomas al-Anba Bula, who with the help of Father Yuhanna al-Anba Bula, the monastery's manuscript librarian, found the miniature in the Psalmody of ʿAbd al-Sayyid al-Mallawani (figs. 35 and 36).[23] I have been able to demonstrate that numerous other illustrations in the codex were also by the painter of the eighteenth-century program in the Cave Church.[24] It is uncertain whether ʿAbd al-Sayyid al-Mallawani was the scribe and also the artist of the paintings of 1712/1713 and the Psalmody of 1715. He was obviously involved in the production of both, but whether he worked alone or with a partner remains an open question. The identity of Sicard's anonymous monk-painter, therefore, continues to be in doubt.

When writing the ARCE guide to the Monastery of St. Paul in 1999, I was struck by the way that the narrative figures used in the Dome of the Martyrs anticipated by at least thirty years iconographic features found in the icons of Ibrahim al-Nasikh and Yuhanna al-Armani.[25] At the time, I suggested that the paintings of the equestrians in the dome were an uncanny harbinger of the flowering of Coptic visual culture in the second half of the eighteenth century, without imagining that they were in any way directly linked to the later icons (fig. 37). The identification of ʿAbd al-Sayyid al-Mallawani as an active participant in the creation of the Cave Church program indicates that such a link definitely existed. At the end of ʿAbd al-Sayyid's reign as Pope John XVII, Ibrahim and Yuhanna began producing the icons that have come to symbolize the Coptic renaissance of the second half of the eighteenth century. Magdi Guirguis has demonstrated the long association between John XVII and Ibrahim al-Nasikh.[26] Gabra and Swanson have further identified an account, in the monastic library, of John XVII's journey to St. Paul's in 1732 as the work of the same Ibrahim the Copyist. The patriarch, accompanied by a long list of Coptic notables, went to the monastery to consecrate the recently completed Church of St. Michael the Archangel and St. John the Baptist. Ibrahim, as part of the patriarch's entourage, must have seen the paintings in the "holy cave of the church of the great saint Anba Paul," probably in the company of John XVII, one of the creators of the program.[27]

A decade later Ibrahim painted his first known icon with Yuhanna al-Armani.[28] In 1745, the year of John XVII's death, Ibrahim produced an icon of the equestrian saint Isidore featuring a talking dog (see fig. 12.49). This rare iconographic detail also is used in the Cave Church program. Although the association is a tantalizing one, I cannot prove that Ibrahim was paying tribute to the patriarch with

FIGURE 35

William Lyster and Father Tomas al-Anba Bula in the northern nave during conservation.

professional painter. Other works of his have been identified in the monasteries of the Wadi al-Natrun and in the churches of Old Cairo. Such a prolific painter, with so many important clients, was almost certainly assisted by a workshop. Mattary is virtually unknown compared to Ibrahim al-Nasikh, but it is evident that he was producing icons in a quantity comparable to that of Ibrahim and Yuhanna ten years before their partnership began.

The modern rebirth of Coptic art is usually described as flowering *ex nilo* in the second half of the eighteenth century.[30] The icons of Mattary prove that it was already blossoming at the beginning of the 1730s, and they further suggest that the seeds were planted even earlier. The role of the Monastery of St. Paul at the beginning of the eighteenth century cannot be overemphasized in this context. The patriarchs who presided over the rebirth of the tradition of professionally produced sacred images were all associated with, or directly involved in, the painting of the Cave Church. John XVI enlarged the church and may have initiated the iconographic program, Peter VI (then known as Murjan) was the superior of the monastery when the work was done, and ʿAbd al-Sayyid is known to have been on the scaffolding painting the inscriptions prior to his elevation to the patriarchal throne. As John XVII, he can also be identified as a patron of the two most prominent icon workshops known from the eighteenth century. Much work still needs to be done on the development of Coptic sacred art in this period but it seems clear that the paintings in the Cave Church represent a vital early stage, previously unrecognized, that permits us to move the genesis of this renaissance back by thirty years or more.

Seen in this light, the 1712/1713 paintings in the Cave Church represent a major landmark in Coptic art history. This remarkable series of murals were produced at a time when teams of professional painters, who were so prevalent in the thirteenth century, had not been active in Egypt for hundreds of years. After this long hiatus and at the beginning of a new era of prosperity, ʿAbd al-Sayyid and the other monks of St. Paul's undertook to revive the lost tradition of sacred wall painting. What an astonishingly ambitious undertaking this was for a group of monks untrained in the production of murals. Through a combination of discipline, determination, and faith, they created the first extensive Coptic cycle of devotional paintings since the thirteenth or fourteenth century. It does not seem a coincidence that twenty years later, when ʿAbd al-Sayyid was patriarch, professional icon painters were again active in Egypt.

To conclude, I return to our point of origin: the elusive Paul the Hermit. Although he is regarded as a saint by east-

this icon. However, he and Yuhanna certainly drew upon the iconography of the Cave Church a number of times during the course of their partnership. The link between the eighteenth-century paintings in the church and the icons of Ibrahim and Yuhanna is obviously much closer than I had previously thought.

John XVII was also associated with another prominent icon painter named Mattary. The patriarch and the archon Jirjis Abu Yusuf al-Suruji commissioned icons from this painter for the two haykal screens they donated in 1732 to the Church of St. Michael and St. John.[29] The technical quality of these icons indicates that Mattary was a

FIGURE 36
Father Yuhanna al-Anba Bula,
the librarian of the monastic
manuscript collection. ADP/SP 7
S1144 97.

carefully calculated tract promoting Egyptian-style monasticism. The intended audience was the highly literate, Latin-speaking Christian aristocracy, who were suspicious of the eastern asceticism that Jerome hoped to encourage. Their doubts were expressed by the prefect of Rome, Rutilius Namatianus, in 417, when he referred to monks as "crazed escapists and masochists who think the divine spark is nourished by squalor."[35] Jerome's strategy, as Davis shows, was first to introduce an ascetic hero with whom his noble audience could identify. He presented Paul as a rich, well-educated member of the upper class who adopted the monastic life even before the great Antony. After establishing Paul in his desert hermitage, Jerome then shifted to an account of Antony's quest. Davis presents the wonders and fabulous creatures encountered by Antony not as fairy tales but as classical and biblical allusions that would have been immediately recognized by Jerome's intended readers. The church father portrayed Paul with consummate skill as a Christian hero, part Aeneas and part Elijah, who by his spiritual presence transforms the barren desert into a new paradise.

The success of Jerome's strategy is indicated by the subsequent spread of monasticism throughout western Europe. Paul the Hermit, as presented by Jerome, has remained a popular Catholic saint for the sixteen hundred years since Jerome wrote the *Vita Pauli*. This narrative also inspired westerners to travel to Egypt in search of the saint's desert hermitage, some of whom wrote of their visit. The importance of these western accounts cannot be denied. They provide us with a continuous, if extremely sporadic, outsider's view of the Monastery of St. Paul, especially over the last five hundred years. Alastair Hamilton's chapter on western descriptions of the monastery, however, is not simply a record of who went to St. Paul's, and when. He presents a more complex picture of a small number of individuals, who between 1395 and 1931, were willing to hazard the desert journey to the Red Sea monasteries. Hamilton provides biographical information on these travelers, and examines their diverse motives for visiting St. Paul's. He considers how they reached the monastery, their accounts of its physical layout, and their reactions to the monks. Each of these difficult journeys contributed to the western rediscovery of not only the Monastery of St. Paul, but also of Coptic culture as a whole.

Hamilton begins in 1395 with Ogier d'Anglure, the earliest known medieval pilgrim to record his visit, but he focuses primarily on later travellers, who were rarely simple pilgrims. Jean Coppin was a soldier, diplomat, and spy, but he was also enough of a pilgrim to take communion in the

ern and western Christians alike, his biography—as written by Jerome—has always troubled historians. As Owen Chadwick noted, "Jerome was criticized in his own day for writing about someone who never existed. There appears to be no good reason for doubting that an early hermit named Paul existed. There appears to be every reason for believing that Jerome knew nothing about him. The *Life* is a piece of literature, a historical novel."[31] J. N. D. Kelly remarked that Jerome's account was not really a biography, "but rather a romantic idealization of monastic withdrawal, as full of wonders and fabulous creatures as a fairy-tale."[32] The confusing mixture of fact and fantasy found in the *Life* certainly contributed to the Catholic Church's decision in 1969 to remove Paul's feast from the General Roman Calendar.[33] Yet the *Life of Paul* was widely read in Jerome's own time, and indeed was one of the most popular and influential of his writings.[34] The book's early success also established Paul as the first hermit throughout the Christian world.

Stephen Davis examines the *Vita Pauli* and demonstrates that Jerome's story, "full of wonders and fabulous creatures," was not an exercise in pious fantasy but a

FIGURE 37

Camels of Iskhirun (A5), 1712/1713.

ADP/SP 15 S1187 02.

abandoned Cave Church in 1638. Sicard, a Jesuit missionary seeking to convert Coptic monks to Catholicism, was keenly aware of—and in fact reenacted—Antony's search for Paul during his own journey between the Red Sea monasteries. He was quick to note that the monk-painter had not forgotten to include Paul's iconographic symbols: "the two tigers, who dug the grave of the saint."[36] Porphyrios Uspensky, an archimandrite of the Russian Orthodox Church, visiting St. Paul's in 1858, hoped to promote union with the Copts while collecting manuscripts. Although unimpressed by the icons and wall paintings of the monastery, he was clearly moved by his visit to "the natural cave in which St. Paul worked out his salvation."[37] The explorer and naturalist Georg August Schweinfurth does not seem to have been overly concerned with the story of Paul, but he could not resist a visit in 1876 to one of the most remote communities in Egypt. In 1904 Agnes Lewis and her sister Margaret Gibson went to great lengths to be the "first women" to visit the Monastery of St. Paul, and they prided themselves on having broken an all-male tradition of sixteen hundred years. Thomas Whittemore of the Byzantine Institute of America led an ambitious expedition to St. Antony's and St. Paul's in order to document the "oldest monasteries in Christendom."[38]

The pilgrims, missionaries, and scholars described by Hamilton were all drawn to the monastery, despite the difficulties they encountered on the way. Every western visitor was essentially an explorer venturing into an unknown desert in search of a hidden mystery. Although each traveler had different motives for making the journey, they were all drawn by the enigmatic figure of Paul the Hermit and the isolated desert monastery that bears his name. The ARCE conservation project at the Cave Church is merely the most recent expression of a long western fascination with the desert fathers of late antique Egypt and their successors, the monks of the Coptic Orthodox Church.

APPENDIX

ARCHITECTURAL DRAWINGS OF THE MONASTERY OF ST. PAUL
AND THE CAVE CHURCH

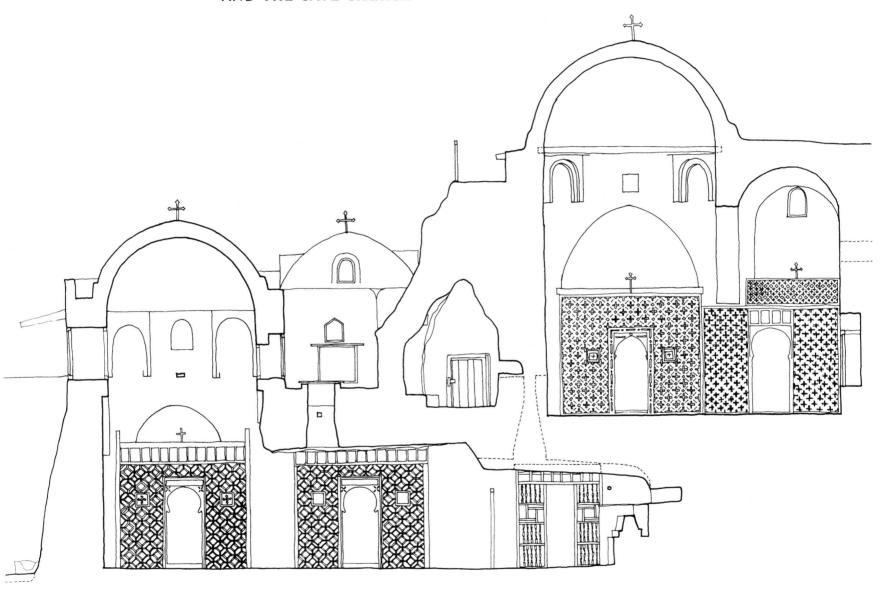

FIGURE 38

Cave Church and Church of
St. Mercurius, north-south section
looking east.

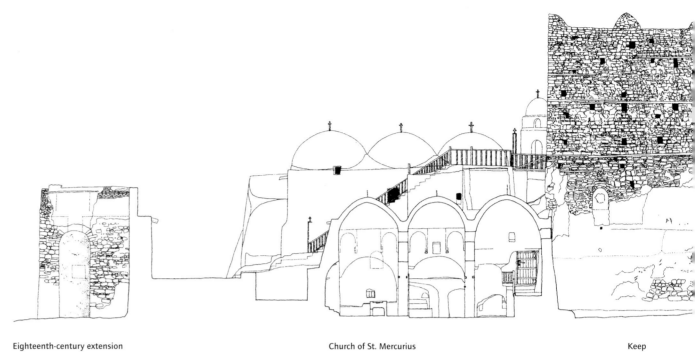

FIGURE 39

Monastery of St. Paul, east-west
section looking south.

Eighteenth-century extension
of walls and site of old fatuli

Church of St. Mercurius

Keep

Cave Church of St. Paul

Thirteenth-century corner tower

Church of St. Mercurius

Refectory

Garden Cave

Garden

Cave Church of St. Paul

FIGURE 40

Monastery of St. Paul, north-south
section looking east.

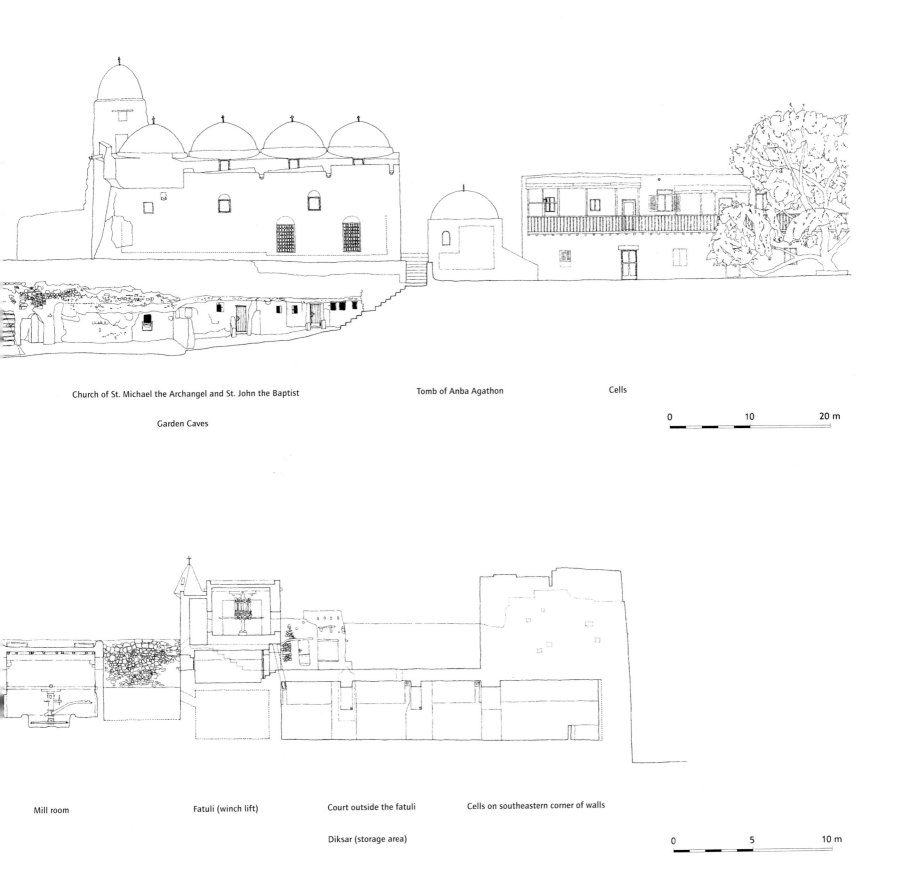

Church of St. Michael the Archangel and St. John the Baptist

Tomb of Anba Agathon

Cells

Garden Caves

0 10 20 m

Mill room

Fatuli (winch lift)

Court outside the fatuli

Cells on southeastern corner of walls

Diksar (storage area)

0 5 10 m

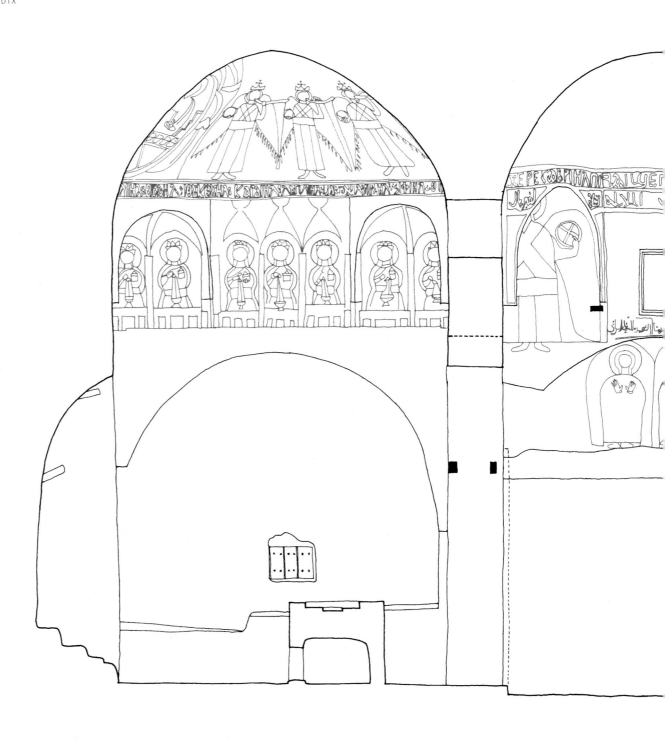

1713

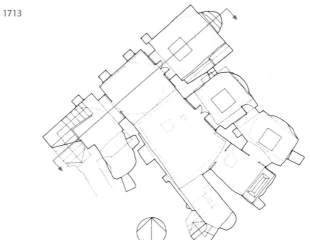

FIGURE 41

Cave Church, east-west section
looking south through the Haykal
of the Twenty-Four Elders, north-
ern nave and narthex.

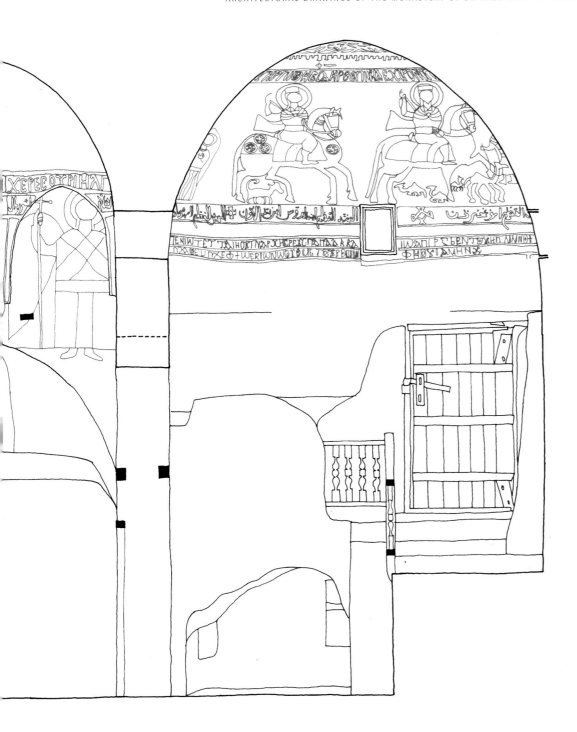

0 1 2 m

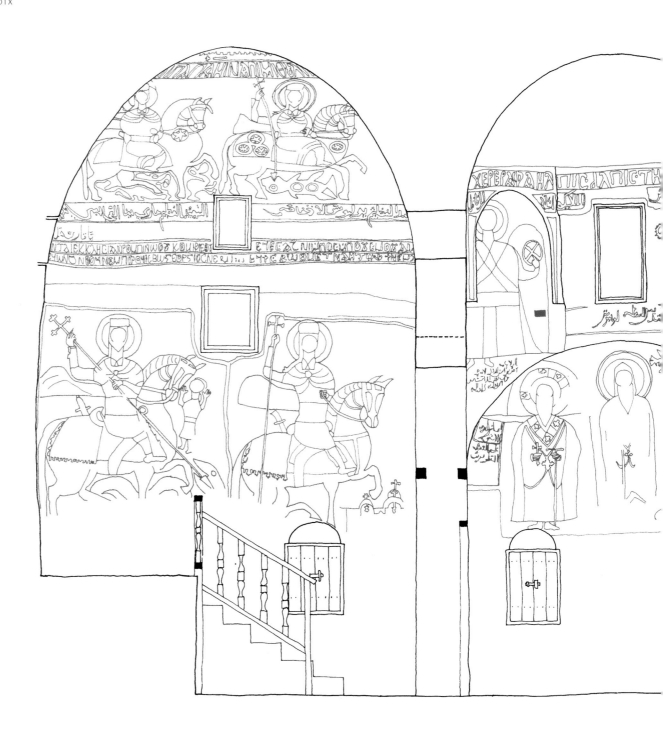

1713

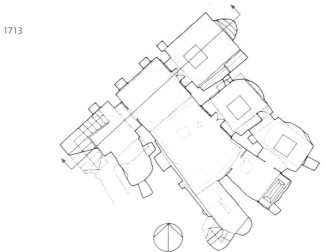

FIGURE 42
Cave Church, east-west section
looking north through the narthex,
northern nave, and Haykal of the
Twenty-Four Elders.

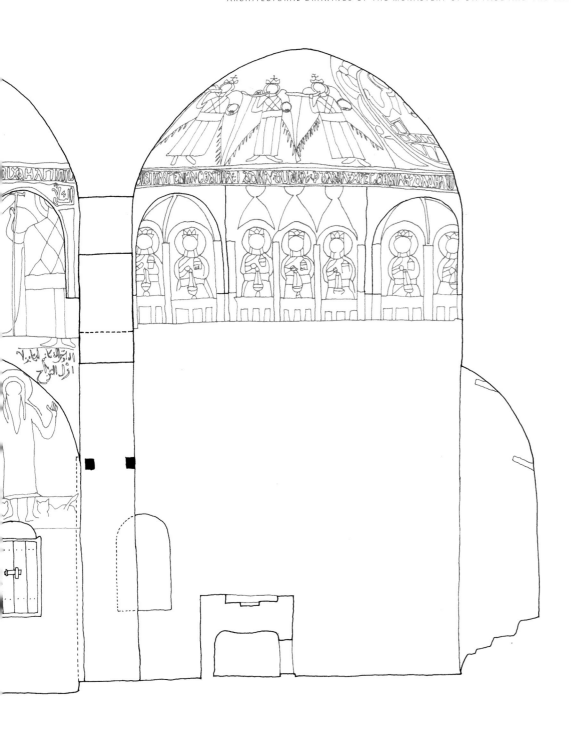

0 1 2 m

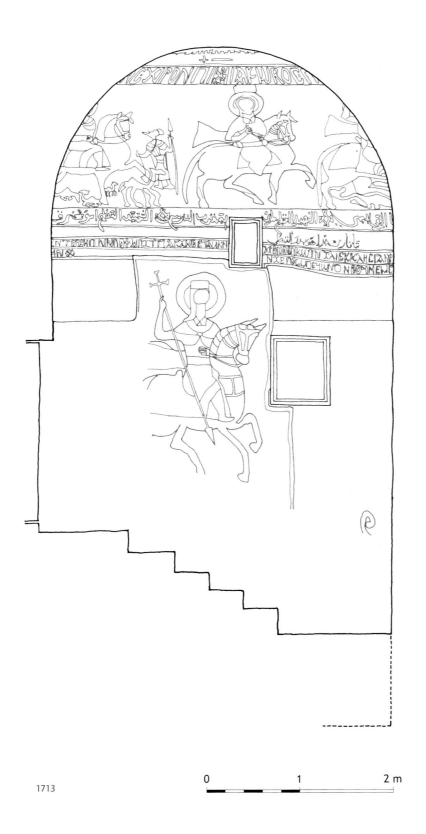

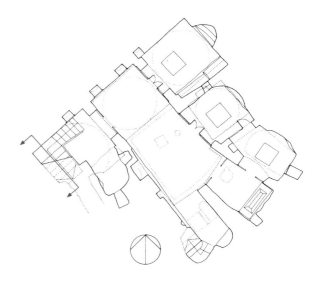

1713

0 1 2 m

FIGURE 43

Cave Church, north-south
section looking west through
the narthex.

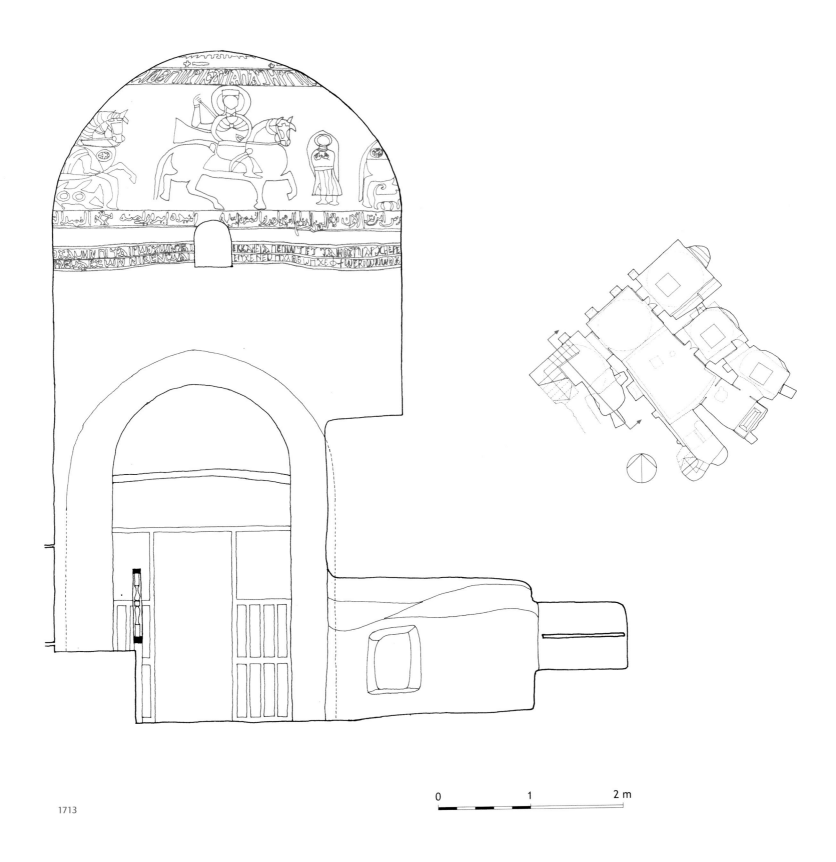

1713

0 1 2 m

FIGURE 44

Cave Church, north-south section
looking east through the narthex
and narthex cave.

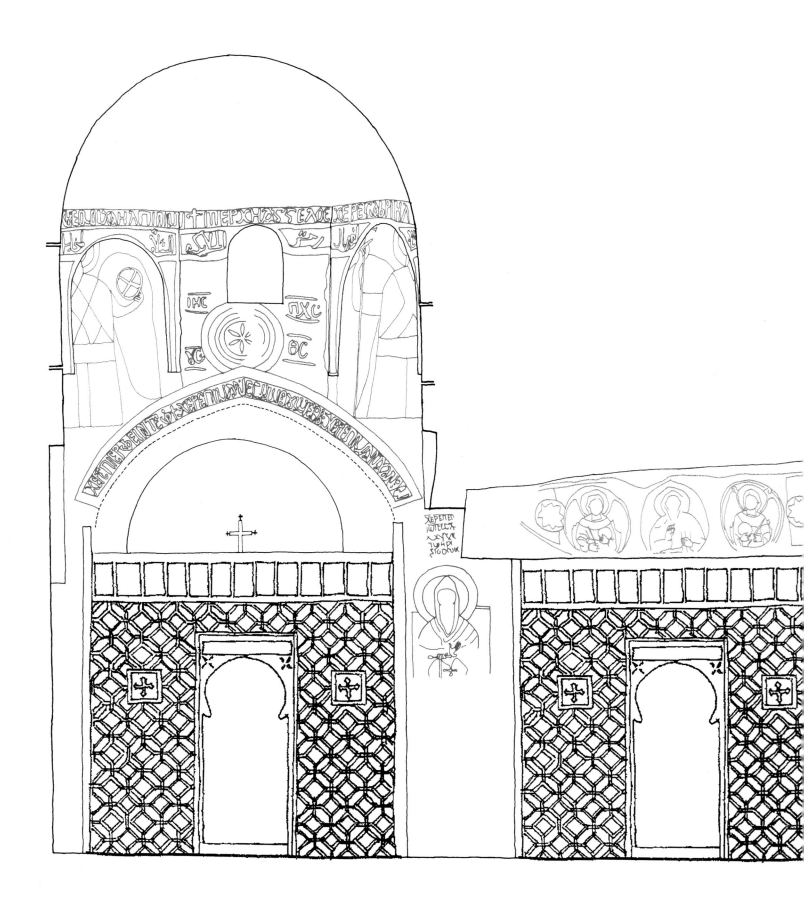

c. 1230 1292 1713

FIGURE 45

Cave Church, north-south section
looking east through the northern
nave, central nave, and Shrine of
St. Paul.

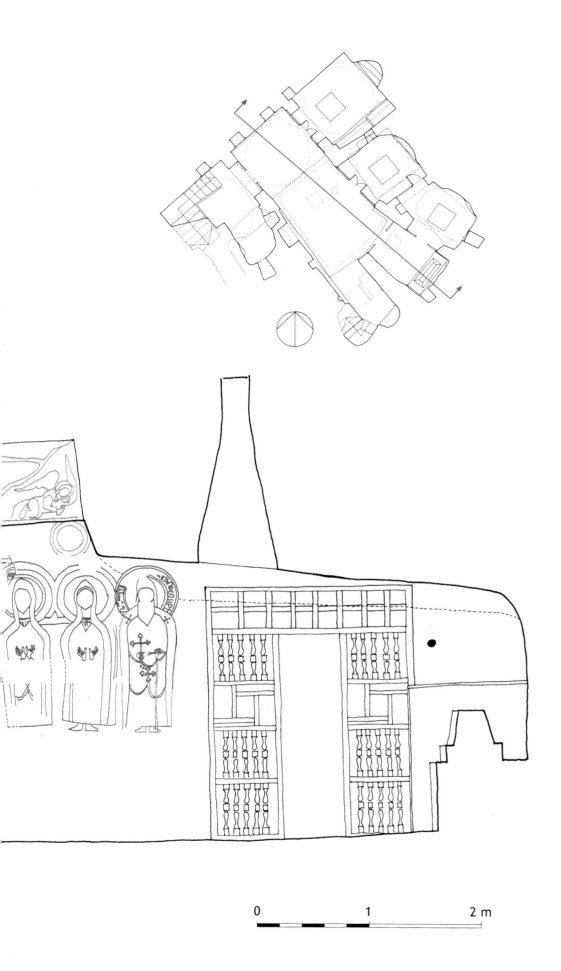

0 1 2 m

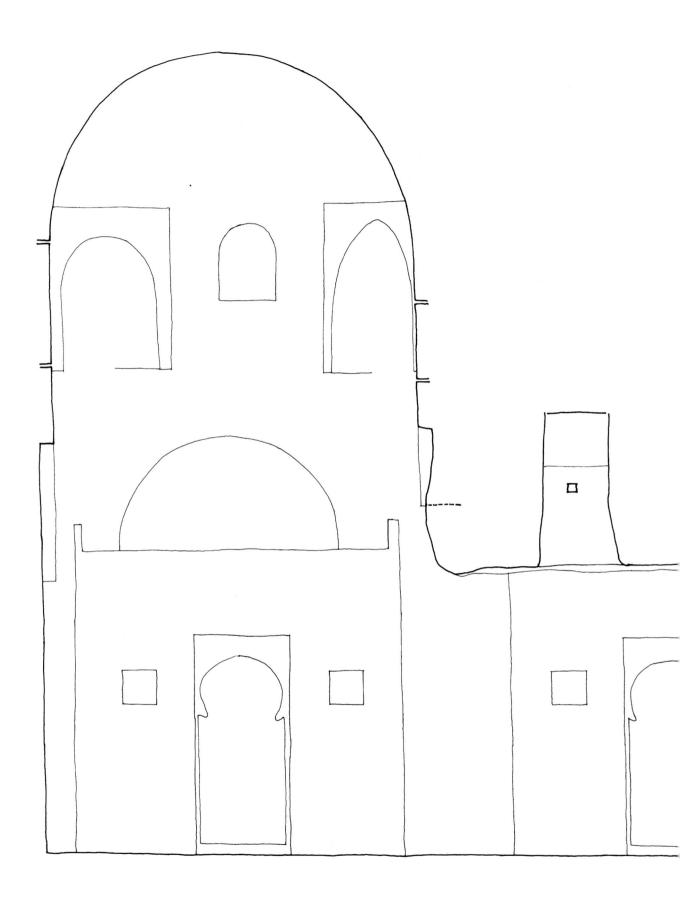

FIGURE 46

Cave Church, north-south section looking east through the northern nave, central nave, and corridor.

1292 1713

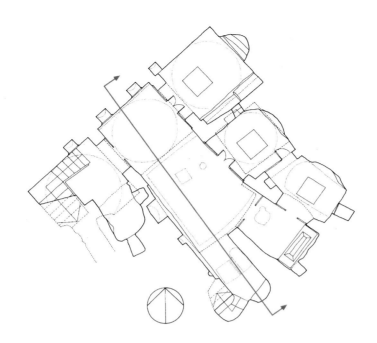

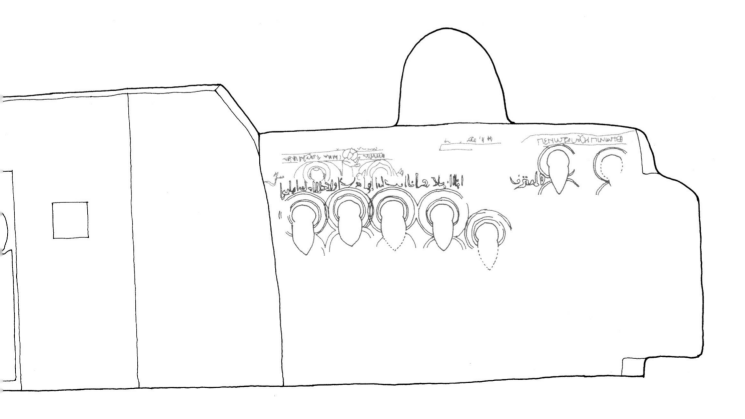

0 1 2 m

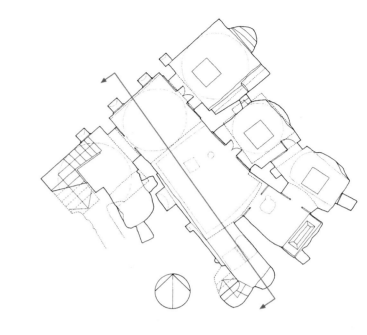

FIGURE 47

Cave Church, north-south section
(looking west) through the corridor,
central nave, and northern nave.

1292 1713

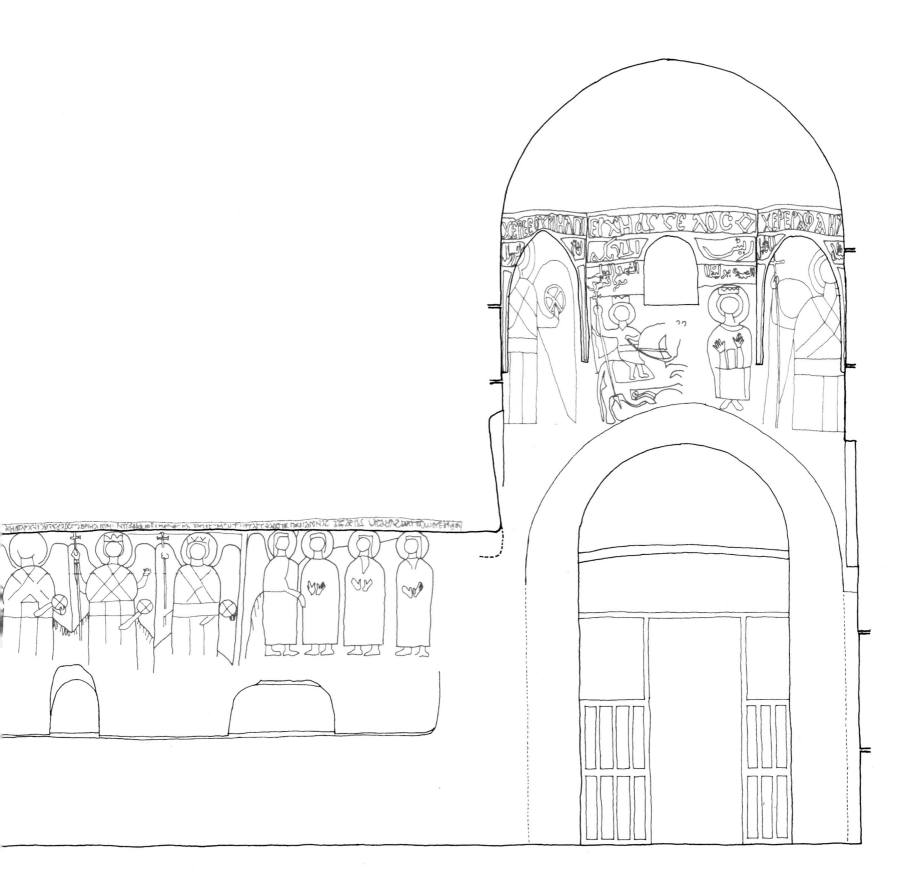

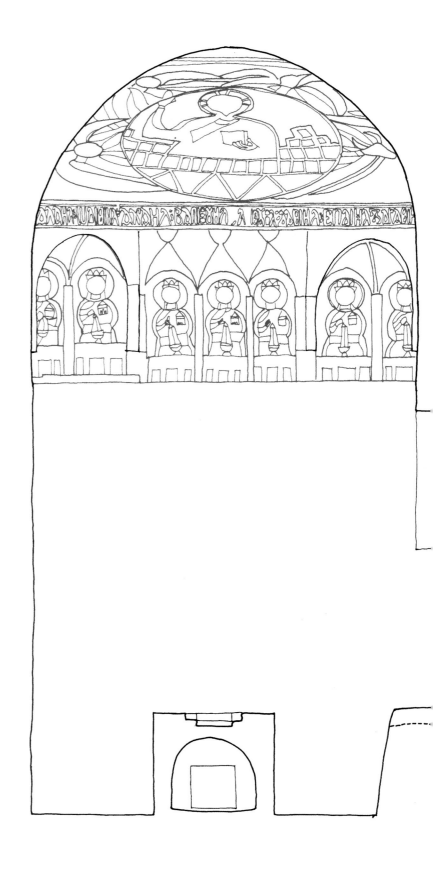

FIGURE 48

Cave Church, north-south section
looking east through the haykals
of the Twenty-Four Elders, St.
Antony, and St. Paul.

ca. 1230 1292 1713

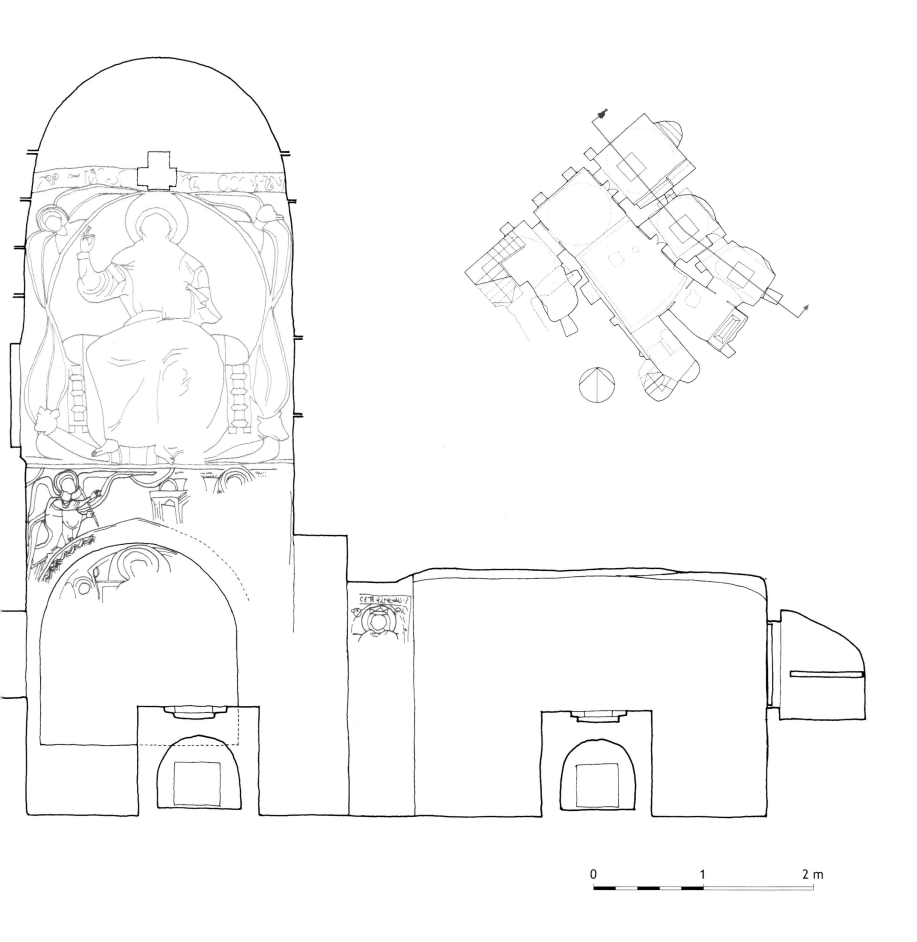

0 1 2 m

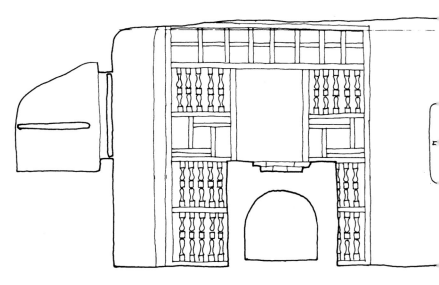

FIGURE 49
Cave Church, north-south section
looking west through the haykals
of St. Paul, St. Antony, and the
Twenty-Four Elders.

1292 1713

316

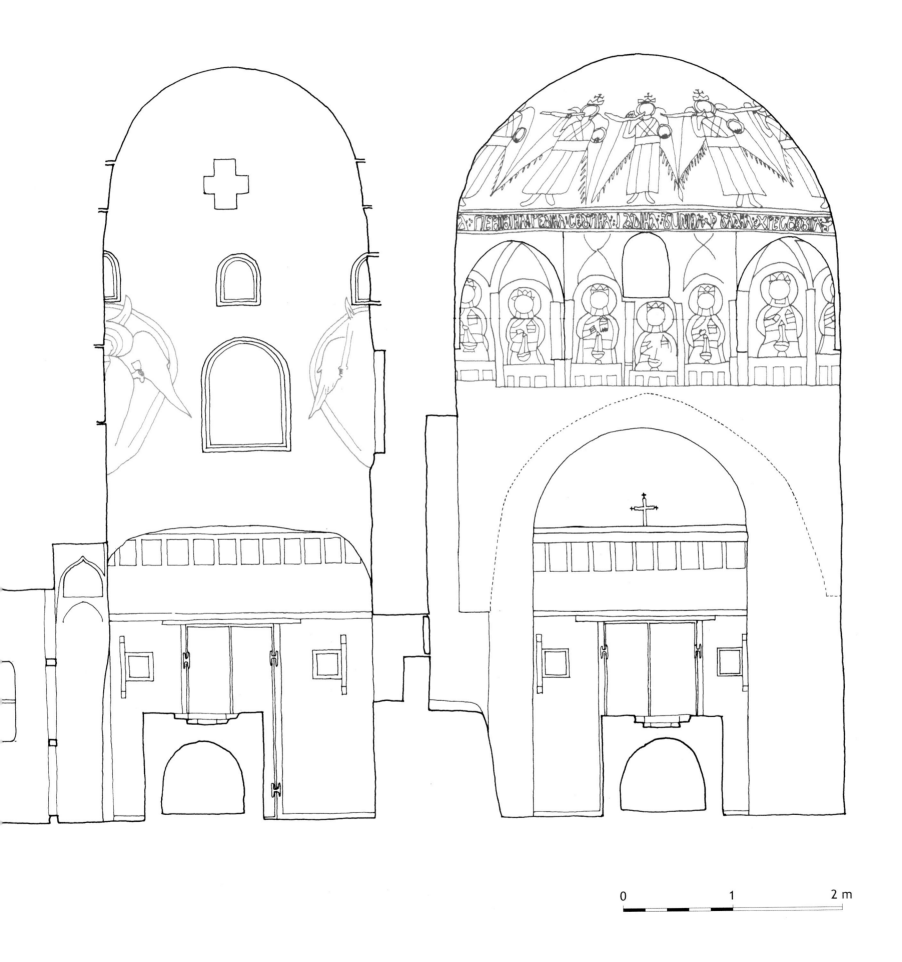

1292 1713

FIGURE 50

Cave Church, east-west section looking
south through the Haykal of St. Antony
and central nave.

0 1 2 m

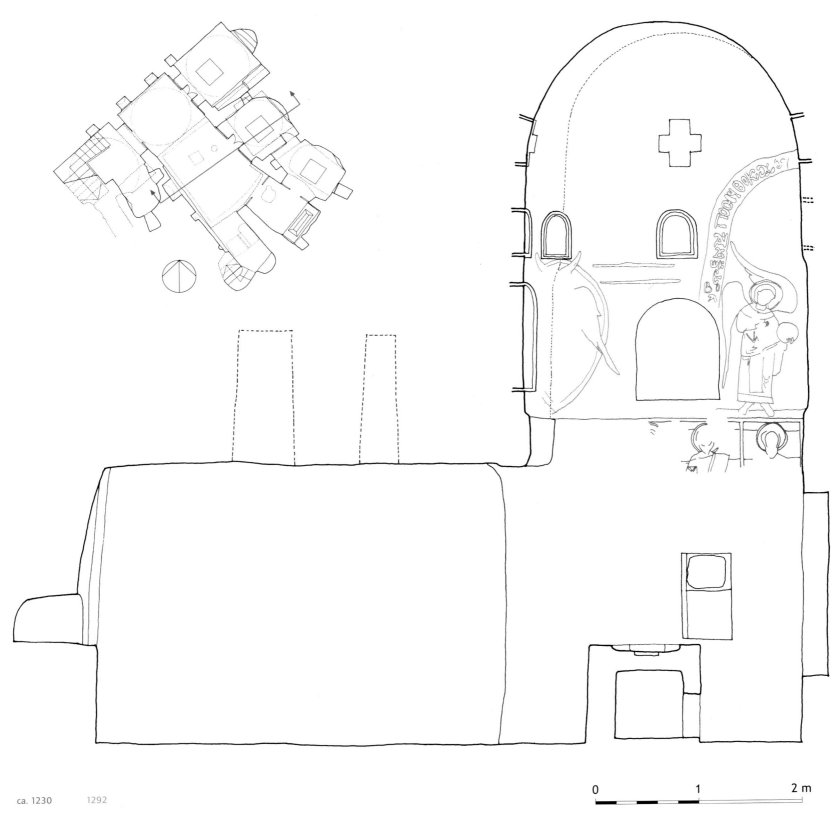

ca. 1230 1292

0 1 2 m

FIGURE 51

Cave Church, east-west section
looking north through the central
nave and Haykal of St. Antony.

ABBREVIATIONS

AI — *Annales Islamologiques*

BARCE — *Bulletin of the American Research Center in Egypt.*

BIFAO — *Bulletin de l'Institut français d'archéologie orientale*

BSAC — *Bulletin de la Société d'archéologie copte*

BSGE — *Bulletin de la Société de géographie d'Egypte*

CC — *Cahiers Coptes*

CE — Aziz S. Atiya, ed. *The Coptic Encyclopedia.* 8 vols. New York: Macmillan, 1991.

CCSL — *Corpus Christianorum, Series Latina.* Turnhout: Brepols, 1953– .

ECA — *Eastern Christian Art.* Leuven: Peeters, 2004– .

Ep — *Epistle* of Jerome

GCS — *Die griechischen christlichen Schriftsteller.* Berlin: Akademie, 1897– .

HPEC — *History of the Patriarchs of the Egyptian Church* (Tarikh batarikat al-iskandariyya al-qipti)

HPEC II/2 — Aziz S. Atiya, Yassa Abd al-Masih, and O. H. E. Khs-Burmester, trans. and annot. *History of the Patriarchs of the Egyptian Church, Known as the History of the Holy Church.* Vol. 2, part 2: *Kay'il III–Shenute II (AD 880–1066).* Cairo: SAC/IFAO, 1948.

HPEC II/3 — Aziz S. Atiya, Yassa Abd al-Masih, and O. H. E. Khs-Burmester, trans. and annot. *History of the Patriarchs of the Egyptian Church, Known as the History of the Holy Church.* Vol. 2, part 3: *Chisto-doulus– Michael (1046–1102) AD.* Cairo: SAC/IFAO, 1959.

HPEC III/3 — Antoine Khater and O. H. E. Khs-Burmester, trans. and annot. *History of the Patriarchs of the Egyptian Church, Known as the History of the Holy Church.* Vol. 3, part 3: *Cyril II–Cyril V (1235–1894 AD).* Cairo: SAC/IFAO, 1970.

HPEC IV/1 — Antoine Khater and O. H. E. Khs-Burmester, trans. and annot. *History of the Patriarchs of the Egyptian Church, Known as the History of the Holy Church.* Vol. 4, part 1: *Cyril III Ibn Laklak (1216–1243 AD).* Cairo: SAC/IFAO, 1974.

ICR — Instituto Centrale del Restauro, Rome

IFAO — Institut français d'archéologie orientale, Cairo

JARCE — *Journal of the American Research Center in Egypt*

JECS — *Journal of Early Christian Studies*

MIFAO — *Mémoires publiés par les members de l'Institut français d'archéologie orientale*

OCP — *Orientalia Christiana Periodica*

ODB — Alexander P. Kazhdan, Alice-Mary Talbot, et al., eds. *The Oxford Dictionary of Byzantium.* 3 vols. Oxford: Oxford University Press, 1991.

PG — J.-P. Migne, ed. *Patrologia Graeca.* Paris: J.-P. Migne, 1857–1886.

PL — J.-P. Migne, ed. *Patrologia Latina.* Paris: J.-P. Migne, 1844–1864.

SAC La Société d'archéologie Copte

SC H. J. DeLubac et al., eds. *Sources chrétiennes.* Paris: Cerf, 1942– .

SOCC *Studia Orientalia Christiana Collectanea*

VA *Vita Antonii* attributed to Athanasius

VH *Vita Hilarion* by Jerome

VO *Vita Onnophrius* by Jerome

VP *Vita Pauli* by Jerome

NOTES

INTRODUCTION: THE MONASTERY OF ST. PAUL THE HERMIT

1 Harmless 2004, 17. He notes on the same page that "this view...is only partially true." See his discussion of the origins of monasticism, 417–458.

2 For a more critical appraisal of Antony's role as father of monasticism, see Goehring 1999, 13–35.

3 For an English translation of Jerome's *Life of Paul*, see White 1998d, 71–84.

4 For a Coptic *Life of Paul*, see Amélineau 1894, 1–14; for an Arabic version, see Basset 1915, 767–781. My thanks to Mark Swanson and Gaw-dat Gabra for these sources. The Coptic version implies rather than states that the grave was in the cave, but for a different interpretation, see Amélineau 1894, 12, n. 5.

5 The name Copt derives from *Aigyptios*, Greek for "Egyptian." The Arabs modified this to *Qibt*, which passed into European languages as *Copt*. The term is currently used to describe Christian Egyptians who belong to the Orthodox Church of Egypt. For a fuller discussion of the term, see Du Bourguet 1991.

6 Piankoff et al. 1930–1940, 1.

7 Abu Al-Izz 1971, 5–8, 237–240.

8 Greenwood 1997, 16–19; Abu Al-Izz 1971, 37, 234–236.

9 Abu Al-Izz 1971, 54–55, 233.

10 Abu Al-Izz 1971, 24–31; Greenwood 1997, 13–16.

11 Abu Al-Izz 1971, 234–236, 246.

12 There is approximately 20 mm (0.78 in.) of precipitation annually. Greenwood 1997, 57–59.

13 Abu Al-Izz 1971, 7, 68, 234, 238–240.

14 Abu Al-Izz 1971, 25.

15 Abu Al-Izz 1971, 7.

16 I thank Father Tomas al-Anba Bula for this figure, which equals three thousand liters.

17 Thirty-five meters marks the widest point of the wadi within the monastic compound; in the vicinity of the Cave Church the distance is only about twenty-five meters.

18 The modern extension of the walls to the west, in the nineteenth or twentieth century, added a further 5,500 square meters to the interior of the compound.

19 Qulzum is derived from Clysma, an ancient town in the vicinity of modern Suez that hosted a number of anchorites. "The Mountain of Antony was often called the Mountain of Clysma, for contemporay texts always indicated the name of the nearest town." Coquin 1991a, 565. See also Wilkinson 2002, 295.

20 There is also a third route between the two monasteries, which is described by Father Maximous El-Anthony in his Preface to this book.

21 Goehring 1999, 18–19. For a recent translation of the Greek *Life of Antony* and a later Coptic version, see Vivian and Athanassakis 2003.

22 *VA* 2–4, 11–12; Vivian and Athanassakis 2003, 58–65, 84–89.

23 *VA* 14.1; Vivian and Athanassakis 2003, 90–91.

24 *VA* 14; Vivian and Athanassakis 2003, 90–93.

25 At least this is the traditional claim; see, for example, Malaty 1993, 52.

26 *VA* 49; Vivian and Athanassakis 2003, 162–165.

27 *VA* 54–55; Vivian and Athanassakis 2003, 172–179.

28 Jerome in his *Life of Hilarion* (written in ca. 391 but set soon after Antony's death) mentioned two monks living at the Inner Mountain. *VH* 30; Fremantle 1989b, 311. The twelfth- to thirteenth-century *History of the Churches and Monasteries* dates the foundation of the monastery to the reign of Julian (360–363). Evetts 1895, 161.

29 Brakke quotes Gregory of Nazianzus (died ca. 390) as saying Athanasius "composed a rule for the monastic life in the form of a narrative." Brakke 1995, 201.

30 *VA* 16–43, 55 (sermons), 48, 54.1–5, 57–59, 71 (miracles), 68–70, 72–80 (heretics and pagans), 5–6, 8–10, 51–53 (devils). Vivian and Athanassakis 2003, 64–73, 76–85, 96–151, 160–163, 168–171, 172–173, 174–179, 180–185, 202–207, 206–209, 208–227.

31 Goehring 1999, 18–20.

32 For the life of Jerome, see Kelly 1975.

33 By the last quarter of the fourth century, the desert of Chalcis "had become peopled with colonies of hermits who, while technically solitaries, maintained in different degrees some minimum of relations with each other." Kelly 1975, 47.

34 Kelly 1975, 60–61.

35 *VP* 1; White 1998d, 75.

36 *VP* 1; White 1998d, 75.

37 *VP* 7; White 1998d, 78.

38 *VA* 91.8; Vivian and Athanassakis 2003, 252–253.

39 Driver 2002, 51–53.

40 Guillaumont and Kuhn 1991, 1926.

41 Corey identifies five Greek versions; the oldest she calls "version *a*." Corey 1943, 144–145. My thanks to Swanson for this source.

42 "Version *b* was shortly afterward made from *a*, probably in Alexandria, whence it spread. It was translated into Syriac and Coptic, enlarged into Ethiopic and Arabic synaxaria, and abridged into short Arabic and Coptic versions." Corey 1943, 145.

43 Corey identifies a third, widely copied, version (*f*) that "was probably composed by Symeon Metaphrates in the latter part of the tenth century. It is a paraphrase of *a*." Corey 1943, 145.

44 In the Catholic Church, however, the feast of Paul was removed from the General Roman Calendar in 1969. McBrien 2001, 77.

45 Guillaumont and Kuhn 1991, 1926.

46 Amélineau 1894, 1–14.

47 Basset 1915, 767–781; al-Maqrizi, in Evetts 1895, 307.

48 *VP* 7; White 1998d, 78.

49 Basset 1915, 777. *VP* 9; White 1998d, 80.

50 The dates for Paul the Hermit are given as AD 228–343 in the inscription on the marble cenotaph of the saint added to the Cave Church in 1946. See Gabra, Chapter 13 of this volume, and Meinardus 1992, 34.

51 The author of the *Historia Monachorum in Aegypto* (ca. 394) used this expression when describing the town of Oxyrhynchus. Russell 1980, 67.

52 Ward 1980, 9.

53 Russell 1980, 148.

54 Russell 1980, 108–110 (Macarius), 111–112 (Amoun).

55 White 1998, xix–xx.

56 Daniélou and Marrou 1983, 274, 276; Ward 1980, 4.

57 Kelly 1975, 124–127.

58 *VH* 30–31; Fremantle 1989b, 310–311.

59 Sulpicius Severus, *Dialogue* 1: 17; Roberts 1989, 32.

60 Russell 1980, 99.

61 *VH* 30; Fremantle 1989b, 311.

62 *VA* 54; Vivian and Athanassakis 2003, 172–173. The Piacenza Pilgrim, who visited the spring of Paul in circa 570, also appears to have walked through the desert, while camels carried the water. He and his party, however, were traveling a different route by way of Sinai. Piacenza Pilgrim, *Itinerary*, 183v; Wilkinson 2002, 146.

63 *VH* 31; Fremantle 1989b, 311.

64 *VH* 31; Fremantle 1989b, 311.

65 Ogier d'Anglure in 1398. Browne 1975, 62.

66 Sulpicius Severus, *Dialogue* 1: 17; Roberts 1989, 32.

67 Evetts 1895, 167; al-Maqrizi in Evetts 1895, 307.

68 Evetts 1895, 166–167.

69 Regnault 1999, 162–173.

70 According to this tradition, the first keep at the Monastery of St. Macarius (Anba Maqar) in the Wadi al-Natrun was constructed sometime before the third sack of Scetis in 444. Matta al-Miskin 1991, 749. Peter Grossmann dated the current keep at St. Macarius to no earlier than the middle of the thirteenth century, but he noted that partially preserved keeps at the nearby monastic settlement of Kellia "are to be dated with certainty to the first half of the fifth century." Grossmann 1991c, 1395–1396.

71 Kelly 1975, 322.

72 I am grateful to Michael Jones for his stimulating remarks, over the years, about the development of the keep and the monastery in general.

73 Evelyn White 1933, 35–36; Cody 1991, 734.

74 In 1895, B. T. A. Evetts published an English translation of the *History of the Churches and Monasteries* (Tarikh al-kana'is wa-al-adyira), which he ascribed to Abu Salih the Armenian. In 1984, Anba Samuel al-Suryani published a different manuscript of the book, in which the author is identified as the Coptic priest Abu al-Makarim. Johannes den Heijer, however, has shown that the text is a compilation rather than the work of a single individual. Evetts 1895; Atiya 1991a, 23; den Heijer 1996, 77–81. I thank Swanson for bringing den Heijer's article to my attention.

75 Evetts 1895, 160.

76 Evetts 1895, 160.

77 Evetts 1895, 163. The monastery is currently known as Dayr al-Maymun. Coquin 1991b, 838–839.

78 Evetts 1895, 163.

79 See Butler's note 1 in Evetts 1895, 163.

80 Coquin 1991b, 838.

81 Evetts 1895, 166–167.

82 Sauneron 1971, 236–237.

83 Van Moorsel 1995, 283; van Moorsel 2000a, 53.

84 Van Moorsel 2002, 19–21.

85 Van Moorsel 2002, 22–25.

86 Grossmann 1991a, 554.

87 For example, the Church of the Virgin at Dayr al-Baramus. Grossman 1991b, 791–792.

88 Jones 2002, 20–30.

89 Hunt 1985; Bolman 2002a, 245–248; Lyster 2002, 121–124.

90 Bolman 2002c, 2002d, 2002e.

91 Van Moorsel 2000a, 53.

92 In 1984, van Moorsel read the date of the inscription framing the second medieval painter's Christ in Majesty as AM 1050 (1333/1334),

although he converted the AM 1050 to 1332/1333. Van Moorsel 2002, 27, fig. 7, 32. After the cleaning of the inscription, however, Gawdat Gabra was able to read the date as AM 1008 (1291/1292). See Chapter 13 of this volume.

93 In the painting of Theodore, however, there is no Annunciation separating the two images. The 1232/1233 painting is illustrated as figure 10.14 in this volume.

94 Identifiable monastic saints in the corridor from the second medieval phase: Arsenius, Shenoute, John, Moses the Black, and perhaps Pachomius. Van Moorsel 2002, 40–46.

95 Van Moorsel 2000a, 51.

96 Bolman 2002b, xiii, fig. 7.

97 Van Loon 1999, 65, 328, plates 75, 76; Zibawi 2003, 144, fig. 184. For the date of these paintings, see van Loon 1999, 72–74.

98 Leroy 1982, plates 75, 76; van Loon 1999, 308, plate 43; Zibawi 2003, 159, fig. 205. For the date of these paintings, see van Loon 1999, 58–60.

99 Browne 1975, 62.

100 Browne 1975, 60.

101 Browne 1975, 60.

102 Browne 1975, 61.

103 Browne 1975, 62.

104 Browne 1975, 62.

105 Browne 1975, 63.

106 Browne 1975, 63.

107 Meinardus 1992, 13.

108 Coquin and Martin give the date of the abandonment of St. Antony's as "towards 1485." Coquin and Martin 1991a, 722.

109 The Monastery of St. Antony was repopulated in 1540. Coquin and Martin 1991a, 722. The chronology of the Monastery of St. Paul for this period is less certain. Coquin and Martin 1991b, 742.

110 The traditional length of time for the second abandonment of St. Paul's is 119 years, or circa 1584–1703. Coquin and Martin 1991b, 742.

111 Coquin and Martin 1991b, 742.

112 *HPCA* III/3, 284. As mentioned below, the walls, keep, and mill are all shown in their current form and placement in the first known plan of the monastery, produced for Claude Sicard after his visit to St. Paul's in 1716. Sicard 1982, 15.

113 Sicard 1982, 41.

114 Van Moorsel 2002, 63–117.

115 Van Moorsel 2002, 47–62.

324

116 Sicard's plan of the monastery is reproduced in figs. 4.2 and 6.21 of this volume.

117 Meinardus 1992, 40.

118 Ibrahim al-Jawhari's involvement with the project and the date AM 1497 is recorded in an inscription above the main entrance of the church. Lyster 1999, 52; van Moorsel 2002, 5, fig. 1. For Ibrahim al-Jawhari, see Motzki 1991, 1274.

119 Lyster 1999, 61.

120 Lewis 1904, 752–753.

121 Lewis 1904, 753. Based on Lewis's description, the church appears to have been the one dedicated to St. Mercurius. Lewis and Gibson do not appear to have seen the Cave Church during their brief visit to the monastery.

122 The Whittemore archive is located in Dumbarton Oaks, Byzantine Photograph and Fieldwork Archives, Washington, D.C. I thank Alice-Mary Talbot and Natalia Teteriatnikov for permission to work with this material. A photograph (A198) in the collection shows the Whittemore team and its military escorts standing before a fleet of Fords at the Monastery of St. Antony; see Bolman 2002b, xxii, fig. 18.

123 Gabra 2002, 182; Meinardus 1992, 42.

124 Gabra 2002, 182; Meinardus 1992, 24–25.

125 The gate and side door are shown in photographs (A110, A122, A126, B112) in the Whittemore collection at Dumbarton Oaks, Washington, D.C.

126 Meinardus 1992, 26–27.

127 Meinardus 1992, 43.

128 I am grateful to Father Sarapamon al-Anba Bula for sharing his memories of St. Paul's in the 1970s and 1980s with me, in numerous conversations between 2002 and 2005.

129 A first survey was carried out by van Moorsel in 1978, followed by two campaigns in 1984 and 1985. Van Moorsel 2000a, 41–42.

130 Van Moorsel 1995, 283–285.

131 Meinardus 1992, 46; Lyster 1999, 33.

132 Elizabeth Oram, in her study of the modern phenomenon of weekend pilgrimages to monasteries by the Coptic laity, quotes a monk of St. Antony's as saying, "About a hundred tour buses show up every Friday and Sunday, carrying about fifty visitors apiece." Oram 2002, 209. During the ARCE conservation project I observed similar numbers on Fridays at the Monastery of St. Paul. Father Tomas al-Anba Bula told me that the number of pilgrims increased greatly for the Feast of St. Paul on February 9, 2005.

133 Lyster 1999.

134 Van Moorsel 2002. Van Moorsel was assisted in the IFAO project by Victor Ghica, Karel Innemée, Kees Crena de Iongh, Alain Lecler, and Johanna Rijnierse.

135 The archival material, published and unpublished, produced during the course of the conservation project at the Monastery of St. Paul is available at ARCE's main office at 2 Midan Qasr al-Dubara, Garden City, Cairo, Egypt.

CHAPTER ONE: JEROME'S *LIFE OF PAUL* AND THE PROMOTION OF EGYPTIAN MONASTICISM IN THE WEST

1 Madrid, Museo del Prado, no. 1169; Blanch 2002, 150, no. 55; see also the Prado Museum Web site at http://museoprado.mcu.es/icuadro_julio.html.

2 *VP* 10; *PL* 23.25B–C; White 1998d, 80. For editions of the Latin text of the *Vita Pauli*, see *PL* 23.17–28; and also Oldfather 1943, 36–42. For English translations, see White 1998d, 75–84, and Harvey 1990, 359–369.

3 Brown 2002, 40.

4 *VP* 7; *PL* 23.22B; White 1998d, 78.

5 *VP* 8; *PL* 23.23A; White 1998d, 78.

6 *VP* 9; *PL* 23.25A; White 1998d, 80.

7 *VP* 12; *PL* 23.26A–B; White 1998d, 81.

8 *VP* 15–16; *PL* 23.27a–28B; White 1998d, 82–83.

9 Jonathan Brown describes this as an "anachronistic procedure" that the Spanish painter probably borrowed from early Netherlandish artists like Joachim Patinir (ca. 1480–1525), who employs this same method (and a similar blue-green tonality) in his painting entitled *Landscape with Saint Jerome* (Madrid, Museo del Prado, no. 1614); Blanch 2002, 311, no. 206; Brown 2002, 40.

10 *VP* 1: "Seeing, then, that an account of Antony has been recorded in both Greek and Latin (*tam Graeco quam Romano stylo*), I have decided to write a few things about the beginning and end of Paul's life." *PL* 23.18A; White 1998d, 75.

11 Sulpicius Severus, *Dialogues* 1.17; *PL* 20.194D; Roberts 1989, 32. In the *Dialogues* (written ca. 400), Sulpicius reports on a conversation in which a friend named Postumianus related stories about two previous journeys he had made to Egypt and about the deeds of the monks there.

12 John Cassian, *Conference* 18.6; *PL* 49.1101A; Gibson 1989, 481.

13 *VP* 1; *PL* 23.17A–18A; White 1998d, 75. Refuting such ancient claims that the desert dwellers Paul and Antony were the first practitioners of monasticism in Egypt, recently uncovered

papyrological evidence shows that village-based ascetics called apotactites (*apotaktikoi*) were in existence even earlier; see Goehring 1999e, 53–72.

14 Merrills 2004, 217–244.

15 Rousseau 1978, 106, 133.

16 *Ep* 14.10; *PL* 22.353–354; Fremantle 1989a, 17.

17 Noting the tone and content of the letter Jerome wrote when he sent the *VP* to his friend Paul of Concordia, J. N. D. Kelly argues that Jerome "was now at Antioch and not, as has often been proposed, in his retreat near Chalcis." Kelly 1975, 60–61.

18 *Ep* 10.3; *PL* 22.344; Fremantle 1989a, 12.

19 Guillaumont 1975, 10. Indeed, by the time Jerome was writing the *Life of Hilarion* in 391, he was already being forced to defend himself against critical reviews of his earlier vita on Paul; see *VH* 1; *PL* 23.30B; White 1998b, 89.

20 In particular, Elizabeth Clark has documented the complex lines of social relationships surrounding Jerome during the Origenist controversy in the late fourth century; see esp. her application of network theory in Clark 1992, 11–42. On Jerome's struggle to maintain a wide circle of friends and supporters, even after his establishment of his monastery in Bethlehem, see Rebenich 1992.

21 Philip Rousseau, "Jerome's Search for Self-Identity," on the web at http://dlibrary.acu.edu.au/research/cecs/rousseau.htm.

22 *VP* 17–18; *PL* 23.28B–C; White 1998d, 83–84.

23 *VP* 4; *PL* 23.20B; White 1998d, 77; cf. *Aeneid* 3.56–57; Fairclough 1999a, 376–377. While Virgil uses these words to describe the Thracian king who betrayed Polydorus, Jerome applies the phrase to Paul's traitorous brother-in-law, who sought to profit by handing him over to the persecutors.

24 DuBois has recognized that ancient epics functioned not only to reaffirm traditional social values, but also "to subject them to scrutiny and to explore their limitations." DuBois 1982, 30; cf. Pavlock 1990, 4.

25 *Ep* 10.3; *PL* 22.344; Fremantle 1989a, 12. The originality of the Latin version of the *Vita Pauli* (over the Greek) was established in the first decade of the twentieth century. See Bidez 1900; Kugener 1902, 513–517; de Decker 1905; and Plesch 1910, 5–21. For a summary of this early history of scholarship, see Kech 1977, 3. On the Greek version of the *Life*, see also Nau 1901, 121–157. The Coptic version of the *Life* is also dependent on the Latin; see Guillaumont and Kuhn 1991, 1925–1926, *contra* Amélineau 1894, 1–14.

26 *VP* 4; *PL* 23.20A–B; White 1998d, 76. In one of Jerome's later letters to Eustochium, ca. 384 (*Ep* 22.36; *PL* 22.421; Fremantle 1989, 38), he also cites the example of Egyptian ascetics in criticizing an overweening concern with wealth and property: "I put their example before you, so that you will despise, not simply gold and silver and other riches, but the very earth and sky." Indeed, throughout his career Jerome continued to pass judgment on the Roman upper class; see, e.g., Curran 1997, 213–229.

27 For this perspective, see, e.g., Hagendahl 1974, 216–227, esp. 217.

28 In this context, I am arguing that the *Vita Pauli* and other ancient hagiographical literature necessarily functioned both as a form of entertainment and as an instrument of religious propaganda. Older studies of early Christian hagiography sometimes constructed a false dichotomy between these two social functions: see, e.g., Musurillo 1954, 275, who observes that "it is frequently difficult to determine when a piece of literature has been written primarily for propaganda…and when its aim is primarily entertainment, though with sharp political overtones." A similar perspective has been voiced by Hendrikx, who distinguishes the didactic and propagandistic aims of some vitae over "true hagiography." Hendrikx 1968, 665. On the propagandistic function of ancient biography, see Miller 1983, who observes that biographies were produced "in an endeavor to crystallize belief and so win converts." Miller 1983, xv, 15–16.

29 For a history of the use of the term "intertextuality" in twentieth-century scholarship, and a helpful introduction to its various applications in the study of literary and nonliterary arts, see Allen 2000.

30 For an example of this approach to intertextuality in the study of early Christian literature, see Hays 1989, esp. 14–21.

31 For an example of a poststructuralist approach to intertextuality in the study of early Christian literature, see my article, Davis 2002.

32 Barthes 1981, 39.

33 Barthes 1977, 159.

34 On the use of preconceived heroic models in the production of ancient biographies, see also Miller 1983, 65. Lynda Coon has noted how late antique and early medieval vitae often "fused Hebrew, classical, and Christian formulaic patterns of behavior." Coon 1997, 8.

35 I borrow these terms from Patricia Cox Miller, who writes concerning these subtle turns of phrase, "Ancient biographies are constellations of such gestures, carefully selected and assembled not to chronicle a life's history but

to suggest its character…. If the facts of history form the 'landscape' of a man's life, character is its 'inscape,' the contours and hollows which give a landscape its individuality. Biographies are like caricatures, bringing landscape and inscape, event and character, together in a single moment of evocative expression." Miller 1983, xi. Miller herself derives her use of the term "inscape" from the British poet Gerard Manley Hopkins, who coined it to refer to the inherent design or pattern he observed in both nature and art. See, e.g., Hopkins 1955, 66, and Carter 2004, 195–200, esp. 198. In the study of early Egyptian hagiography, Douglas Burton-Christie has shown how topography and the language of place could be used to plumb the "inner landscape" of ascetic discipline; see esp. Burton-Christie 1999, 45–65.

36 On the important relation between the production of hagiographical literature and methods of biblical exegesis, see Kech 1977, 2.

37 *VP* 13; *PL* 23.26C; White 1998d, 82.

38 Miller 1994, 137–153, esp. 150–151; Vivian 1996, 166; Frank 2000, 91–96.

39 Russell 1980, 85.

40 Russell 1980, 108–109.

41 *VO* 3; Vivian 1996, 173.

42 *VO* 6; Vivian 1996, 174.

43 *VO* 28–29; Vivian 1996, 184–185.

44 In his early letters to other monks, Jerome reinforces this association of the desert with paradise: *Ep* 2.1 (*PL* 22.331; Fremantle 1989a, 4); *Ep* 3.4.2 (*PL* 22.334; Fremantle 1989a, 5); *Ep* 14.10.3 (*PL* 22.354; Fremantle 1989a, 17); see also Miller 1996, 212.

45 *VP* 1; *PL* 23.17A; White 1998d, 75.

46 Athanasius, *On Virginity*, 191–203, in Casey 1935, 1044–1045 (cf. 1033); cf. *VA* 7. Greek text: Bartelink 1994, 154–156; cf. chapters 7, 8 in Evagrius' Latin translation: *PG* 26.853–854; White 1998a, 14. See also, Brakke 1995, 55, 169, 188, 250–251, 259.

47 *VO* 11; Vivian 1996, 177.

48 *VP* 10; *PL* 23.25B; White 1998d, 80.

49 Matthew 17:2–3; Mark 9:2–4; Luke 9:29–30.

50 Matthew 17:10–13; Mark 9:11–13; Luke 9:31.

51 Coon reflects further on how the "biblical lives of Elijah, Elisha, John the Baptist, Christ, and the apostles form the charismatic prototypes for the sacred biographies of Christian saints." Coon 1997, 1.

52 For the Latin text of Evagrius' translation, see *PG* 26.833–976; cf. *PL* 73.125–170. For an English translation of this work, see White 1998a, 1–70. On Evagrius' friendship with Jerome, see Rebenich 1992, esp. 56–75.

53 Innocentius' death in 374 probably provides a *terminus ante quem* for the completion of Evagrius' translation.

54 *VP* 1; *PL* 23.18A; White 1998d, 75.

55 *VP* 5; *PL* 23.20B–21A; 77; White 1998d, 77; cf. *VA* 17; *PG* 26.869–870; White 1998a, 20.

56 *VP* 4; *PL* 23.20A; White 1998d, 76; cf. *VA* 2; White 1998a, 9. See also Kozik 1968, 23 (2.1–2).

57 *VP* 6; *PL* 23.21B; White 1998d, 77; cf. *VA* 50; cf. *PG* 26.915–916; White 1998a, 39. See also Kozik 1968, 27 (4.1).

58 *VP* 14; *PL* 23.27A; White 1998d, 82; cf. *VA* 92; *PG* 26.971–972; White 1998a, 68. See also Kozik 1968, 42 (12.6).

59 On the literary competition between Jerome's *VP* and the earlier *VA* by Athanasius, see Leclerc 1988, 257–265; Kech 1977, 26–27.

60 *VP* 7; *PL* 23.22A; White 1998d, 78; Leclerc 1988, 262.

61 *VP* 9; *PL* 23.25A; White 1998d, 80; cf. Matthew 7:7 and Luke 11:9.

62 *VP* 11; *PL* 23.26A; White 1998d, 81; Leclerc 1988, 264.

63 *VA* 91; *PG* 26.971–972; White 1998a, 67.

64 *VA* 1; *PG* 26.839–840; White 1998a, 8–9. *VP* 4; *PL* 23.20A–B; White 1998d, 76–77. Jerome's language here (*non se litteris erudiri*) echoes that of Sallust in his description of Sulla: "[*Sulla*] *litteris Graecis et Latinis… eruditus*" *Iugurtha* 95:3; Kozik 1968, 24 (2.3).

65 Leclerc 1988, 258, 265. On western aristocratic attitudes toward monks in late antiquity, see also Fontaine 1979, 28–53. On the "quasi-auto-biographical" nature of Jerome's hagiographical works, see also Rousseau 1978, 133.

66 *Ep* 22.30; *PL* 22.416–417; Fremantle 1989a, 35–36; see also Thierry 1963, 28–40.

67 *Ep* 22.29; *PL* 22.416; Fremantle 1989a, 35.

68 Indeed, Jerome's description of the heavenly court in his vision ironically seems indebted to book 6 of Virgil's *Aeneid;* Thierry 1963, 32–34. On Jerome's extensive use of Virgil, Cicero, and Horace, see Tkacz 1999, 93–104, who enumerates over 350 quotations of these three authors in Jerome's writings (174 for Virgil, 136 for Cicero, and 65 for Horace; see 95); cf. Hagendahl 1958, 101–102, 281–283 (Horace), 276–279 (Virgil), 284–292 (Cicero); Hagendahl 1974, 216–227; Tkacz 1997, 378–382.

69 On Jerome's indebtedness to Virgil in his hagiographical works, see Coleiro 1957, 161–178; Cameron 1968, 55–56; Hagendahl 1974, 217.

70 Virgil's *Aeneid* served as the foundation of a classical Latin education: on the history of ancient educational usage of the "Roman

71 *VP* 9; *PL* 23.25A; White 1998d, 80, translation modified.

72 *Aeneid* 2.650; Fairclough 1999a, 360–361; cf. Kozik 1968, 32 (7.7).

73 *Aeneid* 6.672; Fairclough 1999a, 578–579; cf. Kozik 1968, 32 (7.8).

74 *VP* 16; *PL* 23.27B; White 1998d, 82; cf. *Aeneid* 12.486; Fairclough 1999b, 334–335; cf. Kozik 1968, 47 (14.13).

75 *VP* 16; *PL* 23.28A; White 1998d, 83; cf. *Aeneid* 7.5–6; Fairclough 1999b, 2–3; cf. Kozik 1968, 44 (13.3–4).

76 Kech 1977, 28–29.

77 Hagendahl 1974, 217.

78 I borrow here the language of Kech 1977, 22.

79 Here, I define "landscape" not as actual topography, but as the discursive transformation of the natural world through the perception and imagination of the writer. On this use of the term, see Miller 1996, 209–233, esp. 209–210. Schama (1995, 6–7, 10) writes: "Before it can ever be a repose for the senses, landscape is the work of the mind. Its scenery is built up as much from strata of memory as from layers of rock.... It is our shaping perception that makes the difference between raw matter and landscape."

80 Jerome describes a "vast cavern, hollowed in a mountain's side" (*specus ingens/exesi latere in montis*) where "Proteus shelters himself with the barrier of a huge rock." *VP* 5; *PL* 23.21A; White 1998d, 77; cf. *Georgics* 4.419–420; Fairclough 1999a, 248–249. In Ps.-Virgil, *Culex* 146, birds are described "settling on the spreading branches" (*patulis residentes…ramis*). Fairclough 1999b, 414–415. On these verbal echoes, see also Kozik 1968, 26 (3.7–8, 3.9).

81 *Aeneid* 6.42, 6.237; Fairclough 1999a, 534–535, 548–549.

82 *Aeneid* 8.193ff. (*spelunca*), 8.296–297 (*antra*); Fairclough 1999b, 72–75, 80–81.

83 *VP* 7–8; *PL* 23.22A–24A; White 1998d, 78–79.

84 *VP* 9; *PL* 23.24B; White 1998d, 79.

85 *VP* 16; *PL* 23.27B–28A; White 1998d, 83.

86 On centaurs and satyrs as liminal figures, see DuBois 1982, chapters 1–2; Bartra 1994, esp. 11–47; Miller 1996, esp. 216–225; Merrills 2004, 217–244, esp. 219–226. DuBois writes, "Centaurs were creatures at the boundaries of difference. Speculation about them constitutes part of the Greeks' thinking about sexual, cultural, and species boundaries" (27). In commenting on the presence of centaurs and satyrs in the *VP*, Merrills writes, "Christian monk and classical monster are thus shown to have lived side by side in the same part of the world's periphery" (219).

87 *Aeneid* 6.286, 7.674–677; Fairclough 1999a, 552–553; Fairclough 1999b, 48–49.

88 *Aeneid* 8.314; Fairclough 1999b, 82–83; cf. *Georgics* 1.10–12; Fairclough 1999a, 98–99.

89 Van Buren 1970, 626. The name of the festival, with its Latin root "lup-," may suggest that its ritual activities were designed, in part, to propitiate a wolf-god.

90 Bartra 1994, 45–46; Miller 1996, 224. See also Isaiah 34:14, which describes the desert as being inhabited by wildcats, hyenas, and satyrs, along with the legendary female demon Lilith.

91 On soldiers compared to raging lions or dressed in lion hides and teeth, see *Aeneid* 7.666–669, 9.339–341, 10.454–456, 10.719–724, 12.4–9; Fairclough 1999b, 48–49, 138–139, 204–205, 222–223, 300–301. On soldiers compared to fierce wolves or adorned with wolf-skull helmets, see *Aeneid* 2.355–360, 7.685–689, 9.59–64, 9.563–566, 11.680–681, 11.809–815; Fairclough 1999a, 340–341; Fairclough 1999b, 50–51, 118–119 152–155, 282–283, 292–293. Cf. Virgil's account of how Romulus founded the city of Rome while dressed "in the tawny hide of the she-wolf": *Aeneid* 1.275–277; Fairclough 1999a, 280–281.

92 Mountains: *Aeneid* 4.159; Fairclough 1999a, 432–433. Islands: *Aeneid* 7.15–18; Fairclough 1999b, 2–3. Caves: *Aeneid* 8.295–297; Fairclough 1999b, 80–81.

93 *Aeneid* 7.15–18; Fairclough 1999b, 2–3.

94 *Aeneid* 3.424–432; Fairclough 1999a, 400–401.

95 *VP* 7; *PL* 23.22B–23A; White 1998d, 78.

96 *VP* 9; *PL* 23.24B; White 1998d, 79.

97 *VP* 8; *PL* 23.23A–B; White 1998d, 78–79. Miller notes that the Latin word *mortalis* "refers not simply to a being subject to death … but specifies humankind in particular, often by contrast with the im*mortal* gods." Miller 1996, 223.

98 *VP* 16; *PL* 23.27B–28A; White 1998d, 83.

99 *Aeneid* 1.275–277; Fairclough 1999a, 280–281.

100 *Aeneid* 8.626; Fairclough 1999b, 104–105.

101 *Aeneid* 8.630–634; Fairclough 1999b, 104–105.

102 As mentioned earlier, Jerome's critique of greed within Roman aristocratic society is pointedly underscored by another citation of Virgil in the *VP*. In chapter 4, the greed of Paul's brother-in-law threatens to hinder Paul in his desire to withdraw from society: he tries to make money by turning him in to the persecutors. Jerome laments, "But to what does the accursed greed for gold not drive the hearts of men?" (*PL* 23.20B; White 1998d, 77). This line is a direct quotation from book three of the *Aeneid* (3.56–57; Fairclough 1999a, 376–377), in which Aeneas describes the greed of the Thracian king in betraying Polydorus. A few lines after Jerome's quotation of the *Aeneid,* another intertextual reference reinforces the characterization of such greed as an un-Roman vice. Describing Paul's brother-in-law in more detail, Jerome writes that "he was on the spot, he was insistent, he practiced cruelty as though it were kindness" (*aderat, instabat, credelitate quasi pietate utebatur);* *VP* 4; *PL* 23.20B; White 1998d, 77. The phrase comes from Lucius Annaeus Florus' *Epitome of Roman History* (1.40.7–8), where these words were originally applied to the Pontic ruler Mithridates, an enemy of Rome who ordered the murder of Roman citizens in Asia and violated "the sanctity of private houses, temples and altars, and all laws human and divine." Forster 1966, 180–181.

103 Eusebius of Caesarea, *The Life of Constantine* 3.25–43; Winkelmann 1991, 94–102; Cameron and Hall 1999, 132–138.

104 For examples (and analyses) of such early Christian pilgrimage texts, see Wilkinson 2002. On the phenomenon of Holy Land pilgrimage, see also Hunt 1982 and Wilken 1992, 101–125.

105 On the theory of "cognitive mapping" and its application to early Christian pilgrimage, see Leyerle 1996, 119–143.

106 *PL* 20.183–222; Roberts 1989, 24–54.

107 Piacenza Pilgrim (Antoninus Martyr), *Itinerary;* Geyer 1965a, 129–153; Wilkinson 2002, 129–151; Stewart 1887. In this chapter, I use Wilkinson's translation unless otherwise indicated.

108 Piacenza Pilgrim, *Itinerary,* 43; Geyer 1965a, 151; Wilkinson 2002, 149.

109 *Dialogues* 1.17; *PL* 20.194D; Roberts 1989, 32.

110 Sulpicius Severus himself wrote the well-known *Life of Martin of Tours* before Martin's death on November 11, 397. For a recent edition of the Latin text, see Ruggiero 2003, and also *PL* 20.159–176. For an English translation, see White 1998c, 134–159.

111 *Dialogues* 1.17; *PL* 20.194D; Roberts 1989, 32.

112 *Dialogues* 1.17; *PL* 20.194D; Roberts 1989, 32.

113 Egeria, *Itinerary,* 2–4; Francheschini and Weber 1958, 37–43; Wilkinson 1999, 107–112.

114 Piacenza Pilgrim, *Itinerary,* 37; Geyer 1965a, 151; Wilkinson 2002, 146.

115 In speaking of "*two* monasteries of Saint Antony," Posthumianus was probably refer-

ring to the communities at Pispir (the Outer Mountain) and Mount Qulzum (the Inner Mountain). For more on the history and evolution of the monasteries in the Red Sea region, see Swanson, Chapter 2 of this volume.

116 *Dialogues* 1.7–9: *PL* 20.188B–190A; Roberts 1989, 27–28; *PL* 20.189B; Roberts 1989, 27. The quote here is from *Dialogues* 1.8.

117 *Dialogues* 1.11; *PL* 20.191A; Roberts 1989, 29; cf. *VP* 10–11; *PL* 23.25B–26A; White 1998d, 80–81.

118 *Dialogues* 1.13; *PL* 20.192C; Roberts 1989, 30; cf. *VP* 16; *PL* 23.27B–28A; White 1998d, 83.

119 *Dialogues* 1.15; *PL* 20.193C–194B; Roberts 1989, 31–32.

120 *Dialogues* 1.14; *PL* 20.192C–193C, esp. 193B; Roberts 1989, 30–31; cf. *VP* 9, 16; *PL* 23.24B, 28A; White 1998d, 79, 83.

121 *Dialogues* 1.25; *PL* 20.199C; Roberts 1989, 36.

122 Harmless 2004, 373.

123 *Conference* 18.6; *PL* 49.1101A; Gibson 1989, 481. Cassian describes the *Conferences* as a work designed "for the training of the inner man and the perfection of the heart" (*ad disciplinam interioris ac perfectionem cordis*). *Institutes* 2.9; *PL* 49.97B; Gibson 1989, 208.

124 I want to express my deep appreciation to William Lyster, whose invaluable contributions significantly enhanced my discussion of Paul the Hermit in western medieval art. For a brief discussion of the relationship between the biographies of Antony and Paul, western iconography, and European pilgrimage to Egypt during the late medieval period, see also Hamilton 2006, 108–109.

125 On the iconography of the Ruthwell Cross, see Meyvaert 1992, 95–166, esp. 125–135.

126 For a list of Irish High Crosses on which Antony and Paul are paired, see Harbison 1992, 1: 303–309. Harbison (304–305) cites twelve examples of reliefs featuring the two Egyptian saints breaking bread in the desert. One such example is the eighth- or ninth-century Cross of Moone at Moen Cholurn Cille, County Kildare, Ireland, which displays an image of the raven bringing bread to Antony and Paul, along with the temptation of Antony, the multiplication of the loaves and fishes, the flight into Egypt, and the three Hebrews in the fiery furnace on its north and south faces (Harbison 1992, 1: cat. 181, figs. 518, 953; http://www.celtarts.com/cross3.htm). The north side of the Muiredach Cross in Monasterboice, County Louth, preserves a similar scene of the two Egyptian saints (Harbison 1992, 1: cat. 174, figs. 485, 952; http://www.bluffton.edu/~sullivanm/muiredach/muiredach3.html). For a comparison of the Moone and Muiredach crosses, see O'Neill 1989, 17–19. Pennick (1997, 113–114) cites another

cross at Maughold on the Isle of Man where the monks Paul and Anthony are seated on opposite sides of a wheel-head cross, an image that he confirms is a "popular theme in the Celtic church."

127 Two examples are cited by Harbison: top of the north side of Muiredach's Cross at Monasterboice, County Louth, and top of the east side of the Market Cross at Kells, County Meath. Harbison 1992, 1: 305, figs. 485, 952 (Muiredach's Cross), 330 (Market Cross).

128 One capital on the north wall of the nave (no. 75) preserves a scene of Antony and Paul standing in hooded robes and holding a round loaf of bread between them; another bears an image of Paul's burial (no. 59). See http://vrcoll.fa.pitt.edu/medart/menufrance/vezelay/capitals/vezcap75.html; and Pamela Loos-Noji, "Temptation and Redemption: A Monastic Life in Stone," at http://www.umilta.net/equal5.html.

129 Morisani 1962.

130 Morisani 1962, fig. 10 (also see figs. 8, 9, 11).

131 Harbison 1992, 1: 305.

132 Meiss and Beatson 1974, ff. 183–189v (life of Jerome), 191–193v (life of Paul), and 194–194v (temptations and death of Antony). For selected examples of these folios, see also Rorimer 1958, nos. 19–24. Rice believed the twelve-page cycle devoted to Jerome's life in the *Belles Heures* to be an indicator of an earlier Italian iconographic repertory. Rice 1985, 64–67.

133 In the *Belles Heures*, lions appear on three consecutive folios in the Jerome cycle (ff. 186v–187v) and on four consecutive folios in the Paul cycle (ff. 192–193v). The earliest source that credits Jerome with the domestication of a wild lion is the anonymous ninth-century biography: Boninus Mombritius, *Sanctuarium seu vitae sanctorum*; Benedictines of Solesmes 1910, 2: 31–36, esp. 34, lines 14–35, 55. On the episodes related to Jerome and the lion, and on the resonance of these stories with the *VP* and other ancient hagiographical legends, see Rice 1985, 37–45.

134 Larsen 1988, 1: 147–149 2: 95–97, cats. 217–225.

135 Anthony van Dyck, *Saint Jerome* (ca. 1616), Vienna, Liechtenstein Museum, Liechtenstein Collection, inv. no. GE 56; Larsen 1988, 1: 148 (ill. 56), 2: 95 (cat. 220); also on the Web at http://www.liechtensteinmuseum.at/en/pages/1421.asp#21191805. Anthony van Dyck, *Saint Jerome* (ca. 1617), Rotterdam, Museum Boymans-van Beuningen, inv. no. 22; Larsen 1988, 1: 149, ill. 58; 2: 97 (cat. 225).

136 On the artist and artistry of the *Isenheim Altarpiece*, see Burkhard 1934, 56–69, pls. V–XII; Hayum 1989; Ziermann 2001, esp. 74–152.

137 Burkhard 1934, 67–68.

138 Ziermann 2001, 149.

139 While no stag appears in the original *VP* by Jerome, the pilgrimage account of Postumianus in Sulpicius Severus' *Dialogues* reports on an encounter he had with "a wild animal called an ibex" (*fera, cui Ibicis est nomen*) immediately before visiting the monasteries of Antony and the cave of Paul: Sulpicius Severus, *Dialogues* 16; *PL* 20.194C–D; Roberts 1989, 32. In ancient Egyptian literature and art, ruminants like deer, ibexes, and antelope are represented as wild fauna of the desert, and in monastic contexts "the animals in their tamed state become virtual attributes of the holy man." Frankfurter 2004, 97–109, esp. 106. A similar horned and hoofed creature appears on two illuminated folios depicting scenes from the life of Paul in the *Belles Heures*: Meiss and Beatson 1974, ff. 192–192v.

140 On the Antonine monastic order in medieval Europe, see Mischlewski 1976; Mischlewski 1995; cf. Hayum 1989, 74–75.

141 Hayum (1989, 17–24, 31, cf. 96) and Burkhard (1934, 67) both note how the placid tone of *Saint Antony Visits Saint Paul the Hermit* stands in sharp contrast to the tortured and diseased forms of the demons in the scene of Antony's temptation on the facing panel. The symptoms that plague the demons in the painting conform to those of the notorious Saint Antony's fire (*ignis sancti Antonii*), also known simply as the holy fire. For more on this disease and the therapeutic work of Antonine monasteries, see Mischlewski 1976, 22–25, 29–33, 349–351.

142 Hayum 1989, 76, 108–109.

143 Hayum 1989, 111.

CHAPTER TWO: THE MONASTERY OF ST. PAUL IN HISTORICAL CONTEXT

1 Monastery of St. Paul 2004. The title could also be translated *The Hidden Mystery*.

2 It should be noted that the Arabic recension of the *Vita Pauli* used by the monks differs in some respects from the recensions most closely derived from Jerome: St. Paul hailed from Alexandria (rather than from Thebes), and he became an ascetic after being struck by the futility of earthly wealth after quarreling with his brother Peter, who had attempted to cheat him out of part of his inheritance (rather than after fleeing from his brother-in-law's treachery during the Decian persecution).

3 Meinardus 1961, 81.

4 E.g., Meinardus 1991; Coquin and Martin 1991b; Gabra 2002a, 88–89.

5 Peebles 1949, 184.

6 See the discussion of this text by Davis, Chapter 1 of this volume.

7 See, for example, the detailed description of this itinerary by Ogier d'Anglure in 1395; Browne 1975, 60–64.

8 For a study and edition of the so-called Version *b*, see Corey 1943, 172–198.

9 Pointed out by Nau 1901, 123. Edition of Syriac text: Bedjan 1895, 561–572. English translation: Budge 2002 [1907], 197–203.

10 Translation in Wilkinson 2002, 149. On this text, see the discussion by Davis, Chapter 1 of this volume.

11 On the geology of the site, see Lyster, Introduction to this volume.

12 Grossman 2002, 11, n. 22.

13 On the Monastery of St. Catherine at Mount Sinai, see Forsyth and Weitzmann 1973.

14 Paris, Bibliothèque Nationale, Copte 129[14], f. 125. Edition and German translation in Müller 1968, 295–300. For a description of the manuscript page (which Müller dates to the ninth or tenth century), see 49–50.

15 Müller points out that the choice of figures for the painted program was undoubtedly made carefully; if at the Monastery of St. Macarius, then only after consultation with the patriarch. Müller 1968, 27–28.

16 Another old (ca. ninth century?) indication of the esteem in which St. Paul was held in the Egyptian church is his commemoration along with St. Antony on the latter's feast on 22 of Tybi or Tuba (January 16), according to a Sahidic liturgical index from the Monastery of St. Shenoute (the White Monastery), fragmentarily preserved in Vienna, Paris, and Leiden; Zanetti 1995, 66. This feast may well have been a "major event at Shenoute's monastery," according to MacCoull 1998, 408.

17 For this paragraph, see Davis 2004, 81–84.

18 The term *miaphysite* is a precise rendering of the qualifier "one-nature." The term *monophysite*, still regularly found in western theological and church historical literature, is pejorative and should be avoided.

19 The names of these giants have become attached to their followers. Supporters of the moderate anti-Chalcedonian theology of Severus are sometimes described as Severans or Theodosians for Theodosius I (patriarch of Alexandria, 536–566), Severus' theological successor. The anti-Chalcedonian Copts and Syrians have regularly been known by Jacob's name: Jacobites; or, in Arabic, *Ya'aqiba*, plural of *Ya'qubi*.

20 Swanson forthcoming.

21 See Papaconstantinou 2001.

22 When the Monastery of St. Macarius and the other monasteries of Scetis declined in importance in the mid-fourteenth century, it was especially the monasteries of the Eastern Desert—St. Antony and St. Paul—that came to play a leadership role within the church. See below.

23 See Décobert 2002a.

24 See Gabra 2001.

25 Coquin 1991f.

26 The phrase is that of Décobert 2002a, 152, n. 101.

27 Translation in Evetts 1895, 166–167. On the composition and authorship of this complex text, see den Heijer 1996, 77–81, and the literature mentioned there.

28 Evetts 1895, 159–162.

29 Evetts 1895, 163. The place is known today as Dayr al-Maymun.

30 On what follows, see, for example, Sidarus 2002.

31 This has been demonstrated especially in Maurice Martin's sensitive analyses of the *History of the Churches and Monasteries* (e.g., Martin 1997).

32 MacCoull 1993a, 1993b; Rubenson 1996; Swanson 2004, 246–248.

33 At the time of the enthronement of Cyril III in 1235, only five bishops remained in the Coptic Orthodox Church. In the course of the next year Cyril consecrated more than forty new bishops. *HPEC* IV/1: 135, 144–146.

34 Den Heijer on the Coptic historians of the period, quoted in Swanson 2004, 249.

35 Van Moorsel on the iconography of the period, quoted in Swanson 2004, 249.

36 An excellent example of this is *Compilation of the Fundamentals of Religion* by al-Mu'taman ibn al-'Assal. Chapter 1 is a list of his sources, including a Chalcedonian ("Melkite") and several East Syrian ("Nestorian") writers. Wadi Abuliff 1998–1999, 1: 41–45.

37 Bolman 2002.

38 Pearson 2002, 227, 230, 235.

39 There is a huge literature on the Awlad al-'Assal. See, for example, Samir 1985, 9–21; Wadi Abuliff 1997. The basic tool for the study of the Arabic literature of the period continues to be Graf 1947.

40 Now available in the critical edition, Wadi Abuliff 1998–1999, with Italian translation, Pirone 1998, 2002.

41 Samir 1994.

42 Samir 1985, 25–36.

43 Budge 1928, 1106–1110, here 1107.

44 For these, see Samir 1985, 12–19; MacCoull 1996.

45 Samir 1985, 17–19.

46 This is according to al-As'ad's own description of the manuscripts he used in the introduction to his Gospels translation. Samir 1986, 88–89.

47 Gabriel's manuscript was the archetype from which Paris, ar. 249, Bibliothèque Nationale, was copied.

48 Coptic Museum, Cairo, Bibl. 94 (Simaika 4) (December 1249); and see MacCoull 1996, 360, n. 24.

49 Nakhla 2001, 2: 11–12.

50 Budge 1928, 1108.

51 See Conti Rossini 1923–1925, 502–505, reporting on Paris, Abbadie 222, ff. 110–112. Conti Rossini mistakenly identified the patriarch concerned as Gabriel II ibn Turayk (1131–1145), a mistake passed on in Meinardus 1961, 86. While some elements of the story (such as the patriarch's full name) are confusing, both the general outline of the story and the date preserved in the Ethiopic manuscript tradition for Gabriel's scribal work, April 1267, fit well into what we know of Gabriel III (1268–1271).

52 The work is the *Pandektes* of Nikon, which in the Ethiopic sources is attributed to Antiochus of the Monastery of St. Sabas. According to the Ethiopic text, Gabriel *translated* the work from Greek—but this is unlikely. The Ethiopic translation is known as *Mashafa hawi*. See Graf 1947, 64–66.

53 Conti Rossini 1923–1925, 503–505.

54 The connection between Ethiopian monks and the Red Sea monasteries is clear for the Monastery of St. Antony, where a number of sixteenth- and seventeenth-century Ethiopic graffiti are preserved on the walls; Griffith 2002, 189–190. The Copto-Arabic synaxarion is said to have been translated into Ethiopic at the same monastery by the monk Sem'on around 1400; Guidi 1911, 741–742; Colin 1988, 300.

55 The translator was Abu l-Fath 'Abd Allah ibn al-Fadl of Antioch, who flourished in the mid-eleventh century; Graf 1947, 52–64, esp. 54.

56 The manuscripts are Cairo, Coptic Patriarchate, Theol. 32–33 (Simaika 214–215). See Simaika 1942, 89.

57 Tritton's translation (in Evelyn White 1932, 390) of the note in London, British Library, Add. 14,632, f. lv. See the transcription in Wright 1871, 576–80 (manuscript DCXCV).

58 Wright judged the note to be written in a thirteenth-century hand. For the dates 1235–1245, see Evelyn White 1932, 389, n. 2.

59 *HPEC* III/3: 229–230.

60 Nakhla 2001, 2: 12–13.

61 For general background to the Mamluk period, see, among other possibilities, Irwin 1986; Holt 1986. On the sumptuary laws (based on the so-called "Covenant of 'Umar"), see Fattal 1958, 96–112.

62 For this paragraph and the next, see esp. Little 1976 and now el-Leithy 2005.

63 Even in the later fourteenth century, high-ranking officials from the musalima could be accused of insincerity in their Islam. For example, Karim al-Din 'Abd al-Karim ibn Makanis and his brother Fakhr al-Din 'Abd al-Rahman were so accused. According to al-Maqrizi's report, "Their wives and daughters remained Christian, while their men made light of the Book of God, His religion and His Apostle." Al-Maqrizi 1970–1971, 343–344 (reporting on the brothers' arrest on February 5, 1379).

64 Little 1976, 568.

65 Little 1976, 569.

66 See Evelyn White 1932, 265–392.

67 Evelyn White 1932, 393 ("Next to the fourth, the fourteenth century is the most momentous period in the history of the monasteries"), 400–402.

68 It is noteworthy that his name, paired with that of his fellow monk, the hegumenos Ibrahim al-Fani, is listed in the *majma'* ("assembly") of the saints in the annual psalmody of the Coptic Orthodox Church.

69 The best introduction to Marqus al-Antuni in a European language, which includes an extensive bibliography and a list of six manuscripts of the *Life*, is Wadi Abuliff 1999b. To Wadi's list may be added, thanks to Gawdat Gabra, a manuscript of the Monastery of St. Paul, Hist. 115. And now see Swanson 2007.

70 For the dates, see the passages collected in Gabra, Chapter 5 of this volume.

71 Monastery of St. Paul, Hist. 115, f. 9rv. This fits well with some more recent testimonies that the Monastery of St. Paul was a place for older monks but where young monks were first trained before their return to the Monastery of St. Antony; Meinardus 1961, 90.

72 Hist. 115, ff. 56v–57v.

73 Hist. 115, f. 9v.

74 Hist. 115, f. 57rv.

75 Hist. 115, f. 11r.

76 Hist. 115, f. 10v.

77 Hist. 115, f. 11rv.

78 See the materials gathered by Gabra, Chapter 5 of this volume.

79 Hist. 115, ff. 55v–56v. In addition to this, *Wonder* #5 (ff. 56v–57v) gives us the name of a fourteenth-century superior (*ra'is*) of the Monastery of St. Paul, the priest Girga.

80 I am grateful to Gabra for securing for me a copy of Ibrahim al-Fani's vita, in which the panegyrist is concerned to have Ibrahim remembered in close association with the saintly figure Marqus.

81 According to the vita of Matthew preserved in the *History of the Patriarchs,* Matthew accepted the patriarchate only after consulting with Marqus; *HPEC* III/3: 240–241.

82 For a description of this process of Islamization and the Coptic resistance to it, including the phenomenon of voluntary martyrdom, see el-Leithy 2005, esp. chapter 3.

83 Two of the highest ranking "Muslim Copts" of the late fourteenth century find their way into the pages of Marqus's *Life:* Karim al-Din 'Abd al-Karim ibn 'Abd al-Razzaq ibn Makanis, who escaped from arrest in Cairo and made his way to Marqus (*Wonder* #13, Hist. 115, ff. 68v–69v; cf. al-Maqrizi 1970–1971, 470, notice dated May 1382); and Sa'd al-Din Nasr Allah al-Baqari, who was eventually delivered after having been arrested and savagely beaten (*Wonder* #15, ff. 70v–71v; the story corresponds to al-Maqrizi 1970–1971, 500, dated November 1383).

84 See, for example, the stories of 'Ubayd al-Najjar (*Wonder* #25, Hist. 115, ff. 80v–81r) and Furayj (*Wonder* #32, ff. 87v–88r), whom Marqus encouraged and sent back to their homes with blue turbans.

85 The list of the forty-nine martyrs of Matthew's days has been published a number of times in Arabic (e.g., Nakhla 2001, 3: 44–47, part of a four-fascile series originally published between 1951 and 1954), but only recently in a European language: Wadi Abuliff 1999c. The list is headed by one Ya'qub Abu Muqaytif and his women followers. The *Life* of Marqus explicitly states that Ya'qub was Marqus' disciple, and at least two of the women visited Marqus. Their execution took place in 1380, according to al-Maqrizi 1970–1971, 372–373.

86 Hist. 115, f. 48v.

87 Browne 1975, 52–66 (for Ogier's visit to Egypt). Also see Hamilton, Chapter 4 of this volume.

88 Browne 1975, 60–62. One does wonder whether Ogier's numbers might be inflated, perhaps by as much as a factor of two. Later in its history, the Monastery of St. Paul regularly supported a population of twenty-five to thirty monks—which may indicate the maximum number allowed by the water supply.

89 Evelyn White 1932, 403.

90 Browne 1975, 62–63.

91 Browne 1975, 62–63.

92 Sauget 1983, 487–488.

93 Potvin and Houzeau 1878, 70.

94 Meinardus 1966, 519–520, but see Gabra, Chapter 13 of this volume.

95 Translation in Leroy 1908, 35–36. Al-Maqrizi also reports that the monastery was sometimes known as Dayr al-Namura, or the Monastery of the Tigers.

96 See Luisier 1994a, 1994b for an edition and translation of, and commentary on, the letter of patriarch John XI to pope Eugene IV, in which the Coptic Orthodox patriarch commends Andrea as his spokesman.

97 Samir 1991a, 1130–1133; al-Maqrizi 1972–1973, 760.

98 Hist. 115, f. 17rv. *Wonder* #28, ff. 83v–84r, is set in a time of famine, and details are given: the date was 1373/1374, and the price of a Cairene *irdabb* of grain reached 120 dirhams.

99 Hist. 115, f. 21v: in a time of famine, bedouin looted the Monastery of St. Antony: "They did not leave a cup of cereal in it."

100 Coquin and Laferrière 1978, 278.

101 E.g., Rufa'il 2000, 244.

102 Jean Thenaud, who was part of the embassy of André Le Roy in 1512, observed during a visit to the Sinai that the Monastery of St. Antony had been destroyed seven years previously: Schefer 1884, 81, quoted in Piankoff et al., 1930–1940, 58.

103 See n. 99 above for an example, from the time of Marqus al-Antuni, of how hunger could drive the bedouin to sack a monastery. While the text speaks of deaths, they are deaths from hunger, not bloodshed.

104 Nakhla 2001, 4: 49.

105 Nakhla 2001, 4: 49.

106 Nakhla 2001, 4: 49; Aly Bey Mubarak quoted in Coquin and Laferrière 1978, 279.

107 Paris, Bibliothèque Nationale, arabe 153, ff. 445v–452r.

108 This summary follows Wadi Abuliff 1999a.

109 See Nakhla 2001, 4: 101, where the author states that the monastery was in ruin for 119 years before its restoration (in 1701–1705), pointing to a date in the early 1580s for its definitive depopulation. I do not know his source for the figure 119 years.

110 See the notices from the manuscripts Lit. 38 and Lit. 55, reproduced by Gabra, Chapter 5 in this volume.

111 Nakhla 2001, 4: 101. I assume this would take place on the Feast of St. Paul, 2 Amshir (February 9).

112 Sauneron 1971, 233–241. For more details on Coppin's visit, see Hamilton, Chapter 4 of this volume.

113 Libois 1977, 32–34.

114 Libois 1977, 33.

115 For what follows and as background to this entire section, see Magdi Guirguis 2000, 23–44, as well as Armanios, Chapter 3 of this volume.

116 Iconographers regularly speak of "writing" rather than of "painting" icons, in order to stress the parallel between the icons and (written) scripture as well as to differentiate this activity from that of the artistically subjective and individually creative "painter."

117 Guirguis 2000, 32. The author goes on to discuss the rebuilding of the Monastery of St. Paul as a case in point.

118 Nakhla 2001, 4: 102. I will summarize his presentation at some length in the paragraphs that follow. He gives as his sources the manuscripts Monastery of St. Paul, Lit. 236, and Cairo, Coptic Patriarchate, Hist. 15 (Simaika 675). Also see Gabra, Chapter 5 of this volume.

119 *HPEC* III/3: 277–285.

120 Nakhla 2001, 4: 102.

121 May 24, 1705, in the Gregorian calendar.

122 Nakhla 2001, 4: 102–103. The monks at the monastery have heard that there was once a Church of St. Mark the Evangelist at the monastery, but different possibilities are mentioned as to where it might have been located.

123 Nakhla 2001, 4: 103.

124 *HPEC* III/3: 284; Nakhla 2001, 4: 103.

125 See the examples collected by Gabra, Chapter 5 of this volume. One also finds John's characteristic waqf-statement in a set of printed volumes found in the monastery's lending library, the Propaganda Latin-Arabic Bible of 1671.

126 From the manuscript Lit. 47 in the monastery library. See Gabra, Chapter 5 of this volume.

127 These numbers are collected in Meinardus 1961. Pococke did not himself visit the monastery but passed on information gathered at second hand; see Hamilton, Chapter 4 of this volume.

128 For a full transcription and translation, see Gabra, Chapter 13 of this volume.

129 The dedicatory inscription of the Church of St. Mercurius (reproduced here with no change to the consonantal skeleton of the word, but with added dots when needed, hamza, shadda, and punctuation):

المجد لله في العلا، وعلى الأرض السلام، وفي الناس المسرّة.
هذا هو باب الربّ، وفيه تدخل الأبرار.
وكان المهتمّ بهذه العمارة الأجلّ المكرّم المعلّم إبراهيم جوهريَ،
اذكره، يا ربَ، في ملكوتك! وكان ريس [؟] الأب المكرّم القسَ
عبده في العزبة، اذكره، يا ربَ، في ملكوتك! وذلك مشد[؟]
العمارة عازر، اذكره، يا ربَ، في ملكوتك! وذلك النجّارين
مخائيل وابنه وشنوده وبشارة السوافية، وكان [...] اذكرهم، يا
ربَ، في ملكوتك أجمعين! آمين.

"Glory to God in the highest, and on earth peace, and gladness among the people." [Luke 2:14] "This is the gate of the Lord, through which the righteous enter." [Psalms 118:20] The one who provided for this building was the most exalted, venerable muʿallim Ibrahim Jawhari; remember him, O Lord, in your Kingdom! The superior, the venerable father and priest ʿAbdu, was at the farm; remember him, O Lord, in your Kingdom! Likewise, the building foreman [?] ʿAzir: remember him, O Lord, in your Kingdom! Likewise the carpenters Mikhaʾil and his son, and Shanuda and Bishara of Beni Suef, and [blank spot]: remember them all, O Lord, in your Kingdom! Amen!

In the blank spot in the final line we find the following painted in red:

الله عوضهم و ...

O God, compensate them, and...

Under Ibrahim's titles is carved the date, in Coptic characters: AM 1497, which corresponds to 1780/1781. This is confirmed by the dates painted in red on the left side of the inscription: AM 1497, AD 1781. I wish to extend my thanks to Abuna Tomas al-Anba Bula for his help in reading this and other inscriptions.

130 On these arakhina and their titles, see Guirguis 2000, 27–28. Note that Ibrahim had served as a scribe under patriarch Mark VII—a former monk of the monastery of St. Paul; Motzki 1991.

131 Guirguis 2000, 29–30.

132 Nakhla 2001, 5: 6.

133 Nakhla 2001, 5: 12.

134 See Lyster, Chapters 11, 12 of this volume.

135 It may be worth noting that the next four patriarchs came from the Monastery of St. Antony, meaning that all of the patriarchs between 1676 and 1854, from John XVI through Cyril IV, had come from the Red Sea monasteries.

136 Guirguis 2004.

137 Guirguis 2004, 948.

138 Mulock and Langdon 1946; for a good selection of color reproductions of icons by Ibrahim and/or Yuhanna, see Atalla 1998a, esp. 71–89, 98–118. For a recent study of their technique, see Tribe 2004. On the relationship between the two icon-writers, see Youssef 2003, 443.

139 Monastery of St. Paul, Hist. 117. See Gabra, Chapter 5 of this volume.

140 In addition to Ibrahim's travel to the Monastery of St. Paul with Patriarch John XVII in 1732, we know that he copied a manuscript for the (patriarchal) Church of the Virgin at Harat al-Rum in 1737 (Coptic Patriarchate, Bibl. 124 [Simaika 79]) and was part of a delegation formed by the patriarch in a legal proceeding in 1740 (Guirguis 2004, 949). Ibrahim's workshop was at Harat al-Rum, near the patriarchal residence.

141 See Lyster, Chapter 12 of this volume.

142 Meinardus 1961, 92–99.

143 The other monasteries were St. Antony, al-Muharraq, and al-Baramus. Elli 2003, 2: 421, n. 282.

144 Monastery of St. Paul 2004, 52.

145 Monastery of St. Paul 2004, 55–56.

146 Anonymous Monk 2002, on Abuna Tadurus (1918–1990); ʿUryan 2002, on Hegumenos Marqus (1920–1988); Kamal 2003, on Hegumenos Abadir (1934–1983); a small pamphlet without publication information on Abuna Rufaʾil (1953–2003); and Anonymous 2005, on Father Samaan (1970–2005). Materials are being collected at the Monastery of St. Paul for a booklet on Hegumenos Yassa (1936–1998).

147 On present-day pilgrimage to the monasteries, see Oram 2002, 203–216.

148 Wadi Abuliff 1997, 198–216; on 216 is a helpful chart summarizing information about the manuscripts used. The three manuscripts are Berlin, or. Qt 2098 (copied by the monk Matta in 1655); Birmingham, Mingana chr. ar. 64 (copied by another monk Matta in 1880); and Cairo, Coptic Museum, Theol. 399 (copied by Luqa in 1904). The 1655 date of the first manuscript, if correct, presents a puzzle, since the monastery is believed to have been unoccupied at the time.

149 Swanson 2002, 127–28. The two manuscripts are Birmingham, Mingana chr. ar. 52 (copied by Marqus in 1867), and Cairo, Coptic Museum, Theol. add. 7 (copied by Shanuda in 1876).

150 The manuscript in question is Cairo, Coptic Museum, Hist. 1 (b) (Simaika 94). See *HPEC* II/2: v–vi.

151 Elli 2003, 2: 369.

152 Elli 2003, 2: 420.

153 Father Fanus al-Anba Bula, conversation on December 15, 2004.

154 E.g., Lyster 1999.

CHAPTER THREE: PATRIARCHS, ARCHONS,
AND THE EIGHTEENTH-CENTURY RESURGENCE
OF THE COPTIC COMMUNITY

1 Hathaway 1997, 15.

2 An analogous and contemporaneous revival, part of the broad cultural "outpouring" as defined by Peter Gran, was taking place in Egyptian society as a whole during the mid- to late eighteenth century. See Gran 1979. Also, Tania Tribe argues that the increased wealth of the Coptic community during the latter half of the eighteenth century enabled an artistic revival within that community. Tribe 2004, 84–85. However, my discussion here proves that the Coptic revival dates as far back as the late seventeenth and early eighteenth centuries. Lyster, Chapter 12 of this volume, also shows that Coptic icons were being professionally produced at least as early as 1732.

3 On artistic development, see Lyster, Chapters 11, 12 of this volume, and Tribe's study on the icon painters Ibrahim al-Nasikh and Yuhanna al-Armani. On manuscripts, see Atalla 2000. Finally, on Coptic rituals such as the pilgrimage to Jerusalem and the visitation of saints' shrines during the Ottoman era, see Armanios 2003.

4 Stewart 1991, 229.

5 Winter 1992, 221.

6 Hathaway 1997, 21.

7 Hathaway 1997, 19.

8 Shaw 1962, 189.

9 There were seven Ottoman military regiments in Egypt: the Mutafarriqa, Jawishan, Gonul-luyan, Tufenkjiyan, Sharakisa, Janissaries (Mustahfazan), and 'Azaban. Hathaway 1997, 40–41.

10 Hathaway 1997, 9.

11 Hathaway 1998, 38.

12 As Hathaway has noted, the term beylicate "results from the addition of a Latinate suffix to the Turkish beylik, denoting the post of bey. It is commonly used in secondary scholarship on Ottoman Egypt." Hathaway 1997, 9, n. 10.

13 Crecelius 1981, 24.

14 Hathaway 1997, 11.

15 Crecelius 1998, 67.

16 Hathaway 1998, 39.

17 See esp. Hathaway 2003.

18 Hathaway 1998, 48.

19 The period between 1711 and 1730 was dominated by increasing Qasimiyya and Fiqariyya factional struggles, alliance-building and -breaking, and a weakening of the Ottoman governor's position. See a general discussion in Holt 1966, 89–91.

20 Hathaway 1997, 44.

21 Hathaway 1998, 50. We have chosen "Qaz-daghli," the Arabized spelling of this term, to be consistent with other Arabized spellings used in this chapter. The Ottoman transcription is usually Qazdaǧı.

22 Hathaway 1997, 46.

23 Hathaway 1997, 25.

24 Hathaway 1997, 50–51.

25 Hathaway 1997, 52.

26 Crecelius 1998, 75.

27 Hathaway 1997, 99.

28 Crecelius 1998, 75.

29 Hathaway 1997, 47.

30 For a critical discussion of the term "neo-Mamluk beylicate" and its implications, see Hathaway 1997, 46–51.

31 Crecelius 1981, 27. Muhammad 'Ali deemed the mamluks a political and military nuisance. On March 1, 1811, he invited the mamluks to a banquet held at the Cairo Citadel, and as they marched in a procession from the Citadel, he ordered that they be shot. Those who escaped the massacre or who had not attended the banquet were eventually hunted and killed. See Holt 1966, 179.

32 Crecelius 1981, 46.

33 Shaw 1962, 341.

34 Shaw 1962, 341.

35 Shaw 1962, 202, 345.

36 Qasim 1977, 29–30.

37 Findley 1989, 51.

38 Winter 1992, 203.

39 According to al-Masri 1992, 95, Yuhanna Abu Masri was the head of the mubashirs and was a nazir (supervisor) over the Church of the Virgin at Harit Zuwayla. He redecorated this church, built up its walls, and paid special attention to its library, making the deacon, al-mu'allim Nasim Butrus, the librarian in charge. Al-Masri cites a manuscript kept at the library of the Church of the Virgin in Harit Zuwayla for her discussion.

40 Guirguis 2000, 27. Guirguis cites Patriarchal Document No. 286G, dating from 1704, that confirms Abu Masri's title as mubashir.

41 The Ruzname was the principal administrative bureau of the Egyptian treasury. This bureau managed all other departments in the treasury. See Shaw 1962, 340.

42 Shaw 1962, 338.

43 Shaw 1962, 339.

44 Jirjis Abu Mansur's position is cited in Nakhla 2001, 4: 95. Nakhla did not specify the exact nature of this post. It was possibly the head of the "scribes of the military and civilian corps," which included the scribes working for the military regiments, as well as those working for the Imperial Treasury. See Shaw 1962, 146.

45 See a complete list of these archons and their titles in Guirguis 2000, 27–29. For his survey, Guirguis relied mostly on unpublished manuscripts from the Patriarchal Library in Cairo and from the Monastery of St. Paul.

46 'Uthman Bey Dhu'l-Fiqar's employment of Mercurius Ibrahim is cited in an archival document from the Coptic patriarchate, dating from November 21, 1740. See Guirguis 1999, 55.

47 "During the 1730's, 'Uthman Bey Dhu'l-Fiqar was a source of particular irritation to Istanbul. In addition to failing to remit what remained of his late master's estate, he had neglected to send grain to the Holy Cities and to remit Egypt's annual tribute to Istanbul." See Hathaway 1997, 57.

48 Hathaway 1997, 59; Holt 1966, 91–92.

49 Hathaway 1997, 75.

50 Hathaway 1997, 100.

51 Crecelius 1998, 74–75. For 'Abd al-Rahman's extensive building program, see Raymond 2001, 94–119.

52 Under the leadership of 'Ali Katkhuda al-Jalfi in the early 1730's, the "first alliance between a Jalfi and a Qazdaǧı leader emerges." By the late 1730s, 'Ali Katkhuda al-Jalfi would join the abovementioned 'Uthman Bey Dhu'l-Fiqar, as well as other officers in controlling Egypt's military regiments. The Jalfis, in the long run, would become subordinate clients of the Qazdaghli household. See Hathaway 1997, 56.

53 Ridwan Katkhuda al-Jalfi shared with the Janissary Ibrahim Katkhuda al-Qazdaghli the "headship" (ri'asa), the most powerful position in Egyptian society, between 1748 and 1754. Their partnership symbolized "the height of Jalfi wealth and influence." See Hathaway 1997, 86. After 1756, the Qazdaghli household "had outgrown strategic alliances of the sort it had cultivated with the Jalfis." Hathaway 1997, 136. For Nayruz Abu Nawwar Ghattas' position as mubashir in the Jalfi faction, see Guirguis 1999, 54, n. 24.

54 From the time of the Mamluk rulers in Egypt, the jizya tax placed upon non-Muslims was referred to "mal al-jawali," or "the tax of the wanderers." See Shaw 1962, 151.

55 Crecelius 1981, 66–67.

56 Motzki 1991, 1274.

57 Motzki 1991, 1274.

58 Motzki 1991, 1274.

59 See al-Jabarti 1997, 222–223.

60 Matta'us 1985, 4.

61 Hathaway 1997, 25.

62 Al-Jabarti 1997, 223.

63 Hathaway 1997, 26.

64 Behrens-Abouseif 1985, 55–58.

65 Hathaway 1997, 26.

66 Behrens-Abouseif 1985, 67.

67 At times, it seems that Coptic archons were inspired to invest their finances in charitable endowments in the same way as their Muslim patrons. As Behrens-Abouseif (1994) notes in her study of pious endowments (awqaf) in Ottoman Egypt, "By acting as patrons of religious foundations, [Muslim] rulers sought to gain the support of the population and the opinion-making religious establishment, thus surmounting ethnic and cultural barriers which often existed between rulers and subjects" (271). She indicates that, throughout the seventeenth century, the military aristocracy in Egypt began to become "increasingly active as patrons of religious and charitable foundations" (273). In the eighteenth century, this patronage took the form of the actual building of numerous pious foundations.

68 For a contemporary eighteenth-century account of the construction of this church, see Gabra, Chapter 5 of this volume.

69 The rise to power of influencial laymen within an Ottoman Christian community was not unique to the Copts; a similar situation was taking place within both the Greek and the Armenian Orthodox communities. See Barsoumian 1979, 310–316; Clogg 1982, 185–207.

70 HPEC III/3: 278.

71 HPEC III/3: 290, 292.

72 Gruber 1997, 69–70.

73 HPEC III/3: 286.

74 HPEC III/3: 289.

75 Al-Tukhi 1991, 1348; HPEC III/3: 277–278.

76 Lyster, Chapter 11 of this volume. My thanks to William Lyster for his extensive comments in developing this point and for his advice on this chapter.

77 We do not have a great deal of information about the specific role of Coptic nazirs, but we can deduce their functions from the description we have of Muslim nazirs of pious endowments (awqaf). As Stanford Shaw writes, supervisors were charged with "collecting and expending its [the waqf's] revenues in the manner prescribed by its founder [and also ensured] that the sources of its revenues were being maintained and that the [awqaf] were not subjected to vexatious taxation." Shaw 1962, 43. These posts were often coveted, and Shaw describes how in the late seventeenth century the Janissaries monopolized them and "were able to divert much of the [waqf] revenues to their own profit." Shaw 1962, 191.

78 HPEC III/3: 278–279.

79 HPEC III/3: 282.

80 For a critical discussion of the historicity of these laws and rules, as exemplified in the document often referred to as the Pact of 'Umar, see Cohen 1999.

81 Winter 1992, 220.

82 HPEC III/3: 279.

83 HPEC III/3: 284.

84 HPEC III/3: 78.

85 HPEC III/3: 94. Al-Masri 1992 cites MS Liturgy 128 at the Coptic Museum, Cairo. Also see HPEC III/3: 281.

86 The History of the Patriarchs cites that this pilgrimage took place in 1708/1709 (AH 1120), and Coptic manuscript sources specify that it took place in 1709 (Paramhat AM, 1425). HPEC III/3: 282–283.

87 'Abd al-Masih, assistant to John XVI and pastor of the Church of the Virgin at Minyat Surd, who accompanied the patriarch to Jerusalem, wrote an account of the pilgrimage in 1710. There are two copies of this narrative: the original manuscript of 'Abd al-Masih, and a copy transcribed in 1777 by a priest named Jirjis al-Jawhari al-Khanani, who was pastor of the Church of the Virgin in Harit al-Rum. I am using here the older version of the manuscript, currently housed in the Coptic Museum in Cairo (Coptic Museum Archives, MS Liturgy 128). The 1777 version is in the Patriarchal Library in Cairo. The manuscript contains two separate works, the first being another "miracle": John XVI's consecration of the mayrun (holy oil), a vitally important ritual in Coptic traditions. The second part includes the miracle we are studying here. See Samir 1991b, 1334–1335.

88 Suraiya Faroqhi provided a table of payments made to bedouin individuals and to bedouin tribes by Egyptian caravan leaders in the sixteenth and seventeenth centuries. These payments were made in order to "buy" the protection of the pilgrimage caravan. Faroqhi 1994, 55–56. Bedouin were also used as "desert pilots," who accompanied the caravan in order to navigate the way. Faroqhi 1994, 34.

89 In that regard, al-mu'allim Lutfallah's job as pilgrimage organizer is quite comparable to the job of the Muslim hajj caravan commander known as amir al-hajj, whose duties were to raise expenditures for the pilgrimage, to acquire and organize the supplies for the trip, to send gifts to the bedouin in order to ensure the safety of the caravan, and to deliver contributions (surre) to Mecca and Medina. This commander also directly received revenues from the Porte. This position is well described by Shaw 1962, 241–254.

90 Guirguis 2000, 40.

91 See al-Masri 1992, 82; Guirguis 2000, 40–41.

92 See Gabra, Chapter 13 of this volume, for the text, and Swanson, Chapter 2, for a discussion of the names mentioned.

93 For more on the Catholic missionary movement in Egypt, see Hamilton, Chapter 4 of this volume.

94 Nakhla 2001, 4: 10.

95 HPEC III/3: 287.

96 Al-Masri 1992, 108.

97 HPEC III/3: 288. He was killed "while he was going to his house, on Friday, at the time of dining; and this was in the month of Misra in the year one thousand, four hundred and thirty-six of the Martyrs [August 7–September 5, 1720] which corresponds to (the) year one thousand, one hundred and thirty-two of the Tax (Year) [November 1719–to November 1720]; may God give rest to his soul! And they shrouded him, and they buried him; and this father (Peter VI) celebrated for him, in his name, one thousand Divine Liturgies."

98 Al-Masri 1992, 113; Gurguis 1999, 48.

99 Al-Masri 1992, 131.

100 Guirguis 1999, 54, n. 26.

101 Guirguis 1999, 54, n. 24.

102 Winter 1992, 210.

103 Atiya 1991b, 1348–1349; HPEC III/2: 291.

104 Perlmannn 1975, 10.

105 This story is recounted in al-Jabarti 1997, 196–197.

106 HPEC III/3: 295.

107 Frazee 1983, 219; Bilaniuk 1991, 610–611.

108 Guirgis 2000, 43.

109 Yuhanna 1983, 467.

110 Guirgis 2000, 43–44.

111 See Armanios 2003, chapter 5.

CHAPTER FOUR: PILGRIMS, MISSIONARIES, AND SCHOLARS

1 This is borne out by the remarkably small amount of graffiti that has been detected on the monastery walls. See Kraack 1997, 267–268.

2 The standard survey of travelers to St. Paul's remains Meinardus 1992, 35–43. Since the visitors to St. Paul's usually visited St. Antony's too, further information is to be found in Gabra 2002, 173–183. A still more detailed list of visitors is given in the unpublished *History of the Monasteries of St. Anthony and St. Paul,* produced by the Whittemore expedition team (but above all by Alexandre Piankoff), ca. 1930–1940. The manuscript is in Dumbarton Oaks, Byzantine Photograph and Fieldwork Archives, Washington, D.C.

3 D'Anglure 1878, 71. Ogier's source remains unspecified, and we can only assume that he had contemporary depictions in mind. The origin of the pig as Antony's companion is obscure. For the possibility that it might indeed be derived not only from Antony's alleged patronage of domestic animals but also from Athanasius' biography of the saint where, in chapter 29, he mentions the fact that devils do not even have power over pigs, see Trebbin 1994, 26, 35.

4 D'Anglure 1878, 70–73.

5 Hamilton 2006, 107–115.

6 For a discussion of where Prester John was thought to be, see Zaganelli 1990, 30–31.

7 D'Anglure 1878, 72.

8 Potvin and Houzeau 1878, 70.

9 Gibbon 1994, 893.

10 Libois 1993, 111*–120*.

11 Libois 2002, xli–lxii.

12 Hamilton 2006, 195–208.

13 Sauneron 1971, 200–204.

14 In de Valence 1891, 313, Peiresc mentions Agathange's visit to St. Paul's in a letter to another Capuchin, Gilles de Loches, dated February 9, 1637: "Il a esté à l'hermitage de S. Paul pour Ar…, où il ne trouva plus d'habitans." Elsewhere (p. 270) Peiresc says that Agathange was at St. Antony's together with yet another Capuchin, Benoit de Dijon.

15 Hamilton 2006, 78–79.

16 Da Seggiano 1948, 144–145.

17 Sauneron 1971, 244: "Environ un mois après nostre retour le Pere Agatange revint avec beaucoup de regret de n'avoir rien avancé sur l'esprit des Religieux Cophites."

18 Sauneron 1971, 204–222.

19 Sauneron 1971, 233–240.

20 Sauneron 1971, 244.

21 Carré 1956, 18–19.

22 *The Shield of Europe, or the Holy War, containing political and Christian advice, which can serve as a light to the Kings and Sovereigns of Christendom to guarantee their States against the raids of the Turks and take back those they have occupied from them. With a relation of his Travels in Turkey, the Thebaid and Barbary.*

23 Carré 1956, 1: 19.

24 Coppin 1686, 3–4.

25 See Hamilton and Richard 2004, 56–57.

26 Coppin 1686, 307: "Nous nous entretinmes quelque tems entre nous de la grande compassion que nous sentions de voir des Religieux qui menoient une vie si austere et si bonne en apparence, croupir miserablement dans une infinité d'erreurs, car ils sont de la secte des Cophites, qui est la plus grossiere et la plus absurde de toute celle des Chretiens separez de l'Eglise Romaine qui vivent sous la domination du Turc. Ils retiennent beaucoup de ceremonies Judaïques, ils sont dans les heresies de Dioscore, et d'Eutichés, et n'admettent qu'une nature et qu'une volonté en Jesus Christ, et il n'est pas croyable combien, depuis qu'ils sont separez de l'Eglise Romaine, ils ont rassemblé de faux dogmes, et d'usages abusifs. C'est pourtant cette Religion que suivent une grande partie des sujets du Prete-Jan, et le Patriarche de ces Cophites reside d'ordinaire en Ethiopie." This passage, described by the editor as "une douzaine de lignes où Coppin parle en termes inutilement désobligeants de l'église copte, notant d'ailleurs à ce sujet certains traits inexacts, comme la prétendue fidélité des Chrétiens d'Egypte à la doctrine d'Eutychès," has been removed from Sauneron 1971, 225.

27 Hamilton 2006, 148–151.

28 For a survey of Sicard's life, see Sicard 1982, v–vii.

29 Mansi et al. 1911, cols. 170–176.

30 Libois 2003, 392.

31 Sicard's comments on the monks of St. Antony's provide sufficient evidence of this: "Toucherai-je à l'intérieur? Quel spectacle dégoûtant! L'erreur du monothélisme et monophysisme, une ignorance crasse, une indolence pour la recherche de la vérité qui va jusques à l'abrutissement, l'horreur pour les Francs, l'hypocrisie, la superstition, chercher la pierre philosophale, se mêler de sortilèges, d'écrire des billets préservatifs, d'enchanter les serpents, voilà le caractère des moines coptes. Sont-ce là, dira-t-on, les successeurs de ces astres lumineux qui éclairaient la Thébaide et le monde entier? Qu'est-ce donc devenu ce fameux désert, le paradis de la pénitence, cette portion si précieuse de l'Eglise de Jésus-Christ? Le Seigneur l'a abandonné, il a renversé ces autels vivants." Sicard 1982, 26.

32 Sicard 1982, 19.

33 Hamilton 2006, 95–101.

34 For a survey of Assemani's life and work, see Graf 1949, 444–455.

35 Colombo 1996, 249–253.

36 Volkoff 1970, 93–94.

37 Sicard 1982, 19.

38 Sicard 1982, 28.

39 Sicard 1982, 28–32.

40 Sicard 1982, 30.

41 Sicard 1982, 38–39.

42 Sicard 1982, 40: "Une douzaine de religieux d'une ignorance à faire pitié, d'une antipathie contre les latins à indigner, matant leur corps par le jeûne, nourrissant leur esprit de la plus opiniâtre présomption, en un mot du caractère des autres religieux coptes, c'est ce qui se présenta à nous."

43 Sicard 1982, 40.

44 Sicard 1982, 41.

45 Sicard 1982, 41–42.

46 See Lyster, Chapters 11, 12 of this volume.

47 Sicard 1982, 41: "Ses murailles, qui ont été réparées nouvellement, sont chargées depuis la voûte jusqu'au bas d'histoires sacrées grossièrement peintes, parmi lesquelles on n'a pas oublié celle des tigres qui creusèrent la fosse du Saint. Le peintre auteur de ces dévotes figures se présenta à nous. C'était un moine du couvent. Il nous dit qu'il n'avait jamais appris à peindre, il y parassait à son ouvrage. Il ajouta que les coteaux voisins lui avaient fourni les différentes terres minérales, le vert, le jaune, le rouge, le brun, le noir et les autres couleurs employées dans son dessin."

48 Sicard 1982, 18, for Maurice Martin's introductory discussion of the illustration of the Red Sea monasteries and its fate.

49 Sicard 1982, 40.

50 Sicard 1725, 122–200, esp. 175–176.

51 Colombo 1996, 91–160.

52 Dubernat 1717, 1–125, esp. 43–45.

53 On Pignon, see Mézin 1997, 493–494.

54 The best study of Granger is an unpublished doctoral thesis, Riottot 2002. For Maurepas' orders to "rechercher en Egypte les plantes, les animaux et autres choses qui peuvent servir l'histoire naturelle," see ii, and for the combined plans of Maurepas and Bignon, see 25, 41.

55 Granger 1745, 118. For a reproduction of the inscription, see van Moorsel 2002, 65.

56 Granger 1745, 93: "Ce Monastère est le moins vilain de tous ceux qu'il y a dans la haute Egypte, après ceux de saint Antoine et de saint Paul."

57 Granger 1745, 120: "Le douze à midi je pris congé de ces Moines, très-peu satisfait de ce que j'avois vû chez eux, n'y ayant rien qui puisse satisfaire un curieux et encore moins un dévot."

58 Martin 1983, 53–58.

59 Martin 1983, 54; Martin 1986, 175–180.

60 Pococke 1743, 128, pl. 51.

61 Fahmy 1998, 139–179, esp. 154, 160–163.

62 For their friendship, see Thompson 1992, 45–47. For their tour of the Eastern Desert, see 56–58.

63 James Burton's notes, diaries, and drawings were given to the British Museum by his nephew, the architect Decimus Burton, and are now in the British Library, London, MSS Add. 25,613–625,675. His description of St. Paul's is in MS Add. 25,625, ff. 15–16. Substantial extracts are quoted by Piankoff et al. 1930–1940, 97–104. For Burton, see Cooke 1998, 2001.

64 London, British Library, MS Add. 25,628, ff. 106–112.

65 Thompson 1992, 90–91.

66 Wilkinson 1832, 28–60, esp. 34.

67 Wilkinson 1832, 35. For Burton's almost identical account, see Piankoff et al. 1930–1940, 102. Also see n. 2, above. The monks of St. Paul's still display the European oil paintings of St. Mark and St. Athanasius as icons in the two eighteenth-century churches at the monastery. For the painting of St. Mark, see Lyster 1999, 72.

68 Wilkinson 1832, 35.

69 Wilkinson 1832, 35.

70 Wilkinson 1832, 36.

71 Wilkinson 1832, 34.

72 London, British Library, MS Add. 25,625, f. 16.

73 Wilkinson 1832, 36.

74 For Bonomi's life, see the entry s.v. by Meadows 2004, 569–571.

75 Sharpe 1876, 2: 350–351 (figs. 132–133). The second of the two illustrations, of the interior of the church with the monks, is reproduced and discussed by Keimer 1956, 20–21. The drawing reproduced bears the caption "about 1840," but, as Keimer points out, this cannot be right.

76 For Marmont's life, see the entry by Du Casse 1854–1865, 18–31. For Marmont in Egypt, see Carré 1956, 1: 279–284.

77 See Fahmy 1998, 154; Carrè 1956, 1: 208–209, 257, 270; 2: 56, 90, 101, 109, 251; and the description in Marmont 1837, 3: 260–268, 290–295.

78 Marmont 1837, 1: 5, 4: 3–4.

79 Marmont 1837, 4: 3–4.

80 Marmont 1837, 4: 132.

81 Marmont 1837, 4: 183: "Les églises, quoique assez ornées, sont fort sales et très-mal tenues; rien, en entrant dans ce monastère, n'inspire de respect pour ses habitants. On conçoit qu'avec de tels gens la bibliothèque, ou la réunion de livres que l'on nomme ainsi, ne soit pas considérable. Elle se compose de treize volumes, écrits en cophte."

82 Marmont 1837, 4: 186–187.

83 Chester 1873, 105–116, esp. 116.

84 Platt 1841, 97–98.

85 For a colorful description of Tattam's vicissitudes collecting manuscripts in Egypt, see Volkoff 1970, 177–183.

86 Watson 1898, 20–31.

87 For the missions in the entire area, see Yapp 1987, 132, 144, 166, 197, 201–202. For the missions in Egypt, see Elli 2003, 2: 348–353; 3: 35–54; Weir 1991, 1: 133; Habib 1991, 603–604.

88 Discussed and documented by Davison 1990, 29–50.

89 Cf. Bolshakoff 1943, 99.

90 On Uspensky as a manuscript collector, see Volkoff 1970, 221–222.

91 Elli 2003, 2: 346–351.

92 There are, however, a number of errors in Uspensky's reading of the inscription, which is above the door of the central haykal screen. It records the construction of the church in 1732 (AM 1448) during the reign of John XVII, but identifies Jirjis Abu Yusuf al-Suruji, the greatest archon of the period, as the patron, not the architect.

93 Burton and Wilkinson admired this same large oil painting in 1823. It currently hangs in the Church of St. Michael the Archangel and St. John the Baptist.

94 These figures must be the icons at the top of the two haykal screens donated to the Cave Church in 1705 by John XVI and the great archon Jirgis al-Tukhi. Both screens are made of wood, not stone, as reported by Uspensky.

95 No wall painting of Paul survives in the saint's shrine. Uspensky perhaps described an icon of the hermit, such as the eighteenth-century example in the monastic collection illustrated as fig. 6 of this volume.

96 The relevant extracts from Uspensky's description have been translated by Piankoff 1943, 61–66, esp. 65–66.

97 Schweinfurth 1922, 163.

98 Wilkinson 1847, 268–269.

99 Baedeker 1877, 491.

100 Schweinfurth 1922, XIII–XXVI, for Schweinfurth's autobiographical sketch.

101 Schweinfurth 1922, 186.

102 Schweinfurth 1922, 189–190.

103 Schweinfurth 1922, 162.

104 Schweinfurth 1922, 198: "Die alte Kirche mit dem Grabe des Heiligen Paulus scheint vor etwa zweihundert Jahren renoviert zu sein, nach den äusserst rohen und barbarischen mit koptisch und arabisch geschriebenen Bibelsprüchen versehenen Wandgemälden zu urteilen, die den Kuppelraum am Eingange zieren. Alle Wände dieses uralten Heiligtums sind mit fratzenhaften Karikaturen bedeckt. Die Köpfe der Heiligen und Apostel sind, wie ihre Nimbusscheiben, mit Hilfe des Zirkels entworfen und Augen, Nase und Mund mit geometrischer Regelmässigkeit eingetragen. Reiterbilder machen auch hier den Hauptgegenstand der Darstellung aus. Unter dem jetzigen, bereits stark geschwärzten Bewurf erkennt man die alte Kalkdecke der Mauer mit uralter Ornamentik, und es würde sich wohl der Mühe verlohnen, diese letztere durch die Hilfsmittel der heutigen Technik wieder herzustellen."

105 Schweinfurth 1922, 204–205: "Im profanen Leben, in ihrem gegenseitigen Verkehr und in ihren Gesprächen miteinander geben diese Mönche nicht den geringsten Unterschied von dem einfachen ägyptischen Landmann, überhaupt durchaus keinen Anstrich eines exklusiv kirchlichen, der Welt abgestorbenen Charakters zu erkennen. Verträglich im Umgang, gemütlich und ohne jeden lärmenden Wortwechsel in ihren Plaudereien zeichnen sie sich vor den Übrigen vorteilhaft aus; im allgemeinen lässt sich wenig Nachteiliges über ihr äusseres Leben sagen, nur im Punkte der Reinlichkeit lassen sie viel zu wünschen übrig. Sie ahmen das Beispiel ihres grossen Stifters und Vorbildes nach, diese modernen Anachoreten. Von Antonius wird uns berichtet, dass er sich nie wusch, dass er über sein Haupt- und Barthaar nie eine Schere kommen liess, dass er nie seine Kleidung wechselte und aus Scham vor sich selber sich ihrer nie entledigte. In den Mönchzellen herrscht eine unglaubliche Unordnung, die verschiedensten Dinge liegen da bunt durcheinander: Bücher und Ölsamen von Saflor, Leisten und Schuhleder, angefangene Dattelkörbe und Oliven, Tabakblätter, Decken und Küchengeschirr, das alles fand sich am Boden ein und derselben Wohnzelle vor, die kaum zehn Schritte im Gevierte mass." See also Piankoff 1943, 63, for Uspensky reference to "the narrow, gloomy and untidy cells of the monks scattered without order" at St. Anthony's.

106 Schweinfurth 1922, 209: "Hier hatten die Klöster längst, schon vor der Invasion des

Islams, aufgehört, zu dem politischen wie zu dem religiösen Leben ihrer Zeit in Beziehung zu treten, und heute erblicken wir sie in derslben Erstarrung, wie sie seit vielen Jahrhunderten allen geistigen Dingen im Lande anhaftet, immer noch grundsätzlich entfernt von dem Treiben der Welt, als Klöster in der abstraktesten Bedeutung des Worts."

107 Libois 2003, lviii–lx.

108 On Jullien, see Mayeur-Jaouen 1992, 213–247.

109 Jullien 1889, 59.

110 Jullien 1889, 54: "Ils n'ont aucune idée de l'oraison mentale; ils n'entendent aucune exhortation spirituelle; ils communient rarement et ne conservent jamais le Saint-Sacrement dans leur église. Le chapelet d'ambre ou d'ivoire qu'ils tournent sans cesse dans leurs doigts, comme les bons musulmans, n'est qu'un ornement auquel ils n'attachent aucune prière. Je me figure leur coeur vide, froid, délabré comme leurs églises: le schisme, c'est la mort!" Cf. Mayeur-Jaouen 1992, 234.

111 Jullien 1889, 90–97, esp. 94: "Les murailles et les voûtes de la chapelle sont couvertes de peintures grossières."

112 Beaugé Alençonnaise 1923, 175–179.

113 Somigli di S. Detole 1913, opposite p. 80, for the photograph of "l'unico monastero che sia rimasto, come tutti una volta erano i monasteri nel deserto, senza porta."

114 Somigli di S. Detole 1913, 86: "Le discussioni non erano di breve durata. Mi ricordo che a S. Antonio e più a S. Paolo, ove le speranze parevano più fondate, esse si prolungarono per tutta una notte…Sebbene confusi, i monaci pure si stringevano riverenti e affettuosi quasi intorno all'Abuna Fortunato; e nei commiati notavo qualche cosa, che poteva anche essere commozione."

115 For their lives, see the respective entries s.v. by Müller-Kessler 2004a, 89–90; 2004b, 579–580. For their activities as manuscript collectors, see Volkoff 1970, 265–284, 292–304.

116 Lewis 1904, 745–758, esp. 746.

117 Lewis 1904, 753.

118 Besides St. Antony's and St. Paul's, Lewis included the monasteries of St. Macarius and al-Baramus in the Wadi al-Natrun as sources of future Coptic bishops. Lewis 1904, 756.

119 Lewis 1904, 758.

120 Piankoff et al. 1930–1940, 119.

121 Strzygowski 1902–1903, 49–60. Becker's photograph is opposite 48, and the passage on the paintings is 50–52.

122 Wreszinski 1902–1903, 62–55, esp. 62–64.

123 On Whittemore at St. Antony's, see Gabra 2002, 182, and Piankoff et al. 1930–1940, 119–124, esp. 119.

124 Whittemore 1931, 15.

125 Johann Georg 1931, 19.

126 For a description and an assessment of his activities, see Bauer 1996, 201–227.

127 Johann Georg 1930, 33–43.

128 The visit to St. Paul's is described in Georg 1931, 15–25.

129 Johann Georg 1931, 21.

130 Johann Georg 1931, 18: "Es ist auch keine Bibliothek mehr vorhanden, denn die wenigen Manuskripte, die sie für den Gottesdienst benutzen, und die meistens nicht einmal 100 Jahre alt sind, kann man kaum als solche bezeichnen."

131 Johann Georg 1931, 22: "Am schlimmsten ist es, dass man im XVIII. Jahrhundert einen grossen Teil der Decke und der Wände mit recht hässlichen Fresken überschmiert hat."

132 Judging from Johann Georg's description, the image with a long robe and a staff was probably the painting of Marqus al-Antuni on the eastern wall of the nave. The same eighteenth-century team responsible for the "truly hideous frescos" in the church also produced the paintings of Marqus and the equestrian saints so admired by the duke.

133 The monastic collection currently contains a number of icons of Mary with Antony and Paul, and considerably more icons of the Madonna and child. None can be dated confidently before the eighteenth century. For an illustrated selection of both types, see Lyster 1999, 72–79.

134 Johann Georg 1931, 24.

135 Meinardus 1992, 43.

136 Johann Georg 1931, 24–25: "Es ist sicher nicht eines der bedeutendsten. Aber in seiner unvergleichlichen Lage in den wilden Berge übertrifft es alle anderen. Es wirkt insofern fast wie ein phantastischer Traum. Künstlerisch bietet es viel weniger als das Antoniuskloster oder gar Deir-es-Suriani…Ich möchte zusammenfassend sagen, dass trotz der grossen Hitze und ziemlich bedeutenden Anstrengungen, die uns der Ausflug gebracht hat, der Besuch des Klosters sich sehr gelohnt hat. Die Lage desselben in der wilden Gegend und das Kloster selbst mit seiner uralten Pauluskirche gehören sicher zu den grössten Eindrücken, die mir auf meinen Streifzügen durch die Kirchen und Klöster Ägyptens zuteil geworden sind."

CHAPTER FIVE: NEW RESEARCH FROM THE LIBRARY OF THE MONASTERY OF ST. PAUL

1 Simaika 1932, 122f; see also Coquin and Martin 1991b.

2 Brown 1981, 82.

3 Guirguis 2000, 36f.

4 I would like to thank Samiha Abd El-Shaheed for her assistance during my work in the library, and Mark Swanson for his valuable help in preparing this chapter.

5 Graf 1934, nos. 476/5, 482/2, 724/1, 726/2; Graf 1944, 512; Khater and Burmester 1967, no. 48 (Lit. 33); Troupeau 1972, no. 257/10; Troupeau 1974, nos. 4787/4, 4788/2, 4790/6, 4890/1; Khater and Burmester 1977, no. 120 (Theol. 17); Zanetti 1986, no. 397 (Hag. 31).

6 Amélineau 1894, 1–14; see also Orlandi 1970, 119.

7 Guillaumont and Kuhn 1991, 1926.

8 See Forget 1905, 442–448 (text); Forget 1921, 458–466 (translation); Basset 1915, 767–781. For a shorter text of the synaxarion on St. Paul, see Forget 1905, 245–247.

9 MS 39 (Hist.), f. 63 b.

10 For Marqus al-Antuni, see Samir 1991c; Coquin 1991e; Wadi Abuliff 1999b.

11 Coquin and Martin 1991a, 722; Coquin and Martin 1991b, 742.

12 The archon Jirjis Abu Mansur al-Tukhi donated a second sanctuary screen to the Cave Church at the same time.

13 See also Simaika 1932, 123.

14 Nakhla 2001, 3: 101–103.

15 For the cultural and educational development of the Copts in the eighteenth century, see Guirguis 2000, 35–40; Guirguis 2004, 939–952.

16 See also Simaika 1932, 123.

17 For Jirjis Abu Yusuf al-Suruji, see Guirguis 2000, 28, n. 23.

18 For Ibrahim al-Nasikh, see Guirguis 2004, 948–952.

19 For the role of Coptic notables in the construction of new churches and the restoration of many churches, see Guirguis 2000, 31–35.

20 Cf. Shoucri 1991.

21 It is noteworthy that King Faruq also visited the Monastery of St. Antony; see Griffith 2002, 192.

22 See also MSS 760 (Lit.), 764 (Lit.), 795 (Lit.), 757 (Lit.).

CHAPTER SIX: NEW ARCHAEOLOGICAL
EVIDENCE FOR THE ARCHITECTURAL DEVEL-
OPMENT OF THE CAVE CHURCH

1 Previous descriptions include Leroy 1978,
323–337; Lyster 1999; and Van Moorsel 2002,
who offers the advice that in considering the
development of buildings like the Cave Church
we "should not be led astray by an observation
which has to do with the history of architec-
ture." Van Moorsel 2000a, 54. For the most
detailed description of the architecture of the
church, see Grossmann 2002.

2 Grossmann 2002, 3.

3 Grossmann 2002, 8.

4 Van Moorsel 2000a, 46–47.

5 Grossmann 2002, 13, suggested the origin of
a chapel here may be as early as the fourth
century.

6 Behind this pier we found a fragmentary sec-
tion of two superimposed plaster layers that
were earlier than the first medieval rendering.
This discovery provides physical evidence that
the cave of Paul was covered in plaster at least
twice before the thirteenth century, which
further indicates that it was almost certainly a
shrine before its medieval transformation into a
church.

7 The presence of the tafl shelf below the north
wall of the Haykal of St. Antony may indicate
the level of the top of this path before the con-
struction of the chapel, suggesting a gentle slope
from this point down into the cave itself.

8 The tomb of the saint has been encased in
marble and surmounted by an empty marble
sarcophagus since 1946. The inspiration for the
marble revetment came to one of the monks of
the monastery in a dream; see Gabra, Chapter
13 of this volume.

9 Grossmann 2002, 3, suggests the same
possibility.

10 These caves are like those around the monastic
cells and chapels created from the eighteenth
dynasty north tombs at Tell el-Amarna in
Middle Egypt. See, e.g., Davies 2004.

11 Monastery of St. Paul, MS 115 (History), f. 11a.

12 We note that monastic tradition at the Monas-
tery of St. Paul ascribes the construction of the
first keep to the reign of the same emperor.

13 The same thinking lay behind the winch system,
which provided the only access to the monas-
tery enclosure in the eighteenth and nineteenth
centuries.

14 It is clear that this building predates the eigh-
teenth-century changes to the Cave Church,
for its northern part was cut away by the con-
struction of the south wall of the narthex at the
beginning of the eighteenth century

(see below), while the north wall of the
Church of St. Mercurius appears to be merely
a thickening of the existing southwest corner
of the ruined building. Archaeological evidence
that the ruined building predates the medieval
construction of the Haykal of St. Antony is
more equivocal, but the surviving rooms may
indicate that the eastern part of the building
was demolished to allow light in through the
western windows of the dome. This demoli-
tion may have taken place either during the
construction of the dome or later, around 1291,
when the windows in the eastern face of the
dome were blocked for the second medieval
cycle of paintings.

15 For the ninth-century fortification of Scetis, see
Evelyn White 1933, 35–36; Cody 1991, 734.

16 Evetts 1895, 166–167. On the other hand, Abu
al-Makarim's silence on the layout of St. Paul's
may simply mean that he never visited the
monastery.

17 Van Moorsel 2000a, 43.

18 Grossmann 2002, 3.

19 Providing that the dated inscription on the
lintel above the main entrance of the Church of
St. Mercurius refers to its construction and not
merely a restoration.

20 Sauneron 1971, 236–237. "L'Eglise qui est à la
méme place où Saint Paul de Thebes a passé
soixante années, est enfoncée douze ou treize
pieds sous la terre & on y descend par vingt-
trois degrez; ce n'est pourtant pas une caverne
ou un grotte, & c'est un batiment composé
de murs avec une voute artificielle qui ne se
dément encore en aucun endroit. Cette Eglise
qui n'est pas fort grande est beaucoup plus
longue que large; l'entrée est au milieu d'une
des extremitez de sa longeur." Translation by
Sarah Montgomery and Peter Sheehan.

21 For the function of the khurus as a spiritual
marker between the area of liturgical action
and the congregation, see Bolman 2002, 57–62,
127–154.

22 For the identification of this stone we are grate-
ful to J. A. Harrell. For its use, see Harrell, Laz-
zarini, and Bruno, 2002, 89–96. It is also used in
the basilica of the Monastery of St. Catherine,
personal communication, J. A. Harrell.

23 This bench is illustrated in fig. 6.20.

24 Traces of plaster survived on the northern and
southern edges of the remains of this earlier
altar.

25 It is worth noting also that this alignment con-
tinues through to the possible blocked doorway
to the narthex cave suggested above. However,
the lower part of the "shelf" built along the
western edge of the nave and therefore blocking
this entrance appears from its form of con-
struction to belong to this thirteenth-century

phase. The rough quarried surface of the wall
was lined along the bottom with the small tafl
bricks used also in the walls of the Haykal of St.
Antony. A medieval date for the brickwork of
the "shelf" is also indicated by the fact that it is
cut by the eighteenth-century pier supporting
the southwest corner of the dome over north-
ern nave.

26 However, this flagged floor appears to have
been a relatively modern feature, probably
dating from the mid-twentieth century. The
eighteenth-century floor appears to have been
a thin layer of plaster laid after the area had
been leveled with tafl.

27 Sauneron 1971, 236–237. "& son autre bout
se termine par trois Autels disposez en Croix
dans trois enfoncements ou petites Chappelles.
Celuy qui est directement vis à vis de la porte
et qui par consequent devoit estre le principal,
est posé au Nord; il s'enfonce de sept ou huit
pieds durant le tiers de la largeur de l'Eglise, &
deux angles de mur remplissent le reste afin de
marquer comme la tête de la Croix; les deux
autres Autels font la méme chose à l'Orient &
à l'Occident & tiennent la place des deux bras,
mais pour éclairer ce saint Lieu il n'y a qu'une
seule fenestre qui regarde le lever du Soleil."
Translation by Sarah Montgomery and Peter
Sheehan.

28 Grossmann 2002, 15.

29 Van Moorsel 2000a, 51.

30 A similar arch was also constructed at the
same time to support the eastern arch that
leads to the Haykal of the Twenty-Four Elders.
It is possible that the low arched niche now
preserved in the west wall of the central nave
was once part of a doorway that led to the
narthex cave. Grossmann (2002, 8) suggests, on
the basis of information from the monks, that
this door opened into a passage leading to an
ancient stair, and that this may have been the
original entrance described by Coppin. This
seems to have been one of the reasons for his
identification of the Haykal of St. Antony as the
principal chapel. However, our investigations
showed that the 1.10-meter-high offset that
forms a "shelf" running the length of the west
wall of the central nave is a feature of the
medieval church that was repaired in the
eighteenth century. For the date of the modern
piers, see Grossmann 2002, 7.

31 In 1395, Ogier d'Anglure described the Monas-
tery of St. Paul as being "shut up in good walls,
high and thick, quite like a fortress except that
there is no moat outside." Browne 1975, 62.

32 Sauneron 1971, 235. At the northwest corner
of the medieval enclosure immediately to the
east of the spring of St. Paul are the remains
of massively thick walls raised on the bedrock.
Since Coppin's description shows that they are

not part of the medieval wall, their impressive scale might suggest they form part of the earlier phase of individually defensible monastery buildings or are part of an even earlier construction, perhaps even a Roman *hydreuma* built on the site of the precious spring. One the other hand, in 1884 Michel Jullien published a view of the monastery showing the spring enclosed by its own walls. Sicard's plan of 1717, does not indicate that the well was fortified, but the work could have been carried out later in the eighteenth or nineteenth century. See Capuani 1999, 166, fig. 70.

33 The presence of the light shaft over the main entrance from the thirteenth-century nave to the khurus and sanctuary probably contributed to the particular loss of the original pavement in this area, as the shaft provided easy access for rain and debris to enter the church.

34 The surviving limestone floor of the medieval period may at least initially have remained in use, if the evidence of red paint drips on it can be linked to those visible on the walls below the dome of the northern nave. It is likely, however, that this shows merely the logical progress of the eighteenth-century restoration, with the painting being completed before the mortar floor was laid.

35 This passageway (now partially blocked and rather obscured by the eighteenth-century bell tower of St. Mercurius) appears central to the layout of the early monastery core. In itself this suggests that the stairs in the eighteenth-century narthex may have succeeded a route or pathway up from the wadi. Other features of the passageway, such as a patch of long, narrow stones laid lengthwise in the central area of the pavement, and a curved niche or seat on the eastern side of the passage, probably predate its eighteenth-century conversion into the main access route to the Cave Church.

36 For a plan of the Church of St. Antony showing the location of the basin in the western nave, see Jones 2002, 22.

37 During the course of the conservation project we recorded these piers at the southwest and southeast corners of the northern nave, and at the southeast corner of the Haykal of the Twenty-Four Elders.

38 A straight joint visible in the southwest corner of the Haykal of the Twenty-Four Elders clearly indicates the original edge of the arch in the east wall supporting the dome. The trace of the original arch in the wall above shows it to be contemporary with the painting scheme, while its conversion into the tall ogival apsidal niche visible today is clearly a later development.

39 The westernmost enclosure is a relatively modern feature. Built to protect the source of the monastery's water, it now contains a research library, the new refectory and bakery, as well as a block of cells.

40 Coppin describes a large breach in the west wall of the medieval enclosure that must have been one of the first areas to be repaired. See Sauneron 1971, 235.

41 The foundation inscription on the haykal screen of the Chapel of the Virgin on the top floor of the keep, provides an even more precise date of 1708/1709, at least as *terminus ante quem*.

42 Library of the Monastery of St. Paul, MS 117 (Hist.).

43 For the activities of Ibrahim al-Jawhari, see Motzki 1991, 1274.

44 In 1884 Michel Jullien published two views of the outer walls at the Monastery of St. Antony showing a block gate next to a functioning fatuli. See Capuani 2002, 144, 162, figs. 65, 66. According to Father Maximous El-Anthony the gate was opened only for grain deliveries and important guests.

45 Lewis 1904, 752–753.

CHAPTER SEVEN: THE CONSERVATION OF THE MILL BUILDING, REFECTORY, AND CAVE CHURCH

1 Personal communication from Father Abadir al-Anba Bula, February 25, 1998.

2 Jollois 1813, pls. IX. 8–10, and X. 1.

3 At the Wadi al-Natrun, Evelyn White recorded only an inscribed table hopper similar to those at the monasteries of St. Paul and St. Antony. Evelyn White 1933, 26, 61, pl. XVIIIc.

4 At the Monastery of St. Antony the mill building is a single large rectangular room containing two identical mills. A restored example of this kind of mill room with two mills is the "Mill of Abu Shahin" at Rashid (Rosetta), well illustrated at www.giovannirinaldi.it . . . /rosetta.

5 The quartzite bed stones are slabs cut down from larger architectural elements. A possible source is the pharaonic temples at Ihnasya al-Madinah, near Beni Suef, a site close to the monastery's traditional lands, where quartzite was used for statues and architecture; Petrie 1905.

6 Vesicular basalt has been used extensively in Egypt and the eastern Mediterranean for querns and millstones since the Roman period. The vesicles have sharp cutting edges ideal for milling. Sources for the stone range from the eastern Mediterranean to Yemen. Harrell 1996, 109; Harrell 1998, 139–140; Williams-Thorpe and Thorpe 1993, 263–320. I am grateful to James Harrell for this reference and for information on vesicular basalt.

7 Ibrahim al-Jawhari was a major benefactor of Egyptian churches and monasteries in the second half of the eighteenth century; see Guirguis 2000, 23–44.

8 The date was read by Samiha Abd El-Shaheed in December 2004. For epakt numerals, see Abd El-Shaheed 1993; Megally 1991b, 1820–1822.

9 Sicard's drawing of the monastery in 1716 (see figs. 4.2, 6.21), although highly schematic, shows a single mill in approximately the correct place for it to be this building. Sicard 1982, 38.

10 El-Dahan 1998, 1.

11 Power 2001.

12 Personal communication from Father Macari al-Anba Bula.

13 Information about recent events at the monastery such as this is based on anecdotal evidence provided by the monks, in particular Fathers Macari, Sarapamon, Tomas, and Matta al-Anba Bula.

14 The nabq is a large spreading tree that produces an edible small applelike fruit, also called nabq. See Bircher and Bircher 2000, 499.

15 Whittemore expedition photographs B52, B59. Dumbarton Oaks, Byzantine Photograph and Fieldwork Archives, Washington, D.C.

16 Monastery of St. Paul, MS 47 (Lit.). The identification of the domed room as the mahbasa, however, remains uncertain, especially as the manuscript account indicates that the mahbasa was destroyed in the flood. It may have been rebuilt or only partially damaged in the flood, but there remains the possibility that the recently discovered chamber is another structure altogether.

17 Whittemore expedition photographs B4, B36, B83. Dumbarton Oaks, Byzantine Photograph and Fieldwork Archives, Washington, D.C.

CHAPTER EIGHT: CONSERVATION OF THE WALL PAINTINGS IN THE CHURCH OF ST. PAUL

1 Paolo Mora was the chief conservator at the ICR from 1950 until his retirement in 1986. His *Conservation of Wall Paintings,* written with Laura Mora and Paul Philippot, is the standard reference work in this field (Mora, Mora, and Philippot 1984). Excerpts are also published in Price, Talley, and Vaccaro 1996. Laura Mora was on the staff of the ICR from 1945 until her retirement in 1988. Her husband died in March 1998, but Laura Mora continues to be a valuable source of inspiration and technical expertise. The Moras visited us in Egypt in 1996 and advised us on the conservation of the Church of St. Antony during our initial preparatory survey.

2 Funding for the conservation projects at both the monasteries of St. Antony and St. Paul was generously provided by USAID.

3 Mora, Mora, and Philippot 1984, 294.

4 Mora , Mora, and Philippot 1984, 178–182, 188.

5 The painting of Stephen was documented by the Whittemore expedition in 1931. Whittemore expedition photograph B65, Dumbarton Oaks, Byzantine Photograph and Fieldwork Archives, Washington, D.C.

6 In the corridor we uncovered the lower portions of the monastic saints on the east wall. In the narthex we revealed the dragon's tail and the face of a child in the painting of Theodore, as well as the lower legs of the horse of Victor.

7 The solution consists of about 1.5 percent paraloid B 72.

8 Primal AC 33.

9 Paraloid B 72.

10 Mora, Mora, and Philippot 1984, 238.

11 Primal AC 33 mixed with water at 50 percent.

12 PLMa or limestone dust hydraulic grout.

13 Paraloid B 72.

14 Mora, Mora, and Philippot 1984, 307.

15 Mora, Mora, and Philippot 1984, 307.

16 Mora, Mora, and Philippot 1984, 309.

17 At the request of the monks of the monastery we also used tratteggio to reintegrate missing portions of the paintings of Xiphiel (C1), Macarius (G3), and the Coptic inscription framing the entrance to the Haykal of the Twenty-Four Elders (B10).

18 Van Moorsel 1995, 283.

19 Fifteen grams per liter.

20 The thinner skin of cement superimposed directly on the surviving plaster required a much slower process that was carried out in conjunction with the cleaning of the paintings.

21 The main colors used are yellow ochre, burnt siena, and black ivory.

22 Van Moorsel 1995, 283–285; 2000a, 41–62.

23 Van Moorsel 2002, 19–25.

24 The damage to the medieval plaster layers caused by the modern application of cement makes it impossible to tell whether the second master worked in the Haykal of St. Paul.

25 Van Moorsel (2002, 32) read the date as AM 1050 or 1332/1333.

26 See note 5 above.

27 On very rare occasions, the monk-painter did employ white; for example, he used a thin whitewash on the face of St. Antony in the northern nave and white decorative lines on Victor in the narthex.

28 Van Moorsel 2002, 61–62.

29 Whittemore expedition photograph B65, Dumbarton Oaks, Byzantine Photograph and Fieldwork Archives, Washington, D.C.

30 Whittemore expedition photographs A177 and B14, Dumbarton Oaks, Byzantine Photograph and Fieldwork Archives, Washington, D.C.

31 The situation in the Haykal of St. Paul is particularly difficult to read because of the loss of so much of the early plaster in this room.

32 The lower preparatory layer may have been intended to absorb humidity.

33 This third level of rendering three is partly visible in the deep loss in the area between the haykal screens of St. Antony and St. Paul, above the eighteenth-century paintings of Maximus and Domitius.

34 De Cesaris observed that there were noticeable deposits of dirt between the plaster of rendering one and the yellow wash, indicating a fairly long gap between their application.

35 The yellow wash was not used in the dome of the Haykal of St. Antony.

36 Proof that this rendering predates the eighteenth century is provided by the fact that it is partially covered by the later eighteenth-century plaster of phase seven.

37 This second stage of rendering seven was applied over the green field used as background color for the images of Sarapion and Paul.

38 Rendering seven is found in the following areas of the medieval portion of the church. In the central nave: the sections of the east wall between the three haykal screens (paintings of Marqus, B10, Maximus and Domitius, D11 and D12, and Macarius, G2); the south wall between the entrances of the shrine and corridor (Moses the Black, D18); the south end of the west wall (one of the three archangels, D1), as well as the whole lower section of this wall, which was unpainted. In the Haykal of St. Antony: along the lower portions of the north and east walls. In the corridor: the northern edge of the ceiling, bordering the scene of the Virgin and Cherubim (D19) in the central nave; on the east wall over the filled depression (below F13) and along the lower border of the procession of saints (F4–F6, F8, F9); on the west wall to the north of the figure of Arsenius (F1), as well as under this same figure where a small niche was formed. In the shrine and haykal of St. Paul, the seventh rendering appears to have been applied throughout both rooms.

CHAPTER NINE: THE MEDIEVAL PAINTINGS IN THE CAVE CHURCH, PHASE ONE

1 Bolman 2007, 408–433; Bolman 2001, 41–56; Bolman 1998, 65–77, pls. 1–7.

2 Surviving examples of late antique pilgrimage art are largely portable, but traces of and references to monumental subjects have also survived. The best preserved monumental pre-Iconoclastic example of figural decoration is at the Monastery of St. Catherine on Mount Sinai. The principal apse shows the Transfiguration of Christ, above which are depictions of Moses. Remnants of a late antique mosaic exist in the Church of the Annunciation at Nazareth. Wilkinson 2002, 330-331. The Piacenza Pilgrim mentioned "lights burning day and night" in the grotto under the Church of the Nativity at Bethlehem. Piacenza Pilgrim 29; Wilkinson 2002, 142. The Piacenza Pilgrim also described lamps and countless ornaments at the Holy Sepulcher, and very specifically a "portrait of Blessed Mary on a raised place" in the vicinity of the cross, at the Basilica of Constantine, at the same site. Piacenza Pilgrim 18–20; Wilkinson 2002, 138–140; Vikan 1982. A monumental if somewhat outdated contribution on the subject is Weitzmann 1974, 31–55, esp. 35–37.

3 For photographs of two sites with such elements, see Hilda Petrie 1925, 20–26, pls. XLIX–LV. See also Sauneron and Jaquet 1972, 63–82.

4 Bolman 2007; Bolman 2001; Bolman 1998.

5 Van Moorsel noted the common practice of painting cells and sanctuaries, and also stated that these spaces in the Cave Church would have originally been painted or decorated in some way. Van Moorsel 2000a, 51.

6 De Cesaris and Sucato found no evidence of late antique paintings in the Cave Church but said that they cannot rule out the possibility that they once existed. Email communication, July 6, 2006. When working in the passageway between the haykals of St. Antony and St. Paul, Peter Sheehan found fragments of superimposed plaster at the site of the original door of the cave shrine. These traces of plaster predate the earliest medieval layers in the church. They did not have discernable paint on them, but they show that the interior was plastered twice prior to the thirteenth century. Following standard practice these plaster layers could have been painted at an early date.

7 The closest parallel I have found to these are cross-shaped openings, without stucco work, in the transept of the North Church in the Monastery of the Martyrs, at Esna. Leroy 1975, pl. XII. It is likely that they are medieval, but confirming this, or dating them precisely, would be difficult. Francesca dell'Acqua has recently shown that the earliest clear evidence for Byzantine glass windows with stucco frames dates to the ninth century. Dell'Acqua 2006, 196-200, 206. The relationship between the Byzantine and Egyptian *exempla* in the medieval period is a subject that needs further study.

8 For a discussion of sanctuary screens in late antique and medieval Egypt, see Bolman 2006b.

9 These archaeological points are drawn from Sheehan's original work in the church. See Chapter 6.

10 Byzantine art historians have been exploring the relationship between the names given to various representations of the Virgin Mary and the iconography of those works. Annemarie Weyl Carr has observed that until about the fourteenth century the names that scholars have associated with the various iconographic types were not fixed, and may have made reference to sites instead. Carr 2002, 77–81, 91.

11 Pearson 2002, 227–228, 230.

12 Van Moorsel 2002, 122; van Moorsel 1995, 283; Leroy 1978, 335.

13 Van Moorsel 1995, 283.

14 For the folded ribbon motif at the Monastery of St. Antony, see Bolman 2002, 74, fig. 4.40; and in the same volume see 43, fig. 4.8, for the red border and 66, fig. 4.32, for the red-bordered pearl frame. For the red-bordered pearl frame at the Monastery of St. Macarius, see van Loon 1999, 371–372, pls. 152–155.

15 For examples of the V shape in Theodore's program in the Monastery of St. Antony, see Bolman 2002, 57, fig. 4.24 (the three Hebrews in the khurus), 80, fig. 5.6 (Christ in Majesty in the sanctuary).

16 I have examined paintings in the Monastery of St. Mercurius (Old Cairo; for photographs, see Zibawi 2003, 165–175), the Monastery of St. Macarius (Wadi al-Natrun; see Zibawi 2003, 150–159), the Monastery of al-Baramus (Wadi al-Natrun; see Zibawi 2003, 138–145), and the Monastery of St. Bishoi (Wadi Natrun; see Zibawi 2003, 135).

17 The example from Bawit (now in the Coptic Museum, Cairo, inv. no. 7118) did not come from a church but was in a long room (Room 6) that may have been used to accommodate visitors, given the large number of graffiti in it. The niche was located off axis, on the long east wall of the room. Room 6 belonged to a small complex of rooms that included kitchen facilities and a courtyard and was not (as these early paintings more often were) in a small cell or a freestanding oratory. Maspero and Drioton 1931, 20–23, pls. I, XXI–XXIV. In fact, little early church decoration has survived in Egypt, and the best-preserved, monumental example of the Red Monastery church does not follow the architectural format of a single apse (having three instead), or the two-zoned apse composition. The early sanctuary of the church at the Monastery of the Syrians (now the khurus) no longer preserves its eastern apse. Evidence for the type as a standard Egyptian choice for apse

painting in churches comes from the Monastery of the Martyrs at Esna (twelfth century) and the monasteries of St. Antony and al-Baramus (thirteenth century). For the dating of the paintings in the Monastery of the Martyrs to either 1129/1130 or 1179/1180, see Leroy 1975, 33; Coquin 1975, 253–254. For the dating of the paintings in the Monastery of al-Baramus to the later thirteenth century, see van Loon 1999, 72–74; van Moorsel 1992, 173.

18 For a discussion of this iconographic type in Egyptian Christian art, see van Moorsel 1978, 325–333. See also Bolman 2002e, 65–71. Terry and Maguire (2007, 138–139) provide an excellent interpretation of its significance in the early Byzantine world.

19 Bawit, Cell XXVIII. This painting was not preserved and to the best of my knowledge no longer survives. Clédat 1904, pl. XCVI.

20 For example, the standing Virgin Mary/personification of the church holding a clipeus in a seventh-century Syrian manuscript in the Bibliothèque Nationale, Paris (MS Syrian 341, f. 118r), which is reproduced in Zibawi 1994, 53, fig. 29; and a tenth- or eleventh-century Byzantine ceramic example now in the Musée du Louvre, Paris, which is illustrated in Weitzmann 1982a, 42.

21 Mathews 1995a, 208–209.

22 Belting 1994, 30, 558, n. 3. Belting cites Cyril of Alexandria, *PG* 77: 922–923.

23 The two icons are at Sinai and Moscow (produced in Novgorod). Pentcheva 2000, 44–45, figs. 12–14.

24 Leroy 1982, 99–100.

25 Fakhry 1951, pl. XXIV, Zibawi 2005, 109, pl. 43, 111, pl. 45.

26 Leroy 1982, 99–100. For an example of the Virgin shown positioned frontally, see New York, Pierpont Morgan Library, M597, f. 3v, in Leroy 1974, 103–104, pls. B, 35.

27 Van Moorsel 2000a, 52.

28 Van Moorsel, 2002, 23. The Nativity in the Monastery of St. Macarius is painted in the northeast squinch of the Haykal of St. Mark, with the Annunciation placed above on the spandrels. For reproductions of these paintings, see Leroy 1982, pls. 41–52; van Loon 1999, 309, 371, pls. 44, 152–153; Zibawi 2003, 154, fig. 197. Van Loon dates these paintings to the first half or the middle of the twelfth century. Van Loon 1999, 58–60. Due to stylistic similarities in the Wadi al-Natrun paintings and those of Theodore in the Monastery of St. Antony, I prefer to date them somewhat later, to ca. 1200.

29 The Annunciation, Visitation, Journey to Bethlehem, and Nativity are presented from left to right, in a painted band, in Chapel LI. Clédat 1999, 126–129, figs. 105, 109–113.

30 Leroy 1982, 100.

31 Schiller 1971, 1: 44. Van Moorsel 2000a, 49. Van Moorsel 2002, 124.

32 Stylianou and Stylianou 1997, 126–127, 130, fig. 65.

33 Schiller has pointed out the rarity of the dove prior to the Middle Byzantine period. Schiller 1971, 1: 43. The dove appears in the abbreviated Annunciation in Paris, Institut Catholique, MS 1, f. 106r, of 1249/1250, but not in the illumination of seventy years earlier, in Paris, Bibliothèque Nationale, Copte 13, f. 136r, of 1179/1180. Leroy, 1974, pls. 86, 61.

34 Bolman 2002c, 99–101. The location of this painting in a dome over the altar is not consistent with Middle Byzantine practice, however, where an image of Christ typically was placed in a dome over the nave.

35 For example, the placing of the Annunciation on an arch, or Christ in a dome.

36 Dodd 2004, 59.

37 Leroy, 1978, 334; van Moorsel, 1994, 398; van Moorsel, 2000a, 48.

38 Van Moorsel, 1995, 284; van Moorsel, 2000a, 48–49; van Moorsel, 2002, 24.

39 Freer Gospel covers, ca. sixth century, Washington, D.C., Freer Gallery, inv. no. 06.274, Illustrated in Leroy 1974, pl. 26. For dating, see Dennison and Morey 1918, 67–71.

40 The paintings in the triconch of the Red Monastery church are being conserved as part of a project under my direction that is being administered by ARCE and funded by USAID. The conserved south semi-dome has not yet been published. However, one publication shows it after an initial test cleaning that reveals two of the four evangelists. Bolman 2004a, cover.

41 Bolman 2002a, 244–245, 247; Bolman 2002d, 78–79. Van Moorsel disparaged the style of the first St. Paul painter (and by implication that of Theodore at St. Antony's), describing him as needing "the old stereotypes as his handhold," a pejorative assessment with which I disagree. Van Moorsel 2000a, 49. The traditional style that I identify here is certainly not monolithic. In addition to the types of variations apparent between the closely related paintings in the monasteries of St. Antony and St. Paul, there are others which are not as close. For example, the paintings in the Monastery of al-Baramus have more graceful and softer outlines, and a palette that is different from both the typical late antique one and that seen at the Red Sea monasteries.

42 One possible exception is the wide dark brown lines the painter at St. Paul's used along the nose and under the brows of the angel guarding

the enthroned Virgin Mary (fig. 9.19). However, I see these as shading rather than as outlines.

43 Van Moorsel 2000a, 53.

44 My thanks to Angela Milward Jones for her speedy intervention to ensure the protection and conservation of the painting at Abu Sarga (located in the southern apse), and for inviting me to publish an art historical analysis of it. Bolman 2006a. Milward Jones directed the project. The conservation was undertaken by Luigi De Cesaris (acting as a consultant), Alberto Sucato (heading the conservation), Emiliano Albanese, and Emiliano Ricchi. Funding was provided by the Antiquities Endowment Fund of ARCE. I am grateful to Gerry D. Scott III and Milward Jones for permission to include an illustration of the recently discovered painting in this volume. Milward Jones has written its first publication as an article in *BARCE*. Milward Jones 2006. I am working on a further article on the painting for a scholarly journal. Construction work in the Hanging Church uncovered significant areas of painting that had been obscured by later, unpainted layers of plaster. Much of this was lost before its value was recognized. In a project led by Father Maximous El-Anthony, Adriano Luzi and De Cesaris were invited to conduct test cleanings of the paintings in the Thekla Haymanot Chapel of the Hanging Church in 2000, but the larger project to conserve the paintings was eventually undertaken by a different team. The work is now finished or almost finished. The photograph of the test cleaning shows the work as it looked in 2000. I am grateful to Father Maximous El-Anthony for his permission to publish the photograph.

45 The face of the Christ in Majesty at Abu Sarga is very close to the same subject in the Monastery of St. Mercurius, Old Cairo, and the Monastery of St. Antony. The eyes of the moon and of the tall angels in the Abu Sarga painting have parallels also to the Christ in the St. George Chapel at St. Mercurius. See Zibawi 2003, figs. 218, 220; Bolman 2002d, 80, figs. 5.6–5.7. The throne at Abu Sarga and the incorporeal creature with the head of a man are very close to the same subjects in the Church of St. Antony. See Bolman 2002, 59, fig. 4.25, and 85, fig. 6.15. The angel in the Hanging Church was painted with the same reds and greens visible in the Church of St. Antony and has a virtually identical red-banded pearl border and a stylized, undulating vine and leaf motif.

CHAPTER TEN: THE MEDIEVAL PAINTINGS IN THE CAVE CHURCH, PHASE TWO

1 Klaus Wessel wrote: "We have been obliged to recognize that that which is usually known as 'Coptic Art' is no unified whole, but is divided into two independent branches, a provincial Greek and a Coptic, belonging to two different peoples with distinctive cultural potentialities and traditions.... Finally, we have seen that surviving works of both kinds are to be considered as great art only in a very few cases.... The majority of what survives belongs to the sphere of folk art, and is largely free from the influences of great art.... We have been able to see the stunting and degeneration of Greek folk art and the development and growth of the Coptic." Wessel 1965, 231. While criticizing Wessel vigorously, Pierre M. Du Bourguet nevertheless fell into some of the same pejorative stances regarding Coptic art. "We are not trying to raise Coptic art to that eminence from which Byzantium reigns and must always reign....These traits [of Coptic art] only manifested themselves gradually but, in this very progression, this struggle ending in victory, which one can hardly observe unmoved, Coptic art replaced, even while carrying on its traditional themes, the Graeco-Roman art which had possessed the field before it. Once in full possession of its style and its professional skills, Coptic art might have risen to the level of a very great art....The Moslem conquest interposed an impassable barrier to this legitimate ambition." Du Bourguet 1971, 19, 192. On the postconquest period: "Art in this last period, while it may represent a certain weakening, and doubtless a decadence in relation to the preceding period, commands attention by this outburst of originality which marks one step further along the path charted earlier." Du Bourguet 1971, 162. One of the most interesting critiques of the historiography of Coptic art, and the best from the point of view of identifying the false idea of a nationalistic split between Greek and Coptic, is Török 2005, 9–36.

2 On Christian-Arabic literature, see Atiya 1991c, 1460–1467.

3 See Bolman 2002b, Bolman 2002c, Bolman 2002d, Bolman and Lyster 2002, Bolman 2002e. These chapters document the best-surviving program of medieval Coptic wall painting, located in the Monastery of St. Antony, and contextualize it within the diverse artistic world of Egypt in the thirteenth century.

4 Van Moorsel 2002, 32.

5 Conversation with Luzi and De Cesaris, May 2003.

6 My thanks to William Lyster for his extensive consideration of this subject, on which I depend in this chapter.

7 Interestingly, a similar turquoise was used in the later thirteenth-century paintings in the Ethiopian Church of Gännätä Maryam, not far from Lalibela. Historical ties connected Ethiopian monks and those at the Monastery of St. Antony. Marilyn Heldman has identified iconographic parallels between this Ethiopian church and the earlier thirteenth-century paintings by Theodore in the Monastery of St. Antony. My thanks to Heldman for her generosity in sending me her work on this church. For Gännätä Maryam, see Heldman and Haile 1987, 1–11, and Heldman 2000, 6–12. For Ethiopian monks at the Monastery of St. Antony, see Gabra 2002b, 173–183, and Griffith 2002, 189–190.

8 The addition is clearly visible because of the application of thin lines over the newly painted part of the face. This section of the face could be re-created with reasonable accuracy, both as a mirror image of the left side, and with details taken from the very similar face of Christ on the nave ceiling, certainly by the same hand. The mouth and chin, however, proved impossible to re-create accurately and so were left blank.

9 My evaluation of this artist differs considerably from that of van Moorsel. He esteemed this painting highly, comparing it to Palaiologan Pantocrators. Van Moorsel 2002, 44.

10 Some examples of this style in manuscript illuminations are New York, Pierpont Morgan Library, M 612, f. lv; London, British Library, BMO 6782; ff 1v, 28v; New York, Pierpont Morgan Library, M574; folio lv; Cairo, Coptic Museum, parchment fragment, no. 3852; Leiden, Rijksmuseum van Oudheden, parchment; Insinger 71. These are all illustrated in Leroy 1974, pls. 31, 29.1, 29.2, 34, 27.1, 27.2. They date to the seventh through the tenth centuries.

11 Bolman 2001; Bolman 2007.

12 Bolman and Lyster 2002, 152–154; Bolman 2002a, 245–248; Hunt 1998a, 319–342; Hunt 1985, 111–155; Georgopoulou 1999, 295–296; Carr 1997, 380–381; Thomas 1997, 367.

13 Washington, D.C., Freer Gallery, no. 55.11; Leroy 1974, 113, pl. 43.

14 For the Fatimid contribution to this tradition, see Bierman 1998, esp. 60–132; and for the legacy of this practice, see her Afterword, 133–145.

15 See Ettinghausen 1977 for the Arab tradition of medieval miniature painting. My thanks to Lyster for his assistance in characterizing this style.

16 The most elaborate arabesque and hexagonal designs are found in the full page illustrations, especially the portraits of the evangelists in the portion of the manuscript in the collection of the Institut Catholique, Paris. See Leroy 1974, pls. 75 (Matthew, f. 1v), 83 (Mark, f. 65v), 85 (Luke, f. 105v), and 89 (John, f. 174v). The evangelist portraits are reproduced in color in Zibawi 2003, 122–123, figs. 153–156.

17 See Haldane 1978, 62–63, pls. 19–21. Haldane also examines similar designs in other illustrated manuscripts produced under the Mamluk sultanate of Egypt and Syria and includes tables of textile patterns. Haldane 1978, 32–38.

18 The Indian compilation, known as the *Pancatantra*, was first translated (and modified) into Middle Persian during the reign of the Sasanid king Khusrau Anushirvan (531–579) when the work was retitled *Kalila and Dimna* after the names of two jackals in one of the fables. O'Kane 2003, 22–27. My thanks to Lyster for his contributions to this section of the chapter.

19 *Kalila wa Dimna*, Paris, Bibliothèque Nationale, MS Arabe 3465. Atil 1981, 61; Ettinghausen 1977, 61–63.

20 The lion in MS Arabe 3465 (f. 49v) has some parallels to the lion in the Cave Church, and while the basic stylistic tradition continues, its clarity and formulation in the fourteenth century shows closer ties to the painting in the Monastery of St. Paul. For an illustration of a lion in the thirteenth-century manuscript, see Ettinghausen 1977, 63.

21 Oxford, Bodleian Library, Pococke 400. For the lions, see especially ff. 58b, 60a, 63a. For color illustrations, see Atil 1981, 24–25, 28. The distinctive bump on the eagle's beak is repeated in an illumination of a heron in *Manafiʾ al-Hayawan* (Usefulness of Animals) of the mid-fourteenth century that may have been produced in Egypt. Madrid, El Escorial, Cod. (arab. num.) 898, f. 80r. Haldane 1978, 50–51, fig. 7. Ettinghausen 1977, 1.

22 The eyes of the lion, wolf, and jackal in f. 60a of the Oxford MS, as well as many others in this manuscript, follow the same format that we see in the Cave Church eagle. Oxford, Bodleian Library, Pococke 400, f. 60a. For color illustrations, see Atil 1981, 25.

23 Hunt 1985, esp. 117–118, 136–137.

24 Paris, Bibliothèque Nationale, MS orientaux, Copte 129. Boudʾhors 2004, 44–45. Also see another illustration from the manuscript in the same volume, 10.

25 Bierman 1998, esp. 60–132.

26 Van Moorsel 2002, 32.

27 Medieval examples of this subject appear in the Monastery of the Martyrs (Esna), in the Monastery of Anba Hatre (called St. Simeon, at Aswan), in the Monastery of al-Baramus (Wadi al-Natrun), in two chapels on the second floor of the Church of St. Mercurius, Monastery of St. Mercurius (Old Cairo), and elsewhere. See Zibawi 2003, figs. 117 (Baramus), 220 (Chapel of the Virgin, Monastery of St. Mercurius; Gabra 2002a, fig. 10.2–10.4 (Anba Hatre); Leroy 1975,

pls. 13–21, 26–27 (Martyrs); van Loon 1999, 285, fig. 4 (St. George Chapel, St. Mercurius).

28 Van Moorsel remarked that the loros worn by each angel "calls to mind Byzantine parallels." Van Moorsel 1995, 284.

29 Van Moorsel 2000b; van Moorsel 1978, 325–333; Belting-Ihm 1992.

30 Van Moorsel 2000c.

31 Ibn Kabar, *Misbah al-zulma fi idah al-khidma* (The lamp of darkness in the elucidation of service), in Zanetti 1991a, 84. Translated from the French by Bolman.

32 Zanetti 1991a, 84.

33 I treat the subject of the liturgical moment dictating the symbolic meaning of the haykal screen in Bolman 2006b, 93–95.

34 Medieval sources describe the way that the liturgical calendar changed the symbolic significance of areas in the church and even liturgical furniture. Ibn Kabar recounted the transformation of the screen on the Friday before Easter, at the third hour. The fabric curtains are removed, and seven censers are hung from the door (presumably from the curtain rod or hooks). An icon of the crucifixion is placed outside of the screen-tabernacle, and encircled with fragrant herbs. The rationale for the placement of the crucifixion icon outside of the sanctuary, he explains, is that Christ was crucified outside of the city. These actions transform the sanctuary into the earthly Jerusalem, and the doors into the city gates. Appropriate texts are then read as part of the ritual. Ibn Kabar, *Misbah al-zulma fi idah al-khidma*, U f. 196r; Villecourt 1925, 287.

35 Cherubim and seraphim are not always clearly distinguished in Coptic, or indeed Byzantine, art. The seraphim of Isaiah's vision (6:1–3), who stood above the throne of God, each had a single head and six wings. Cherubim were envisioned initially as regular angels with two wings (1 Kings 6:23–29), but following the visions of Ezekiel (1:4–25, 10:1–22) and John (Revelation 4:6–9) they were eventually provided with four or six wings covered with eyes, as well as the four heads of the incorporeal living creatures. Kazhdan and Ševčenko 1991a, 419. The living creatures can themselves be identified, at least in the vision of Ezekiel, as tetramorph cherubim. Peers 2001, 43–44. The liturgy of John Chrysostom makes no physical distinction between these two ranks of angels, referring to "the cherubim, the seraphim, six-winged and many eyed." Peers 2001, 48. Glenn Peers has observed that the iconographers of the fifth- or sixth-century apse mosaics of the Church of Hosios David at Thessalonike, the earliest known Byzantine depiction of these exalted members of the heavenly hierarchy, already conflated Isaiah's seraphim, Ezekiel's cherubim, and the six-winged creatures of

Revelation. Peers 2001, 46. The same uncertainty is encountered in the painting of a cherub or seraph (fifth–seventh century) in the apse niche of Chapel XXVI at Bawit, where the angel is depicted with one head and six wings covered with eyes. Peers 2001, 46, n. 59. Peers has also remarked that by the Middle Byzantine period "differentiation of the angelic beings is often possible only through inscriptions." Peers 2001, 49.

36 Van Moorsel 1995, 284–285. The ghost of the censer can be made out despite the loss of pigment, in the hand of the angel in the northwest corner.

37 Van Moorsel, 1995, 284–285.

38 The four living creatures are also said to perform the task of protecting the throne of God. Wansink 1991, 27–47.

39 In addition to the four six-winged figures, each of the two western corners of the sanctuary features a conventional two-winged angel holding a crossed staff and an orb (or perhaps a eucharistic loaf). Leroy 1975, 20–23, pls. 53–59, 78. For the date (AM 865), see Leroy 1975, 22.

40 Mango 1991, 1791. The earliest surviving rhipidia, dated 577, are from the Kaper Koraon Treasure, discovered ca. 1908 near Aleppo. One, now in the collection of Dumbarton Oaks (and illustrated in Mango 1991, 1791; see also Mango 1986, 147–154), is in the form of a silver disk with scalloped edges, a type Alfred Butler referrers to as "common" in Coptic churches. Butler 1884, 2: 46. The rhipidia depicted in the Dayr al-Fakhuri, however, are ax-shaped, a form observed by Butler at the Church of St. Shenoute in Old Cairo in the late nineteenth century. Butler 1884, 2: 48.

41 Mango 1991, 1790–1791; Kazhdan and Ševčenko 1991a, 419.

42 This association is also expressed by rhipidia being referred to as *hexapterygon* ("with six wings"), a common epithet of seraphim. Mango 1991, 1791; Kazhdan and Ševčenko 1991b, 1870.

43 Leroy 1975, pls. 54–55 (lion), 56–57 (bull).

44 Al-Muʾ taman ibn al-ʿAssal, *Maghmu usul al-din* (Totality of aspects of religion), in Zanetti 1991a, 80.

45 Van Loon 1999, 122–123.

46 Kazhdan and Ševčenko 1991a, 420.

47 *Encomium on the Four Bodiless Living Creatures,* attributed to John Chrysostom. New York, Pierpont Morgan Library, M612, ff. 3vb–f. 4ra (dated 892/893); 1991, 29.

48 M612, f. 8ra; Wansink 1991, 33.

49 M612, f. 9ra; Wansink 1991, 33–34.

50 Peers has observed that the liturgical use of this identical chant of the seraphim and cherubim encouraged the iconographic mixing of the two types of angels. Peers 2001, 47–48.

51 M612 f. 4ra; Wansink 1991, 29.

52 M612 ff. 9va–9vb; Wansink 1991, 37.

53 M612 f. 13rb; Wansink 1991, 37.

54 M612 ff. 14vb–15rb; Wansink 1991, 38–39.

55 *Encomium on the Four Bodiless Living Creatures*, Berlin, Ägyptisches Museum and Papyrussammlung, Staatliche Museen, P.11965, ff. 3va–3vb; Wansink 1991, 44.

56 Ševčenko 1979 590–591; Malaty 1973, 441–442.

57 Van Moorsel 1994, 395–401; van Moorsel 2000a, 50.

58 The conservators have established that the plaster in both light wells is the first medieval rendering.

59 Examples of angels holding roundels that closely resemble the eucharistic loaf can be seen at Saqqara (Cell 709; sixth or seventh century) and at the Monastery of St. Antony (sanctuary, 1232/1233; and arch between the nave and the khurus, mid- to late thirteenth century). Bolman 1998, 74; Bolman 2002e, 71, figs. 4.28, 4.35; Bolman and Lyster 2002, 134, figs. 8.14, 8.15.

60 The similarity of the tuft of hair at the top of the forehead is not, actually, an indication that the same painter worked on these two faces. When the conservators partially restored the face of Christ in Majesty in the Haykal of St. Antony in tratteggio, they incorporated this detail from the very similar face of Christ in the central nave. See n. 8 above.

61 Lyster has observed that this area is easier to reach, which may account for the greater confidence in rendering.

62 My thanks to Lyster for this observation.

63 For one example, see the *Kalila wa Dimna* of ca. 1200–1220, now in Paris (Bibliothèque Nationale, MS Arabe 3465, f. 49v), and an Egyptian version of the *Maqamat* of 1337, now in Oxford (Bodleian Library, Marsh 458, f. 45r). Both are reproduced in Ettinghausen 1977, 63, 152. My thanks to Lyster for this interesting connection.

64 Paris, Bibliothèque Nationale, MS Copte 13. In particular, see ff. 108v (Healing the Blind Man, Mark 8:22–26), 167v (Transfiguration, Luke 9:28–36), 193r (Healing of the Leper, Luke 18:11–19), and 259v (Raising of Lazarus, John 11:1–44), illustrated in Leroy 1974, pls. 60.1, 65.2, 66.1, and 71.2. In most cases, they indicate outdoor settings, but in the illustration of the Cleansing of the Temple (f. 59v, Matthew 21:12–14), three large flowers are used in a purely decorative

manner, floating in space and framed by vine scrolls. Leroy 1974, pl. 54.1. A similar motif is also used to divide the lines of text on f. 233r; see Leroy 1974, pl. 70.2. My thanks to Lyster for his contributions to this part of the chapter.

65 I am grateful to Michael Jones for several stimulating discussions on this subject in 2002 and 2003.

66 Much of the early evidence was discovered by Thomas Mathews, and with his generous permission it is published in Bolman 2006b, 87–88. A number of these low-relief panels set within medieval haykal screens in Old Cairo are illustrated in Zibawi 2003, 108–113.

67 One of these medieval screens, in the Thekla Haymanot Chapel in the Hanging Church, includes two icons that Lucy-Ann Hunt has proposed were Byzantine gifts, unusually introduced into the Coptic icon screen. Hunt 1998b, 62. Whether or not the medieval screen rose to the ceiling of the nave, as is the case with the present eighteenth-century screen in this low extension of the cave, medieval screens were high enough that they obscured the viewer's ability to see the images in the sanctuary.

68 Van Moorsel 2000a, 40; van Moorsel 2002, 50.

69 *Protevangelium of James*, 22.3, in Schneemelcher 1991, 1: 436.

70 Bolman and Lyster 2002, 134–135.

71 One example is the painting of Abraham, Isaac, and Jacob in the khurus. Bolman 2002e, 59, fig. 4.25. The second instance is the depiction of the Women at the Tomb and the Meeting of Christ and the Women in the Garden in the vault of the khurus. Bolman and Lyster 2002, 129, fig. 8.4.

72 One typical example of this pattern is the depiction of the Christ child on an altar, suggesting sacrifice. A medieval example with this feature is in the Thekla Haymanot Chapel in the Hanging Church, Old Cairo; see Atalla n.d., back cover illustration.

73 Van Moorsel also suggested that these two prophets were intended to represent Isaiah and Micah. Van Moorsel 2002, 38.

74 Van Moorsel 2000a, 51.

75 Gertrud van Loon is undertaking a large study of the iconography of the infancy of Christ and that of John the Baptist in Coptic art, which will surely inform our understanding of the iconographic antecedents to the cycle in the Monastery of St. Paul. One part of her larger project includes work at Dayr Abu Hennis, in collaboration with Alain Delattre. My thanks to both of them for stopping their work to show me around the site. Van Loon and Delattre 2004, 89–112; van Loon and Delattre 2005, 167; van Loon and Delattre 2006, 119–134.

76 Thierry 1998, 5–16. My thanks to Marguerite Rassart-Debergh for sending me this interesting publication. I tend to agree with the early end of Thierry's proposal that these paintings date to the late-fifth or early-sixth century. See also van Loon and Delattre 2004, 100–101.

77 Clédat 1999, 26, figs. 16–17.

78 Paris, Bibliothèque National, MS Copte 13, f. 5r; Leroy 1974, 44.

79 Paris, Bibliothèque National, MS Copte 13, f. 6v; Leroy 1974, 45.

80 Leroy identifies this first section as Matthew from a colophon on f. 87r. Leroy 1974, 131.

81 Paris, Institut Catholique, MS 1, f. 4v. Leroy 1974, 77.

82 Carr and Kazhdan 1991, 1487.

83 The Haykal of St. Mark, Monastery of St. Macarius, includes some infancy scenes, as does the nave in the Church of the Virgin Mary, Monastery of al-Baramus. Both of these programs are medieval. Zibawi 2003, figs. 180 (al-Baramus) and 197 (St. Macarius).

84 The coloration, ornamental features, and close relationship to the accompanying medieval inscriptions indicate to my mind that the entire area above the eighteenth-century rendering of the Virgin and Christ child with cherubim belongs to the work of the second medieval painter of the Cave Church.

85 Van Moorsel 2000a, 50; van Moorsel 2002, 54; De Cesaris and Luzi 2002, 4.

86 Van Moorsel 2002, 49, 57–58.

87 My thanks to Lyster for this suggestion.

88 For an illustration of the Esna archangel, see Leroy 1975, pls. 36–37.

89 E.g., the Church of St. Michael the Archangel, at the Monastery of St. Paul. See also the *Sermon on the Archangel Gabriel* by Archealos, Vatican Coptic MS LIX, ff. 30r–49v, transcribed and translated, with a discussion of its popularity and diffusion in multiple languages, in de Vis 1990, 242–291.

90 *Discourse on the Compassion of God and on the Freedom of Speech of the Archangel Michael*, by Severus of Antioch, London, British Museum, MS Oriental 7597, ff. 11b, 36b, 37a, transcribed and translated by Budge 1915, 736, 737, 758, 759.

91 *Encomium on the Archangel Raphael*, attributed to John Chrysostom, in London, British Library, Coptic MS, BMO 7022, f. 3a, Budge 1915, 529, 1036.

92 The Coptic liturgy today includes a reference to the three archangels as a symbol of the Trinity. Shenouda III 1993, 44. Youhanna Nessim Youssef has observed that Ibn Kabar (d. 1324)

343

made reference to what may be this doxology. Youssef has noted that it does not appear in the psalmodia until the eighteenth century (Berlin, MS 474, ff. 99–104, dated 1760), and he and Hany Takla have stated that it becomes somewhat less rare in the nineteenth century. Email messages of November 3, 2005 (Takla), and November 6, 2005 (Youssef). I am very grateful to both of them for this information. For the *Philoxenia of Abraham* and Trinitarian symbolism, as well as numerous other aspects of angels in Byzantine art and devotion, see Peers 2001, esp. 36–41.

93 For a comprehensive list of the depictions of this subject in late antique and medieval Egypt, and an analysis of its possible range of meanings, see van Loon 1999, 167–176. For postconservation photographs and a discussion of the role of this painting in the Monastery of St. Antony, see Bolman 2002e, 57–60, fig. 4.24.

94 Van Loon has assembled a considerable body of evidence demonstrating this point. Van Loon 1999, 173.

95 Van Loon 1999, 174–175.

96 Van Loon 1999, 175–176.

97 *Panegyric on the Three Youths of Babylon,* Vatican Copte LXIX, f. 105v, in de Vis 1990, 70.

98 *Panegyric on the Three Youths of Babylon,* Vatican Copte LXIX, ff. 112v–113r; de Vis 1990, 86.

99 *Panegyric on the Three Youths of Babylon,* Vatican Copte LXIX, f. 113v; de Vis 1990, 87–88. Vatican Coptic LXII and LXIX, dating between the ninth and eleventh centuries, include more accounts of miracles performed by the three youths. De Vis 1990, 121–202.

100 The relevant inscription has been read as AM 846 or 896, corresponding to either 1129/1130 or 1179/1180. Coquin 1975, 241–284, pls. 40–50; Leroy 1975, 253–254; for the painting, see pls. 13, 14, 22, 25.

101 Van Loon proposed that one of the fragmentary saints in the Chapel of Benjamin, Church of St. Bishoi, Monastery of St. Bishoi (Wadi al-Natrun), is also Stephen. In that instance he holds a censer and book. Van Loon 1999, 77. A good color illustration of the painting in the Monastery of St. Macarius is in Zibawi 2003, 149, fig. 191. For the dating of these paintings to the ninth century (with reservations), see Leroy 1982, 27. See also van Loon 1999, 197, n. 894 for a list of references to the date of this haykal, and for the possibility that the paintings are somewhat later.

102 Bolman 2002e, 48; Bolman 2004b, 1–16; Bolman 2001, 43, 45.

103 The circa fifteenth-century Ethiopic text in question provides an account of the martyrdom of St. Menas that accords in most respects to earlier versions. London, British Museum, Oriental MS 689, ff. 74b1–74b2. Budge 1909, 46–47.

104 Van Moorsel 2002, 43, identified the anonymous saint (F15) as Pachomius. Gabra, however, found no such evidence; see Chapter 13 of this volume.

105 Van Moorsel was able to discern, prior to cleaning and conservation, that Arsenius was painted by the second artist who worked in the Haykal of St. Antony. Van Moorsel 2002, 43.

106 Van Moorsel 2002, 41.

107 For a discussion of many of the ways in which medieval paintings of monks worked, see Bolman 2002e, 53–54.

108 My thanks to Lyster for his sustained and considerable assistance with this conclusion, and with the challenge of evaluating the character of the second medieval painter's work.

109 Bolman 2002a, 247–248.

110 I have benefited greatly from repeated discussions with Lyster, Luzi, De Cesaris, and Sucato on this subject.

111 See Bolman 2002e.

112 See Bolman and Lyster 2002.

113 Bolman 2002d, 78–79; Bolman 2002a, 244–245, 247. See Chapter 9, no. 41.

114 Bolman and Lyster 2002, 140–152.

115 Paris, Bibliothèque National, Copte 13. See, for example, f. 6r (Mary), f. 21v (woman at right); Leroy 1974, 44, 47.

116 Little 1976, 552–553.

117 The prohibition on building and repairing churches was one of the sumptuary laws associated with the so-called Covenant of ʿUmar that were periodically imposed on Christians and Jews throughout Islamic history. According to the medieval historian al-ʿAyni, the Copts were "in a state of extreme humiliation and degradation" under Qalawun that likely included the usual ban on church building. Such a decree was certainly issued in 1301 by the sultan's son an-Nasir Muhammad. Little 1971, 553–556.

118 Of inestimable help to me in evaluating the position of medieval Christian Egyptian authors on the subject of images is the work of Ugo Zanetti: Zanetti 1991a, 77–92, Zanetti 1991b, 93–100.

119 Zanetti 1991a. Sawirus ibn al-Muqaffaʿ, *Kitab tartib al-kahanut* (Book of the order of priesthood), 78; Abu al-Khayr ibn al-Tayyib, *Tiryaq al-ʿuqul fi ʿilm al-ʿusul* (The Theriac of intellects in the foundational sciences), 78–79; al-Muʾtaman al-ʿAssal, *Maghmu usul al-din,* 79–80.

120 Our authors normally refer to those needing to be taught as women and children, an audience of little relevance to our study of the Cave Church, but presumably the didactic function of icons worked for men and monks as well.

121 Zanetti 1991a. al-Muʾ taman ibn al-ʿAssal, *Maghmu usul al-din,* 80; Sawirus ibn al-Muqaffaʿ, *Kitab tartib al-kahanut,* 78.

122 Zanetti 1991a, 83.

123 Zanetti 1991a. 83.

124 Cairo, Coptic Museum, Biblical MS 94.

125 Bolman 2002e, 48. Bolman 2004b, 1–16. Bolman 2001, 43, 45.

CHAPTER ELEVEN: REVIVING A LOST TRADITION

1 Sicard 1982, 41, translated from the French by E. Bolman.

2 Meinardus 1967–1968, 186.

3 Piankoff 1943, 65–66.

4 Meinardus 1967–1968, 188.

5 Hamilton, Chapter 4 of this volume.

6 Hamilton, Chapter 4 of this volume.

7 Meinardus 1967–1968, 181.

8 Leroy 1978, 335.

9 Van Moorsel 1994, 396.

10 Da Vinci 1935. *Oeuvres choisies,* tome 2 (Leningrad, Moskva), 112. Cited in Brodskaïa 2000, 56.

11 Meinardus 1992, 40.

12 Piankoff 1943, 65.

13 Meinardus 1967–1968, 188.

14 Van Moorsel 2000a, 44.

15 Van Moorsel 2000a, 44.

16 Van Moorsel 1994, 396.

17 Rhodes 2000, 24.

18 Rubin 1984a, 240–343.

19 Quoted in Rubin 1984, 1: 5.

20 Rubin 1984, 1: 5. For a discussion on "primitive" as an art-historical term, see Antliff and Leighten 2003.

21 Rhodes 2000, 24.

22 Goldwater 1967; Ratnam 2004, 159.

23 Ratnam 2004, 159.

24 Franciscono 1998, 95.

25 Temkin 1987, 26.

26 Helfenstein 1998, 148; Rhodes 2000, 33.

27 Also see Paul Klee, *Sick Girl* (Krankes Mädchen), 1937. Private collection, illustrated in Helfenstein 1998, 149, fig. 128; Paul Klee, *Actor* (Schauspieler), 1923. Private collection, illustrated in Lanchner 1987, 184.

28 Lanchner 1987, 328.

29 Quote in Langen 1990, 64. For more on the *Book of the Precious Pearl* (Kitab al-jawhara al-nafisa) by Yuhanna ibn Abi Zakariya ibn al-Sabbaꞌ (ca. 1350) and the related *Order of the Priesthood* (Kitab tartib al-kahanut), attributed to Sawirus ibn al-Muqaffaꞌ, writing in the tenth century but possibly the work of an anonymous thirteenth-century author, see Atiya 1991c, 1464; van Loon 1992, 497–498; van Loon 1999, 14–15.

30 On the imitation of the saints by Coptic monks in late antiquity, see Bolman 1998, 65–77, and Bolman 2001, 41–56; for a modern example from the Coptic lay community, see van Doorn 1990, 104.

31 Zanetti 1991, 93; van Doorn 1990, 104–105.

32 Bolman 2002e, 55–57; van Doorn 1990, 104–105.

33 Den Heijer 1990, 89–100.

34 Den Heijer 1990, 94 (miracle 6).

35 Van Doorn 1990, 105.

36 Van Doorn 1990, 106.

37 Wansleben spent about three years in Egypt in 1664 and 1672–1673. Chaillot 1990, 81.

38 Johann Wansleben, *Relazione Dello Stato Presente dell' Egitto* (Paris, 1671). Selections of the original Italian quotation are taken by Chaillot from pages 177–188 and translated into French. Chaillot 1990, 82. The translation from French to English is by Bolman.

39 Bolman 2002e, 55.

40 Van Moorsel 2000a, 44–45.

41 Sicard 1982, 41.

42 The uncertainty surrounding the dating of most Coptic wall paintings makes this assertion difficult to prove. However, Pierre du Bourguent (1971, 186) observed that "in the thirteenth century Coptic art breathed its last." Gertrud van Loon (1999) in her more recent study of Old Testament scenes in Coptic churches mentioned no example later than the thirteenth century. Such lack of evidence, when combined with the known political, economic, and demographic decline of the Coptic community in the fourteenth century, strongly suggests that the ancient tradition of Coptic wall painting came to an end sometime after the second medieval painter of the Cave Church was active (1291/1292). The demise of professional Coptic icon production is even more obscure. Linda Langen (1990, 65) wrote that a "strange but intriguing fact is the absence of Coptic icons from the 7th century until the 18th century. No Coptic icons from this period are preserved in Egypt." In contrast, Zuzana Skalova (2006a, 171–209) would like to see a number of icons in Egypt painted in a Byzantine style as products of Byzantine-trained painters working in Coptic workshops or for Coptic patrons. I disagree with the dates and provenances she assigns these icons, and question whether they were produced in Egypt or even originally for Coptic patrons. However, Skalova is to be commended for publishing an exceptionally large number of icons presently in Egypt, including a painting on linen of the archangel Michael in the Coptic Museum (inv. 8452) that has a Sahidic inscription and is dated AM 1044 or 1327/1328 (210–211, cat. 19). This medieval painting has stylistic similarities to the wall painting of the enthroned Virgin and child in the White Monastery church near Sohag, which I would therefore date to the first half of the fourteenth century. Otherwise, I know of no other Coptic painting that can currently be dated with confidence to the fourteenth century, much less the fifteenth. For the painting of the enthroned Virgin, see Zibawi 2003, 196, fig. 261.

43 Little 1976. For a more detailed account of this period, see Swanson, Chapter 2 of this volume.

44 Al-Maqrizi in Little 1976, 568.

45 Raymond 2000, 161–162.

46 Armanios notes in Chapter 3 of this volume that the ceremonial production of the mayrun oil essential for the consecration of icons was last performed in 1461, before being revived by John XVI in 1703.

47 For the late medieval abandonment of monasteries and the impoverishment of the patriarchs, see Swanson, Chapter 2 of this volume.

48 Leroy 1982, 113.

49 For photographs of the paintings, see Evelyn White 1933, pls. XIII–XVI; and Zibawi 2003, 202, figs. 268 and 269.

50 The term "medieval," especially when used for nonwestern societies, is inexact at best, but in an Egyptian context it is usually employed until the fall of the Mamluk sultanate in 1517. The Ottoman period is postmedieval or early modern, although the era of Modern Egypt is usually said to begin with the westernization programs of Muhammad ꞌAli (the "father of modern Egypt") in the first half of the nineteenth century.

51 For the military and administrative organization of Ottoman Egypt, as well as the political history of the period, see Hathaway 1997, Crecelius 1981, and Holt 1966.

52 Raymond 2000, 210.

53 The archons and their pivotal role in fostering the eighteenth-century revival of the Coptic community are examined in more detail by Swanson and Armanios in Chapters 2 and 3 of this volume.

54 John XVI's name before becoming patriarch was Ibrahim al-Tukhi. Al-Tukhi 1991, 1348.

55 *HPEC* III/3: 277–278.

56 *HPEC* III/3: 278.

57 *HPEC* III/3: 279.

58 *HPEC* III/3: 282.

59 For more on the eighteenth-century repopulation of St. Paul's, see Swanson, Chapter 2, and Gabra, Chapter 5, both in this volume. Also see *HPEC* III/3: 284.

60 Raymond 2000, 210.

61 *HPEC* III/3: 279.

62 In 1950 and 1951, the two haykal screens were repaired and the icons placed within new frames at the top of each one. At the same time, four of the icons from the northern screen were replaced with modern copies. A photograph of the reverse side of the northern screen by the Whittemore expedition of 1930–1931 (B14) indicates that the icons and their frames were part of the original screen. Dumbarton Oaks, Byzantine Photograph and Fieldwork Archives, Washington, D.C. Also see De Cesaris 2003, 6–7. Swanson in Chapter 2 of this volume mentions that John XVI consecrated icons during his visit to the monastery.

63 Van Moorsel 1994, 396.

64 *HPEC* III/3: 282–283.

65 An account of the flood is translated by Gabra in Chapter 5 of this volume.

66 A noted authority on Coptic art often used a wet sponge to better see paintings covered by soot. The water revealed the images clearly for the brief time the painting was wet, but it also caused damage to the pigments.

67 The Coptic year AM 1429 corresponds to August 29, 1712, to August 28, 1713. O'Leary 1937, 34–35.

68 MS 368 (Lit.). The colophon names ꞌAbd al-Sayyid al-Mallawani, and gives the date 24 Mesor, AM 1431 (August 17, 1715).

69 Ishaq 1991, 2024–2025. "The Psalmodia was sung three times a day: after the Morning Prayer (Martins), after Compline and after the Midnight Prayer. The Psalmodia of the morning is short…but the other two consist of hymns, four biblical odes…Song of the Three Hebrews…a Theotokia (Hymn to the Virgin, a different one for every day of the week), doxologies (praise to the saints, regulated by the calendar), intercessions and prayers." Van Loon 1999, 122.

70 These examples of the psalmody serving as a source for inscriptions in the Cave Church follow Gabra, Chapter 13 of this volume.

71 Gabra did not have enough time in the library of St. Paul's to determine whether the exemplar of the psalmody copied by ꞌAbd-Sayyid was among the monastic manuscript collection.

72 This abridged list of the categories of saints is from the "Commemoration of the Saints" in the current Coptic liturgy. Shenouda III 1993, 251–255.

73 Atiya 1991e, 2173. O'Leary, however, noted that in the 1930s, the reading of the lives of the saints was a regular part of the Night Office at the Monastery of St. Macarius in the Wadi al-Natrun.

74 Atiya 1991e, 2173.

75 Atiya mentioned copies of the Coptic synax-arion from the fourteenth, seventeenth, and eighteenth centuries. Atiya 1991e, 2173. Coquin has distinguished two principal forms: the quasi-official recension of Lower Egypt, and another from Upper Egypt. Coquin 1991h, 2172.

76 Ishaq 1991a, 900–901; Ishaq 1991b, 2024–2025; O'Leary 1937, 32–33.

77 O'Leary 1937, 19–21.

78 Malone 1956, 201–228; Bolman 2001, 45; Bolman 2002e, 49–50.

79 Bolman 2002e, 38.

80 Bolman 2002e, 40–57.

81 The images produced in 1517 by the Ethiopian monk at the Monastery of St. Macarius are also of equestrian martyrs, and monks and hermits.

82 For the condition of the medieval paintings at the Monastery of St. Antony before the ARCE conservation project, see Bolman 2002d, 77–78.

83 Van Moorsel 1994, 396; van Moorsel 2002, 46.

84 Van Moorsel 2000a, 45.

85 For the costumes of the equestrians in Theodore's program, see Lyster 2002, 111–116.

86 O'Leary places George's martyrdom under Dadianus, the "lawless king of the Persians…in days of old." O'Leary 1937, 140–145. Megally, however, cites another Coptic tradition that dates the saint's passion to the reign of Diocle-tian. Megally 1991a, 1139–1140. Van Doorn esti-mates that more than half of all current Coptic churches are dedicated to George; van Doorn 1990, 110. For James the Persian, see O'Leary 1937, 161.

87 For Victor, see O'Leary 1937, 278–281; van Esbroeck 1991, 2303–2305. For Theodore Stratelates, see O'Leary 1937, 262–265; Orlandi 1991e, 2237–2238. For Menas, see O'Leary 1937, 194–197; Krause 1991, 1589–1590. For Iskhirun of Qalin, see Kamal 2004.

88 Abadir and his sister Ira'i are also known as Ap-ater and Eirene, and Ter and Erai, see O'Leary 1937, 79–80; Orlandi 1991d, 2209. For Isidore of Antioch, see O'Leary 1937, 160; Orlandi 1991b, 1307–1308.

89 For Julius of Aqfahs, see O'Leary 1937, 174–175.

90 This iconographic format can also be seen in the paintings of equestrian martyrs in the Church of the Archangel Gabriel, at Naqlun in the Fayyum, also medieval in date, and presumably would have been seen elsewhere in now lost paintings. However, the proximity of the paintings in the Church of St. Antony, and the fact that 'Abd al-Sayyid was originally from the Monastery of St. Antony, suggest to me that the paintings of Theodore were likely the primary medieval source for this aspect of the eighteenth-century program.

91 *Encomium on the Theodores,* Vatican Copt. 65 (olim XIV), ff. 30–98; Winstedt 1979, 1–133. The section on Theodore killing the dragon is ff. 87–98; Winstedt 1979, 123–132. For a discus-sion of Theodore Stratelates in the program of Theodore, see Bolman 2002, 42–44.

92 O'Leary 1937, 279–280. For Victor in the pro-gram of Theodore, see Bolman 2002e, 46–47.

93 For George in Theodore's program, see Bol-man 2002e, 61, 116, fig. 7.22 (nave), 120, fig. 7.31 (khurus).

94 Henry Maguire provides an account of such a miraculous intervention by an icon of George. Maguire 1993, 78.

95 The children in the painting were discovered during the course of conservation, although a photograph (B14) taken of the painting by the Whittemore expedition shows that they were still visible in 1931. Dumbarton Oaks, Byzantine Photograph and Fieldwork Archives, Washing-ton, D.C.

96 The monk-painter also did not depict Victor's costume in the same fashion as Theodore. In the thirteenth-century painting, the saint wears princely attire rather than the military garb used for most of the other equestrians. Accord-ing to his legend, Victor refused to be a soldier because of his Christian beliefs. In the Cave Church he is dressed in the same manner as the other military saints in the narthex. Bolman 2002e, 47.

97 For Menas in Theodore's program, see Bolman 2002e, 41–42.

98 *Encomium on St. Menas,* New York, Pierpont Morgan Library, Cod. M. 590 f. 62; Drescher 1946, 141–142.

99 Cod. M. 590, ff. 50–68; Drescher 1946, 128–149. Drescher believed the author to be either John III (677–686) or John IV (775–789). Drescher 1946, 127.

100 Cod. M. 590, ff. 60–61; Drescher 1946, 140–141.

101 O'Leary 1937, 161.

102 This icon is depicted as fig. 12.49 of this volume. Unfortunately, I have not been able to find an account of this miracle. Bishop Matta'us, superior of the Monastery of the Syrians in

the Wadi al-Natrun, has recently published a life of Isidore based on a manuscript in the monastic library (MS 263). Although he does not mention the miracle of the talking dog, he gives another account of the saint causing an idol to speak in order to confound the emperor Diocletian. Anba Matta'us 2005, 29. I thank Samir Morcos for finding this booklet.

103 The icons are in the Church of St. Mercurius, Old Cairo and the Monastery of St. Bishoi, Wadi al-Natrun. The icon in Cairo is depicted in fig. 12.51. Both icons are illustrated in Atalla 1986, 58–59, 96–97.

104 Kamal 2004, 59. Although Yu'annis Kamal does not refer to the man as a bedouin, he is so described in an inscription on Ibrahim al-Nasikh's icon in the Monastery of St. Bishoi. Both of Ibrahim's icons of Iskhirun also feature small depictions of the miraculously trans-ported church. For an account of that miracle, which is claimed implausibly to have taken place in AM 1596 (1879/1880), more than a cen-tury after the miracle was depicted by Ibrahim, see Kamal 2004, 50–55. I thank Samir Morcos for his help in translating these passages and the icon inscriptions.

105 Van Moorsel 2002, 96.

106 Theodore painted in the dome over the central sanctuary. See Bolman 2002, 62, 99.

107 Michael Jones made this observation in conver-sation in April 1998.

108 *HPEC* IV/1: 48.

109 Originally, the north wall shared by the narthex and northern nave was continuous at this point, extending under a broad arch. In the mid-twentieth century, a stone load-relieving arch was constructed within the eighteenth-century arch, creating a smaller entrance and a more pronounced division between the two rooms. The painting of the small church protected by George was partially covered by the new arch, which no doubt contributed to its current damaged state. The new arch also diminished the illusion that the saints were progressing into the interior.

110 For Cyriacus and Julitta, see Husselmann 1965, 79–86; O'Leary 1937, 116; Orlandi 1991a, 671.

111 This area of wall is further restricted by a small window above the arch in the drum of the dome.

112 O'Leary 1937, 127.

113 Among the extremely rare depictions of female saints in Coptic wall paintings, an unusually large number come from the monastic settings of Bawit and Saqqara, ca. the sixth or seventh century. Paintings of an unidentified woman dressed as a monk and carrying a codex were found in Cell F in the main church and in two

other cells at the Monastery of Apa Jeremiah at Saqqara. Rassart-Debergh 1991, 778. A painting of Ama Rachel, the head of the women's monastery at Bawit, was discovered in Room 40 in the Monastery of Apa Apollo at Bawit. Bolman 2006a, 426–427, fig. 20.12. Also at Bawit, two paintings of Ama Sibylla surrounded by personifications of the Virtues of the Holy Spirit were recorded in chapels III and IV. Tim Vivian has observed that Sibylla was most likely an angelic rather than historical figure. "The monks at Bawit may have seen Sibylla as the 'Mother of the Virtues,' and possibly as their spiritual mother and patron in the cultivation of the virtues." He also suggests that Sibylla was probably the unidentified woman-monk depicted six times at Saqqara. Vivian 1998–1999, 4. If Vivian is correct, Ama Rachel is therefore the only known *human* female saint from Bawit and Saqqara, underlining the rarity of paintings of holy women in Coptic art.

114 Van Moorsel 2002, 43. Gabra, however, found no evidence of such an identification (Chapter 13 of this volume).

115 For Pachomius (d. 349), see Harmless 2004, 115–163; Veilleux 1991, 1859–1864. For Shenoute (d. 466), see Harmless 2004, 445–448; Kuhn 1991, 2131–2133. For Moses the Black (d. 407), see Harmless 2004, 203–206; Regnault 1991d, 1681. For John the Little (d. 409), see Harmless 2004, 196–202; Regnault 1991c, 1359–1361; van van Esbroeck 1991, 1361–1362. For Arsenius (d. 449), see Harmless 2004, 217; Regnault 1991b, 240–241. For John Kama (d. 859), see Coquin 1991d, 1362–1363; O'Leary 1937, 172–173. There are a number of other monastic saints named John—for example, John of Lycopolis (d. 395) and John, hegumenos of Scetis (d. 675). See Harmless 2004, 294–296, for the former and Coquin 1991d, 1362, for the latter.

116 As I discuss in the following chapter, 'Abd al-Sayyid and the monk-painter may have initially intended the medieval Coptic inscriptions to identify four of the eighteenth-century saints in the corridor. Later in the project, however, they increased the number of images to seven and apparently provided the figures with new names.

117 For Abib and Apollo (fourth century), see Coquin 1991g, 1953–1954; O'Leary 1937, 82–83. For Samuel of Qalamun (born ca. 597), see Alcock 1991, 2092–2093; O'Leary 1937, 242–243.

118 The remains of what appear to be two circular red frames of halos (D12, G2) survive on the medieval plaster level at the top of the wall.

119 For Macarius (d. 390), see Guillaumont 1991, 1491–1492; Harmless 2004, 194–196. For Maximus and Domitius, see van Esbroeck 1991b, 1576–1578; O'Leary 1937, 192–194.

120 For Sarapion (d. 370), see Griggs 1991, 2095–2096; O'Leary 1937, 245.

121 The complete garment is not shown, but it could be either an omophorion, worn draped around the neck, or more likely an epitrachelion, a band of material with an opening for the head. Innemée 1992, 50–52, 45–46. Theodore used similar vestments in his program when depicting bishops and patriarchs. See fig. 2.2 for Theodore's painting of Severus of Antioch and Dioscorus of Alexandria.

122 De Cesaris 2003, 19.

123 Van Moorsel 2000a, 51.

124 O'Leary 1937, 187–188.

125 For a catalogue of Antonian monastic vestments, see Innemée 1992, 116–128. For a fifth-century description of the Egyptian monastic costume and its symbolism, see John Cassian, *The Institutes of the Coenobia*, Book 1: *Of the Dress of the Monks;* Gibson 1989, 201–205.

126 Forget 1921–1926, 389, cited in Innemée 1992, 93.

127 In Egypt, the analabos is sometimes referred to as the *schema,* which modern Copts call the *eskim.* Generally the term signifies the monastic habit in general. The more particular association with the analabos may be due to the leather harness being a characteristic part of the costume. There is some confusion in its usage. Innemée 1992, 124–127. See also Bolman 2007, 414–416.

128 Innemée mentions the staff, symbolizing the "wood of life," as part of the monastic costume. Innemée 1992, 107. Although the upper portion of Antony's staff is lost, other monastic saints in the Cave Church hold tau-staffs, suggesting Antony did as well.

129 The analabos of Domitius survives only faintly in outline.

130 *Apophthegmata Patrum,* M: 33; Ward 1975, 134.

131 Regnault 1991a, 177–178.

132 Each of the archangels is commemorated with a feast in the Coptic calendar. See van Esbroeck 1991 (Michael); Pérez 1991a (Gabriel); Pérez 1991b (Raphael); Bishop Gregorius 1991 (Suriel).

133 Van Moorsel expressed surprise at the monk-painter's duplication of the archangels. Van Moorsel 1994, 396.

134 Peers 2001, 7.

135 Johann Wansleben, *Histoire de l'Eglise d' Alexandrie* (Paris, 1677), chapter 3, 138–139; Chaillot 1990, 84.

136 "The loros, the imperial insignium par excellence…" Piltz 1997, 43.

137 Maguire 1997a, 255.

138 It is also the most common form of cherub in Byzantine iconography; see Kazhdan and Ševčenko 1991a, 419.

139 Both pairs of angels are discussed with accompanying photographs in Bolman and Lyster 2002, 136–143.

140 Podskalsky and Gonosová 1991, 97. The anonymous author of the *Historia Monachorum in Aegypto* states in the preface: "For in Egypt I saw many fathers living the angelic life as they advanced steadily in the imitation of our divine Savior…while dwelling on earth in this manner they live as true citizens of heaven." *HMA,* Prologue 5; Russell 1980, 49–50.

141 Innemée 1992, 124–125.

142 *HPEC* III/3: 285 (Peter VI), 290 (John XVII).

143 The central haykal of the Church of St. Antony is illustrated in Bolman 2002e, 63, fig. 4.27, 64, fig. 4.28, 66, fig. 4.31). The twenty-four elders appear with markedly less frequency in Coptic art than Christ in Majesty, but pre-eighteenth-century remnants of them survive. For example, the elders are depicted in an eleventh- or twelfth-century wall painting in the Monastery of Anba Hatre (also known as the Monastery of St. Simeon), in Aswan. Gabra 2002a, 122. So many Coptic wall paintings have been destroyed over the centuries that we cannot fully evaluate the popularity, or lack thereof, of the Apocalyptic group of elders. See Meinardus 1968–1969.

144 Revelation 4:2–8 (New King James Version, 1979, Thomas Nelson, Inc.).

145 Van Moorsel 2000a, 44.

146 Revelation 8:2 (New King James Version, 1979, Thomas Nelson, Inc.).

147 De Cesaris 2004, 5–6.

148 In Theodore's program the southern sanctuary of the church features images of bishops and patriarchs revered by the Coptic Church (see fig. 2.2). The theme of Episcopal saints was apparently to be continued in the northern haykal, but apart from Mark the Evangelist (the first patriarch of Alexandria), the paintings in this room were never completed. Bolman 2002e, 70–71.

149 Van Moorsel 2000a, 45.

150 Van Moorsel 2000a, 45.

151 Theodore painted twelve equestrian martyrs (one lost; George twice); the Cave Church program has ten (one in the northern nave). Only four are common to both: Victor, Theodore Strateletes, George, and Menas.

152 The anonymous monastic saint in the corridor makes the exact number uncertain. Monastic saints in the Cave Church that are found in

the 1232/1233 program: Antony, Paul, Macarius, Maximus, Domitius, Moses the Black, Arsenius, John the Little, and Samuel of Qalamun.

153 For the chronology of the workshop of Ibrahim and Yuhanna, see van Moorsel, Immerzeel, and Langen 1994, 16–17.

154 Van Moorsel, Immerzeel, and Langen 1994, 6–7.

155 Icons by the workshop of Ibrahim and Yuhanna: Victor (Atalla 1998a, 80, 104; Mulock and Langdon 1946, 24–25), George (Atalla 1998a, 81, 106; Atalla 1998b, 123; Mulock and Langdon 1946, 30–31, 36–37, 46–47), Theodore Stratelates (Atalla 1998a, 108; Mulock and Langdon 1946, 32–33), Menas (Atalla 1998a, 108, 141, 142; Atalla 1998b, 140; Mulock and Langdon 1946, 38–39, 52–53).

156 Icons by the workshop of Ibrahim and Yuhanna: Antony and Paul (Atalla 1998a, 112), Macarius (Atalla 1998a, 113), Maximus and Domitius (Atalla 1998a, 114).

157 Icons by the workshop of Ibrahim and Yuhanna: James the Persian (fig. 12.52 of this volume), Isidore (fig. 12.49 of this volume), Iskhirun of Qalin (fig. 12.51 of this volume), Julius of Aqfahs (fig. 11.6 of this volume), Cyriacus and Julitta (Atalla 1998a, 118), Apollo and Abib (Atalla 1998a, 115), Marqus al-Antuni (fig. 2.4 of this volume).

CHAPTER TWELVE: RESHAPING A LOST TRADITION

1 Sicard 1981, 41.

2 The evidence for the use of guidelines is clearest in the Haykal of the Twenty-Four Elders. The thrones of the elders were positioned using lines that were never painted over. There is also a series of similar lines on the lower north wall, where the program was to be extended. The positioning of many other figures in the church was obviously determined by the same method. De Cesaris 2004, 5.

3 MS 368 (Lit.). See figure 12.5 for a page of this manuscript illustrating this technique.

4 These traditional motifs are catalogued by Leroy 1974, 52–85. For a more recent photographic survey of Coptic illuminated manuscripts, see Atalla 2000.

5 Abd El-Shaheed 2005, 83. The icon painter Ibrahim al-Nasikh (active ca. 1742–1780) was both a scribe and an illuminator of manuscripts. He did not, however, always perform both tasks in the same manuscripts. An Arabic translation of the Pentateuch in the Patriarchate Library dated AM 1490 (1773/1774) (serial no. 110, Bibl. No. 184), for example, has full-page miniatures by Ibrahim or his workshop, but the scribe is identified as Butrus Sa'ad Nakhla. Atalla 1998b, 143–145.

6 For more on 'Abd al-Sayyid's role as iconographer of the Cave Church program, see Chapter 11 of this volume.

7 De Cesaris 2004, 5–6.

8 De Cesaris 2003, 19.

9 Monastery of St. Paul MS 47 (Lit.). See Gabra, Chapter 5 of this volume, for a full account of this flood.

10 For van Moorsel's discussion of this painting, see van Moorsel 2002, 52–54.

11 Van Moorsel 2000a, 50; van Moorsel 2002, 54; De Cesaris and Luzi 2002, 4.

12 Sicard 1982, 41.

13 I thank Samir Morcos, who has seen such mineral-rich clay in Egypt, for this suggestion.

14 Monastery of St. Paul MS 115 (Hist.), f. 54a–b.

15 Patriarch John XVI donated numerous books to the monastery soon after its repopulation; see Swanson, Chapter 2, and Gabra, Chapter 5, in this volume.

16 On one occasion, the painter added a thin layer of whitewash to the plaster when forming the face of Antony.

17 De Cesaris and Luzi 2002, 6.

18 De Cesaris 2004, 6.

19 For van Moorsel's discussion of these painting, see van Moorsel 2002, 43.

20 Van Moorsel seems to agree with this suggestion; see van Moorsel 2002, 45.

21 Van Moorsel 2002, 43. Gabra, however, found no evidence for his identification of this figure; see Chapter 13 of this volume.

22 Traces of these earlier colors can be seen in the space between the shoulders and halos of the two saints, where the later green pigment has fallen away.

23 The presence of a niche in the west wall caused the painter to modify the position of Gabriel slightly. The hem of his tunic does not conform to the lower guideline used for the other two angels; it is shorter and the feet are placed higher up in order to avoid the niche. The painting of Michael is damaged at the lowest level, but if the monk-painter used the same type of tunic with a horizontal band at the hem (now lost) found on the other archangels, the feet would have aligned with those of Raphael. The three Hebrews are slightly shorter than the archangels, probably in order to avoid overlapping a similar niche. For van Moorsel's discussion of these paintings, see van Moorsel 2002, 54–59.

24 The orbs may be Eucharistic loaves. The crosses drawn on the white circles resemble the impressed centers of typical Coptic loaves, and the

presence of what appears to be napkins to hold the objects also suggests a Eucharistic function. See Bolman and Lyster 2002, 134.

25 The painting of the three Hebrews was damaged during late twentieth-century attempts at conservation, which resulted in severe pigment loss, especially on the two central figures. De Cesaris and Luzi 2002, 18–19. However, the damage revealed that the monk-painter inscribed yellow ovals in which he formed the hands after painting the tunics.

26 A manuscript in the monastic library, MS 49 (Lit.), records the date of the reconstruction and repopulation of St. Paul's as AM 1420 (1703/1704). The following year, John XVI consecrated the monastery and the Cave Church. However, based on the foundation inscription in the narthex, construction of the church was not completed until AM 1429 (1712/1713).

27 See Gabra, Chapter 13 of this volume, for the text and translation of this inscription. See also van Moorsel 2002, 98–102.

28 De Cesaris, personal communication, May, 2002. When working in the dome the monk-painter must have used additional scaffolding, such as the equivalent of a table or a bench, to reach the apex of the dome, which is more than two meters higher than the presumed platform.

29 Nabil Selim Atalla (2000) illustrated a number of decorative compass-drawn medallions in Coptic manuscripts, including three that are identical to the one in the Dome of the Martyrs. Cairo, Coptic Museum Library, serial no. 141, Lit. no. 361, date of original section AH 750 (1349/1350); Atalla 2000, 124. Cairo, Coptic Patriarchate Library, serial no. 691, Lit. no. 21, ca. eighteenth century (two examples); Atalla 2000, 238–239; Anne Boud'hors has published a medallion with the same design as one in the 1715 Psalmody, illustrated in fig. 12.5, from a manuscript dated 1555. Paris, Bibliothèque Nationale, MS orientaux, Copte 144, f. 56v. Boud'hors 2004, 28–29 and back flap.

30 'Abd al-Sayyid's dotted sigma is found in the inscriptions of Iskhirun (A5a), James (A6a), Julius (A8a), and Isidore (A10a).

31 For van Moorsel's discussion of these paintings, see van Moorsel 2002, 99–112.

32 De Cesaris and Luzi 2002, 6.

33 It is interesting to note that the only depiction of a horse, or perhaps a donkey, in the Psalmody of 1715 looks nothing like the spirited creatures in the narthex.

34 For my discussion of these iconographic details, see Chapter 11 of this volume.

35 Van Moorsel 1994, 396.

36 De Cesaris and Luzi 2002, 16. The two stages of the process could indicate that more than one monk was involved, but both inscriptions are clearly in the hand of 'Abd al-Sayyid. Note his use of fourteen dotted sigmas in each one.

37 For van Moorsel's discussion of these paintings, see van Moorsel 2002, 113–116.

38 For Johann Georg's visit to St. Paul's in 1930, see Hamilton, Chapter 4 of this volume.

39 Van Moorsel 2000a, 44.

40 Atalla illustrates three undated manuscripts from the Monastery of St. Paul that feature similar combinations of medallions and inscriptions used as full-page illuminations. Atalla 2000, 161, 166.

41 'Abd al-Sayyid's distinctive sigma is found in the inscriptions identifying Raphael (B3a), Michael (B7a), and Suriel (B14a). For van Moorsel's discussion of these paintings, see van Moorsel 2002, 80–89.

42 De Cesaris observed that the beams were originally placed in two higher positions within the dome, probably serving as a platform for the plastering of the inner shell. As the work was completed, the beams were shifted to a lower level, and the holes were filled in and plastered over. This work was probably executed during the earlier phase of construction between 1703 and 1705 (AM 1420–1421), eight to ten years before the completion of the narthex and the painting of the church in 1712/1713 (AM 1429). De Cesaris 2003, 7.

43 The bodies of Ira'i and the mother beseeching Theodore, both in the narthex, were also drawn without a compass.

44 For van Moorsel's discussion of these paintings, see van Moorsel 2002, 96.

45 The martyrs are named only in Arabic; it is noteworthy that a Coptic version was not provided. The letters are painted black on a red band above Cyriacus but change to red on white above Julitta. Such uncertainty is unusual in the inscriptions of 'Abd al-Sayyid. The Arabic script is also smaller than the upper inscription, and the calligraphy is less accomplished. It is possible that a different epigrapher, who may not have known Coptic, was responsible for these inscriptions.

46 'Abd al-Sayyid did not supply Coptic inscriptions for these four saints, which suggests he was not involved in this stage of the project. He may have produced the current Arabic inscriptions, but only after the change in the iconography caused by the later addition of Antony. These inscriptions and similar ones in the corridor could well be his final contribution to the project. On the other hand, they may have been added by someone else at a later date. For van Moorsel's discussion of these paintings, see van Moorsel 2002, 90–95, 97.

47 Similar simplified hands that nevertheless depict all five fingers are also found on the narrative figure of the mother in the painting of Theodore Stratelates, in the narthex. The same assistant painter could have been responsible for this figure, as well as those of Julitta and Eirene.

48 If an assistant painted the body of Eirene, then there is the possibility that he was also involved in producing the body of Sarapion. Both figures feature the same use of irregular lines that are quite distinct from the more confident and regular lines displayed on Marina and Paul, which I believe are by the monk-painter.

49 For van Moorsel's discussion of these paintings, see van Moorsel 2002, 68–79.

50 De Cesaris noted that there is no evidence of wooden beams having been inserted into the walls to serve as a platform for plastering the dome, as was the case in the northern nave. De Cesaris, personal communication, April 2005.

51 Each elder located in the center of the four squinches, such as Lapdiel, is placed in the hood, but the seat of his throne straddles the two walls of the upper corner so that it forms a right angle. The painter appears to have anticipated this feature, probably from his earlier work in the squinches of the northern nave, and positioned all the thrones exactly at this point, where the four walls of the room make the transition to the octagonal drum.

52 De Cesaris 2004, 6.

53 'Abd al-Sayyid's dotted sigma can be found in the names of Suriel (C2a) and Chresthouel (C4a).

54 A distinction must be made between accidental drips and the painter's conscious use of lines radiating from his figures. The wings of most of his angels, for example, are fringed with yellow lines that were clearly intentional but could be mistaken for paint spills.

55 For van Moorsel's discussion of these paintings, see van Moorsel 2002, 40–46, 118–119.

56 One partial exception is the halo of the Christ child in the central nave, where the painter used a second very small circle to ring the child's head, but the effect is very different from the two larger circles, each a different color, that the painter employed elsewhere in the church.

57 Of course the painter depicted John the Little as shorter than the other figures, and so he had no need to position his image exactly.

58 If I am correct that the monk-painter produced these images at different stages, then the Arabic inscriptions identifying the saints must have been added after all the paintings were completed. As is also the case with Antony in the northern nave, the iconographic program was apparently modified during the course of the

project, but the inscriptions identify the final selection of images. For example, the Arabic text groups together "Anba Apollo and Anba Abib" (F8a, F7a) even though they seem not to have been originally painted as a couple. It is uncertain whether these inscriptions are the work of 'Abd al-Sayyid or another scribe. In either case, they appear to have been inserted as an afterthought.

59 Some of the paintings, however, must have required some kind of platform, although probably nothing more than the equivalent of a worktable.

60 For van Moorsel's discussion of this painting, see van Moorsel 2002, 50–51.

61 For van Moorsel's discussion of this painting, see Moorsel 2002, 62.

62 Paul the Hermit, in contrast, is shown with a full head of hair.

63 For van Moorsel's discussion of this painting, see van Moorsel 2002, 61.

64 Unfortunately, the lower portions of Marqus al-Antuni, Moses the Black, and the desert fathers in the corridor are lost, which makes it impossible to say whether the painter used similar landscape features when depicting these saints.

65 For van Moorsel's discussion of this painting, see van Moorsel 2002, 90–95.

66 De Cesaris 2003, 19.

67 For van Moorsel's discussion of this painting, see van Moorsel 2002, 59–60.

68 Johann Georg, who examined this painting by torchlight, believed it represented Paul the Hermit. He described the saint as wearing long robes and holding a staff. As the eighteenth-century painting of Paul depicts the saint in a short robe and without a staff, Johann Georg must be describing the image of Marqus. See Hamilton, Chapter 4 of this volume. As mentioned above, Johann Georg also dated the equestrian saints in the narthex a hundred years before the other eighteenth-century paintings; see Hamilton, Chapter 4.

69 Notice the presence of two dotted sigmas in the inscription.

70 For my speculation on the iconographic subjects planned for the lower haykal, see Chapter 11 of this volume.

71 *HPEC* III/3: 286.

72 It is possible that the largely unexplored manuscript library at the monastery will in time provide more details of the eighteenth-century monks at St. Paul's.

73 Van Moorsel 2000a, 46.

74 An early nineteenth-century manuscript in the library of the Monastery of St. Paul features miniatures of a number of saints, including the one of Paul the Hermit illustrated as figure 12.44. All are drawn with heads and halos formed by a compass. Three of the illuminated folios are illustrated in Atalla 2000, 155.

75 Many twentieth-century wall paintings in modern Coptic churches are in a quasi-western style, for example, in the Church of St. Mark on Cleopatra Street in Heliopolis. A more distinctive Coptic style was developed and popularized by Isaac Fanous (1919–2007), who produced sacred images in the form of icons, mosaics, and wall paintings. His style appears to be gradually replacing the earlier western-inspired paintings, as, for example, in the new Coptic Cathedral of St. Michael the Archangel in Aswan. For Fanous, see Sadek and Sadek 2000, esp. 71–129, where a number of his wall paintings and wall mosaics are illustrated.

76 Besides painting icons, artists of the second half of the eighteenth-century painted sacred images on the four sides of the wooden boxes that hold eucharistic chalices. This object is known as the throne (*kursi*) of the chalice. An example in the Syrian Monastery painted by Ibrahim al-Nasikh is illustrated in Atalla 1998b, 52–53. Eighteenth-century artists also painted sacred images in the inner domes of ciboria. A ciborium is a free-standing, columned structure surmounted by a cupola that covers the altar. Adeline Jeudy has discussed painted examples by the workshop of Ibrahim and Yuhanna in four churches of Cairo. Jeudy 2004, 70–75. For more on ciboria, see Grossmann 1991a, 202–203.

77 Van Moorsel, Immerzeel, and Langen 1994, 16–18.

78 Van Moorsel 2000a, 46.

79 I am assuming here that neither Murjan nor ʿAbd al-Sayyid was the artist of the project, which is by no means certain.

80 A copy of the four Gospels in Arabic, containing numerous full- and double-paged miniatures, produced in AM 1405 (1688/1689), the twelfth year of John XVI's reign, is another very important surviving example. Cairo, Coptic Museum, serial no. 28, Bibl. no. 99. Illustrated in Skalova 2006b, 130–131; Atalla 2000, 118–123; Atalla 1998b, 152–153.

81 Wansleben, *Histoire de l' Eglise d' Alexandrie* (Paris, 1677), chapter 3, 138–139; Chaillot 1990, 84. The translation from French is by Bolman. Wansleben was in Egypt in 1664 and 1672–1673.

82 It is also possible to understand this passage as referring to Greek-style icons and Coptic wall paintings, but given the absence of such wall paintings from the postmedieval period, I think that Wansleben was describing two types of icons.

83 Immerzeel 1997.

84 Immerzeel 1997, 25.

85 Immerzeel 1997, 24.

86 Meinardus 1967, 311–341; Immerzeel 1997, 28, 124–125. The second issue of *Eastern Christian Art* (2005) features nine articles from the proceedings of a symposium "Proskynetaria: Pilgrim's Souvenirs from the Holy Land (18th–19th Century)" held in Hernen Castle, Netherlands, September 11, 2004.

87 Van Moorsel and Immerzeel 2000, 252; Immerzeel 1997, 28.

88 For a color photograph, see Skalova 2005, 101, pl. 5. There are also two eighteenth-century examples in the Coptic Museum, Cairo (inv. 3396 and 6982). See van Moorsel, Immerzeel, and Langen 1994, 89–93, figs. 1–2, plates K1–K2; van Moorsel and Immerzeel 2000, 252, 206, fig. 2 (for inv. 3396). For John XVI's pilgrimage, see Armanios, Chapter 3 of this volume.

89 Immerzeel 1997, 27–28.

90 A selection of icons in the Monastery of St. Paul, including Coptic, Palestinian, Syrian, Greek, Russian, and western European (the last in the form of oil paintings) are illustrated in Lyster 1999, 72–79.

91 Skalova 2006b, 137; Tribe 2004, 75; van Moorsel, Immerzeel, and Langen 1994, 16.

92 Langen 1990, 66; van Moorsel, Immerzeel, and Langen 1994, 16.

93 The ritual was last performed in 1461; see Armanios, Chapter 3 of this volume. The ceremonial preparation of the mayrun lasts for about ten days. Van Moorsel, Immerzeel, and Langen 1994, 5, 162, n. 4.

94 Langen 1990, 65. Mayrun is believed to contain the Holy Spirit, and one of the reasons for honoring icons, according to the author of the *Order of the Priesthood,* is that they are anointed with the mayrun. Van Moorsel, Immerzeel, and Langen 1994, 5, 162, n. 4.

95 See Chapter 11, n. 62.

96 A large narrative icon of the meeting of Antony and Paul dated 1714 with a dedicatory inscription naming Abu Khazam and his daughter Marium, in the Church of St. Michael and St. John at the Monastery of St. Paul, could be another example of an icon by an early eighteenth-century workshop. Lyster 1999, 72–74. Another possible example is an icon in the Coptic Museum, Cairo (no. 3362) of the Virgin and Christ child with Michael and Gabriel that was apparently produced in the last years of John XVI's reign. Van Moorsel and his associates have read its inscribed date as either AM 1431 or 1434 (1714/1715 or 1717/1718). Van Moorsel, Immerzeel, and Langen 1994, 64–65, pl. E2; Langen 1990, 68–69, pl. 4.2.

97 Atiya 1991d, 1919.

98 For more detailed accounts of John XVII's visit to the Monastery of St. Paul, see Swanson, Chapter 2, and Gabra, Chapter 5, of this volume.

99 Van Moorsel 2000a, 45–46.

100 Van Moorsel and Immerzeel 2000, 255; van Moorsel, Immerzeel, and Langen 1994, 47. The signed icon is illustrated in Skalova 2006b, 135, figs. III. 59–III. 59a.

101 Van Moorsel and Immerzeel 2000, 254–255. At least twelve icons of Mattary in the Wadi al-Natrun and Old Cairo have been published. Coptic Museum: two icons, one depicting Antony and two disciples (inv. 3765), the other the twenty-four elders (inv. 3766,) both originally from the Church of the Virgin al-Damshiriya in Old Cairo, see van Moorsel, Immerzeel, and Langen 1994, pl. 14a (Antony), pl. F1 (elders); van Moorsel and Immerzeel 2000, 262, fig. 4 (Antony); Skalova 2006a, 225, cat. 26 (elders). Monastery of the Syrians, Wadi al-Natrun: two icons, the signed triptych of the four desert fathers, cited in the note above, and one of Tekla Haymanot, see van Moorsel and Immerzeel 2000, 261, fig. 3. Monastery of St. Bishoi, Wadi al-Natrun: triptych of the three Macarii, see Atalla 1998a, 58–59; icon of the three Macarii, see Skalova 2006b, 135, III. 60. Monastery of St. Macarius, Wadi al-Natrun: Crucifixion triptych, see Skalova 2006b, 152, fig. III. 71. Church of St. Barbara, Old Cairo: triptych of John, Cyriacus, Julitta, and Barbara, see Atalla 1998a, 66; Skalova 2006b, 132. Church of St. Mercurius, Monastery of St. Mercurius, Old Cairo: repainted medieval vita icon of Mercurius, see Skalova 2006a, 187–189, cat. 11; icon of the Crucifixion, see Skalova 2006b, 133, III. 55; icon of the three Hebrews, see Skalova 2006b, 133. III. 56; icon of George, see fig. 12.48 in this chapter.

102 Van Moorsel and Immerzeel 2000, 255. The vakkos is worn by each of the twenty-four elders in the icon in the Coptic Museum, and by John the Baptist, who is identified as a "priest, son of a priest" in the icon of the Baptism of Christ above the northern haykal screen in the Church of St. Michael and St. John at the Monastery of St. Paul.

103 The Armenian community of Jerusalem also enjoyed a revival during this same period under Patriarch Grigor the Chainbearer (1715–1749). See Ervine 1995, 102–111.

104 Skalova 2006a, 226–227, cat. 27; Skalova 1990a, 75–76.

105 See in particular Tribe's discussion of narrative figures and inscriptions "that characterize the highly discursive style of the icons produced both by the Yuhanna and Ibrahim workshop and in Greater Syria." Tribe 2004, 79–83.

106 Miniatures of Menas: Monastery of St. Macarius, Coptic-Arabic MS 407, f. 116v, dated 1727; Monastery of the Syrians, Coptic-Arabic MS 295, f. 171r, dated 1727/1728. Both miniatures are illustrated in Skalova 2006b, 134, III. 57 and III. 58.

107 Mattary produced the miniatures of Menas the year before John XVII became patriarch. It seems unlikely that these paintings are the artists' earliest commissions. Van Moorsel and Immerzeel have stated that Mattary was active in Egypt "around the year AD 1700 or so," which seems too early to me by at least twenty years. Van Moorsel and Immerzeel 2000, 254.

108 Motzki 1991, 1274.

109 Ibrahim al-Jawhari was responsible for building or possibly renovating the Church of St. Mercurius at the Monastery of St. Paul in AM 1497 (1780/1781). In the same year he funded the repair of one of the mill rooms at the monastery, and possibly the construction of the other. According to monastic tradition, verified by Peter Sheehan, he also rebuilt portions of the outer walls at the same time.

110 See also Guirguis 2004, 948.

111 MS 117 (Hist.).

112 Icons of Iskhirun by Ibrahim al-Nasikh are illustrated in Atalla 1986b, 58–59 (Church of St. Mercurius, Old Cairo) and 96–97 (Monastery of St. Bishoi, Wadi al-Natrun).

113 Anastasi al-Rum (active ca. 1832–1871) painted an icon of Iskhirun, now in the Church of the Virgin, Harit Zuwayla, which features the bedouin and his camels as narrative elements. Atalla 1986a, 52–53.

CHAPTER THIRTEEN: THE COPTIC AND ARABIC INSCRIPTIONS IN THE CAVE CHURCH

1 Wreszinski 1902, 62–64.

2 Meinardus 1967–1968; Meinardus 1968–1969; Leroy 1978; van Moorsel 2002.

3 MS 368 (Lit.).

4 Some other examples of the distinctive sigma of ʿAbd al-Sayyid al-Mallawani in the eighteenth-century Coptic inscriptions in the Cave Church: George (A3a), Iskhirun of Qalin (A5a), James the Persian (A6a), Julius of Aqfahs (A8a), Isidore (A10a), Raphael (B3a), Michael (B7a), the abbreviated formula framing a medallion (B9a), Marqus al-Antuni (B10a), Suriel (B14a), Suriel (C2a), Chresthouel (C4a).

5 See below, nn. 16, 25, 26, 41.

6 Van Moorsel 2002, 27, 32.

7 Megally 1991b, 1820–1822.

8 Van Moorsel 2002, 27, fig. 7.

9 Du Bourguet 1951, 46, fig. 3.

10 Schweinfurth 1922, 198f; Meinardus 1966, 519f; Kraack 1997, 257, 267f.

11 Meinardus 1966, 515–519; Kraack 1977, 68f, 249–257.

12 Meinardus 1966, 520–524; Kraack, 258–267; see also Griffith 2002, 191f.

13 For this martyr, see Leroy 1978, 328, n. 1; van Moorsel 2002, 111f. See also Samir 1991d; Meinardus 1963–1964, 125.

14 Van Moorsel 2002, 113f.

15 Van Moorsel 2002, 115f.

16 There is no doubt that the phrase "my master the king," which does not appear in any other text accompanying or identifying the depiction of St. George, has been taken from the psalmody; see al-Muharraqi 1960, 73. There is no critical study on the history of the Coptic psalmody; see Ishaq 1991b; Awad 2004.

17 The Coptic "Abba" means father in Aramaic; its translation into Arabic is "Anba," see Graf 1954, 14. "Anba" is widely used today, and certainly in the eighteenth century, as a title of patriarchs and bishops, and saints as well.

18 Coptic notables (arakhina) played an important role in the development of the Coptic Church during the eighteenth century; see Guirguis 2000.

19 For similar traditional donation formulae, see Pearson 2002, 218.

20 Van Moorsel 2002, 109f.

21 Van Moorsel 2002, 103.

22 Van Moorsel 2002, 105.

23 Van Moorsel 2002, 106.

24 Van Moorsel 2002, 107.

25 Iraʾi is no doubt depicted here because she and her brother Abadir are venerated together in the psalmody; see al-Muharraqi 1960, 75f. It is noteworthy that the whole program of wall paintings at the Monastery of St. Antony (1232/1233) does not include any female saints except the Virgin Mary; see Bolman 2002e.

26 Van Moorsel 2002, 108. In the psalmody, Isidore and Bandalawn (Coptic: Panteleon) are commemorated together. Al-Muharraqi 1960, 77. For Pantaleon, see Orlandi 1991c. It is noteworthy that all the abovementioned martyrs are commemorated together in the psalmody's section entitled al-Majmaʿ (collective litany prayer); see al-Muharraqi 1960, 73–77.

27 Van Moorsel 2002, 96.

28 Van Moorsel 2002, 96.

29 Van Moorsel 2002, 87.

30 The reason for placing this Arabic text next to Sarapion is unknown. Van Moorsel 2002, 92. Although al-dala (familiarity) occurs many times in Bustan al-ruhban (The garden of the monks), which is widely used by Coptic monks, it does not occur in a text attributed to Sarapion. For usages of al-dala in Bustan al-ruhban, see Anonymous 1968, 14, 209,210, 237.

31 Van Moorsel 2002, 92.

32 Van Moorsel 2002, 92.

33 Van Moorsel 2002, 84.

34 Cf. Psalms 24: 7–9 (LXX Psalms 23: 7–9).

35 Van Moorsel 2002, 65.

36 Van Moorsel 2002, 59.

37 Van Moorsel 2002, 84.

38 Van Moorsel 2002, 97.

39 Van Moorsel 2002, 97.

40 Van Moorsel 2002, 87.

41 Meinardus 1968–1969, esp. 153f; Leroy 1978, 333f; van Moorsel 2002, 63–79, esp. 73f. It is interesting to note that the northern nave is dedicated to the four archangels Michael, Gabriel, Raphael, and Suriel. The adjacent Haykal of the Twenty-Four Elders features paintings of Christ in Majesty with the four living creatures of the Apocalypse and seven archangels. The painted program is based on the text of the psalmody, in which the doxologies of the archangels are followed by the doxologies of the four creatures and the twenty-four elders, and the seven archangels praising the Pantocrator, serving the hidden mystery; see al-Muharraqi 1960, 336–351.

42 Van Moorsel 2002, 56.

43 Van Moorsel 2002, 57; al-Muharraqi 1960, 57–69. See also Muyser 1953.

44 Cf. Psalm 24:7–9 (LXX Psalm 23: 7–9).

45 Cf. Psalm 43:4 (LXX Psalm 42:4).

46 Cf. Psalm 5:8 (LXX Psalm 5:7).

47 Cf. Luke 1:28.

48 Cf. Luke 1:35.

49 Van Moorsel 2002, 38.

50 Van Moorsel 2002, 38f.

51 Van Moorsel 2002, 51.

52 Van Moorsel 2002, 54.

53 Van Moorsel 2002, 24f.

54 Van Moorsel 2002, 23.

55 Cf. Horner 1969: Luke 1:28, 38; van Moorsel 2002, 23.

56 Van Moorsel 2002, 23.

57 See my introduction for Van Moorsel's reading of this date as AM 1050 (1333/1334).

58 Van Moorsel 2002, 43.

59 Van Moorsel 2002, 118.

60 Van Moorsel 2002, 119.

61 Van Moorsel 2002, 119. The Arabic text links F8a and F7a: "Anba Apollo and Anba Abib."

62 Van Moorsel 2002, 119.

63 Van Moorsel 2002, 40.

64 Arsenius is held to have been the tutor of the sons of Emperor Theodosius. See Regnault 1991b. See also F6a.

65 Van Moorsel 2002, 40.

66 Van Moorsel 2002, 43.

67 The name "Moush" (Moses) is written without the last letter. Cf. Anonymous 1960, 267.

68 Cf. van Moorsel 2002, 40, fig 15; 41, fig. 16; 43 nn. 59–60.

69 The Coptic mmisi is an "artificial" translation of the Arabic ميلادية (year of the Christian era).

CONCLUSION

1 *VP* 1; White 1998d, 75.

2 Wilkinson 2002, 149.

3 Evetts 1895, 166–167.

4 Al-Maqrizi in Evetts 1895, 307.

5 *SV* 266–269; Browne 1975, 62–63.

6 *SV* 263; Browne 1975, 62.

7 *VH* 30; Fremantle 1989b, 311.

8 Lewis 1904, 748.

9 Piankoff 1943, 66.

10 Van Moorsel 1994, 396.

11 The "Hidden Mystery" is the alternative translation of the title *al-Sirr al-maktum,* published by the Monastery of St. Paul in 2004. Cited by Swanson in Chapter 2 of this volume.

12 The most recent is a four-lane highway between Cairo and 'Ayn Sukhna, completed in 2005.

13 For the numerical increase of Coptic monks in eleven major monasteries between 1960 and 1986, see Meinardus 1992, x.

14 See Oram 2002, 203–213.

15 Van Moorsel 1995, 283–285.

16 Little 1976, 553.

17 Van Moorsel 2000a, 46.

18 Monastery of St. Paul, MS 115 (Hist.), f. 16b.

19 In particular, see Hathaway 1997, 1998, 2003; Crecelius 1981, 1998.

20 Hathaway 1997.

21 Sicard 1982, 41.

22 Whittemore expedition photograph B198. Dumbarton Oaks, Byzantine Photograph and Fieldwork Archives, Washington, D.C.

23 My thanks to Father Tomas al-Anba Bula for helping me locate this manuscript, and to Father Yuhanna al-Anba Bula for generously allowing me to photograph the miniatures.

24 Father Yuhanna al-Anba Bula observed that the Psalmody of 'Abd al-Sayyid al-Mallawani was well known among the monastic community, but the miniatures had not been associated with the paintings in the Cave Church. The photograph at Dumbarton Oaks (B198), however, suggests that the Whittemore team may have made the connection in 1930–1931. By not publishing the information, the possible association was forgotten.

25 Lyster 1999, 46–47.

26 Guirguis, 2004.

27 This is how Ibrahim al-Nasikh described the Cave Church in his account of John XVII's visit in 1732. From MS 117 (Hist.) at the Monastery of St. Paul.

28 Van Moorsel, Immerzeel, and Langen 1994, 16.

29 Van Moorsel, Immerzeel, and Langen 1994, 47.

30 Skalova 2006b, 137; Tribe 2004, 75; van Moorsel, Immerzeel, and Langen 1994, 16.

31 Chadwick 1968, 5. Cited by Harmless 2004, 105.

32 Kelly 1975, 60.

33 McBrien 2001, 76–77.

34 Kelly 1975, 60.

35 Rutilius Namatianus, *De red. suo* 1: 515–526. Cited in Kelly 1975, 104 n. 2.

36 Sicard 1982, 41.

37 Piankoff 1943, 66.

38 Piankoff et al. 1930–1940, 1.

Glossary

Abba (Coptic from Aramaic, *apa*, "father"): Title of respect given to senior Coptic monks.

Abu (Arabic, "father"): Used as a type of Arabic name, known as a *kunya*, composed of "father of" combined with either the name of the man's son (e.g., father of Joseph), or something he is supposedly endowed with or possesses (e.g., father of gold).

Abuna (Arabic, "our father"): Title of respect given to Coptic monks.

*Agha (*Turkish, "commander"*)*: Commanding officer of an Ottoman regiment.

AH (anno hijirae): Muslim lunar calendar with 354 days per year, known as the "era of the Hijra," which began with the prophet Muhammad's migration (*hijra*) from Mecca to Medina on July 16, 622.

AM (anno martyrorum): Coptic solar calendar with 365 days per year, known as the "era of the Martyrs," which began on August 29, 284, the (approximate) date of the accession of the Roman emperor Diocletian, who inaugurated the Great Persecution of 303–313.

Amir (Arabic, "commander" or "prince"): Muslim political-military rank beneath that of sultan, which is often equated with the Ottoman Turkish rank of bey.

Amir al-hajj (Arabic): Leader of the annual Muslim pilgrimage (*hajj*) to Mecca and Medina.

Analabos (Greek): Harness of leather bands worn by senior monks signifying bearing the Cross.

Anba (Arabic): Title of respect given to saints, patriarchs, and bishops.

Apophthegmata Patrum (Greek, "sayings of the fathers"): Collection of sayings and anecdotes of the early desert fathers of Egypt, probably written in the late fifth century. There are two basic forms: the Alphabetical Collection (sayings of individual monks, whose names are arranged alphabetically) and the Systematic Collection (sayings arranged thematically).

Archon (Arabic, *arkhun*, pl. *arakhina*, via Greek, *archon*, a high magistrate): Title of respect given to influential Coptic notables in Muslim Egypt.

Awlad al-ʿAssal (Arabic, "the sons of ʿAssal"): Four brothers who played a prominent role in the cultural flowering of Coptic culture in the first half of the thirteenth century. One was a wealthy civil servant, the other three scholars of note.

Ayyubid Sultanate: Muslim dynasty founded by Salah ad-Din al-Ayyubi (Saladin) that ruled Egypt between 1171 and 1250.

ʿAzab (pl. *ʿAzaban*; Arabic, "bachelor"): Ottoman infantry regiment stationed in Egypt, second in size to the Janissaries.

Battitura di filo (Italian, "thread imprint"): Painting technique whereby a string covered in soot is stretched across a wall, thereby leaving a black line that is then used as a guide by the painter.

Bey (Turkish, "lord"): In the Ottoman administrative and military system, a rank between pasha and effendi. In Ottoman Egypt, one of a group of grandees who governed the country's major subprovinces or held important positions, such as being the amir al-hajj.

Beylicate (from Turkish, *beylik*, denoting the post of a bey): Pertaining to the military and administrative authority of the beys, who dominated Ottoman Egypt in the seventeenth and eighteenth centuries.

Birka (Arabic): Pond.

Chalcedon, Council of: Ecumenical council held in 451 that deposed Dioscorus, patriarch of Alexandria, and acknowledged Christ "in two natures," eventually resulting in a schism between what would become the Greek Orthodox and Roman Catholic Churches, on the one hand, and the Coptic and Syrian Orthodox Churches, on the other.

Chiton (Greek): Classical and Byzantine tunic usually worn by Old Testament figures, as well as Christ and the apostles, in Christian art.

Clipeus (Latin): Roman patrician families sometimes painted ancestral portraits on round shields (*imago clipeata*), a practice adopted by Christians, who used the form to depict busts of Christ.

Copt ("Egyptian," from Greek *aigyptios*, via Arabic *qibt*): Member of the Orthodox Church of Egypt.

Dar al-Islam (Arabic): "Realm of Islam" or the Islamic world.

Dayr (Arabic): Monastery.

Dhimmi (Arabic, "protected"): Member of an earlier revealed religion, primarily Judaism and Christianity, living within the Dar al-Islam, whose community was granted protection and certain rights within Muslim society as members of a monotheistic faith prior to Islam.

Difnar (Arabic from Greek, *antiphonarion*): Liturgical book containing hymns for the whole year commemorating the saints associated with each day of the month.

Diksar (Coptic): Magazine, larder, or storage area.

Dinar (Arabic from Latin, *denarius*): Gold coin with a standard weight of 4.23 grams.

Dirham (Arabic from Greek, *drachme*): Silver coin of varying purity. Thirteen full silver dirhams (or 30 to 40 dirhams of a lower silver content) equaled the value of a dinar.

Diwan (Arabic): Administrative council or bureau.

Diwan al-Ruzname (Turco-Arabic): Principal Ottoman administrative bureau of the Egyptian treasury.

Doxology (Greek, from *doxa*, "glory"): Liturgical formula of praise.

Effendi (Turkish): Lowest rank in the Ottoman administrative hierarchy usually denoting a scribal function.

Encomium (Greek): Hagiographic text praising a saint or martyr.

Epakt numbers (Greek, "borrowed"): Coptic numerical system adopted from the Greeks, whereby letters of the Copto-Greek alphabet are given numerical value. By the medieval period, a more cursive version had been developed, in which the symbols often had little resemblance to the original letters.

Fatimid Caliphate: Shi'i Muslim dynasty that ruled Egypt between 969 and 1171.

Fatuli (uncertain origin): Rope lift, powered by a windlass, used as a security precaution in pre-modern Coptic monasteries as the only means of entry into the monastic compounds.

Fatwa (Arabic): Opinion on Islamic law rendered by a Muslim legal scholar.

Firman (Turkish): Ottoman imperial order or decree giving specific instructions or granting special privileges to the individual or group to whom it was sent.

Florilegium (Latin, literally "gathering flowers"): Compilation of texts from earlier theological authorities.

Gebel (or *Jabal*): Arabic for "mountain" or, less formally, "rock."

Hajj (Arabic): Muslim pilgrimage to Mecca.

Harat al-Rum (Arabic, "district of the Greeks"): Despite its name, an important Coptic quarter in Cairo that became the residence of the patriarch in the late seventeenth century.

Haykal (Arabic): Sanctuary of a Coptic church.

Haykal screen: Wooden screen separating the nave or khurus from the sanctuary, serving a similar function as a templon or iconostasis.

Hegumenos (Greek): Superior or abbot of a monastery.

Himation (Greek): Mantle draped over the left shoulder, used in Christian art when depicting people dressed in antique grab, such as Christ or the prophets.

Household (derived from *bayt*, Arabic for "house"): Military faction in Mamluk and Ottoman Egypt defined by a configuration of military, political, and administrative power united by a common allegiance to a single leader, and usually centered in his place of residence.

Ibn (Arabic, "son"): Often used as part of a man's name, such as Ibrahim ibn Sim'an (Ibrahim the son of Sim'an).

Iltizam (Arabic): "Tax farm," whether in the form of agricultural land, urban real estate, or an economic activity.

Jacobite: Popular name used for the Orthodox Church of Syria, derived from Jacob Baradaeus, bishop of Edessa (ca. 543–578), an opponent of the Council of Chalcedon and ally of the Coptic patriarch.

Jalfi: Military faction in eighteenth-century Egypt that emerged within the 'Azab regiment.

Janissary (Turkish, *yenitcheri*, "new troops"): Largest and most powerful of the Ottoman regiments stationed in Egypt.

Jarid (Arabic): Palm frond ribs.

Jizya (Arabic): Tax imposed on non-Muslims.

Kabir al-mubashirin (Arabic, "eldest/greatest of the mubashirs"): Head of the financial bureau of a government department or a military household in Ottoman Egypt.

Katib (Arabic): Scribe.

Katkhuda (Farsi, "steward"): Ottoman military officer, technically second in command to the agha but often holding the real authority in a regiment.

Keep: Fortified tower used as a place of refuge in Coptic monasteries.

Khurus (Greek, "choir"): A transitional room in Coptic churches, located between the nave and sanctuary that is reserved for priests.

Logos (Greek): Word of God or the second person of the Trinity.

Loros (Greek): Stole about five meters long, often studded with precious stones, worn by the Byzantine emperor and empress, as well as by angels in Byzantine art.

Mahbasa (Arabic): Hermitage.

Malikane (Turkish): Hereditary tax farm introduced throughout the Ottoman empire at the beginning of the eighteenth century.

Mamluk (Arabic, "possessed"): Military slave, ultimately manumitted and often entrusted with great authority.

Mamluk Sultanate: Two Muslim dynasties of slave-soldiers that ruled Egypt between 1250 and 1517. The Bahri ("River") Mamluks (1250–1382) were predominately Turkish, their successors were Circassians (1382–1517).

Mandorla (Greek): Almond-shaped halo encompassing the figure of Christ in Christian art.

Maphorion (Greek): Shawl worn over the head and upper body.

Maronite (from St. Maron, a fourth- or fifth-century hermit): Eastern church in alliance with Rome centered primarily in Lebanon.

Mashrabiyya (Arabic): Wooden lattice-work grill primarily used to cover windows.

Mastaba (Arabic): Rectangular bench-like structure, usually made of brick.

Mayrun (Arabic from Greek, *myron*): Sacred oil used in anointing and in ceremonies of consecration in the Coptic church.

Melkite (from Syriac/Arabic, literally "royalist"): Eastern orthodox Christians loyal to the Council of Chalcedon.

Menologion (Greek): Litugical book of hagiographic texts for the feasts of the daily sanctoral cycle.

Mu'allaqa (Arabic, "suspended" or "hanging"): The popular name of a famous church of the Virgin in Old Cairo, so called because it is constructed spanning the tops of two towers of the Roman fortress of Babylon.

Mu'allim (Arabic, "teacher" or "elder"): Polite title often bestowed on leading Christians and Jews in Muslim Egypt.

Mubashir (pl. *mubashirun*; Arabic): Privy secretary; financial agent; accountant.

Muhasiba (Arabic): Accounting department of the Egyptian treasury.

Multazim (Arabic): Holder of a tax farm (*iltizam*).

Musalima (Arabic): Medieval Christian officials who had (at least) nominally converted to Islam.

Mustahfazan (Turkish from Arabic, *mustahfiz,* "guardian"): Popular name of the Janissaries stationed in Egypt.

Nazir (Arabic): In a Christian context, a secular "supervisor" of a church or monastery responsible for its physical maintenance.

Orans (also *orant;* Latin, "prayer"): Name given to the position of early Christian prayer: standing with upraised hands.

Ottoman Sultanate: Muslim Turkish empire (ca. 1281–1924) that ruled Egypt officially from 1517 to 1914. In the eighteenth and nineteenth centuries, however, de facto control of the Nile valley passed to local grandees, most notably the dynasty of Muhammad ʿAli Pasha (1805–1953) and foreign occupiers, in particular the British (1882–1956).

Pasha (Turkish): Highest nonroyal military-administrative rank in the Ottoman empire granted to provincial governors and other important officials.

Psalmody (Greek): A choir book containing the hymns to be sung in preparation for the liturgy.

Qazdaghli: Military faction in eighteenth-century Egypt that emerged within the Janissary regiment and eventually gained control of the beylicate.

Raʾis al-arakhina (Arabic, "head of the archons"): Semi-official title given to the leading Coptic notable in eighteenth-century Egypt.

Raʾis al-kuttab (Arabic, "head of the scribes"): Head of the scribal bureau of a government department or a military household in Ottoman Egypt.

Rhipidion (pl. *rhipidia*; Greek): Liturgical fan.

Rif: Arabic term for rural cultivated areas.

Scetis: Ancient name for the Wadi al-Natrun.

Schema (Greek): Traditional Coptic monastic costume, also called the "angelic dress."

Shaduf (Arabic): Egyptian device with a counterpoised beam used to raise water.

Soffit: Undersurface of an arch.

Spandrel: Triangular area on either side of the hood of a niche or between two adjacent arches.

Squinch: Arch built across each corner of a square room in order to form a hexagonal support for a superstructure, such as a dome.

Synaxarion (Greek): Liturgical book containing brief hagiographical texts about the saints, arranged according to their feast days in the church calendar.

Tafl (Arabic, "potters' clay"): Clay mixed with debris from the desert that is washed down from higher ground during flash floods. It can form thick deposits ideal for carving caves or making bricks.

Templon (Greek): Screen or barrier separating the nave from the sanctuary. Most early medieval examples are of marble, but in the post-Byzantine period carved wooden templa gained in popularity. Such a wooden templon is usually called an iconostasis.

Theotokos (Greek, "God-bearing"): Title of the Virgin Mary.

Tratteggio (Italian, "outline with dotted lines"): Conservation technique whereby the restored portion of a damaged painting is distinguished from the original by the addition of faint parallel lines.

Wadi (Arabic): Valley; more precisely, a watercourse in the desert, dry except after occasional rain storms.

Wadi al-Natrun: Desert depression between Cairo and Alexandria. Known as Scetis in late antiquity, it was an early monastic center, and remains one today.

Waqf (pl. *awqaf;* Arabic): A pious endowment given in perpetuity to support a religious or charitable institution. A waft could be any donation of value, ranging from a book to large agricultural estates.

Bibliography

Abd El-Shaheed, Samiha. 1993. "Epact Numerals." In
 Johnson 1993, 13–19.

Abd El-Shaheed, Samiha. "Copyists and the Copying
 of Manuscripts in the Coptic Church, 13th–18th
 Century." *BSAC* 44: 81–84.

Abu Al-Izz, M. S. 1971. *Landforms of Egypt.* Cairo: Ameri-
 can University in Cairo Press.

Abuliff, Wadi. *See* Wadi Abuliff

Alcock, Anthony. 1991. "Samu'il of Qalamun, Saint."
 CE 7: 2092–2093.

Allen, Graham. 2000. *Intertextuality.* London: Routledge.

Amélineau, Emile. 1894 "Monuments pour server
 à l'histoire de l'Egypte chrétienne: Histoire des
 monastères de la Basse-Egypt." *Annales du Musée
 Guiment* 25: 1–14. Paris: Ernest Leroux.

Anonymous. 1960. *Al-Qudasat al-thalathah* (The three
 anaphoras). Cairo: Jamaʿiyya Abnaʾ al-Kanisa al-
 Urthudhuksiyya.

Anonymous. 1968. *Bustan al-ruhban* (The garden of the
 monks). Cairo: Dar al-ʿAlam al-ʿArabi.

Anonymous Monk of Dayr al-Baramus. 2002. *Hikayat
 rahib fi l-qallaya al-mujawara: Sirat Tadurus al-Anba
 Bula al-habis bi-Dayr al-Baramus* (Story of a monk in
 the cell next door: The life of Tadurus al-Anba Bula,
 the hermit at Dayr al-Baramus). Cairo: Dar al-Jil.

Anonymous. 2005. *Tayf malak* (An apparition of an
 angel). Cairo: Coptic Orthodox Diocese of Ireland,
 Scotland, and N.E. of England, and the Monastery
 of St. Paul.

Antliff, Mark, and Patricia Leighten. 2003. "Primitive."
 In Nelson and Shiff 2003, 217–233.

Armanios, Febe. 2003. "Coptic Christians in Ottoman
 Egypt: Religious Worldview and Communal Beliefs."
 Ph.D. diss., Ohio State University.

L'Art copte. 1964. Catalogue of the exhibition in the Petit
 Palais, Paris, June 17–September 15. Paris: Ministère
 d'Etat, Affaires Culturelles.

Atalla, Nabil Selim. N.d. *Coptic Art.* Vol. I: *Wall Paintings.*
 Cairo: Lehnert and Landrock.

Atalla, Nabil Selim. 1986a. *Coptic Egypt.* Cairo: Lehnert
 and Landrock.

Atalla, Nabil Selim. 1986b. *Coptic Icons.* Cairo: Lehnert
 and Landrock.

Atalla, Nabil Selim. 1998a. *Coptic Icons I.* Cairo: Lehnert
 and Landrock.

Atalla, Nabil Selim.1998b. *Coptic Icons II.* Cairo: Lehnert
 and Landrock.

Atalla, Nabil Selim. 2000. *Illustrations from Coptic Manu-
 scripts.* Cairo: Lehnert and Landrock.

Atil, Esin. 1981. *Kalila wa Dimna: Fables from a Four-
 teenth-Century Arab Manuscript.* Washington, D.C.:
 Smithsonian Institution.

Atiya, Aziz S. 1991a. "Abu al-Makarim." *CE* 1: 23.

Atiya, Aziz S. 1991b. "John XVII." *CE* 4: 1348–1350.

Atiya, Aziz S. 1991c. "Literature, Copto-Arabic." *CE* 5:
 1460–1467.

Atiya, Aziz S. 1991d. "Patriarchs, Dates and Succession
 of." *CE* 6: 1913–1920.

Atiya, Aziz S. 1991e. "Synaxarion, Copto-Arabic: The List
 of Saints." *CE* 7: 2173–2190.

Atiya, Aziz S., Yassa Abd al-Masih, and Oswald H. E.
 Khs-Burmester, trans. and annot. 1948. *History of the
 Patriarchs of the Egyptian Church, Known as the His-
 tory of the Holy Church.* Vol. 2, part 2: *Kayʿil-Shenute
 II AD 880–1066.* Cairo: SAC/IFAO.

Atiya, Aziz S., Yassa Abd al-Masih, and Oswald H. E.
 Khs-Burmester, trans. and annot. 1959. *History of the
 Patriarchs of the Egyptian Church, Known as the His-*

tory of the Holy Church. Vol. 2, part 3: *Chistodoulus—Michael (AD 1046–1102).* Cairo: SAC/IFAO.

Awad, Magdi. 2004. "Untersuchungen zur koptischen Psalmodie: Christologische und liturgische Aspekte." Ph.D. diss., Martin-Luther University, Halle.

Baedeker, Karl. 1877. *Aegypten: Handbuch für Reisende.* Leipzig: Karl Baedeker.

Bagnall, Roger S., ed. 2007. *Egypt in the Byzantine World, 300–700.* Cambridge: Cambridge University Press.

Barsoumian, Hagop. 1982. "The Dual Role of the Armenian Amira Class Within the Ottoman Government and the Armenian Millet (1750–1850)." In Braude and Lewis 1982, 171–184.

Bartelink, G. J. M., ed. 1994. *Vita Antonii.* Sources chrétiennes 400. Paris: Cerf.

Barthes, Roland. 1977. *Image-Music-Text.* London: Fontana.

Barthes, Roland. 1981. "Theory of the Text." In Young 1981, 31–47.

Bartra, Roger. 1994. *Wild Men in the Looking Glass: The Mythic Origins of European Otherness.* Ann Arbor: University of Michigan Press.

Basset, René, trans. and annot. 1915. *Le synaxaire arabe Jacobite (rédaction copte).* Vol. 3. Paris: Firmin–Didot.

Bauer, Iso. 1996. "Das sächsische Königshaus und die Ostkirchen: Die Prinzen Johann Georg (1869–1938) und Max (1870–1951) als Forscher, Sammler und Schriftsteller." *Oriens Christianus* 80: 201–227.

Beaugé, Charles. 1923. *A travers la Haute-Egypte: Vingt ans de souvenirs.* Alençon: Imprimerie Alençonnaise.

Bedjan, Paulus, ed. 1895. *Acta martyrum et sanctorum.* Vol. 5. Paris: Otto Harrassowitz.

Behrens-Abouseif, Doris. 1985. *Azbakiyya and Its Environs: From Azbak to Ismail, 1476–1879.* Cairo: IFAO.

Behrens-Abouseif, Doris. 1994. *Egypt's Adjustment to Ottoman Rule: Institutions, Waqf and Architecture in Cairo (16th and 17th Centuries).* Leiden: Brill.

Belting, Hans. 1994. *Likeness and Presence: A History of the Image Before the Era of Art.* Chicago: University of Chicago Press.

Belting-Ihm, Christa. 1992. *Die Programme der christlichen Apsismalerei: Vom vierten Jahrhundert bis zur Mitte des achten Jahrhunderts.* Stuttgart: Franz Steiner.

Benedictines of Solesmes, eds. 1910. *Plerosque nimirum: Boninus Mombritius. Sanctuarium seu vitae sanctorum.* 2 vols. Paris: Albertum Fontemoing.

Berger, Catherine, Gisèle Cleric, and Nicolas Grimal. 1994. *Hommages à Jean Leclant.* Cairo: IFAO.

Bidez, Joseph. 1900. *Deux versions grecques inédites de la "Vie de Paul de Thèbes."* Gand: H. Engelcke.

Bierman, Irene A. 1998. *Writing Signs: The Fatimid Public Text.* Berkeley: University of California Press.

Bilaniuk, Petro B. T. 1991. "Coptic Relations with Rome." *CE* 2: 609–611.

Bircher, Alfred G., and Warda H. Bircher. 2000. *Encyclopedia of Fruit Trees and Edible Flowering Plants in Egypt and the Subtropics.* Cairo: American University in Cairo Press.

Blanch, Santiago Alcolea. 2002. *The Prado Museum.* Barcelona: Ediciones Polígrafa.

Bolman, Elizabeth S. 1998. "*Mimesis,* Metamorphosis and Representation in Coptic Monastic Cells." *Bulletin of the American Society of Papyrologists* 35: 65–77.

Bolman, Elizabeth S. 2001. "Joining the Community of the Saints: Monastic Paintings and Ascetic Practice in Early Christian Egypt." In McNally 2001, 41–56.

Bolman, Elizabeth S., ed. 2002. *Monastic Visions: Wall Paintings in the Monastery of St. Antony at the Red Sea.* New Haven: Yale University Press.

Bolman, Elizabeth S. 2002a. "Conclusion." In Bolman 2002, 241–248.

Bolman, Elizabeth S. 2002b. "Introduction." In Bolman 2002, xiii–xxvii.

Bolman, Elizabeth S. 2002c. "Theodore's Program in Context." In Bolman 2002, 91–102.

Bolman, Elizabeth S. 2002d. "Theodore's Style, the Art of Christian Egypt, and Beyond." In Bolman 2002, 77–89.

Bolman, Elizabeth S. 2002e. "Theodore, 'The Writer of Life,' and the Program of 1232/1233." In Bolman 2002, 37–76.

Bolman, Elizabeth S. 2004a. "Chromatic Brilliance at the Red Monastery Church." *BARCE* 186: 1, 3–9.

Bolman, Elizabeth S. 2004b. "Scetis at the Red Sea: Depictions of Monastic Genealogy in the Monastery of St. Antony." *Coptica* 3: 1–9.

Bolman, Elizabeth S. 2006a. "The Newly Discovered Paintings in Abu Serga, Babylon, Old Cairo: The *Logos* Made Visible." *BARCE* 190: 14–17.

Bolman, Elizabeth S. 2006b. "Veiling Sanctity in Christian Egypt: Visual and Spatial Solutions." In Gerstel 2006, 73–104.

Bolman, Elizabeth S. 2007. "Depicting the Kingdom of Heaven: Paintings and Monastic Practice in Early Byzantine Egypt." In Bagnall 2007, 408–433.

Bolman, Elizabeth S., and William Lyster. 2002. "The Khurus Vault, an Eastern Mediterranean Synthesis." In Bolman 2002, 126–154.

Bolshakoff, Serge. 1943. *The Foreign Missions of the Russian Orthodox Church*. London: SPCK.

Boud'hors, Anne, ed. 2004. *Pages chrétiennes d'Egypte: Les manuscripts des Coptes*. Paris: Bibliothèque Nationale.

Boud'hors, Anne, Jean Gascou, and Denyse Vaillancourt, eds. 2006. *Etudes Coptes 9: onzième journée d'études*. Leuven: Peeters.

Brakke, David. 1998. *Athanasius and Asceticism*. Baltimore: Johns Hopkins University Press.

Braude, Benjamin, and Bernard Lewis, eds. 1982. *Christians and Jews in the Ottoman Empire*. Vol. 1. New York: Holmes and Meier.

Brodskaïa, Natalia. 2000. *Naïve Art*. New York: Parkstone.

Brown, Jonathan. 2002. "Velázquez and Italy." In Stratton-Pruitt 2002, 40.

Brown, S. Kent. 1981. "Microfilming." *Bulletin d'Arabe Chrétien* 5: 79–86.

Browne, Roland A., trans. 1975. *The Holy Jerusalem Voyage of Ogier VIII, Seigneur d'Anglure*. Gainesville: University Presses of Florida.

Budge, Ernest A. Wallis, trans. and ed. 1909. *Texts Relating to Saint Mena of Egypt and Canons of Nicea in a Nubian Dialect*. London: British Museum.

Budge, Ernest A. Wallis, trans. and ed. 1915. *Miscellaneous Coptic Texts in the Dialect of Upper Egypt*. London: British Museum.

Budge, Ernest A. Wallis, trans. and ed. 1928. *The Book of the Saints of the Ethiopian Church*. 4 vols. Cambridge: Cambridge University Press.

Budge, Ernest A. Wallis, trans. and ed. 2002. Reprint of the 1907 ed. *The Sayings and Stories of the Christian Fathers of Egypt: The Paradise of the Holy Fathers*. 2 vols. London: Kegan Paul.

Buren, Albert William van. 1970. "Lupercalia." In Hammond and Scullard 1970, 626.

Burkhard, Arthur. 1934. "The Isenheim Altar." *Speculum* 9: 56–69.

Burton-Christie, Douglas 1999. "The Place of the Heart: Geography and Spirituality in *The Life of Antony*." In Luckman and Kulzer 1999, 45–65.

Butler, Alfred J. 1884. *The Ancient Coptic Churches of Egypt*. 2 vols. Oxford: Clarendon.

Cameron, Alan. 1968. "Echoes of Virgil in St. Jerome's *Life of St. Hilarion*." *Classical Philology* 63: 55–56.

Cameron, Averil, and Stuart G. Hall. 1999. *Eusebius: Life of Constantine. Introduction, Translation, and Commentary*. Oxford: Oxford University Press.

Capuani, Massimo. 2002. *Christian Egypt: Coptic Art and Monuments Through Two Millennia*. Cairo: American University in Cairo Press.

Carr, Annemarie Weyl. 1997. "The Four Gospels." Catalogue entry no. 251 in Evans and Wixom 1997, 380–381.

Carr, Annemarie Weyl. 2002. "Icons and the Object of Pilgrimage in Middle Byzantine Constantinople." *Dumbarton Oaks Papers* 56: 75–92.

Carr, Annemarie Weyl, and Alexander Kazhdan. 1991. "Nimbus." *ODB* 3: 1487.

Carré, Jean-Marie. 1956. *Voyageurs et écrivains français en Egypte*. 2 vols. Cairo: IFAO.

Carter, James Finn. 2004. "The Inshape of Inscape." *Victorian Poetry* 42, no. 2: 195–200.

Casey, Robert P. 1935. "Der dem Athanasius zugeschriebene Traktat PERI PARTHENIAS." *Sitzungsberichte der Preussischen Akademie der Wissenschaften* 33: 1026–1045.

Cassidy, Brendan, ed. 1992. *The Ruthwell Cross*. Princeton: Princeton University Department of Art and Archaeology.

Cassidy, Brendan, ed. 1993. *Iconography at the Crossroads*. Princeton: Princeton University Department of Art and Archaeology.

Chadwick, Owen. 1968. *John Cassian*. Cambridge: Cambridge University Press.

Chaillot, Christine. 1990. "L'Icône, sa vénération, son usage d'après des récits de Wansleben au XVIIe siècle." *Le Monde Copte* 18: 81–88.

Chester, Greville J. 1873. "Notes on the Coptic Dayrs of the Wadi Natrun and on Dayr Antonios in the Eastern Desert." *Archaeological Journal* 30, no. 18: 105–116.

Clark, Elizabeth. 1992. "Elite Networks and Heresy Associations: Toward a Social Description of the Origenist Controversy." *Semeia* 56, no. 1: 79–117.

Clarke, Martin L. 1971. *Higher Education in the Ancient World*. London: Routledge and Kegan Paul.

Clédat, Jean. 1904. *Le monastère et la nécropole de Baouît* MIFAO t.12. Cairo: IFAO.

Clédat, Jean. 1999. *Le monastère et la nécropole de Baouît*. Ed. Dominique Bénazeth and Marie-Hélène Rutschowskaya. MIFAO t.114 Cairo: IFAO.

Clogg, Richard. 1982. "The Greek Millet in the Ottoman Empire." In Braude and Lewis 1982, 185–207.

Cody, Aelred. 1991. "Dayr Anba Bishoi: History." *CE* 3: 734–735.

Cohen, Mark. 1999. "What was the Pact of the 'Umar? A Literary-Historical Study." *Jerusalem Studies in Arabic and Islam* 23: 100–157.

Coleiro, E. 1957. "St. Jerome's Lives of the Hermits." *Vigiliae Christianae* 11: 161–178.

Colin, Gérard, 1988. "Le synaxaire éthiopien: Etat actuel de la question." *Analecta Bollandiana* 106: 273–317.

Colombo, Angelo. 1996. "La nascita della chiesa copto-cattolica nella prima metà del 1700." *Orientalia Christiana Analecta* 250: 249–253. Rome: Pontificium Institutum Studiorum Orientalium.

Conti Rossini, C. 1923–1925. "Aethiopica (IIᵃ Serie)." *Rivista degli Studi Orientali* 10: 481–520.

Cooke, Neil. 1998. "The Forgotten Egyptologist: James Burton." In Starkey and Starkey 1998, 85–94.

Cooke, Neil. 2001. "James Burton and Slave Girls." In Starkey and Starkey 2001, 209–217.

Coon, Lynda L. 1997. *Sacred Fictions: Holy Women and Hagiography in Late Antiquity.* Philadelphia: University of Pennsylvania Press.

Coppin, Jean. 1686. *Le bouclier de l'Europe, ou la Guerre Sainte.* Lyons: Chez Antoine Briasson.

Coquin, René-Georges. 1975. "Les inscriptions parietals des monastères d'Esna: Dayr al-Suhada'—Dayr al-Fahuri." *BIFAO* 75: 241–284.

Coquin, René-Georges. 1991a. "Clysma." *CE* 2: 565.

Coquin, René-Georges. 1991b. "Dayr al-Maymun." *CE* 3: 838–839.

Coquin, René-Georges. 1991c. "John, Hegumenos of Scetis." *CE* 5: 1362.

Coquin, René-Georges. 1991d. "John Kama, Saint." *CE* 5: 1362–1363.

Coquin, René-Georges. 1991e. "Murqus al-Antuni." *CE* 6: 1699.

Coquin, René-Georges. 1991f. "Patriarchal Residences." *CE* 6: 1912–1913.

Coquin, René-Georges. 1991g. "Phib, Saint." *CE* 6: 1953–1954.

Coquin, René-Georges. 1991h. "Synaxarion, Copto-Arabic: Editions of the Synaxarion." *CE* 7: 2172–2173.

Coquin, René-Georges, and Maurice Martin. 1991a. "Dayr Anba Antuniyus: Chronology." *CE* 3: 721–723.

Coquin, René-Georges, and Maurice Martin. 1991b. "Dayr Anba Bula: Historical Landmarks." *CE* 3: 742.

Coquin, René-Georges, and Pierre-Henry Laferrière. 1978. "Les Inscriptions pariétals de l'ancienne église du monastère de St. Antonine dans le désert oriental." *BIFAO* 78: 267–321.

Corey, Katharine Tubbs. 1943. "The Greek Versions of Jerome's *Vita Sancti Pauli.*" In Oldfather 1943, 143–250.

Crecelius, Daniel. 1981. *The Roots of Modern Egypt: A Study in the Regimes of ʿAli Bey al-Kabir and Muhammad Bey Abu al-Dhahab, 1760–1775.* Minneapolis: Bibliotheca Islamica.

Crecelius, Daniel. 1998. "Egypt in the Eighteenth Century." In Daly 1998, 59–86.

Curran, John. 1997. "Jerome and the Sham Christians of Rome." *Journal of Ecclesiastical History* 48, no. 2: 213–229.

El-Dahan, Rami, and Karem El-Dahan. 1998. "Monastery of St. Paul Conservation Final Report." Unpublished. Cairo: ARCE.

Daly, M. W., ed. 1998. *The Cambridge History of Egypt.* Vol. 2: *Modern Egypt, from 1517 to the End of the Twentieth Century.* Cambridge: Cambridge University Press.

Daniélou, Jean, and Henri Marrou. 1983. *The Christian Centuries.* Vol. 1: *The First Six Hundred Years.* London: Darton, Longman and Todd; New York: Paulist Press.

Da Seggiano, Iganzio. 1948. "Documenti inediti sull'apostolato dei Minori Cappuccini nel Vicino Oriente (1623–1683)." *Collectanea Francescana* 18: 144–145.

Davies, Norman De Garis. 2004. *The Rock Tombs of el-Amarna.* Cairo: Egypt Exploration Society.

Davis, Stephen J. 2000. "A 'Pauline' Defense of Women's Right to Baptize? Intertextuality and Apostolic Authority in the *Acts of Paul.*" *JECS* 8, no. 3: 453–459.

Davis, Stephen J. 2002. "Crossed Texts, Crossed Sex: Intertextuality and Gender in Early Christian Legends of Holy Women Disguised as Men." *JECS* 10, no. 1: 1–36.

Davis, Stephen J. 2004. *The Early Coptic Papacy: The Egyptian Church and Its Leadership in Late Antiquity.* Vol. 1 of *The Popes of Egypt.* Ed. Stephen J. Davis and Gawdat Gabra. Cairo: American University in Cairo Press.

Davison, Roderic H. 1990. *Essays in Ottoman and Turkish History, 1774–1923: The Impact of the West.* Austin, Tex.: Saqi.

De Cesaris, Luigi. 2003. "Technical Report (22 February–20 December 2003): The Monastery of St. Paul Conservation of the Wall Paintings in the Cave Church (with the collaboration of Alberto Sucato)." Unpublished. Cairo: ARCE.

De Cesaris, Luigi. 2004. "Technical Report (5 March–29 May 2004): The Monastery of St. Paul Conservation of the Wall Paintings in the Cave Church (with

the collaboration of Alberto Sucato).” Unpublished. Cairo: ARCE.

De Cesaris, Luigi. 2005. “Final Report (4 March–29 May 2005): The Monastery of St. Paul Conservation of the Wall Paintings in the Cave Church (with the collaboration of Alberto Sucato).” Unpublished. Cairo: ARCE.

De Cesaris, Luigi, and Adriano Luzi. 2002. “Technical Report (25 February–19 December 2002): The Monastery of St. Paul Conservation of the Wall Paintings in the Cave Church.” Unpublished. Cairo: ARCE.

De Decker, Josué. 1905. *Contribution à l’étude des “Vies de Paul de Thèbes.”* Gand: J. Vuylsteke.

Dell’Acqua, Francesca. 2006. “Enhancing Luxury through Stained Glass, from Asia Minor to Italy.” *Dumbarton Oaks Papers* 59: 193–211.

Den Heijer, Johannes. 1990. “Miraculous Icons and Their Historical Background.” In Hondelink 1990, 89–100.

Den Heijer, Johannes. 1996. “Coptic Historiography in the Fatimid, Ayyubid, and Early Mamluk Periods.” *Medieval Encounters* 2: 67–98.

Depuydt, Leo, ed. 1991. *Homiletica from the Pierpont Morgan Library.* Leuven: Peeters.

De Valence, Apollinaire, ed. 1891. *Correspondance de Peiresc avec plusieurs missionnaires et religieux de l’Ordre des Capucins, 1631–1637.* Paris: Alphonse Picard.

De Vis, Henri. 1990. Reprint of the 1929 ed. *Homélies coptes de la Vatican.* Vol. 2. Louvain: Peeters.

Décobert, Christian, ed. 1992. *Itinéraires d’Egypte: Mélanges offerts au père Maurice Martin S.J.* Cairo: IFAO.

Décobert, Christian, ed. 2002. *Alexandrie médiévale.* Vol. 2. Cairo: IFAO.

Décobert, Christian. 2002a. “Maréotide médiévale: Des bédouins et des chrétiens.” In Décobert 2002, 127–167.

Dennison, Walter, and Charles R. Morey. 1918. *Studies in East Christian and Roman Art.* New York: Macmillan.

Dodd, Erica Cruikshank. 2004. *Medieval Painting in the Lebanon.* Wiesbaden: Reichert.

Doorn, Nelly van. 1990. “The Importance of Greeting the Saints: The Appreciation of Coptic Art by Laymen and Clergy.” In Hondelink 1990, 101–118.

Doorn-Harder, Nelly van, and Kari Vogt, eds. 1997. *Between Desert and City: The Coptic Orthodox Church Today.* Oslo: Novus, and Instituttet for sammenlignende kulturforskning.

Drescher, James, ed. and trans. 1946. *Apa Mena: A Selection of Coptic Texts Relating to St. Menas.* Cairo: SAC.

Driver, Steven D. 2002. *John Cassian and the Reading of Egyptian Monastic Culture.* London: Routledge.

Dubernat, Guillaume. 1717. “Lettre d’un missionnaire en Egypte, à Son Altesse Sérénissime Monseigneur le Comte de Toulouse.” In *Nouveaux mémoires des missions de la Compagnie de Jésus dans le Levant* 2: 1–125. Paris: Chez Nicolas Le Clerc.

DuBois, Page. 1982. *Centaurs and Amazons: Women and the Pre-History of the Great Chain of Being.* Ann Arbor: University of Michigan Press.

Du Bourguet, Pierre M. 1951. “Saint-Antoine et Saint-Paul du désert.” *Bulletin de la Société française d’égyptologie* 7: 37–46.

Du Bourguet, Pierre M. 1971. *The Art of the Copts.* New York: Crown.

Du Bourguet, Pierre M. 1991. “Copt.” *CE* 2: 599–601.

Du Casse, Albert. 1854–1865. “Marmont.” In Michaud 1854–1865, 18–31.

Duval, Yves-Marie, ed. 1988. *Jérôme entre l’occident et l’orient: XVIᵉ centenaire du départ de saint Jérôme de Rome et de son installation à Bethléem.* Paris: Etudes augustiniennes.

Edwards, Steve, and Paul Wood, eds. 2004. *Art of the Avant-Gardes.* New Haven: Yale University Press.

Elli, Alberto. 2003. *Storia della chiesa copta.* 3 vols. Cairo: Franciscan Centre of Christian Oriental Studies; Jerusalem: Franciscan Printing Press.

Ervine, Roberta. 1995. “Grigor the Chainbearer (1715–1749): The Rebirth of the Armenian Patriarchate.” In O’Mahony 1995, 102–111.

Esbroeck, Michel van. 1991a. “John Colobos, Saint: Arabic Tradition.” *CE* 5: 1361–1362.

Esbroeck, Michel van. 1991b. “Maximus and Domitius, Saints.” *CE* 5: 1576–1578.

Esbroeck, Michel van. 1991c. “Michael the Archangel, Saint.” *CE* 5: 1616–1620.

Esbroeck, Michel van. 1991d. “Victor Stratelates, Saint. Coptic Tradition.” *CE* 7: 2303–2305.

Ettinghausen, Richard. 1977. *Arab Painting.* Geneva: Editions d’Art Albert Skira; New York: Rizzoli.

Evans, Helen C., and William D. Wixom, eds. 1997. *The Glory of Byzantium.* New York: Metropolitan Museum of Art.

Evelyn White, Hugh G. 1932. *The Monasteries of the Wadi’n Natrun.* Part 2: *The History of the Monasteries of Nitria and Scetis.* New York: Metropolitan Museum of Art.

Evelyn White, Hugh G. 1933. *The Monasteries of the Wadi'n Natrun*. Part 3: *The Architecture and Archaeology*. New York: Metropolitan Museum of Art.

Evetts, Basil T. A., trans., with notes by Alfred J. Butler. 1895. *The Churches and Monasteries of Egypt and Some Neighbouring Countries Attributed to Abu Salih, the Armenian*. Oxford: Oxford University Press.

Fahmy, Khaled. 1998. "The Era of Muhammad 'Ali Pasha, 1805–1848." In Daly 1998, 139–179.

Fairclough, H. Rushton, ed. and trans. 1999a. *Virgil*. Vol. 1: *Eclogues, Georgics, Aeneid 1–6*. Rev. by G. P. Gould. Cambridge, Mass.: Loeb Classical Library, Harvard University Press.

Fairclough, H. Rushton, ed. and trans. 1999b. *Virgil*. Vol. 2: *Aeneid 7–12, Appendix Vergiliana*. Rev. G. P. Gould. Cambridge, Mass.: Loeb Classical Library, Harvard University Press.

Fakhry, Ahmed. 1951. *The Necropolis of El-Bagawat*. Cairo: Sevice des antiquités de l'Egypte.

Faroqhi, Suraiya, 1994. *Pilgrims and Sultans: The Hajj Under the Ottomans, 1517–1683*. London: I. B. Tauris.

Fattal, Antoine. 1958. *Le statut légal des non-musulmans en pays d'Islam*. Beirut: Imprimerie Catholique.

Findley, Carter. 1989. *Ottoman Civil Officialdom: A Social History*. Princeton: Princeton University Press.

Fineberg, Jonathan, ed. 1998. *Discovering Child Art: Essays on Childhood, Primitivism, and Modernism*. Princeton: Princeton University Press.

Fleurier, David-Dominique. 2004. "Feuillets d'un manuscript sahidique des Epitres catholiques." Catalogue entry no. 16 in Boud'hors 2004, 44–45.

Fontaine, Jacques. 1979. "L'Aristocratie occidentale devant le monachisme au IVe et Ve siècles." *Rivista di storia e letteratura religiosa* 15: 28–53.

Forget, Iacobus, ed. 1905. *Synaxarium Alexandrinum*. Rome: Excudebat Karolus de Luigi.

Forget, Iacobus, ed. and trans. 1921–1926. *Synaxarium Alexandrinum*. 2 vols. Louvain: Peeters.

Forster, Edward S., ed. and trans. 1966. *Florus: Epitome of Roman History*. Cambridge, Mass.: Loeb Classical Library, Harvard University Press.

Forsyth, George H., and Kurt Weitzmann. 1973. *The Monastery of Saint Catherine at Mount Sinai: The Church and Fortress of Justinian*. Ann Arbor: University of Michigan Press.

Francheschini, E., and R. Weber, eds. 1965. *Egeria: Itinerary*. In Geyer 1965, 27–90.

Franciscono, Marcel. 1998. "Paul Klee and Children's Art." In Fineberg 1998, 95–121.

Frank, Georgia. 2000. *The Memory of the Eyes: Pilgrims to Living Saints in Christian Late Antiquity*. Berkeley: University of California Press.

Frankfurter, David, ed. 1998. *Pilgrimage and Holy Space in Late Antique Egypt*. Leiden: Brill.

Frankfurter, David. 2004. "The Binding of Antelopes: A Coptic Frieze and its Egyptian Religious Context." *Journal of Near Eastern Studies* 63, no. 2: 97–109.

Frazee, Charles. 1983. *Catholics and Sultans: The Church and the Ottoman Empire, 1453–1923*. Cambridge: Cambridge University Press.

Fremantle, William H., trans. 1989. *The Principal Works of Jerome*. In Schaff and Wace 1989.

Fremantle, William H., trans. 1989a. "Letters." In Schaff and Wace 1989, 1–295.

Fremantle, William H., trans. 1989b. "The Life of St. Hilaron." In Schaff and Wace 1989, 303–315.

Gabra, Gawdat, ed. 2001. *Be Thou There: The Holy Family's Journey in Egypt*. Cairo: American University in Cairo Press.

Gabra, Gawdat. 2002a. *Coptic Monasteries: Egypt's Monastic Art and Architecture*. Cairo: American University in Cairo Press.

Gabra, Gawdat. 2002b. "Perspectives on the Monastery of St. Antony: Medieval and Later Inhabitants and Visitors." In Bolman 2002, 173–183.

Georgopoulou, Maria. 1999. "Orientalism and Crusader Art: Constructing a New Canon." *Medieval Encounters* 5, no. 3: 288–321.

Gerstel, Sharon E. J., ed. 2006. *Thresholds of the Sacred: Architectural, Art Historical, Liturgical, and Theological Perspectives on Religious Screens, East and West*. Washington, D.C.: Dumbarton Oaks.

Geyer, Paul, ed. 1965. *Itineraria et Alia Geographica*. Turnholt: Typographi Brepols Editores Pontificii.

Geyer, Paul, ed. 1965a. "Piacenza Pilgrim (Antoninus Martyr): Itinerary." In Geyer 1965, 129–153.

Gibbon, Edward. 1994. *The History of the Decline and Fall of the Roman Empire*. Vol. 3. Ed. David Womersley. London: Penguin.

Gibson, Edgar C. S., trans. 1989. "The Works of John Cassian." In Schaff and Wace 1989, 161–641.

Goehring, James E. 1999. *Ascetics, Society, and the Desert. Studies in Early Egyptian Monasticism*. Harrisburg, Pa.: Trinity.

Goehring, James E. 1999a. "The Origins of Monasticism." In Goehring 1999, 13–35.

Goehring, James E. 1999b. "Through a Glass Darkly: Images of the Ἀποτακοί(αί) in Early Egyptian Monasticism." In Goehring 1999, 53–72.

Goldwater, Robert. 1967. *Primitivism in Modern Art.* New York: Vintage.

Graf, Georg. 1934. *Catalogue de manuscrits arabes chrétiens conservés au Caire.* Vatican City: Biblioteca apostolica vaticana.

Graf, Georg. 1944. *Geschichte der christlichen-arabischen Literatur.* Vol. 1: *Die Übersetzungen.* Vatican City: Biblioteca apostolica vaticana.

Graf, Georg. 1947. *Geschichte der christlichen arabischen Literatur.* Vol. 2: *Die Schriftseller bis zur Mitte des 15. Jahrhunderts.* Vatican City: Biblioteca apostolica vaticana.

Graf, Georg. 1949. *Geschichte der christlichen arabischen Literatur.* Vol. 3: *Die Schriftsteller von der Mitte des 15. bis zum Ende des 19. Jahrhunderts. Melchiten, Maroniten.* Vatican City: Biblioteca apostolica vaticana.

Graf, Georg. 1954. *Verzeichnis arabischer kirchlicher Termini.* Louvain: L. Durbecq.

Gran, Peter. 1979. *The Islamic Roots of Capitalism: Egypt 1760–1840.* Austin: University of Texas Press.

Granger, Claude. 1745. *Relation du voyage fait en Egypte, par le Sieur Granger, en l'année 1730. Où l'on voit ce qu'il y a de plus remarquable, particulièrement sur l'histoire naturelle.* Paris: Chez Jacques Vincent.

Greenwood, Ned H. 1997. *The Sinai: A Physical Geography.* Austin: University of Texas Press.

Gregorius (Bishop). 1991. "Suriel, Archangel." *CE* 7: 2160.

Griffith, Sidney H. 2002. "The Handwriting on the Wall: Graffiti in the Church of St. Antony." In Bolman 2002, 185–193.

Griggs, C. Wilfred 1991. "Sarapion of Tmuis, Saint." *CE* 7: 2095–2096.

Grossmann, Peter. 1991a. "Church Architecture in Egypt." *CE* 2: 552–555.

Grossmann, Peter. 1991b. "Dayr al-Baramus: Architecture." *CE* 3: 791–793.

Grossmann, Peter. 1991c. "Keep." *CE* 5: 1395–1396.

Grossmann, Peter. 2002. "L'architecture de l'église de Saint-Paul." In van Moorsel 2002, 3–15.

Gruber, Mark Francis. 1997. "The Monastery as Nexus of Coptic Cosmology." In Doorn-Harder and Vogt 1997, 67–82.

Guidi, Ignazio. 1911. "The Ethiopic Senkessar." *Journal of the Royal Asiatic Society of Great Britain and Ireland* 43: 739–758.

Guillaumont, Antoine. 1975. "La conception du désert chez les moines d'Egypte." *Revue d'histoire des religions* 188: 3–21.

Guillaumont, Antoine. 1991. "Macarius the Egyptian, Saint." *CE* 5: 1491–1492.

Guillaumont, Antoine, and Karl H. Kuhn. 1991. "Paul of Thebes, Saint." *CE* 6: 1925–1926.

Guirguis, Magdi. 1999. "Idarat al-azamat fi tarikh al-Qibt: Namudhaj min al-qarn al-thamina ʿashra" (Crisis management in the history of the Copts: An example from the eighteenth century). *AI* 33: 45–59.

Guirguis, Magdi. 2000. "Athar al-arakhina ʿala awdaʾ al-qibt fi al-qarn al-thamina ʿashra" (The effect of the notables on Coptic institutions in the eighteenth century). *AI* 34: 23–44.

Guirguis, Magdi. 2004. "Ibrahim al-Nasih et la culture copte au XVIIIᵉ siècle." In Immerzeel and van der Vliet 2004, 2: 939–952.

Gwynn, Aubrey. 1926. *Roman Education from Cicero to Quintillian.* Oxford: Clarendon.

Habib, Samuel. 1991. "Coptic Evangelical Church." *CE* 2: 603–604.

Hagendahl, Harald. 1958. *Latin Fathers and the Classics: A Study on the Apologists, Jerome and Other Christian Writers.* Göteborg: Institute of Classical Studies, University of Göteborg.

Hagendahl, Harald. 1974. "Jerome and the Latin Classics." *Vigiliae Christianae* 28: 216–227.

Haldane, Duncan. 1978. *Mamluk Painting.* Warminster, U.K.: Aris and Phillips.

Hamilton, Alastair. 2006. *The Copts and the West, 1439–1820: The European Discovery of the Egyptian Church.* Oxford: Oxford University Press.

Hamilton, Alastair, and Francis Richard. 2004. *André Du Ryer and Oriental Studies in Seventeenth-Century France.* London: Arcadian Library; Oxford: Oxford University Press.

Hammond, Nicholas G. L., and Howard H. Scullard. 1970. *Oxford Classical Dictionary.* Oxford: Clarendon.

Hanna, Nelly. 1983. *An Urban History of Boulaq in the Mamluk and Ottoman Periods.* Cairo: IFAO.

Harbison, Peter. 1992. *High Crosses of Ireland: An Iconographical and Photographic Survey.* 3 vols. Bonn: R. Habelt.

Harmless, William. 2004. *Desert Christians: An Introduction to the Literature of Early Monasticism.* Oxford: Oxford University Press.

Harrell, James A. 1996. "Geology." In Sidebotham and Wendrich 1996, 99–126.

Harrell, James A. 1998. "Geology." In Sidebotham and Wendrich 1998, 121–148.

Harrell, James A., Lorenzo Lazzarini, and M. Bruno. 2002, "Reuse of Roman Ornamental Stones in Medieval Cairo, Egypt." In Lazzarini 2002, 89–96.

Harvey, Paul B. Jr. 1990. "Jerome: *Life of Paul, the First Hermit.*" In Wimbush 1990, 359–369.

Hathaway, Jane. 1997. *The Politics of Households in Ottoman Egypt: The Rise of the Qazdağlıs.* Cambridge: Cambridge University Press.

Hathaway, Jane. 1998. "Egypt in the Seventeenth Century." In Daly 1998, 34–58.

Hathaway, Jane. 2003. *A Tale of Two Factions: Myth, Memory, and Identity in Ottoman Egypt and Yemen.* Albany: State University of New York.

Hays, Richard. 1989. *Echoes of Scripture in the Letters of Paul.* New Haven: Yale University Press.

Hayum, Andrée. 1989. *The Isenheim Altarpiece: God's Medicine and the Painter's Vision.* Princeton: Princeton University Press.

Heldman, Marilyn E. 2000. "Wise Virgins in the Kingdom of Heaven: A Gathering of Saints in a Medieval Ethiopian Church." *Source: Notes in the History of Art* 19, no. 2: 6–12.

Heldman, Marilyn E., and Getatchew Haile. 1987. "Who Is Who in Ethiopia's Past. Part 3: Founders of Ethiopia's Solomonic Dynasty." *Northeast African Studies* 9, no. 1: 1–11.

Helfenstein, Josef. 1998. "The Issue of Childhood in Klee's Late Work." In Fineberg 1998, 122–156.

Hendrikx, Ephraem 1968. "Saint Jérôme en tant qu' hagiographie." In Manrique 1968, 243–249.

Hewison, James 1914. *The Runic Roods of Ruthwell and Bewcastle.* Glasgow: John Smith and Son.

Holt, Peter M. 1966. *Egypt and the Fertile Crescent, 1516–1922: A Political History.* Ithaca: Cornell University Press.

Holt, Peter M. 1986. *The Age of the Crusades: The Near East from the Eleventh Century to 1517.* London: Longman.

Hondelink, Hans, ed. 1990. *Coptic Art and Culture.* Cairo: Netherlands Institute for Archaeology and Arabic Studies.

Hopkins, Gerard Manley. 1955. *The Letters of Gerard Manley Hopkins to Robert Bridges.* Ed. Claude Colleer Abbott. London: Oxford University Press.

Horner, George William. 1969. *The Coptic Version of the New Testament in the Northern Dialect.* Vol. 2. Osnabrück: Otto Zeller.

Hunt, Edward D. 1982. *Holy Land Pilgrimage in the Later Roman Empire, AD 312–460.* Oxford: Clarendon.

Hunt, Lucy-Ann. 1985. "Christian-Muslim Relations in Painting in Egypt of the Twelfth to Mid-Thirteenth Centuries: Sources of Wallpainting at Deir es-Suriani and the Illumination of the New Testament MS Paris, Copte-Arabe 1/Cairo, Bibl. 94." *Cahiers Archéologiques* 33: 111–155.

Hunt, Lucy-Ann. 1998. *Byzantium, Eastern Christendom and Islam: Art at the Crossroads of the Medieval Mediterranean.* Vol. 1. London: Pindar.

Hunt, Lucy-Ann. 1998a. "Churches of Old Cairo and the Mosques of al-Qahira: A Case of Christian-Muslim Interchange." In Hunt 1998, 319–342.

Hunt, Lucy-Ann. 1998b. "Iconic and Aniconic: Unknown Thirteenth- and Fourteenth-Century Byzantine Icons from Cairo in their Woodwork Setting." In Hunt 1998, 60–96.

Husselman, Elinor M. 1965. "The Martyrdom of Cyriacus and Julitta in Coptic." *JARCE* 4: 79–86.

Immerzeel, Mat. 1997. *Syrische Iconen/Syrian Icons.* Rotterdam: Snoeck-Ducaju and Zoon.

Immerzeel, Mat, and Jacques van der Vliet, eds. 2004. *Coptic Studies on the Threshold of a New Millenium.* 2 vols. Louvain: Peeters.

Innemée, Karel C. 1992. *Ecclesiastical Dress in the Medieval Near East.* Leiden: Brill.

Irwin, Robert. 1986. *The Middle East in the Middle Ages: The Early Mamluk Sultanate, 1250–1382.* Carbondale: Southern Illinois University Press.

Ishaq, Emile Maher. 1991a. "Difnar." *CE* 3: 900–901.

Ishaq, Emile Maher. 1991b. "Psalmodia." *CE* 6: 2024–2025.

al-Jabarti, ʿAbd al-Rahman. 1997. *ʿAjaʾib al athar fi l-tarajim wa-l-akhbar* (Wonders of the traces in biographies and chronicles). Vol. 3. Beirut: Dar al-Kutub al-ʿIlmiyya.

Jeudy, Adeline. 2004. "Icônes et ciboria: relation entre les ateliers coptes de peinture d'icônes et l'iconographie du mobilier liturgique en bois." *ECA* 1: 67–87.

Johann Georg Herzog zu Sachsen. 1930. *Neue Streifzüge durch die Kirchen und Klöster Ägyptens.* Leipzig: B. G. Teubner.

Johann Georg Herzog zu Sachsen. 1931. *Neueste Streifzüge*

durch die Kirchen und Klöster Ägyptens. Leipzig: B. G. Teubner.

Johnson, D. W. 1993. *Acts of the Fifth Congress of Coptic Studies.* Washington, D.C., August 12–15, 1992. 2 vols. Rome: CIM.

Jollois, Pierre. 1813. *Description de l'Egypte. Etat Moderne* Vol. 2. *Arts et métiers.* Paris: Imprimerie Impériale.

Jones, Angela Milward. 2006. "Conservation of the Medieval Wall Paintings in the Church of Sts. Sergus and Bacchus (Abu Serga)." *BARCE* 190: 9–13.

Jones, Michael. 2002. "The Church of St. Antony: The Architecture." In Bolman 2002, 20–30.

Jullien, Michel. 1884. *L'Egypte, souvenirs bibliques et chrétiens.* Lille: Société Saint-Augustin Desclée, De Brouwer et Cie.

Kamal, Yu'annis. 2003. *Sira 'atira: al-rahib al-qummus Abadir al-Anba Bula (al-shahir bi-l-Jazzar) (1934– 1983 m.)* (A fragrant life: The monk and hegumenos Abadir al-Anba Bula [known as al-Jazzar] [AD 1934– 1983]). Cairo: Maktabat Kirillu.

Kamal, Yu'annis. 2004. *Al-Shahid al-'azim Abiskhrun al-jundi al-qalini* (The great martyr Abiskhirun the soldier of Qalin). Cairo: Maktabat Kirillu.

Kazhdan, Alexander P., et al. 1991. *The Oxford Dictionary of Byzantium.* 3 vols. Oxford: Oxford University Press.

Kazhdan, Alexander P., and Nancy Patterson Ševčenko. 1991a. "Cherubim." *ODB* 1: 419–420.

Kazhdan, Alexander P., and Nancy Patterson Ševčenko. 1991b. "Seraphim." *ODB* 3: 1870.

Kech, Herbert. 1977. *Hagiographie als christliche Unterhältungsliteratur: Studien zum Phänomen des Erbaulichen anhand der Mönchsviten des hl. Hieronymus.* Göppingen: Alfred Kümmerle.

Keimer, Louis. 1956. "Les prosternations pénitentiaires des moines du couvent de St. Paul dans le désert de l'Est." *CC* 11: 20–21.

Kelly, John N. D. 1975. *Jerome: His Life, Writings, and Controversies.* London: Duckworth.

Khater, Antoine, and Oswald H. E. Khs-Burmester. 1967. *Catalogue of the Coptic and Christian Arabic MSS. Preserved in the Cloister of Saint Menas at Cairo.* Cairo: SAC.

Khater, Antoine, and Oswald H. E. Khs-Burmester, trans. and annot. 1970. *History of the Patriarchs of the Egyptian Church, Known as the History of the Holy Church.* Vol. 3, part 3: *Cyril II–Cyril V (1235–1894 AD).* Cairo: SAC/IFAO.

Khater, Antoine, and Oswald H. E. Khs-Burmester, trans. and annot. 1974. *History of the Patriarchs of the Egyptian Church, Known as the History of the Holy Church, According to MS Arabe 302 Bibliothèque Nationale, Paris, Foll. 287v.–55r.* Vol. 4, part 1: *Cyril III Ibn Laklak (1216–1243 AD).* Cairo: SAC/IFAO.

Khater, Antoine, and Oswald H. E. Khs-Burmester. 1977. *Catalogue of the Coptic and Christian Arabic MSS Preserved in the Library of the Church of Saints Sergius and Bacchus Known as Abu Sargah at Old Cairo.* Cairo: SAC/IFAO.

Kozik, Ignatius S. 1968. *The First Desert Hero: St. Jerome's "Vita Pauli."* Mount Vernon, N.Y.: King Lithographers.

Kraack, Detlev von. 1997. *Monumentale Zeugnisse der spätmittelalterlichen Adelsreise: Inschriften und Graffiti des 14.–16. Jahrhunderts.* Göttingen: Vandenhoeck and Ruprecht.

Krause, Martin. 1991. "Menas the Miracle Maker, Saint." *CE* 5: 1589–1590.

Kries, D., and C. B. Tkacz. 1999. *Nova Doctrina Vetusque: Essays on Early Christianity in Honor of Fredric W. Schlatte.* New York: Peter Lang.

Kugener, Marc-Antoine. 1902. "Saint Jérôme et la *Vie de Paul de Thèbes.*" *Byzantinische Zeitschrift* 11: 513–517.

Kuhn, Karl H. 1991. "Shenute, Saint." *CE* 7: 2131–2133.

Lanchner, Carolyn. 1987. *Paul Klee.* New York: Museum of Modern Art.

Langen, Linda. 1990. "Icon-Painting in Egypt." In Hondelink 1990, 55–72.

Larsen, Erik. 1988. *The Paintings of Anthony Van Dyck.* 2 vols. Freren: Luca.

Lazzarini, Lorenzo, ed. 2002. *Interdisciplinary Studies on Ancient Stone.* Padua: Bottega d'Erasmo Aldo Ausilio Editore.

Leclant, Jean, and Jean Verrcoutter, eds. 1978. *Etudes Nubiennes.* Cairo: IFAO.

Leclerc, Pierre. 1988. "Antoine et Paul: Métamorphose d'un héros." In Duval 1988, 257–265.

El-Leithy, Tamer. 2005. "Coptic Culture and Conversion in Medieval Cairo, 1293–1524 AD." Ph.D. diss., Princeton University.

Leroy, Jules. 1974. *Les manuscrits coptes et coptes-arabes illustrés.* Paris: Librairie Orientaliste Paul Geuthner.

Leroy, Jules. 1975. *Les peintures des couvents du désert d'Esna.* Cairo: IFAO.

Leroy, Jules. 1978. "Le programme décoratif de l'église

de Saint-Paul du désert de la mer Rouge." *BIFAO* 78: 323–337.

Leroy, Jules. 1982. *Les peintures des couvents du Ouadi Natroun.* Cairo: IFAO.

Leroy, L. 1907. "Les églises des chrétiens: Traduction de l'arabe d'al-Makrizi." *Revue de l'Orient Chrétien* 12: 190–208, 269–279.

Leroy, L. 1908. "Les couvents des chrétiens: Traduction de l'arabe d'al-Makrizi." *Revue de l'Orient Chrétien* 13: 33–46, 192–204.

Lewis, Agnes Smith. 1904. "Hidden Egypt: The first visit by women to the Coptic monasteries of Egypt and Nitria, with an account of the condition and reasons for the decadence of an ancient Church." *Century Magazine* 68: 745–758.

Leyerle, Blake. 1996. "Landscape as Cartography in Early Christian Pilgrimage Narratives." *Journal of the American Academy of Religion* 64, no. 1: 119–143.

Libois, Charles, ed. and trans. 1977. *Le Voyage en Egypte du Père Antonius Gonzales (1665–1666).* 2 vols. Cairo: IFAO.

Libois, Charles, ed. 1993. *Monumenta Proximi-Orientis.* Vol. 2: *Egypte (1547–1563).* Rome: Institutum Historicum Societatis Iesu.

Libois, Charles, ed. 2002. *Monumenta Proximi-Orientis.* Vol. 5: *Egypte (1591–1699).* Rome: Institutum Historicum Societatis Iesu.

Libois, Charles, ed. 2003. *Monumenta Proximi-Orientis.* Vol. 6: *Egypte (1700–1773).* Rome: Institutum Historicum Societatis Iesu.

Little, Donald P. 1976. "Coptic Conversion to Islam Under the Bahri Mamluks, 692–755/1293–1354." *Bulletin of the School of Oriental and African Studies* 39: 552–569.

Loon, Gertrud J. M. van. 1992. "The Symbolic Meaning of the Haykal." In Rassart-Debergh and Reis 1992, 1: 497–508.

Loon, Gertrud J. M. van. 1999. *The Gate of Heaven: Wall Paintings with Old Testament Scenes in the Altar Room and the Khurus of Coptic Churches.* Istanbul: Nederlands Historisch Archaeologisch Instituut te Istanbul.

Loon, Gertrud J. M. van, and Alain Delattre. 2004. "La frise des saints de l'église rupestre de Deir Abou Hennis." *ECA* 1: 89–112.

Loon, Gertrud J. M. van, and Alain Delattre. 2005. "La frise des saints de l'église rupestre de Deir Abou Hennis. Correction et Addition." *ECA* 2: 167.

Loon, Gertrud J. M. van, and Alain Delattre. 2006. "Le cycle de l'enfance du Christ dans l'église rupestre de saint Jean Baptiste à Deir Abou Hennis." In Boud'hors, Gascou and Vaillancourt 2006, 119–134.

Luckman, Harriet A., and Linda Kulzer, eds. 1999. *Purity of Heart in Early Ascetic and Monastic Literature: Essays in Honor of Juana Raasch, O.S.B.* Collegeville, Minn.: Liturgical Press.

Luisier, Philippe. 1994a. "Jean XI, 89ème patriarche copte: Commentaire de sa lettre au Pape Eugène IV, suivi d'une esquisse historique sur son patriarcat." *OCP* 60: 519–562.

Luisier, Philippe. 1994b. "La lettre du patriarche copte Jean XI au Pape Eugène IV: Nouvelle édition." *OCP* 60: 87–129.

Lyster, William. 1999. *Monastery of St. Paul.* Cairo: ARCE.

Lyster, William. 2002. "Reflections of the Temporal World: Secular Elements in Theodore's Program." In Bolman 2002, 103–126.

MacCoull, Leslie S. B. 1993. *Coptic Perspectives on Late Antiquity.* Brookfield, Vt.: Variorum.

MacCoull, Leslie S. B. 1993a. "The Strange Death of Coptic Culture." In MacCoull 1993, essay 26, 120–125.

MacCoull, Leslie S. B. 1993b. "Three Cultures Under Arab Rule: The Fate of Coptic." In MacCoull 1993, essay 25, 61–70.

MacCoull, Leslie S. B. 1996. "A Note on the Career of Gabriel III, Scribe and Patriarch of Alexandria." *Arabica* 43: 357–360.

MacCoull, Leslie S. B. 1998. "Chant in Coptic Pilgrimage." In Frankfurter 1998, 403–413.

Maguire, Henry. 1993. "Disembodiment and Corporeality in Byzantine Images of the Saints." In Cassidy 1993, 75–90.

Maguire, Henry, ed. 1997. *Byzantine Court Culture from 829 to 1204.* Washington, D.C.: Dumbarton Oaks.

Maguire, Henry. 1997a. "The Heavenly Court." In Maguire 1997, 247–258.

Malaty, Tadros Y. 1973. *Christ in the Eucharist.* Alexandria: St. George's Orthodox Church.

Malaty, Tadros Y. 1993. *Introduction to the Coptic Orthodox Church.* Alexandria: Maktabat Kanisat Mari Jirjis, Sporting.

Malone, Edward E. 1956. "The Monk and the Martyr." In Steidle 1956, 201–228.

Mango, Marlia M. 1986. *Silver from Early Byzantium: The Kaper Koran and Related Treasures.* Baltimore: Trustees of the Walter's Art Gallery.

Mango, Marlia M. 1991. "Rhipidion." *OBD* 3: 1790–1791.

Manrique, A., ed. 1968. *Homenaje al P. A. C. Vega.* Madrid: Real Monasterio de el Escorial.

Mansi, Giovan D., et al., eds. 1911. *Sacrorum conciliorum nova, et amplissima collectio.* Vol. 46. Paris: Hubert Welter.

Al-Maqrizi, Taqi al-Din Ahmad ibn ʿAli. 1970–1971. *Kitab al-suluk li-maʿrifat duwal al-muluk* (The book of following the path in knowing the kingdoms). Vol. 3, in 3 parts. Ed. by Saʿid ʿAbd al-Fattah ʿAshur. Cairo: Matbaʿat Dar al-Kutub.

Al-Maqrizi, Taqi al-Din Ahmad ibn ʿAli. 1972–1973. *Kitab al-suluk li-maʿrifat duwal al-muluk.* Vol. 4, in 3 parts. Ed. Saʿid ʿAbd al-Fattah ʿAshur. Cairo: Matba ʿat Dar al-Kutub.

Marmont, Auguste-Frédéric-Louis Visse de. 1837. *Voyage du Maréchal Duc de Raguse en Hongrie, en Transylvanie, dans la Russie Méridional, en Crimée, et sur les bords de la Mer d'Azoff, à Constantinople, dans quelques parties d'Asie-Mineure, en Syrie, en Palestine et en Egypte.* Vol. 3. Paris: Chez Ladvocat.

Marrou, Henri I. 1956. *A History of Education in Antiquity.* New York: Sheed and Ward.

Martin, Maurice 1983. "Granger est-il le rédacteur de son voyage en Egypte?" *AI* 19: 53–58.

Martin, Maurice. 1986. "Sicard et Granger (suite et fin)." *AI* 22: 175–180.

Martin, Maurice. 1991. "Quelques comportements symboliques spécifiques de la communauté copte: l'icôn." *Le Monde Copte* 19: 103–106.

Martin, Maurice. 1997. "Le Delta chrétien à la fin du XIIᵉs." *OCP* 63: 181–199.

Maspero, Jean, and Etienne Drioton. 1931. *Fouilles executées à Baouît.* MIFAO t.59. Cairo: IFAO.

Al-Masri, Iris Habib. 1992. *Qissat al-kanisa al-qibtiyya* (Story of the Coptic Church). Vol. 5: *1517–1870.* Alexandria: Maktaba Kanisat Mari Jirjis, Sporting.

Mathews, Thomas F. 1995. *Art and Architecture in Byzantium and Armenia: Liturgical and Exegetical Approaches.* Aldershot, U.K.: Variorum

Mathews, Thomas F. 1995a. "The Early Armenian Iconographic Program of the Ejmiacin Gospel." In Mathews 1995, 208–209.

Matta al-Miskin. 1991. "Dayr Anba Maqar." CE 3: 748–756.

Anba Mattaʾus. 1985. *Al-Arkhunayn al-ʿazimayn al-muʿallim Ibrahim al-Jawhari wa-shaqiqahu al-muʿallim Jirjis al-Jawhari* (Two great archons, Ibrahim al-Jawhari and his brother Jirjis al-Jawhari).

Cairo: Kanisat al-Shahid al-ʿAzim Mari Jirjis al-Athariyya bi-Masr al-Qadima.

Anba Mattaʾus. 2005. *Sirat al-shahid al-ʿazim Isidhurus* (The life of the great martyr Isidore). Cairo: Touch.

Matthew, Colin, and Brian Harrison, eds. 2004. *Oxford Dictionary of National Biography.* Vols. 22 and 33. Oxford: Oxford University Press.

Mayeur-Jaouen, Catherine. 1992. "Un jésuite français en Egypte: le père Jullien." In Décobert 1992, 213–237.

McBrien, Richard P. 2001. *Lives of the Saints.* New York: HarperCollins.

McNally, Sheila, ed. 2001. *Shaping Community: The Art and Architecture of Monasticism.* Oxford: Archaeopress.

Meadows, Peter. 2004. "Bonomi." In Matthew and Harrison 2004, 569–571.

Megally, Fuad. 1991a. "George, Saint." *CE* 4: 1139–1140.

Megally, Fuad. 1991b. "Numerical System, Coptic." *CE* 6: 1820–1822.

Meinardus, Otto F. A. 1961. "The Monastery of St. Paul in the Eastern Desert." *BSGE* 34: 81–110.

Meinardus, Otto F. A. 1963–1964. "A Comparative Study on the Sources of the Synaxarium of the Coptic Church." *BSAC* 17: 111–156.

Meinardus, Otto F.A. 1966. "The Medieval Graffiti in the Monasteries of SS. Antony and Paul." *SOCC* 11: 513–528.

Meinardus, Otto F. A. 1967. "Greek Proskynitaria of Jerusalem in Coptic Churches in Egypt." *SOCC* 12: 311–341.

Meinardus, Otto F. A. 1967–1968. "The XVIIIth Century Wall-Paintings in the Church of St. Paul the Theban, Dair Anba Bula." *BSAC* 19: 181–197.

Meinardus, Otto F. A. 1968–1969. "The Twenty-Four Elders of the Apocalypse in the Iconography of the Coptic Church." *SOCC* 13: 141–157.

Meinardus, Otto F. A. 1991. "Dayr Anba Bula: Chronology." *CE* 3: 741–742.

Meinardus, Otto F. A. 1992. *Monks and Monasteries of the Egyptian Desert.* Rev. ed. Cairo: American University in Cairo Press.

Meiss, Millard, and Elizabeth H. Beatson. 1974. *The Belles Heures of Jean, Duke of Berry.* New York: George Braziller.

Merrills, Andrew H. 2004. "Monks, Monsters, and Barbarians: Re-Defining the African Periphery in Late Antiquity." *JECS* 12, no. 2: 217–244.

Meyvaert, Paul. 1992. "A New Perspective on the Ruthwell Cross: *Ecclesia* and *Vita Monastica.*" In Cassidy 1992, 95–166.

Mézin, Anne. 1997. *Les consuls de France au siècle des lumières (1715–1792)*. Paris: Documentation Ministère des Affaires Étrangères.

Michaud, Louis-Gabriel, ed. 1854–1865. *Biographie universelle ancienne et moderne*. Vol. 27. Paris: Chez Mme C. Desplaces; Leipzig: F. A. Brockhaus.

Miller, Patricia Cox. 1983. *Biography in Late Antiquity: A Quest for the Holy Man*. Berkeley: University of California Press.

Miller, Patricia Cox. 1994. "Desert Asceticism and 'The Body from Nowhere.'" *JECS* 2: 137–153.

Miller, Patricia Cox. 1996. "Jerome's Centaur: A Hyper-Icon of the Desert." *JECS* 4: 209–233.

Mischlewski, Adalbert. 1976. *Grundzüge der Geschichte des Antoniterordens bis zum Ausgang des 15. Jahrhunderts*. Cologne: Böhlau.

Mischlewski, Adalbert. 1995. *Un ordre hospitalier au Moyen Age: Les chanoines réguliers de Saint-Antoine-en-Viennois*. Grenoble: Presses universitaires de Grenoble.

Monastery of St. Paul, the Community of Monks of the. 2004. *Al-Sirr al-maktum* (The preserved secret). Cairo: Monastery of St. Paul and Printo Press.

Monferrer-Sala, Juan-Pedro, ed. 2007. *Eastern Crossroads: Essays on Medieval Christian Legacy*. Piscataway, N.J. Gorgias.

Moorsel, Paul van. 1978. "The Coptic Apse-Composition and Its Living Creatures." In Leclant and Verrcoutter 1978, 325–333.

Moorsel, Paul van. 1992. "Treasures from Baramous, with Some Remarks on a Melchizedek Scene." In Rassart-Debergh and Ries 1992, 1: 171–177.

Moorsel, Paul van. 1994. "The Medieval Decoration of the Church of Saint Paul the Hermit as Known by 1700 AD." In Berger, Cleric, and Grimal 1994, 395–401.

Moorsel, Paul van. 1995. "On Medieval Iconography in the Monastery of St. Paul near the Red Sea." In Moss and Kiefer 1995, 283–287.

Moorsel, Paul van. 2000. *Called to Egypt: Collected Studies on Painting in Christian Egypt*. Leiden: Nederlands Instituut voor het Nabije Oosten.

Moorsel, Paul van. 2000a. "The Medieval Iconography of the Monastery of St. Paul as Compared with the Iconography of St. Anthony's Monastery." In van Moorsel 2000, 41–62.

Moorsel, Paul van. 2000b. "On Coptic Apse-Compositions, Among Other Things." In Moorsel 2000, 106–114.

Moorsel, Paul van. 2000c. "The Vision of Philotheus (On Apse-Decorations)." In Moorsel 2000, 91–95.

Moorsel, Paul van. 2002. *Les peintures du monastère de Saint-Paul près de la mer Rouge*. Cairo: IFAO.

Moorsel, Paul van, and Mat Immerzeel. 2000. "A Short Introduction into the Collection of Icons in the Coptic Museum in Old Cairo." In Moorsel 2000, 251–263.

Moorsel, Paul van, Mat Immerzeel, and Linda Langen. 1994. *Catalogue General du Musée Copte: The Icons*. Cairo: Supreme Council of Antiquities Press and Leiden University.

Mora, Paolo, Laura Mora, and Paul Philippot. 1984. *Conservation of Wall Paintings*. London: Butterworths.

Mora, Paolo, Laura Mora, and Paul Philippot. 1996. "Problems of Presentation." In Price, Talley, and Vaccaro 1996, 343–354.

Morisani, Ottavio. 1962. *Gli Affreschi di S. Angelo in Formis*. Naples: Di Mauro Editore.

Moss, Christopher, and Katherine Kiefer, eds. 1995. *Byzantine East, Latin West: Art-Historical Studies in Honor of Kurt Weitzmann*. Princeton: Princeton University Department of Art and Archaeology.

Motzki, Harold. 1991. "Ibrahim al-Jawhari." *CE* 4: 1274.

Al-Muharraqi, ʿAtallah Arsaniyus. 1960. *Kitab al-absal-mudiyya al-sanawiyyah al-muqaddasa* (The book of the psalmody for the whole year). Cairo: Ain Shams.

Müller, Gustav, and Casper Detlef, ed. and trans. 1968. *Die Homilie über die Hochzeit zu Kana und weitere Schriften des Patriarchen Benjamin I. von Alexandrien*. Heidelberg: Carl Winter Universitätsverlag.

Müller-Kessler, Christa. 2004a. "Agnes Smith Lewis." In Matthew and Harrison 2004, 22: 89–90.

Müller-Kessler, Christa. 2004b. "Margaret Dunlop Gibson." In Matthew and Harrison 2004, 33: 579–580.

Mulock, Cawthra, and Martin Telles Langdon. 1946. *The Icons of Yuhanna and Ibrahim the Scribe*. London: Nicholson and Watson.

Musurillo, Herbert. 1954. *The Acts of the Pagan Martyrs: "Acta Alexandrinorum."* Oxford: Clarendon.

Muyser, Jacob. 1953. "Le culte des trois saints jeunes gens chez les Coptes." *CC* 3: 17–31.

Nakhla, Kamil Salih. 2001. *Silsilat tarikh al-babawat batarikat al-kursi al-iskandari* (Series on the history of the popes, the patriarchs of the Alexandrian See). 2nd ed. Wadi al-Natrun, Egypt: Matbaʿat Dayr al-Sayyida al-ʿAdhraʾ (Dayr al-Suryan).

Nau, François. 1901. "Le texte grec original de la *Vie de S. Paul de Thèbes.*" *Analecta Bollandiana* 20: 121–157.

Nelson, Robert S., and Richard Shiff. 2003. *Critical Terms for Art History.* Chicago: University of Chicago Press.

Ogier d'Anglure. 1878. *Le saint voyage de Jherusalem du seigneur d'Anglure.* Ed. François Bonnardot and Auguste Longnon. Paris: Librairie de Firmin Didot.

O'Kane, Bernard. 2003. *Early Persian Painting: Kalila and Dimna Manuscripts of the Late Fourteenth Century.* Cairo: American University in Cairo Press.

Oldfather, William Abbott, ed. 1943. *Studies in the Text Tradition of St. Jeromes's "Vitae Patrum."* Urbana: University of Illinois Press.

O'Leary, De Lacy. 1937. *The Saints of Egypt.* London: Society for Promoting Christian Knowledge; New York: Macmillan.

O'Neill, Aine. 1989. "St. Anthony and St. Paul in the Desert: A Note on a Common Motif on the Crosses of Muiredach and Moone." *Trowel* 2: 17–19.

O'Mahony, Anthony, ed. 1995. *The Christian Heritage in the Holy Land.* London: Scorpion Cavendish.

Oram, Elizabeth E. 2002 "In the Footsteps of the Saints: The Monastery of St. Antony, Pilgrimage, and Modern Coptic Identity." In Bolman 2002, 203–213.

Orlandi, Tito. 1970. *Elementi di lingua e letteratura copta.* Milan: La Goliardica.

Orlandi, Tito. 1991a. "Cyriacus and Julitta, Saints." *CE* 3: 671.

Orlandi, Tito. 1991b. "Isidorus, Saint." *CE* 4: 1307–1308.

Orlandi, Tito. 1991c. "Pantaleon, Saint." *CE* 6: 1881–1882.

Orlandi, Tito. 1991d. "Ter and Erai, Saints." *CE* 7: 2209.

Orlandi, Tito. 1991e. "Theodorus, Saint." *CE* 7: 2237–2238.

Papaconstantinou, Arietta. 2001. *Le culte des saints en Egype des byzantins aux abbasides: L'apport des inscriptions et des papyrus grecs et coptes.* Paris: CNRS Editions.

Pavlock, Barbara. 1990. *Eros, Imitation, and the Epic Tradition.* Ithaca: Cornell University Press.

Pearson, Birger A. 2002. "The Coptic Inscriptions in the Church of St. Antony." In Bolman 2002, 217–239.

Pearson, Birger A., and James E. Goehring, eds. 1986. *The Roots of Egyptian Christianity.* Philadelphia: Fortress.

Peebles, Bernard M., trans. 1949. *Sulpicius Severus: Writings.* In *The Fathers of the Church.* Vol. 7. New York: Fathers of the Church.

Peers, Glenn. 2001. *Subtle Bodies: Representing Angels in Byzantium.* Berkeley: University of California Press.

Pennick, Nigel. 1997. *The Celtic Cross: An Illustrated History and Celebration.* London: Blandford.

Pentcheva, Bissera V. 2000. "Rhetorical Images of the Virgin: The Icon of the 'Usual Miracle' at the Blachernai." *Res* 38: 34–55.

Pérez, Gonzalo Aranda. 1991a. "Gabriel, Archangel." *CE* 4: 1135–1137.

Pérez, Gonzalo Aranda. 1991b. "Raphael." *CE* 7: 2052–2054.

Perlmannn, Moshe, ed. and trans. 1975. *Shaykh Damanhuri on the Churches of Cairo, 1739.* Berkeley: University of California Press.

Petrie, Hilda. 1925. "The Hermitage." In William M. Flinders Petrie 1925, 20–23.

Petrie, William M. Flinders. 1905. *Ehnasya 1904.* London: Egyptian Exploration Fund.

Petrie, William M. Flinders. 1925. *Tombs of the Courtiers and Oxyrhynkhos.* London: British School of Archaeology in Egypt, and Bernard Quaritch.

Piankoff, Alexandre. 1943. "Two Descriptions by Russian Travellers of the Monasteries of St. Anthony and St. Paul in the Eastern Desert." *Bulletin de la Société royale de géographie d'Egypte* 21: 61–66. Cairo: IFAO.

Piankoff, Alexandre. "Thomas Whittemore: Une peinture datée au monastère de Saint-Antoine (avec une planche)." *CC* 7–8: 19–24.

Piankoff, Alexandre, et al. 1930–1940. "History of the Monasteries of St. Anthony and St. Paul." Unpublished manuscript. Washington, D.C.: Dumbarton Oaks, Byzantine Photograph and Fieldwork Archives.

Piltz, Elisabeth. 1997. "Middle Byzantine Court Costume." In Maguire 1997, 39–51.

Pirone, Bartolomeo, trans. 1998. *Al-Muʾtaman Ibn al-ʿAssal, Summa dei principi della Religione.* Vol. 1. Cairo: Franciscan Center of Christian Oriental Studies; Jerusalem: Franciscan Printing Press.

Pirone, Bartolomeo, trans. 2002. *Al-Muʾtaman Ibn al-ʿAssal, Summa dei principi della Religione.* Vol. 2. Cairo: Franciscan Center of Christian Oriental Studies; Jerusalem: Franciscan Printing Press.

Platt, Miss. 1841. *Journal of a Tour Through Egypt, the Peninsula of Sinai, and the Holy Land in 1838, 1839.* 2 vols. London: Richard Watts.

Plesch, Julius. 1910. *Die Originalität und literarische Form der Mönchsbiographien des hl. Hieronymus: Program zum Jahresbericht über das K. Wittelsbacher Gymnasium in München für das Schuljahr 1909/10.* Munich: K. Wittelsbacher Gymnasium.

Pococke, Richard. 1743. *A Description of the East, and Some Other Countries. Volume the First: Observations on Egypt*. London: W. Bowyer.

Podskalsky, Gerhard, and Anna Gonosová. 1991. "Angel." *ODB* 1: 97.

Potvin, Charles, and Jean-Charles Houzeau, eds. 1878. *Oeuvres de Ghillebert de Lannoy, voyageur, diplomate et moraliste*. Louvain: Lefever.

Power, Conor M. 2001. "Structural Stability Survey of the Cave Church of Saint Paul of Thebes, Egypt." Unpublished report submitted to ARCE, April 17, 2001.

Price, Nicholas, M. Kirby Talley Jr., and Alessandra Melucco Vaccaro, eds. 1996. *Historical and Philosophical Issues in the Conservation of Cultural Heritage. Readings in Conservation*. Los Angeles: Getty Conservation Institute.

Qasim, Qasim Abdu. 1977. *Ahl al-dhimma fi Misr, al-ʿusur al-wusta* (People of the dhimma in Egypt in the middle ages). Cairo: Dar al-Maʿarif.

Rassart-Debergh, Marguerite. 1991. "Dayr Apa Jeremiah: Paintings." *CE* 3: 777–779.

Rassart-Debergh, Marguerite, and Julien Ries, eds. 1992. *Acte du IVe Congrès copte, Louvain-la-Neuve 5-10 Septembre 1988*. 2 vols. Louvain-la-Neuve: Institut orientaliste de Louvain.

Ratnam, Niru. 2004. "Dusty Mannequins: Modern Art and Primitivism." In Edwards and Wood 2004, 156–183.

Raymond, André. 2000. *Cairo: City of History*. Cambridge, Mass.: Harvard University Press.

Raymond, André. 2001. *Le Caire des Janissaires: L'apogée de la ville ottomane sous ʿAbd al-Râhman Katkhudâ*. Paris: CNRS Editions.

Rebenich, Stefan. 1992. *Hieronymus und sein Kreis: Prosopographische und sozialgeschichtliche Untersuchungen*. Stuttgart: Franz Steiner.

Regnault, Lucien. 1991a. "Apophthegmata Patrum." *CE* 1: 177–178.

Regnault, Lucien. 1991b. "Arsenius of Scetis and Turah, Saint." *CE* 1: 240–241.

Regnault, Lucien. 1991c. "John Colobos, Saint: Coptic Tradition." *CE* 5: 1359–1361.

Regnault, Lucien. 1991d. "Moses the Black, Saint." *CE* 5: 1681.

Regnault, Lucien. 1999. *The Day-to-Day Life of the Desert Fathers in Fourth-Century Egypt*. Petersham, Mass.: St. Bede's.

Rhodes, Colin. 2000. *Outsider Art: Spontaneous Alteratives*. London: Thames and Hudson.

Rice, Eugene. 1985. *Saint Jerome in the Renaissance*. Baltimore: Johns Hopkins University Press.

Riottot, Alain. 2003. "Claude Granger: Voyageur-naturaliste (1730–1737)." Ph.D. diss., Université de Paris 7–Denis Diderot.

Roberts, Alexander, trans. 1989. "The Works of Sulpitius Severus." In Schaff and Wace 1989, 1–122.

Rorimer, James, ed. 1958. *The Belles Heures of Jean, Duke of Berry, Prince of France*. New York: Metropolitan Museum of Art, The Cloisters.

Rosenstiehl, Jean-Marc, ed. 1995. *Christianisme d'Egypte: Hommages à René-Georges Coquin*. Louvain: Peeters.

Rousseau, Philip. 1978. *Ascetics, Authority, and the Church in the Age of Jerome and Cassian*. Oxford: Oxford University Press.

Rubenson, Samuel. 1996. "Translating the Tradition: Some Remarks on the Arabization of the Patristic Heritage in Egypt." *Medieval Encounters* 2: 4–14.

Rubin, William, ed. 1984. *Primitivism in Twentieth Century Art*. 2 vols. New York: Museum of Modern Art.

Rubin, William. 1984a. "Picasso." In Rubin 1984, 1: 240–343.

Rufaʾil, Yaʿqub Nakhla. 2000. *Tarikh al-umma al-qibtiyya* (History of the Coptic community). Cairo: St. Mark Foundation for Coptic History Studies.

Ruggiero, F., ed. 2003. *Sulpicius Severus: Vita de Martino*. Bologna: EDB.

Russell, Norman, trans. 1980. *The Lives of the Desert Fathers: "Historia Monachorum in Aegypto."* London: Mowbray; Kalamazoo, Mich.: Cistercian.

Sadek, Ashraf, and Bernadette Sadek. 2000. *L'Incarnation de la Lumière. Le renouveau iconographique copte à travers l'oeuvre d'Isaac Fanous*. Limoges: Le Monde Copte.

Samir, Samir Khalil, ed. 1985. *Al-Safi ibn al-ʿAssal: Brefs chapitres sur la Trinité et l'Incarnation*. Turnhout, Belgium: Brepols.

Samir, Samir Khalil. 1986. "Arabic Sources for Early Egyptian Christianity." In Pearson and Goehring 1986, 82–97.

Samir, Samir Khalil. 1991a. "Gabriel VI." *CE* 4: 1130–1133.

Samir, Samir Khalil. 1991b. "Jirjis al-Jawhari al-Khanani." *CE* 4: 1334–1335.

Samir, Samir Khalil. 1991c. "Marqus al-Antuni." *CE* 5: 1542.

Samir, Samir Khalil. 1991d. "Victor of Shu." *CE* 7: 2302.

Samir, Samir Khalil. 1994. "La version arabe des évangiles d'al-Asʿad Ibn al-ʿAssal." *Parole de l'Orient* 19: 441–550.

Sauget, Joseph-Marie. 1983. "Trois recueils de discours de Grégoire de Nazianze en traduction arabe: Simples réflexions sur leur structure." *Augustinianum* 23: 487–515.

Sauneron, Serge, ed. 1971. *Voyages en Egypte de Jean Coppin 1638–1639, 1643–1646.* Cairo: IFAO.

Sauneron, Serge, and Jean Jaquet. 1972. *Les ermitages chrétiens du désert d'Esna.* Vol. 1. Cairo: IFAO.

Schaff, Philip, and Henry Wace, eds. 1989. Reprint of the 1890–1898 ed. *Nicene and Post-Nicene Fathers.* 2nd ser., vol. 6: *The Principal Works of Jerome.* Edinburgh: T and T Clark; Grand Rapids, Mich.: Eerdmans.

Schaff, Philip, and Henry Wace, eds. 1989. Reprint of the 1890–1898 ed. *Nicene and Post-Nicene Fathers.* 2nd ser., vol. 11: *Sulpitius Severus, Vincent of Lerins, John Cassian.* Edinburgh: T and T Clark; Grand Rapids, Mich.: Eerdmans.

Schama, Simon. 1995. *Landscape and Memory.* New York: Knopf.

Schefer, Charles. 1884. *Le voyage d'outremer de Jean Thenaud: Suivi de la relation de l'ambassade de Domenico Trevisan auprès du Soudan d'Egypte 1512.* Paris: Ernst Leroux.

Schiller, Gertrud. 1971. *Iconography of Christian Art.* Vol. 1. Greenwich, Conn.: New York Graphic Society.

Schneemelcher, Wilhelm. 1991. *New Testament Apocrypha.* 2 vols. Cambridge: James Clark.

Schweinfurth, Georg. 1922. *Auf unbetretenen Wegen in Aegypten.* Hamburg: Hoffmann und Campe.

Ševčenko, Nancy P. 1979. "Bread Stamps with St. Philip." In Weitzmann 1979, 590–591.

Sharpe, Samuel. 1876. *The History of Egypt from the Earliest Times till the Conquest by the Arabs AD 640.* Vol. 2. London: George Bell and Sons.

Shaw, Stanford. 1962. *The Financial and Administrative Organization of Ottoman Egypt, 1517–1798.* Princeton: Princeton University Press.

Shenouda III, Committee Formed by His Holiness Pope. 1993. *The Coptic Liturgy of St. Basil.* Cairo: St. John the Beloved Publishing House.

Shoucri, Mounir. 1991. "Macarius III." *CE* 5: 1488–1489.

Sicard, Claude. 1725. "Lettre du Père Sicard, Missionnaire de la Compagnie de Jésus en Egypte. Au Père Fleuriau, de la même Compagnie." In *Nouveaux mémoires des missions de la Compagnie de Jésus dans le Levant* 5: 122–200. Paris: Guillaume Cavelier.

Sicard, Claude. 1982. *Oeuvres.* Vol. 1: *Lettres et relations inédites.* Ed. Maurice Martin. Cairo: IFAO.

Sidarus, Adel. 2002. "The Copto-Arabic Renaissance in the Middle Ages: Characteristics and Socio-Political Context." *Coptica* 1: 41–60.

Sidebotham, Steven, and Willemina Wendrich. 1996. *Preliminary Report of the Excavations at Berenike (Egyptian Red Sea Coast) and the Survey of the Eastern Desert.* Leiden: Research School CNWS.

Sidebotham, Steven, and Willemina Wendrich. 1998. *Preliminary Report of the Excavations at Berenike (Egyptian Red Sea Coast) and the Survey of the Eastern Desert.* Leiden: Research School CNWS.

Simaika, Marqus. 1932. *Guide to the Coptic Museum.* Vol. 2. Cairo: al-Matbaʿat al-Amiriyya.

Simaika, Marqus. 1942. *Catalogue of the Coptic and Arabic Manuscripts in the Coptic Museum, the Patriarchate, the Principal Churches of Cairo and Alexandria, and the Monasteries of Egypt.* Vol. 2, Fasc. 1. *Catalogue of the Manuscripts in the Library of the Coptic Patriarchate.* Cairo: Publications of the Coptic Museum.

Skalova, Zuzana. 1990a. "Conservation Problems in Egypt: Introductory Report on the Condition and Restoration of Post-Medieval Coptic Icons." Hondelink 1990, 73–88.

Skalova, Zuzana. 1990b. "Les vicissitudes des icons: Problemes de conservation en Egypte." *Le Monde Copte* 18: 111–121.

Skalova, Zuzana. 2005. "A Holy Map to Christian Tradition: Preliminary Notes on Painted Proskynetaria of Jerusalem in the Ottoman Era." *ECA* 2: 93–103.

Skalova, Zuzana. 2006a. "Catalogue." In Skalova and Gabra 2006, 159–244.

Skalova, Zuzana. 2006b. "History of Icon Painting in Egypt and Sinai." In Skalova and Gabra 2006, 44–158.

Skalova, Zuzana, and Gawdat Gabra. 2006. *Icons of the Nile Valley.* Cairo: Egyptian International–Longman.

Smith, Jonathan Z. 1987. *To Take Place: Toward Theory in Ritual.* Chicago: University of Chicago Press.

Somigli di S. Detole O. F. M., Teodosio. 1913. *Il P. Fortunato Vignozzi da Seano O. F. M. Missionario apostolico nell'Alto Egitto (1857–1912).* Florence: Quaracchi.

Starkey, Paul, and Janet Starkey, eds. 1998. *Travellers in Egypt.* London: Tauris.

Starkey, Paul, and Janet Starkey, eds. 2001. *Unfolding the Orient: Travellers in Egypt and the Near East.* Reading, U.K.: Ithaca.

Steidle, Basilii, ed. 1956. *Antonius Magnus Eremita.* Rome: Herder.

Stewart, Aubrey 1887. *Of the Holy Places Visited by Antoni-nus Martyr.* London: Palestine Pilgrims' Text Society.

Stewart, Randall. 1991. "Archon." *CE* 1: 229.

Stratton-Pruitt, Suzanne L., ed. 2002. *The Cambridge Companion to Velázquez.* Cambridge: Cambridge University Press.

Strzygowski, Josef. 1902–1903. "Der koptische Reiter-heilige und der hl. Georg." *Zeitschrift für Ägyptische Sprache und Altertumskunde* 40: 49–60.

Stylianou, Andreas, and Judith Stylianou. 1997. *The Painted Churches of Cyprus.* Nicosia, Cyprus: A. G. Leventis Foundation.

Swanson, Mark N. 2002. "'Our Brother, the Monk Eustathius': A Ninth-Century Syrian Orthodox Theologian Known to Medieval Arabophone Copts." *Coptica* 1: 119–140.

Swanson, Mark N. 2004. "Recent Developments in Copto-Arabic Studies: 1996–2000." In Immerzeel and van der Vliet 2004, 1: 239–267.

Swanson, Mark N. 2007. "'Our Father Abba Mark': Mar-qus al-Antuni and the Construction of Sainthood in Fourteenth-Century Egypt." In Monferer-Sala 2007, 217–228.

Swanson, Mark N. Forthcoming. *The Coptic Papacy in Islamic Egypt.* Ed. Stephen J. Davis and Gawdat Gabra. Vol. 2: *The Popes of Egypt.* Cairo: American University in Cairo Press.

Temkin, Ann. 1987. "Klee and the Avant-Garde, 1912–1940." In Lanchner 1987, 13–37.

Terry, Ann, and Henry Maguire. 2007. *Dynamic Splen-dor: The Wall Mosaics in the Cathedral of Eufrasius at Poreč.* 2 vols. University Park: Pennsylvania State University Press

Thierry, J. J. 1963. "The Date of the Dream of Jerome." *Vigiliae Christianae* 17: 28–40.

Thierry, Nicole. 1998. "Les peintures de Deir Abou Hen-nis." *Solidarité-Orient.* Bulletin 207, part 2: 5–16.

Thomas, Thelma K. "Christians in the Islamic East." In Evans and Wixom 1997, 364–371.

Thompson, Jason. 1992. *Sir Gardner Wilkinson and His Circle.* Austin: University of Texas Press.

Tkacz, Catherine Brown. 1997. "Ovid, Jerome and the Vulgate." *Studia Patristica* 33: 378–382.

Tkacz, Catherine Brown. 1999. "*Quid Facit Cum Psalterio Horatius?* Seeking Classical Allusions in the Vulgate." In Kries and Tkacz 1999, 93–104.

Török, László. 2005. *Transfigurations of Hellenism: Aspects of Late Antique Art in Egypt AD 250–700.* Leiden: Brill.

Trebbin, Heinrich. 1994. *Sankt Antonius: Geschichte, Kult und Kunst.* Frankfurt am Main: Haag and Herchen.

Tribe, Tania C. 2004. "Icon and Narration in Eighteenth-Century Christian Egypt: The Works of Yuhanna al-Armani al-Qudsi and Ibrahim al-Nasikh." *Art History* 27: 62–94.

Troupeau, Gérard. 1972. *Catalogue des manuscrits arabes.* Part 1: *Manuscrits chrétiens.* Vol. 1: *Manuscrits dispersés entre les nos. 1–323.* Paris: Bibliothèque Nationale.

Troupeau, Gérard. 1974. *Catalogue des manuscrits arabes.* Part 1: *Manuscrits chrétiens Vol. 2: Manuscrits dispersés entre les nos. 780 et 6933.* Paris: Bibliothèque Natio-nale.

Al-Tukhi, Rushdi. 1991. "John XVI." *CE* 4: 1347–1348.

'Uryan, Ayman. 2002. *Barr fi kanisat al-abkar: al-qummus Marqus al-Anba Bula, siratuhu wa-khidma-tuhu wa-mu'jizatuhu* (A righteous man in the church of the pure: Hegumenos Marqus al-Anba Bula, his life, service, and miracles). Vol. 1. Cairo: Silsilat al-Injil al-Mu'ash.

Van Buren, Albert William. *See* Buren, Albert William van

Van Doorn, Nelly. *See* Doorn, Nelly van

Van Esbroeck, Michel. *See* Esbroeck, Michel van

Van Loon, Gertrud J. M. *See* Loon, Gertrud J. M. van

Van Moorsel, Paul. *See* Moorsel, Paul van

Veilleux, Armand. 1991. "Pachomius, Saint." *CE* 6: 1859–1864.

Vikan, Gary. 1982. *Byzantine Pilgrimage Art.* Washington, D.C.: Dumbarton Oaks.

Villecourt, Louise 1925. "Les observances liturgiques et la discipline du jeûne dans l'église copte." *Le Muséon* 38: 261–320.

Vivian, Tim. 1996. *Journeying into God: Seven Early Mo-nastic Lives.* Minneapolis: Fortress.

Vivian, Tim. 1998–1999. "Ama Sibylla of Saqqara: Prior-ess or Prophet, Monastic or Mythological Being?" *Bulletin of the Saint Shenouda the Archimandrite Coptic Society* 5: 1–17.

Vivian, Tim. 2002. "St. Antony the Great and the Mon-astery of St. Antony at the Red Sea, ca. AD 251 to 1232/1233." In Bolman 2002, 3–16.

Vivian, Tim, and Apostolos N. Athanassakis, trans. 2003. *The Life of Antony by Athanasius of Alexanderia.* Kalamazoo, Mich.: Cistercian.

Volkoff, Oleg E. 1970. *A la recherche de manuscrits en Egypte.* Cairo: IFAO.

Wadi Abuliff. 1997. *Studio su al-Muʾtaman Ibn al-ʿAssal.* Cairo: Franciscan Center of Christian Oriental Studies; Jerusalem: Franciscan Printing Press.

Wadi Abuliff, ed. 1998–1999. *Al-Muʾtaman Ibn al-ʿAssal, Summa dei principi della Religione.* 4 vols. Cairo: Franciscan Center of Christian Oriental Studies; Jerusalem: Franciscan Printing Press.

Wadi Abuliff. 1998–1999a. "Giovanni di Numrus." In *Enciclopedia dei santi: Le chiese orientali.* 1: 1157–1158. Rome: Città Nuova.

Wadi Abuliff. 1998–1999b. "Marco l'Antoniano." In *Enciclopedia dei santi: Le chiese orientali.* 2: 410–413. Rome: Città Nuova.

Wadi Abuliff. 1998–1999c. "Quarantanove Martiri." In *Enciclopedia dei santi: Le chiese orientali.* 2: 866–868. Rome: Città Nuova.

Wansink, Craig S., trans. 1991. "Encomium on the Four Bodiless Living Creatures." In Depuydt 1991, 27–47.

Ward, Benedicta, trans. 1975. *The Sayings of the Desert Fathers: The Alphabetical Collection.* Oxford: Mowbray; Kalamazoo, Mich.: Cistercian.

Ward, Benedicta. 1980. "Introduction." In Russell 1980, 1–46.

Watson, Andrew. 1898. *The American Mission in Egypt, 1854 to 1896.* Pittsburgh: United Presbyterian Board of Publication.

Weir, Hilary. 1991. "Anglican Church in Egypt." *CE* 1: 133.

Weitzmann, Kurt. 1974. "*Loca Sancta* and the Representational Arts of Palestine." *Dumbarton Oaks Papers* 28: 31–55.

Weitzmann, Kurt, ed. 1979. *Age of Spirituality: Late Antique and Early Christian Art, Third to Seventh Century.* New York: Metropolitan Museum of Art and Princeton University Press.

Weitzmann, Kurt, ed. 1982. *The Icon.* New York: Knopf.

Weitzmann, Kurt. 1982a. "The Icons of Constantinople." In Weitzmann 1982, 11–83.

Wessel, Klaus. 1965. *Coptic Art.* New York: McGraw-Hill.

White, Carolinne, trans. 1998. *Early Christian Lives.* London: Penguin.

White, Carolinne, trans. 1998a. "Life of Antony by Athanasius." In White 1998, 1–70.

White, Carolinne, trans. 1998b. "Life of Hilarion by Jerome." In White 1998, 85–115.

White, Carolinne, trans. 1998c. "Life of Martin of Tours by Sulpicius Severus." In White 1998, 129–159.

White, Carolinne, trans. 1998d. "Life of Paul of Thebes by Jerome." In White 1998, 71–84.

Wilken, Robert. 1992. *The Land Called Holy: Palestine in Christian History and Thought.* New Haven: Yale University Press.

Wilkinson, John Gardner. 1832. "Notes on a Part of the Eastern Desert of Upper Egypt." *Journal of the Royal Geographical Society of London* 2: 28–60.

Wilkinson, John Gardner. 1847. *Hand-book for Travellers in Egypt.* London: John Murray.

Wilkinson, John. 1999. *Egeria's Travels.* Warminster, U.K.: Aris and Phillips.

Wilkinson, John. 2002. *Jerusalem Pilgrims Before the Crusades.* Rev. ed. Warminster, U.K.: Aris and Phillips.

Williams-Thorpe, O., and R. S. Thorpe. 1993. "Geochemistry and Trade of Eastern Mediterranean Millstones from the Neolithic to Roman Times." *Journal of Archaeological Science* 20: 263–320.

Wimbush, Vincent L. 1990. *Ascetic Behavior in Greco-Roman Antiquity: A Sourcebook.* Minneapolis, Minn.: Fortress.

Winkelmann, Friedhelm, ed. 1991. *Eusebius Werke.* Vol. 1: *Über das Leben des Kaisers Konstantin.* 2nd ed. GCS. Berlin: Akademie.

Winstedt, Eric Otto, ed. and trans. 1979. Reprint of the 1910 ed. *Coptic Texts on St. Theodore.* Amsterdam: APA–Philo.

Winter, Michael. 1992. *Egyptian Society Under Ottoman Rule.* London: Routledge.

Wreszinski, Walter. 1902. "Zwei koptische Bau Urkunden." *Zeitschrift für Ägyptische Sprache und Altertumskunde* 40: 62–65.

Wright, William 1871. *Catalogue of Syriac Manuscripts in the British Museum Acquired since the Year 1838.* Vol. 2. London: British Museum.

Yapp, Malcolm E. 1987. *The Making of the Modern Near East, 1792–1923.* London: Longman.

Young, Robert. 1981. *Untying the Text: A Post-Structuralist Reader.* Boston: Routledge and Kegan Paul.

Youssef, Youhanna Nessim. 2003. "The Icon Writer Hanna al-Armani According to an Ottoman Legal Document." *AI* 37: 443–448.

Yuhanna, Mansi. 1983. *Tarikh al-kanisa al-qibtiyya* (History of the Coptic Church). Cairo: Maktaba al-Mahabba.

Zaganelli, Gioia, ed. 1990. *La lettera del Prete Gianni.* Parma: Pratiche Editrice.

Zanetti, Ugo. 1986. *Les manuscrits de Dair Abu Maqar: Inventaire.* Geneva: Patrick Cramer.

Zanetti, Ugo. 1991a. "Les icônes chez les théologiens de l'église copte." *Le Monde Copte* 19: 77–92.

Zanetti, Ugo. 1991b. "La prière copte de consécration d'une icône." *Le Monde Copte* 19: 93–100.

Zanetti, Ugo. 1995. "Un index liturgique du Monastère Blanc." In Rosenstiehl 1995, 55–75.

Zibawi, Mahmoud. 1994. *Orients chrétiens: entre Byzance et l'Islam.* Paris: Desclée.

Zibawi, Mahmoud. 2003. *Images de l'Egypt chrétienne: Iconologie copte.* Paris: A. et J. Picard.

Zibawi, Mahmoud. 2005. *Bagawat: Peintures paléochrétiennes d'Egypte.* Paris: A. et J. Picard.

Ziermann, Horst, with Erika Beissel. 2001. *Matthias Grünewald.* New York: Prestel.

Contributors

Febe Armanios is assistant professor of Middle East history at Middlebury College, Vermont. She has published various articles, including "A Christian Martyr Under Mamluk Justice: The Trials of Salib (d. 1512)," written with Boğaç Ergene, in *Muslim World* (2006), and "The Virtuous Woman: Images of Gender in Modern Coptic Society" in *Middle Eastern Studies* (2002). Her research interests include Coptic-Muslim relations in the Ottoman era and comparative popular religion in modern Egyptian society. Armanios is currently preparing a book on Coptic religious practices in Egypt during the sixteenth to the eighteenth centuries.

Elizabeth S. Bolman is associate professor of medieval art at Temple University, Philadelphia, and adjunct associate professor at the University of Pennsylvania. She edited and was the principal contributor to *Monastic Visions: Wall Paintings in the Monastery of St. Antony at the Red Sea* (Yale University Press and ARCE, 2002). Bolman is currently writing a gender studies analysis of depictions of the Galaktotrophousa (the nursing Virgin Mary) in the late antique and middle Byzantine periods. She is the director of two site-specific projects in Sohag, Egypt: the conservation of the wall painting at the Red Monastery, and a multidisciplinary study of the White Monastery.

Stephen J. Davis is associate professor of religious studies at Yale University, specializing in the history of ancient and early medieval Christianity. He is author of *The Cult of St. Thecla: A Tradition of Women's Piety in Late Antiquity* (Oxford University Press, 2001) and

The Early Coptic Papacy: The Egyptian Church and Its Leadership in Late Antiquity (American University in Cairo Press, 2004). He is director of the Egyptian Delta Monastic Archaeology Project (EDMAP).

Luigi De Cesaris is a master conservator and former teacher at the Istituto Centrale del Restauro in Rome. He worked with Paolo and Laura Mora on the wall paintings in the tomb of Nefertari in Luxor, and on numerous projects with his colleague Adriano Luzi, including the conservation of Bernini's *Ecstasy of St. Teresa* in Rome. De Cesaris and Luzi collaborated with ARCE on the preservation of the Coptic wall paintings at the monasteries of St. Antony and St. Paul. Following Luzi's death in 2003, De Cesaris continued working on behalf of ARCE. He is currently cleaning and conserving the wall paintings at the Red Monastery at Sohag, dedicated to St. Bishoi, as well as the early fourth-century Roman paintings in the Temple of Luxor. In 2004, De Cesaris received the Chevalier des Arts et Lettres for his contribution to the conservation of the cultural heritage of the French Republic.

Maximous El-Anthony, a monk at the Monastery of St. Antony, has been involved in many aspects of conservation work throughout Egypt. He was instrumental in persuading ARCE to clean and preserve the thirteenth-century wall paintings in the Church of St. Antony at the Monastery of St. Antony and has worked closely with Adriano Luzi, Luigi De Cesaris, and Alberto Sucato on other ARCE conservation campaigns at the Monastery of St. Paul, the Church of St.

Sergius and St. Bacchus (Abu Sarga), and the Coptic Museum. Father Maximous was a member of the ARCE Coptic Icon project and is currently directing the excavation of late antique monastic cells discovered recently in the Monastery of St. Antony. On behalf of the Coptic Church, he established a museum at the Monastery of St. Antony and organized the conservation of the twentieth-century wall paintings of the Church of St. Mary in Zatun, the site of a celebrated apparition of the Virgin in 1968.

Gawdat Gabra is the former director of the Coptic Museum, a member of the board of the Society of Coptic Archaeology, and chief editor of the St. Mark Foundation for Coptic History Studies. He is the author, coauthor, and editor of numerous books related to the literary and material culture of Egyptian Christianity, including *Coptic Monasteries: Egypt's Monastic Art and Architecture* (American University in Cairo Press, 2002) and *Christianity and Monasticism in the Fayoum Oasis* (St. Mark Foundation and American University in Cairo Press, 2005.) Gabra is currently visiting professor of Coptic Studies at Claremont Graduate University.

Patrick Godeau is a freelance professional photographer specializing in monuments under conservation. He has worked throughout the Mediterranean area, on projects in Italy, Egypt, Syria, and Cyprus. Godeau has been a consultant for ARCE since 1994 and is documenting the group's ongoing conservation of the Coptic wall paintings at the Red Monastery in Sohag. Based in Egypt for many years, Godeau now lives in Rome.

Alastair Hamilton is emeritus professor of the history of the Radical Reformation at the University of Amsterdam and former C. Louise Thijssen-Schoute Professor of the History of Ideas at Leiden University. He is now the Arcadian Visiting Research Professor at the School of Advanced Study, London University, attached to the Warburg Institute. He has published extensively on western ecclesiastical history in the sixteenth century and on relations between Europe and the Arab world. His publications include *The Copts and the West, 1439–1822: The European Discovery of the Egyptian Church* (Oxford University Press, 2006). Hamilton is a Fellow of the British Academy.

Michael Jones is an archaeologist who has worked at numerous sites in Egypt since the 1970s. In 1996 he joined ARCE to manage the conservation projects at the Monastery of St. Antony, the Monastery of St. Paul, the Ottoman Fort at al-Qusair, and the Tomb of Sety I in the Valley of the Kings. He is now associate director at ARCE for Egyptian antiquities conservation projects. Jones has published numerous articles on his work and was a contributor to Elizabeth S. Bolman's *Monastic Visions: The Wall Paintings in the Monastery of St. Antony at the Red Sea.*

William Lyster is an independent scholar specializing in Coptic and Islamic art and architecture. He has lived in Cairo for thirty years and has acquired an in-depth familiarity with the historic monuments of Egypt. Lyster contributed to Elizabeth S. Bolman's *Monastic Visions: The Wall Paintings in the Monastery of St. Antony at the Red Sea* and Gawdat Gabra's *Be Thou There: The Holy Family's Journey in Egypt* (American University in Cairo Press, 2001). He is the author of *Monastery of St. Paul*, a guide published in 1999 by ARCE on behalf of the monastic community of St. Paul's.

Gerry D. Scott III holds a doctoral degree in Egyptology from Yale University with a specialty in ancient Egyptian art history. He has held various curatorial and administrative appointments in leading American museums, and he became the director of ARCE in 2003.

Peter Sheehan is an archaeologist who has been based in Egypt since 1989. Most of this time he has worked in and around the Roman fortress of Babylon in Old Cairo, on which he has published a number of articles and is currently completing a book. Sheehan is also involved with survey and archaeological research projects at a number of important Egyptian Christian sites, notably the Red Sea monasteries and the White Monastery of St. Shenoute at Sohag.

Mark N. Swanson is the Harold S. Vogelaar Professor of Christian-Muslim Studies and Interfaith Relations at the Lutheran School of Theology at Chicago. He taught for many years at the Evangelical Theological Seminary in Cairo, and he received his doctorate from the Pontificio Istituto di Studi Arabi e d'Islamistica

(PISAI) in Rome. He is the author of numerous studies in early Arabic Christian literature, including that of the Coptic Orthodox Church. Swanson recently edited (with Emmanouela Grypeou and David Thomas) *The Encounter of Eastern Christianity with Early Islam* (Brill, 2006), and is preparing a book on the medieval Coptic patriarchs for the American University in Cairo Press.

Alberto Sucato is a graduate of the Istituto Centrale del Restauro and the Università degli Studi di Roma (La Sapienza). A key member of the conservation team of Luigi De Cesaris and Adriano Luzi, he worked on both the ARCE projects at the Red Sea monasteries. Since Luzi's death Sucato has collaborated with De Cesaris on the ARCE wall painting conservation missions at the Red Monastery at Sohag, and at the Temple of Luxor. He was the field director of the ARCE Coptic Museum wall painting project, and chief conservator of the recently uncovered medieval Coptic paintings in the Church of St. Sergius and St. Bacchus (Abu Sarga) in Old Cairo. Sucato is currently working with De Cesaris on a project in Cyprus to conserve the altar, ciborium, and iconostasis of the Cathedral of St. Mamas in Morphou.

Robert K. Vincent, Jr., has worked in archaeology and heritage conservation in the Near and Middle East since 1968. He was the president of the Institute of Nautical Archaeology at Texas A&M University and is a graduate of Yale University and the University of Pennsylvania Law School. From 1994 to 2004 he was the director of the Egyptian Antiquities Project at ARCE, responsible for numerous conservation missions in Egypt, including the monasteries of St. Antony and St. Paul.

Nicholas Warner is an architect and architectural historian trained at Cambridge University. He came to Egypt in 1992 to conduct research on the Islamic architecture of Cairo. Since then he has participated in or directed numerous projects related to the documentation, preservation, and presentation of historic structures and archaeological material throughout Egypt. His recent books include *The Monuments of Historic Cairo: A Map and Descriptive Catalogue* (American University in Cairo Press, 2005) and *The True Description of Cairo: A Sixteenth-Century Venetian View* (Oxford University Press, 2006).

INDEX

Illustration Credits

All photographs with the prefix ADP/SP or ADP/SA are by Patrick Godeau, copyright © ARCE. All photographs with the prefix EG are copyright © ARCE.

All plans, maps, and architectural drawings are by Nicholas Warner, copyright © ARCE, unless otherwise noted. All graphic documentation of the conservation of the Cave Church are by Sergio Tagliacozzi and Maria Antonietta Gorini, copyright © ARCE.

Elizabeth S. Bolman (figs. 23, 5.3, 9.10, 9.11, 9.21, 10.9, 35); Joseph Bonomi in Sharp 1876, vol. 2, pp. 350, 351, figs. 132, 133 (figs. 4.3, 4.4); Sarapamon al-Anba Bula (fig. 26); *Description de l'Egypte: Etat Moderne* (1813), vol. 1, pls. 43, 67, 68 (figs. 3.3, 3.5, 3.2); Ashraf Faris (figs. 3.1, 11.6, 12.48, 12.49, 12.51, 12.52); Patrick Godeau (figs. 3, 2.1, 2.13, 4.1, 7.6, 8.13, 8.21); Johann Georg Herzog zu Sachsen 1936, pp. 15, 20, 22, figs. 32, 43, 47 (figs. 4.11, 2.6, 4.12); Michael Jones (6.11, 7.12, 8.2, 8.9, 8.20, 29); Lewis 1904, pp. 751, 752 (figs. 4.6, 4.7); Erich Lessing/Art Resource, NY (figs. 1.7, 1.8, 1.9, 11.3); Tim Loveless (fig. 9.20); William Lyster (figs. 2.9, 2.10, 5.4, 5.5, 5.6, 10.28, 12.2, 12.3, 12.5, 12.12, 12.16, 12.18, 12.23, 12.44, 12.45, 12.46, 12.47, 34); J. C. Montgomerie in Hewison 1914, frontispiece (fig. 1.5); Richard Pococke 1743, vol. 1, p. 128, pl. 51 (fig. 4.1); Scala/Art Resource, NY (fig. 1.1); Georg Schweinfurth 1922, opposite p. 162. (fig. 4.5); Robert K. Vincent (figs. 4, 5, 6.22, 7.16, 8.2, 8.7, 8.25).